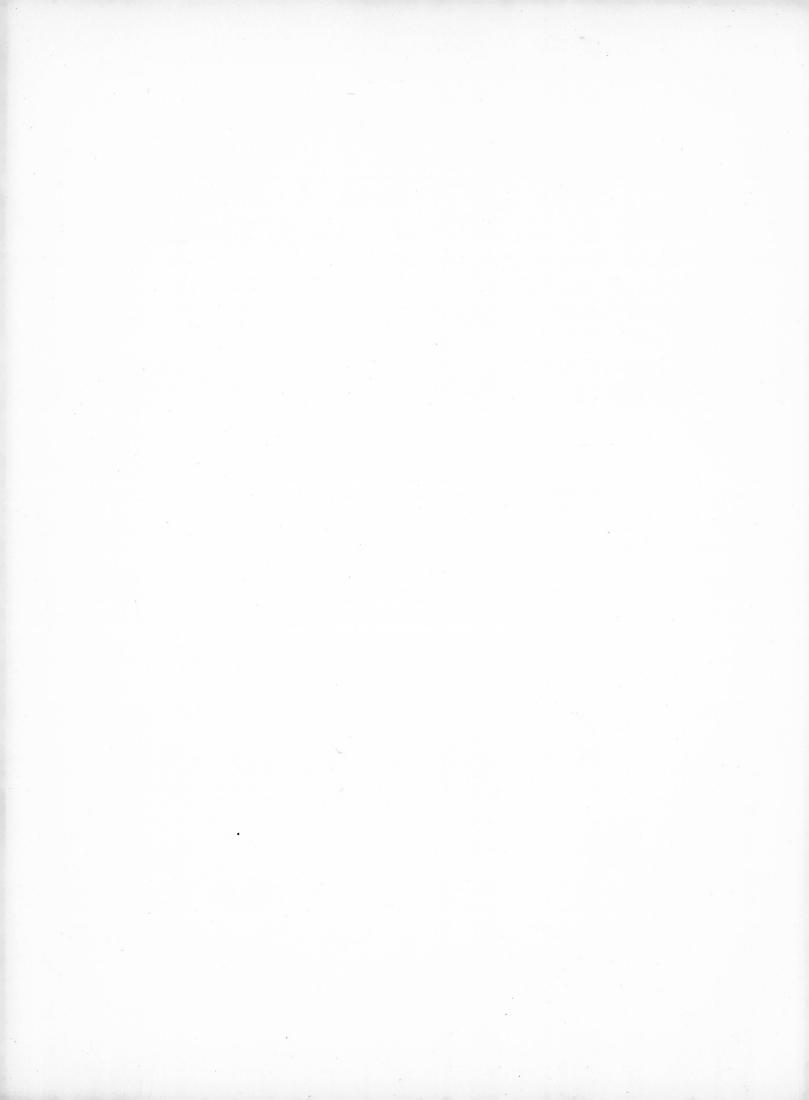

The Tamarind
Book of Lithography:
Art & Techniques

The Tamarind Book of Lithography: Art & Techniques

Garo Z. Antreasian
PROFESSOR OF ART, UNIVERSITY OF NEW MEXICO

with Clinton Adams
DEAN, COLLEGE OF FINE ARTS, UNIVERSITY OF NEW MEXICO

TAMARIND LITHOGRAPHY WORKSHOP INC., LOS ANGELES
HARRY N. ABRAMS, INC., PUBLISHERS, NEW YORK
1971

Standard Book Number: 8109-9017-2
Library of Congress Catalogue Card Number: 76-121328
All rights reserved. No part of the contents of this book may be
reproduced without the written permission of the publishers
Harry N. Abrams, Incorporated, New York, N.Y.
Printed and bound in Japan by Toppan Printing Co., Ltd.
Book design: Ben Feder

Preface

When, in 1959, I designed the Tamarind project, the art of lithography had gone into a grave decline in both Europe and the United States. The reasons for that decline were different on each continent, but the results were the same: master printers were extinct in the United States and were dying out in Europe.

In Europe, paradoxically, lithography had sickened as the art market grew. High-priced School of Paris artists enjoyed a profitable secondary market for their graphics among buyers who could not afford their paintings. To save the time of noted artists, a covert practice grew: sketches, gouaches, and even canvases were taken to master printers to "interpret" onto stone in place of the artists—to draw the images as well as print them. It was only a short step from making these "interpretations" by hand to making photolithographic reproductions by machine, which then were sold as original lithographs although only the artists' signatures were bona fide. When I worked in Paris, the master printers I knew wryly referred to themselves as "esclaves" and "faux monnayeurs." Nor were apprentices attracted to the once proud métier: the pay was too low and the morale even lower. At this writing, the best of the European master printers are over sixty, and their names are unknown except to a handful of us within the field.

By contrast, in the United States there had been no significant market for paintings by living American artists until the fifties, so it goes without saying that graphics went begging at five dollars a piece. Half a dozen or so hand-proofers, from commercial shops, collaborated with artists for brief periods, but they depended on industrial offset lithography to earn their living. The medium really was kept alive by artists who printed their own stones and who as "printmakers" were consigned to an aesthetic limbo by critics, curators, and even by fellow artists who knew little of the medium and cared less. By 1959, only one printer still pulled stones for artists in this country, and, unfortunately, his technical skills were irrelevant to the then dominant aesthetic of Abstract Expressionism.

Other problems afflicted the medium—too many to discuss here—and I experienced them all myself. Yet I also had created lithographs under good, even great, conditions, when I could buy the undivided attentions of Lynton Kistler during the late forties in Los Angeles, and Marcel Durassier in Paris during the mid-fifties. So I planned the Tamarind Lithography Workshop as an aesthetic socioeconomic manipulation of the environment, to support artists and master printers. Tamarind, as a nonprofit organization, would train a

small population of master printers, bring them together with mature artists, and supply their necessary materials and services. The roles of artist and printer would be defined anew, to restore the division of responsibilities and the ethics that had gone astray. An honest print market would be built, one that appreciated lithography as a primary medium, and for which Tamarind would set the precedent of complete disclosure of techniques and edition sizes. Above all, master printers would emerge as valued professionals in their own right. Our approach interested the Division of Humanities and the Arts of the Ford Foundation, and they provided an initial grant, followed by supplementary grants as we progressed toward our goals.

It turned out that creating the works of art was the easiest part of the Tamarind project. Excellent artists were plentiful, and idealistic young persons could, and did, devote themselves to artisan careers in the métier. But materials and equipment proved unbelievably difficult to obtain. The stone quarries of Bavaria had exhausted their veins of lithographic-quality limestone, so we were obliged to search for used stones at home and abroad and stockpile them as best we could. Reliable supplies, once located or developed, were, and still are, difficult to get. The label on a can of ink does not reveal that a factory has been sold, bought, and sold again by corporations more interested in pushing their stock than the product: thus one good pound of light-fast ink does not guarantee a second good pound. Papers, chemicals, metal plates, presses, tools—all the products that have a transient shelf life—are suspect and need constant monitoring. Nor can an art medium buy its supplies in large enough quantity to satisfy the mass production hungers of an economy based on technological obsolescence. And where are those talented workers who could sew a leather roller or fashion a replacement part for a unique press?

In this book, Garo Antreasian and Clinton Adams reveal lithography in many new dimensions, clarifying variables that plagued artists and printers of a previous generation. However, in a world that seems bent on destroying even its own oxygen supply, it is likely that this book's content may be nearly as bizarre in twenty years as alchemy is today. If mankind is to save itself from the horrors of misused technology, every aspect of behavior will have to change radically in both concept and expression. Life enhancement must become a modus vivendi as well as a *raison d'être* and perhaps, for once, the goals of life and art will be symbiotic for everyone.

Inevitably, this resource book will tend to shape the future of lithography into a "tradition," and that worries me. Not that this book is not worthy of being influential, but its implicit attitudes are perhaps more important than its data. Tamarind has been an informed energy, not an institution: an active expression of a yearning for creative freedom and excellence. Such energy is easier to transmit person to person than through the written word, which freezes into exhortation when set in type. Therefore I find a certain perverse pleasure in the abrasive difficulties recounted here: the reader will be forced to be as intense, lean, and inventive as we have been if this book is to be usable. Active engagement with the medium will produce new methods, new insights, new aesthetics, and that is a Tamarind tradition that does not worry me at all.

June Wayne

LOS ANGELES, JUNE 8, 1970

Contents

CHAPTER 10

MATERIALS AND EQUIPMENT

CHAPTER 11

LITHOGRAPHIC INKS

CHAPTER 12

PAPER FOR LITHOGRAPHY

CHAPTER 13

THE PRINTING PRESS

CHAPTER 14

THE INKING ROLLER

CHAPTER 15

SPECIAL PROCESSES

CHAPTER 16

THE LITHOGRAPHY WORKSHOP

Introduction

The inventor of lithography, Aloys Senefelder, called his new process *chemical printing*. The term did not gain acceptance, but it was more accurate than *lithography*, the term that did, for, as Senefelder recognized, the principle upon which the process rests is that grease and water will not mix. Lithography (derived from the Greek words for "stone" and "writing") has nevertheless come to be used for all compositions made on this principle, whether printed from stone, zinc, or aluminum.

Lithography is a planographic medium. The stone or plate from which the print is made is completely flat. The artist uses a greasy material to make an image on this surface; the surface is then treated chemically so that only the image will accept the printing ink. Although the solution used for this purpose is called an *etch*, its effect is not to bite into the stone (as in an etching made on a copper plate), but only to separate chemically the image and nonimage areas.

Offset lithography, although evolving from the same chemical principles as hand lithography, is a separate and distinctly different process. Instead of direct impression of ink upon the paper from the printing surface, ink from an offset plate is transferred to a rubberized printing blanket, from which it is then impressed on the paper. In consequence, offset lithographs have qualities different from those of lithographs printed by direct impression. Offset lithography requires complex automated inking and printing equipment; the printing image is characteristically reproduced photographically, and the chief advantages of the process are for high-volume production in commercial printing. Although it is possible for hand-drawn plates to be printed by the offset technique (a popular practice in Europe for printing large editions), as yet few American artists have been attracted to this mechanical method of printing. In view of the plentiful current literature on offset lithography, no attempt has been made to cover the subject in the present book.

Because artists' lithographs are made by drawing on a stone or plate with lithographic pencils, crayons, and tusche, materials that have much in common with ordinary crayons and inks, most artists can approach the medium with ease. Because of the variety of materials and techniques that may be used by the artist to make an image, lithography is exceedingly versatile. Its autographic nature allows the artist to visualize easily the print that will come from his drawing. Because of its planographic character, lithography is an ideal medium in which to make color prints, for one image can be printed over another without the difficulties created by embossment.

Although the principles of lithography are in essence simple, the technical processes involved in the printing of fine lithographs are exceptionally complex. For this reason, artists wishing to make lithographs have, since the early years of the nineteenth century, worked in collaboration with master lithographic printers: Géricault with Hullmandel and Villain, Redon with Blanchard and Clot, Picasso and Braque with Mourlot and Desjobert.

Any lithograph printed from a stone or plate conceived and executed by the artist is an original lithograph, whether it is printed by the artist himself or by a collaborating printer. Until late in the nineteenth century, lithographs were rarely signed in pencil, and individual impressions were seldom numbered. Since that time,

however, it has become customary for artists to sign and number each impression, attesting in this way both to the authenticity of the print and to its quality. Often, prints made in a lithographic workshop also bear the printer's blindstamp or chop. Like the artist's signature, this mark attests to the quality of the work.

Original lithographs are normally printed in limited editions, although the size of the edition may vary over a wide range. In the United States, artists' editions characteristically range from ten to one hundred; in Europe, editions of two hundred or more are not uncommon. The limiting of editions is due not so much to technical considerations as to intention. The artist may wish as a matter of principle to limit editions of his work, or he may wish to avoid an undue commitment of time or money to a single edition.

Any lithograph worth printing is worth printing well, in the finest way, on the finest paper, in accordance with the highest standards of the art. These standards have been established over a period of 170 years by the greatest artists and printers of Europe and America. Certainly, before undertaking to make a lithograph, an artist wishing to explore the medium is well advised to study the great prints of the past and present, not in reproduction but in the original.

By 1960, lithographic workshops had all but disappeared in this country. There were few master printers, and it was only with the greatest difficulty that an artist might engage himself in lithography. As a result, few of the major artists working in the United States made lithographs during the 1940s and 1950s.

In 1960, Tamarind Lithography Workshop was established in Los Angeles under a grant from the Ford Foundation for the primary purpose of providing a new stimulus to the art of the lithograph in the United States. Since 1960, a number of professional lithographic workshops have opened throughout the country, many of them staffed by artisans trained at Tamarind. The lithographic workshops maintained at art schools and university art departments have likewise increased in number and, under the influence of the Tamarind program, have greatly improved in quality. Now, in the United States as well as in Europe, the artist again finds it possible to work in collaboration with skilled printers, and in these circumstances American lithography has enjoyed a notable renascence.

Tamarind's studies of the economic aspects of lithography workshops and of the marketplace have provided a new basis for the survival of the art. The Tamarind Institute, established at the University of New Mexico in 1970, will have as its principal missions the maintenance of Tamarind standards, the training of professional artisans, and continuing research into both the technical and economic aspects of artists' lithography.

From the beginning of the Tamarind program it was necessary to review existing literature on the subject of lithography so as to reconcile conflicting practices advocated by early authorities and at the same time update the materials, equipment, and techniques of the past. Beginning with Senefelder's own book, first published in Munich in 1818, many books and articles have been printed: technical works, general historical works, and monographs on the lithographs of individual masters. A selected bibliography is provided in the present volume. Certain technical texts devoted to commercial hand lithography near the turn of the century have afforded a wealth of long-forgotten techniques of particular relevance for present-day use.

Gradually the printers at Tamarind refined many old processes, developed new ones, substituted up-to-date materials, and uncovered new supply sources. Because of the widespread interest in these advances, it was apparent that a comprehensive resource book on the entire subject of the hand-printed lithograph would be of great benefit to other printers, artists, students, curators, and connoisseurs of fine prints. Accordingly, the form as well as much of the content of the present book is based on research and practice undertaken at Tamarind during the past ten years. Special attention has been given to detailing key aspects of basic processes omitted from many current publications.

One of the most vexing problems was the necessity for constant revision during the many years that this text was in preparation. Techniques and processes were in a continuous state of improvement. Often, several equally dependable procedures or materials would be developed; appraisals would then be required as to which should be included in the text and which left out. In the final analysis, we have recorded as thoroughly as possible those techniques and materials which collective experience has shown to be the most efficient and trouble-free.

Perhaps Tamarind's most important contribution is the undeniable fact that hand lithography in the United States is again a fluid and dynamic medium, subject to continual modification and improvement. The prospects for future creative advancement are unlimited. It is our hope that this resource book will serve as a useful reference for all who are interested.

As with many works of such scope, this book owes its existence to many contributors to whom the author is much indebted. First and foremost, I wish to express my

deep gratitude to June Wayne, Director of Tamarind Lithography Workshop. Without her vision, fortitude, and deep love for the art of the lithograph, neither the Tamarind project nor this book would have been possible. I extend very special thanks also to my close friend and collaborator Clinton Adams, Dean of the College of Fine Arts, University of New Mexico, who has shared equal responsibility with me in the preparation of the text. In addition to serving as contributing author, he has provided cogent advice and keen attention throughout all phases of the preparation of this work, bringing order and additional breadth out of what could easily have been chaos. When the first drafts of this book were begun, I was a member of the faculty of the Herron School of Art. I am indebted to Dean Donald Mattison for his encouragement of my investigations in lithography at that time, and also for the use of the Herron workshop facilities to record some of the photographic material used herein. Thanks also are extended to Clifford Smith, Tamarind Educational Director, for coordinating and updating technical data developed for inclusion in the book. I am grateful to Ken Tyler, former Technical Director at Tamarind and now Director of Gemini G.E.L., for his early experiments with metal plates, and for providing information on the hand preparation of photo-processed plates. Vera Freeman, representing Andrews-Nelson-Whitehead, provided valuable technical advice and specification data for fine papers imported by that firm. Singular thanks are due to Louise M. Lewis for her continued good spirits and perseverance during the preliminary editing and typing of the numerous drafts. Finally, to all printers and staff members at Tamarind over the years and to numerous students who have worked under me, I offer my appreciation for the many special insights they have provided.

G.Z.A.
Albuquerque, New Mexico, 1969

The Tamarind
Book of Lithography:
Art & Techniques

Drawing a Lithograph

1.1 PLANNING A LITHOGRAPH

A lithograph begins with the conception of the artist. It reaches completion in a printed image on a sheet of paper. Between conception and completion many decisions must be made, and, if difficulties are to be avoided, these decisions must be reached with a total view of the process: the stone or plate to be used, the making of the image, the process of printing, the print itself.

For the moment, we shall assume that the print to be made will be drawn on stone and printed in black and white. In later chapters we shall discuss work on metal plates, multicolor prints, work by means of transfer techniques, and other special processes.

The first decision the artist must make is related to size. This decision is best made by giving primary consideration to the sheet of paper upon which the print will finally be made. In order to take advantage of the quality of the natural edge of the paper, many lithographs will be printed on full sheets. Others will be printed on sheets that can be torn economically from full sheets. Only by giving full consideration to the size of the paper can waste be avoided. Otherwise, scraps and odd pieces will soon pile up, and amount to a sizable loss of expensive paper.

The size of the paper chosen will determine the size of stone upon which to work. It is always desirable that the sheet of paper be slightly smaller than the stone: at least one-half inch in each dimension. This permits the placing of registry marks at the edge of the stone, so that the paper for each print may be laid accurately in relation to the image.

For technical reasons, it is necessary that the image be kept at least one inch away from the edge of the stone, that is to say, that there be a clear border on all four sides. This border is needed in order to permit the scraper bar of the press to engage the stone outside the image while not being so close to the edge of the stone as to be dented or to cause the stone to hop or move on the press. The clear area will also serve to permit the image to be inked safely without catching the roller on the beveled edges of the stone, thereby producing dirty margins on the print.

It follows that if the image is to fill the paper completely, to bleed off the sheet without a margin, the paper must be at least two inches smaller than the stone in each dimension. For $22 \times 30''$ paper, a stone of at least $24 \times 32''$ is required.

It should be kept in mind that, aesthetically, the margin is an integral part of the print. Some great prints have had extremely wide margins, some narrow margins, others none at all. In any event, the margin should be planned, just as the image itself is planned.

1.2 SELECTING A STONE

Every stone is different. Because the characteristics of lithographic stones are so intimately involved with every stage of the lithographic process, it is necessary to discuss them at some length. The physical and chemical properties of lithographic stone will be discussed in greater detail later. (See sec. 9.6.)

Many types of limestone have been used in lithography, but by far the best is the stone that comes from Solnhofen in Bavaria, sometimes called *Kellheim stone*. The superiority of this stone is due to its fine and uniform molecular structure, which leads to a stable and consistent reaction to the processes of drawing, etching, and printing.

Vast quantities of these stones, cut and prepared in a variety of sizes (from $4 \times 6 \times 2''$ to $62 \times 42 \times 5''$), were shipped to the United States during the nineteenth century

for use in commercial lithographic printing. The smallest stones were originally used for vignette drawings and illustrations, the largest for posters and billboards. In limited quantities, some stones are still being quarried today.

At one time the sizes most commonly used by artists were $10 \times 12''$, $16 \times 20''$, and $18 \times 22''$. Recently the larger sizes have become more popular, and it is now common to see prints from stones measuring $20 \times 30''$, $26 \times 36''$, or even $30 \times 43''$. Through the years, stones of the larger sizes have become increasingly difficult to find; and the shortage may be expected to become still more critical in the future.

1.3 CHARACTERISTICS OF STONES

Solnhofen stones are harder and more brittle than domestic limestone. Because of this, they are easily chipped and broken, and should be handled with care. Their texture is compact yet porous; and they will retain moisture on their surface for considerable periods of time.

Stones vary in color from yellow or buff to a blackish gray. Their color is an index to their hardness: the darker the color, the harder the stone. In general, the harder stones are best suited to lithographic printing. Because of the difficulties encountered in working on dark gray stones, particularly the distortion of value relations, light gray stones should be used whenever possible for delicate or complex work. The softer buff and yellow stones should be reserved for drawings having relatively simple tonal values.

Few stones are perfect. Many stones, however, have only minor defects to which no special attention need be paid. Many light-colored stones have red iron marks or stains. These have no effect on drawing or printing, and such stones are completely usable. "Chalk marks," or a gray-white mottling on the surface, present a more difficult problem. The whitish areas are frequently soft and tend to grind and etch unevenly. Stones so marked should be discarded or used only for simple work. Feldspar crystals often appear in the surface of stones. These crystals, since they have no affinity for grease, will print as white spots. Usually they appear in small groups or clusters, making it possible to work around them. When this cannot be done, another stone should be chosen.

The most common defects found in stones are tiny veins, which appear as hairline cracks differing from the surrounding stone in color and hardness. These may be very troublesome. At times they will print as faint white lines; at times they will take ink and print as black lines;

at other times they will not affect the work. They are to be tolerated unless their effect is disruptive to the image.

Veins in stones should be watched carefully from one printing to the next. Fracturing of the stones under press pressure will most often occur along these lines. Minimum pressure should be used in printing from a veined stone, particularly when a slight give is noticed along the veins. As a precaution it is sometimes advisable to pull an impression on transfer paper for retransfer to a second stone. (See sec. 8.2.)

1.4 LEVELING THE STONE

Before the grinding begins, stones that have not been printed previously should be tested to determine whether their surfaces are truly level. Stones that have depressions or are thicker at one end than the other will print poorly. Testing is done with a metal straightedge and a strip of newsprint paper. When the straightedge is placed across the stone over the strip of newsprint, it should not be possible to move the paper without tearing it (see fig. 1.1). The test is repeated at many places and in all directions. If at any point the strip can be moved, a depression in the surface of the stone is indicated. Irregularities thus located may be spot-ground with the levigator or a small lithographic stone. This takes time and care; but, once a stone is level, it is easy to keep it that way through proper grinding.

1.5 GRINDING THE STONE

The stone to be ground is placed on the graining table and thoroughly washed with water. All surface dirt and grit must be carefully removed. Grinding may then begin, using either a levigator or a second stone. Grinding of larger stones is both easier and quicker with the levigator. The use of two stones permits both to be grained at once. This method, although safe and efficient when the two stones are of similar size, must be used with great care when one stone is much smaller than the other, for uneven grinding can easily come about. (See fig. 1.1.)

When two stones are ground together, the drawing on the upper stone will be effaced more quickly than the drawing on the lower stone; hence grinding should begin with the darker and heavier image on top. Midway in the graining process, the position of the two stones should be reversed.

The stone should be covered with a thin film of water when the abrasive is sprinkled on. Only experience will

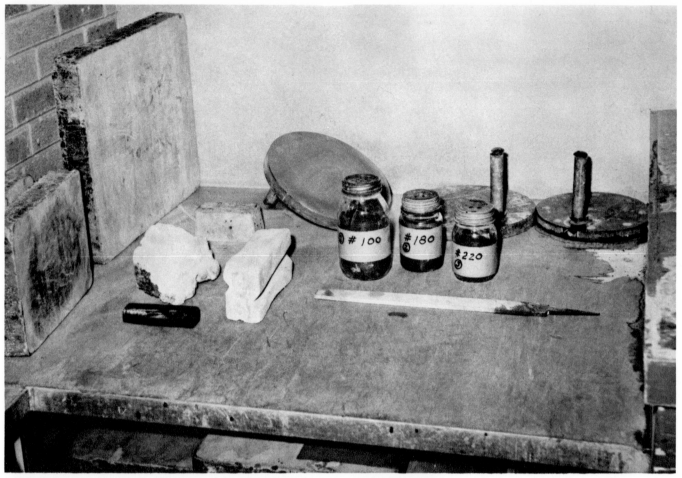

a. The materials for graining the stone

b. Sprinkling abrasive on the stone

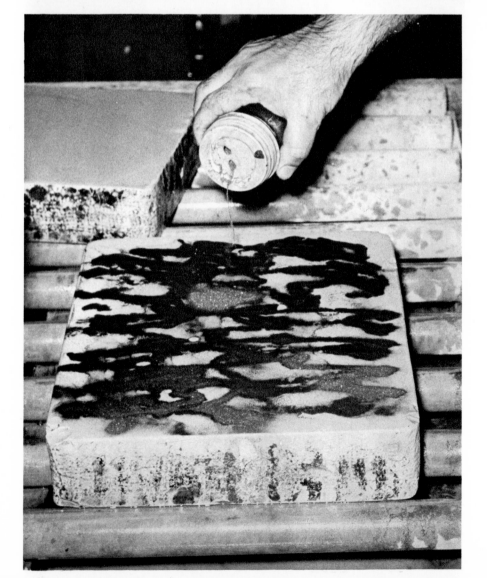

1.1 Stone-graining techniques

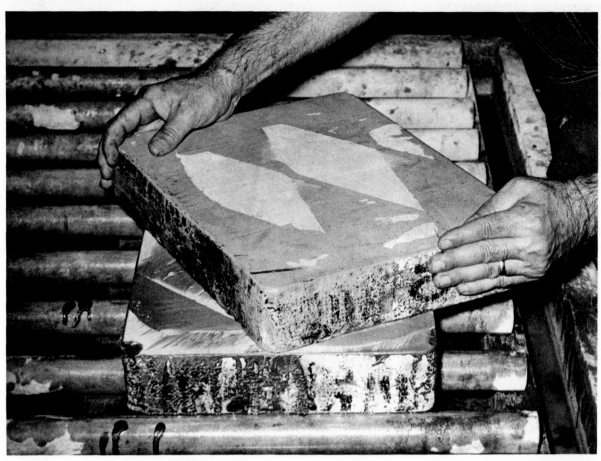

c. Grinding one stone against another

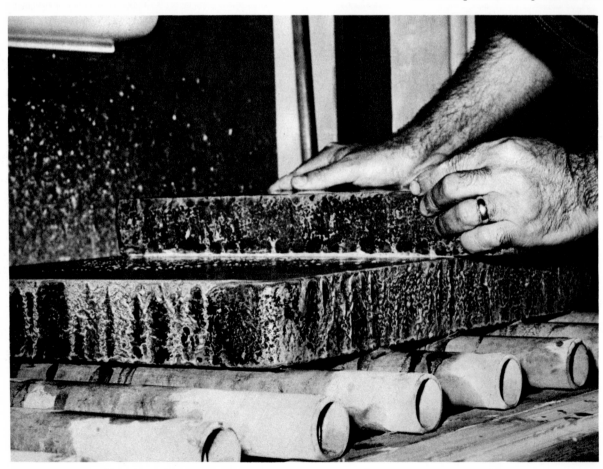

d. The film of abrasive and water can be seen
between the two stones

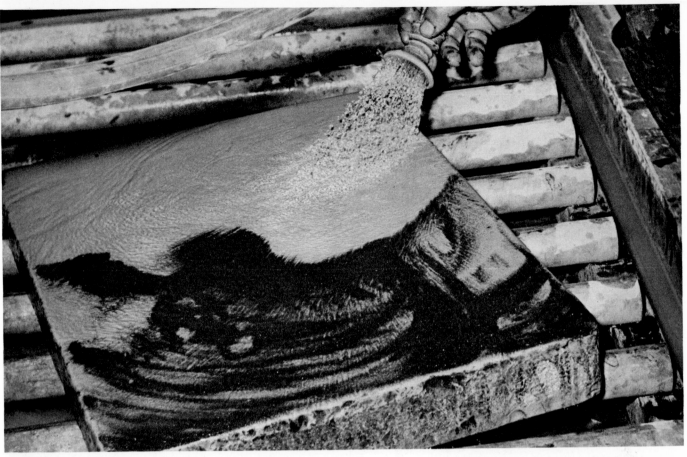

e. Removing the residue of graining with water

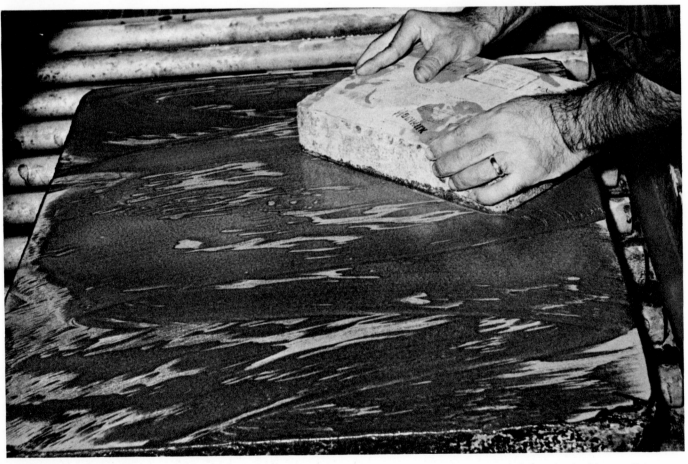

f. A large stone being grained with a smaller stone

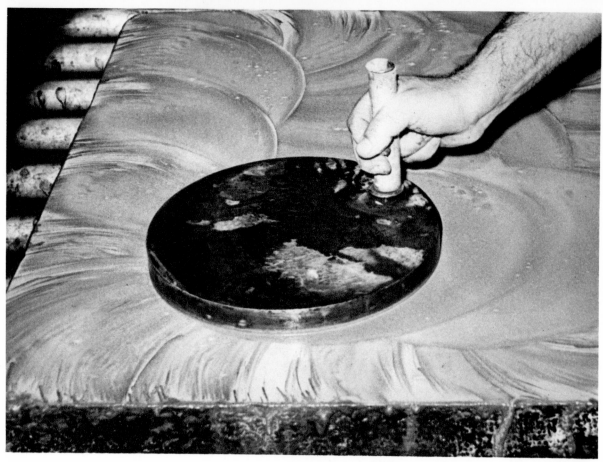

g. A large stone being grained with the levigator

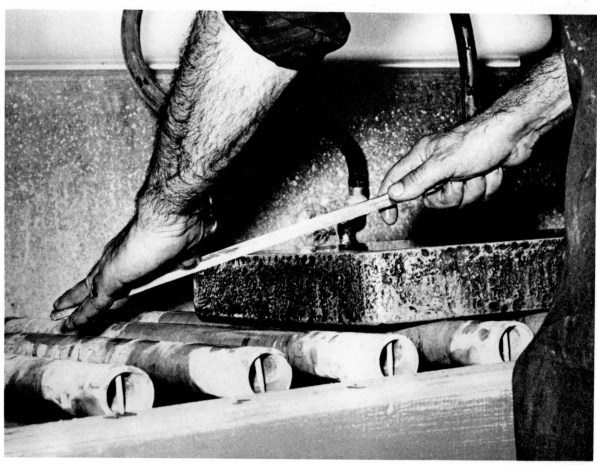

h. The edges of the stone being beveled with a rasp

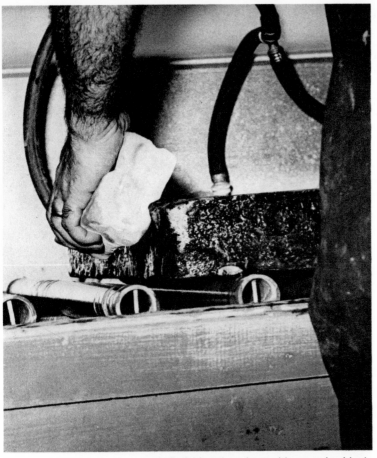

i. Polishing the edges with a pumice block

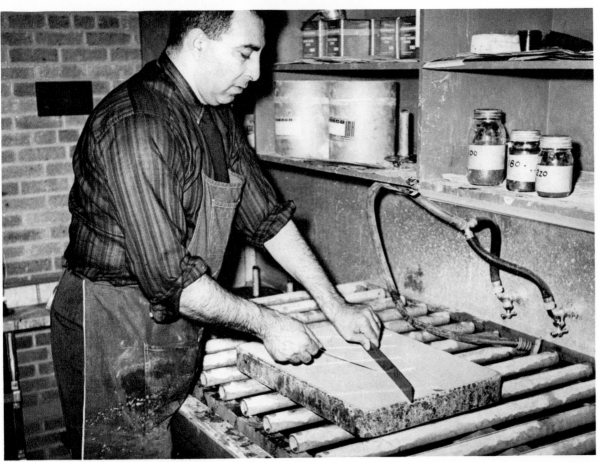

j. Testing the level of a stone

indicate the correct proportion of water to abrasive. If too much abrasive is used and not enough water, the grinding will be difficult and exhausting, although grinding action will be faster. If too much water is used, the abrasive will flow off the stone, and the grinding action will be lessened. Curiously, it will be found that either too much or too little abrasive will tend to cause scratches. Such scratches should be avoided, for extra grinding is needed to remove them. If not removed, the scratches will appear as lines in the finished print.

Whether a stone or a levigator is used, a regular pattern of grinding should be followed. For small stones a figure-eight pattern works well. An equally good pattern, also suited to larger stones, may be ground in a regular series of rows or bands, first horizontally across the stone, then vertically, alternating at regular intervals. (See fig. 1.2.) Whatever pattern is used, the basic consideration is to ensure that all parts of the stone's surface receive the same amount of grinding. To grind longer in one spot than another will cause uneven abrasion and destroy the level of the stone.

Grinding should begin with the coarser grades of carborundum, followed successively by finer grades, until the desired surface is attained (see secs. 10.9 and 15.1). A standard procedure is to start grinding with #100 grain, continuing until the previous drawing on the stone has disappeared and has been replaced by its negative image (see sec. 10.8). The areas that were dark in the drawing will now appear bright, as in a photographic negative.

From two to six separate grindings are normally required, each with fresh abrasive. Grinding should continue until a rather stiff and dry sludge gathers, at which time it is necessary to wash the stone and levigator thoroughly with water, removing all abrasive and stone particles, which can cause scratches in subsequent grinds. Special attention is required when switching from one grit to another. Should one coarser grain of carborundum remain, it will surely cause scratching. Accordingly, great care should be exercised in storing grit in properly marked containers. Never fill empty containers with the wrong particle size.

Sometimes during grinding it will happen that two stones stick together. Suction takes place because of the evenness of the two surfaces and the adhesive character of a dry graining sludge. Never under any circumstances try to knock such stones apart, for they will surely crack or break. Try instead to squirt water between their edges or to insert the tip of a thin knife. If a small amount of air can get between the stones, they will separate easily.

After the old image has disappeared, the grinding normally continues with two grinds of #180, followed by two grinds of #220. This will be sufficient for most work. The #220 grain is suitable for most techniques and procedures in lithography, and is the grain most commonly used.

When the grinding has been completed, the edges of the stone are carefully beveled and rounded, especially at the surface edge of the stone, so that ink from the roller will not be caught by the edge in printing. (See fig. 1.3.) A coarse file or stone rasp is used for this work, followed by a block of pumice or a fragment of lithograph stone. The stone is then washed thoroughly and dried. A squeegee or the palm of the hand may be used to remove water and hasten drying. The stone is then taken from the graining table and placed on edge on the work table, preferably on a clean sheet of newsprint. Wet stones are like blotters and will absorb dirt or dust from the surface on which they are resting as if by capillary action.

When the stone is dry it is ready to receive the artist's work. If not to be used at once, the grained surface should be covered with clean paper, taped to the edges of the stone. When storing stones, it is advisable to make note of the grain on the covering paper.

1.6 PREPARING TO WORK ON THE STONE

Before the artist begins to draw on the stone, adequate physical arrangements should be made. The stone should be placed on a stout table or support of sufficient size and strength. Because the stone itself cannot easily be moved, it is desirable to be able to walk around the work. The light must be good, whether from natural or artificial sources. As the image on the stone will become glossy, the direction of the light should be such as to avoid glare. For better vision and ease in working, one may wish to tilt the stone by placing a block of wood under the far edge.

It is necessary to keep hands and arms off the surface of the stone while working, for grease from the skin may make a lithographic mark. A clean, curved barrel stave called a *bridge* may be used as an arm or hand rest to facilitate close work. A soft, clean cloth may also be used for this purpose, provided that care is taken not to rub or smudge work already done. When work is interrupted, the stone should always be covered with a clean sheet of paper to protect it against dirt, dust, and contamination. Dirt may well leave all but invisible marks, which will, nonetheless, show up in printing. Saliva marks, a result of talking or sneezing near the stone, are likely to appear as white marks at the time of printing. For this reason it is poor practice to blow loose specks of crayon off the stone. A large, soft brush is useful for this purpose.

It should be remembered that in lithography, as in

Graining pattern—stone to stone

Graining pattern—levigator on small stones

Graining pattern—levigator on large stones

Pattern of overlap when using levigator

1.2 Graining patterns

$\frac{5''}{16}$

$\frac{5''}{16}$

This point to be smooth + without edge

1.3 Detail of beveling

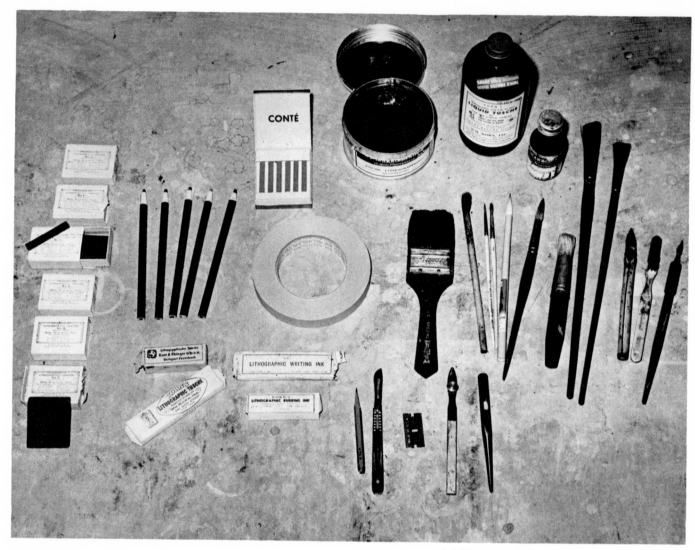

1.4 The materials for drawing a lithograph

other print mediums, the image will be reversed in printing, and the effect of such reversal should be considered in planning the work. A mirror of good size is useful in checking the progress of the work. It is especially helpful to the inexperienced printmaker in overcoming unwanted distortions and awkward left-to-right relations.

1.7 PRELIMINARY WORK ON THE STONE

At times the artist may wish to work directly on the stone, without reliance on earlier drawings or studies. At other times, particularly in color work, he may wish to trace or transfer a fully developed image to the stone. In either case, he will wish to make temporary marks on the stone, marks that will not print later. Neither lead pencil nor carbon paper can be used, for both create a printing

image. A red conté pencil or crayon is ideal for the purpose. Its inert ingredients will not react chemically with the stone; its color will not be confused with later work in black.

Drawing may begin directly on the stone with the conté pencil or crayon. Should changes become necessary, the crayon can be wiped off with a clean cloth or washed completely away with a clean sponge and water. Care must be taken not to draw too heavily or to pile up the chalk, for this might well prevent the subsequent lithographic drawing from making intimate contact with the surface of the stone.

Two additional methods are available for making a preliminary image on the stone.

The first utilizes a kind of red-chalk tracing paper which is made by rubbing powdered conté crayon or red oxide pigment on one side of a sheet of newsprint. This red-

chalk paper is then used as carbon paper would be used, to trace the drawing with a hard pencil so as to transfer its image clearly to the stone. The chalk paper may be saved and used over and over again.

The second method is called a *set-off*. In this method, the drawing is done in red conté on a sheet of thin paper. With the stone on the press, the drawing is placed face against it, and the stone is run through the press under moderate pressure. It should be noted that when this process is used the final print will not be a reversal of the drawing, for the image will have been reversed twice, once in transfer to the stone and a second time in printing.

Red chalk may also be used to indicate in a preliminary way the position in which the paper is to be laid, thus defining the margins of the print.

1.8 MAKING THE IMAGE ON THE STONE

The basic materials used in making an image on the stone are lithographic pencils, crayons, and tusche (fig. 1.4). The various ways in which these simple materials can be used are all but limitless. In general, any manner of working is technically acceptable as long as it does not violate the fundamental principles of lithography.

The discussion that follows is by no means a complete catalogue of every technique and procedure available to the artist. Rather, it is a description of the principal materials, together with comments on their use. It will remain for the artist to determine how best to use these materials in realizing his intentions. The careful study of fine lithographs by the major masters of the nineteenth and twentieth centuries is recommended as an excellent means of arriving at an understanding of the possibilities that exist.

1.9 THE NATURE OF CRAYON AND TUSCHE

The materials used to draw on the stone must be capable of making marks that are both greasy and visible. The greasiness must be in proportion to the apparent tone or value of the mark, so that, when the drawing is later replaced with ink, the value will remain substantially unchanged. Beyond this, it is only necessary that these materials be of a form and consistency suitable to the artist's work.

Basically, it is sufficient for our needs to think of lithographic crayons and tusche as materials containing grease and black pigment. The grease produces the printing; the pigment is needed only so that the artist may see what he is drawing. All these materials, whether liquid, paste, or solid, contain grease and an emulsifying agent that permits them to be diluted with water or solvents. (See sec. 9.3.)

Since excellent drawing materials are manufactured commercially, there is now no need for the artist to make his own (see Appendix A). The fact that the crayons and tusche made by several American and European companies differ from one another can be of advantage to the artist. Regardless of the manufacturer, it is good practice to use only fresh materials. Old crayons and tusche, particularly liquid tusche, tend to produce unpredictable results because of the instability of their fatty contents.

1.10 CRAYONS AND PENCILS

Lithographic crayons are available in several forms and in seven degrees of hardness. They can be obtained in short sticks, tablets, and pencils. Each form is useful for the specific handling it permits. A numbering system is employed to identify degrees of hardness, ranging from #00, the softest and greasiest, to #5, the hardest. The very soft crayons and pencils produce rich, smoky blacks; the harder ones (containing less grease) produce the lighter and finer tones. Experience in drawing and printing will quickly indicate those grades best suited to individual needs. It will often be found that the grades between #0 and #4 are most useful.

It is well to remember that the consistency of the crayon will affect the character of the drawing as well as the printing. The surface of the lithograph stone is hard and abrasive. Even the hard crayons do not long retain a point or edge, and the softer crayons become blunt in the course of drawing a single line. Soft crayons thus lead to a "mushy" line; harder crayons give a crisper effect.

Crayon tones are traditionally built up slowly, starting with a hard crayon and gradually moving to softer as darker tones are reached. The slow, repetitive stroking of the stone with the crayon builds up a beautiful bloom that can range from the most delicate silver-gray to the softest velvety black. The luminosity that can be obtained through this method is unobtainable through any other. (See figs. 1.5 and 1.6.)

The sequential use of first hard and then soft crayons has a technical as well as an aesthetic justification. If the sequence is reversed, applying hard crayon over soft, the work may *look* darker but will not print that way. The reason for this is that the soft crayon has already imparted its maximum grease to the stone, and the harder but less greasy crayon on top can add no more. It will create the illusion of darker-looking work; but this is an optical

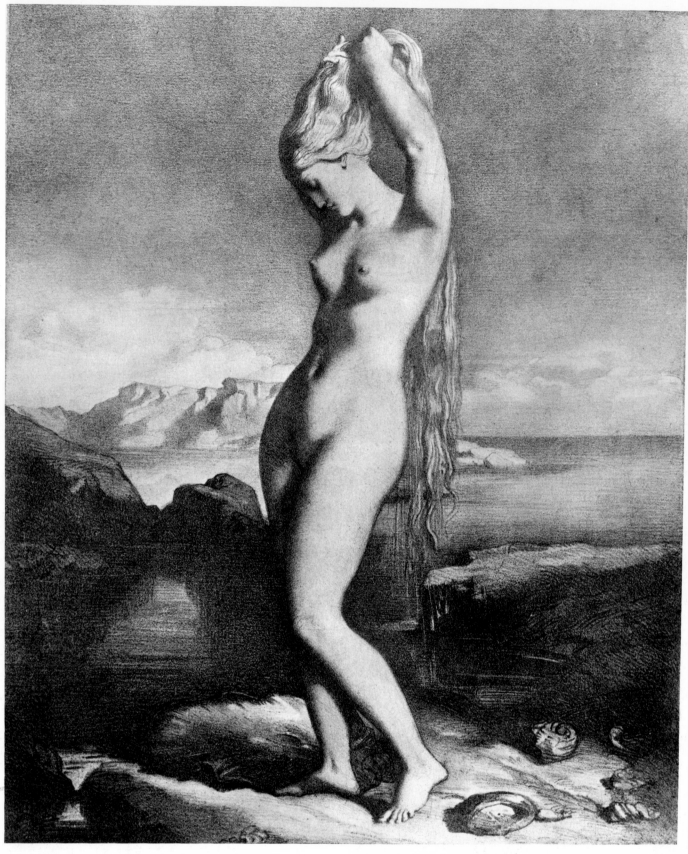

1.5 THÉODORE CHASSÉRIAU: *Venus Anadyomène.* 1839.
Lithograph, 11 1/4 × 9". Collection Mr. and Mrs. Clinton Adams.
Albuquerque, N.M.

An exceptionally fine example of the subtle luminosity and broad
tonal range that can be achieved by carefully manipulated crayon
techniques. This masterpiece is one of the few lithographs exe-
cuted by the great Neoclassic draftsman

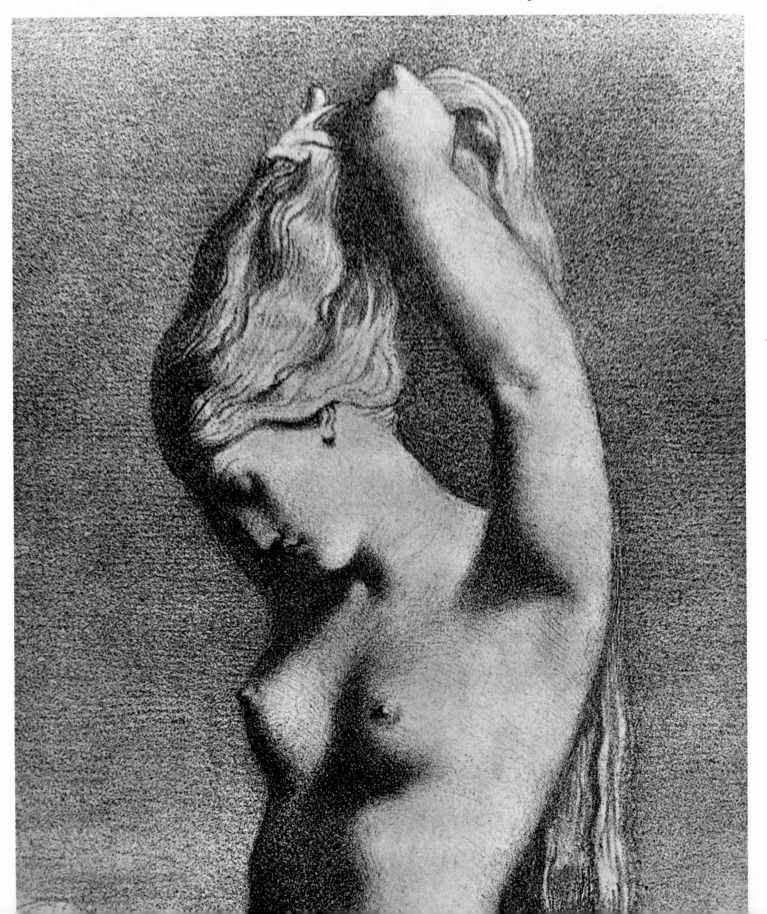

Detail: Note the fine granularity and division of tones imparted by the delicately applied crayon. The control of drawing technique to show textural differences among sky, flesh, and hair is clearly revealed in this enlargement

1.6 FEDERICO CASTELLÓN: *New Robe.* Lithograph, 12 3/8 ×10". University Art Museum, The University of New Mexico, Albuquerque

A contemporary lithograph in which traditionally delicate crayon techniques have been achieved with a sharply pointed lithographic crayon or pencil. A second stone printed in a neutral tint has been used to increase the tonal range of this image and to heighten the highlights

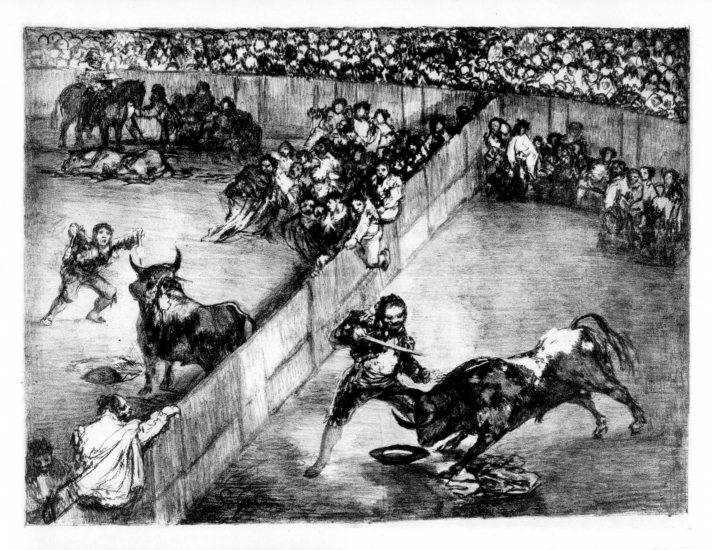

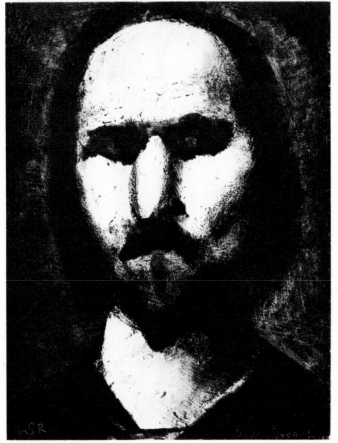

1.7 FRANCISCO GOYA: *Plaza Partida* (*The Divided Arena*, from the series *The Bulls of Bordeaux*). 1825. Lithograph, 11 7/8 ×16 3/4″. The Art Institute of Chicago. The Clarence Buckingham Collection

This masterpiece illustrates the spirited use of blunt crayons applied spontaneously to a stone of medium-fine surface. The drawing is further enriched by some scraping

1.8 GEORGES ROUAULT: *Portrait of André Suarès* (from *Souvenirs Intimes*, Paris; published by Frapier). 1926. Lithograph, 9 1/2 × 7″. The Museum of Modern Art, New York. Gift of Mrs. Edith Gregor Halpert

The early states of this lithograph were probably drawn with soft crayons which were slightly diluted with water or solvent after application. Further modification with liquid tusche and scraping in this later state enrich and give dimension to the surface qualities of the print, which resemble characteristics more familiar in paintings by Rouault

rather than a chemical effect and will be lost in printing.

In drawing with lithographic crayons and pencils, the artist will notice several ways in which they differ from ordinary drawing materials. When tones are put on with back-and-forth strokes, it will be seen that the crayon tends to pick up work at the end of each stroke, leaving a small white dot. The firmer the stroke and the softer the crayon, the more this is so. This effect is due to the tackiness of the crayon. Crayon clings to crayon more readily than to stone, particularly at the maximum point of pressure, usually at the beginning or the end of a stroke. Over large areas, such tiny white marks may give an unpleasant salt-and-pepper look to an otherwise even tone. This can be avoided by stroking in one direction only, with the crayon in motion both before and after it touches the stone.

Soft crayons, when used on the side and stroked rapidly and with heavy pressure, will give a coarse, raspy appearance because of the way in which crayon particles cling to one another as the tone is built up. (See fig. 1.8.) This effect, like all others inherent in the nature of the materials, may be utilized when appropriate.

Sharpening the crayons and pencils to chisel edges or extremely fine points produces lines and tones of an entirely different character from those obtained with an unsharpened crayon. (See figs. 1.5, 1.6.)

The crayon, because of its fragile structure, should always be sharpened by cutting *away* from the point rather than toward it. When working with sharpened crayons, metal crayon holders make work much easier.

It will be found that extremely dark accents, particularly over established tones, will best be achieved by pushing rather than pulling the crayon across the stone. The pressure thus exerted tends to squash the crayon more firmly into the stone. Soft crayons held perpendicularly and pulled rapidly will skip or hop, producing a jumpy or dotted line.

Crayons are soluble in water, turpentine, and other solvents. Drawing through films of these solvents on the stone will produce varying effects somewhere between those of a pure wash and a pure crayon drawing. The more solvent is present, the more crayon is dissolved, ultimately leading toward a wash. The character of the wash is conditioned not only by the type of solvent used, but also by the softness of the crayon and by the amount of solvent.

Interesting effects have been obtained by dipping a crayon in kerosene before drawing. Since kerosene is greasy by nature, it imparts additional fat to the crayon, at the same time softening it. The resulting stroke is oily and fat, of smudgy character and broad delineation. The excess fatty content of the work tends to make it print darker than it looks on the stone; however, experimentation and careful observation will suggest methods that can be controlled.

1.11 RUBBING CRAYON

Rubbing crayon differs from other forms of lithographic crayon both in form and in use. It is supplied in a thick block and in three grades: hard, medium, soft. It is much greasier than other forms of lithographic crayon and hence will easily produce rich and smoky darks. The normal "hard to soft" sequence principle would indicate that rubbing crayon is best used last, rather than under work with other crayons.

As its name implies, the function of rubbing crayon is to provide a means of creating soft, rubbed tones not unlike those of smudged charcoal. (See fig. 1.9.) The crayon block is first rubbed with a fine piece of silk, nylon, or chamois, wrapped around the finger. After the cloth has been sufficiently charged with crayon, it is gently rubbed across the stone. For smooth tones it is best to build up the crayon on the stone very slowly, constantly changing the direction of the stroke. Through variations in the amount of crayon used and the pressure of application, beautiful gradations of tone can be achieved. Care must be taken not to overwork; the high grease content of the crayon is such that tones may rapidly become darker than intended, and so soft and spongy in character as to have little effectiveness.

The block of crayon may also be used to draw directly on the stone. Because of its bulk and greasiness, it provides a means of making powerful and husky tones. It is often useful as a quick and simple means to soften lines and edges or to pull together work in need of greater tonal unity.

1.12 TUSCHE AND ITS USES

Lithographic tusche is available in three forms: stick, paste, and liquid. Although the three are compounded of basically similar materials, each has subtly different characteristics. The stick and paste tusches are more flexible in that they may be used with water, turpentine, or a petroleum solvent.

In this country Wm. Korn, Inc., is the only maker of either crayon or tusche. (See Appendix A.) Korn's Autographic Tusche (a liquid tusche, brown in color) is especially good for linear work and solids. It dries fast, is thin enough in consistency to work easily with a pen, and

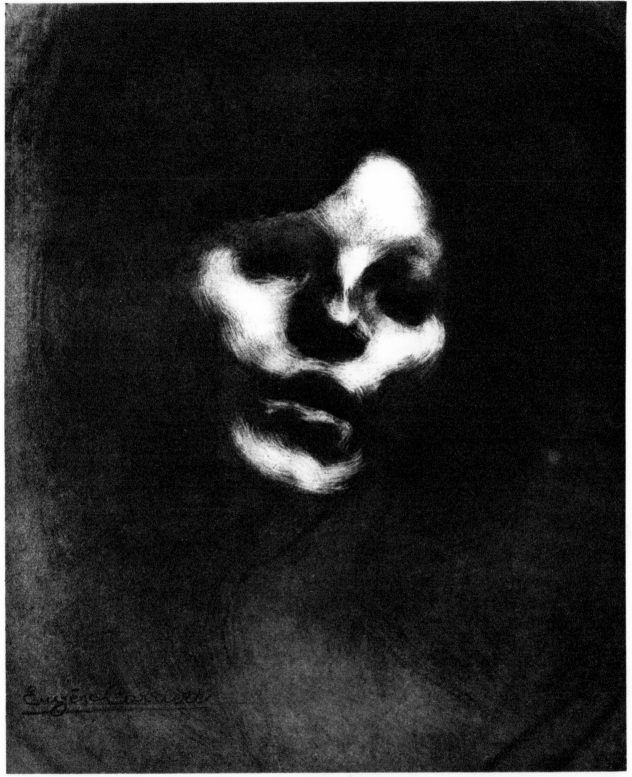

1.9 EUGÈNE CARRIÈRE: *Marguerite Carrière*. 1901. Lithograph printed from three stones, 17 × 13 3/4". University Art Museum, The University of New Mexico, Albuquerque

Carrière has used three stones, each printed with a carefully calculated ink mixture, to extend the tonal range of this print beyond that possible from a single stone. Each stone was drawn with rubbing crayon and heightened with scraped highlights to create a rich and deeply veiled romantic atmosphere

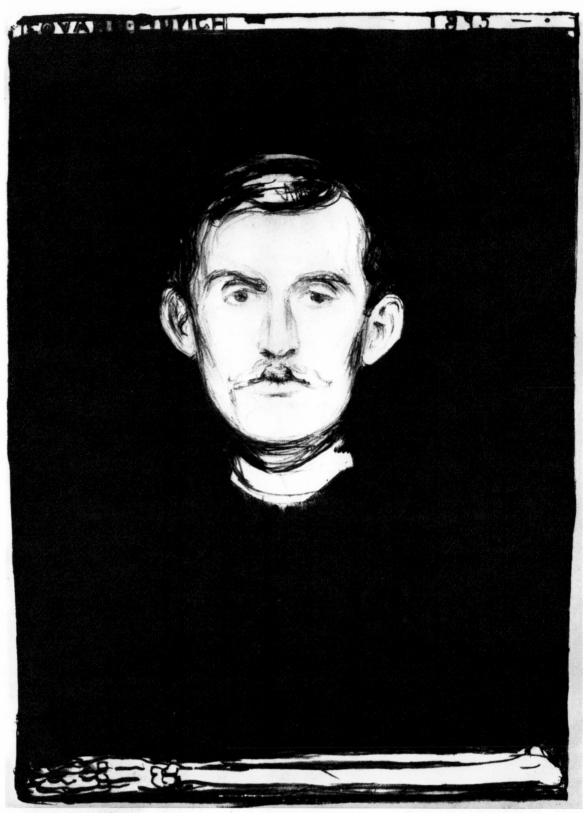

1.10 EDVARD MUNCH: *Self-portrait with Arm Bone.* 1895.
Lithograph, 18 1/8 × 12 3/4". The Museum of Modern Art, New
York. Gift of James L. Goodwin in memory of Philip L. Goodwin

Full-strength liquid tusche has been used to fill in the background
and to project the face and arm bone, drawn with crayon, into
light

prints a strong black. The liquid tusche made by Cornellisen is also useful for linear work. The French paste tusche made by Charbonnel is excellent for all-round work. A French stick tusche, *La Favorite*, is exceptionally dependable in the preparation of tusche washes. (See Appendix A.)

In general, tusche mixed with water flows more freely and dries more slowly. Tusche mixed with other solvents tends toward greater viscosity and penetrates more deeply into the stone. The image so produced, being more deeply seated, is richer and more resistant to etching than the image made with water tusche. As a result, solvent-tusche images have a tendency to print darker than they appear in the drawing.

Tusche, when diluted with either water or solvent, is extremely sensitive to the slightest variations in use. Careless handling leads to uncertain and unpredictable results. In the hands of an experienced lithographer, however, tusche is a fine and versatile material with an all-but-infinite range of uses.

Before a liquid tusche is used, the bottle should be well shaken to ensure an even suspension of the liquid. Water tusche in any form should be diluted *only* with distilled water. Tap water contains minerals that may affect either the stability of the tusche, causing it to separate, or its greasiness. Should lime be present in the water used to dilute tusche, the greasiness of the mixture will be reduced, leading to a pale and unpredictable image.

Stick or paste tusches also may be mixed with distilled water. The best way to prepare stick tusche is to rub it vigorously against a dish or saucer. Heating the saucer first by holding it against an incandescent light bulb for a few moments will cause the tusche to soften and make the process easier. Water is then added a few drops at a time, and the tusche is worked up with the fingers or a brush. (See fig. 1.11.)

Paste tusche can be mixed easily with water, using a brush or a palette knife. There is no objection to adding a few drops of water directly to the tusche in the can. If this is done, however, the same can should not be used later for mixing tusche with other solvents. One can of tusche should be used for water mixtures and a second can for solvent tusche.

1.13 MAKING SOLID BLACKS

Tusche is used full strength in making solid blacks. If liquid tusche is used, it should be shaken thoroughly, for it tends to separate in the bottle or can. Stick tusche should be mixed until fairly thick, so that it will be a rich black when brushed on the stone. (See fig. 1.10.) Korn's Autographic Tusche also is excellent for making solids, although its light brown color makes it difficult to use in combination with crayon or other forms of tusche. Technically, the difference in color creates no problem, but it is a psychological and visual problem in the development of the image.

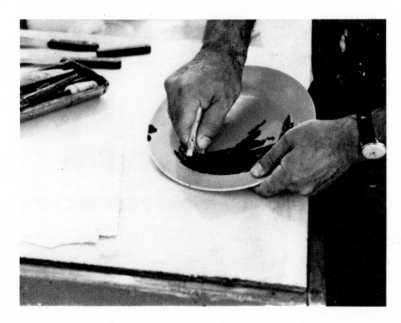
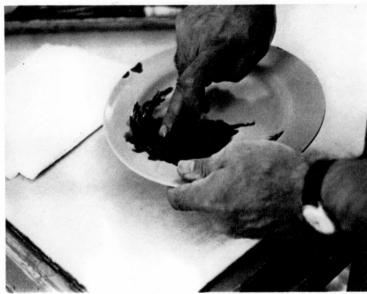

1.11 Mixing tusche

a. Rubbing stick tusche around the rim of a dish
b. Stirring the tusche and distilled water with the finger

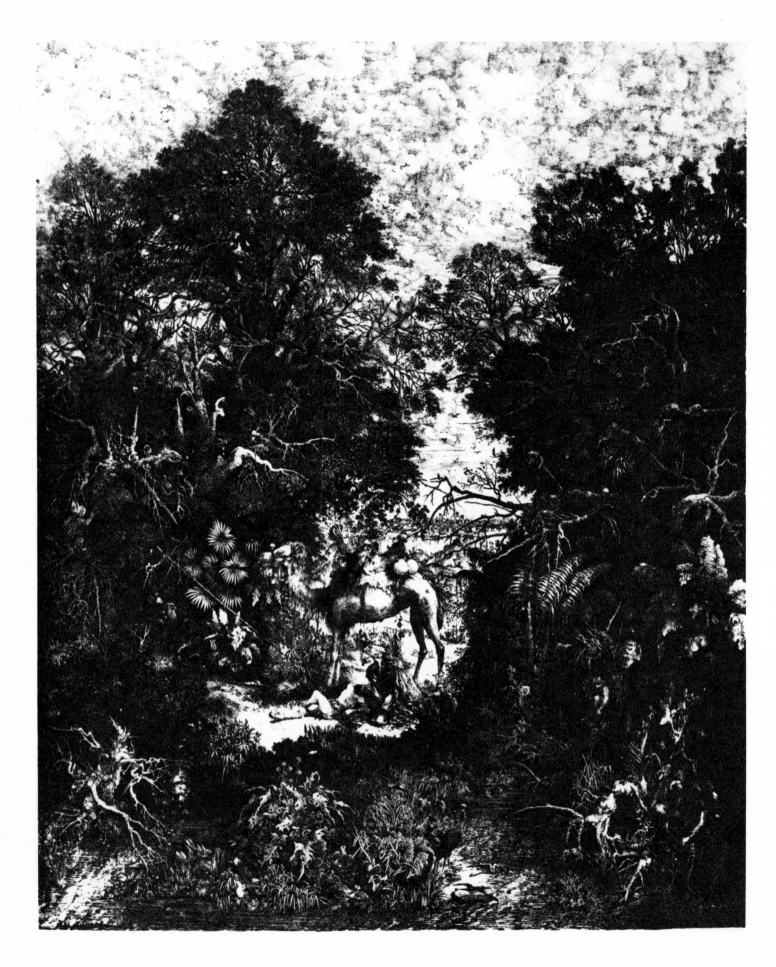

1.12 RODOLPHE BRESDIN: *Le Bon Samaritain* (*The Good Samaritan*). 1861. Lithograph, 23 1/2 × 17 1/2". University Art Museum, The University of New Mexico, Albuquerque

This remarkable print, executed entirely with a pen and liquid tusche, is one of the outstanding masterpieces in the history of lithography

Detail: More than simply a technical achievement, the work reveals in this detail the intensely visionary imagination and superb draftsmanship of a highly individualistic artist

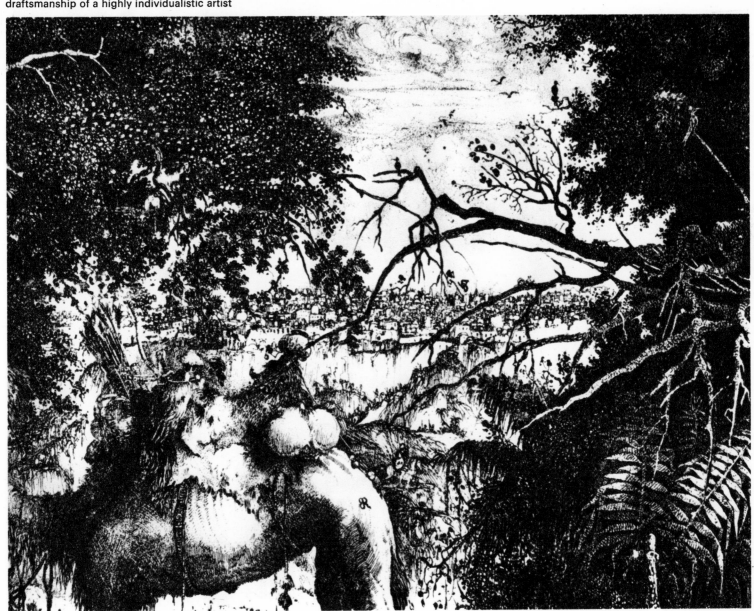

1.13 Tusche Scumble

Applying paste tusche in a viscous consistency. Note the use of a stiff-bristle brush and the character of the scumbled areas

In simple geometric or hard-edge images it is sometimes desirable to develop the image in reverse, that is to say, to draw the areas that will remain white rather than those which are to be black. This can be done through the use of a gum arabic solution to which a few drops of nitric acid have been added. The gum is applied to the margins of the stone and to all areas within the image that are to remain white when printed. (See sec. 1.18.) A solution of liquid asphaltum is then poured on the stone and wiped down to a thin film. The greasy asphaltum will produce a black image in all areas not protected by the gum mask.

NOTE: For processing of asphaltum images and comments on other uses of this material, see sec. 2.11.

Tusche may also be used for linear drawings that approximate the character of pen and ink on paper (see fig. 1.12). When working with a pen it is best to use either Autographic Tusche (if its color can be tolerated) or Cornellisen's liquid tusche, called Liquid Writing Ink. Either tusche may be used in steel nib pens, although it will be necessary to clean the points frequently to prevent clogging. Bamboo pens, quills, and sharpened wooden sticks are also useful for drawing with tusche on stone. For any work with pen or quill it is highly desirable to use a very fine-grained stone.

Scumbled or dry-brush techniques may be used on stone, working with bristle brushes and tusche (see figs. 1.13, 1.14). For this purpose, stick tusche is best, for its viscosity can be controlled most easily. In the absence of stick tusche, liquid tusche may be allowed to evaporate partially by placing it overnight in a shallow, uncovered dish.

1.14 TUSCHE WASHES

When liquid tusche is diluted with water or when stick or paste tusche is mixed to a consistency thinner than that required for the making of solid blacks, the resultant washes create images that will print as intermediate grays (see fig. 1.16). The problem in using tusche-wash techniques is that it is difficult to predict with accuracy the precise value at which a given wash will print. The dilution of the greasy material that creates the printing image is not always in direct proportion to the dilution of the black pigment that creates the visual image on the stone; hence the work may print either lighter or darker than its pigment. The deceptive character of tusche washes is such that they present problems in the preparation of the stone for printing. It is difficult to calculate the strength of the etch that should be used; and later, after initial proofing, if the image prints either much lighter or darker than expected, it is difficult to determine the cause.

Either the dilution of the tusche may be at fault, or the etch may have been too weak or too strong. Moreover, if the wash was mixed without measurement or if the etch was not recorded, it may not be possible in subsequent work to benefit from the experience.

From the foregoing it is apparent that there are many advantages in a systematic approach designed to minimize uncertainty. One excellent system is to execute a series of test stones using carefully measured washes of varying strengths (10 drops tusche to 1 ounce water; 20 drops tusche to 1 ounce water, and so forth). If the tusche dilutions are standardized, and so are the methods of applying the washes to the stone and the strength of the etches, an artist can gain through experience a high degree of control over wash techniques. (See sec. 9.4.)

1.15 THE USE OF TUSCHE WITH ADDITIVES

The physical and chemical properties of tusche may be used by the artist to create a wide range of visual effects that are uniquely lithographic. Many such effects can be produced through the use of additives.

The addition of small amounts of lithotine or gasoline to water tusche will cause the tusche to separate. When brushed out on the stone, it will break into globules, producing a broken or mottled appearance, with a filmy gray tone between the larger spots. The size of the spots or globules will depend upon the speed of the stroke, the size of the brush, and the consistency of the liquid.

Many variations are possible, each producing its own characteristic quality. Instead of mixing lithotine into water tusche, pure water tusche may be used to draw upon a stone that has been coated with lithotine. Gasoline (or lithotine) may be brushed or spattered into puddles of water tusche.

Liquid lithotine tusche undergoes a similar breakdown when water is added to it, although the visual qualities differ. When water is spattered onto a stone flooded with a wash of diluted lithotine tusche, the resulting image is quite different from that produced by spattering water tusche with lithotine or gasoline.

The addition of alcohol tends to break down the tusche emulsion, causing it to clot and form patterns that are again different from those produced by the methods described above. The addition of carbonated water or beer to water tusche will cause it to froth and separate, creating a characteristic broken pattern on the stone.

If salt is lightly sprinkled into a still wet wash, the tusche will immediately draw around each grain, producing a pattern of tiny white dots ringed with black. Epsom salts can be used to produce similar qualities on a larger

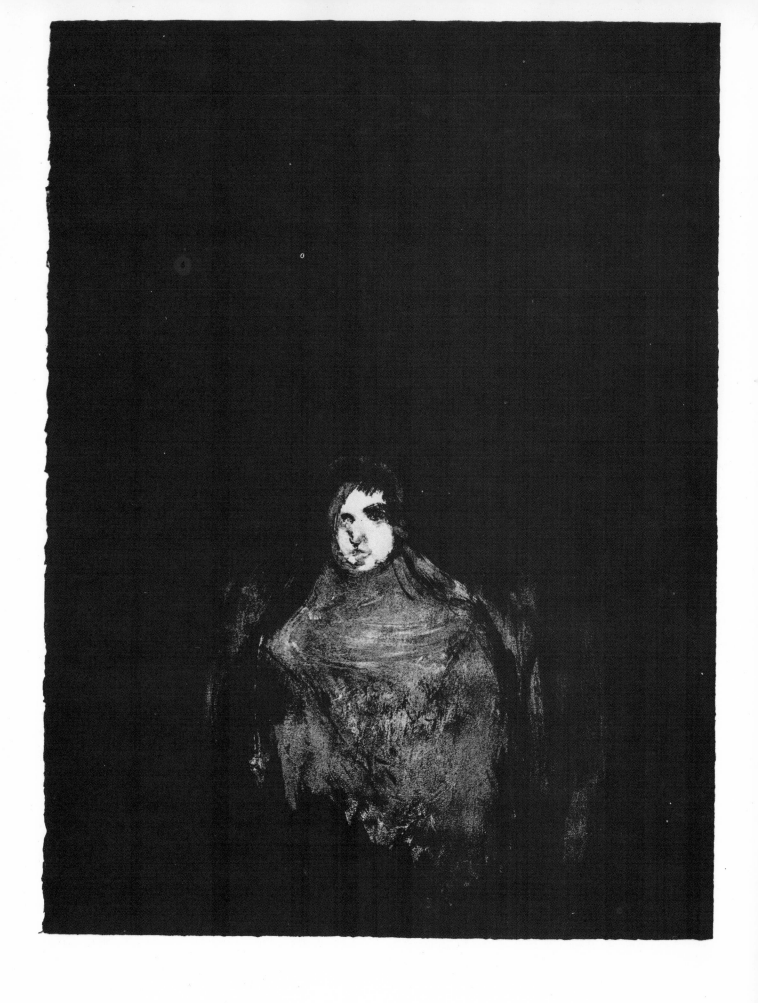

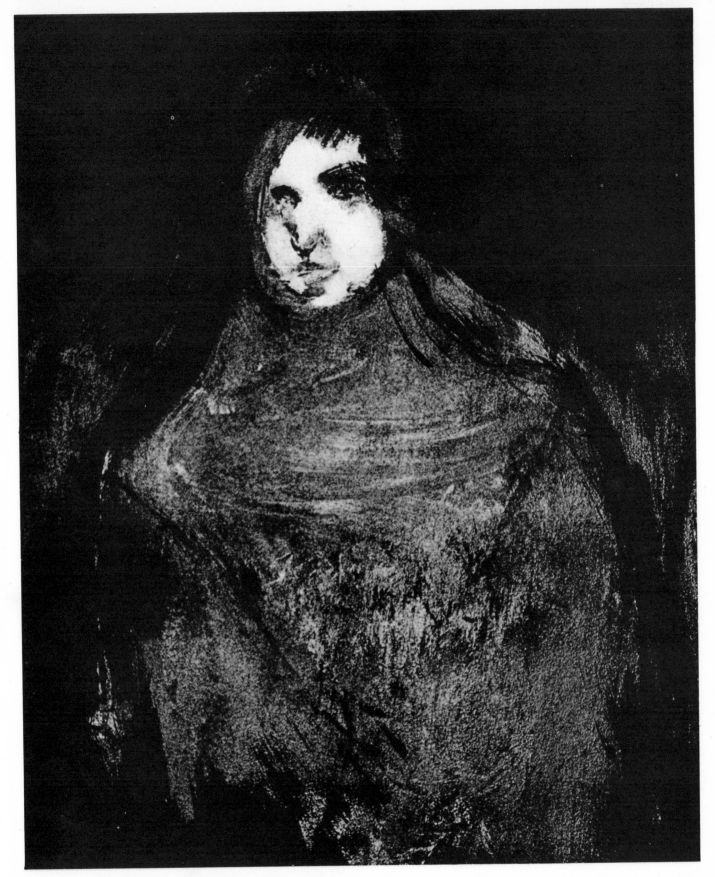

1.14 JOHN PAUL JONES: *Spanish Woman.* 1963. Lithograph, 26 × 19″. Tamarind Impression (T–712a). And detail

This lithograph is the second state of an earlier and totally different print titled *Young Girl.* It was first drawn on transfer paper, then put on stone. After the first state was printed the stone was extensively reworked by the artist, who added the dark background and darkened the image throughout. The scumbling technique is clearly revealed in the face and figure

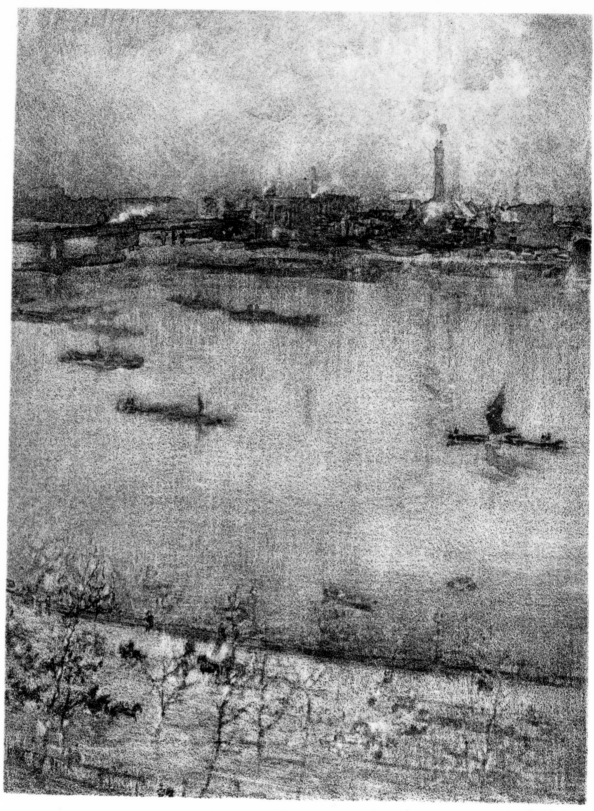

1.15 JAMES McNEILL WHISTLER: *The Thames.* 1896. Lithograph, 10 1/2 × 7 5/8". The Art Institute of Chicago. The Clarence Buckingham Collection

The remarkably delicate washes in this lithograph were developed through many states by scraping, acid biting, and re-application of diluted tusches under the careful supervision of the master printer Thomas Way

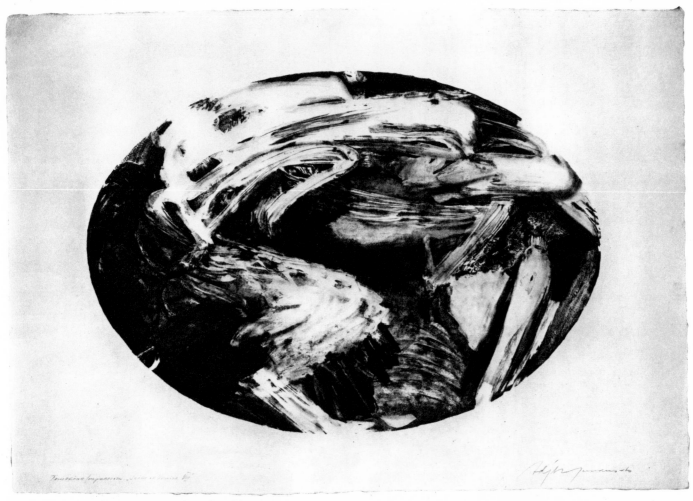

1.16 ADJA YUNKERS: *Untitled* (Plate VIII from the suite *Skies of Venice*). 1960. Lithograph, 29 1/2 × 42 1/2". Tamarind Impression (T–195)

A dramatic contemporary use of diluted tusche washes supplemented with delicate tones of rubbing crayon

1.17 Applying liquid tusche with a soft-bristle brush

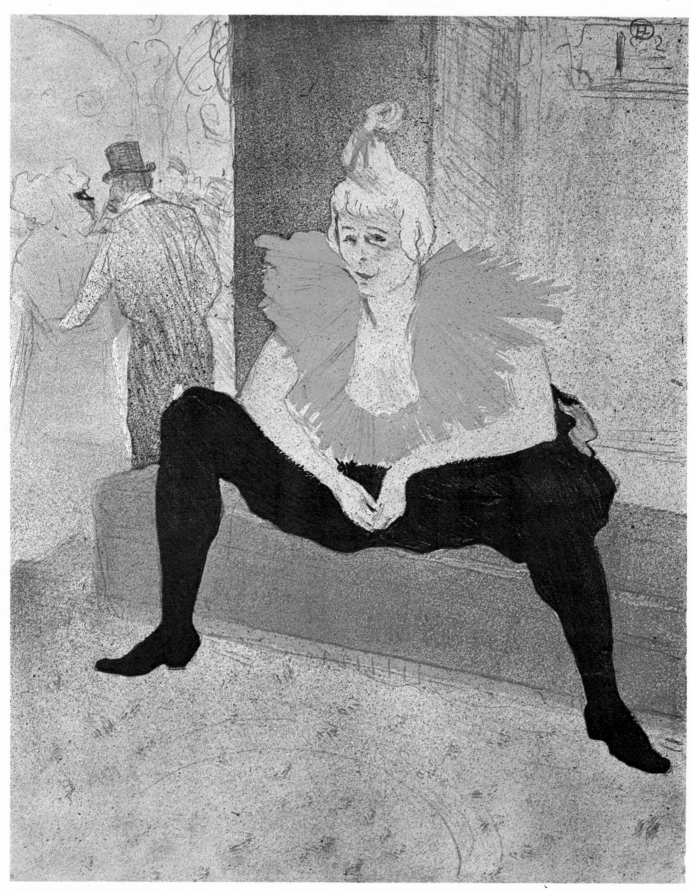

1.18 HENRI DE TOULOUSE-LAUTREC: *Clownesse Assise (The Seated Clowness,* from the series *Elles).* 1896. Color lithograph, 20 3/4 × 15 7/8". The Museum of Modern Art, New York. Gift of Abby Aldrich Rockefeller

1.19 JOHN ALTOON: *Untitled*. 1965. Color lithograph, 22×30."
Tamarind Impression (T–1354)

Four-color lithograph printed from one stone and three zinc plates.
The drawings on the plates (printed in yellow, blue, and magenta)
were made by applying tusche in a pencil-type airbrush to create
veils of color somewhat more delicate than those produced by
spattering

scale. Further experimentation suggests the incorporation of flakelike additives, thickeners, dispersing agents, and so forth, each of which might serve to alter or modify the properties of the tusche.

The unique characteristics produced through the use of tusche washes in the presence of additives are attractive as a source of automatic images which may then be accepted, altered, transformed, or controlled in accord with the artist's aesthetic intent.

1.16 SPATTER WORK AND AIRBRUSH TECHNIQUES

Spatter work became a common lithographic technique in the late nineteenth century, as seen characteristically in the work of Chéret and Toulouse-Lautrec.

Spatter work is usually done by dipping a toothbrush in liquid tusche and either pushing it across a piece of wire mesh or dragging a knife across the bristles. Spattering thus produced is small in scale and easily controlled.

Liquid tusche may be used in an atomizer or airbrush to create passages of finely textured tones. Care must be taken not to clog the pores of the stone; otherwise they will close up, and a solid black will be produced.

A variety of useful textures can be achieved through the use of airbrush techniques together with stencils that serve to mask areas of the stone. Sand, rice, beans, and so forth may be used as partial masks to create textured areas, allowing the sprayed tusche to settle around them in softened stencil-like effects. It is often more effective to spray the tusche into the air above the stone, allowing it to settle, than to spray it directly on the stone.

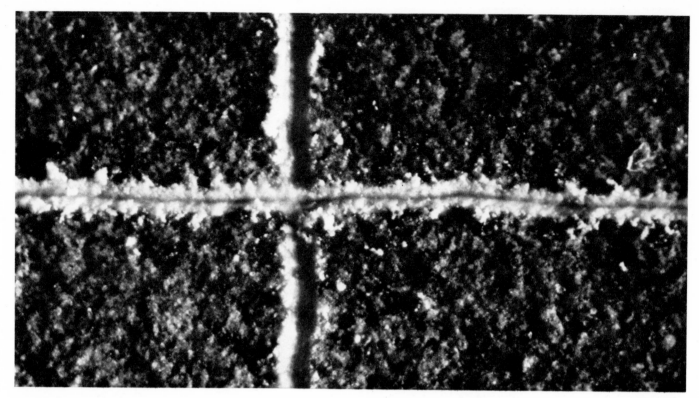

a. An example of a tusche wash on a stone before etching : 50x magnification. Razor blade scratches were added after the wash had dried. Note the covering capacity and dark tonality of the wash

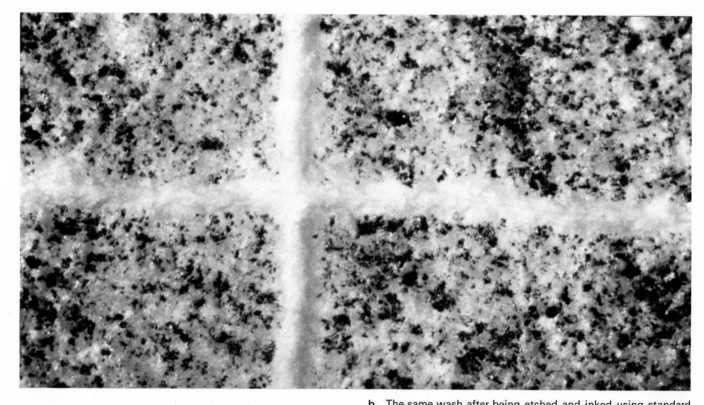

b. The same wash after being etched and inked using standard procedures: 50x magnification. Loss of tonality is caused by an excessive ratio of pigment to fatty particles in the original wash. A slight smoothing of the stone grain resulting from the corrosive properties of the etch can also be detected

1.20 A tusche wash before and after etching

1.21 Subtractive techniques

Effects of drawing and grain reduction by honing and scraping

Partial grain and grease removal

Total grain and grease removal

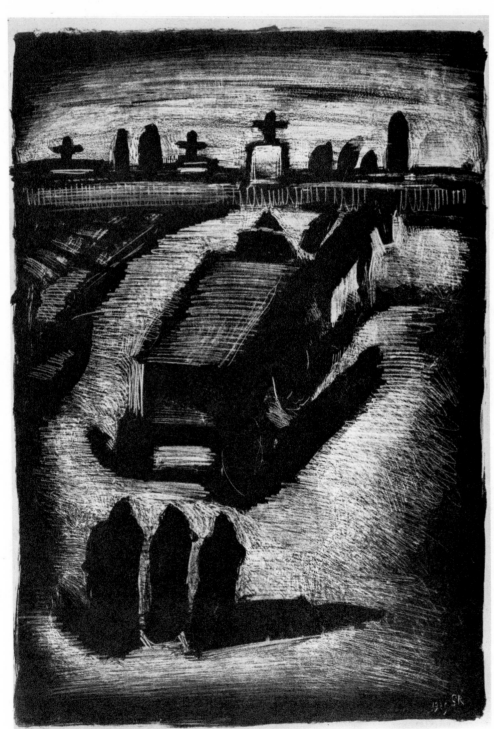

1.22 GEORGES ROUAULT: *Burial of Hope* (from the series *Petite Banlieue*). 1929. Lithograph, 13 1/4 × 8 7/8". The Museum of Modern Art, New York

An example of heavily scraped tusche drawing, probably carried through several states, with proof impressions being printed in between

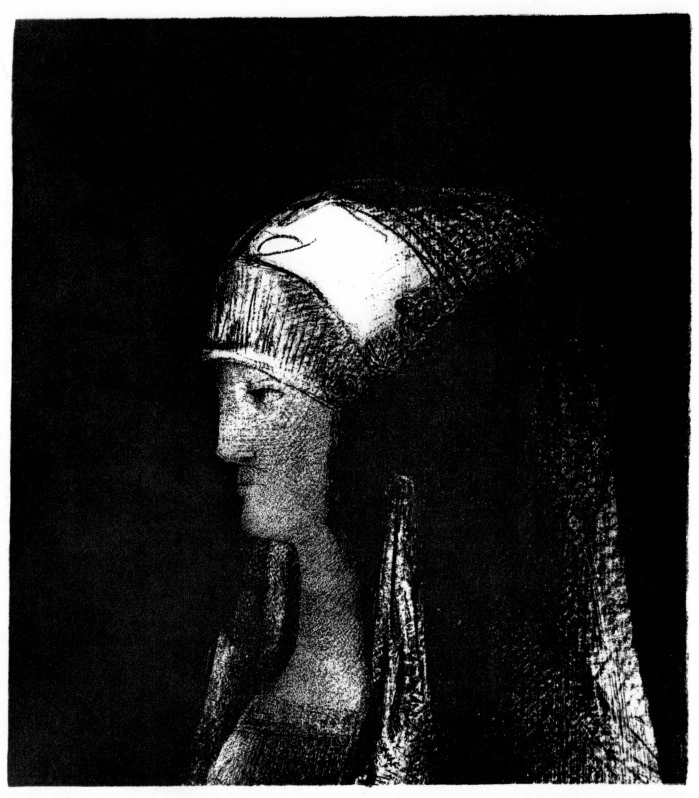

1.23 ODILON REDON: *Druidesse.* 1892. Lithograph, 9×7″. Collection Mr. and Mrs. Clinton Adams, Albuquerque, N.M. And detail

Originally conceived with crayon drawing on transfer paper, the image was altered and enriched by scraping techniques followed by additional drawing on the stone after transfer

1.17 SUBTRACTIVE TECHNIQUES

Lithography is well adapted to a range of subtractive techniques in which tusche or crayon images are scraped, scratched, or bitten away. Such techniques are often used for correcting errors in work already completed, but they also constitute an important source of visual qualities that cannot be obtained otherwise. (See secs. 2.15 and 4.6.)

In scratching or scraping the stone it is important to recall the structure of the image. Close examination of a stone upon which a drawing has been made will reveal that the tusche and crayon rest upon the peaks of the grain as well as in the pores. If the image is most gently scraped with a razor blade, the peaks of the grain will be removed, thus leaving minute white points which serve optically to lighten the tone of the area. Heavier scraping exposes more stone, lightening the area still further. Considerable scraping may be needed in order to remove all traces of tusche and regain a surface of clear stone. Care must be taken, however, not to scratch too deeply, for if the stone becomes heavily furrowed the grooves will catch and hold ink, printing mechanically.

If solid tones are scraped with varying pressures, a subtle range of grays will result, not unlike the comparable tones which may be produced on an intaglio plate by scraping back an aquatint. (See sec. 15.8.) Tones produced in this way must be etched with care when the stone is prepared for printing. The tiny dots of exposed stone will tend to fill and darken unless completely desensitized by the etch.

A double-edge razor blade, which can be slightly bent between the fingers, is the best tool with which to achieve delicate gradations of tone.

Other tools will also prove useful. Single-edge razor blades are both versatile and readily available. Intaglio scraping tools may be used to excellent effect, for the slight curve in their scraping edges makes it possible to avoid making the lines that might result from rectangular blades. Surgeons' dissecting scalpels with disposable blades have similar advantages. A number of sharp needles and picks should be at hand for delicate corrections. With skillful manipulation of the needle, such corrections may be kept virtually imperceptible, simulating the original texture of the stone. An experienced lithographer can use these tools to give luminosity to an area that might otherwise be flat or dead. Pointed tools may be used to draw fine white lines across dark areas of tusche or crayon.

For crisp work, blades and points must be sharp. Cutting edges quickly become dull when used on stone and must be either sharpened quite frequently or discarded.

Coarse sandpaper can be used to alter the surface appearance of a drawing, although it must be used with care if unwelcome smeared effects are to be avoided.

Any kind of scratching or scraping has the effect of altering the original surface of the stone. Once this has been done, it is possible to draw again with crayon, producing textures of great variety. Although somewhat laborious and time-consuming, methods involving alternate crayon work, scratching, and crayon work may be used, producing rich and expressive surfaces. Special processing techniques are likely to be required. (See sec. 2.5.)

1.18 STOP-OUTS AND RESISTS

The use of a gum arabic mask to preserve white areas within the image or to protect the margins of the stone has already been discussed. (See sec. 1.13.) Many variations on such a working method are available. All involve blocking out areas of the stone with some sort of stop-out or resist and, subsequently, applying tusche, either full strength or diluted. When the tusche flows across the areas that have been blocked out, it is unable to reach the stone, and these areas remain white in the printing image.

One of two principles can be applied: (1) the resist may be used to desensitize areas of the stone so that the tusche cannot create a printing mark, or (2) the resist may simply create a physical barrier between the tusche and the stone.

Gum arabic is the most frequently used stop-out. For such use, about five or six drops of nitric or phosphoric acid should be added to an ounce of gum. The acidified gum may then be used for brush drawing to create either solid areas or calligraphic strokes. Wherever the gum is placed, the stone is desensitized. Because of the liquid consistency of the gum, strokes drawn with it tend to be very crisp and sharp.

For softer edges, blending from white to gray, a more viscous stop-out is required. Chinese white gouache of tube consistency is excellent. This is considerably stickier than the gum solution, and it can be used either as it comes from the tube or thinned with water. Because it contains gum arabic, it serves partially to desensitize the stone. Applied in varying thicknesses, it can also serve as a physical resist, although care must be taken not to pile it up too thickly, for it may then crack and expose the stone to tusche.

As both gum arabic and white gouache are water-soluble, it is best to employ them in combination with lithotine or solvent tusche. Because the white gouache contains no acid, it should never be employed with water tusche. Acidified gum arabic *may* be used with water

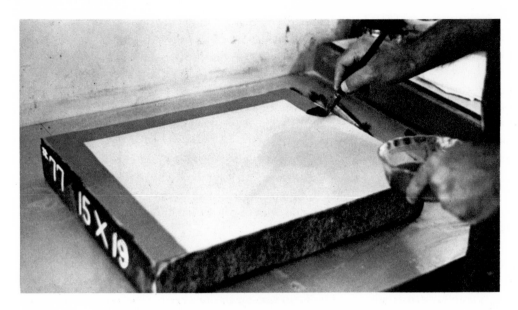

1.24 Masking stone with gum arabic

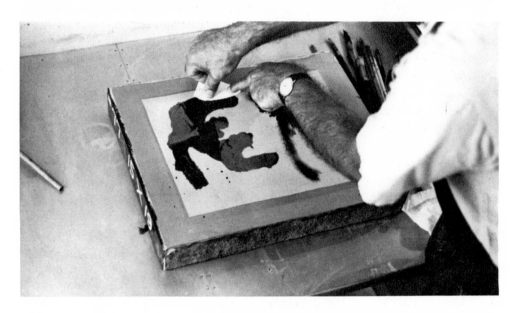

1.25 Blotting wet tusche

Lifting wet areas of tusche by blotting. The detail shows the character of blotted areas

tusche provided care is taken. There is always danger that some of the gum may be dissolved by the water tusche and carried to areas of the stone other than those intended.

Other physical resists can be used to cover portions of the stone. Pressure-sensitive tapes and materials such as rubber cement have been used for this purpose. Before using any such material it is necessary to determine through experiment whether it will serve effectively as a mask without itself making a printing image.

1.19 LIFT-OFFS AND BLOTTINGS

A variety of complex visual effects can be obtained through use of lift-off or blotting techniques. With experience it is possible to achieve considerable control and to produce passages of pattern and texture that could not otherwise be obtained.

Tusche is first applied wetly and at full strength to an area of the stone. A torn piece of blotting paper is then pressed evenly and firmly against the liquid tusche. When the paper is lifted off, much of the tusche will be taken with it, leaving a lighter area with a distinctive surface character, its edges conditioned by the torn edges of the blotter.

If, instead of blotting paper, another material is used, a different surface character will result. Nonabsorbent materials tend to change the surface appearance of the tusche rather than remove it. Many materials may be used: newsprint, cardboard, tissue, cloth, and so on. The resulting textures will be conditioned not only by the blotting material, but also by the density and fluidity of the tusche.

Somewhat different effects result when either lithotine tusche or asphaltum is used in place of water tusche, for these materials are absorbed by the blotter in a slightly different manner.

On occasion, artists have used lift-off techniques as a primary working method, painting tusche over an entire stone and lifting it off, while still wet, with a sheet of newsprint. The rich and varied texture that results can then be manipulated as raw material in the evolution of an image.

If such a method is used without purpose it can become a mere trick. The patterns of blotted tusche are not in themselves aesthetically meaningful; they must be given meaning by the artist who employs them.

1.20 COMPLETING THE DRAWING

When the image has been completed to the satisfaction of the artist, it is ready for processing. First, however, it is desirable to examine the entire surface of the stone and to make a final clean-up. All specks of crayon and grease should be removed from the margins with a scraper or razor blade. Red chalk marks indicating the position in which the paper is to be laid should be replaced either with lithographic crayon marks or with a scratched line, just deep enough to be visible (the red chalk will, of course, be washed away during processing). Any additives, such as salt, that remain on the surface of the stone should be carefully brushed away.

Frequently it will be useful to view the stone in a mirror. Minor changes and corrections will often suggest themselves to the artist when he sees the image in the left-right position of the final print, rather than reversed as on the stone.

The stone may then be moved to the table upon which processing is to begin.

Processing the Stone

2.1 PROCESSING THE DRAWING

Processing the drawing to prepare it for printing is one of the critical phases of lithography. Because mistakes at this point can easily destroy the drawing on the stone, the greatest care must be taken to proceed correctly and to understand fully each step involved.

Despite the critical nature of the process, there is no need to approach it with fear or uncertainty. Actually, controlled processing of the lithographic stone is not difficult to understand, although, because of a lack of reliable information, a cult of mystery has surrounded it.

The aim of processing is to separate chemically the image and nonimage areas of the drawing so that they will receive or reject ink consistently. When processing begins, the image areas consist of passages drawn with greasy lithographic crayon or tusche. Through chemical processing the fatty-acid particles contained in the drawing are liberated, permitting them to combine with the stone itself. Once the grease has been transferred, there is no further need for the drawing materials that contained it. The greasy areas are now ink-attractive and form the printing image. Simultaneously, the undrawn or nonimage areas are so treated that they will receive water and repel grease. This twofold reaction is brought about through a process called *etching*, in which a mixture of gum arabic and acid is applied to the stone, desensitizing its surface. The strength and formulation of the etch is determined through consideration of the character of both the lithographic drawing and the stone.

NOTE: For an extended discussion of lithographic theory and chemistry, see chapter 9.

In lithography the term *etching* does not refer to a physical change in the printing surface, as it does in intaglio printing. In intaglio work the copper plate is actually engraved, scratched, or bitten away by acids, producing depressed lines or marks that hold the ink for printing. Although in some circumstances the lithographic etch does produce slight surface changes, these are normally irrelevant to the printing of the image. The purpose of the lithographic etch is to produce a chemical separation rather than a physical demarcation between printing and nonprinting areas.

There are many possibilities and variations in etching techniques. Alternatives to the basic procedure described below will be considered at a later point in the text (see sec. 15.14).

Customarily, a sequence involving two separate etches is employed. The first etch partially desensitizes the stone, so that the drawing materials may be removed with solvent, a process called the *washout*. The cleaned image, now an integral part of the stone, is inked with a roller, a process called the *roll-up*. The inked image is then given a second etch to complete the desensitization of the stone and to provide a durable separation of ink-attracting and ink-rejecting areas during subsequent inking and printing.

To summarize the steps in processing:

1. The stone is given a first etch that (a) liberates grease from the drawing into the stone and (b) desensitizes the nondrawn areas of the stone so that they will no longer attract grease. The nondrawn areas become *hygroscopic*; that is, they now attract and retain water films. The drawn areas become *hydrophobic*, or resistant to water but attractive to grease. By magnification it may be seen that the process affects each minute dot and grain of the stone's surface.

2. The drawn and etched work is washed out with solvent to remove surface materials; these materials are replaced during the roll-up with a layer of print-

2.1 Materials for etching the stone

2.2 Materials for the wash-out and roll-up

ing ink. While in this condition, the stone may be proofed at the press or minor corrections may be made. Additional desensitization is usually required before extended printing.

3. The inked image is protected, cleaned, and given a second etch, completing desensitization of the stone. If the etches have been correct in strength, prolonged printing of the stone will now be possible.

2.2 FACTORS THAT GOVERN ETCHING

The following factors govern the selection, application, and effectiveness of etches during the process of desensitizing the stone:

1. THE GREASE CONTENT OF THE DRAWING

Drawings weak in grease content require relatively little acid to liberate their fatty components into the stone. Excessive acid in the etch will destroy weak grease deposits and will attack the grain of the stone, coarsening the image. Drawings containing heavier grease deposits require proportionately greater amounts of acid to liberate their contents.

2. THE VOLUME AND pH OF THE ETCH

Formulas for etching small stones up to $18 \times 22''$ are based upon a single ounce of gum arabic. Larger stones require a minimum of two ounces of gum arabic in the etch solution to cover their surface effectively. Customarily, formulas for etching stone specify a given number of drops of acid per ounce of gum arabic. The relative acidity of the solution is referred to as its *pH value*. Increases in either the number of drops per ounce or the total volume of the etch solution will significantly alter its pH value through logarithmic progression.

NOTE: The role of pH in lithographic solutions is discussed in sec. 9.9.

3. THE CUMULATIVE RESULT OF ETCHING

Theoretically, there is an ideal point at which the strength of etches and the cumulative result of their application will totally desensitize any given drawing without injuring either its image or its nonimage areas. In a few cases the single application of a weak etch is sufficient to desensitize a delicate drawing having meager fatty content. Most drawings, however, require a total desensitization that cannot be achieved in a single application. While one of sufficient strength would weaken or destroy image formation, a single application of a weaker solution would be insufficient to desensitize

the nonimage areas. Therefore, the printer must work out practical approaches to ensure that the cumulative effect of etching will impair neither image nor nonimage areas.

The standard procedure is to etch the work in two separate stages. The strength of the first etch should be sufficient to establish the drawing deposits so that they may be replaced with ink. The second etch completes the desensitization by fortifying both image and nonimage deposits. Several etches of different strengths may be required for drawings in which the grease content varies greatly over an extended range. Depending on conditions, these etches may be applied in either two or three stages of etching, so that the cumulative total will not injure the work.

4. THE HARDNESS OF THE STONE

Hard and dense stones may be etched with relatively strong solutions. Soft stones must be etched with weaker solutions; otherwise, their grain will be coarsened or destroyed. Thus drawings that require stronger etches should be placed on hard stones, or, if this is not possible, etching should be carefully controlled to achieve total desensitization without eroding the stone's surface.

5. ATMOSPHERIC CONDITIONS

The chemical action of an etching solution is accelerated by high temperatures and dry atmosphere; it is retarded by low temperatures and humid atmosphere. If, due to high temperature and humidity, the etch reacts too quickly, it is difficult to control its application. For this reason, weaker etches should be used in summer than in winter in regions having variable climates.

6. REACTION TIME FOR ETCH SOLUTIONS

When the etching solution makes contact with the stone, its chemical reaction will vary in time from about a half minute to three minutes, depending on the strength of the solution, the hardness of the stone, the grease content of the drawing, and the atmospheric conditions. Present evidence suggests that the major reaction occurs during the period of time in which carbonic gas is being produced from the contact of the acid with the stone. Gradually the carbonates of the stone neutralize the reaction, after which the solution is spent. Several applications of solution are often necessary to liberate and localize heavy grease deposits, whereas only single applications may be necessary for weaker deposits. Since many types of drawings contain both kinds of work, the manipulation of the etch to favor one area or another becomes a critical matter of control. Some printers control strong etches by making several applications, arresting each of

these before the reaction is spent; cumulatively they are sufficient to the task. Other printers use weaker solutions, applying them for longer periods of time to allow for more deliberate manipulation. These alternatives are possible because a stronger solution applied for half the time will accomplish much the same result as a weaker solution applied over a longer period. A combination of both approaches is often necessary, in order to achieve effective desensitization.

In view of the great variety of lithographic drawings, the factors listed above interrelate in many ways. In a later section (2.5) various types of drawings have been categorized in order to examine more closely the practical controls that govern etching.

2.3 ETCHING SOLUTIONS

Gum arabic is the major constituent of lithographic etches for stone. Although normally water-soluble, it is capable of forming, on the nonimage areas of the stone, adsorbed films that permit the retention of water for prolonged periods. Image deposits are formed in the stone by including varying proportions of nitric, phosphoric, or tannic acids with the gum solution. The acids liberate the fatty components of the drawing materials, permitting them to unite chemically with the stone. Nitric acid in the solution causes more vigorous etching action; mixtures of phosphoric acid permit a gentler response. The addition of tannic acid to etch solutions toughens the dried-gum film, thus increasing its resistance to the repetitive friction of inking and printing.

In the early days of lithography, the liberation of drawing components into the pores of the stone was accomplished by flowing solutions of nitric acid and water onto the drawing surface; this was followed by a separate operation of gumming to desensitize the nonimage areas. Present-day procedure incorporates the acids with the gum for simultaneous application and preparation of image and nonimage areas. The chemistry of the etching process for stone, the principles of adsorption, and the more specific analyses of ingredients in the etching solutions are detailed in chapter 9.

The following etch formulas offer the broadest control for all types of work. The first is a widely used table suitable for basic procedures. The second table, developed by Lynton R. Kistler, a pioneer hand printer in Los Angeles, permits more critical formulations. It is particularly recommended for delicate works that require precise control in processing.

Both etch tables relate to average conditions of temperature and humidity. The formulas are based on drops of nitric acid or phosphoric acid and grains of tannic acid per ounce of gum arabic. As previously noted, the size of the stone determines the volume of etch required; the volume of etch is directly related to its pH value, and hence its effective strength.

Standard Etch Table

Characteristics	Ounces Gum Arabic	Drops Nitric Acid
Weak etch	1	6—12
Moderate etch	1	13—18
Moderately strong etch	1	19—26
Very strong etch	1	27—33

The descriptive characteristics of etch strength are stated in table form for purposes of convenient reference. The formulas as well as descriptions may be further subdivided as required.

Kistler Etch Table

	Heavy Drawing	Medium Drawing	Light Drawing	Delicate Drawing	Very Delicate Drawing
YELLOW STONE					
Drops nitric acid	15	12	6	4	0
Drops phosphoric acid	5	5	4	3	0
Grains tannic acid	6	6	6	5	6
LIGHT GRAY STONE					
Drops nitric acid	18	15	10	5	0
Drops phosphoric acid	5	5	4	3	0
Grains tannic acid	6	6	6	5	6
DARK GRAY STONE					
Drops nitric acid	20	18	13	8	3
Drops phosphoric acid	5	5	5	4	2
Grains tannic acid	6	6	6	6	8

The Kistler etch table, in addition to providing for differences in the drawing, allows for the variable hardness of the lithograph stone. Further subdivision of this table is unnecessary. Although Kistler etches might appear to be generally weaker than standard etches, the cumulative properties of the phosphoric and tannic acids within the solution make up for the difference. Although they achieve much the same results as standard etches, the reduction of their nitric acid content permits gentler and less corrosive action.

2.4 METHODS OF ETCH MIXING AND APPLICATION

Etching solutions are prepared by measuring the gum arabic in a glass graduate. The most efficient method for measuring nitric and phosphoric acids is by dispensing from laboratory drop bottles. Acids can also be dispensed by pipette, burette, or eye dropper; none, however, is so efficient as the drop bottle. Tannic acid (measured on a laboratory scale) is added last to the mixture, and the whole is thoroughly stirred with a glass rod. The etch solution is then transferred to a shallow glass bowl which permits more practical distribution. (See sec. 10.7.)

Etching solutions are distributed on the stone by (1) brushing them on with special acid-resistant etch brushes, or (2) applying them with well-saturated sponges or cotton tufts, or (3) flowing them across the stone with well-saturated cloths, which cover the entire surface in one wipe. Distribution with the etch brush is by far the easiest and best method of control. It should be noted that application by cloth or cotton swab will usually require a greater volume of etch in order to saturate the carrying instrument fully and still permit coverage of the stone.

2.5 PROCEDURES FOR CONTROL OF ETCHES

Individual lithographic images vary greatly in character according to the drawing materials and techniques employed. An infinite number of variations is possible, but these may be classified according to major types. The simplest techniques are discussed first. The inexperienced lithographer is advised to execute a series of test stones in the sequence given, mastering the processing of each technique before proceeding to the next.

1. DRAWINGS MADE WITH HARD CRAYONS AND PENCILS

Drawings made with #4 or #5 crayons or pencils have minimum grease content. The first etch should be of weak strength (see etch tables, p. 59). The palest and most delicate areas are sometimes protected with pools of pure gum that weaken the etch as it reaches these areas. The effervescence will be insufficient for timing the reaction of weak etches; hence weak etches should be manipulated over the work for approximately two or three minutes to ensure maximum reaction before wiping down. The second etch should usually be weaker than the first; in many cases pure gum arabic without the addition of acid is sufficient.

2. CRAYON AND TUSCHE WORK WITH A BALANCED TONAL RANGE

Crayon and tusche drawings that are not too heavily worked can receive moderate to moderately strong etches. The second etch (depending on the character of the roll-up) should be somewhat weaker than the first. If the tonal range is predominantly light with only a few darks, two solutions should be mixed for the first etch. The major solution should be of moderately weak strength and related to the paler tonality. The second solution, related in strength to the darks, is applied on the greasiest areas (directly over the weaker solution) with a spotting technique. Several applications of the stronger etch may be necessary, depending on the extent of the grease deposits. The strong etch should be carefully localized so as not to endanger the weaker parts of the image. Works of predominantly dark tonality are etched in the opposite manner; the major etch is mixed to relate to the darks. A weaker solution is mixed for the lights. Both etches are applied locally, with the weaker etch applied first. A variant of this procedure is to apply only the stronger etch while protecting the weaker areas with previously applied pools of pure gum arabic. Depending on observations made during the roll-up, similar approaches may be necessary for the second etch.

3. LINEAR BLACK WORK AND SOLIDS

Full-strength blacks with or without white lines should receive moderately weak etches. One should specifically guard against overetching this type of work. Full blacks that are even slightly overetched are not only difficult to ink, but, more important, they lose richness, so that the impressions taken from them tend to be flat and lifeless. Second etches for this type of work should also be weak.

4. DRAWINGS WITH HEAVY GREASE CONTENT

Drawings made with soft crayons, thinned transfer ink, asphaltum, or heavy tusche mixtures have the greatest tendency to fill in when printed. This is especially true of areas where the tonal passages are dark and close in value.

Works of this type should be etched rather strongly. Several strengths of etch solution may be necessary, and these may require localized dilution through pools of gum arabic. The strong etch is applied in the desired areas; as effervescence occurs, it is brushed away from the weaker areas toward the stronger. This procedure is repeated a number of times, so that short intense etching action may occur in the greasiest areas. The solutions must be confined to their proper areas while being kept in constant motion; otherwise the work will be weakened by being overetched. Since several etch solutions are involved, separate small brushes are necessary for each. Because the work pattern is rapid, care must be exercised not to carry solutions across the wrong areas.

The over-all period of etching may be longer than usual, even though individual, localized spotting is of short duration. Dormant etch puddles may become too tacky to permit thin wiping of their film. If this occurs, the etch should be gently washed from the stone with water and replaced with gum arabic before wiping to a thin coating.

Second etches for work of this type follow the same procedures, with concentrated local etching on areas that reveal tendencies to fill in during the roll-up.

5. HEAVILY SCRAPED AND RUBBED WORKS

Works of this nature often require moderately strong to strong etches, because the grease deposits are removed from the top of the stone grain and deposited along its slopes and valleys. Some latent grease may also remain in the pores at the top of the grain. The etch must be sufficiently strong to localize this transfer of grease. Strong etches will tend to remove totally the latent grease in the top pores of the stone by dissolving that portion of the stone away. Slightly weaker etches will prevent the latent deposits from spreading or attracting additional ink, but will permit the halftones of these deposits to remain. Both procedures are useful for the specific results they produce. They are employed for the first etch when the scraping technique has been used *over drawing materials*. In such cases the second etch is determined by the characteristics of the roll-up. A standard second etch is employed if the roll-up indicates that the image has been fairly well stabilized by the first etch. When the scraping technique is undertaken on the ink film *after the first etch*, the above procedures are employed for the second etch. The first etch is determined by the character of the original drawing.

6. TUSCHE DRAWINGS (WATER TUSCHE)

Because of their continuous tonal gradations, tusche wash drawings must be etched with great caution. Etches too strong for weak gradations will tend to coarsen the work, since only the stronger grease particles within the wash will resist the etch. Etches that are too weak cannot confine grease particles; hence darkening, spreading, and eventual filling of the wash will occur. Continuous tonal washes almost always require local spot etching and several strengths of etch. This procedure is not applicable when tusche dilutions have been measured and applied in relation to a standard strength of etch. (See sec. 9.4.)

If the predominant tonal range of the washes is darker than 50 per cent gray, the etch solution should be mixed:

(a) to a strength based on the median of those values. A second etch is mixed for the strongest darks, and gum pools are employed to protect the pale tints. The median etch is applied over the entire stone and manipulated for longer periods over values darker than the median and for shorter periods over areas that are lighter. Meanwhile the strongest etch is applied locally to those areas for which it has been mixed. The number of applications and the periods of time each solution is left on the stone will depend on the particular characteristics of the work.

(b) to a strength based on the darkest areas, while the weaker areas are protected by gum pools. This approach is utilized if the lighter areas are few and separated and if the darker tonal range is of close value. The darker areas are controlled by manipulating the etch away from their lighter parts and allowing it to remain for greater periods of time on the darker passages.

If the predominant tonal range of the washes is lighter than 50 per cent gray, the etch solution is mixed:

(a) to the median strength of their values, with a stronger solution mixed for the darker areas, while pools of gum are used for the weaker tints. This procedure follows that of item (a) above.

(b) to a strength based on the weaker portions of the work, if these are in the majority. The entire stone is etched with this solution followed by spot etching with a stronger etch where necessary.

Second etches for the above works are best determined after assessment of roll-up characteristics. In general, these will reveal that the palest areas require only very weak etches (or even pure gum), while the strongest areas should receive the same or slightly weaker solutions than are used for the first etch. In other words, the characteristic tendency for most tusche washes after the first etch is to become paler for values lighter than 50 per cent gray and to grow darker in values below this median. Etching procedures should be perfected to control these tendencies.

2.3 The steps in processing the drawing

a. Mixing the etching solutions

b. Stirring the etching solutions

c. The completed drawing prior to processing

d. Applying talc

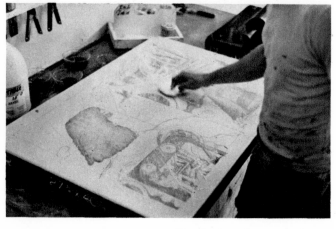

e. Distributing talc over the image

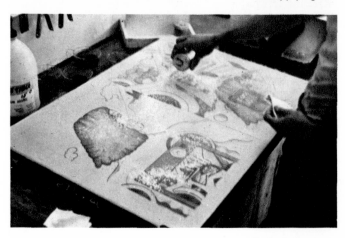

f. Applying rosin

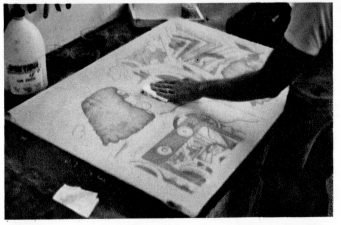

g. Distributing the rosin over the image

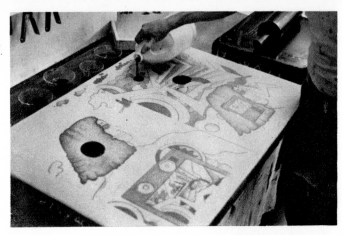

h. Applying pools of gum arabic over pale areas

i. Distributing the gum arabic

j. Applying the etch solution

k. Distributing the etch solution

l. Smoothing the etch film in preparation for wiping dry

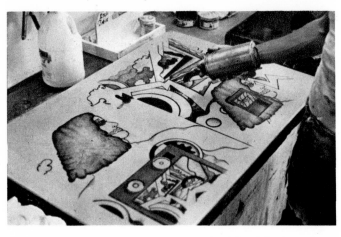

m. Applying lithotine solvent

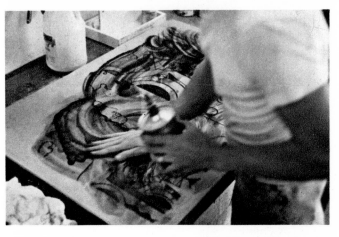

n. Washing out the drawing

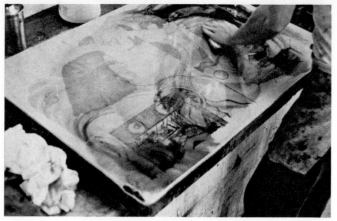

o. Removing the dissolved residue of the drawing

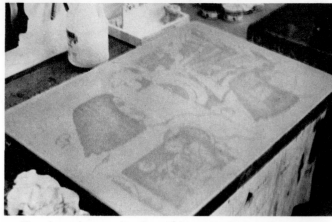

p. The cleaned stone showing a faint trace of the image deposits

q. Applying asphaltum

r. Distributing the asphaltum

s. The stone showing an evenly distributed asphaltum film

t. Applying water

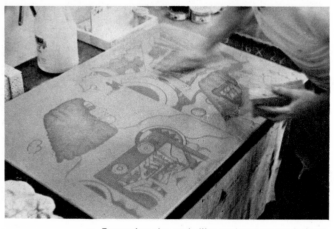

u. Removing the etch film and excess asphaltum

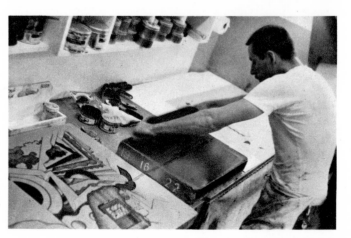

v. Charging the roller with ink

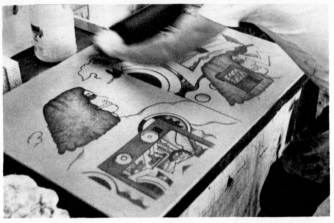

w. Rolling up the image with ink

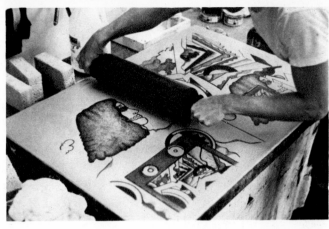

x. Changing the direction of the rolling pattern

y. Removing imperfections with a hone

z. Note the numerous spots and blemishes being deleted

aa. Applying rosin to the inked drawing

bb. Distributing the rosin

cc. Applying the second etch after powdering the image with talc

dd. Distributing the second etch

ee. Wiping dry the second etch

ff. The completed stone after processing

7. TUSCHE DRAWINGS (SOLVENT TUSCHES)

Drawings made with solvent tusches are etched according to the procedures outlined for water tusches. It should be noted, however, that solvent-tusche suspensions are greasier and more penetrating than water tusches; for this reason the strength of their etches should be correspondingly greater for comparable tonalities.

8. TUSCHE DRAWINGS (SCUMBLED)

Because of their substantial grease content, tusche drawings made by scumbling and dry-brush techniques are etched according to procedures described in paragraph 4 above.

2.6 THE FUNCTION OF ROSIN AND TALC

Drawings to be processed must first be protected with a resistant material in order to withstand the corrosive properties of the acid contained in the etching solution. Although there are many acid-resistant substances, the two having ideal properties for lithography are rosin and talc (French chalk). Both are used in the process, each performing certain tasks better than the other. Rosin is the major etch resist because it possesses the following properties: (1) it is available in a finely ground flourlike form; (2) it is insoluble in water; (3) it is soft and easily soluble in lithotine; (4) it is easily melted by heat; and (5) its particles bind together instead of remaining separated under the acid. (See sec. 10.8.)

Talc also is unaffected by nitric or phosphoric acid; however, it does not exhibit the uniting properties of rosin, and it tends to separate under watery solutions. Consequently, talc is not recommended as an absolute resist. Its most valuable function is to overcome the tendency of the greasy image to repel the watery solutions of gum and etch. By destroying surface resistance, it permits these solutions to lie more evenly on the work during the course of etching.

Since rosin is accepted as the major acid resist, it should, theoretically, be applied to the image before talc. In actual practice, however, some printers use only talc as an acid resist for the first etch, because (1) drawing materials, being less tacky than ink, are less likely to hold the rosin particles in place during etching; (2) the constituents of the drawing materials are more resistant to the etch than are those of ink. Many printers continue to employ rosin and talc for the first etch as further protection. Although its benefits at this stage are doubtful, there is no harm in the practice. Talc is also employed without rosin for all processes that require that the stone be gummed without acid etches.

Both rosin and talc must be used in the second etch. The rosin must be applied first, so that it attaches itself to the tacky ink particles, providing for their maximum resistance. The talc is applied separately. Mixing rosin and talc together for application in a single operation is not recommended, inasmuch as it offers no certainty that the rosin particles will be attached first to the ink; hence the protection of the image against the etch could be uneven.

Both rosin and talc are gently applied to drawn and inked surfaces with tufts of cotton; all excess powder is removed after each application. The chemical properties as well as storage and handling of rosin and talc are discussed in sec. 10.8.

2.7 MATERIALS AND EQUIPMENT FOR PROCESSING THE STONE

Whenever possible, stones are processed in an area of the shop designated for this purpose only. The processing

station, consisting of a sturdy etching table and the various other materials and equipment listed below, should be located near the shop water source and chemical storage. Detailed description of the processing station along with descriptions of the materials for processing are discussed in Part Two (see secs. 10.8 and 16.6).

FOR THE FIRST ETCH

8-ounce glass graduate
1-pint acid drop bottles containing nitric acid and phosphoric acid
Container of gum arabic solution
Etch brush or brushes
Shallow glass bowls for carrying the etch
Rosin box
Chalk box
2 gum-wiping cloths

FOR THE WASHOUT AND ROLL-UP

Lithotine dispenser
Washout rags
2 bowls of water: one for washing out and one for stone dampening
2 sponges: one for washing out and one for stone dampening
Black roll-up ink and ink knife
Ink slab
Leather inking roller
Liquid asphaltum or other ink base

FOR CORRECTIONS AFTER THE ROLL-UP

A small box in which the following corrective tools are carried:
Razor blades
Snake slips
Scotch hones
Rubber hones
Sandpaper

FOR THE SECOND ETCH

The same materials as used for the first etch

FOR CLEANING UP AFTER PROCESSING

Kerosene
Clean-up rags

2.8 PREPARING THE STONE TO RECEIVE THE FIRST ETCH

The stone carrying the completed drawing is positioned on the etching table after all the processing materials are laid out. A determination of the etching solutions and operational procedure may now be made. Because no two stones present the same circumstances either for etching or for inking, the few moments of appraisal will be well spent. Once the processing is under way, there is little opportunity to weigh the merits of one or another approach. When careful consideration has been given to the stone and procedures for etching and inking have been decided, the etching solution is mixed, the stone is dusted with talc, and the processing is under way.

2.9 THE FIRST ETCH

APPLYING THE FIRST ETCH

The stone must always be dusted with talc before the first etch. The etching solution is then tested on the borders of the stone, to determine the strength of reaction on that particular stone. The contact of the acidic mixture with the carbonates of the stone will produce an effervescence of carbonic gas bubbles, which will indicate the strength of the etch. If the reaction is violent and instantaneously produces a rich white froth, the etch is probably too strong; it should be diluted with gum arabic. A satisfactory etch should react *almost* instantaneously, producing a gentle frothing. Weak etches will not effervesce until several seconds have elapsed; then they do so very mildly. Strong etches applied through pools of gum react like weak etches. Extremely weak etches may not effervesce at all. If the etch appears too strong during application, it should immediately be diluted by adding gum arabic, or it should be brushed away from the drawing and toward the borders of the stone. Such etches should not be removed with a dampened sponge, because the water-soluble ingredients of the drawing may be endangered or smeared.

The basic application procedure is to flow the etch across the whole stone, rapidly and evenly subjecting all areas of the image to equal amounts of solution. The area of the stone to be etched may be reduced by first covering all the borders with the etch. Next, a generous brushful of etch is carried in a single sweep across the top of the image from one side to the other. The brush is charged again and a second stripe is carried across the stone, just overlapping the first. The brush will need recharging for each stripe, because its solution will be practically exhausted as well as somewhat neutralized by reaction with the limestone. This pattern is repeated until the entire stone is covered. At the same time the strongest effervescence is brushed away from the weaker areas of the drawing and is

deposited on the stronger. When the stone is completely covered, the remainder of the solution is applied more deliberately, at right angles to the first application. Further manipulation of fluid over the greasier areas of the drawing is advisable at this time.

The etching should proceed with continuous manipulation for two or three minutes; after this the total volume of the solution and most of the chemical reaction will have been spent. The solution is left on the stone for several more minutes (just enough time to wash the brushes, etch bowl, and graduate in preparation for the second etch). The etch should not be left on the stone too long, however, for it cannot then be dried into a thin coating.

The procedures described above are the basic methods of etch application. More specific approaches for etch control as it relates to particular types of work have already been described in sec. 2.5. The techniques of application for these approaches should follow the framework of the basic procedure. The more complex approaches require several strengths of etch solution and sometimes pools of gum arabic as well. These should be mixed beforehand, and, along with an assortment of Japanese brushes (for spot etching), should be readily available from the outset of work. (See sec. 10.8.)

DRYING THE ETCH

The importance of properly drying etch and gum coatings cannot be emphasized too strongly; the thinner and evener the coating, the better will be the desensitization of the stone. The wiping and polishing technique forces the film of etch or gum into the valleys of the stone grain and exposes the image for easy solvent removal during the washout. The adsorbed films of the etch or gum coating serve as a water-bearing and ink-rejecting mask, covering each grain and pore of the nonprinting surface. Coatings that are too thick or uneven often cover parts of the drawing, making it difficult for the washout solvent to penetrate and dissolve the image. Moreover, unevenly adsorbed coatings cannot retain water films equally; hence they impair the inking of the image and can, in serious cases, produce gum streaks which are impossible to remove from the stone and which appear on the impressions printed from it. (See sec. 9.12.)

Etch and gum coatings should be dried with two folded cheesecloth pads; the first mops up and evens the bulk of the etch solution, and the second polishes and dries the remainder to a thin, even film. It is beneficial to pat a little water on the pads before use to enhance their softness and pliability. However, too much water is harmful, for the wet pad will dilute and remove practically all the coating during the wiping.

The wiping is done with gentle and even pressure, following the side-to-side and top-to-bottom pattern described for brushing the etch. Wiping pressure should come from the heel of the hand rather than from the fingers. Pressure from the fingers will rake the surface of the stone and cause gum streaks. The wiping cloths are thoroughly washed with clean water after use and hung without folds to dry.

Heavily piled-up crayon and tusche work may become dislodged or slightly smeared during the wiping process. This should not be viewed with alarm. The displaced surface contents of the drawing cannot harm the stone, since the etch has already desensitized the nonimage areas, making them resistant to grease. Even if a great amount of grease has been displaced, the image will not be impaired, although its receptivity to ink in the areas from which the grease has been displaced will be retarded. Images in this condition are usually reinforced with asphaltum during the washout process so that they may receive ink with equal rapidity.

Early lithographic practice advocated that the etched stone be left overnight before further processing. This was thought to permit maximum desensitization within the pores of the stone. This practice has generally been abandoned at Tamarind because it has been demonstrated that the strength of adsorbed films is constant once they are dry. Additional periods of drying have no further consequence on either gum-film formation or the grease formation within the stone. It should be noted, however, that humid atmospheric conditions retard the drying of gum and etch solutions considerably. Even though appearing dry on the outer surface of the stone, these solutions may be damp within its pores. It must be remembered that maximum film adsorption necessitates complete drying.

When the first etch is thoroughly dry, either the stone can be washed out, rolled up, and given a second etch, or it can be stored for future completion of processing. It is preferable to complete the processing by inking the stone and giving it a second etch before storing for long periods. In this condition the lithographic properties of the stone are fully established and cannot be endangered.

2.10 THE WASHOUT

After the first etch the fatty components of the drawing become an integral part of the stone, and the nonprinting image comprises a surface that is partially water-receptive and ink-rejective. The original ingredients of the drawing materials are no longer needed; these are removed in the washout process, which prepares the ex-

posed image on the stone to receive ink. Images may be washed out in one of two ways:

METHOD I (PREFERRED)

This method of washout is recommended for clean, safe, and efficient results.

1. The work is washed out through the dry coating of etch or gum, using lithotine and a clean, dry rag. The solvent has the ability to penetrate the thin etch coating without dissolving it. The etch coating acts as a protective mask over the nonprinting areas, preventing the dissolved sludge from making contact with the stone.

 NOTE: If the etch or gum coating is too heavy, it will prevent the solvent from washing out the drawing thoroughly. When this occurs, the entire stone must be washed with water, and the procedure thereafter must follow Method II.

2. The dissolved sludge is wiped away and the stone is fanned dry, permitting the solvent to evaporate.

3. When the stone is dry, it is washed with the washout sponge and water, dissolving the etch coating and removing all the residue of the drawing materials.

4. From this point on, the stone must be kept wet with a clean film of water applied with the dampening sponge.

5. The separation of image and nonimage areas is now established. The surface of the stone will appear clean, with its printing image faintly visible, similar to a photographic negative.

6. In this condition the stone is immediately rolled up with the stiff roll-up ink and the leather roller. The roll-up should proceed more rapidly in this method than in Method II, because the drawing will not wash out through the dry etch coating as completely as in Method II. As such, its image, partially sensitized by the small residue of grease left from the original drawing, will receive the ink more quickly.

METHOD II (THE "WET WASHOUT")

1. The dried etch coating is washed from the stone, using the washout sponge.

2. From this point on, the entire stone must be kept moist with a film of water.

3. Lithotine is sprinkled on the wet stone, and the drawing is quickly dissolved and wiped with a clean cloth.

 NOTE: If the protective barrier of water dries, the dissolved greasy sludge will settle and attach itself permanently to the partially desensitized surface.

4. The sludge is carefully removed by washing the stone clean with washout sponge and water.

5. It is then dampened with the dampening sponge and immediately rolled up with ink.

 NOTE: The following points should be clearly understood to avoid difficulty when using Method II:

- The procedure removes the drawing more completely than Method I, although it is messier and contaminates sponges and water bowls with the greasy residue that is dislodged.
- Unless all remaining solvent is removed by washing with clean water, it will mix with and increase the greasiness of the roll-up ink. Ink in this condition will surely ruin the design by closing it in.
- Because the drawing is so thoroughly washed out, the rolling up with ink will take somewhat longer to build up to the optimum.
- Asphaltum printing bases cannot be used in this method (see sec. 2.11).

2.11 ASPHALTUM AND CORNELIN

The ink receptivity of a lithographic image is directly proportional to the extent of its fatty deposits. Heavy deposits of grease will tend to attract ink from the roller more rapidly than weak deposits. Hence, during the roll-up, the dark areas of an image will sometimes appear fully inked before the light areas have achieved their full tonality. If the stone has also been inadvertently over-etched, even slightly, the light areas will accept ink all the more slowly. Inking further to assist the development of the light areas may result in overinking of the darks.

Printing bases are designed to overcome this problem. Either liquid asphaltum or Cornelin (a proprietary printing base) may be applied to the image to fortify the fatty deposits and to equalize ink receptivity. Works treated in this way will roll up more evenly and rapidly.

Liquid asphaltum has been used as a standard printing base in lithography for many years. (See sec. 10.5.) When applied on the image and dried, its greasy constituents fortify the fatty image deposits, leaving a tenacious and tacky film which is highly receptive to ink. Because of its greasy nature, asphaltum is also beneficial in reinforcing areas that have suffered minor grease loss from overly strong etching.

Cornelin solution is a mixture of solvent, gum arabic, and asphaltum, originally designed as a one-step washout solution to dissolve the surface image while simultaneously fortifying its grease deposits. Unlike liquid asphal-

tum, its coating does not require drying in order to be effective. Hence Cornelin finds its greatest application in hand printing when used for Method II washouts, where asphaltum cannot be used.

APPLICATION PROCEDURE FOR ASPHALTUM

1. The drawing is washed out through the dry-gum mask, following the washout procedure of Method I.
2. Asphaltum solution is applied with a clean cloth in an even film over the entire work and then is fanned dry.

NOTE: The solution should only be applied over a protective mask of gum or etch; otherwise it will attach itself everywhere, attracting ink over the entire stone. Unless applied to a dry stone, it will neither adhere nor dry properly.

3. The dried coating is washed with water. This removes the etch or gum mask from the nonimage areas. The image areas will retain a firm tacky coating which forms the ink base.
4. The stone is kept damp and is immediately rolled up with ink. It will be seen that the image will accept ink more quickly and evenly. Slightly overetched areas will regain their original value. If they do not, the overetching has been severe, and very little can be done to correct the error without counteretching the work. (See sec. 4.9.)

APPLICATION PROCEDURE FOR CORNELIN

1. The etch or gum coating is washed from the stone with water. The stone must be kept damp at all times thereafter.
2. Lithotine is applied, and the surface image is washed out. Cornelin (because of its solvent content) can be used for the washout instead of lithotine; greater amounts are necessary, however, and the work is time-consuming.
3. The stone is washed clean with water, and, while damp, it is wiped with an even film of Cornelin solution.
4. The excess Cornelin is removed from the stone with sponge and water, and the dampened stone is immediately rolled up.

NOTE: The above is a somewhat dirty process in which both sponges and water bowls accumulate greasy residue; they require thorough cleaning before further use.

The proper time to use an ink base is often a matter of personal preference. It should always be employed, however, when there is doubt about overetched work or the roll-up characteristics of weak drawings. Images that have large areas of solids will roll up more dependably if a printing base is used. Many printers prefer to use a printing base for all work, both for the initial processing and for the washout preceding the printing. As well as equalizing ink distribution, the printing base protects the image against the cumulative abrasion of the inking and printing process.

Because printing bases greatly increase the ink receptivity of an image, the work will tend to roll up rapidly. In the hands of an inexperienced printer there is always a possibility of overinking. This is particularly true when a work has been underetched. If overinking does occur, the work should be:

 (1) dusted with talc, gummed, and dried;
 (2) washed out with lithotine;
 (3) coated with asphaltum (if desirable);
 (4) washed with water to lift the gum mask;
 (5) rolled up slowly, and with less ink;
or:
 (1) washed out wet by using Method II;
 (2) coated with Cornelin (if desirable);
 (3) rolled up slowly and with less ink.

2.12 THE ROLL-UP

The application of ink after the washout is one of the critical phases of stone processing. The objective is to deposit a layer of ink on the image, exactly duplicating the visual characteristics of the original drawing. The inking procedure must be executed with care and deliberation, inasmuch as the stone is only partially desensitized by the first etch.

Assuming that the first etch has satisfactorily performed its function, the success of the roll-up is conditioned by (1) the type of ink employed, (2) the technique of roller manipulation, and (3) the control of moisture on the stone.

Only the stiffest lithographic ink (called Roll-up Black) is used for the roll-up process. Its minimum fatty content and stiff consistency help to prevent fill-in of the partially desensitized stone. In addition, the ingredients of the best roll-up ink are specially selected for their resistance to the corrosive action of the second etch, which is necessary for the completion of desensitization. (See chapter 11.)

The handling of the ink roller is largely a matter of individual touch. Although no two printers manipulate this instrument identically, there are general principles regarding roller operation that are essential for all successful inking techniques. These are given here, with addi-

tional details about inking control reserved for sec. 2.13.

The control of moisture on the stone is vitally important. The water film lies on the nonimage areas, keeping them clean because of its ink-rejective properties, and confines the ink within the limits of the image. The stone must be kept constantly damp with a thin, even film throughout the inking. Excessive water on the stone will prevent the roller from distributing ink; simultaneously, the ink receptivity of the image will also be retarded. Conversely, if the stone becomes too dry, the ink will catch on its surface, clogging the image areas and scumming the margins.

PROCEDURE

The roller, lightly charged with ink, is passed over the work rapidly and lightly four or five times without stopping. Examination of the work will show that the image is beginning to receive ink in an increasing or decreasing degree, depending on its particular characteristics. The procedure of rapid rolling with minimum pressure limits the discharge of ink and enables the printer to assess the receptivity of the image to the ink. Within the period of the first few passes of the roller, the printer must determine the rolling techniques necessary for that particular stone. If ink acceptance is slow, the rolling should proceed more slowly and with gradually increased pressure. If ink acceptance is fast, rapid rolling and minimum pressure should continue.

As the image develops, the roller is recharged with fresh ink from the slab, the stone is redampened, and the rolling is continued. These steps are repeated with periodic inspection of the work until the image is fully charged with ink and duplicates the tonalities of the original drawing. In this condition it is ready to receive minor corrections; these are followed by the second etch for the completion of desensitization.

2.13 CONTROL FACTORS DURING THE ROLL-UP

Some pertinent factors governing the roll-up are listed below.

1. If the image is smaller in either of its dimensions than the width of the roller, the rolling should begin along the smaller dimension. In this way, the critical first inkings will completely cover the image without lap marks.

2. If the first few passes of the roller are uneven, the effect will be magnified by subsequent inkings. This is particularly true for lap marks, which are exceedingly difficult to even out once they have become established.

Should this occur, the work should be washed out and rolled up again.

3. After an even layer of ink has been established, the stone should be inked at right angles to the first inking, even if it necessitates lapping the rolling. Several passes should be given diagonally from corner to corner as well. The rolling patterns should be calculated so that the last few passes of the roller are in the same direction as the first passes. The purpose of changing rolling patterns is to permit ink from the roller to engage the ink dots of the image from all directions. Otherwise, the ink will build up along one side of each dot and will gradually distort the tonal values of the image.

4. If the image is larger in both directions than the roller width, a lapping pattern of inking is employed. It should begin from the direction that permits minimum lapping. The inking starts with one pass of the roller on the right side, two passes on the left, and returns with a single pass on the right. This procedure is recommended because the first pass deposits the greatest amount of ink from the freshly charged roller. The two passes on the left side slightly more than balance this. The ink supply on the roller is, by now, greatly diminished, so that only a little is deposited during the final pass on the right side. This is just sufficient to equalize the total pattern. The next inking starts with a single pass on the left side, two on the right side, and so on, alternating the starting point with each fresh change of ink. As this sandwiching of overlapped passes is taking place, the stone is occasionally rolled diagonally and also at right angles to the first patterns.

5. Sometimes an image will roll up very slowly, refusing to build up to the maximum darks. This usually indicates either that the drawing was less greasy than supposed or that some of its grease content was weakened by the etch. When asphaltum or Cornelin solutions are ineffective, a slightly softer ink may prove successful, or the stone may be allowed to dry for a few minutes before resuming damping and rolling. Images left "open" (dry and without gum protection) for varying lengths of time will tend to darken when inking is resumed. Darkening can be controlled to a limited extent by keeping some areas of the image moist while permitting other sections to dry for varying periods.

6. Stones that have received relatively weak etches can be overloaded with soft ink in order to modify the character of their images. For example, a drawing that appears too hard and dry can be darkened and given broader and softer overtones by overinking. During the roll-up, certain areas may be permitted to dry while others remain wet. The dry areas will catch ink and produce soft

roller tones, which can be localized by the edges of the moisture film. Linear work can be given beautiful soft edges in this manner. The success of these manipulations depends on one's skill with the roller and on the weakness of the first etch (it must have been weak enough to permit the ink to overcome it and form its impression in the stone). In anticipation, the artist may wish to underetch the work during the first etch, bearing in mind that he will probably have to compensate with a stronger second etch in order to stabilize the inked image fully.

This manipulative procedure is contrary to the classic approach of rolling up to conform to the original drawing. If the artist is printing his own work, he can view this as a natural extension of the image-forming process. Procedures such as this allow much flexibility; however, the image will eventually need to be stabilized if duplicate impressions are to be printed.

2.14 PRELIMINARY PROOFING AFTER THE ROLL-UP

Some printers like to print a few preliminary proof impressions from the stone after the first etch and roll-up. Printed impressions allow appraisal of the work at an early stage and provide an accurate guide for corrections, if these are necessary. It must be remembered, however, that the image being proofed is only partially stabilized. Inking and printing must be undertaken cautiously at this stage. There is an ever-present possibility that the pressure of the printing press will overcome the image and non-image formations on the stone, causing them to break down. In such cases, the image will gradually thicken and fill in as the ink is physically forced into the partially formed nonimage areas.

The violation of partially stabilized boundaries may sometimes be put to practical use. Images that refuse to roll up to full tonality after the first etch can be encouraged to do so by the pressure of the press during proof printing. This procedure must be carefully controlled so as not to overthicken the work. When the tonalities of the image have reached the desired point, the proofing should be suspended and the stone given the second etch.

Occasionally works will proof with great ease and with no apparent increase in their tonal range. In such cases, the single etching will have been sufficient to prepare their image fully for prolonged printing. This is most often true for very pale drawings that have a limited value scale. Works of this type are spot-corrected, and their borders are cleaned and locally etched immediately after proofing. Next, the stone is dried, dusted with talc, and gummed. After the gum is dry, the work may be washed out and rolled up, and the printing of an edition may begin.

2.15 CORRECTIONS AFTER THE FIRST ETCH

After the stone has received the first etch and has been washed out and rolled up with ink, it is ready for minor corrections and cleaning in preparation for the second etch. If preliminary proofing is undertaken after the first etch, corrections and cleaning of the stone follow this process.

The type of corrective work to be undertaken at this stage is usually of the simplest kind, involving removal of unwanted areas in the drawing and margins of the stone and touching up of broken lines and solids with full-strength tusche. More complex corrections should be delayed until the stone has been fully desensitized by the second etch and after impressions printed from it have been examined. The corrective procedure requires that deletion of work be undertaken first, because the stone must be periodically sponged with water during the process of removal. After the addition of new work, the stone cannot be further dampened, because of the solubility of the drawing materials.

PROCEDURE FOR DELETIONS

If the corrective processes are extremely simple and the stone can be kept partially damp, rosin and talc etch resists are not applied to the image until all corrections have been completed. For more complex corrections, the stone is dried and dusted with rosin and talc before correction in order to (1) protect the inked image from smearing when corrections are made, (2) prevent stone particles from the removal process from attaching to the inked image, and (3) prevent the image from darkening or spreading when the stone is permitted to dry during lengthy cleaning. After the excess rosin and talc are removed, the stone is dampened with sponge and water; this causes the powder that sticks to the ink to become transparent and permits the work to be clearly seen.

Undesirable areas of the image may be lightened by partial scraping or may be removed completely. Tonal harmonies can be made more luminous by delicate picking with engraving needles and blades. Areas can be sandpapered and scratched to coarsen as well as lighten their passages. Sizable smudge marks, finger prints, and dirt spots can be removed by polishing with Scotch hones, which are especially useful for cleaning the borders of the stone (see sec. 10.8). The hone may be drawn against a T-square or metal straightedge if crisp and mechanically true borders are desired. The hones (used wet) may also

be employed to remove internal parts of the image. Strokes made by the hone are softer and less crisply defined than those made with blades. Sometimes large areas of work are first removed by honing, and then further modified with a blade for added crispness. It should be noted that areas polished by honing do not accept additions of work with the same sensitivity as the original grained surface.

Reasonable care should be exercised during the deletion process so as not to displace soft ink films adjacent to corrected areas. There should be a damp sponge or drawing bridge to support the hands so that they will not touch the surface of the damp stone. After deletions have been completed, all remaining residue is sponged from the surface with clean water, and the stone is fanned dry. The addition of work can then be undertaken.

PROCEDURE FOR ADDITIONS

Only full-strength solutions of tusche are feasible for the addition of work between the first and second etch. The extremely fatty content of the tusche is essential for image formation over the partially desensitized nonimage areas. It is doubtful that diluted tusches or lithographic crayons have sufficient greasiness to overcome the resistant adsorbed film of the first etch.

The tusche (autographic, solvent, or water type) can be applied with brush, pen, stick, rag, or sponge, depending on the effects desired. The addition of work with tusche is usually limited to the touching up of light specks and imperfections not perceived until the image was rolled up with ink. The nature of the material confines its use to lines, solids, stipples, and dry-brush techniques.

The tusche must be thoroughly dry before the stone is again dusted with rosin and talc in preparation for the second etch.

2.16 THE SECOND ETCH

The second etch is the final step in the preparation of the stone for printing. By uniting with the adsorbed film deposits of the first etch, it further reinforces the nonimage areas of the stone, increasing water receptivity and grease rejection during prolonged periods of printing. The second etch is made with the same materials as the first etch, and volume and degrees of acidity are also identical (see etch tables, sec. 2.3). The strength of the second etch is determined after observing the characteristics of the ink roll-up following the first etch. For example:

1. Normal Roll-up. If the first etch was of moderate strength (18 drops of acid to 1 ounce of gum arabic) and a normal roll-up produced good fidelity, the second etch should be slightly weaker (14 drops of acid to 1 ounce of gum arabic). One must guard against overetching during the second etch. Too often, the novice, after producing an excellent first etch and roll-up, loses delicate demitints and freshness of image by using a second etch that is too strong. The damage (not apparent until the stone is printed) will produce a flat and lifeless print. The degree of reduced acidity for the second etch is determined by the character of the work. Images with weaker grease deposits can withstand greater reduction than those with heavy deposits. Excessive acid reduction will result in insufficient desensitization, causing the work to darken and fill in during the printing.

2. Slow and Laborious Roll-up. If the first etch was moderately strong (22 drops of acid to 1 ounce of gum arabic) and full blacks could not be achieved even after prolonged rolling, the darks should be retouched with tusche and the stone given a weaker second etch (12 drops of acid to 1 ounce of gum). This problem is characteristic of an overly strong first etch which prevented a rich roll-up. The error should not be compounded by a second strong etch. If image loss has been critical, the stone should be treated only with pure gum. More often than not, the image will require extensive modification after proofing, or else will have to be abandoned.

3. Abnormally Rapid Roll-up. If the first etch was moderately strong (24 drops of acid to 1 ounce of gum arabic) and the roll-up was extremely rapid (the image tending to darken and fill in), it is likely that the first etch was, nevertheless, too weak. The second etch should be nearer to the strength of the first etch. It may be even stronger if the condition is very pronounced.

These theoretical examples, although extremely generalized, illustrate how the characteristics of the roll-up reveal the effectiveness of the first etch and suggest formulation of the second. In actual practice, the relative characteristics of image, etch, and roll-up are so variable that the second etch will require other controlling techniques such as those described for the first etch (see sec. 2.5). These are employed, as necessary, within the broad framework of approaches just described. One is reminded that the cumulative properties of the two etches ultimately determine the fidelity and printability of the original drawing.

2.17 APPLYING THE SECOND ETCH

After the image has been dusted with rosin and talc, the solutions for the second etch are freshly mixed. Application procedures are similar to those for the first etch, though perhaps modified by the controlling patterns previously described. As before, the etches are first tested on the borders of the stone to determine their relative strength.

After application, the excess etch solution is removed from the stone with gum-wiping cloths, and the remainder is polished into a smooth thin coating. This completes the processing operation. The stone, with its image, is now fully prepared. In this condition the stone can either be stored or removed to the press for proofing and printing. Water bowls, sponges, and etching apparatus should be thoroughly cleaned before further work is undertaken

The Artist and the Printer

3.1 THE COLLABORATIVE RELATIONSHIP

In chapters 1 and 2 we described the making of a drawing on stone and the process of transforming it by chemical means into a printing vehicle. In chapter 4 we shall discuss the procedures employed in printing multiple impressions from the stone. Before doing so, it is necessary to consider the working relationship between the artist and the printer.

Historically, because the skills required of the master printer are many and complex, lithographs have characteristically been made by an artist and a printer working collaboratively together. In Europe such a collaborative relationship has long been taken for granted, and only in rare instances have major European artists printed their work themselves.

Within twenty-five years after the invention of lithography by Aloys Senefelder in 1798, workshops were opened in most of the major European cities. Senefelder himself established the first such workshops in Munich and Offenbach in 1799. Having been granted exclusive rights to the new process in Bavaria, Senefelder sought also to obtain patents in England, France, and Austria. He was at this point primarily concerned with the reproductive and commercial potential of lithography, and gave little thought to its possible use as a medium by artists.

Forming a partnership with Johann André, a music publisher in Offenbach, Senefelder went to London in 1800, accompanied by André's brother Philipp. After obtaining a patent in 1801, Senefelder returned to Offenbach, leaving Philipp André to run the new lithographic establishment. In the same year, 1801, Frédéric André, another brother, applied for a patent in Paris and opened a workshop there.

By 1804 lithographic printing had begun in Vienna and Berlin. Subsequently, workshops were established in Milan, Rome, Madrid, and Barcelona. By 1818 there were also workshops in Russia and the United States.

The first original *polyautographs*, as they were called at that time, were printed in England by Philipp André, who was successful in persuading a number of the leading English artists of the day to do drawings on stone. André's folio *Specimens of Polyautography*, published in 1803, contained twelve prints by as many artists, the earliest by Benjamin West in 1801. In France, the first original polyautographs, printed by Frédéric André, were drawn by Pierre Bergeret, circa 1803. In 1804 a series of *Polyautographic Drawings by Outstanding Berlin Artists* was published in Berlin by Wilhelm Reuter.

These early polyautographs were drawn with pen and tusche. In 1804 the first successful "chalk drawings" were made; and it was the subsequent rapid development of the chalk (or crayon) technique that led most of the major artists of the early nineteenth century to become interested in lithography as a medium for creative expression. Because crayon lithography lent itself to the most delicate nuances of light and shadow, ranging from misty luminosity to deep and mysterious blacks and permitting emphasis on tone and color rather than delineation, it was far more congenial to the aims of the French Romantic painters than etching and engraving.

Before 1816, lithography was used in France principally for commercial printing. In that year both Charles de Lasteyrie and Godefroy Engelmann opened their workshops in Paris, providing printing services at a new level of excellence and working competitively to interest noted French painters in the medium. In collaboration with Engelmann, Baron Taylor undertook publication of the

monumental series *Les Voyages pittoresques et romantiques dans l'ancienne France*, a work which included original lithographs by many distinguished artists, among them the Englishmen Richard Bonington and Thomas Boys, Eugène Isabey, Paul Huet, and Louis-Jacques-Mandé Daguerre, who later invented the daguerreotype.

Théodore Géricault and Eugène Delacroix made their first lithographs in 1817 and 1819, respectively. Both contributed immensely to the development of the art in France; and Géricault, through his work with the London printer Charles Hullmandel, influenced English lithography as well. Hullmandel's workshop, established in 1819, two years before publication of Géricault's *English Series* in 1821, provided an impetus to English lithography directly comparable to that provided by Lasteyrie and Engelmann in France.

Even in Bordeaux, where the Spanish master Francisco Goya lived in exile during his later years, a workshop was available, making it possible for Goya to resume his work in lithography. He had first drawn on stone in Madrid in 1819; in Bordeaux in 1825, working in collaboration with the printer Gaulon, he did his most important lithographic work.

A comprehensive account of the early European printing establishments and of their contribution to the history of art will be found in Michael Twyman, *Lithography 1800-1850**. Our purpose in this discussion is not to review that history but rather to emphasize the importance of the collaborative relationship that has existed between the artist and his printer since the early nineteenth century.

In the United States, partially because of commercial pressures and partially because of the lack of a solid artisan tradition, there were in the nineteenth century few lithographic workshops devoted primarily to printing for artists. Most of the workshops devoted themselves primarily to illustration and reproduction. With the development of chromolithography in the 1830s and of photographic printing in the 1860s, an immense market was developed for lithographic printing. When offset lithography was introduced, shortly after the turn of the century, printing from stone became all but obsolete, and those artists who wished to continue creative work in lithography found it ever more difficult to do so while remaining in the United States. As a result, many of the American artists who made the most significant contributions to the history of nineteenth-century lithography, James McNeill Whistler foremost among them, did their

work in England, France, and other parts of Europe.

Although limited in number and capacity, some American printers managed to survive. George Bellows, the most important American lithographer of the early twentieth century, worked first in collaboration with Bolton Brown and later with George Miller, both of whom printed for artists in New York. Miller also worked with many artists of the depression years. In the west, Lynton Kistler and Lawrence Barrett operated workshops in Los Angeles and Colorado Springs. But in most of the United States there were no workshops at all; and, even at their best, the American workshops could not compare with those in Europe. As late as the 1950s, many American artists who wished to become seriously involved in lithography, like Whistler earlier, found it more satisfying and productive to go to France to work with Mourlot, Desjobert, or Durassier, rather than in the American workshops still available to them.

Other artists learned to print for themselves. For most artists, however, this was no solution. Lacking the temperament or the skills essential to the printer, lacking access to equipment and facilities, and unwilling to make the required commitment of time, they abandoned the medium altogether.

The collaborative relationship is far more than a simple merger of the artist's creative energies and the printer's technical skills. In the lithography workshop, a printer and an artist work intimately together and share a common purpose. A strong understanding develops between them and, with time, they reach a subtle interpersonal relationship which is the ideal condition for the making of great lithographs.

Although for most artists collaboration is a source of satisfaction and fulfillment, it may be for some a cause of friction and unrest. Frequently, the artist who comes to the lithography workshop for the first time has had no previous experience working closely with others in the making of a work of art. In this new situation, the medium is unfamiliar and the surroundings even more so; even the printer may be felt to be a threat of some sort.

Yet the artist knows that other artists have worked successfully with the printer; that the printer has the technical knowledge to eliminate frustrating trial and error; that the printer has the skill to make the best possible use of the shop's equipment and resources. And once a *bon à tirer* is achieved, the printer will pull a more expert and excellent edition than the artist could himself.

Perhaps even more important is the gain resulting from separation of two sometimes incompatible considerations. The artist who prints his own work influences his

* See also Felix H. Man, *150 Years of Artists' Lithographs*, and Wilhelm Weber ,*A History of Lithography*.

P'Emile. Planche lithog: A. Senefelder et c.ª

3.1 ALOYS SENEFELDER: *Lion Killing a Deer*, after P. Emile. 1823. Lithograph, 7 1/2 × 6 7/8″. University Art Museum, The University of New Mexico, Albuquerque

This impression bears the following handwritten inscription: "Je certifie la présente lithographie conforme à l'édition entière qui en a été faite. Paris le 15 janvier 1823. A. Senefelder." ("I certify the present lithograph to conform to the complete edition which has been made from it. Paris, January 15, 1823. A. Senefelder.")

3.2 NICOLAS CHARLET: *Imprimerie Lithographique (Lithography Shop).* 1825. Lithograph on mounted China paper, 9 1/4 × 6 7/8". University Art Museum, The University of New Mexico, Albuquerque

The following amusing commentary is printed below the title of this print: "Si le bourgeois y est pas les presses y ne va pas. Voyez chez le md. de vins." ("If the gentleman is not there the presses do not work. See him at the wineseller's place.")

own creative decisions by appraising them from the vantage point of his role as printer. When an artist's knowledge as a printer feeds back into his aesthetic, a cycle may develop that can have the effect of confusing technical goals with creative goals. The resultant problems have been the basis for some critical rejection of "printmakers." Although exceptions come to mind, many artist-printers, after experiencing the opportunities inherent in collaboration, prefer it to their former isolated condition.

Unquestionably, the artist-printer gains from his own technical knowledge of lithography. And the same artist also will benefit from collaboration with a printer who may have other information and skills in his repertoire. The ideal collaboration is surely between a master printer and an artist who is himself a master in the art. But such a relationship takes time and exposure to develop.

From the viewpoint of the printer, the artist who has been making lithographs, either alone or with other printers, presents a different problem from one who has no lithography experience at all. The artist will tend to expect all printers to use the procedures he is accustomed to and may assume that all others are wrong. The key to resolution of this issue is an awareness that each printer has his own style, just as each artist differs from other artists. In spite of the considerable technologies in lithography, it is an art, not a science; therefore mutual respect, adaptability, and cooperation will be needed from both collaborators no matter what expectations they may bring from previous experience.

Artists and printers need not become personal friends, but they must be good colleagues. Courtesy, empathy, pride in craft and creativity, and, above all, an interest n the work of art will allow all other differences to be surmounted. Indeed, there is something to be said for keeping a certain formal distance so as to minimize frictions that might arise outside the workshop context.

By the nature of things, printers work with more artists than vice versa. Thus they are economically vulnerable to the vicissitudes of collaboration. They experience many kinds of pressure, yet must beware of projecting their irritation with one artist upon another. Maturity and patience are tested constantly. Some printers become increasingly suspicious and even defensively rigid in their dealings with artists, but when this happens it is more likely due to thoughtlessness on the part of artists than to insurmountable problems in the medium itself.

Conversely, a printer may project dislike or distrust onto an artist and burden him with a sense of pessimism or disapproval that cannot be identified, even while it infects the workshop with tensions. Such printers rarely remain in the medium and, fortunately for everyone, tend to go off and become loners. Collaboration means the ability to be civilized, and this ability, together with a sense of humor, will save many a work of art when the going is stormy.

Among other things, a workshop is not a quiet place. Inevitably, many tasks proceed at once. Apprentices grain stones or prepare for future work while printers work at the presses. But a distinction should be made between those noises and distractions which are an inevitable part of the workshop's operation and those which are needless and avoidable. Where a number of men are working closely together, what is pleasing to one may be annoying to another. Some artists—and some printers—find it very difficult, even impossible, to do their best work when the sound of radios, anecdotal conversation, singing, or horseplay is superimposed upon the background noise of the workshop.

The artist who comes to a lithographic workshop for the first time may also miss the seclusion of his studio, the privacy in which to make mistakes. He will become aware that all he does is public, and he well may feel that the printers are watching his every move. The novice lithographer who is an established and well-known artist is particularly exposed and vulnerable.

It is at this point that men respond in different ways. Some artists approach the new situation with ease. Secure in their abilities, they experiment, ask questions, accept their failures philosophically, and rapidly gain control of the medium, adapting it to their needs and intentions. Others, less secure, may become arrogant or hostile, creating constant problems both for themselves and for the printers with whom they work.

Both the artist and the printer must learn to cope with the problems arising from temperament and personality. All parties in the collaborative relationship (including the artist, the printer, the workshop office staff, and the various shop and curatorial assistants) must be aware of what they say, of the possible effect of their words, or even their tone or gestures, upon those with whom they work. A single slip of the tongue, a bit of inadvertent gossip, may create misunderstandings that are difficult to correct.

Despite the fact that the collaborative relationship is never twice the same, and that the problems that arise can never be precisely defined or readily anticipated, certain principles can serve as a guide to successful collaboration.

1. The printer must avoid the imposition of his aesthetic viewpoint upon that of the artist. Most printers in the United States have entered the profession only after having first studied art. A few are able artists in their own

3.3 RICHARD PARKES BONINGTON: *Rue du Gros-Horloge
(Rouen).* 1824. Lithograph, 9 5/8 × 10″. University Art Museum
The University of New Mexico, Albuquerque

3.4 FRANCISCO GOYA: *Portrait of the Printer Gaulon.* 1825.
Lithograph, 10 5/8 × 8 1/4″. Davison Art Center, Wesleyan
University, Middletown, Conn.

right. Many have thus formed convictions with respect to the value or disvalue of various styles and artistic positions. The artists with whom they collaborate will often work in directions quite different from their own. The experienced printer is one who is able to assist the artist to realize his objectives, whatever they may be.

A problem arises when, in the printer's private and personal view, the artist's work seems to be of little merit. Successful collaboration may in such circumstances be all but impossible, for in the close working relationship between artist and printer, it is exceedingly difficult totally to hide even those thoughts which remain unspoken. The solution for the printer is to distinguish between technical judgments and artistic judgments. In his collaborative relationship with the artist he should avoid the latter entirely and concentrate upon achieving the finest possible impressions of the work the artist has put on stone.

2. The printer must carefully judge when and how to intervene with advice and suggestions. As the artist who is new to lithography begins to work on the stone or plate he will have many questions to ask, principally technical. These present no problem; the printer answers them.

At times, however, particularly after the stone is processed and proofing or printing is begun, other questions of a more difficult character may arise. The printer may be aware that the artist's wish to reopen the stone for a minor correction is likely to cause serious technical problems, perhaps a critical loss of quality in a subtle or fragile passage. He may feel that the artist should at least consider a possibility he appears to have overlooked, or he may know a better technical procedure through which the artist might achieve his apparent goals.

In these circumstances the printer should learn to make suggestions, but he should also be aware that the manner and timing of his suggestions are as important as their content, and that he must be governed not only by technical considerations but, more importantly, by a sensitive perception of the artist's probable response. Above all, he should endeavor to present the artist with alternatives, not directions, and to let the artist make the final decision among the alternatives available. If some possible course of action entails risk of serious deterioration of the printing surface or an unacceptable loss of quality in the printed impressions, the printer should clearly warn against it. At the same time, the printer should be careful not to close the door unnecessarily when an artist employs methods that are unfamiliar or unconventional. The novice in the medium, unrestricted by knowledge of traditional techniques, can sometimes discover new ways of working that, if technically sound, can extend the range of lithography.

From time to time, an artist may ask his printer questions that enter the area of aesthetic judgment. Which of two colors does the printer prefer? Would the print read better if a line were left in or taken out? The way the printer handles such questions must necessarily be determined by his empathy with the artist. Is he really seeking advice, or is he merely thinking aloud as a means to clarify his own intentions? Only when the printer has established a firm and clear relationship with an artist should he venture aesthetic judgments, and even then he should do so with all possible tact and full recognition that the artist's judgments, not his own, are the ones that count.

3. The printer must have infinite patience. The artist will often find it necessary to do things that impose on the printer's time and cause him extra work. If fine lithographs are to result from the collaboration between artist and printer, the artist must always feel free to do whatever he thinks is required; he must never be inhibited, either directly or indirectly, by feeling for the convenience of the printer. If corrections may be made with technical safety, then no matter how long it takes, the artist must be free to make them. Even when to the printer these corrections seem unimportant or inconsequential he must patiently assist the artist in the task.

In color work, hours of proofing may often be required, and at times the artist may be exasperatingly indecisive, causing the printer to mix color after color, clean slab after slab, and roller after roller, while proof after proof is pulled. But, whatever is required, the printer must learn to do it without either a sign of impatience or an indication that the work is other than normal.

4. The printer should recognize the danger signals of either psychological or physical fatigue. When work goes badly after a long proofing session or a day of many corrections and changes at the press, both the artist and the printer are likely to feel and show the strain. Either or both may become edgy and irritable.

At such times continued work is seldom productive. The printer should take the initiative in advising the artist that the work be put aside until both men can approach it freshly once again.

5. Both printer and artist have to be prepared to deal with total failure. Lithography is not a predictable art. Despite all skills, despite all care, accidents can happen. A stone may break in the press, or an image may be lost through conditions quite beyond the printer's control. Alternatively, the artist may simply decide that a project must be abandoned, at times after a considerable investment of time and work.

It is essential in these circumstances that the printer

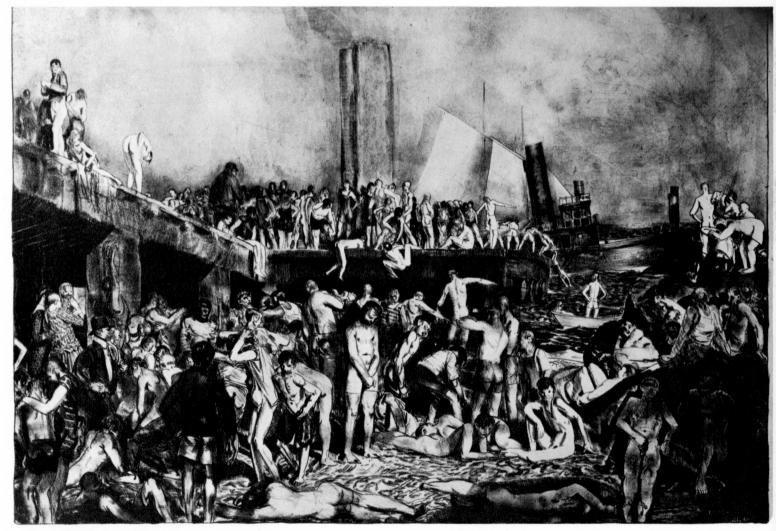

3.5 GEORGE BELLOWS: *River Front*. Lithograph, 14 3/4 ×
20 3/4". University Art Museum, The University of New Mexico,
Albuquerque. Gift of the Friends of Art

and the artist reach a financial understanding before work is begun. The importance of a clear, equitable contract, properly drawn and well understood, cannot be overstated, for neither party can afford to underwrite all loss, and both may suffer in a crisis. Both may lose money; additionally, the printer, who is in the business of providing his services, may suffer damage to his reputation. A financial agreement will not prevent such problems, but it will go far to lessen misunderstandings.

3.2 THE ECONOMICS OF COLLABORATION

It is not our intention here to discuss the many factors that should properly be involved when a schedule of charges is established by a lithographic workshop. (See sec. 16.7.) Such a schedule must necessarily take into account a large investment in equipment and supplies, substantial overhead expenses and salaries paid to staff, as well as the risk and uncertainties of lithographic printing.

Whatever the charges, they must be paid by the artist, his dealer, or a publisher. And whatever their amount, the collaborative relationship between the artist and the printer is inevitably affected by them. Economic considerations are often at odds with artistic considerations. What might be best for the print may involve extra time, hence extra cost; and both the artist and the printer may be tempted to cut corners at a sacrifice to quality.

Many of the dull and lifeless lithographs printed in American workshops during the 1930s and 1940s owe their inferior character to compromises made to permit the printing of large editions at low cost. For the convenience and economic benefit of the printer (or publisher) artists were encouraged to avoid all but the simplest and most predictable technical procedures. The result was not only to limit the quality of the prints but, perhaps more important, to discourage many American artists from making lithographs at all.

Although economic considerations should never be allowed to affect adversely the quality of the print, it is only sensible to avoid procedures and techniques that entail unnecessary risk. There is no merit, aesthetic or otherwise, in doing things the hard way. The proper goal is to seek the most efficient procedures consistent with the highest possible quality.

Precisely because there can be no compromise of quality, it is imperative that the printer's schedule of charges be established at a level high enough to take account of difficult projects and unforeseen events. The written contract between the printer and the artist should define these charges clearly.

True, in some cases there may be a need to revise the rate originally agreed upon. As an example: the artist may have contracted with the printer for an edition of twenty impressions; if later, after approving the *bon à tirer*, he decides to increase the edition, the printer should be prepared to quote the extra cost. Or the artist may decide to add a fifth color to what was originally planned (and contracted for) as a four-color print. Again, the printer should be able to quote a price, one high enough not only to cover basic costs in terms of time and material, but also to take care of contingencies.

The artist should welcome such clear-cut arrangements, for, as a result, both he and the printer may concentrate fully upon the making of the lithograph. On the other hand, if the collaborators fail to reach prior agreement about the printer's charges, misunderstandings and difficulties are sure to follow.

3.3 THE PRINTER AND HIS ASSISTANT

Printing is easier and more efficient when the printer has a press assistant. Many lithographs can, in fact, be printed efficiently *only* by two men working together on opposite sides of the press. A well-coordinated team can reduce printing time by as much as fifty per cent, particularly in the case of very large prints or those which require precise registration. The two-man operation is at the same time likely to improve the quality of the work, for by performing many of the less critical tasks, the assistant leaves the printer free to concentrate upon the printing itself.

In some workshops it may prove practical for the artist, if he is experienced in lithography, to work as a press assistant. More frequently, the printer will employ an apprentice who, by working with the printer at the press, will gradually become able to assume greater responsibility.

The assistant printer should in no way enter into the collaborative relationship between the printer and the artist. He should be at all times pleasant but neutral. Specifically, he should avoid either words or gestures that might indicate a lack of confidence in the work of either the artist or the printer. Negative comments, grousing, or even unnecessary conversation on the part of the printer's assistant can easily impair the relationship between the printer and the artist, often at critical moments in the progress of the work.

The amount and character of the work the printer assigns to his assistant will vary greatly depending upon the nature of the lithograph that is being printed and the

experience of the assistant. Typically, however, both men participate in every stage of the printing process, dividing their labor somewhat as follows:

1. The Initial Set-up. The *printer* positions the paper kit on the press table in correct alignment for printing, mixes the ink to proper consistency, and distributes it on the ink slab and roller. (See sec. 4.5.)

The *assistant* positions the stone and scraper bar, places limit marks on the press bed indicating the traverse points, lubricates the scraper and tympan, prepares all water bowls and sponges, and prepares antitint solutions and press etch.

2. The Washout and Inking Operation. The *printer* governs the washout and inking of the stone. It is his responsibility to mix the ink, replenish the ink slab and roller, establish the rhythm of the inking and the pace of the entire production.

The *assistant* gears his pace to that of the printer so that work may proceed without hesitation or delay.

3. Dampening and Cleaning Operations. The *assistant* controls the dampening of the stone. He maintains a constant film of water to the degree preferred by the printer. All water bowls and sponges are kept on the assistant's side of the press. The dampening must be correctly timed to precede the inking. The stone is dampened while the printer is gathering ink from the ink slab; the dampening is completed by the time he returns to the stone so that he may ink without pausing. The assistant replenishes the sponges with water while the printer is inking the stone. He scans the stone to make certain it is clean after completion of inking. Scumming, ink blemishes, flecks, lint, etc., are removed and antitint solution is wiped off.

The assistant dries or dusts his hands with talc before receiving the print paper from the printer.

4. Paper Positioning. The *printer* dusts his hands with talc while the assistant is cleaning the stone. He takes the print paper lightly by the lower corners, carries it to the press, and holds it out to the assistant, who lightly grasps the upper corners of the sheet and swings it upward and toward himself. This permits the printer to lower the corners nearest him to the positioning marks on the stone. Upon a given signal from the printer, the assistant releases his side of the paper, which falls securely into position.

The *assistant*, after positioning the paper, lightly places one finger on it to prevent it from shifting when the printer lowers the backing sheet, an operation which often produces an onrush of air. The assistant positions the tympan, while the printer lightly holds the backing sheet with his right hand and with his left hand moves the press bed into starting position. The assistant has aligned the lubricant bead on the tympan with the scraper bar by the time the press bed has reached the starting limit mark.

5. Press Operation. The *printer* adjusts the press pressure and engages the press by bringing down the pressure lever, cranks the press bed forward until reaching the rear limit mark of the traverse (meanwhile the assistant redampens the dampening sponge in preparation for the next inking), releases the pressure lever, and grasps the edge of the backing sheet with his right hand (to prevent shifting) while with his left hand pulling the press bed into return position. He is aided by the assistant, who grasps the tympan edge with his left hand and with his right hand assists in returning the press bed. By the time the press bed has completed its return, the tympan has been removed by the assistant and placed on the press box. The printer then removes the backing sheet and places it on the press box, removes the print, inspects it, and places it on the edition pile. He then recharges the roller to resume inking.

The *assistant* dampens the stone, redistributes the lubricant on the tympan when necessary, cleans up the stone, etc., between the time the printer removes the printed impression and returns to ink the stone. The work sequence is repeated with methodical rhythm until the printing is completed.

6. Corrections at the Press. Critical spot corrections are usually undertaken by the printer, and less complicated procedures are undertaken by the assistant. For example, localized etch application may be put on by the printer and mopped up by the assistant. Honing and etching borders, removing ink skin, and generalized cleaning are usually done by the assistant. The balance of tasks is dependent on the extent of the assistant's skill and the printer's need for relief in order to devote attention to the replenishment of ink or examination of the edition, etc.

7. Final Clean-up. The *printer* secures the stone by gumming it or washes out the image before regrinding the stone. He then cleans the ink slab and roller, cleans the work counter and all materials on his side of the press, and attends to the paper kit.

The *assistant* cleans all sponges, water bowls, and etching apparatus, cleans the tympan sheet, removes the stone from the press, washes the press bed, and disposes of all remaining waste.

Proofing and Printing

4.1 PREPARING FOR PRINTING

Many of the materials and some of the equipment required in the proofing and printing of a lithograph have been mentioned in discussing the work of the printer and his assistant. The condition of these materials, as well as their convenient arrangement adjacent to the press, is of the utmost importance. Following is a checklist of materials required and of the sequence in which they should be assembled and made ready before actual work at the press begins:

MATERIALS AND EQUIPMENT

1. **The Hand Press and Related Equipment***
 a. scraper bar
 b. tympan sheet
 c. tympan backing sheet
 d. press box
 e. lubricant for the scraper and tympan
2. **The Inking Equipment***
 a. leather roller
 b. ink slab
 c. proofing and printing inks
 d. ink knife
3. **The Washout and Dampening Equipment**
 a. two water bowls
 b. washout sponge
 c. dampening sponge
 d. washout rags
 e. asphaltum printing base
 f. lithotine solvent
4. **Corrective Equipment**
 a. antitint solution and felt pad

*The handpress and related equipment are discussed in detail in chapter 13; inking equipment is discussed in chapter 14.

 b. water bowl and sponge for antitint solution
 c. ¾-ounce strong etch for spot correcting
 d. small etch brush
 e. corrective tools (hones, blades, points)
 f. talc box and cotton
 g. rosin box and cotton
5. **The Paper Kit**
 a. newsprint for rough proofing
 b. newsprint for interleafing
 c. intermediate quality proof paper
 d. fine quality edition paper
 e. chipboard covers for paper kit
6. **Materials for Cleaning**
 a. kerosene
 b. clean-up sponge
 c. clean-up rags

SEQUENCE OF PREPARATION

1. The proofing and edition papers are torn to size, sorted, and stacked. The paper kit is correctly positioned to accommodate the printer's working pattern. Paper preparation should be the first step of the setting-up procedure, because the hands are cleanest then.

2. The stone is centered on the press bed, and the scraper bar is aligned with the stone. Limit marks for the printing traverse are placed on the press bed.

3. Water bowls, sponges, rags, and corrective materials are set out.

4. The tympan and backing sheet are positioned on the press box. Both tympan and press scraper are lubricated.

5. The ink is mixed and distributed on the ink slab.

6. The roller is charged with ink.

7. All items are checked for position and accessibility. The proofing process may then begin.

4.2 CHOICE OF PAPERS FOR PROOFING AND PRINTING

Because of its complexity, the subject of paper for lithography is described as a separate topic in sec. 12.1. Before beginning the proofing and printing operation, the reader should become acquainted with the various types of proofing and edition papers described therein as well as with their preparation and the handling procedures. It must be emphasized that both one's choice of paper and the handling and printing of that paper are just as important as the drawing itself and the preparation of that drawing for printing. Each of these depends on the other if the full potential of the medium is to be realized.

4.3 CHOICE OF INKS FOR PROOFING AND PRINTING

The choice of inks for proofing and for printing depends on experience and on the nature of the work to be printed. Some lithographs require stiff inks and others require somewhat softer inks. Unless experience suggests otherwise, it is advisable to start the proofing operation with stiff, roll-up black ink. The working properties and printing quality of the ink are assessed during the course of the proofing. Because this type of ink has a minimum fatty-acid content, the printer has the greatest possible control during the proofing, when the stabilization of the image and nonimage areas must take place. As the work becomes stabilized, it may be desirable to modify the viscosity and body of the ink slightly to permit easier inking or to improve the quality of the impressions. Inks should be modified first in small amounts. Larger quantities for edition printing are compounded only after the trial mixture has proved successful. Sometimes the nature of the work will not permit ink modification; hence the entire edition is printed with roll-up ink.

It is occasionally desirable to print with black ink that has a slight color tonality. Brownish, bluish, or greenish blacks often impart valuable expressive properties to the image beyond those offered by a relatively neutral black; the warm or cool chromatic casts in the demitints heighten the tonalities of the image. Chromatic blacks are produced by adding small amounts of colored lithographic ink to the basic roll-up black ink. Before modifying the ink color, it is advisable for the printer to proof the image with the roll-up ink until it has become stabilized. Although this necessitates more proofs, it is a safer approach. It is usually not necessary to wash out the work when substituting a modified black ink. To exhaust the previous ink from the stone, however, a sufficient number of impressions must be pulled.

The many properties and behavioral characteristics of lithographic inks, like those of paper, are a large subject in themselves. They are discussed in Part Two. The student is urged to familiarize himself with the subject of ink before proceeding with printing. (See sec. 11. 1.)

4.4 THE PROOFING PROCESS

A proof offers the earliest printed evidence of the drawn and processed stone. The artist, by examining trial impressions, must determine whether the aesthetic intent of his drawing has been realized; the printer must determine whether the printing quality of the image matches its potential. If both the artist and the printer judge a proof to be satisfactory, the edition can be printed without further delay. As mentioned before, it is always more efficient to print the edition within the same work period and with the same initial set-up that is used for proofing.

Frequently, the examination of the trial proofs will indicate a need for corrections of the image. When these are minor (such as cleaning margins and removing small imperfections), the printing of the edition can immediately follow their completion. Sometimes either major changes of the image are required or the stabilization of the printing element becomes necessary. These usually require more lengthy and sometimes repetitive sessions of correcting and proofing, which can leave both the artist and the printer physically and emotionally exhausted. In such cases it is advisable to print the edition at another time. The work can then be approached with a fresh outlook devoted entirely to the mechanics of printing and unencumbered by the problems of creativity.

Because the objectives of proof printing are entirely different from those of edition printing, they should be clearly understood by both the artist and the printer:

1. The initial objective of the proofing process is to secure an accurate impression of the printing image. Several trial proofs may be necessary before inking procedures and press adjustments prove satisfactory.

2. When a reasonably accurate trial proof has been made, the artist should examine it from the viewpoint of aesthetic intent. If corrections are necessary, the artist and printer determine the best procedure and sequence for their execution. During this period, the work is considered to be in a somewhat fluid state and subject to change if this is desired by the artist. However, the artist's creative intent must necessarily

4.1 Layout of materials for printing

Layout of the press station for proofing and edition printing

1. Press
2. Printing stone
3. Paper table
4. Paper kit
5. Talc bowl
6. Press table
7. Printed impressions
8. Main ink slab
9. Color ink mixing slab
10. Color ink knives
11. Clean rags
12. Ink spatula
13. Lithotine dispenser
14. Kerosene dispenser

15. Asphaltum
16. Gum arabic
17. Wash-out rags
18. Wash-out sponge
19. Wash-out water
20. Dampening sponge
21. Dampening water
22. Clean water
23. Mopping sponge
24. Press etch
25. Etching brush
26. Stone cleaning solution
27. Felt pad

4.2 The steps of proofing and printing

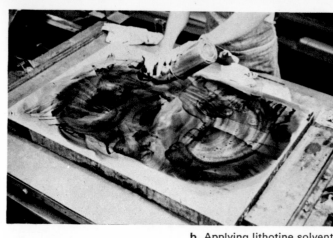

b. Applying lithotine solvent

a. The layout of materials for proofing

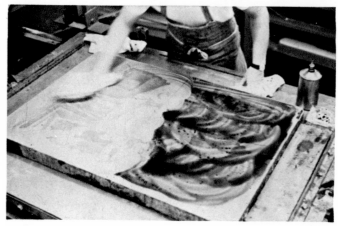

c. Washing out the image

d. The cleaned stone with image washed out

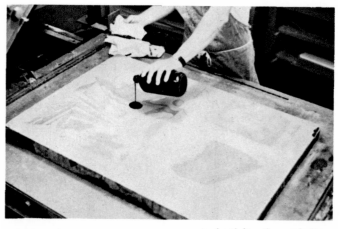

e. Applying the asphaltum

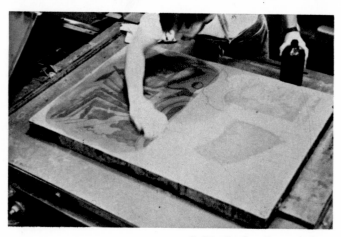

f. Distributing the asphaltum

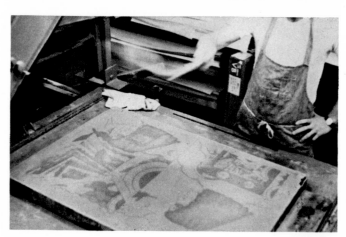

g. Fanning dry the asphaltum

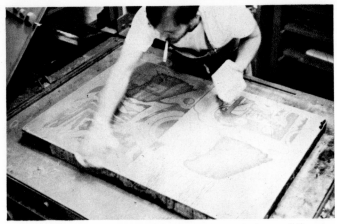

h. Removing the etch film and excess asphaltum with water

i. Charging the roller with ink

j. Inking the image

k. The press assistant dampening the stone

l. Changing the direction of inking

m. Dampening the stone again

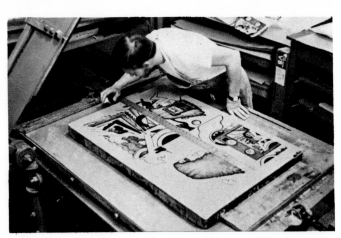

n. Measuring the image prior to applying lay marks

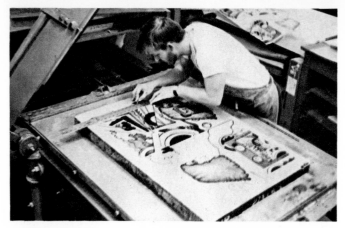

o. Drawing the lay mark at one end

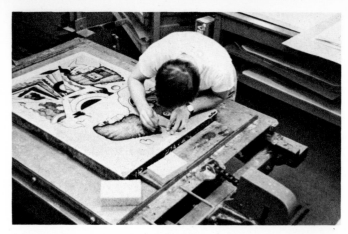

p. Drawing the T-line at the other end

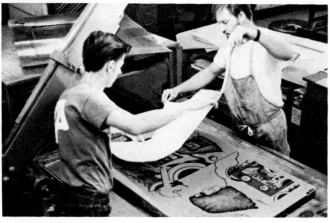

q. Positioning the paper to the lay mark

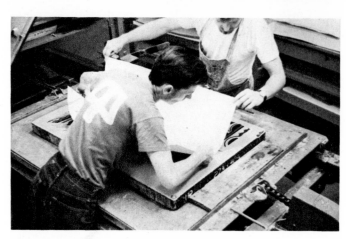

r. Aligning the paper to the T-line

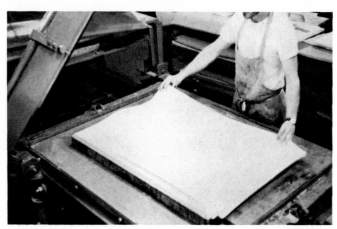

s. Positioning the backing paper

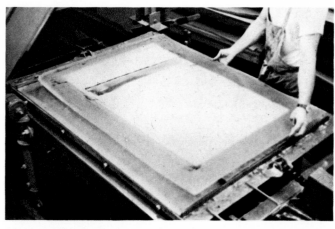

t. Positioning the press tympan

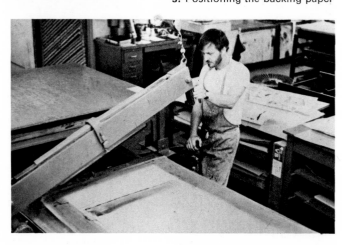

u. Bringing down the scraper box

v. Locking the scraper box

w. The press assistant removes a printed impression

x. The printer and his assistant examine the proof

function within the technical limitations prescribed by the printer; otherwise the reliability of the printing element may be jeopardized. Depending on the nature and extent of the corrective procedures, it may be necessary to correct and proof the work in alternating stages.

3. After all corrections have been made, the last series of trial proofs is printed. Final refinements of ink mixture, inking techniques, rolling pattern, and paper positioning are undertaken.

4. During this period the final printing stability of the stone should also be established. Unless the image and nonimage areas function reliably, no two impressions will appear the same. To assure this final stabilization, the stone should be gummed and spot-etched if necessary.

5. A definitive impression is printed on the paper for the edition.

The steps of the basic proof-printing procedure will now be described. They will be followed by descriptions of the techniques of paper positioning and the various processes for correcting the image.

1. The image is washed out with lithotine through the dried etch coating, in the same manner as during the roll-up. If several weeks have elapsed between processing and proofing, it is advisable to wash off the dried etch coating with water and replace it with a pure gum arabic coating. This will ensure a cleaner and more rapid washout.

2. The dissolved ink is removed with a rag, and the solvent is fanned dry. The stone is washed with the washout sponge and water.

3. The stone is moistened with the dampening sponge. From this point on a constant film of moisture must be maintained on its surface.

4. Stiff roll-up black ink is always used during the initial phases of the proofing process. The image is inked, following rolling techniques established during the processing roll-up. Ideally, the image should accept ink at the same pace as before; however, it sometimes responds more slowly as a result of the

second etching. The inking is continued until the image appears fully developed.

5. The hands are dusted with talc, and a clean sheet of newsprint proof paper is positioned on the stone. All but the largest papers can be efficiently maneuvered by gripping the sheet from diagonal corners. To avoid slurring the ink, the sheet should not be moved once it is positioned, even if it is crooked.

6. The backing sheet is carefully positioned over the proof paper, and the tympan is placed on top of the sheet. The press bed is moved to its starting position; the press pressure is adjusted; the stone is passed through the press. The pressure is released, and the press bed is returned to the starting point.

NOTE: The printing press, tympan, and backing sheet, and operating procedures for each are described in chapter 13.

7. After removal of the tympan and backing sheet, the trial proof is carefully lifted from the stone by gently holding the near corner and peeling from left to right. The stone is immediately dampened; the print may then be closely examined.

8. After the trial proof has been examined, whatever is necessary is done to improve the condition of the drawing. Sometimes only one or two minor adjustments are necessary, but more often a combination of modifications is called for. Some of these are described at the end of this section.

9. The stone is successively dampened, inked, and proofed on newsprint until a reasonably satisfactory impression of the image is obtained. This should be achieved within two to four impressions, but considerably more impressions may be required.

10. The next trial impression should be printed on an intermediate-quality proof paper or on a sample of the edition paper. This impression is examined by the artist for its aesthetic merit and by the printer for its print quality. The following questions should be considered during the appraisal:

a. How is the positioning of the image on the sheet? Is the image well-centered and are the pro-

portions of the margins satisfactory?

b. Does the image need correcting or cleaning? Will additions or deletions be needed? What corrective methods should be employed?

c. Is the quality of the impression rich, crisp, and clear?

d. Does the printing element appear dependably stabilized?

e. Are the ink consistency and color tone satisfactory?

11. Corrections and modifications are undertaken where indicated, and the printing of trial proofs on intermediate proofing paper is continued until all problems have been satisfactorily resolved.

12. A final proof impression is then taken on a sheet of the edition paper. If the artist gives his approval to this proof, the edition may then be printed.

Various problems may occur during the roll-up or during the printing of the first few proofs. These problems and their remedies are described below. The problems should be pursued through a process of elimination using the sequence given for remedies, the simple preceding the more complex.

ROLL-UP PROBLEMS

1. The image rolls up too quickly and there is danger of its filling in.

a. If this is due to an excess of ink on the roller and ink slab, reduce the ink supply by 50 per cent, gum and wash out the work, and roll it up again.

b. If this is due to underetching of the stone, reduce the ink supply, gum, wash out, and roll up. Alternatively (or additionally) dust the stone with rosin and talc and apply a relatively weak etch (10–13 drops of nitric acid to one ounce of gum arabic). Pale areas of the work should be protected with pools of pure gum arabic. If the work appears only slightly underetched, the etch solution should be correspondingly weak.

2. The image rolls up very slowly.

a. Use a printing base such as asphaltum.

b. Apply a little more ink on the slab and roller. Apply the inking roller more slowly with heavier downward pressure.

c. Modify the ink to a slightly softer consistency by incorporating small amounts of #3 or #0 lithographic varnish.

d. Pull a few impressions through the press, alternately inking and printing. If there is no improvement, the stone has probably been overetched, and little can then be done except to add new work or abandon the job.

3. The image generally accepts ink, but there remain a few tardy areas.

a. Pull a few proof impressions by alternately inking and printing. Often the pressure of the press will force the ink into the tardy areas, permitting them to become gradually more receptive.

b. Use an asphaltum printing base. If unsuccessful, make spot corrections.

PRINTING PROBLEMS

1. The printed impression is too light.

a. Several more proofs should be printed on newsprint; increased passes of the inking roller will darken the work. Two to four proofs should be sufficient to develop the image fully. Meanwhile the press pressure may be gradually increased until it is quite firm.

b. A gradual softening of the ink may be helpful, but this should not be undertaken until the above methods have been tried.

2. The tonal values of the impression are satisfactory, but the work does not look crisp and clear.

a. Roll on the ink more briskly.

b. Increase the press pressure.

c. Scrape the ink roller. Dirty, clogged, wet ink rollers distribute ink poorly and are not capable of keeping the image fresh.

d. Use a thinner and harder backing sheet under the tympan.

3. The values appear uneven in the impression, but seem satisfactory on the inked stone.

a. Change the inking pattern and try rolling the ink more uniformly.

b. Check the level of the stone and, if uneven, try *makeready* under the stone in the light areas. (See sec. 13.8.)

4. The proof has a light, even streak running its entire length.

a. Check the scraper wood and leather for nicks, bumps, or other imperfections.

b. Check the backing sheet and tympan for imperfections.

c. Change the ink-rolling pattern to eliminate light lap marks caused by loss of ink from the revolution of the roller.

5. The proof has a light or dark streak running across the width of the image.

a. The press was stopped before completion of the traverse; the streak is the mark of the press scraper. If this happens, it is best to wash out the work and roll up again; otherwise there is a danger that the

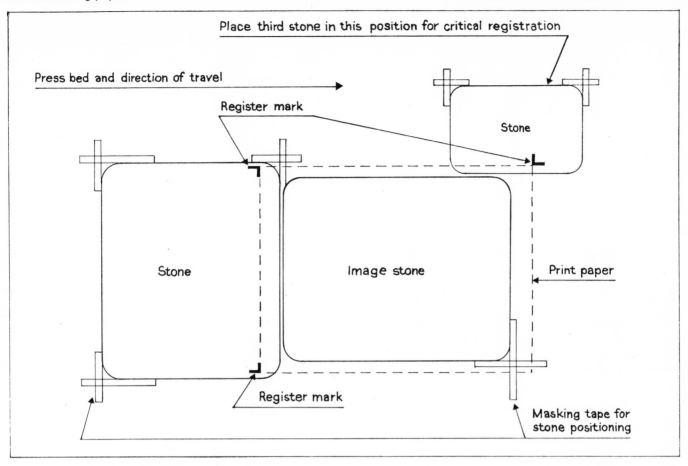

impressed pattern of the streak will continue to deform the printing image.

6. The proof looks dirty and sooty, and there are smudges and stains on the margins and in the lights. (See sec. 4.13.)

a. Use a stiffer or "shorter" ink.

b. Use antitint solution.

c. Be sure the print paper has not slipped during the positioning.

7. The work looks satisfactory on the stone, but prints the impression too dark.

a. Use fewer passes of ink on the stone.

b. Use a stiffer ink.

c. Loosen press pressure slightly.

8. One proof looks satisfactory, but the following proof appears lighter, and the next one appears darker, with no change of procedure.

a. The inking is not even.

b. The ink supply on the slab and roller is becoming depleted and must be replenished (if the proofs appear gradually lighter).

c. Make sure the same number of passes and the same amount of ink are applied to the stone for each printing. Also make sure to keep the moisture film constant.

9. Successive proofs gradually get darker, and the delicate passages begin to fill in.

a. Use antitint solution (until the clogged areas are opened).

b. Use less ink (but perhaps more passes with the roller).

c. Use stiffer ink.

d. Release press pressure slightly.

4.5 PAPER POSITIONING

All work to be printed should carry a positioning reference for the paper. This assures that the position of the image will be identical on each printed sheet. The simplest method of reference utilizes the edges of the stone for positioning the paper. This approach requires (1) a stone that is truly rectangular and of reasonably regular contours, (2) paper that is torn to the exact dimensions of the stone, and (3) an image that is centered on the stone. Various other systems of positioning employ marks (called *lay marks*) whose location is determined by (1) the size of the sheet to be printed and (2) the number of persons (one or two) handling it.

The following systems are satisfactory for the positioning of most black-and-white work. More precise positioning techniques are described in subsequent topics relating to color lithography. (See secs. 7.8-7.11.)

1. Papers of small dimension that are cut smaller than the stone are usually positioned by one person (the printer or his assistant). The marks are located at the

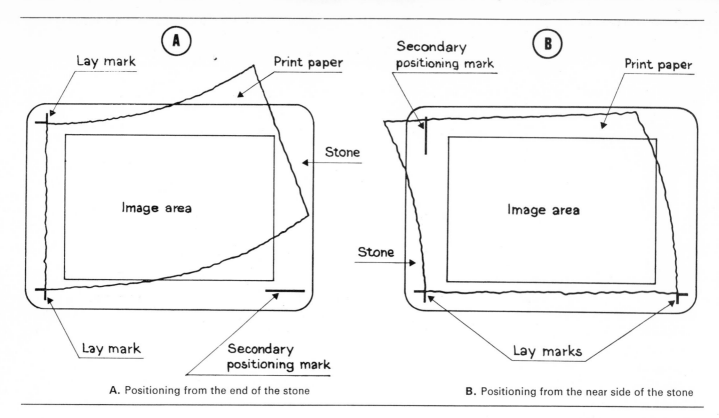

A. Positioning from the end of the stone

B. Positioning from the near side of the stone

upper and lower corners of the left end of the stone. The paper is held high on the right end and tipped until its left corners coincide with the lay marks. When it is positioned, the left end is lightly held with the finger tips; the right side is lowered and permitted to fall free on the stone. Larger sheets must be positioned by printer and assistant together; each holds the sheet and guides its lower end to the nearest lay mark.

2. Figure 4.4 illustrates alternative locations of lay marks for positioning large sheets of paper cut slightly smaller than the stone. Two people are required for the paper lay. The marks are located at the outer ends along the length of the stone nearest the printer or his assistant (whoever is to guide the sheet). One person holds the paper high by the two nearest corners, while the other guides the two corners nearest him to the lay marks. When positioned and lightly pinioned with the finger tips, the high side of the sheet is permitted to fall freely to the stone. Both methods of positioning permit maximum maneuverability without danger of spoiling the paper by dragging it across the inked image.

3. Theoretically, exact positioning requires that all sheets of paper be the same size. In actual practice, handmade papers have some variations in dimension and irregularity of edge from one sheet to the next. It is therefore necessary that each sheet be guided first to the same mark before alignment with the other. Thus discrepancies of sheet size will occur along the same margin for each impression. Such discrepancies are usually negligible and are not noticeable. On the other hand, the separate center-

ing of each sheet is time-consuming and usually results in no two impressions having identical margins.

4. Papers larger than the stone require another method of positioning (see fig. 4.3). A platform that is slightly lower and wider than the top surface of the printing stone is required. A second lithograph stone may be used for this purpose. The platform is butted securely to the left end and broadside to the printing stone; the corners of both stones are marked with chalk or tape on the press bed. Thus both stones can be realigned if shifting occurs during printing. (This procedure is characteristic for presses with small beds, because of the very limited clearance in which to ink, position the stone, and lay down the tympan. In such cases, the platform is removed for each inking and repositioned before each sheet is laid.) The paper lay marks are positioned on the platform, which serves as an extension of the printing surface. It is important that the surface of the platform be clean. If it is lower than the printing stone, neither dampening sponge nor roller will touch it.

Two methods are used to place lay marks on the printing stone. If the paper size is known at the time the drawing is made, the marks are scratched in the stone with a sharp point or blade. This can be accomplished before the first etch or after the roll-up (prior to the second etch). In this way the scratched marks will be desensitized and will resist ink. Their chief disadvantage is that they are hard to see on the stone. More discernible lay marks can be applied during the proofing process with a short piece of printer's lead. When applied on a damp stone, a clear,

Drawing particles deleted with strong nitric acid etch

4.5 Acid biting
Effects of drawing deletion and grain reduction by spot etching

indelible mark is produced which will not accept ink. The marks will accept ink if applied on a dry stone; being on the outer edges of the print paper they will offset onto the backing sheet and from it onto the backs of subsequent sheets of print paper. Indelible and lead pencils should not be used for this purpose, even on damp stone, because they will always form a printing mark.

4.6 CORRECTING THE IMAGE DURING PROOFING

Corrections of the image are often necessary during the proofing process. These may vary in type from minor touching up of the image to major transformations of the work. Various techniques can be employed for partial or total removal of existing work as well as for addition of new work. The reader is advised to review the principles behind these corrections before proceeding. (See sec. 2.15.)

Many lithographers are reluctant to subject a stone to extensive or repetitive corrective processes, believing that the initial image and nonimage formations become weakened. They reason that the corrected work lacks the freshness of quality of the original state and at the same time is less dependable in its printing function. If corrections were carelessly made, this would be true. There are controllable methods of correction, however, and these methods lessen neither the quality nor the dependability of the printing image. Moreover, corrected works often print more dependably and for longer editions than those not having corrections.

The significance of corrective measures to the aesthetic merit of a work may be seen by examining prints by some of the great masters of the medium. Lithographs by such diverse artists as Bonington, Isabey, Fantin-Latour, Redon, Rouault, and Picasso could not have been produced without extensive and dependable proofing and corrective procedures. Comparisons between the early and late states of some of their prints will illustrate the extent of the modifications employed. In view of the frequency of such modifications, it is clear that proofing and correcting are not only highly developed among printers but also necessary so that the artist's concepts may be crystallized. Hence, corrective procedures, in addition to their remedial function, are often essential to the creative and expressive potential of the medium.

Successful deletions during proofing, like deletions made after the first etch, require the partial or total destruction of the printing image in the areas to be corrected (see sec. 2.15). Images can be physically removed by using blades, needles, and other tools, or they can be removed chemically, using acids. After the fatty acids of the image are weakened or destroyed, the virgin stone that is now exposed must again be desensitized by etching, to prevent the attachment of new grease. The desensitizing etches are composed of nitric acid and gum arabic; these can be applied locally (spot-etched) or over the complete image, depending on the nature and extent of the corrections.

New work cannot be added without prior removal of the adsorbed etch film on the nonimage areas of the stone. Sensitizing solutions (called *counteretches*), consisting of acetic acid or alum and water, are employed for the removal of etch deposits, thus restoring the basic grease receptivity of the stone. Drawings made with lithographic crayons or tusche over these sensitized areas must be etched in order to desensitize the stone from further additions of grease. Desensitizing etches for additions of this type consist of weakly acidified gum arabic. The chemistry of corrective processing is documented more completely in sec. 9.13.

Corrections that are neither complex nor time-consuming are undertaken during the initial proofing session. The stone then remains on the press bed, for resumption of proofing immediately after the corrections have been made. Extensive corrections are more satisfactorily carried out on the etch table or at the drawing station.

a. Applying rosin to the inked image

b. Removing dirt and blemishes with the hone

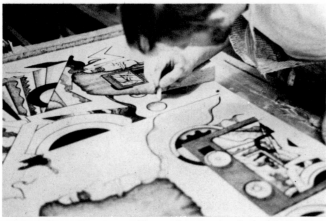

c. Sharpening the drawing with the hone

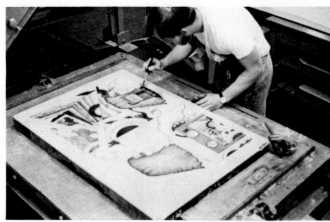

d. Spot etching the deleted areas

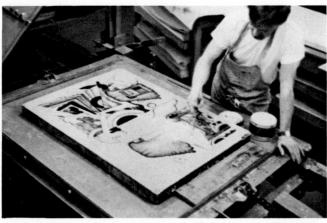

e. Applying rosin again prior to counteretching

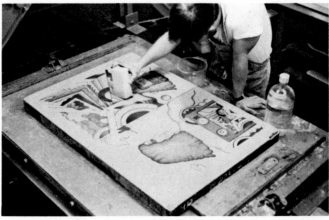

f. Applying the counteretch locally with a sponge

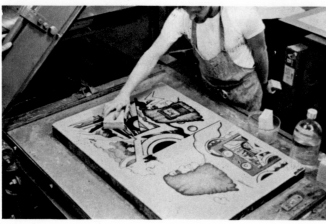

g. Removing the counteretch with sponge and water

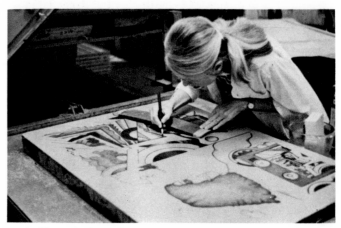

h. The artist Irene Siegal making spot corrections with a lithograph pencil

i. Detail showing use of the bridge to support the hand

j. Applying etching solution locally to the areas where work was added

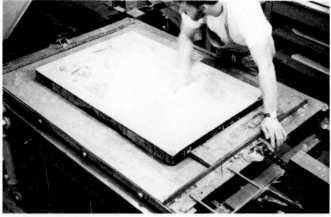

k. Dusting the stone with talc

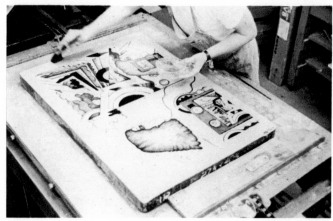

l. Applying gum arabic over the entire stone

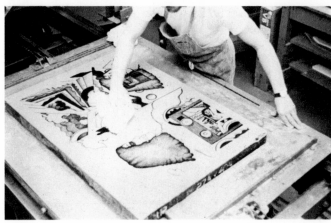

m. Wiping the gum arabic dry

n. Pinning up a proof of the corrected image

o. The artist, the printer, and the press assistant examine the proof impression

4.6 Corrective processes during proofing: deleting and adding work

4.7 REMOVING WORK BY PICKING, SCRAPING, SCRATCHING, AND HONING

The instruments and techniques for picking, scraping, scratching, and honing are identical with those previously described for drawing processes and for minor corrections following the first etch (see secs. 1.17 and 2.15). Because the areas to be removed are covered with ink rather than crayon, they require sharp instruments and deliberate manipulation to ensure effective alteration. Dull instruments merely smear or displace the ink on the surface of the stone without appreciably altering the fatty image deposits below.

The surface grain of the stone is physically altered in varying degrees during the course of this type of deletion. Depending on the techniques employed, the grain structure will be coarsened, reduced in definition, or polished completely away. The character of new drawing on these areas will be determined by the surface condition: coarsened areas will contribute to coarse drawing effects; polished areas of the stone (having no grain definition) will not accept corrections other than linear work and tusche solids.

ETCHING TECHNIQUES

Moderate to strong etches are required to desensitize areas of the stone exposed by processes of physical deletion. All unwanted fatty deposits must be totally overpowered so that they will not attract ink when printing is resumed. Total deletions that are crisp and clean require less strong etches than those in which grease removal has been partial. Partial scrapings over heavily inked areas require moderate to very strong etches to stabilize the remainder of grease deposits in the pores of the stone. Sometimes areas of this type will attract too much ink when proofing is resumed. In such cases, the stone should be gummed, washed out, rolled up, and lightly re-etched over the troublesome area.

Whenever possible, etching should be done only over the areas of the stone that have been deleted, the theory being that the remaining areas have been satisfactorily desensitized during the initial processing. Additional etching over the remaining areas will weaken their image formation, resulting in loss of tonal range and freshness. Thus, deletions in isolated areas of the stone are spot-etched, and the entire stone is coated with gum arabic and then dried. When deletions are widespread and cannot be spot-etched conveniently, the entire stone must be etched. Pools of gum arabic are distributed over the originally untouched portions of the image to dilute the etch as it reaches these areas. Delicate passages surrounding deleted areas also may be protected with pools of gum arabic against encroachment of the etch. Additional control can be exercised by manipulating etch solutions away from the weaker areas and toward those requiring stronger etch reaction.

The satisfactory strength of etches for specific types of deletion can be discussed only in general terms because of the many variables involved. The printer should perfect his procedures and techniques through experience and observation.

Etching Tables

For cleanly picked, scratched, and delicate deletions:	10—20 drops nitric acid 1 oz gum arabic
For scraped, scratched, and honed deletions over heavy grease deposits and for partial removal of work over heavy grease deposits:	18—28 drops nitric acid 1 oz gum arabic

PROCEDURE

1. The stone is inked (as for pulling a proof), then dried and dusted with rosin and talc.

2. The stone is dampened with sponge and water; this rids its surface of excess powder and exposes the image clearly.

3. The necessary deletions are made.

4. The corrected areas are spot-etched; or, if complete reworking is required, the entire stone is etched for approximately two minutes.

5. If the etching is localized, the solution is sponged off, and the stone is covered with gum arabic, which is dried to a thin, even film. Etches covering the entire stone are dried without gumming.

6. The stone is ready for washing out and rolling up for the resumption of proofing.

4.8 ALTERING WORK BY ACID BITING

Acid biting is used primarily for alteration rather than removal of images. Strong mixtures of nitric acid and water or gum arabic, applied directly on the unprotected ink film, dissolve the stone grain through corrosive action. Depending on the strength of the solution, the fatty image deposits are undermined and weakened, lightening tonalities and changing the character of the image.

When a mixture of nitric acid and water is applied on an unprotected ink film, it is partially rejected by the greasy ink and lies in broken and globular formations.

The image is bitten in this droplet pattern. Mixtures containing greater proportions of acid produce more pronounced biting patterns by removing greater amounts of the image; these leave the surface of the stone heavily pitted.

A solution composed of nitric acid and gum arabic (because of its greater viscosity) lies somewhat more evenly on the inked image. It produces a more finely textured pattern of droplets, quite different from that produced by nitric acid and water mixtures. If desired, the mottled droplet patterns can be avoided altogether by applying talc on the inked image to reduce surface resistance and brushing somewhat weaker acid solutions back and forth over the area without stopping.

Corrections produced by direct acid biting, as contrasted with shaved and scraped deletions, have a soft-edge quality. In addition, reducing tones by this method produces warm chromatic contrast against the surrounding values of the work. This effect occurs because the etch destroys grease formations resting on top of the stone grain. The fatty deposits at the base and between each tooth of the grain remain as an undertone. As a result, the area attracts less ink and appears lighter in value when printed. The undertone of the ink is thus able to assert itself.

Basic Etch Solutions

WATER ETCH		GUM ETCH	
Nitric acid	50 drops	Nitric acid	30 drops
Water	1/2 oz	Gum arabic	3/4 oz

PROCEDURE

The acid solutions are usually prepared in bartenders' shot glasses, which provide a convenient means for measuring solutions. The etches are applied with Japanese brushes of various sizes. (See Appendix A.) A small half-sponge and water bowl (used only for this purpose) are employed to halt the etching action at the proper time. The damp sponge permits absorption and removal of the etch without touching adjacent areas of the work; the stone-dampening sponge remains uncontaminated with acid.

The extent of the alteration depends on the fatty content of the work, the strength of the solution, and the length of time it remains on the stone. The standard water etch applied on a very greasy image will react vigorously for approximately two minutes before becoming neutralized. Considerable grain reduction will occur during the reaction. Image alteration is controlled by (1) repeated applications of the etch, (2) arresting each application with the small sponge before it is spent, and (3) using solutions weaker than the basic formula. Weaker etches react less vigorously and give softer biting patterns. Gum etches function like water etches, though somewhat more slowly. The basic gum etch is also used for desensitizing honed corrections on the borders of the stone during all proofing and printing operations. As such, it is sometimes referred to as the *press etch* and is prepared at the time the set-up is made for printing.

One proceeds by applying the etch directly on the unprotected ink film of the stone. After the etch has remained for sufficient time, it is lifted with the small sponge. Although applications may be repeated, the extent of each biting will not be fully apparent until the image is re-inked. Hence, it is advisable to bite the work and print proofs in alternate stages. Works that are over-bitten require counteretching before new drawing can be added. It should be noted that pitted surfaces produced by acid biting are difficult to draw on.

The etch must be completely removed from the stone after each stage of biting. The stone is moistened again with the dampening sponge and is rolled up with ink in the usual way. After proof impressions are printed, work with the etch may continue, if desired.

An interesting variant of these methods provides sharper definition and more precise control of the bitten pattern. Absorbent paper such as tissue or newsprint is cut or torn to the shape that the artist desires to bite. It is applied to the inked stone, on which it will adhere quite readily. A strong solution of acid and water is brushed onto the paper pattern. The etch penetrates the paper, attacking the image but remaining localized within the confines of the mask. After several applications of the etch, the mask may be lifted and acid carefully removed from the stone. A clean and sharply edged pattern in the shape of the mask will be exposed. Very complicated bitings can be done in this manner. In addition, a criss-crossing of alternating masking and biting over dark areas will produce transparent veils of value and texture that convey strong spatial characteristics.

4.9 ADDING WORK BY COUNTERETCHING

New work can be added to the image by resensitizing the surface of the stone so that it can accept fresh grease. The process, called *counteretching*, is accomplished with solutions of either acetic acid and water or alum and water. Counteretching is one of the most useful processes in lithography; the control of its subtleties requires constant practice and observation. It can be used repeatedly within limits; if it is overused, the surface of the stone

will become so altered that fresh drawing corresponding to the original state can no longer be added.

The following are standard formulas for resensitizing solutions:

Acetic Acid Counteretch

Glacial acetic acid	one part
Water	nine parts

The mixture should be made in one-pint quantities and kept on hand as a basic stock solution. It is used full strength for either spot or over-all application on stones having medium to strong image formation. It may be diluted by as much as 50 per cent when counteretching delicate work.

Alum Counteretch

Powdered potassium alum
Add water to make a saturated solution

Alum counteretches should be mixed fresh for each occasion. The solution becomes unstable during prolonged storage.

Both types of counteretch perform equally well; their chemical behavior and effect on the stone are, however, somewhat different. Generally the acetic acid mixture is preferred because it is easy to prepare and can be stored in bulk. The standard volume of solution for stones up to $16 \times 20''$ is one ounce. Larger stones require two ounces of solution. Smaller amounts of counteretch may be used for spot applications.

Solutions of alum counteretch that remain on the stone too long tend to dissolve the grain and produce a slippery surface which is difficult to draw upon. Acetic acid solutions also exert a limited corrosive effect on the stone, although it is less pronounced than either alum counteretches or nitric acid etches. It is possible for the corrosive properties of either solution to weaken and even destroy the original work unless preventive measures are taken.

PROCEDURE

1. The inked image is dusted with rosin and talc.
2. The counteretch solution is applied evenly on the areas of the stone to be resensitized. The solution is carried with a soft brush reserved only for this purpose.
3. The counteretch is kept moving on the surface of the stone for approximately two minutes.
4. The solution is mopped up with a small half-sponge (used only for this purpose) and water. The liquid should not be permitted to touch other areas of the stone.
5. The stone is dried, and new work is added with the standard lithographic drawing tools. Some care is neces-

sary in order to match the new work to the surrounding areas of the original image, particularly because of the change in the grain. In view of the greater sensitivity of the freshly counteretched surface, some artists prefer using slightly harder crayons or pencils for corrective work.

6. When the drawing is completed, the entire image is again dusted with rosin and talc in preparation for re-etching.
7. The re-etching solution should be very weak in order not to injure the new work, which is barely attached to the stone at this time. A mixture of three to five drops nitric acid and one ounce gum arabic usually provides a satisfactory etch. Somewhat stronger etches may be necessary for very fatty tusche washes. Medium to delicate additions are sometimes etched with pure gum arabic and no nitric acid.
8. On works that are re-etched locally, the solution is lifted with a blotter or small damp sponge without touching other areas. The entire stone is gummed and dried. Etches covering the entire stone are dried without further gumming.
9. The dried stone may be stored or washed out and rolled up for proofing.

All freshly added work, especially that which has been etched with pure gum, should be observed carefully during the proofing. The slightest tendency toward filling and darkening may necessitate direct application of weak spot etches to further stabilize the work.

4.10 THE BON A TIRER IMPRESSION

The final objective of the proofing process is to print a perfect impression of the work. This impression will then serve as a definitive guide to which each subsequent print in the edition may be compared for quality and fidelity. The impression is called the *bon à tirer* (good to take), following French tradition, or is otherwise known as the *printer's proof*.

Inasmuch as it is the definitive proof, the *bon à tirer* cannot be printed until all corrections of the image have been satisfactorily completed, and the printer is satisfied that the work is firmly stabilized for printing the required number of edition impressions. It is printed on the same paper on which the edition is printed.

Traditionally, the *bon à tirer* impression bears the signature or initials of the artist, and in professional shops this serves as a recorded authorization to proceed with the edition. The print is usually pinned to the wall adjacent to the press or placed near the paper stack so that the printer can compare impressions during the printing of

the edition. It becomes his responsibility to maintain the same quality throughout the printing.

The *bon à tirer* impression usually remains the property of the printer after the edition is completed. Such impressions often carry marginal inscriptions of homage, through which the artist expresses his respect for or gratitude to the printer.

4.11 PRINTING THE EDITION

The printing of an edition may proceed whenever the objectives of the proofing session have been fully met. At this point, each of the following has been done:

1. Accurate trial proofs have been printed.

2. On the basis of these proofs, the artist has made all necessary corrections.

3. The printing and nonprinting areas (including all corrections) have been firmly established so that the required number of impressions may be produced.

4. The ink consistency and rolling patterns have been determined and the correct press pressure has been established.

5. A satisfactory *bon à tirer* impression has been printed.

As mentioned earlier, the moment these objectives have been met, the creative aspect of the work has been completed. Thereafter the printer's attention should be directed entirely to the printing of an edition of identically perfect impressions.

Throughout the printing of the edition an attitude of fine craftsmanship should prevail. This requires utmost cleanliness and efficiency in the handling of material and equipment. If such printing immediately follows the proofing session, the materials to be used, such as sponges, water bowls, ink slab, etc., should first be cleaned or freshened.

Procedure. The stone is rolled with ink in the pattern initiated during proofing. Care is taken that the same number of rolling passes are given for each inking and that the same amount of ink is being transferred to the image. When the image is fully inked, the hands are dusted with talc (unless paper grips are employed), and the printing paper is carefully positioned to the lay marks on the stone. The backing sheet and tympan are lowered, and the work is passed through the press. The stone is dampened immediately after the print has been lifted from it. The impression is compared with the *bon à tirer* and then placed face down on the first newsprint slip sheet of the edition pile.

The mechanical objective of edition printing is to duplicate each step of the process so that a series of

4.7 A complex development of an image by artist Robert Nelson

a. The artist applies the counteretch around his partial drawing, which was previously transferred, processed, and proofed

b. The counteretch is mopped with a sponge and water

c. The stone is fanned dry

d. The stone is ready to receive additional drawing

e. The artist completes the figure with brush and paste tusche

f. Additional details are added with a lithograph pencil

g. The completed drawing is dusted with rosin and talc

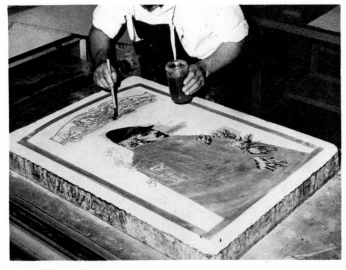

h. The original parts of the drawing are protected with pools of gum arabic

i. The stone showing the protective pools of gum arabic

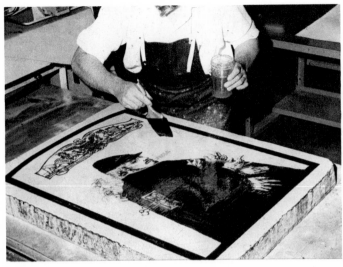

j. An etch of moderate strength is brushed over the image

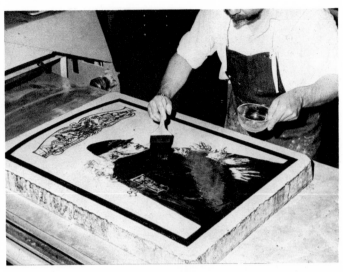

k. A strong etch is applied locally over the heaviest areas

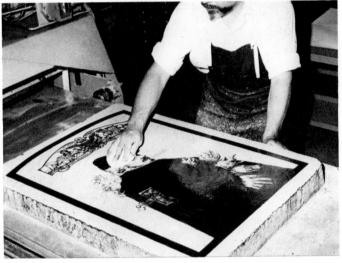

l. The etching solutions are wiped dry

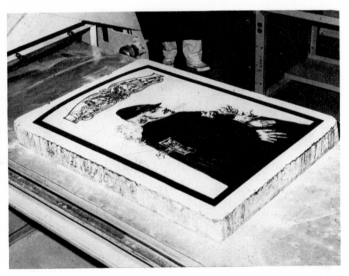

m. The completed drawing is ready for proofing

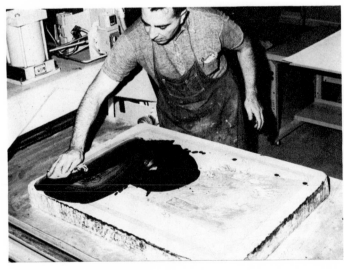

n. Asphaltum is applied after washing out the image

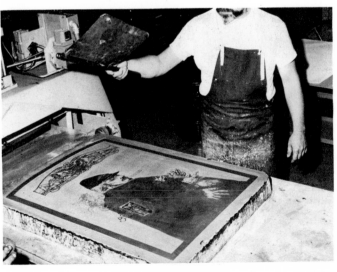

o. The asphaltum film is fanned dry

p. The etch coating and excess asphaltum are removed with sponge and water

q. The image is rolled up with ink

r. The margins are cleaned by honing

s. Unwanted areas of the drawing are also removed by honing

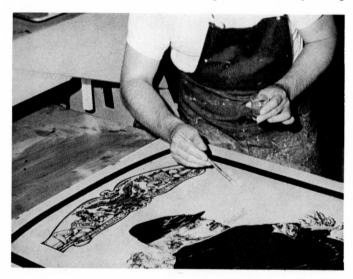

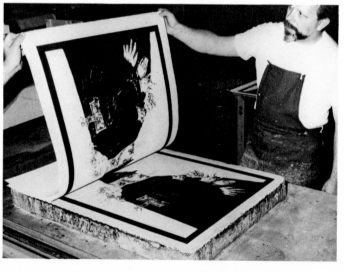

t. The deleted areas are spot-etched

u. The artist removes a proof impression from the stone

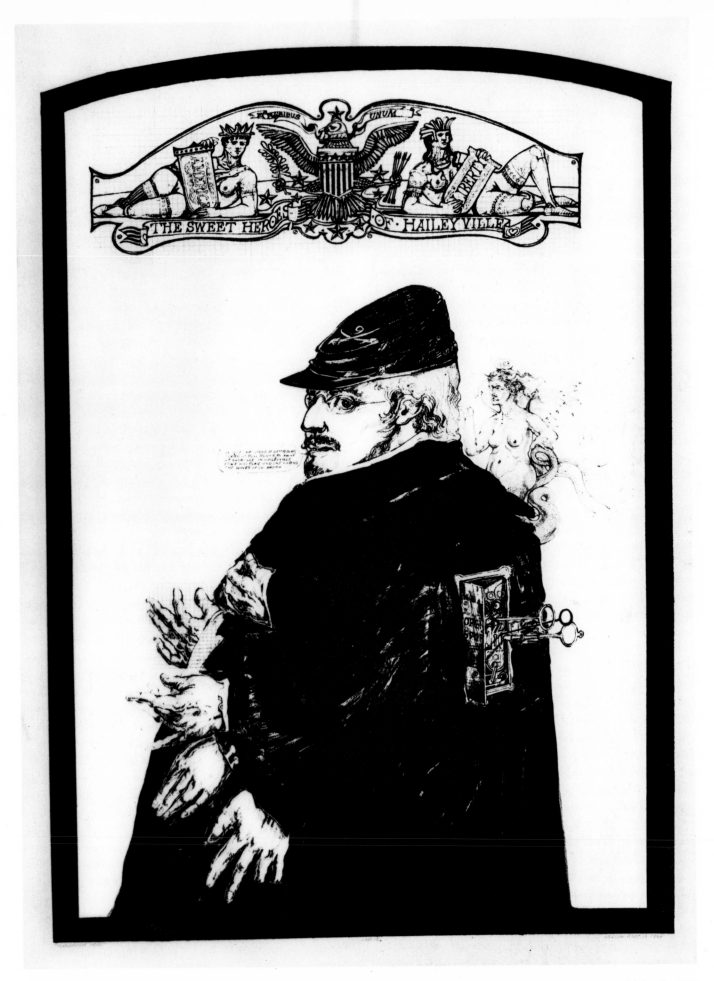

v. The completed print, "Haileyville Hero," 42 1/2 × 30"

identical results may be achieved. This was not possible during proofing, because interruptions for necessary technical and aesthetic decisions interfered with the steady flow of work. The production sequence should now be geared so that the printer can proceed in a rapid and efficient manner. He should establish patterns of movement: from the ink slab to the stone and back to the ink slab; from the paper table to the stone and back to the paper table.

Within a few impressions a cyclic rhythm will have been established which can be maintained throughout the printing. The pace will depend on the individual; speed is less important than consistency. Continual effort should be made to avoid unnecessary motion; otherwise time and physical effort will be wasted and the quality of the impressions may vary. As stated before, well-meshed teamwork is imperative if the printing is a two-man operation. Proper coordination between the printer and his assistant can considerably reduce both work load and printing time.

As the routine of printing becomes established, the printer can direct his attention to other matters. After a few impressions he will perceive that the stone's ability to receive and retain water is improved, indicating that both image and nonimage areas have been perfectly stabilized and the printing element is operating at peak efficiency. Less water will be required to keep the stone damp, and it will be easier to maintain a constant moisture level on its surface throughout the printing. The reader will recall that variations in the dampness of the stone will allow more or less ink to be applied to the image from one printing to the next, thus changing the appearance of the printed impressions. Some printers prefer a little more moisture than others, and this depends, to a certain extent, on the nature of the image. Once the moisture level is established, however, it should be kept constant.

Once moisture control is established, the printer should consider the problems of ink distribution on the stone and ink replenishment on the slab. The proofing session will have determined the correct number of inking passes on the ink slab and on the image to produce a perfect impression. As the ink from the slab is gradually depleted, additional passes will be necessary to charge the roller and image fully. Thus if the inking requires three returns to the slab to recharge the roller (a standard average), the last impression before the slab is replenished with fresh ink may require four returns and a few extra passes on the stone. By comparison, only two returns to the slab may be necessary after fresh ink is laid out. In other words, in printing each impression, compensation should be made for depletion and addition of ink on the slab.

The frequency and amount of ink replenishment on the slab will depend on the nature of the work and the consistency of the ink. Very large stones with vast areas of image solids will require constant renewal of ink, possibly one or two fresh bands of ink on the slab for each impression. If too much ink is put on the slab at one time, the roller will become overloaded, and it will over-ink and fill in the image. Images that are small and pale may require only a single spread of ink on the slab to print an entire edition.

Ink consistency is closely related to the problems of distribution and replenishment. When printing the edition, many printers prefer to use a somewhat softer ink than that used for proofing. This ink allows more rapid rolling, less rolling pressure, and, often, fewer inking passes (thus less work) than the stiff roll-up ink. The printed impressions are usually slightly richer in quality than the proofs. The degree of ink modification is necessarily limited by the characteristics of the printed image. Some images cannot tolerate soft inks and will rapidly darken and fill in; these must be printed with the stiff roll-up ink. Others may tolerate inks of varying softness; this only experience can determine. Several excellent printing inks of softer consistency are listed in sec. 11.11. If desired, the stiff roll-up ink can be softened with minute additions of #0 or #3 lithographic varnish. It will be noted that the softer inks (by reason of reduced tack) are more rapidly exhausted on the roller and ink slab; hence they are replenished more frequently than is the roll-up ink.

Ink distribution is further affected by the amount of moisture picked up by the roller during the course of printing. Both ink and roller will appear shiny when wet, and matte when in ideal working condition. If the roller becomes too wet, a problem that often occurs during the printing of large editions, it will refuse to accept or release ink properly. It should be passed rapidly over the ink slab a number of times until both are dry. It is always good practice to do this immediately after inking the image and just before laying the paper. Both ink slab and roller will then be in the proper condition for inking the following impression. Eventually, a certain amount of moisture will unite with the ink on the slab by emulsification, the ink will becomes short and rubbery, and its distribution will be decreased. Fresh ink applied to the slab will eventually clog the roller, for the accumulation exceeds the depletion. Rollers in this condition cannot feed or distribute ink properly. Both the slab and roller must be scraped to remove the emulsified ink, and fresh ink must be set out before the printing can be resumed. For the printing of very large editions, it is sometimes desirable to keep a spare roller at hand, substituting it for the first roller in order to avoid interruption of working patterns.

Problems of ink consistency, distribution, and replenishment can be discovered only through examination of each impression after it is printed. Since other matters relating to the quality of the print must also be checked, it is necessary for the printer to establish a routine work rhythm in which each print can be efficiently and completely examined. The logical time for examination is while the print is being lifted from the stone, carried to the press table, and deposited between slip sheets in the edition pile. At this time, the following questions are asked in comparing the print with the *bon à tirer* impression:

1. Is the impression too light or too dark, and what remedies are needed? Comparisons will be facilitated if the printer already has in mind some key areas of the *bon à tirer* which might be expected to shift during printing. These should be fairly well dispersed and should include the maximum darks and palest grays. By rapidly comparing these areas of an impression to the *bon a tirer*, the printer can decide what remedy should be used in printing the next impression. It may be necessary to modify one or more of the following: (a) moisture control, (b) ink consistency, (c) ink distribution, (d) ink replenishment, (e) rolling technique.

2. Is the printing image losing its fidelity through breakdown of (a) the image area, (b) the nonimage area, (c) both areas? What remedies are needed? Comparisons with the same or other areas on the *bon à tirer* will permit the necessary judgments to be made. Remedies may be: (a) etching or gumming the work, (b) modifying inking patterns or rolling techniques, or (c) employing an antitint solution.

Other questions will become evident as prints are examined. From previous experience, each printer will have developed a series of "check points" that he uses to measure the quality of an impression. He must immediately remedy printing faults in order to protect the printing element and to assure the quality of the edition. Some of the more common printing problems and their remedies are discussed in the next section.

Although it is desirable to maintain an even flow of work throughout printing, many factors may interfere. The printer may need to stop to replenish ink, to scrape the roller, to clean the borders of the stone, to wash his hands, or just to rest. During such intervals the moisture level of the stone should be maintained. Delays of one-half hour or longer necessitate gumming the stone. The gum arabic is applied directly to the inked image with a dampened sponge and without prior application of talc. The gum must be rapidly distributed and fanned dry before the greasy ink film can throw aside the watery gum.

When printing is resumed, the dried gum is simply washed from the stone with water, and the image is inked on top of the original ink film. (If talc were applied before gumming, the image would require washing out before inking.)

If an edition is too large for completion in one day, the stone must be inked and dusted with talc before gumming and storage. Sometimes two or three drops of nitric acid are added to the solution to serve as a very mild etch. This tends to clean and open heavily inked images and to fortify the nonimage areas. For the next printing, the image must be washed out and rolled up. A few proofs should then be taken before printing of the edition is resumed.

4.12 CONSIDERATIONS AFFECTING THE SIZE OF THE EDITION

Before an edition of lithographs can be printed, a decision must be made as to the number of impressions to be pulled. Sometimes this decision is made before the proofing operation, thus making it possible to prepare all the paper at one time. On other occasions the size of the edition is determined after the proofing, when the merits of the print can be more accurately assessed. In either case, a number of factors may determine the size of an edition. Some of the more important of these are discussed below.

The Limited Edition. Although more than 1000 impressions can be printed from some stones, the desirability of limiting editions for aesthetic as well as practical reasons is well established in hand printing. The objective of producing works of quality rather than quantity has always been one of the major differences between the hand-printing processes and the automated, commercial printing industry. Moreover, the economics of production force practical limitations on the size of hand-printed editions. There is very little difference in cost of materials and production time between 100 and 2500 mechanically printed impressions. No such saving of time or materials exists in hand printing. The rate of productivity is very low and remains relatively constant for each printed impression.

Production Costs versus Marketability. The production cost of an average edition of lithographs is substantial. Unless this can be underwritten by a dealer or publisher who has a reliable market for the prints, the project is entirely speculative. Artists not having an established market must, therefore, limit the size of their editions in order to avoid too great a financial investment.

Prints of the established modern European masters have characteristically been published in signed editions

ranging from 50 to 250 impressions. In the United States artists have tended to print quite small editions, although recently, as the market for prints by American artists has expanded, editions of 100 impressions have not been uncommon.

Complexity of Production. Nowadays the editions of many lithographs are limited, because of either the size of the image or its technical complexity. Such lithographs, which may be very expensive to produce, must necessarily command a high price and, hence, will find a relatively small market.

Technical Hazards. Infrequently, editions must be limited because of unforeseen technical hazards. The printing element may deteriorate before the edition planned has been printed, or the stone may break, thus forcing a premature termination of the printing. If ten or more impressions of *bon à tirer* quality were printed before the mishap, they may be considered a bona fide edition. If there are less than ten impressions, they are more correctly called artist's proofs.

Extra sheets of paper beyond the anticipated edition size should always be prepared before the printing, including newsprint and intermediate proofing papers as well as a small surplus of fine edition papers. The extra sheets replace those wasted by faulty impressions, an inevitable part of the hand-printing process. The printer should endeavor to waste as little paper as possible, for professional as well as economic reasons. In normal printing there may be a waste of 20 per cent in printing editions of 20 impressions or less, and 10 per cent thereafter. More complex prints may show a 5 per cent increase over these estimates. Sometimes very little waste occurs. In such cases, the edition may be numbered beyond the size originally intended, or some of the extra impressions may be marked as artist's proofs (see sec. 5.2).

4.13 SOME COMMON PRINTING PROBLEMS AND THEIR REMEDIES

Before a printing problem can be corrected, it is first necessary to isolate and identify it. In lithography problems are often caused by a number of factors operating either independently or in conjunction with others; a series of interrelated problems may occur simultaneously. The printer without prior experience will find such problems extremely vexing and will need to separate and identify them through the laborious process of trial and error. He should attack first those problems which threaten the stability of the printing element. As he gains additional experience he will recognize the more familiar problems and will often be able to prevent their occurrence, by taking preventive measures beforehand. The following

more common printing problems and their remedies illustrate methods of procedure for the beginning lithographer.

DIRTY MARGINS

The most common and easily corrected problem is that of dirty margins. This problem appears in several forms, each requiring a somewhat different corrective approach.

1. If the print shows a thin black band corresponding to the outer edges of the stone: Examination will reveal ink attached to the extreme edges of the stone either because these are insufficiently beveled or because the ink roller has traveled an unnecessary distance past the image. The problem is further aggravated because the moisture film dries more rapidly on the bevel than on the surface of the stone. This is remedied by rasping a broader and rounder edging, which is then given a moderately strong localized etch and dried. Limiting the rolling pattern to the confines of the image further minimizes the chance of inking the bevel.

The above procedure should also be used when printing on paper smaller than the stone. Unless treated, the bevel, while not printing on the impression, will print on the backing sheet, from which it may offset onto the back of the following impression.

2. If the printed impression has ink smudges and stains on its margins: The margins were probably insufficiently cleaned and etched during proofing, or ink was permitted to accumulate through careless moisture control and rolling technique. The areas should be cleaned by brisk honing, after which they should be desensitized with the strong press etch (30 drops nitric acid to ¾ ounce gum arabic). After the etch is washed away, the printing can proceed. If the smudges reappear, the procedure is repeated, and the etch is permitted to dry completely before it is washed away.

3. If the print margins and white areas inside the image show tiny black specks and a tint or veil of ink lying on their surface: This is most often a result of dirty sponges and dampening water which have accumulated dirt particles and oily residue from the work surfaces. Sponges and water bowls should be thoroughly cleaned before printing is resumed. Sponge faces should be kept off the work surfaces, either by standing them on edge against the water bowls or by laying them on a clean paper towel.

Occasionally, bits of ink skin will be transferred to the stone from the printing roller. To prevent this, the ink must be kept fresh, and foreign particles must be removed from the ink slab as soon as they appear. A closely related problem is produced by friction against the roller grips. Unless their inner surface is well cleaned and periodically dusted with talc, small bits of leather and flakes

of shellac from the handles will be worn off. These particles drop onto the ink slab and stone and soon find their way onto the printed sheet. It is important that the roller grips be shaken free of all loose talc, for this also can cause a faulty impression by falling on the inked image.

HALOS AND SCUMMING

Two additional types of ink veils exhibit slightly different characteristics:

1. An oily film may appear to creep out from around the edges of the inked image, and this will print as a pale, greasy halo around all the darks. The film is caused by the separation of the oil ink vehicle; this oily substance then spreads onto the moisture film of the stone. Unless quickly arrested, it will be impressed into the stone by the press and, by overcoming the desensitized areas, will form a permanent printing image. This condition is especially prevalent when thin varnishes have been incorporated into the ink mix, and the printing is being done on a warm or hot day. (See secs. 11.4 and 11.9.) The printer must either resort to a stiffer ink formulation by using heavier varnishes or should "shorten" the consistency of the ink by adding magnesium carbonate. At the same time the moisture level of the stone should be reduced as much as is safely possible while rolling for a longer period of time. In this way the greasy film is given less opportunity to crawl onto the water film, because the stone will be almost dry before the rolling stops.

2. Another troublesome problem resulting from soft, oily inks is that of scumming; this too is more noticeable in warm weather. The condition manifests itself in a gathering of ink over the margins and image, producing greasy, unattractive tints over the stone and the print. If cleaning the sponges and water bowls and stiffening the ink do not solve this problem, a chemical cleansing agent called an *antitint solution* should be employed. (See sec. 4.14.)

DARKENING OF THE IMAGE

A condition commonly encountered during the printing of an edition is the gradual darkening of the image. Although almost imperceptible from one printing to the next, the condition is clearly evident when the first impression is compared with the fifth, or the fifth to the twentieth. This can be the result of several different factors which may cause permanent loss to the image unless corrected in time.

1. Darking of the image is most commonly caused by overinking. Unless the problem can be attributed to careless inking techniques, the fault is probably psychological in nature. The lithographer continually trying to improve the print will have a tendency to overink. Attracted by the resulting richer impression, he will subjectively reject the *bon à tirer* and pursue the qualities perceived in the new impression. Gradually, the printing image is forced to accept ink beyond its maximum chemical capability. The excess ink, having nowhere to go, is gradually forced into the stone by the press. Before long it becomes permanently attached, and it expands and overcomes nonimage areas surrounding the image.

If the problem of image darkening is noted at an early stage (within one or two prints), wiping with a small felt pad and clean water may be all that is required to clear the image of excess ink. Printing one or two newsprint sheets without further inking will also help. If these measures are insufficient, antitint solution should be employed. Several applications, with intermittent proofing, may be necessary to clear the image. If these are unsuccessful, and the work tends to return to its darkened condition, it may be assumed that the image is permanently enlarged. In such cases the image should be gummed, washed out, and rolled up afresh to the point desired. It is then dusted with rosin and talc and is given a weak etch (six grains tannic acid to one ounce gum arabic). This procedure should prevent the image from spreading further. Subsequent impressions, however, will never duplicate the original *bon à tirer*.

2. Darkening of the image may also occur when press pressure is either too heavy or too light. This problem is more frequently encountered than is generally supposed. Excessively heavy press pressure tends to force heavy inkings beyond the confines of the printing image. This most often occurs along the trailing end of the image as the stone moves through the press. If the image happens to be etched in very slight relief, the ink will be dragged over the edge of the relief, producing a slightly ragged contour on the trailing edge of each image dot. In time the dragged ink will overcome the nonimage barrier and permanently affix itself to the stone. This fault is difficult to correct if aggravated by the relief of the image. Sometimes a slight reduction of press pressure is helpful, along with the use of a stiffer ink.

When the press pressure is too light, not enough ink will be transferred from the stone to the printing paper. Although the printed impression may appear satisfactory, the ink remaining on the stone will multiply with each new printing. Gradually the accumulated surplus will produce an overinked stone.

The problems of press adjustment should be carefully considered during the proofing operation. Once edition printing is under way, there should be little need for additional pressure regulation.

3. Darkening of images also occurs when a stone is underetched. This can produce problems very similar to

those resulting from overinking, and the two faults are often confused with each other. Contrary to general belief, darkening of images is more often the fault of poor inking practices and improper press pressures than of underetching. The printer should first eliminate the first two as possibilities before considering re-etching.

Underetched images should be prudently re-etched, following standard etching practice and using a mildly acidic solution. Kistler etches are excellent for this purpose. Inasmuch as there is always some risk of image loss in the re-etching procedure, one should always make sure that re-etching is indeed required.

4.14 ANTITINT SOLUTION (STONE CLEANER)

Antitint solution functions for stone lithography in much the same way as fountain solution for metal-plate lithography (see sec. 6.28). Its ingredients of watery gum arabic and phosphoric acid provide mild desensitizing properties that are extremely useful for the removal of free ink particles. It is sometimes referred to as *stone cleaner*, being one of the most valuable agents in the shop for controlling image stability during edition printing.

Antitint Solution

Gum arabic	one part
Water	five parts
Phosphoric acid	four drops for average strength; six drops for strong solution

Antitint solution must be freshly mixed for each job; it cannot be stored.

Several ounces of solution are poured into a shallow bowl. A small felt pad about three inches square is used for applying the solution to the stone. A separate small bowl of water and a small half-sponge are used to remove the solution. These materials should always be set out as part of the basic equipment for printing of either proofs or editions. (See sec. 10.8.)

Antitint solution should be applied only on a damp stone. The felt pad, well saturated with solution, is rubbed in a gentle circular motion, covering the areas of the stone that are to be cleaned. Free ink particles will attach themselves to the coarse surface of the felt. Meanwhile the solution provides a mild cleansing action by permitting its chemical ingredients to combine with the adsorbed etch film on the stone, thereby fortifying the nonimage areas.

Either of two different application procedures can be used. The first involves use of the solution after the final inking of the stone, just before positioning the paper. This procedure is employed to overcome surface ink scum and tinting produced by the inking process on the margins and undrawn areas of the stone. After the scum or tint has been removed with the felt, the areas are dry-mopped with the small water sponge in order to remove the solution. Unless the solution is removed, its gummy consistency will glue the print paper to the stone when the work is passed through the press.

In the second procedure the solution is applied after the completion of one printing, just before the inking for the next impression. This method is used to overcome problems of image darkening and filling due to overinking. The antitint solution is applied over the troublesome areas with the felt pad. As before, the fluid will dislodge the excess ink particles and permit them to attach to the felt. Gentle pressure should be employed during this process in order not to abrade or weaken the image. Several applications of antitint solution may be necessary to correct stubborn areas. Each application should be removed with sponge and water, taking care that the solution does not make contact with other areas of the image. It is often necessary to print a few trial proofs, applying antitint solution between proofs, before the problem is completely solved.

Antitint solution should be employed only until troublesome conditions are overcome. These will normally lessen and disappear within a very few prints; the solution is then set aside. There is some hazard to the image from prolonged and unnecessary application of strong antitint solutions. Being a mild etch, these can weaken and destroy very delicate passages of the image and prohibit full darks from printing with maximum richness.

The stronger antitint formulation is used to overcome aggravated cases of scumming, particularly those resulting from the printing of heavy black tones with soft ink. In some cases it even becomes necessary to employ the antitint solution, rather than the dampening water, in order to moisten the stone. For such occasions the water content of the solution is increased and the stone is lightly wiped with clean water just before the paper is positioned.

The beginning lithographer should recognize the value of antitint solutions for the removal of ink from the margins of the stone. The common practice of removing ink by rubbing the stone with the fingers is perhaps the most harmful practice in hand printing. The abrasive friction of the finger tips will gradually wear away the adsorbed etch film on the stone, thus reducing its ability to retain moisture and reject ink. Ironically, this method of cleaning simply compounds the problem; the more the stone is rubbed, the more its ink-rejective properties are reduced. By comparison, the application of antitint solution, instead of weakening the adsorbed film, actually strengthens it by infusing additional acidified gum.

After the Edition Is Printed

5.1 SIGNING AND NUMBERING THE EDITION

When all impressions have been printed, the chipboard cover is placed on top of the pile of completed prints, which are still between the newsprint slipsheets. The entire pile, protected top and bottom by chipboard, is then removed from the press area.

The finished lithographs should be stored in an area that is clean and secure at all times, preferably outside the pressroom. Ideally it will be in a room with good light and sufficient space so that completed prints can be spread out on tables for examination and signature. These tables must be immaculately clean, and preferably are covered with paper.

Because lithographic inks dry slowly, it is advisable to let the prints rest in storage for several days before collating the edition. Even then, they should be handled with great care so as to avoid all possibility that the still fragile ink surface might be marked or smeared.

Before the artist begins to sign and number the prints, each impression must be examined and compared with the *bon à tirer*. Weak or flawed impressions must be placed aside, later to be destroyed. In some workshops the printer may wish to look through the edition before the artist; in other workshops a curator may be employed to examine all editions prior to signature. Although either the printer or a curator may reject an impression that does not meet the workshop's standard, the artist has final responsibility for acceptance. Through his signature he attests to the quality of each impression and to his acceptance of it.

Both the form and the placement of the signature are determined by the artist. He may use his initials or his full name; he may use pencil or colored crayon; he may place the signature in any position on the face of the print, in the margin or within the image. Occasionally, when the aesthetic of the work demands it, he may elect to place his signature on the reverse side of the print.

As the prints are signed they are also numbered or designated as proofs. The numbered impressions in an edition of twenty are marked 1/20, 2/20, and through to 20/20. As all impressions should be identical with the *bon à tirer*, with which each is compared at the time of signature, the sequence of the numbers has no meaning; the first print in an edition of lithographs should be no different from the last. As a result, few printers make a practice of numbering impressions at the press. In color lithography such a practice would in any event be fruitless, for the impressions will not normally be printed in the same sequence as each color is added. The true meaning of the number 1/20 is thus that the impression is one of an edition of twenty, not specifically that it is the first of twenty.

At times, particularly when a large edition is printed, a reserved or preferred edition will be printed on a different kind of paper. Two hundred impressions might be made on Arches paper, for example, and another twenty-five on Japan. When this is done it is customary to use Roman numerals on the preferred edition: I/XXV, II/XXV, etc.

After all the numbered impressions have been signed, a few remaining impressions of good quality may be designated artist's proofs. Although there is no universally accepted limit, the number of artist's proofs should be very small. To permit a large number of artist's proofs is to practice a deception, for the numbering of the edition thus becomes meaningless.

By custom, the *bon à tirer* impression, after signature by the artist, becomes the property of the workshop or the

collaborating printer. Because such impressions are unique and of perfect quality they have a particular appeal to collectors, thus tending to command a premium price when on occasion they enter the marketplace.

5.2 DESIGNATION OF PROOFS

Signed impressions beyond the numbered edition are variously described:

1. Artist's proofs are impressions of a quality fully comparable to that of the numbered edition. They may be printed upon the same paper as that used for the edition or, if projected and planned in advance, upon a special paper. In France such impressions may be marked either *épreuve d'artiste* or, alternatively, *hors commerce*, sometimes abbreviated *h.c.*

2. Trial proofs are impressions printed before the *bon à tirer*. Trial proofs may sometimes differ slightly from the numbered edition in that they were printed before minor corrections were made in the stone or plate. At other times they may simply be weak impressions printed en route to the *bon à tirer*. It is misleading and incorrect to call a weak impression printed during the run of the edition a trial proof; such impressions are merely faulty impressions, and, as such, should be destroyed.

3. State proofs are impressions that differ markedly from the numbered edition. Such impressions come into being before major alterations in the stone or plate. If an image undergoes a series of major modifications, there may well be a series of differing state proofs which together record the stages in its evolution. On occasion, a numbered edition may be printed, the stone may subsequently be altered, and a second edition printed. In this event, the prints may be regarded as two separate but related editions, and only the intermediate proofs between them (if any) would be designated state proofs.

4. Progressive proofs are impressions from single stones for a color lithograph or from a combination of such stones, short of the final print. A set of progressive proofs for a four-color lithograph might well consist of the following:

Stone A alone
Stone B alone
Stone A plus B
Stone C alone
Stone A plus B plus C
Stone D alone

(An impression with all four stones would be the *bon à tirer* of the edition. See sec. 7.18.)

5. Color trial proofs are impressions that differ from the edition in the color of the ink used. Such impressions characteristically come into being as adjustments are being made in color, and it is not uncommon that in the printing of a complex color lithograph there are many of them, each differing from the others.

6. Presentation proofs are impressions of a quality comparable to that of the edition, which are not otherwise designated but which are inscribed by the artist to a friend or collaborator.

7. Cancellation proofs are made after the full edition has been printed in order to provide a record of the defacement or permanent alteration of the image on the stone. In professional shops the cancellation proof is never made until after the edition has been collated and signed. Only when the artist verifies that the desired number of impressions indeed exists is it safe to modify the stone for printing of the cancellation proof.

Various methods are employed to cancel a stone. Portions of the image can be scraped, honed, or deleted with a strong etch. In any case, the character of the cancellation should clearly reveal that the printing image has been permanently altered and that no further impressions identical with the edition can be taken from it.

Cancellation proofs should be printed on paper identical with that of the edition. Because only one cancellation proof is printed for each edition, such impressions are unique and hence valued by specialized collectors.

After the edition and the cancellation proof have been printed, the ink should be removed from the stone with lithotine. In this condition the stone can be stored or its image can be effaced by grinding in preparation for new work. Images that are eventually to be effaced should not be stored or reground while ink is on their surface. Dried ink is difficult to remove, and its presence during grinding, though not serious, sometimes prolongs the process.

Prints made on newsprint paper or other proofing papers should not be signed by the artist. Because such papers are subject to rapid deterioration, all such proofs should be destroyed.

5.3 THE PRINTER'S MARK

Once the artist has finished signing the edition, all unsigned prints should be destroyed. Although it is economically tempting to preserve rejected impressions so that the unspoiled side of the sheet may be used for future proofing, good practice argues against it. There is always a risk that unauthorized impressions of an artist's work may reach the marketplace, to the disadvantage of both the artist and the workshop. The only adequate safeguard is to destroy rejected impressions immediately.

After all impressions have been signed they should be

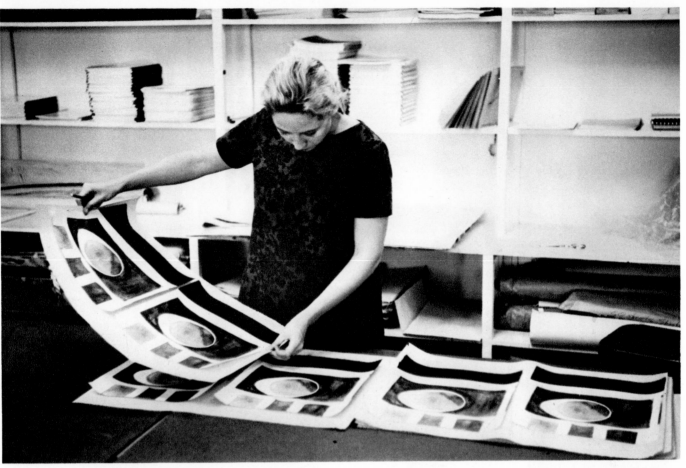

5.1 Comparing impressions with the bon à tirer

5.2 Signing and numbering the edition

5.3 Cancelling the stone

5.4 Pulling the cancellation proof

marked with the printer's chop or blindstamp. This mark serves not only as an aid to future identification but also as the printer's guarantee of both the quality and authenticity of each impression. In a small workshop, with but a single master printer, the printer's chop may serve as a workshop chop or, conversely, a workshop chop may serve to identify the printer. In a larger workshop, such as Tamarind, the print may carry two chops: the workshop mark and that of the individual printer. A publisher's chop may sometimes appear either in place of or in addition to the workshop's chop.

Blindstamps that emboss the paper, making an inkless mark, have three advantages: (1) because they are inkless, they do not impinge visually upon the image; (2) because they are embossed, they cannot easily be removed or altered; and (3) they are far easier and faster to use than seals or chops printed in ink.

The location or placement of the chop is a matter for the artist to decide. If a print has margins, the chop will normally be placed in the lower margin adjacent to the image or in the corner of the sheet. If the print completely fills the sheet, it may be possible in some cases to place a chop within the area of the design. But just as the artist may at times decide to place his signature on the reverse of the print rather than on its face, so it may be necessary at times to vary the placement of the printer's mark. The aesthetic of some prints is such that any mark on the face of the print would be disturbing or disruptive. In such cases workshop or printer's marks may be stamped on the back of each sheet in lithographic ink.

Wherever and however the mark is made and placed, no impression should leave the workshop without it. In large workshops it is essential that adequate security be kept, so that there is no possibility of unauthorized, unsigned, and unchopped impressions being bootlegged from the shop.

If a blindstamp is used, care must be taken to ensure that it is placed uniformly on each impression. The die must be kept clean, and the prints must be handled with care when it is used. If the blindstamp is placed within the printed image, the embossment should be made through a piece of tissue in order to avoid transfer of ink from the lithograph to the blindstamp.

5.4 RECORDING THE EDITION

A professional lithographic workshop should maintain full and complete records of every work printed. For this purpose a job or identification number should be assigned to each new print as it is begun. While work is in progress this number will serve the printer in scheduling press time. It will be used to keep track of time and materials expended and of technical procedures employed. It will also be of value in maintaining office records.

At the time the prints are signed and chopped it is excellent practice to write the workshop's identification number lightly in pencil on the back of each impression. A logical place is adjacent to the workshop blindstamp. Such identification numbers, like the chops themselves, are a permanent aid not only to the artist and his dealers but to collectors and museums as well.

The workshop should also prepare a permanent documentation of each edition, listing all impressions signed by the artist and including all significant information about the lithograph. The documentation form used by Tamarind is an excellent model to follow. Under Tamarind practice, both the artist and the printer sign the documentation to attest that it is an accurate record of the edition printed.

Ideally, the documentation will tell whether the edition was printed from stone or from zinc or aluminum plates, when the printing was begun and ended, how many impressions were printed, on what papers and how designated, and whether the stone (or plate) was effaced. Other details with respect to the inks used or technical procedures employed may also appropriately be included.

5.5 STORAGE AND CARE OF ORIGINAL PRINTS

When the workshop prepares an edition of completed lithographs for delivery to the artist, the newsprint slipsheets should be removed and replaced by tissue or glassine paper. Prints should never be stored with newsprint slipsheets, for the sulphur content of the newsprint will affect the paper of the prints adversely.

The fine papers used in artists' lithography are stable and long-lasting only if cared for properly. Prints may easily be damaged through improper handling or storage. They should be protected to the greatest possible extent from dust, extremes of temperature or humidity, and overexposure to light, particularly direct sunlight.

The artist who works with any regularity as a printmaker will soon accumulate a sizable stock of completed prints. Unless the sale of his work is immediate he must provide storage for these prints, either in Solander boxes or in cabinets with shallow drawers. Open shelves should never be used for storage of prints; not only will the prints become dirty, but particles of dust will soon abrade and scratch the print surface, causing irreparable damage.

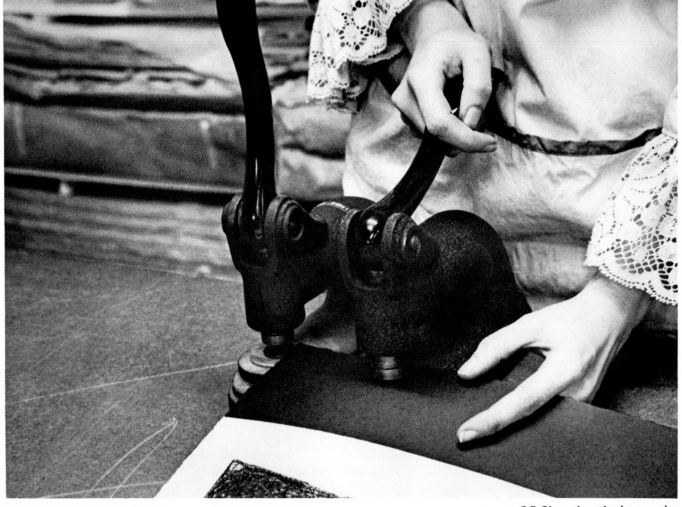

Solander boxes are designed specifically for storage of fine prints. They are lined with all-rag paper and have hinged lids that open to a horizontal position, thus making it possible to slide the prints from one side to the other when examining them. Although in some ways preferable to cabinets, Solander boxes will prove to be a very expensive form of storage for the artist who must make provision for a large number of prints.

Appropriate cabinets are made in both wood and metal in a variety of sizes. They are usually listed as blueprint cabinets by manufacturers and retailers. Each of the stacking units customarily consists of five drawers approximately two inches in depth. Shallow drawers are preferred to deeper drawers, for to have too many prints in a single drawer increases the risk of damage in handling them. The other dimensions of the drawers will obviously be determined by the maximum size of the prints to be stored.

Even when properly stored in cabinets or Solander boxes, prints may still not be adequately protected from attack by paper-destroying insects, such as silverfish or cockroaches, or from microbiological infections that might result in mildew or foxing. Such problems will be particularly severe in areas of the country that characteristically have long periods of high humidity. The only adequate protection in such circumstances is to provide storage for fine prints in an air-conditioned room.*

When despite precautions a print is damaged or soiled, the artist should be extremely conservative in attempting repairs. Great harm can be done through unskilled attempts at restoration. If a print is creased or torn it is best left that way until such time as an expert paper restorer can be consulted. Minor spots of dirt can often be successfully removed with a soft rubber eraser, although this should be done very cautiously. Even the most careful use of an eraser will tend to disturb the fibers of the paper. In some circumstances, particularly in the case of papers having a relatively soft or loose structure, it is better to accept a small spot or mark than to attempt to erase it. The notion that a piece of bread dough can safely be used to clean the surface of prints is an old wives' tale; the effect of such treatment is to scour the surface of the print

* A brief but authoritative discussion of the care and conservation of fine prints is contained in *A Guide to the Collecting and Care of Original Prints* by Carl Zigrosser and Christa M. Gaehde. New York, Crown Publishers, 1965.

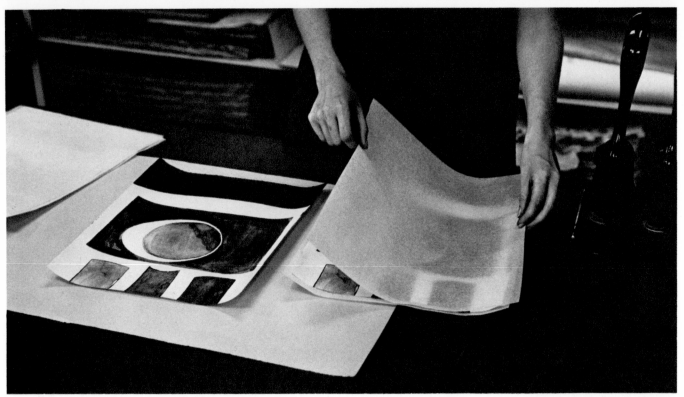

with the abrasive particles of dust that are themselves the cause of the treatment. If through lack of proper care a print is covered with dust or grime, there is no harm in attempting to remove as much as possible by softly brushing its surface with a sable or camel's hair brush.

The key point in the storage of fine prints is to provide proper care and conservation so that restoration may be made unnecessary.

5.6 PRACTICES IN MATTING AND FRAMING

Much of the damage done to original prints is caused by improper matting and framing.† Unfortunately, the use of faulty materials and procedures is not only harmful but widespread. Commercial framers have been known all but to destroy fine prints by gluing or drymounting them to low-grade chipboard, or by using masking tape across the surface of the print. As such barbaric practices are concealed within the frame, the artist or collector is frequently unaware of the damage that has been done.

A primary purpose of a mat or frame is to safeguard the print against physical damage. Only materials of the highest quality should be used, and practices known to cause damage to fine paper should be studiously avoided.

The traditional window mat, hinged to a supporting board, remains the best protection for a print. Only 100

† See Zigrosser and Gaehde, *op. cit.*

per cent rag-fiber mat board should be used. Such board is made in one-ply, two-ply, and four-ply thicknesses. The weight of the board selected should be determined by the size of the print. Large prints can be provided adequate protection only if both the window sheet and backing are of four-ply board. Even for the smallest prints two-ply board is desirable.

If the print is designed with margins, the window of the mat is normally cut to a size slightly larger than that of the image; if the print is a "bleed print," a print without margins, the entire sheet of paper may be exposed, or floated, within the window of the mat. The size of the window is determined by the print. If the print has a margin, a portion of the margin should be allowed to show on all sides of the print, perhaps a bit more at the bottom where the artist's signature appears. Although the width of the mat is a matter of taste, it should in all cases be wide enough to provide the protection that is desired. The sharply cut edges of the window should be rubbed with fine sandpaper so as to eliminate all possibility of damage to the print.

The window sheet should be hinged to the backing sheet with gummed white linen tape. Brown gummed paper tape should be used only if the mat is to serve a purely temporary purpose. Self-adhesive tapes such as masking tape and Scotch tape should never be used for any purpose in the matting or framing of fine prints; all such tapes are likely to cause severe damage and permanent discoloration.

Even more critical are the materials used to fasten the

ARTIST: Paul Brach Tamarind No. 1507

TITLE: "Silver Series"
 Printed between November 23 and December 14, 1965 at the
 University of New Mexico Lithography Workshop under the super-
 vision of Garo Z. Antreasian.

A multi-color lithograph printed from three stones in four runs as follows:

NOTE: The main image of this lithograph consists of nine circles of
 graduated grey tones (progressing from dark to light) arranged
 equidistant in three rows of three circles each. One roller was
 used to apply the color in a _blended inking_ method for each row
 of grey circles. The circles were printed in two runs (runs #2
 and #3 below): two rollers were used in run #2, a different
 roller of blended greys to ink the top and bottom horizontal
 rows of circles; in run #3, one roller of blended greys was
 used to ink the middle horizontal row of circles.

1. Stone: light grey (Charbonnel Black, Hanco Black and Cover White).
 Execution: same stone as run #1 of Tamarind No. 1506.

2. Stone: six graduated greys (Charbonnel Black, Hanco Black, Leaf
 Brown, Cover White). Execution: Korn's Liquid Tusche applied
 with compass and brush.

3. Stone (same as run #2): three graduated greys (Charbonnel Black,
 Hanco Black, Leaf Brown, Cover White). Execution: same as run #2.

4. Stone: middle value blue grey. Execution: Korn's lithographic
 pencils #3, #4, and #5.

Paper size: 21" x 21" cut to hard edge bleed image after printing.

Record of printing:

1 Bon a Tirer on German Etching paper
1 UNM Impression on German Etching paper
4 trial proofs of which two are on Rives BFK and two are on German
 Etching paper
2 artist's proofs on Rives BFK
9 Tamarind Impressions on Rives BFK
20 artist's edition (numbered) on German Etching paper
No cancellation proof
 NOTE: Stone from run #1 was held for Tamarind No. 1508

All other proofs and impressions have been destroyed
The stones from runs #2, #3, and #4 have been effaced.

This lithograph bears the chop of printer-fellow John Beckley.

Artist:_____

Printer:_____

5.7 A typical Tamarind document sheet
See p. 180 for a reproduction of this lithograph

print to the backing sheet. Traditionally, small hinges made of Japanese paper have been used, with a vegetable or flour paste as the adhesive. The hinges should be weaker than the paper of the print, so that under stress the hinge will give way, not the print. Brown paper tape, cellulose tape, etc., should never be used in hinges, nor should adhesives such as rubber cement ever be employed.

In lieu of hinges, plastic flanges‡ may be employed. These flanges (which resemble the transparent tabs used for indexing file folders) are manufactured in strips. Only

‡ Plastic flanges may be purchased in twelve-inch lengths from E. Joseph Cossman, Dept. T, 12502 Milbank Street, Studio City, California 91604.

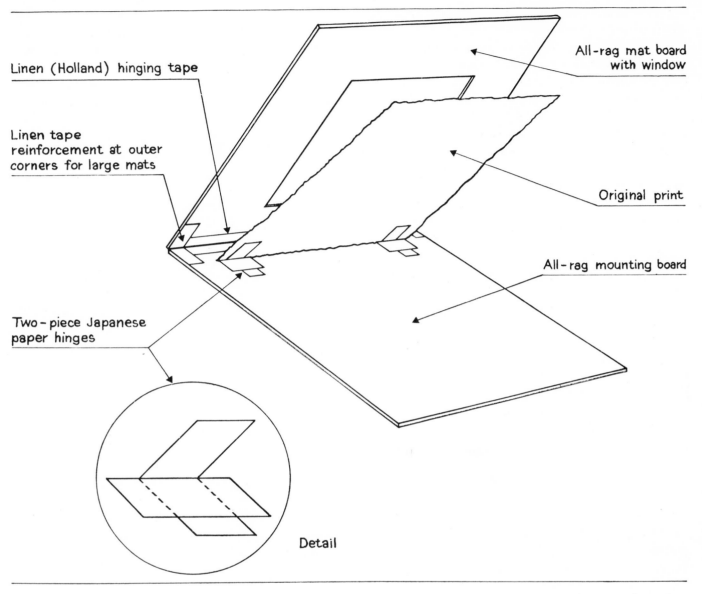

Linen (Holland) hinging tape

Linen tape reinforcement at outer corners for large mats

Two-piece Japanese paper hinges

All-rag mat board with window

Original print

All-rag mounting board

Detail

5.8 Technique for mounting prints

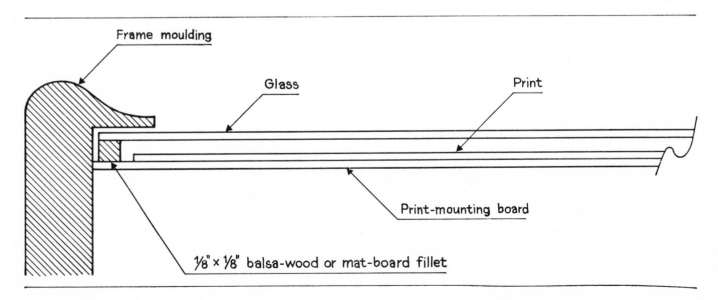

Frame moulding

Glass

Print

Print-mounting board

⅛" × ⅛" balsa-wood or mat-board fillet

5.9 Detail: Separating fillet between glass and print

the back of the flange, which touches the backing board, is coated with pressure-sensitive adhesive; nothing is fastened to the print itself. Small sections of the plastic, which can easily be cut with ordinary scissors, are slipped over the edges of the print and pressed in place against the backing board. The amount of plastic flange required depends upon the size and weight of the print. Use of flanges rather than hinges is strongly recommended for all prints on paper of normal weight, such as Arches or Rives; flanges should not be used on very thin or fragile papers, such as unmounted China and India papers, as there is danger of tearing.

For purely *temporary* mats in which the print will remain for a very limited period of time, it is justifiable to use mat board other than the 100 per cent rag board described above. For museum exhibitions, particularly juried exhibitions, artists will wish to construct mats of very heavy weight. Such mats may be made of ordinary mat board, hinged to heavy chipboard, with the print held in place by plastic flanges. Fine prints should never be permanently fastened to such temporary mats, nor should they ever be stored in them. Extended storage in a mat made of low-grade materials increases the dangers of foxing and mildew. Mat burn, a discoloration of the margin of the print caused by the acids in wood pulp boards, is also likely to occur.

The print without margins, the print in which the image is designed to fill the entire sheet of paper, presents special problems, particularly if it is large in size. Although such prints can be floated within a window mat, this solution may be satisfactory neither in terms of the protection afforded the print nor aesthetically. As an alternative such prints may be mounted with plastic flanges (or hinges) on a sheet of all-rag backing board and then enclosed in an envelope made of sheets of transparent acetate or Mylar (a trade name for polyethylene terephthalate). Such envelopes should not be made completely airtight, for moisture might then condense inside them, damaging the prints.

When prints are framed, new problems arise. Although the frame and its glass provide additional protection for the print, condensation of moisture is encouraged in humid climates, and the print when hung on a wall is directly exposed to light.

In all cases the print should be so framed that an air space separates it from the glass. If a window mat is used, the mat will serve to provide the needed separation; if a mat is not used, a strip of rag board or balsa wood can be inserted as a fillet all around the frame between the backing board and the glass. Fine prints should never be closely framed between two sheets of glass.

If the standard 100 per cent rag-fiber mat board does not provide the desired visual effect, there are several sound alternatives. Fabric-covered boards are excellent, so long as they are inert. Linen is popular; cotton and silk are also used. Burlap should be avoided since it contains active chemicals. If the cloth covering is applied to a sheet of chipboard (or comparable pulp board), care must be taken to isolate the back of the window from contact with the print. This can be done by inserting a sheet of one-ply rag board cut to the same pattern as the mat.

When materials of dubious quality are to be used in framing, the sound procedure is first to mat the print in an all-rag mat, then to place this mat inside a second mat of whatever materials may be desired for their visual effect.

The back of the frame should be sealed with tape in order to keep out dust. Framed prints should never be hung in direct sunlight, nor even in places where they will be exposed to excessive reflected daylight. Exposure to daylight and bright fluorescent light cause decomposition of the paper, resulting in embrittlement, and changes in color of both the paper and the color inks. If a print is to remain on the wall of a brightly lit room for extended periods of time, it is possible that a special Plexiglas should be substituted for glass: a Plexiglas (UF-1) which filters out the rays of ultraviolet light.

Plexiglas may, of course, be used in any frame. Its basic advantages are that it is unbreakable and that it weighs much less than glass—a considerable advantage when a very large print is to be framed. Its disadvantages are that its surface is easily scratched and that its electrostatic character causes it to attract dust, a deficiency that can be partially corrected through use of antistatic cloths or chemical solutions.

Above all, the artist—or collector—should be cautious in his dealings with commercial framers. Unless from prior experience he is certain that the framer will adhere to high professional standards, he should take adequate precautions. In case of doubt it is best first to place the print in a standard all-rag window mat, then to instruct the framer to build the frame and decorative mat around it.

Quick-change frames in standard sizes have much to recommend them. Whether made of metal, wood, or plastic, such frames make it easy to rotate prints for exhibition, either in standard mats or floated on backing boards. Rotation of prints in frames has several advantages: it provides an opportunity to remove dust, mold, and moisture from the inside of the frame, and it gives each print a chance to rest away from exposure to light.

Metal-plate Lithography

6.1 METAL PLATES IN LITHOGRAPHY

Mechanically grained zinc and aluminum sheets of relatively thin gauge have been used as printing surfaces since the earliest periods of lithography. The use of zinc is mentioned by Senefelder as early as 1818 and by numerous lithographers in England, France, and Germany shortly thereafter. Aluminum, the more recently discovered metal, was introduced to the printing trade in 1891. Although metal-plate lithography was practiced continuously, it did not achieve widespread popularity until the invention of the steam-driven rotary offset press in 1895. The rotary press, along with the metal lithographic plate, revolutionized the commercial printing industry and rapidly superseded the slower and more cumbersome process of flatbed printing from stone. Since that time metal-plate lithography has had far greater application in commercial lithography than in the hand printing of artists' lithographs; all subsequent improvements of plates, chemicals, and processing techniques have been initiated by the offset industry and patterned to assist commercial printing requirements.

Although much practiced in France and Great Britain, lithography on metal plates was never very popular among artists in the United States. Aside from brief activity in the 1930s, there was no serious exploration of metal plates for hand printing in this country until mid-century. It appears that technical knowledge was either unavailable or inadequate to provide the control found when working on stone. In consequence, few American lithographs printed from metal prior to 1960 are comparable in quality to those printed abroad at that time.

The need to perfect dependable metal-plate processes for hand printing was recognized from the very beginning of the Tamarind project. Because of the relative scarcity of fine-quality lithograph stone in the United States, it was reasoned that, unless substitute printing surfaces could be perfected, the future development of lithography for American artists would remain severely restricted. Fortunately, progress in plate technology has been quite rapid as a result of the concerted efforts of Tamarind personnel. Existing technical data compiled by research within the offset industry have also made possible a better understanding of fundamental plate chemistry and have provided for the introduction of improved materials and processes for hand printing.

Although the principles of metal-plate lithography are basically similar to those for stone lithography, they necessitate different procedures in drawing, processing, and printing. Drawings on metal must be chemically treated with solutions whose constituents are different from those for stone. The processed work is printed on the hand press in the same manner as with stone, although, since the metal plate is so thin, it must be elevated from the press bed by a stone or metal support in order to engage the scraper bar of the press. Impressions printed from metal plates also differ in subtle ways from those printed on stone because of differences in the granularity of metal and stone surfaces.

Zinc and aluminum plates fall into two categories: uncoated and coated. Uncoated plates are manufactured without surface treatment and have for many years been used successfully for hand printing. Plates are also manufactured with various types of surface coatings to improve water retention and image stability. A recent example is a ball-grained aluminum sub-base plate which has shown great promise for hand printing. Another type of coated plate, with photosensitized surface, is being used more and more by artists who incorporate photographic imagery in their work.

The demands of today's offset industry have virtually standardized the quality and manufacture of metal plates. Although many different grain structures and surface treatments are available, only a few are applicable for hand printing, and these few vary little from one supplier to the next.

Despite the general similarity of lithographic principles, there are many differences among the printing surfaces themselves: between metal plates and stone, between zinc and aluminum, and between plates that are coated and uncoated. These differences affect procedure, and they must be fully understood if the various problems of each printing surface are to be controlled effectively. A general description of these characteristics follows; additional information will be found in Part Two.

6.2 DIFFERENCES BETWEEN STONE AND METAL PLATES

Lithograph stones and metal plates differ in many ways:

1. Metal plates are easy to obtain, are modestly priced, and may be re-used a number of times if regrained.

2. Metal plates are lightweight, and, by virtue of their thinness, require little space for storage.

3. Processing materials are slightly more costly than those for stone, although plate preparation is neither more complex nor more time-consuming.

4. Metal plates, because of their different surface and chemical properties, permit the development of images that cannot be duplicated on stone. For example, wash drawings on zinc differ from those on stone. Hence, plates provide certain aesthetic characteristics uniquely their own.

5. Plates are useful as an adjunct to stone in the printing of color work. For example, certain images for a color print may be drawn on metal and others on stone. When stones are in short supply, the use of metal plates enables a greater number of printing projects to be carried forward simultaneously.

The major physical difference between the lithograph stone and the metal plate is the metal's lack of natural porosity. The reader should recall that lithographic formations on stone are dependent on (1) the stone's porosity, (2) the stone's grain, and (3) the ability of the gum and etch to repel the greasy image deposits applied to the stone and to form water-receptive, nonimage deposits firmly anchored within pores of the stone. This can be demonstrated by grinding an old image off a stone; a

layer of stone approximating the thickness of a metal plate may have to be removed before the surface is clean. It would seem, therefore, that an image penetrating a metal plate to the same extent might be expected to appear through the back of the plate. This is not the case; grease penetration on metal is so slight that the thin plate can be regrained and redrawn many times. Because of lack of porosity, both image deposits and gum-etch films on zinc and aluminum plates are less secure than on stone. If the chemical treatments are not executed properly, scumming and filling in of the image tend to occur.

The graining of metal plates compensates to some extent for their lack of porosity. The tooth produced serves to offer footholds for image and nonimage areas and increases the surface area of the plate. In this way the minute reservoirs of the grain permit retention of moisture films on the nonimage areas for longer periods of time than would otherwise be possible. Additionally, the graining of metal plates, as with stone, permits tonal gradations in drawing. Because the graining process is different from that for stone, plate grains are deeper, crisper, and more uniform, imparting a subtly different character to drawings done on metal.

Thus, the lithographic process on metal plates is more heavily dependent on grain characteristics than is stone lithography. Since image and nonimage deposits penetrate less and do not abundantly combine with the plate, they are dependent for foothold on the roughened surface of the plate. It may be generalized that the printing and nonprinting areas are chemically less definite and, therefore, are more easily subject to displacement. In consequence, greater care must be taken during every stage of metal-plate work in order to assure printing stability.

6.3 RELATIVE MERITS OF ZINC AND ALUMINUM

The merits of zinc and aluminum have been debated since their introduction to lithography. Each metal has had strong advocates, and excellent work has been produced over the years using both materials. From the practical viewpoint, there is little difference between the two metals in cost, outlay of processing materials, and ease of printing. It is safe to say that each type of plate when handled knowledgeably will perform equally well. The choice of whether to stock one or both types of plates and suitable processing materials for each is largely dependent on the objectives of the lithography shop. It might be advisable for school shops to stock only one metal in order to minimize cost and to avoid confusion

6.1 Magnified plate grain

Magnified section of a metal plate showing crisp grain and lack of porosity

6.2 Three views of the Patt plate-graining machine

With cover closed

With cover open

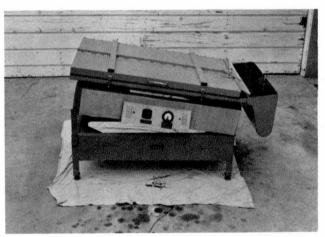

With tray tilted

a. The materials for counteretching metal plates

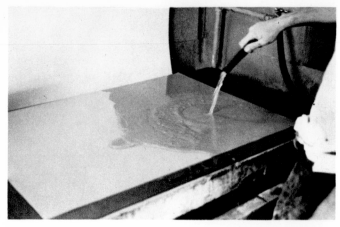

b. Flushing the plate with water

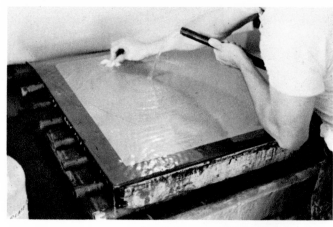

c. Scrubbing the plate with cotton swabs

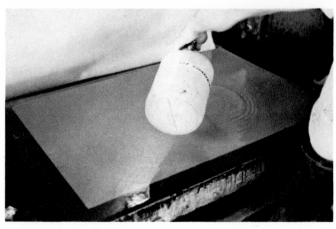

d. Applying the counteretch solution

e. Rocking the plate to distribute the solution

f. Hosing off the counteretch

6.3 Counteretching the metal plate

g. Blotting the plate with clean newsprint

h. Drying is hastened by rubbing the newsprint with the hand

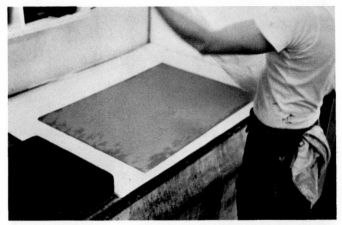

i. The partially dried plate

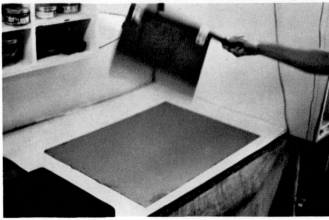

j. Fanning the plate completely dry

and contamination of the processing materials necessary for both types of plates. However, large professional shops should provide both metals when possible, so as to offer a greater choice of materials to the artist.

It should be noted that the increased use of standardized disposable aluminum plates by the offset industry has resulted in a sharp decline in the use of zinc plates. The reasons for this decline, while too numerous to mention, have seriously affected the plate-graining industry, whose services are gradually disappearing. It may well be that, within a few years, zinc plates and regraining services for zinc plates will no longer be commercially available. Although the future of zinc in hand lithography is indeterminate, its qualities will continue to hold strong attraction for artists. Hence, both zinc and aluminum will be discussed at length in this text. The following chart comparing the merits of the two metals will serve as a basic guide.

Zinc	Aluminum
Darker surface color, somewhat detrimental for close-valued tonal drawing. Crayon and wash drawings appear markedly different from those on stone.	Lighter surface color, easier to see the drawing of close tonal work. Crayon and wash drawings appear more nearly like those on stone.
Peau de crapaud wash techniques possible.	*Peau de crapaud* wash techniques not possible.
Inherently sensitive to grease.	Inherently less sensitive to grease.
Inherently less sensitive to water.	Inherently very sensitive to water.
Produces strong image areas.	Produces moderately strong image areas.
Produces less firm non-image areas.	Produces excellent non-image areas.
Easy to stabilize added work after counteretching.	Somewhat difficult to stabilize added work after counteretching.
Prone to scumming when printing, unless effectively desensitized.	Resistant to scumming when printing.
Moderately difficult to stabilize deleted work after processing.	Moderately easy to stabilize deleted work after processing.
Oxide films jeopardize effective desensitization.	Oxide films jeopardize effective desensitization.

6.4 ROBERT MOTHERWELL: *Automatism B.* 1964. Lithograph,
30 × 21 1/4″. University Art Museum, The University of New
Mexico, Albuquerque

6.4 PLATE SIZES AND GAUGES

Zinc and aluminum plates are supplied in many sizes and thicknesses to conform to the various types of commercial offset presses. Some plates have holes already punched along the front and back for fastening to small duplicating presses. Plates of this type are less desirable for hand printing, since the edges of the holes become bent in handling or are prone to accumulate ink during printing. Either plates should be purchased without holes or the hole strip should be trimmed off the plate with metal shears before drawing and processing.

The following plate sizes have been found to be the most practical for hand printing:

$15\frac{1}{2} \times 20\frac{1}{2}''$
$24 \times 34''$
$25\frac{1}{2} \times 36''$
$30 \times 42''$

The plate sizes should conform as closely as possible to the stone sizes in the shop, since the stones are sometimes used as plate supports on the press bed and processing table.

Metal plates are available in thicknesses varying from .015″ caliper for thick plates to .0035″ for thin. Zinc and uncoated aluminum plates of .010″ caliper are the most practical for hand printing because they can be regrained for use many times before being discarded. Coated aluminum plates are usually purchased in .012″ caliper and discarded rather than regrained after use; the price of new coated aluminum plates in this gauge is nearly the same as the cost of regraining.

Sometimes metal plates will curl during the process of hand printing. This is less a problem of plate thickness than of surface tension produced by graining the plate in one direction. Plate grainers can grain such plates on the reverse side, thus equalizing tension and lessening tendencies to curl.

6.5 GRAINING METAL PLATES

Zinc and aluminum plates are mechanically grained with abrasives and water in a power-driven oscillating machine containing steel marbles. The graining action produces a very even and crisply conical tooth on the plate surface; on this texture drawing characteristics are produced that are somewhat different from those of grained lithographic stones. Plates that have a medium grain (approximately 220 grit abrasive) are the most desirable for hand printing.

As stated before, the role of the plate grain on both zinc and aluminum is of even greater importance than on

stone. Because neither metal possesses the natural porosity of stone, the plate grain is essential in providing a physical foothold for drawing and processing chemicals. In addition, the fine tooth increases the surface area of metal plates for greater water retention.

Because of its importance, plate graining must be accomplished with great care and uniformity. When purchased, plates have already been grained by the manufacturer, using carefully regulated production-line techniques. Used plates are customarily regrained by professional plate grainers, using specially designed equipment to destroy the old printing image and to prepare a fresh plate surface. Graining plates with a hand levigator is not recommended because it is difficult to control uniformity from one plate to another. However, Tamarind has designed a relatively inexpensive plate-graining machine (fig. 6.2) that can surface plates efficiently and dependably in the workshop.* As the popularity of disposable plates in the offset industry continues to threaten the existence of commercial plate grainers, small plate-graining machines will become increasingly necessary for hand-printing lithography shops.

Procedures used at Tamarind for graining both zinc and aluminum plates are as follows:

1. All plates are grained with #220 aluminum oxide powder only. This abrasive (much softer than Carborundum) produces an excellent tooth for all varieties of drawing and also eliminates the need to clean the machine thoroughly. Such cleaning is needed when several different grits are employed.

2. The graining balls are standard industrial "soft-polished" steel balls (Benton A. Dixon Company, Los Angeles, see Appendix A). Quantities used in the machine are 150 pounds of balls $\frac{3}{4}$ inch in diameter and 50 pounds $\frac{1}{2}$ inch in diameter.

3. The graining-machine bed, ball hopper, and lid are hosed clean with water before graining begins. This removes graining sludge left over from the previous operation of the machine. The sludge, containing trisodium phosphate (TSP), is never removed from the machine at the end of a graining cycle; by coating the graining balls, it prevents them from rusting between cycles.

4. Plates to be regrained are washed with benzine to remove the old image and then are hosed with water to remove dust, gum, or other foreign matter. To avoid

*This machine was originally developed by the Tamarind staff, working in collaboration with Patt and Co., Los Angeles. Information about this machine may by obtained by addressing an inquiry to the Tamarind Institute, University of New Mexico, Albuquerque.

6.5 JACQUES LIPCHITZ: *The Bull and the Condor.* 1962.
Lithograph, 30 × 22". Tamarind Impression (T–627)

6.6 JUNE WAYNE: *At Last a Thousand II*. 1965. Lithograph, 24 × 34″. Tamarind Impression (T–1000B)

A four-color lithograph, three aluminum plates and one zinc plate. The last, the key image (printed in black) drawn with diluted tusche washes, shows characteristic *peau de crapaud* textures

chemical reaction, zinc plates should never be grained at the same time as aluminum plates. After insertion in the machine, they are clamped at the center of two opposite ends. The Tamarind plate grainer will hold one 30 × 40″ plate or two 24 × 34″ plates, or three plates 16 × 22″ or smaller.

5. The hopper is raised to release the graining balls into the machine bed, from which they are distributed evenly by hand to cover the plates completely. The hopper is then returned to its normal down position.

6. The appropriate amount of TSP and abrasive is sprinkled over the graining balls for the first cycle (see graining schedule, which follows). Two gallons of water are added, the lid is closed and locked, the timer is set, and the machine is started.

7. The machine stops automatically at the end of the first cycle, signaled by a buzzer. The lid is raised, and the indicated amount of TSP and abrasive for the second cycle is added to the mixture remaining from the first cycle (see graining schedule). Sufficient water is added to equal the original two gallons. (This can be determined by gauging the water level against the graining balls at the beginning of the first cycle.) The lid is lowered and locked; the timer is set for the second cycle; and the machine is started.

NOTE: Plates are grained in two short cycles instead of one long cycle in order to ensure suspension of the graining materials. Long cycles encourage the deposit of graining sludge on the plate surface; this produces dirty plates and lifeless grain.

8. When the buzzer signals the completion of the second cycle, the lid is raised and secured in position. The button is pressed to tilt the graining bed; simultaneously the machine is started again to begin the rotating motion o graining. This enables the graining balls to oscillate as they tumble into the hopper. To prevent scratching of the plate grain, the balls should not be permitted to roll or slide.

9. The machine is stopped when most of the marbles have dropped into the hopper. The plate clamps are released, and one plate is removed without washing. It is placed grained side up on a clean chipboard at the stone graining sink.

10. The sludge is hosed off the plate. Meanwhile the

6.7 DICK WRAY: *Untitled*. 1964. Lithograph, 29 × 41″. Tamarind Impression (T–972). And detail

Layers of diluted tusche were flowed on a zinc plate and hosed away with water before they were completely dry. The partially formed grease deposits account for the filmy character and peculiar granularity produced by this highly adventurous technique, which required considerable experimentation in order to produce predictable results

surface is scrubbed vigorously with a stiff, natural-bristle scrub brush to remove abrasive particles from the grain. The pattern of scrubbing should cover the plate systematically from side to side and top to bottom. The plate is then lifted and hosed to clean the reverse side. It is extremely important that all hosing and scrubbing be performed as rapidly as possible to deter the formation of surface oxides. Oxidation can begin as soon as the wet plate is exposed to air. (The plates remaining in the graining machine will not oxidize until hosed, because they are covered with TSP in the graining sludge.)

11. After final hosing, the plate is immediately placed face up on a previously prepared clean, flat surface. Clean sheets of newsprint are used to blot the surface completely dry. The time span of hosing, scrubbing, and drying should not exceed three to four minutes.

12. The dried plate can then be immediately drawn or it can be stored. If it is to be stored, its surface should be completely covered with a clean sheet of proofing paper taped to the reverse side. (See sec. 6.29.)

13. After the remaining plates in the grainer have been removed and cleaned individually, the machine should be hosed in preparation for the next cycle of grinding. If additional grinding is not to be done for at least twenty-four hours, the graining sludge should remain in the machine to prevent oxidation of the graining balls.

14. Normal maintenance of the graining machine is very simple. In addition to the usual hosing of the bed, hopper, and lid, sponging of the sides of the machine with water is required once a week. The worm screw located beneath and to the left of the hopper is cleaned of abrasive grit and lubricated with oil monthly, as are the shaft alleys for the rotating pads. These are located on the underside of the graining bed.

Graining Schedule for Metal Plates

Type of image on plate prior to graining	Trisodium phosphate		220 Aluminum oxide powder		Time to be set for graining cycle (variations in time are due to differences of image coverage)			
First Cycle					Less than 50% covered		50% or more covered	
	24×34" or smaller	larger than 24×34"	24×34" or smaller	larger than 24×34"	24×34" or smaller	larger than 24×34"	24×34" or smaller	larger than 24×34"
Heavy Image (Flats, solvent tusche, heavy crayoning, Korn's Autographic Ink, retransfer ink)	2—3 oz	3—4 oz	2—3 oz	3 oz	30—35 minutes	30—40 minutes	30—45 minutes	45 minutes
Light Image (Water washes, light and medium crayoning, pencils, rubbing ink, light spray)	2 oz	2—3 oz	2 oz	2—3 oz	30—35 minutes	30—40 minutes	30—45 minutes	45 minutes
Second Cycle								
Heavy Image (See above)	2 oz	2—3 oz	2 oz	2—3 oz	30 minutes	30—45 minutes	30—45 minutes	45 minutes
Light Image (See above)	1 1/2—2 oz	2 oz	1—2 oz	2—3 oz	15—30 minutes	30 minutes	30 minutes	30—45 minutes

6.6 COUNTERETCHING METAL PLATES

Unlike stones, freshly grained zinc or aluminum plates are usually sensitized by counteretching prior to drawing. Two exceptions are aluminum plates supplied with precoated surfaces and zinc plates processed by the Lozingot method. Counteretching removes surface oxides from zinc plates and sensitizes both zinc and aluminum so that they are especially receptive to fatty image deposits and desensitizing gum etches. The chemistry of counter-

6.8 PHILIP GUSTON: *Wash Shapes.* 1966. Lithograph, 22 × 30".
University Art Museum, The University of New Mexico, Albu-
querque

etching metal plates is given in sec. 9.14.

Procedures for counteretching are identical for zinc and aluminum plates, although the chemical ingredients in the counteretch solutions usually differ. A commercially prepared counteretch solution is preferred by some printers because of its reliability and ease of preparation. This material, Imperial Counter-Etch (Lithoplate Company, see Appendix A), is diluted, two ounces stock solution to one gallon of water for counteretching either zinc or aluminum plates. Equally satisfactory shop formulas that are easy to make are listed in order of preference:

Counteretch Solutions for Sensitizing Metal Plates

For Zinc		For Aluminum	
Hydrochloric acid (concentrated)	1 oz	Phosphoric acid 20 drops (85% syrupy)	
Water	1 gal	Potassium alum	3 oz
Nitric acid	1/4 oz	(water to make a saturated solution)	
Potassium alum	2 oz	Hydrochloric acid	
Water	32 oz	(concentrated) 1/2 oz	
(shake until dissolved)		Water	32 oz
Acetic acid (25%)	1 oz	Nitric acid	1 1/2 oz
Nitric acid	1 oz	Potassium alum	5 oz
Potassium alum	4 oz	Water	32 oz
Water	1 gal	Acetic acid (99%)	
			6 oz
		Water	1 gal

Ideally the plate should be placed in a shallow enameled etching tray for counteretching. In lieu of this, it may be placed on a large, clean sheet of cardboard or on a clean lithograph stone of the same size or slightly larger.

The plate is first rinsed thoroughly with clean water and scrubbed with several cotton wipes. When a wipe becomes soiled from the removal of oxide, it is replaced with a clean pad until the entire plate has been covered. The plate is again flooded with water and the counteretch solution is flowed over the entire surface. To ensure that the entire plate is cleaned evenly, the solution is applied a second time, rocking the etching tray gently. The quantity of solution used is not critical so long as it covers the plate generously. One or two minutes is sufficient to sensitize the metal; the plate is thoroughly rinsed again with water, drained, and fanned dry.

Counteretched plates should be dried as quickly as possible while being protected from dirt, dust, or other contamination. When possible, drying may be hastened by (1) draining the plate and then placing it in front of a fan, air jet, or heat lamp; or (2) by blotting the plate with clean sheets of newsprint after draining excess water.

Drawings should proceed immediately after the counteretched plate has dried, in order to minimize new formation of surface oxidation. Wrapping the plate with clean newsprint will best protect drawings which must be delayed or which require working periods of more than one day. As in all phases of metal-plate work, it is advisable to "close" or desensitize the finished drawings by etching as soon as possible. A minimum loss of time in counteretching, drawing, and etching of the plate is desirable. This does not imply that the drawing must be hastily executed in order to protect the plate. A thoughtful and efficient work schedule, however, can provide maximum security against oxidation or contact with chemical impurities detrimental to the performance of metal plates.

6.7 DRAWING ON METAL PLATES

The techniques for producing drawings are identical on zinc and aluminum plates unless otherwise noted. The materials are handled in much the same way as they are for stone; there is a considerable difference, however, in their "feel" against the metal surfaces. This difference is due to properties of the grained surface and the greater resiliency of the metal. As described earlier, these characteristics, though seemingly secondary, play an important role in the visual appearance of the completed drawing and its printed impression.

From the outset of drawing, it is well to remember that metal plates are more attractive to grease than stone is; therefore greater caution is required in handling as well as in drawing. Clean plates that have been counteretched should be carried from underneath or wrapped in clean newsprint for protection. Contact of the hands with the plate surface should be avoided. Drawing areas should be clean and dust-free, and the surface on which the plate is placed for drawing should be smooth and free from bumps and irregularities. The thinness of the plate will allow surface imperfections from beneath to be picked up in the drawing; on occasion this is utilized to produce specific surface characteristics in the work. The plate is usually placed on clean newsprint on the table or drawing board or laid on a clean lithograph stone. If desired, the plate may be taped to a drawing board and supported vertically on an easel, to provide a working arrangement similar to that for painting.

Both metals are darker than most stones. The tonal

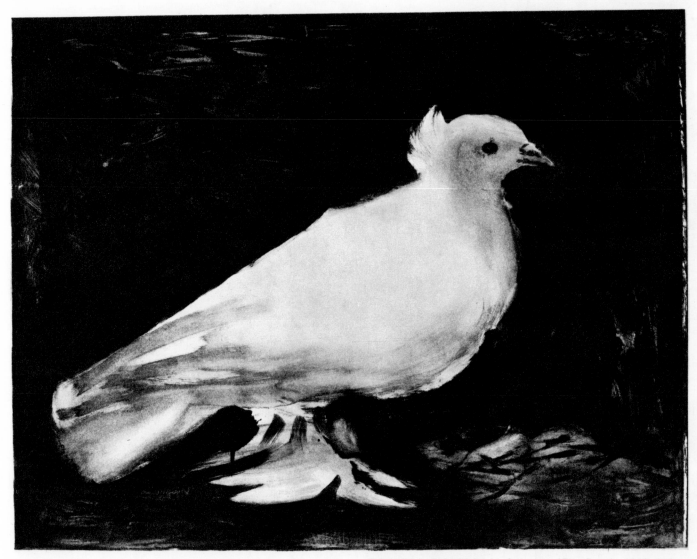

6.9 PABLO PICASSO: *La Colombe* (*The Dove*). 1949. Lithograph, 21 × 27 1/2". The Art Institute of Chicago. The Clarence Buckingham Collection

A magnificently controlled example of delicate tusche washes and bold scumbles executed on a zinc plate. Some of the washes have been further weakened by solvent removal and acid biting, enabling the white areas to stand out vividly against the dark background

6.10 PABLO PICASSO: *David and Bathsheba,* after Cranach the Elder, 1st state. 1947. Lithograph, 25 1/4 × 19 1/4". The Art Institute of Chicago

This, and the example on the opposite page, are but two of ten states in which the image, originally drawn on zinc with pen and wash, has been radically transformed by Picasso

6.11 PABLO PICASSO : *David and Bathsheba,* 4th state. 1947.
Lithograph, 25 1/4 × 19 1/4". The Art Institute of Chicago

In this state, the composition has been entirely re-covered with
ink and re-drawn with a sharply pointed tool

scale of the drawing should be adjusted with this in mind; otherwise the undrawn areas of the plate will provide excessive contrast when the work is printed on white paper. There is a greater tendency for this to occur in working on zinc, since zinc is the darker of the two metals.

Drawing traces, margins, and preliminary register marks are indicated with red conté crayon, chalk, or sanguine powder. The drawing should be positioned on the plate with a minimum margin of 1½″ on each end and at least 1″ along the sides to ensure safe engagement of the scraper bar of the press. Smaller tolerances can be troublesome during the printing, as will be more fully noted later. Lead pencil is sometimes used to indicate permanent register marks, since it contains sufficient fatty material to produce a firm printing mark.

6.8 CRAYON DRAWINGS

All grades of lithograph pencil and crayon perform satisfactorily on metal plates. Because the plates are more grease-attractive than stone, a given grade of crayon will take more readily and print more heavily than on stone. For example, a #4 crayon on metal will provide characteristics similar to those of a #3 crayon on stone. For this reason, it is advisable to use slightly harder crayons on metal plates than on stones. It is seldom necessary to work with crayons softer than #1; and, when using rubbing crayons, it is safer to rely on the hard or medium grades. The softer grades of crayon will slip more on metal. They have a greater tendency to clog the grain of the plate; hence, tonalities will pile up.

It sometimes happens that, in piling up, the crayon produces rich, smoky clots. When the work is etched and rolled up, these appear disappointingly weak or ghostly. It would seem that the heavy areas of grease had not taken well on the plate and were washed away during the processing. This condition results from the following causes: the first crayon strokes slip on the surface and fill the top grains of the plate without reaching the valleys in between; subsequent strokes piled on top increase the tonality and impart a rich visual appearance. When the work is etched and washed out, the valleys between the grains are exposed, but, never having received the crayon, they cannot accept ink. The tonal range of the drawing is thus reduced by at least 50 per cent. This problem most often occurs when softer grades of crayon are used and is most troublesome when temperatures are warm (which softens the crayon) or when drawing strokes are made too rapidly (which facilitates slippage).

6.9 TUSCHE SOLIDS AND SCUMBLES

The simplest forms of tusche work are (1) flat solid areas and (2) fine lines with full-strength solutions. An excellent material for this type of work is Korn's Autographic Tusche. If desired, other types of tusche may be used, provided that their consistency is free-flowing and that they are of maximum fatty concentration. (See sec. 1.12.)

Full-strength tusche is also used to create scumbled (dry-brushed) passages of dark broken texture. Paste or stick-type tusche, ground in distilled water or solvent to a viscous consistency, is applied to the plate with stiff bristle brushes. A variety of tonal gradations can be produced, depending on the dryness of the scumble and the amount of tusche carried by the brush. The stiffness of the brush bristles, the length and suppleness of the hairs, and the speed of the strokes are the controlling factors for this method of work. Spatters, drips, and stipples are other variations of fundamental approaches using full-strength tusches.

6.10 TUSCHE WASHES

The techniques and materials for drawing tusche washes on metal plates are essentially the same as for stone. Behavioral characteristics are somewhat different, however, and demand more precise controls for dependable results. Differences are largely due to (1) the dissimilar physical and chemical properties of the metals and of stone, (2) the configuration of the grained surfaces, and (3) the function of their respective etches. These matters, because of their complexity, are discussed in detail in a separate section devoted to the mechanics and chemical behavior of tusche washes on stone and metal plates. (See sec. 9.4.) Both artist and printer should undertake a series of test plates, as described therein, to familiarize themselves with the various aspects of tusche-wash behavior.

6.11 PEAU DE CRAPAUD

An interesting phenomenon may be observed when very fluid water-tusche washes are placed on a zinc plate. Instead of lying smooth when dried, the tone will appear granulated and broken into dots and linear scrawls quite different from washes applied on stone or aluminum plates. This singular visual effect is called *peau de crapaud* by French lithographers, or, literally, "skin of a toad"

a. Placing tracing tissue under the key drawing

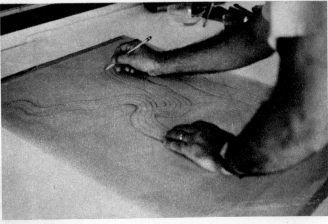

b. Tracing the drawing

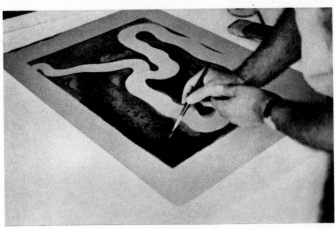

c. Drawing the image with tusche washes

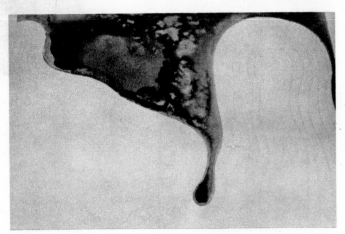

d. Detail of the tusche wash

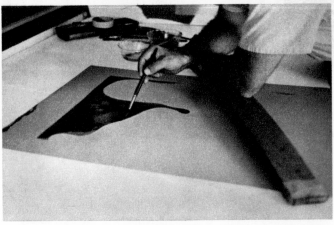

e. Completing the background areas

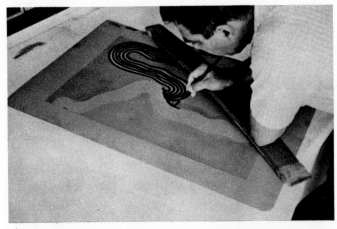

f. The linear elements are drawn with full-strength tusche

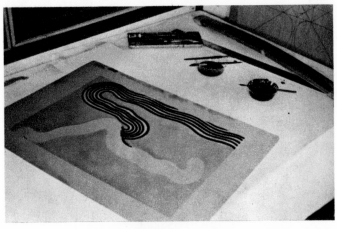

g. The partially drawn image and the drawing materials

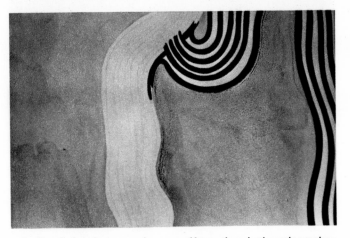

h. Detail showing *peau de crapaud* formations in the pale washes

6.12 Drawing on a metal plate

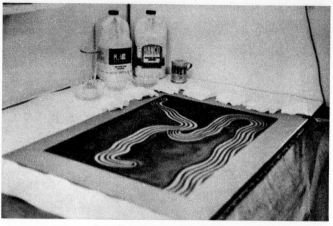

a. The finished drawing and processing chemicals

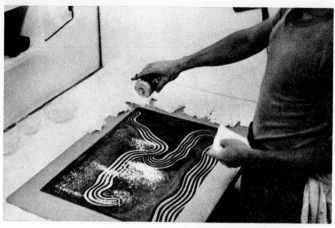

b. Dusting the plate with talc

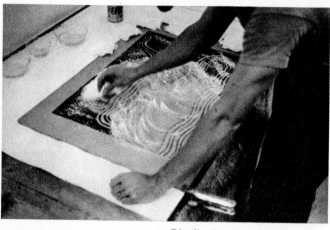

c. Distributing the talc with cotton

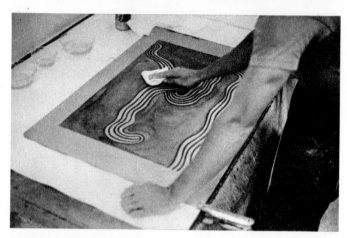

d. Buffing the talc

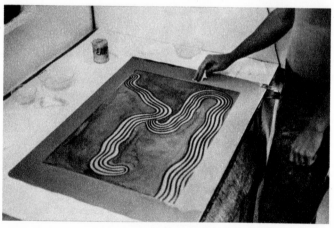

e. Protecting the borders of the plate with gum

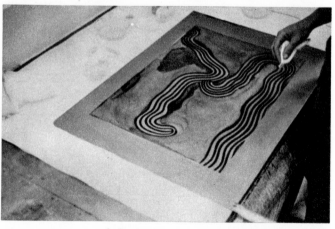

f. Protecting the pale tints with gum puddles

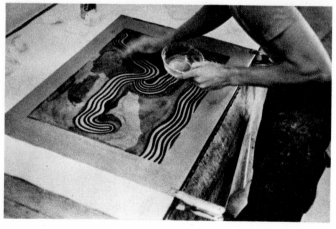

g. Applying the etch

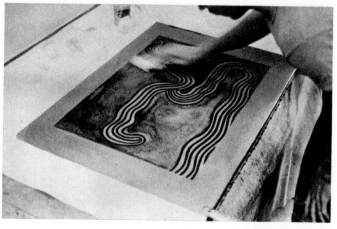

h. Drying the etch

6.13 Processing a zinc plate

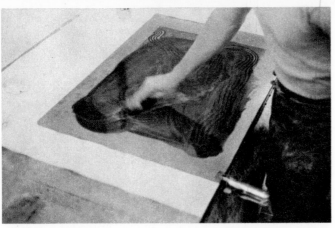

i. Washing out the image with lithotine

j. The image completely washed out

k. Applying Triple Ink

l. Distributing the Triple Ink

m. Fanning dry the Triple Ink

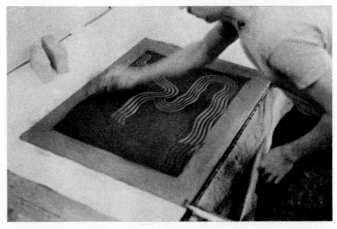

n. Removing the etch film and Triple Ink with water

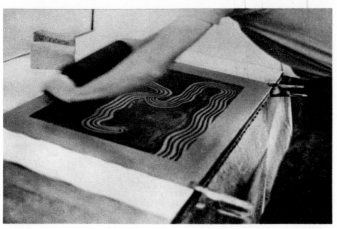

o. Rolling up the image

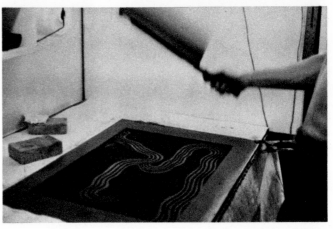

p. Fanning the plate dry

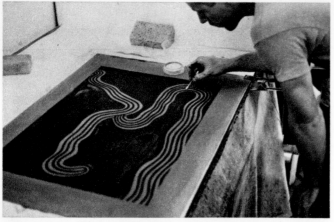

q. Removing blemishes with plate cleaner

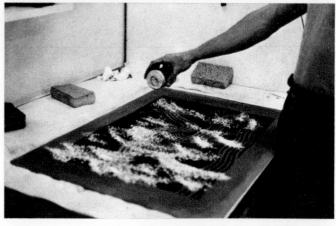

r. Applying talc to the inked plate

s. Buffing the talc

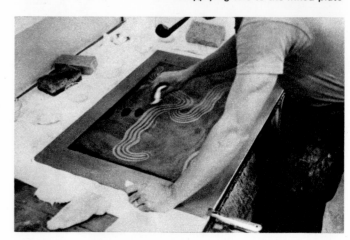

t. Spot-etching the plate

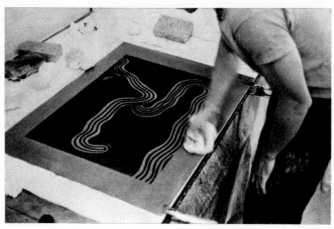

u. Wiping down the etch film

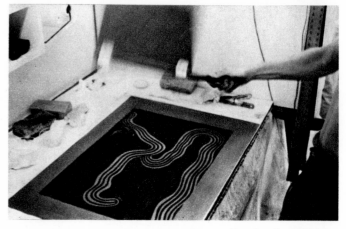

v. Fanning the plate dry

(which it closely resembles). The condition, peculiar to zinc, is the result of the plate surface's oxidizing in the presence of oxygen and the water of the tusche wash. The greater the water content of the wash puddle and the slower its drying time, the more magnified will plate corrosion be. The fatty particles of the wash tend to gather in the fissures of the corroded surface to produce unusual organic patterns. *Peau de crapaud* is a controllable process that has been utilized by many artists to produce extremely intriguing and luminous imagery.

There are several techniques for control of *peau de crapaud* washes. Sand may be sprinkled on the plate as a bordering agent, either before or during the application of the wash. In this way the solution can be localized within desirable boundaries. After the wash has dried, the sand is carefully brushed away; because of its inertness it will not affect the printability of the plate. Additional control of particle flow and of corrosion can be achieved by using an air jet or hair dryer to hasten the drying of the water film.

Finished plates containing *peau de crapaud* must be carefully processed in order to prevent scumming when

printed. Standard etching procedures are followed by a very careful wiping of the etch and gum solutions in order to secure tight desensitizing bonds. Additionally, the roll-up should be somewhat lean, for there is a tendency for the organically clustered grease particles to fill in. It is sometimes necessary to use a fountain solution as a scum deterrent when printing this type of plate. (See sec. 6.27.)

6.12 LITHOTINE TUSCHE WASHES

Stick or paste tusche can be used to make tusche washes with lithotine or other solvents. Test plates should be made for these, following the guidelines specified for water-tusche dilutions (see sec. 9.4). Acceptable gradations will not conform to the same dilutions as water tusche. Weaker dilutions are necessary because of the greasier nature of solvent-tusche suspensions. The reticulation of drying tusche washes will be lessened considerably, if not completely, owing to the greater viscosity of the solvent vehicles. Hence the halo effect is less a characteristic of this type of wash. It is conceivable that both water and solvent tusches could be incorporated in the same work in order to utilize the advantages of each, but this hardly seems necessary for most works.

Mottled effects produced by flowing water tusche into a film of lithotine or by flowing lithotine tusche into a film of water are as easily created as when working on stone. These present no problem during processing or printing; one is cautioned to make sure, however, that the tusche film is completely dry before processing begins.

6.13 GUM AND ETCH MASKS

Borders and parts of the drawing on metal plates can be masked by gumming or etching in the same way as when working on stone. Gum arabic solutions are usually used for masking out crayon work. Imperial Hydrogum 14° Baumé, a commercially prepared mesquite gum, is excellent for this purpose because it is less viscous than other gums and dries fast. Thin, sharp lines and contours are easy to draw with this type of gum. Cellulose gum and gum arabic also work satisfactorily.

Only tusches of the solvent type should be employed when masking is required. In such cases cellulose gum, hydrogum, or standard plate etches are used as the masking fluid in order to secure more complete desensitization. The gum or etch film should be thoroughly dry before additional work proceeds. Masking out by spattering or by dragging gum films across the plate is also feasible. It should be noted that heavy coatings prohibit subsequent drawing, particularly fluid washes, from lying in close contact with their contour. The washes are thrown away from these raised coatings, forming a light aureole around each formation. This aureole is sometimes utilized as an expressive device within the work.

6.14 ASPHALTUM SOLIDS

Solid flat areas can be produced on either zinc or aluminum plates by using asphaltum. The procedure is the same as when working on stone. The liquid is evenly wiped and dried over the plate surface, which has previously been masked out with gum to preserve the whites. The dried plate is washed with water to release the gum mask, after which ink is applied over the asphaltum until a solid black has been achieved. The plate is dried, cleaned, dusted with talc, and given the standard etch followed by gumming. Solids of this type are easy to produce and are useful for black-and-white printing as well as color.

6.15 PROCESSING DRAWINGS ON METAL PLATES

Drawings on zinc and aluminum plates are processed in an identical manner, similar to that for stone, but with different types of desensitizing etches. The chemistry of metal-plate desensitization is detailed in sec. 9.14.

Briefly, the steps of processing are as follows:

1. The finished drawing is dusted with talc, given the first etch, and dried.

2. The etch is removed with water, and the plate is gummed and dried.

NOTE: It is important for the etching and gumming to follow as separate steps; also each solution must be wiped dry into a thin, streakless film. This procedure ensures maximum film adsorption, which is necessary for effective plate desensitization.

3. The drawing is washed out with lithotine through the dried gum coating.

4. A plate base (Triple Ink or asphaltum) is applied.

5. The plate base is washed off with water, and the plate is carefully rolled up with ink.

6. Minor corrections are undertaken.

7. The plate is dusted with talc, given a second etch, and dried.

8. The etch is removed with water, the plate is

gummed and dried; it may now be stored or moved to the press for proofing.

Gum arabic and cellulose gum are the basic desensitizers for zinc and aluminum plates. Either performs satisfactorily on zinc plates, although cellulose-gum films show a slight superiority in moisture retention. Gum arabic, however, is preferable for aluminum plates. Plate etches are composed of one of these gums plus phosphoric acid and various inorganic salts, which serve as buffering agents. The range of acidity in etching solutions used for metal plates is relatively limited in comparison with stone. Overly acidic etches are harmful. In view of the critical sensitivity of the metal plates to the etching solutions, measurements of acidity are taken on the pH scale rather than in drops per volume. (The role of pH in lithographic solutions is fully described in Part Two; see sec. 9.9.) The recommended pH of pure gum solutions is 5.5; the acidity of zinc-plate etches should vary from pH 5.0 (for weak etches) to pH 2.5 (for strong etches). By comparison, aluminum-plate etches are slightly more acidic and range from pH 4.0 (for weak etches) to pH 1.8 (for strong etches).

The volume of etch solution to be used is determined by the size of the plate. Plates up to $16 \times 20''$ require a minimum of one ounce of gum or etch solution, those up to $26 \times 36''$ require two ounces; larger plates may require three ounces of solution.

Because metal-plate etches have a restricted amount of acidity, they are controlled either by dilution of their contents with gum or by timed application. Some printers prefer using strong etches applied for short periods of time; others prefer weaker etches applied for longer periods. Simple drawings are usually etched with a single application of solution for a given length of time. Complex drawings with highly variable grease content require localized spot etching with several strengths of etch applied for different lengths of time. Typical formulas of zinc- and aluminum-plate etches and gumming solutions are listed on the following pages, after which more specific procedures for plate processing are described.

6.16 ETCHES FOR ZINC

There are various formulas for zinc-plate etches. These contain gum arabic or cellulose gum, modified with other chemicals to achieve proper acidity. In all cases, plates are gummed after etching with cellulose gum or pure gum arabic solutions in order to form tighter adsorption bonds.

Two commercial plate etches are especially commendable for processing zinc plates, because of their dependability and ease of preparation. These are MS-448 Hanco Cellulose Gum Solution of pH 4.0 to 4.5 (used for weak etches and for gumming) and MS-571 Hanco Cellulose Gum (Acidified) pH 2.5 (used for strong etches). Both materials are currently used at Tamarind as all-purpose processing etches. For printers desiring to make their own etches, the following are traditionally reliable zinc-plate etches that can easily be hand-mixed in the shop. General characteristics are given after each formula as a guide for selection.

Cellulose Gum (Plain) pH 5.5

CMC 71 (powdered)	212 grams
Water	4000 cc
Phenol	7.5 cc
(See 10.2 for mixing procedures)	

This formula is used as a weak etch or to gum plates whenever stronger etching solutions are not required. It is similar to Hanco Pure Cellulose Gum #448 (though less acidified). Applied in the same manner as gum arabic, it should be buffed to a thin, dry film.

Gum Arabic (Acidified) pH 4.0

Gum arabic	16 oz
Tannic acid	2 oz
Phosphoric acid—85% syrupy	10 drops

This slightly acidified gum arabic solution can be used as a weak etch or for applications in which pure gum arabic or cellulose gum are employed.

Cellulose Gum (Acidified) pH 4.0 to 4.5

Cellulose gum (plain)	pH 5.5
Phosphoric acid, 85% syrupy	
Add small amounts of the acid to lower the pH to 4.0 or 4.5.	

This solution may be used as a mild first etch for transfer and very weak images. It can also be used as an excellent scum deterrent or to fortify plates on the press whose etch barriers are beginning to deteriorate. Greater amounts of acid, lowering the pH to 2.5, will make a strong etch comparable to MS-571 Hanco Cellulose Gum (Acidified).

Green Etch pH 3.0
(Graphic Arts Technical Foundation)

Water	40 oz
Tannic acid, technical grade	2 1/2 oz
Potassium chrome alum	3 3/4 oz
Phosphoric acid, 85% syrupy	1 1/4 oz
Gum arabic solution (14° Baumé)	80 oz

Dissolve the tannic acid in the water first, then add the chrome alum and stir until completely dissolved before adding the phosphoric acid. Finally, add the gum arabic solution and mix thoroughly. The finished etch should have a pH value of around 3.0. If this is too strong to put down on fine crayon tints or washes, reduce the amount of acid or double the amount of gum used.

Because the potassium chrome alum is sensitive to light, this solution should be kept in an amber glass bottle. Upon drying, this etch will rapidly form a tough insoluble desensitizing film. After a few days, the solution will turn green. This does no harm; in fact, it seems to act more gently. Straight gum arabic is used for gumming the plate after the etch is rinsed off.

White Etch pH 3.5 to 4.5

Ammonium nitrate	3 oz
Ammonium phosphate	3 oz
Ammonium fluoride	1/2 oz
Calcium chloride	1/2 oz

Dissolve into one pint of water for twelve hours and strain into one gallon of gum arabic (14° Baumé). This etch is somewhat comparable in quality and working properties to the green etch.

6.17 ETCHES FOR ALUMINUM

Etch formulas for aluminum plates are usually simpler than for zinc, being basically composed of phosphoric acid and gum arabic. After etching, aluminum plates should be gummed with pure gum arabic.

NOTE: Cellulose gum is not advisable for aluminum-plate processing because it creates a pit-type corrosion on the plate surface.

The simplest aluminum-plate etch formulas are known in the lithographic industry as 1:32 etches, i.e., 1 part phosphoric acid to 32 parts gum arabic. These are very easy to formulate by proportionate measurement, for example, 1 cc to 32 cc, 1 oz to 32 oz, 1qt to 32 qt, etc. If too strong, the solution can be reduced proportionately: 1 part acid to 64 parts gum arabic, etc. The following are formulas that have a specific pH concentration:

Ba # 11 pH 1.8

Phosphoric acid, 85% syrypy	20 cc
Ammonium nitrate	11.5 grams
Gum arabic (14° Baumé)	1000 cc

Ba # 10 pH 2.0

Phosphoric acid, 85% syrupy	31 cc
Gum arabic (14° Baumé)	1000 cc

Ba # 13 pH 3.0

Phosphoric acid, 85% syrupy	2 oz
Gum arabic (14° Baumé)	1 gal

At Tamarind, a variant procedure is used to mix a stock aluminum-plate etching solution:

Tamarind Stock Solution pH 2.5

Phosphoric acid, 85% syrupy	2-1/2 oz
Gum arabic (14° Baumé)	3/4 gal

Small additional amounts of the acid or gum may be added until the pH of the solution is 2.5. This serves as a stock solution from which stronger or weaker etches can be formulated, when needed, by adding acid or gum arabic. Although the stock solution can be stored indefinitely, its pH should be checked periodically and readjusted when necessary.

Another aluminum-plate etch used at Tamarind with excellent results is # 54 Pro-Sol Fountain Solution.[†] This proprietary material is an ammonium bichromate etch which is very easy to apply and which can also be used as a scum deterrent (1 oz Pro-Sol, 1 oz gum arabic, 1 gal water). (See sec. 6.19.)

6.18 PRINTING BASES ON METAL PLATES

The image on the plate is subject to wearing away through abrasion during the printing process. Thus, it is desirable to fortify the image. A tough protective film receptive to the fatty particles of the image and to the printing ink as well protects the image on the bare plate so that the metal never comes into direct contact with the ink or the roller. Films that function in this way are called *printing bases.*

An equally important function of printing bases is to protect the image on the bare metal from "water burn." This condition is most likely to occur during the washout

† Manufacturer: Polychrome Corporation. See Appendix A.

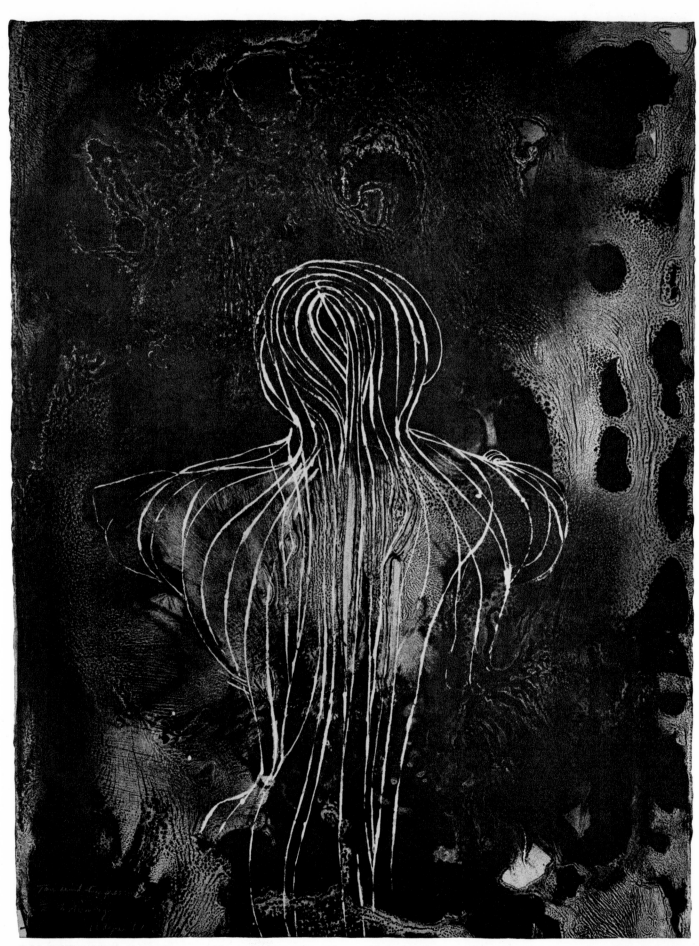

6.14 JUNE WAYNE: *Tenth Memory*. 1961. Lithograph, 30×22″.
Tamarind Impression (T–365)

The white lines in this print from a zinc plate were formed by
biting the inked surface with caustic lye drawn with a toothpick
instead of a brush

stage, either during the etching process or just prior to printing. During the washout, the solvent removes the drawing materials or ink film from the gummed plate and leaves the metal exposed with only a very thin film of insoluble adsorbed grease clinging to its surface. Then the water sponge is passed over the surface, lifting the gum mask and dampening the plate surface to receive the ink. It is at this point that the greatest risk to the image occurs. In some cases an almost instantaneous oxidation is thought to take place when the water comes in contact with the exposed image: the adsorbed grease film is damaged; the plate surface is permanently altered; and the inking becomes imperfect. Inasmuch as water burn occurs at one time and not another, it is still unknown whether it is brought about by impurities in the water or by simple contact of the water in the presence of oxygen on the exposed plate surface. Whatever the reason, protecting the bare metal image with a printing base immediately after the washout provides a barrier that prevents direct contact of water and metal surface.

Asphaltum is sometimes used as an effective printing base. It has several disadvantages, however. First, its high ink receptivity tends to subject the image to a very rapid roll-up of ink; there is an ever-present danger of overinking and filling the image. Zinc plates, because of their grease-loving characteristics, are particularly sensitive to this condition. Second, asphaltum, because of its dark color, tends to strike through very transparent light-color inks and discolor the printed impression.

Commercially prepared printing bases are now available that perform excellently without the disadvantages previously associated with asphaltum. Some of these are composed of vinyl acetate or other synthetic resins that form tough lacquerlike films (see sec. 15.18). Upon drying, these films are virtually water-insoluble and are very ink-receptive.

NOTE: These bases can also be used for drawing solids and linear work, somewhat like tusche.

Other bases are mixtures of ink, gum arabic, and solvents, which are applied to the plate as thin water-resistant and ink-receptive films for black-and-white printing. One standard material of this type is Imperial Triple Ink, which has been used effectively for both zinc and aluminum plate work at Tamarind for several years. Printing bases of this type are formulated to be lean in grease content and, in this capacity, offer the greatest control during the roll-up. Additional control can be gained by thinning Triple Ink with lithotine to the consistency of light cream. This further reduces the grease content and is particularly recommended for very sensitive drawings.

An effective procedure for color printing is to apply a thin film of color ink which has been reduced with litho-

tine, instead of using a prepared printing base. This will give maximum assurance of clean printing color without the danger of strike-through of a dark-colored printing base. This procedure is recommended only for the printing phase, after the plate has been effectively processed with a regular printing base.

Most printing bases are applied using the same techniques. After the first etching and gumming, the dried plate is washed out with lithotine. The image is then carefully wiped with a thin, even layer of the printing base. Very soft cloth pads or cotton wipes should be used for this purpose so as not to damage the plate. After the printing base has been fanned dry, the plate is washed with sponge and water, which dissolves the gum coating and throws off the printing base from the nonprinting areas. In this condition, the clean, dampened plate has a tough ink-receptive surface over the image areas, ready to receive ink fully and evenly.

6.19 ETCHING PROCEDURE—THE FIRST ETCH

The finished plate to be etched is brought to the etching table and placed on a clean sheet of heavy paper, a lithograph stone, or a plate support. Whatever the underlying surface, it must offer a true and unyielding support in order to allow an even roll-up when inking.

Some printers prefer to secure the plate to the edge of the table with spring clamps positioned at the outer corners of the margin. Others prefer supports that elevate the plate surface above the etching table because of the greater cleanliness and control offered during etching and inking.

The drawing is carefully dusted with a cotton swab charged with talc. It is important that the talc form intimate contact with the drawing; hence, excess talc is wiped off and a gentle polishing action is exerted on the remainder until it has virtually fused with the drawing. Heavily applied tusche drawings (because they remain tacky) should be gently dusted rather than polished, so as not to smear the work.

NOTE: In view of the milder acidity of the etches, rosin is generally not employed as an etch resist on zinc and aluminum plates.

Zinc-plate desensitizers having cellulose gum are much more viscous than those made with gum arabic. Etches of this type must be applied rather thinly; heavy applications will react with the plate and alter its surface. This occurrence is signaled by discolored streaks where the sharp tooth of the grain has been eroded. Scumming often occurs along these streaks during printing.

The etch solution is flowed over the plate with the gentle gliding action of a brush, a small sponge, or cotton pads (Webril Wipes). Most printers prefer to use the sponge or cotton pads for etching plates, believing that the etching action is more evenly distributed and that there is less chance for displacement of the greasy particles of the drawing. When several strengths of etch are being used on one plate, each should be carried by a separate applicator. Since effervescence will not occur, as it does when etching stone, the printer must rely on the predetermined pH of the etch and the duration of its application to ensure effective desensitization. It should be remembered that the first etch must ensure total conversion of the fatty drawing constituents and simultaneous desensitization of the nonimage areas of the plate. The strength of the etch and the duration of its application will depend on the type of etch used, the character of the drawing, and whether the plate is zinc or aluminum. The following tables give generalized relationships of etch strength and duration of application for simple types of drawings. In view of the countless variables of drawing and processing, each printer should perfect his own etch tables following the guidelines shown.

Etch Table for Zinc Plates

Etches used: MS-448 Hanco Cellulose Gum Solution and MS-571 Hanco Cellulose Gum (Acidified)

Type of Drawing	Proportion of Etch	Duration, in minutes
Light crayon, #5, #4	50% pure gum arabic 50% MS-448	1 1/2—2
Medium crayon, #4, #3	100% MS-448	2
Dark crayon, #1, #0	50% MS-448 50% MS-571	2
Rubbing crayon	75% MS-448 25% MS-571	2
Full-strength solids and lines (tusche)	90% MS-448 10% MS-571	1 1/2—2
Light washes (water tusche)	100% MS-448	1 1/2—2
Light washes (solvent tusche)	85% MS-448 15% MS-571	2
Medium washes (water tusche)	75% MS-448 25% MS-571	2
Medium washes (solvent tusche)	60% MS-448 40% MS-571	2
Dark washes (water tusche)	50% MS-448 50% MS-571	2—2 1/2
Dark washes (solvent tusche)	40% MS-448 60% MS-571	2 1/2—3

Drawings that have great variations of grease deposited in different locations should be etched locally with several solutions of different pH, applied for varying lengths of time. As with drawings on stone, the palest areas are protected with pools of pure cellulose gum or gum arabic before acidified solutions are applied for short periods. Heavier concentrations of grease are etched for longer periods with more acidified etches. Etches that are to remain on the plate for the longest period of time are applied first and followed by etches of successively shorter duration. Localized etching should be manipulated so that the completion of the last solution applied will coincide with the correct duration for all the other solutions. Unless the etching schedule is carefully calculated beforehand, the technique, maneuverability, and effectiveness of local etching will be unsuccessful.

An example of timed localized etching on zinc is described for a mixed-media drawing. Three separate etch solutions are used: (1) pure gum arabic, (2) MS-571 Cellulose Gum, and (3) 50 per cent MS-448 and 50 per cent MS-571 Cellulose Gum (Acidified).

Localized Drawing Technique	Etching Solution	Duration
Autographic tusche solids	50% solution I 50% solution II	15 sec.
Medium and heavy crayon	100% solution II	15 sec.
Dark gray brush marks (water tusche)	100% solution III	1 1/2 min.
Offset "found" objects (transfer ink)	100% solution III	45 sec.

1. Pure gum arabic is applied over the tusche solids.

2. The tusche brushed areas are etched with solution III.

3. After 45 seconds the areas containing "found" objects are etched with solution III.

4. After 15 seconds the gum arabic-covered solids are etched with solution II.

5. After 15 seconds the crayon areas are etched with solution II.

6. After 15 seconds the entire plate is wiped dry.

Etches shown in this table can also be used for timed, localized processing of aluminum plates, using techniques

Etch Table for Aluminum Plates

Etch used : Stock solution, gum arabic/phosphoric acid pH 2.5 and pure gum arabic pH 4.0

Type of Drawing	Proportion of Etch	Duration
Light crayon, #5, #4	75% gum arabic 25% stock slution	30—45 sec
Medium crayon #4, #3	50% gum arabic 50% stock solution	30—45 sec
Dark crayon #1, #0	100% stock solution	1 min
Rubbing crayon	25% gum arabic 75% stock solution	45 sec 1/2—1 min
Full-strength solids and lines (tusche)	75% gum arabic 25% stock solution	30—45 sec
Light washes (water tusche)	50% gum arabic 50% stock solution	30—45 sec
Light washes (solvent tusche)	75% gum arabic 25% stock solution	30—45 sec
Medium washes (water tusche)	50% gum arabic 50% stock solution	45—60 sec
Medium washes (solvent tusche)	25% gum arabic 75% stock solution	1—2 min
Dark washes (water tusche)	100% stock solution	1—2 min
Dark washes (solvent tusche)	100% stock solution or 100% pH 2.0	1—2 min 30—45 sec

described for zinc plates.

The procedure for etching aluminum plates with #54 Pro-Sol Fountain Solution is:

1. Mix 50 per cent Pro-Sol Fountain Solution with 50 per cent pure gum arabic 14° Baumé (1 to 1½ oz of each, depending on plate size).

2. Liquid drawing materials (Autographic Tusche and tusche washes) should be thoroughly dry before processing; otherwise they are likely to dissolve and weaken when subjected to this particular type of etch.

3. Apply the etch liberally with a soft brush or sponge; because of the thinness of the solution, do not use absorbent cotton wipes. The darkest passages of the image are usually etched first, but there is little need to favor particularly strong or weak passages. Although the duration of application is less important than it is for other etches, the entire volume of the solution should be used.

After etching, zinc and aluminum plates are wiped to a smooth and moderately thin, dry film. It should be noted that wiping cloths wear out much faster when working with metal plates, for they tend to catch and tear on the sharp corners of the plates. They should be replaced with fresh cloths whenever necessary, in order to dry the etch and gum coatings smoothly. The dried etch is removed with sponge and water.

NOTE: Plates etched with Pro-Sol solution are dried for 15–20 minutes before washing with Kimwipes (paper cloths) and water, to prevent smearing softened drawing materials. Excess water is removed with a soft sponge, and the plate is gummed while still damp. In order to prevent oxidation from water burn, the plate should not be permitted to dry before the gum is applied. Zinc plates are gummed with either pure gum arabic or cellulose gum; aluminum plates are gummed with pure gum arabic only. The gum is wiped to a thin, smooth, dry film. The plate with the dried-gum coating is now ready for the washout, roll-up, and second etch.

6.20 THE WASHOUT, THE ROLL-UP, AND THE SECOND ETCH

Washing out and rolling up the plate may proceed as soon as the gumming that follows the first etch is completely dry. Here again, the procedure is similar to that used when processing stone. Lithotine is sprinkled on the plate and the drawing is carefully dissolved, using a clean rag or a cotton pad. Water must not make contact with the plate at this time or it will dissolve the gum mask, permitting the greasy residue of the drawing to affix itself in unwanted areas. Worse, it may produce water burn. Triple Ink, or other appropriate printing base, is applied to the plate and dried to a smooth film. At this stage the plate should be lifted (if not clamped to the etching table), and its supporting base should be lightly sponged with water. The plate is then slid onto the support in such a manner that suction will be created to hold it securely while it is rolled with ink. The plate surface is washed with sponge and water to remove the dried gum and excess printing base. From this time until the image is fully inked, the plate surface must be kept damp. Less water is necessary to maintain moisture control than is needed in stone processing. This difference is due to the nature of plate-desensitizing films and to the crisper grain structure of the metal surface.

The image is rolled up on the dampened plate using stiff roll-up ink. Much less ink is used on the ink slab and roller than for inking stone work. Moreover, it is sound practice to scrape the roller lightly to remove previously accumulated ink before processing metal plates. As the roll-up proceeds, ink is added when necessary. The inking should develop more slowly than for stone, because

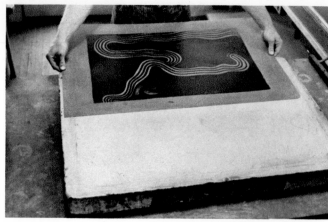

a. Dampening the plate support

b. Sliding on the plate

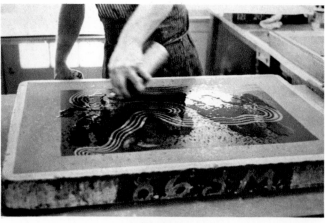

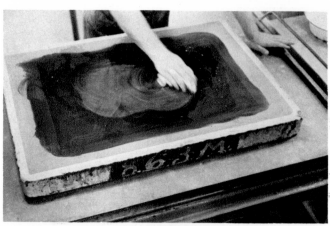

c. Washing out the image with lithotine

d. Removing the residue of the wash-out with a cloth pad

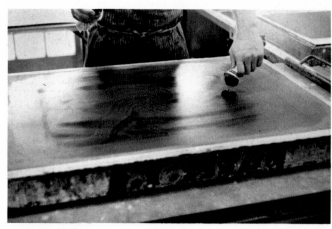

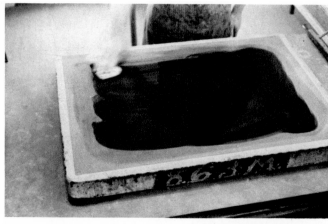

e. Applying Triple Ink

f. Distributing the Triple Ink

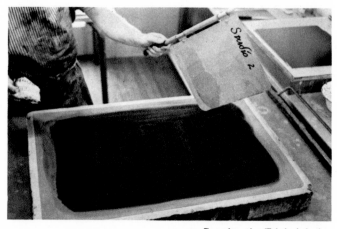

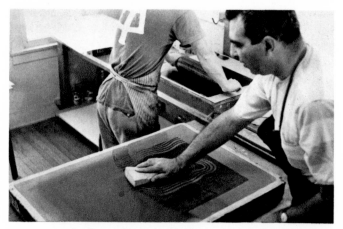

g. Fanning the Triple Ink dry

h. Removing the etch film and Triple Ink with water

6.15 Proofing and printing metal plates

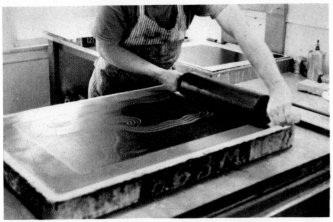

i. Rolling up the image with ink

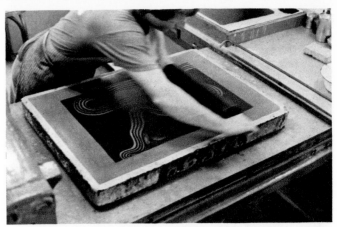

j. Reversing the inking pattern

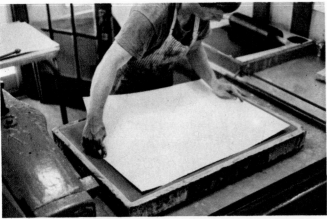

k. Positioning the proof paper

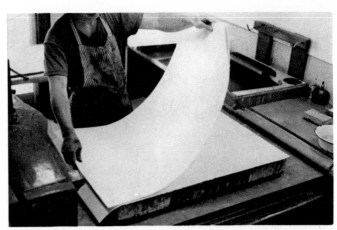

l. Positioning the backing sheets

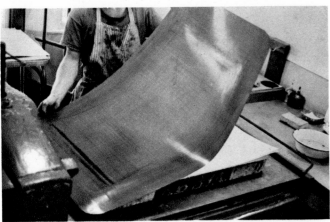

m. Positioning the tympan

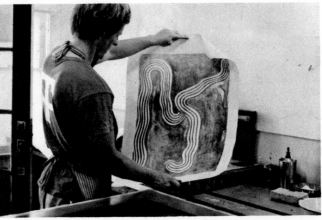

n. Examining the first proof impression

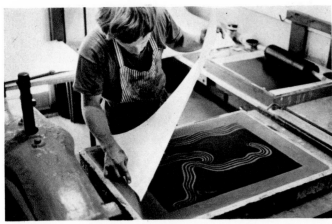

o. Aligning fine edition paper to the center-line mark

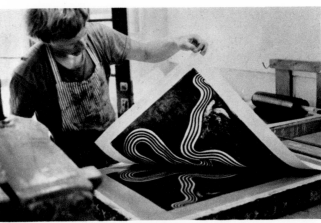

p. Removing a fully inked impression

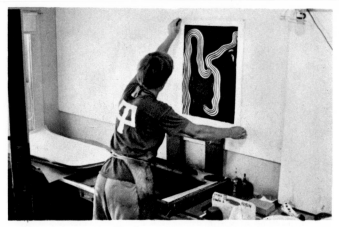

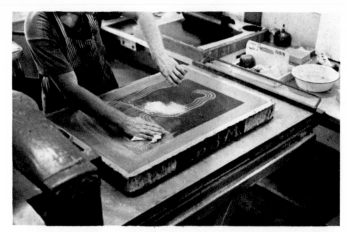

q. The impression is pinned up for examination

r. Following the printing or proofing session, the plate is dusted with talc prior to gumming and storage

of the greater sensitivity of metal-plate images. Rolling should begin with a brisk, light touch, gradually increasing downward pressure where needed to interpret the darkest passages. Care must be taken not to overload any area. The fully inked image is fanned dry, and the work is inspected for minor corrections. (Corrective procedures are described in a later topic.) After corrections have been made, the plate is dusted with talc, as before, and the second etch is applied.

The second etch is generally applied in the same manner and for the same duration as the first etch, unless special circumstances during the roll-up suggest the need for stronger or weaker solutions. However, there is less leeway for compensation by the second etch than there is when working on stone. The major contribution of the second etch on metal plates is toward additionally fortifying the adsorbed gum film deposited by the first etch. After the etch is wiped dry, it is washed off with water; pure cellulose gum or gum arabic is applied to the damp plate and wiped dry. In this condition the plate may be removed to the press for immediate proofing, or it may be stored for printing at another time.

6.21 CORRECTIONS ON METAL PLATES

Corrections of the image on metal plates are often necessary (1) during the process of drawing, (2) between the first and second etch, and (3) after printed impressions have been proofed, following the second etch. As with stone, deletion should be done separately and before the addition of new work. This sequence is both efficient and reliable.

The basic differences between zinc and aluminum (the former being essentially a grease-loving material and the latter water-loving) have important bearing on the corrective processes. It is relatively easy to add work on

zinc, but difficult to remove it once it has been established. There is a greater tendency for deleted areas to return or to scum during the course of printing. The opposite is true for aluminum: it is difficult to add work on this metal once it has been etched, although the removal of work is relatively easy. One's choice of metal plate will therefore determine the type of corrections that can be made safely.

An equally important matter affecting corrective processes is the relationship of the image and nonimage areas to the plate grain. Unlike those on stone, these areas are only "skin deep," and depend almost entirely on crisp grain structure to form secure footholds on the plate surface. The more the plate grain is deformed by the corrective processes of scraping, scratching, and polishing, the less secure will be the establishment of new work. As the physical and chemical demarcation between image and nonimage areas diminishes, there is greater opportunity for their displacement during the course of printing. Hence, the processes of deletion, whenever possible, should minimize the physical abrasion of the plate grain, particularly if new work is to be added over the deleted areas.

Thus, corrective processes, although feasible for metal plates, are somewhat more limiting than those on stone, and greater care is necessary for their successful execution. One must keep the basic properties of the two metals clearly in mind in order to take advantage of their assets and to minimize those functions which are clearly a liability.

6.22 CORRECTING DRAWINGS BEFORE THE FIRST ETCH

Portions of drawings may be removed and replaced with fresh work relatively easily on both zinc and alu-

minum plates before the first etch. The usual procedure is to remove all residual grease particles from the areas requiring change with rather powerful grease solvents that have a reasonably rapid rate of evaporation. Benzine, gasoline, and lactol spirits (in order of preference) work satisfactorily for this purpose.

The solvent should be applied carefully to the parts of the drawing that are to be deleted, without permitting it to creep onto surrounding areas. The techniques of application will depend on the ingenuity of the artist and the nature of the deletion. Various brushes or tiny tufts of cotton wrapped around a thin stick are the usual instruments for carrying the solvent. Application of the solvent is immediately followed by blotting with clean cotton or blotting paper, to prevent the solution from spreading. This process is repeated a number of times, until all visible traces of the drawing have disappeared. The number of applications will depend on the nature of the work to be removed. The removal of crayon and light tonal work is relatively easy compared with tusche drawings, particularly of the solvent type. Numerous applications of solvent may be necessary to lift all traces of the latter from the lower crevices of the plate grain.

Corrective drawing with crayon or tusche may proceed over the deleted area as soon as the solvent has evaporated. If new work replaces the old, it is less important that the deletion be completely free of residual grease. As long as the additions are appreciably fattier, they will overcome the minute remainder. However, if new work is not to be added where the deletion has been made, then all traces of grease must be removed if it is to print clean.

6.23 CORRECTIONS BETWEEN THE FIRST AND SECOND ETCH

Only the simplest and most obvious corrections should be made between the first and second etches. All other deletions or additions should be delayed until the plate has been proofed, so that they can be more readily assessed from the printed impressions.

This type of correction is begun immediately after the washout and roll-up, when the image is fully charged with ink. Procedures are the same for zinc as for aluminum. The plate is dried and dusted with talc; the talc is lightly polished into the ink film. The deletions are done first. These may involve extensive cleaning of the plate margins or minor removal of parts of the image. Whenever possible, removal should be with solvents, following procedures described in the preceding section. Inasmuch

as ink, rather than drawing materials, is to be removed, a solvent superior to those previously described is preferable. Lithpaco Plate Cleaner (Lithoplate Company), a thick white liquid composed of solvents, pumice powder, whiting, and diatomaceous earth, is a commercial preparation designed especially for this purpose. (See Appendix A.) The Plate Cleaner is applied with brush, cotton swab, or pointed stick; being heavy, it remains localized and does not spread.

Occasionally, it becomes necessary to remove work by honing. Rubber hones (Weldon Roberts Retouch Transfer Sticks) are best for this purpose, being least injurious to the plate surface. They are sharpened to desirable shape and are used like erasers to remove ink. One must continually turn a new face of the hone to the work in order to prevent smudging and dragging ink into unwanted areas. Honing can proceed on either the dampened or dry plate surface.

Shaving or scraping with blades may also be done sparingly at this stage if one is certain of intention. Corrections of this type should be clean and crisp.

All residue from solvent, honing, or scraping must be thoroughly cleaned from the plate surface with sponge and water, after which the plate is dried. If additions are not made at this time, the plate is given the second etch in the customary way.

Additions to the image are made only after the residue of deletion has been removed. Only full-strength solids and heavy tonal passages can be added at this stage without counteretching. These should be applied with Korn's Autographic Tusche or one of the other tusches used full strength. If applied rather firmly, soft grades of lithographic crayon may also be used.

The plate is again dusted with talc after all corrections have been completed and dried. It is given the second etch following the usual procedures; after gumming and drying, it is ready for proofing or storage.

6.24 CORRECTIONS AFTER THE SECOND ETCH AND PROOFING

Major corrections on lithographic images are usually made after a series of trial proofs has been printed. The extent of necessary corrections can be more readily determined from a printed impression than from a plate, and the establishment of image and nonimage areas is more secure after the plate has received the second etch. In such condition, the plate can withstand major alterations with less risk to its printing stability.

DELETION MATERIALS AND PROCEDURES

Materials used for deletions include abrasives, hones, scrapers, liquid solvents, and caustic agents. Each material works in a different manner, and a certain amount of experience is necessary to determine suitability for particular types of work.

ABRASIVES

Fine pumice powder can be used, wet or dry, to remove portions of an inked drawing by abrasive action. The material is applied with a small glass or metal grinding disc; in addition to removing or lightening the work, the abrasive imparts fresh tooth to the plate grain. A pen-type airbrush and pumice powder can accomplish more complex deletions. This instrument can totally delete work or lighten tonal passages, leaving extremely smooth gradations.

HONES

In addition to the rubber hones mentioned, Scotch hones may be used, as when working on stone. Although the hones reduce or remove the grain of the plate, the surface will probably remain sufficiently rough to hold desensitizing etches. However, it is not advisable to add work over such areas, since counteretching salts would be less securely attached on the deformed grain. This type of honing is best confined to total removal of work, such as cleaning margins and small areas within the image.

The softer rubber hones are often used for partial removal of work. When used skillfully, they can remove grease from the tops of the plate grain without disturbing deposits in the valleys. By reducing the total surface area of each ink dot and etching the exposed grain, they yield a tone that will print as a lighter value. This process is somewhat risky to image stability because of increased chance of scumming.

SOLVENTS

Lithpaco Plate Cleaner‡ (see under topic 6.23) is the preferred solvent for totally removing parts of a drawing. The contours of hard-edge drawings are cleaned with Lithpaco Plate Cleaner in the following way:

1. Clear, pressure-sensitive contact paper is applied over a previously inked image that has been dusted with talc and gummed dry.

2. The areas to be deleted are exposed by carefully cutting and peeling away the contact paper with a razor blade.

‡ Inasmuch as this material removes adsorbed gum films as well as grease deposits, all areas contacted must be re-etched and gummed.

3. The Plate Cleaner is applied; when dry, the powdery residue is washed off with distilled water, and the work is dried.

4. The deleted area is etched with MS-571 cellulose gum (acidified) for zinc or gum arabic/phosphoric acid pH 2.5 for aluminum.

5. After the etch is dry, the remaining contact paper mask can be carefully peeled off.

6. The entire plate is gummed and dried; it is then ready for the press.

Benzine is another useful solvent for the removal of simple open work. Either solvent may be used on zinc or aluminum.

CAUSTIC REMOVAL

Parts of the image can be totally dissolved with caustic agents, as long as these are not injurious to the metal. A saturated solution of caustic potash (household lye) is used on zinc plates, and concentrated sulphuric acid is used on aluminum. (The use of sulphuric acid is discouraged on zinc plates because it accelerates decomposition of the metal.) Both substances are highly corrosive and require utmost care in handling. They should be dispensed from a glass container and deposited on the plate with a glass-bristled brush, cotton swabs, or pointed sticks. Rubber gloves should be worn for protection. Caustic solutions are removed from the plate with sponge and water or with blotting paper; care must be taken against dripping or spattering.

The areas to be removed are first dusted with talc and then treated with the caustic solution; the solution is permitted to remain for a few minutes before it is blotted off. Several applications may be necessary for heavy work. Removal may be hastened by gentle rubbing with the sponge, taking care not to touch surrounding areas. The cleaned metal is then thoroughly washed, dried, dusted with talc, and etched or counteretched in the usual way.

NOTE: Continuous or overly liberal applications of caustic solutions can damage the plate grain and, in severe instances, weaken the base metal.

Oxalic acid is another caustic material that can be used to remove work. It is applied in saturated solution, as are lye and sulphuric acid. It can also be used in crystalline form by sprinkling the plate; a dampened sheet of newsprint is carefully laid over the granules, moistening them, and permitting them to bite the work. Biting time may be several minutes to several hours, depending on the grease content involved. The result is a textural pattern of white spots corresponding to the positioning of the particles. The granules are sponged off the plate with water, and the exposed areas are etched and gummed.

SHAVING AND PICKING

Parts of a drawing may be altered in shape or value by shaving and picking with various types of blades and points. As with stone, the fatty particles of the drawing are delicately shaved; this exposes clean metal on top of each grain. Tones can be lightened by dividing image dots with steel-pointed instruments. In both cases the deletions should be crisply made, so as to offer clean physical definition between image and nonimage areas. In this way, the desensitizing etch can obtain maximum foothold. The bared areas can then be etched to repel ink.

Deletions by scratching are not advised for metal plates. The fine lines thus produced begin to clog with ink after only a few impressions are taken. The work eventually prints like an intaglio plate, showing black lines instead of white. This is more a mechanical problem than a failure of desensitization. Even though the narrow walls of the lines are fully desensitized, they cannot resist the resiliency of the roller as it passes over them, leaving ink in their crevices. Once forced in, the ink becomes very difficult to remove and collects increasingly with each pass of the roller.

ETCHING AFTER DELETIONS

Procedures for etching deleted work will vary, depending on the nature and extent of the deletion. Small areas should be locally spot-etched (with solutions of pH 3.0 for zinc and pH 2.0 for aluminum). Large areas may require that the entire plate be etched. Zinc and aluminum plates are etched in the same way, using standard procedures for each metal. (See secs. 6.15 through 6.17.)

Areas of total deletion, from which only small amounts of grease were removed, may usually be etched with one application of solution moved over the area for approximately two minutes and then dried. Areas which contain heavy grease concentrations or which require partial removal of work may require repeated applications of etch for periods of up to three minutes. The etch should always be wiped or fanned dry before the plate is washed off with water and gummed. After the gum has dried, the plate may either be stored or washed out and rolled up with ink for resumption of proofing.

ADDITIONS OF WORK

Counteretch solutions for resensitizing metal plates to add new work are different from those used for sensitizing before the original drawing is made. (See sec. 6.6.) However, application procedures are identical for zinc or aluminum.

The simplest type of added work consists of minor

Counteretch Solutions for Resensitizing Metal Plates

For Zinc		For Aluminum	
Nitric acid	10 drops	Nitric acid	24 drops
Distilled water	3 oz	Phosphoric acid (85% syrupy)	30 drops
		Acetic acid (glacial)	1 oz
		Potassium alum (distilled water to make saturated solution)	3 oz

touching up with crayon, such as for repairing broken lines, darkening existing passages, or pulling together tonal imbalances. Areas of this type, which are sufficiently isolated and not too numerous, should be counteretched locally. For numerous generalized corrections, the entire plate should be sensitized.

NOTE: It is assumed that all corrective *deletions* have already been made and have been etched and dried.

The gum is washed from the plate with water; after drying, the image is dusted with talc. For localized application the counteretch solution is applied with a small brush or cotton swab; it is permitted to stand for approximately two to three minutes and then lifted with a dry cotton swab or blotting paper. The corrective drawing can proceed after the counteretched area has been washed with distilled water and dried. Drawing procedures are the same as those for the original work, although some practice may be necessary to match the tones of the surrounding areas. Medium grades of crayons and pencils offer the greatest control for this type of correction. The completed plate is again dusted with talc and is locally etched over areas containing the new work. The entire plate is etched if it has been completely resensitized for correction.

The etching solution depends on the nature of the added grease deposits. Weak grease deposits are etched with dilute solutions of the standard etch for each metal; in some cases only cellulose gum or gum arabic is used. Heavy grease deposits require full concentrations of etch. Localized etching usually requires several applications and blottings of solution, whereas over-all etching can be accomplished with one application (because a greater volume of fluid is involved). Etches are thoroughly dried before being washed off and gummed, to obtain maximum plate desensitization. Afterwards, the plate can be washed out and rolled up for continued proofing, or it may be stored.

Localized additions of tusche washes are much easier to control if positioned on undrawn areas of the plate or

over areas that have been totally deleted by a solvent. In either area, the original plate grain will have retained its crisp definition. Sensitizing and desensitizing procedures for this type of work remain the same as before.

The addition of work over existing tusche washes is somewhat more hazardous. Washes to be touched up or only slightly altered without appreciable change in their quality or tonal range should be carefully modified with rubbing crayon. Diluted tusche washes can be applied over existing pale washes if total tonal and visual configuration is to be altered. Considerable experience is necessary to achieve desired values, and there is always danger that the entire area will become clogged with excessive fatty particles and will print black.

Wash drawings that have been corrected by retouching with rubbing crayon should be etched with half-strength solutions, whereas washes corrected with additional tusche applications should receive full-strength etch. Counteretching and etching procedures are the same as those previously described.

A final corrective approach may consist of a major reworking of the image with crayon and tusche. Because this is not a touch-up procedure, there is less concern about matching the tonalities of the existing drawing. Moreover, it is easier to achieve an over-all continuity of image tonality at this stage. Although the work may print darker than anticipated, it will be consistent throughout. Etching procedures for this type of work should be identical with those used for processing the original state.

6.25 PROOFING AND PRINTING METAL PLATES

The basic procedures for proofing and printing metal plates are the same as for stone; the only difference is that the plate must be sufficiently elevated above the press bed to engage the scraper bar. The use of plate supports for this purpose is described in sec. 6.26.

The behavioral characteristics of plates during printing are somewhat different from those of stone, because of their basic chemistry. Since the physical and chemical demarcation between the image and nonimage barriers is more tenuous, metal plates require somewhat more sensitivity and skill on the part of the printer to maintain stability throughout the edition. There is a greater tendency for zinc plates to scum or fill in. Although aluminum plates may also scum, the condition is easier to overcome. It sometimes occurs that the image on aluminum plates will gradually weaken and refuse to accept full charges of ink. Because of the intrinsic water-loving nature of the plate, this is an indication that the greasy image formation is being overcome or displaced. This sometimes occurs if the sub-base coating ruptures through physical abrasion or chemical impurity. Once the coating is ruptured, very little can be done to save the plate.

It will be found that, given reasonable care and sound procedures, the metal plates will produce excellent results. In general they are easier to ink and require less moisture for dampening than stone. Once the plate is printing satisfactorily, it is advisable to complete the edition without delay. Delays that require that the plate be gummed and washed out complicate procedure; if poorly executed, these measures can endanger the plate's stability and performance.

6.26 PLATE SUPPORTS

Metal plates must be elevated on a firm base to engage the scraper bar of the hand press. Lithograph stones of various sizes have been used by many printers for this purpose. Commercial hand printers of the past, who produced a great volume of metal-plate work, employed removable iron bed plates on their presses, instead of stones, in order to accommodate the various sizes of plates in their shops. These plates, about two and one-half inches high, had a smoothly planed face and slightly beveled edges. Larger bed plates were cast with supporting ribs beneath, in order to withstand the heavy press pressure necessary for large works. The advantages of the metal bed plate were the ease with which it was kept clean and the greater structural strength it had, obviating risk of cracking under pressure. Today metal bed plates are no longer manufactured. However, anyone considering a good deal of metal-plate printing would do well to have several supports of different sizes fashioned for this purpose. The fabricator should be informed that it is essential for the support to have a true and smooth plane; otherwise it will be useless for the task. A new material that has been recently utilized for this purpose is Benelex, a synthetic and highly compressed Masonite substance about two inches thick, which is used in the machinists' trade for making dies. Benelex bed plates are better if covered with sheet metal; otherwise acid etches have a tendency to chew up their fibrous surface. Laminated plywood bed plates are not satisfactory, owing to the uneven density of their laminations, which are unable to withstand press pressure dependably.

Ideally, the bed plate should be the same size as the metal plate to be printed. It can be larger, and in cases where the paper to be printed is larger than the printing

plate, this can be an advantage for placing registration marks outside the plate. It should never be smaller than the printing plate, for the plate will be creased under pressure wherever it hangs over its support.

The printing plate is held to its support through suction. This is accomplished by sponging the support with water and slipping the plate on with a sliding motion. The contact is so intimate that even under the slightest pressure the plate will stay immobile and permit continued inking and printing for long periods. Some printers dampen the bed plate with a little gum arabic instead of water, in order to provide an even more viscous bond. The printing plate is easily removed by prying up one corner with the finger nail or blade edge, permitting air to break the suction and release the plate.

A common error of the novice is to apply the water film on the support too liberally. When the plate is printed, the pressure squeezes the excess water out from under its edges onto the print paper and backing sheet, ruining both. To remedy this problem the printing plate is removed, and excess moisture is blotted before printing is resumed. Similarly, excess water should not be employed when dampening the printing plate for inking, for this too will creep under the edge of the plate and then be squeezed back out under pressure.

When work extends nearly to a plate's edge, the plate must be printed on a larger bed plate. The margins of the printing paper extend beyond the printing plate and are registered on the bed plate. It becomes necessary for the scraper bar to engage the immediate leading edge of the printing plate and to traverse completely past its trailing edge in order to secure the total impression. Since pressure must be maintained all the way to the plate edges, there is every likelihood that some moisture will be squeezed out from under to soil the margins of the impression. This may be partly remedied by drying the moisture film in a one-inch strip beneath the leading and trailing edges of the printing plate. In addition, strips of clean newsprint may be placed along both plate edges after the image is inked and just before the printing paper is laid down. These serve as blotting foils, to protect the margins of the impression from receiving squeezed-out moisture.

A second problem will be detected in printing under these circumstances. The margins of the impression will carry an indentation of the plate edge at the beginning of the print and at its ending. If the scraper bar and printing paper also are wider than the plate, the indentations will appear on all four sides, resembling the characteristic plate marks of intaglio prints. There is nothing that can be done to avoid such marks, except to plan future work in such a way that the scraper bar will begin and end its engagement on the plate. The image should be planned to provide sufficient margins for printing paper smaller than the dimensions of the plate.

6.27 SCUMMING AND FILLING IN METAL-PLATE PRINTING

Perhaps the most frequently encountered problem in plate printing is the tendency for the printing surface to gather a scum of ink over its nonimage areas. This may occur as greasy smudges on borders and large undrawn areas, or, upon closer examination, may reveal itself in the tiny spaces between ink dots. Scumming and filling of the image are more frequent in zinc plates but can occur on aluminum as well; if permitted to continue, they will produce a rapid coarsening of the drawing and eventual loss of the plate.

The appearance of scumming is an indication that the desensitized areas of the plate are breaking down, a condition brought about by one or more of the following factors:

1. A poorly etched or gummed plate.
2. Use of a "greasy" ink that overcomes the desensitized areas and attaches itself to the plate.
3. Impurities in the dampening water that chemically destroy the desensitized areas of the plate.
4. Friction and physical abrasion from the inking roller and printing press that mechanically weaken the adsorbed etch and gum film.
5. Offsetting of ink on the plate surface by previously printed impressions.

Remedies will vary, but in all cases should be used in an orderly way to trace the problem. For example, poorly processed plates retain their water film inadequately. They tend to dry fast; and, at the same time, the tonal values of the drawing are difficult to maintain during inking. The plate darkens rapidly, sometimes in the initial inking. Plates in this condition should be dried, gummed, washed out, and carefully rolled up with lean inking. Next they are cleaned; if necessary, they are powdered with talc, re-etched along standard procedures, and, finally, regummed.

Some pigments or vehicles in printing inks contain heavy concentrations of fatty-acid particles. These are more likely to be present in color inks, but can occur in black ink when it has been modified for special purposes with soft varnishes. Inks in this condition can overcome the desensitized barriers of the plate by overpowering the ink-rejective adsorbed gum-etch film. Dirty and heavily charged ink rollers can also induce scumming, particu-

larly if they carry soft inks. The remedy is to dry and gum the plate, scrape the roller and ink slab, and mix fresh ink of a leaner and "shorter" consistency, if possible. The plate is washed out and re-inked with less ink on the roller but with more passes to ink the image fully. It will be found that the regumming along with the change of ink will reduce the problem considerably.

Impurities in the dampening water are perhaps the most subtle offenders causing plate scum. These can occur in a number of different ways. Water that is highly alkaline can gradually neutralize the etch barriers on the plate and in essence resensitize such areas so that they become receptive to grease. Dampening sponges containing vestiges of counteretch solution produce similar conditions. Another problem produced by the dampening water occurs when printing is done with greasy inks during a prolonged period. As it passes repeatedly over the inked plate, the dampening sponge picks up concentrations of free fatty-acid particles. These are gradually deposited in the water bowl and eventually returned to the plate in the water film, where they attract fresh ink from the roller. pH readings taken after two hours of printing will show that the acidity of the water has risen sharply, and this may seriously affect ink-receptive and ink-rejective areas of the plate.

Impurities in the dampening water and sponges can be overcome by thoroughly cleaning water bowls and sponges. Alkaline waters are corrected either chemically or by using soft water or neutralized water (distilled). Fresh water should be introduced periodically during prolonged printing, and pH readings of the dampening water taken from time to time will be informative.

Destruction of the desensitized areas of the plate through physical abrasion is a gradual process. The effect is not unlike that of a poorly processed plate, except that it does not manifest itself until a number of impressions have been printed. Gradually the plate refuses to retain its water film so evenly as at first or for so long a period. The remedy here is simply to fan the plate dry and apply talc and gum. After the gum has been wiped completely dry, the plate is washed out and rolled up with ink, and the printing is continued.

A condition somewhat similar to scumming is called *tinting;* here a pale film of ink is deposited over most of the plate surface each time it is inked. Close examination will reveal that this film is deposited in large part on the damp water film of the plate rather than on the plate itself. Its presence will show on the printed impressions, and, if it continues long enough, it will attach itself permanently to the plate. Tinting, at least in its early stage, is essentially an ink (rather than a plate) problem. Scumming, on the other hand, is a plate problem, and it occurs on the plate surface rather than on the water film. It has been discussed generally here; the chemistry of scumming is described in sec. 9.14.

In summary, many of the above described problems may either be brought on or aggravated by careless craftsmanship. Since plate problems often occur in multiple and subtle combinations, the printer must be perceptive about their origin and familiar with sound corrective procedures. Unless corrections are quickly undertaken, the plate will be lost.

6.28 FOUNTAIN SOLUTIONS FOR USE ON METAL PLATES

In some cases the previously described remedies for scumming and filling are insufficient. This is particularly true when the nature of the work requires printing with heavy or greasy charges of ink. In cases where scumming persists, a different approach is necessary, which in essence is a continuous etching of the plate throughout the printing. A chemical solution, essentially a weak etch (pH 5.5 to 5.0), is incorporated directly in the dampening water; so, every time the plate is sponged for inking, it receives a desensitizing fluid which fortifies the previously adsorbed gum etch. Commercially, these solutions are called *fountain etches,* and they are carried in the water fountains of automatic presses and distributed on the plate by the dampening rollers. In hand printing they are similar to the antitint solutions used in printing from stone. An excellent commercial preparation of this type for either zinc or aluminum plates is NGN Non-Tox Solution; it is diluted, one ounce of stock solution to one gallon of water. Another reliable fountain solution can be formulated in the shop as follows:

Ammonium phosphate	¼ oz
Thin gum arabic	13 oz
Water	1 gal

Either of these solutions can be stocked in the shop and used as necessary in place of the dampening water. They are applied to the plate with a sponge reserved for this purpose.

In hand printing it is advisable to use fountain solution only until the troublesome scumming disappears. This should occur after four to six impressions have been taken on newsprint or proof paper. Ordinarily, when the scumming has been controlled and the plate is printing clean, the solution should be replaced with pure water for dampening. Indiscriminate use of the solution can endanger very delicate passages in the drawing and, by

overcoming the ink-receptive areas, can render the image sharp and contrasty, with loss to the demitints. It is occasionally necessary to use fountain solution in the dampening water throughout the entire printing: sometimes during the printing of plates that require large areas of heavy inking and sometimes when a specially soft ink is used to obtain a satisfactory impression. In such cases, the plate is first dampened with fresh water and given one pass with the ink roller; thereafter it is dampened with the fountain solution for the rest of the inking. After the impression is printed, the plate is again dampened with fresh water, and the procedure is repeated as before.

The following procedures are recommended for aggravated cases of scumming that do not respond to light sponging with the fountain solution. Each technique should be used with black ink on the image. If color ink is being used, the plate should be stripped with several newsprint impressions and rolled up in stiff black ink before proceeding.

REMOVING SCUM FROM ZINC PLATES

1. The plate is dried and dusted with talc, which is polished down over the inked areas.

2. The scummed areas are massaged locally with NGN Non-Tox Solution (one ounce stock solution to one gallon water, pH 5.5), using a cotton wipe. The solution is applied until the scum is released from the plate surface and can be washed away with sponge and fresh water.

3. Equal parts of hydrogum and cellulose gum acidified are massaged briskly on the plate surface with a gum sponge for several minutes, then removed with water.

4. Pure hydrogum is applied to the plate and wiped dry. The plate is allowed to remain under the gum for ten minutes; it is then washed with water, dried, and dusted with talc.

5. The plate is etched with cellulose gum acidified, using standard procedures for original drawings.

6. After drying for ten minutes, the image is washed out and rolled up for the resumption of printing.

REMOVING SCUM FROM ALUMINUM PLATES
Method I

1. The plate is dried and dusted with talc.

2. The scummed areas are massaged gently with a cotton wipe and Imperial Alum-O-Lith Plate Conditioner (negative working).

3. After removal of scum, the plate is given a mild etch, dried, washed out, and rolled up with ink for printing.

Method II

1. The plate is dried and dusted with talc.

2. The following mixture is applied with a sponge: equal parts hydrogum and Imperial Alum-O-Lith Plate Cleaner (negative working).§

3. The solution is applied until all scum has been removed.

4. Equal parts of hydrogum and cellulose gum acidified are massaged over the plate for two minutes and washed off.

5. Pure hydrogum is applied and wiped dry.

6. The gum is washed off; the plate is dried and dusted with talc.

7. The plate is etched and wiped dry, using standard procedures.

8. The image is washed out and rolled up with ink for printing.

Method III (for particularly stubborn cases)

1. The plate is dried and dusted with talc.

2. The plate is dampened and rolled up with ink and again dried and dusted with talc.

3. The process is repeated until several layers of ink and talc are built up to protect the image.

4. The following mixture is applied with a cotton wipe: $\frac{1}{3}$ part Imperial Alum-O-Lith Plate Cleaner (negative working); $\frac{1}{3}$ part cellulose gum; $\frac{1}{3}$ part hydrogum and sufficient whiting to form a thin paste.

5. Massage gently over the plate, avoiding the image areas as much as possible. Accumulated sludge is removed with a sponge and hydrogum.

6. After removal of scum, the plate is dried, dusted with talc, and given a standard etch.

7. When dry, the image is washed out and rolled up with ink for printing.

It is worth noting that local application of the fountain solution with a cotton wipe (Webril Litho Pad) resembles similar treatment for work on stone using a felt pad. Felt pads, however, should never be used on metal plates because of the undue physical abrasion they exert on the image and nonimage areas of the plate.

Plates that continue to resist response to the previously mentioned treatments are probably lost and should be discarded. Lack of response can usually be traced to the fact that the proper remedies were not provided soon enough.

The chemistry of fountain solutions is described in Part Two.

§ Imperial Alum-O-Lith Plate Cleaner (negative working) is a chemical solution different from Imperial Alum-O-Lith Plate Conditioner (negative working). Neither solution should be used on zinc plates: the chemical reaction will destroy image deposits and cause filling in.

6.29 STORAGE OF METAL PLATES

A certain amount of care is required in the storage of metal lithographic plates upon receipt from the supplier; careless storage practices can ruin unused plates and render already processed plates unfit for further printing.

New plates from the supplier are usually packaged in stout cardboard packages with waterproof inner wrappers and tissues between each plate. When received from the plate grainer, they will usually be interleafed with clean newsprint sheets. The slip sheets minimize dirt, dust, and scratching of the plate grain during storage and removal from the package.

The most important provision during storage is moisture prevention. It has been shown that high humidity in the atmosphere can induce plate oxidation even though the plates are covered. If the moisture content of the slip sheets between the plates increases while in storage, the plates will oxidize even before removal from the package. Prolonged oxidation of this type can completely ruin new plates (particularly zinc), which must then be regrained before use. It is therefore essential that the package of plates be carefully rewrapped each time a plate is removed. Unless these are already provided, it is also advisable to wrap an inner or outer covering of plastic film or other such waterproof barrier around the entire package as further protection against moisture. Periodically, the package should be opened; if there is suspicion of moisture absorption, the slip papers should be replaced with clean dry newsprint. Packages of plates wrapped in this way should be stored in drawers or on shelves, away from areas of the press room where water, chemicals, solvents, and inks are used.

The storing of drawn and processed work requires other procedures. Plates that have been etched and proofed and are awaiting edition printing within a few weeks are stored as follows:

1. The plate is inked with roll-up ink, dusted with talc, gummed, and wiped dry.
2. The back of the plate is thoroughly dried after removal from the bed plate.
3. The dried plate is wrapped in clean newsprint, labeled, dated, and put on a shelf or hung from an upright rack designed for this purpose.

NOTE: Commercial plate racks are available from lithographic suppliers; similar racks can be simply devised. The rack permits plates to hang freely from spring clamps which grip their edges. This permits air to circulate freely around the plates and prevents the plates from touching one another. Plates hung in this way need not be wrapped with newsprint.

Plates to be stored for longer periods of time, such as those awaiting a second edition or future modification and reprinting, are stored in another way. After prolonged storage, the roll-up ink on the image might become so dry and hard that it could not easily be washed off with solvent when the plate was ready to be reprinted. To prevent this, the plate should be first washed out and put under asphaltum before being stored. The following is the usual procedure:

1. After printing, the plate is rolled up with roll-up ink, dusted with talc, and gummed.
2. The image is thoroughly washed out with lithotine through the dried gum film.
3. A solution of asphaltum is applied on the plate and wiped down to a thin, even film.
4. The plate is removed from the press bed. Care is taken not to get moisture on the image as its back is dried. The plate is then wrapped in newsprint for shelf storage, or hung unwrapped from the plate rack.

The asphaltum is somewhat greasy and will not dry to a hard insoluble coating. Accordingly, it can preserve the ink receptivity of the image for several years if necessary. One must remember that there is a film of desensitizing gum arabic under the asphaltum film on the nonimage areas of the plate. When the plate is to be run again, the asphaltum is washed out with lithotine; the plate is fanned dry, and a thin film of Triple Ink is wiped on the image. When it is dry, the plate is sponged with water, which dissolves the gum and lifts off excess Triple Ink. This leaves the nonimage areas clear, with the Triple Ink remaining only on the image areas to receive the ink.

Color Lithography

7.1 COLOR LITHOGRAPHY

A color lithograph is produced when two or more images are individually drawn, processed, and then printed, each with a different color, on a single sheet of paper. The chemistry of color lithography is identical with that of black-and-white lithography. Making a color lithograph, however, requires many more steps and a more complex series of technical and aesthetic considerations.

A color lithograph can evolve in several ways. It may begin from an existing drawing or painting, from a previously printed black-and-white lithograph, or it may develop from sketches prepared for it exclusively. In each case the customary steps for making the print begin by determining the number of colors to be used. A color study is prepared, from which color separations are diagrammed to indicate major color areas. A full-size diagram, called the *key drawing*, is then made to outline the basic composition and color positions. The areas for each color are traced separately from the key drawing onto individual stones or metal plates. These are called the *color plates*.* Black-and-white drawings representing appropriate chromatic and tonal passages are made on each color plate with standard lithographic materials. The color plates are then processed and proofed separately in a predetermined sequence; the print paper must be properly aligned for each printing. When necessary, corrections of the drawings and color ink mixtures are made. Proofing is repeated until a satisfactory impression is achieved. The edition is then printed, following the same sequence and steps of procedure determined during proofing.

The next three topics examine some of the more important aesthetic, psychological, and theoretical factors that must be considered by both the artist and the printer before a color lithograph is made. The actual working processes are described later.

7.2 AESTHETIC CONSIDERATIONS IN COLOR LITHOGRAPHY

Attitudes regarding the aesthetics of color lithography constantly change. They are conditioned partly by (1) movements in art that parallel the historical evolution of the medium, (2) the relationship of color lithographs to prints produced by other printing processes, and (3) technical characteristics inherent in the over-all craft of printing.

THE EVOLUTION OF COLOR LITHOGRAPHY

Color lithography was initiated when Senefelder realized that a black-and-white lithograph could be printed just as easily with colored ink. By 1816 he had developed a method of printing color from several stones for the calico printing trade. In the early nineteenth century a few artists began producing two-color chiaroscuro lithographs from a flat-tint plate and a drawing plate, using the traditional techniques already perfected in engraving and relief printing. By the 1830s the craft of color lithography had so advanced that works were printed carrying as many as twelve to fifteen separate colors. Unfortunately, this was a period in which the painterly qualities of tonal modulation and texture in the graphic arts were over-

* Color lithographs can be made either on stones or on metal plates. References to color plates indicate drawings placed on either surface unless metal plates are specifically indicated.

7.1 CLINTON ADAMS: *Window Series I.* 1960. Chiaroscuro lithograph, 18×15". Tamarind Impression (T–122)

A contemporary translation of the traditional chiaroscuro technique. The key plate is printed in black and the tone plate is printed in a middle-value chromatic tint. Instead of being used to heighten the three-dimensional characteristics of the image, the tone plate has been employed to emphasize the highlights and to support two-dimensional implications

7.2 JULES CHÉRET: *Folies Bergère—Fleur de Lotus (Folies Bergère—Lotus Flower).* 1893. Color lithograph, 47 1/2×32". University Art Museum, The University of New Mexico, Albuquerque

7.3 PABLO PICASSO: *Figure au Corsage Rayé (Figure in a Striped Blouse)*. 1949. Lithograph in six colors, 25 1/2 × 19 1/2″. The Museum of Modern Art, New York

shadowed by the linear austerity of Neoclassic art. Color usage in printmaking was mostly confined to the popular arts. Accordingly, most of the color lithographs prior to 1870 were produced for commercial purposes, such as ornamental printing, book illustration, facsimile reproduction, posters, and advertisements. The lively colors and imaginative images of poster art (exemplified by the works of Jules Chéret) eventually encouraged certain French artists of the 1870s to utilize the resources of color lithography as a medium for fine art. During this period, Impressionist and Post-Impressionist color theories also contributed enormously to the evolution of aesthetic and stylistic concepts of the medium. By the end of the century, color lithography, supported by publishers like Vollard, Roger Marx, Kleinman, and Mellerio, had reached unparalleled popularity among French artists and public alike. During this period, Toulouse-Lautrec,

Vuillard, Signac, and Sisley made major contributions to the art.

In the first half of the twentieth century a succession of movements in art revolutionized aesthetic and stylistic attitudes for artists working in every medium throughout the world. Cubism, Expressionism, Dadaism, Surrealism, and nonobjective art have all exerted their influence on contemporary printmaking. In color lithography, the works of Edvard Munch, the German Expressionists, Picasso, and Miró were a primary influence upon the artists of midcentury.

Between 1950 and 1960 Gustave von Groschwitz of the Cincinnati Art Museum provided an important showcase for color lithography in the United States with a series of international biennial exhibitions. These comprehensive exhibitions enabled American lithographers for the first time to identify differences in their concepts

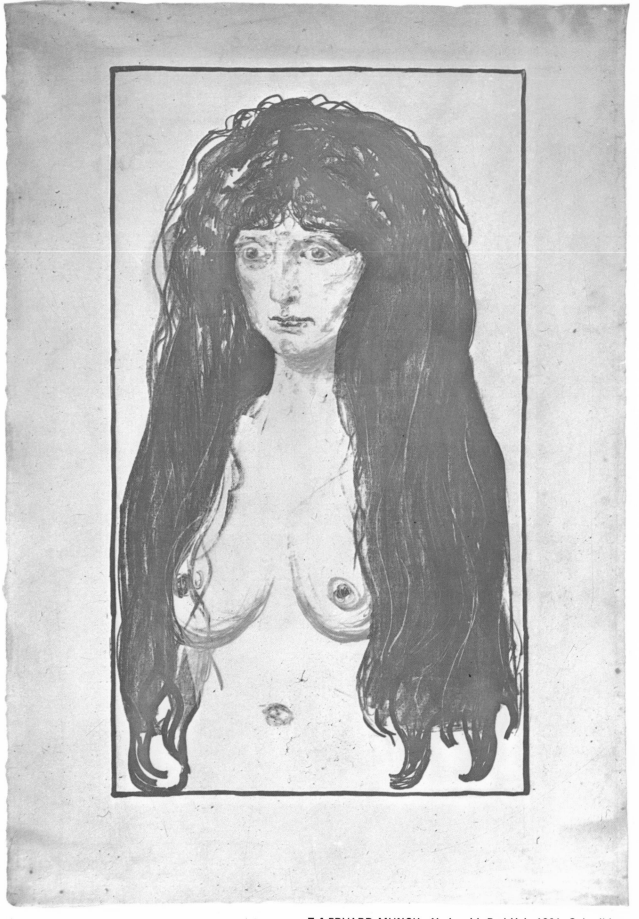

7.4 EDVARD MUNCH: *Nude with Red Hair.* 1901. Color lithograph, 27 3/8 × 15 3/4″. The Museum of Modern Art, New York. Gift of James Thrall Soby

7.5 JOAN MIRÓ: *Acrobats in a Night Garden.* 1948. Color lithograph, 25 1/4 × 19 3/4". The Museum of Modern Art, New York

7.6 HENRI DE TOULOUSE-LAUTREC : *Aristide Bruant dans son Cabaret.* 1893. Color lithograph, 50 × 36 1/4″. The Museum of Modern Art, New York

and working procedures from those of their counterparts throughout the world. Concurrently, attitudes in American art during this same period shifted significantly away from European influence. Thereafter color lithography in this country has mainly followed dominant directions in American art, even though some of the earlier European traditions continue to be explored.

The Tamarind Lithography Workshop in 1960 established the first systematic program for training artisan printers, developing technical processes, and setting modern standards for American lithography. Leading artists were encouraged to produce lithographs (many in color) under the Tamarind aegis. Color lithography in this country was encouraged further by the activities of the Pratt Graphic Arts Center, Universal Limited Editions, Inc., and the Print Council of America. These major centers of professional activity, together with workshops founded by printers trained at Tamarind, have been instrumental in the development of a truly American art form in color lithography. Similar efforts in Great Britain and in Germany have also stimulated the emergence of important independent directions in color lithography.

Approaches to Color Organization. Color organization in contemporary lithography is a direct outgrowth of systems used in France between 1870 and 1900. Two principal approaches have been employed since that time. THE FIRST APPROACH is characterized by the use of flat color patterns, held together by either contrasting hues or strong structural contours. This method can be recognized in the works of Toulouse-Lautrec and in the early prints of Bonnard. It is a descendant of the French poster style (itself influenced by Japanese prints). As used by the Post-Impressionists and by the artists of the Art Nouveau period, this approach provided striking results. The contours and imagery of these prints tend to be highly decorative, limited in modeling, and forceful in patterning. Variations were used by the German Expressionists to impart powerful and symbolic properties to their lithographs. Modifications of this method have also been used by Picasso, Miró, and Léger. More recently this system has been employed by Hard-Edge and Pop artists to create large color fields having structural and expressive impact (Albers, Reichek, Leslie, Allen Jones).

THE SECOND APPROACH is an outgrowth of theories from Impressionist and Post-Impressionist painting. It is characterized by the multiple overprinting of colors that produce luminous and graduated nuances of color modulation that envelop the image. The later works of Bonnard, Pissarro, and Vuillard are examples of this approach. Later manifestations can be seen in the lithographs of Braque and Chagall, as well as in those of the romantic abstractionists from the School of Paris such as Clavé and Manessier. Following the demise of Romantic Abstraction in recent years, the use of luminous color modulation by twentieth-century artists has deteriorated generally into a fussy mannerism. Prints in this style are often complicated by overly rich surface textures and superficial structural façades and have lost much of the charm and freshness of their forerunners.

Number of Colors Employed. The aesthetic qualities of color lithographs developed in either of the two approaches just described depend as much on the number of colors used as on the color arrangement. Some excellent lithographs contain only two colors, and others equally fine have numerous colors. Today most American and British lithographs use three to five separate color plates to project direct and bold graphic statements. The European tradition continues to employ an average of five to seven color plates (as seen in Toulouse-Lautrec and Bonnard prints) to develop more extended color nuances. Exaggerated examples of this tradition can be viewed in some lithographs by Chagall or Braque in which eight to twelve individual colors have been used. Although the number of colors used is usually a matter of personal taste, it is closely related to economic considerations, since extensive proofing and printing are time-consuming and costly.

Regardless of the number of color plates used, an original lithograph should be a creative and independent work. The chromolithographs of the nineteenth century lack aesthetic appeal not because of their numerous colors but because of their attempt to duplicate characteristics more appropriate to paintings and watercolor illustrations. Color lithographs with even a few colors can be equally unsatisfactory aesthetically. Heavy and pasty ink films or thin and lifeless coloration tend to produce qualities of artificiality which seldom appear as an integral part of the graphic statement. As with other mediums, the interplay of color and imagery should appear inseparable and interdependent in order for the print to retain its integrity.

The influence of the *chromiste* has also contributed to the undesirable reproductive properties of some color lithographs. *Chromistes* are craftsmen employed traditionally by the larger European print shops to interpret the artist's color sketches. The artist may draw the major key stone and furnish colored sketches or notations on proof impressions from the color plate. The *chromiste* then draws the separate color plates in the style of the artist, following established techniques. Lithographs produced in this way are usually flawlessly executed, but sel-

7.7 FERNAND LÉGER: *Marie the Acrobat.* 1948. Color lithograph, 21 3/4×16 3/4". The Museum of Modern Art, New York. Gift of Victor S. Riesenfeld

7.8 JESSE REICHEK: *Untitled.* 1966. Color lithograph, 35 1/4 × 22″. Tamarind Impression (T–1767)

7.9 JOSEF ALBERS: *Day and Night III.* 1963. Color lithograph, 15 3/4 × 15 3/4". Tamarind Impression (T–915)

7.10 ÉDOUARD VUILLARD: *Interior with Pink Wall-paper I, II,* and *III* (Plates V, VI, and VII from *Paysages et Intérieurs*). 1899. Lithographs in five colors, 14 × 11". The Museum of Modern Art, New York. Gift of Abby Aldrich Rockefeller

PL.Y X/10

Marc Chagall

7.11 MARC CHAGALL: *Untitled* (Plate VII from *Four Tales from the Arabian Nights*). 1948. Color lithograph, 14 3/4 × 11″. The Museum of Modern Art, New York.

Chagall drew all the images for this *livre de luxe* on zinc plates, which were printed on an offset press by the American printer Albert Carman

dom contain the vitality or technical innovation characteristic of truly creative involvement. Most of the color lithographs of Cézanne, Renoir, Sisley, and Utrillo were produced in this way. Current attitudes in American printmaking are strongly opposed to the practice of the *chromiste*. Although it is unnecessary for the artist actually to print the work, his direct involvement in drawing and correcting all the color plates is essential to the authenticity of the completed print.

RELATIONSHIP OF COLOR LITHOGRAPHY TO THE OTHER COLOR PRINTING PROCESSES

Color lithographs differ subtly from color prints produced by other processes. Once understood, these differences can be explored to further the aesthetic merit of the work. Each can be described by comparison to the other print processes.

Properties of the Drawn Image. Drawings for color lithographs are made with the same materials and techniques as are those for black-and-white lithographs. The autographic properties of the medium make possible a directness of transcription unattainable by the other printmaking processes. Because the materials for drawing are inherently tonal, they permit a much easier development of color gradation. This is one reason why many painters prefer color lithography to most of the other print processes. Compared to lithography, etching and engraving are essentially linear mediums. Techniques for achieving tonal coloration are less direct and are visually quite different.

Most relief and serigraphic processes are characterized by either linear properties or flat patterns. Although textural modulation is easy to achieve, the multiple layering of colors by these processes tends to emphasize two-dimensional properties of the print surface. In recent years the medium of serigraphy has enjoyed a dramatic revival in the United States and Great Britain because of its adaptability to the development of large flat patterns coupled with photographic imagery. Both posterized and polarized photographic techniques, as used in commercial reproduction processes, are being employed for the development of artist's prints.† When used to develop collage-like forms of photographic material, serigraphy offers an anonymity of touch (quite the opposite of lithography) that has been highly appealing for a growing number of artists.

Characteristics of the Ink Film. Pigments used in lithographic color inks are mostly transparent or semi-

† Posterization breaks a photograph down into tonal color separations, and polarization separates a photograph into line and tone without the use of halftones.

transparent. Even greater transparency can be achieved by adding a colorless reducing agent to the ink. Coupled with the principles of planographic printing, these characteristics produce thinner ink deposits on the print paper than any other printing process. Thus it is possible to print multiple layers of color that can vary from extremely soft luminosity to brilliant clarity. At the same time, the ink film remains closely integrated with the surface of the paper. Color density or opacity can also be achieved by mixtures with opaque inks and by printing light colors over darker ones.

Color etchings and intaglios print incisive films of ink that penetrate deeply into dampened print paper. Prints of this type are capable of color resonance unobtainable in lithography. Carefully wiped plate tones or fine-grain aquatinting can also provide extremely pale tints. Intaglio processes can extend the chromatic range of hue, value, and intensity for any given color further than is generally possible in lithography. A comparison of the intaglio prints of Miró and Braque with their lithographs containing similar images and coloration will illustrate this point.

Unlike lithographs, intaglios are technically complicated to print in multiple colors. Multiple overprintings tend to produce muddy intermixtures. In addition, it is difficult to achieve total color integration without using color plates that have been painstakingly executed and wiped. Accordingly, in many intaglio prints, a black or dark key plate is used to carry the major image, and color is employed sparingly to provide chromatic interplay.

Color woodcuts and wood engravings also print heavier ink films than lithography. The physical substance of the relief printing surface and the character of the incisions made on it produce qualities of ink transfer which often appear hard, coarse, and granular; these tend to be more on the outer surface of the print paper.

Serigraphic inks have greater opacity and covering capability than inks for any of the other print processes. Although it is possible to obtain color transparencies, their general character is flat. The body of ink films on serigraphs more closely approximates paint films, and, when many colors are used, there is a tendency for them to pile up without integrating with the paper surface. The over-all appearance of the ink films is heavy, dry, and pasty when matte inks are used, and unpleasantly brittle when glossy inks are used. More recent innovations, in which this medium is being employed to print on surfaces other than paper (cloth, metal, and plastic), have opened greater potentials for a process which too often has been abused by ill-considered attempts to approximate qualities of paintings or facsimile reproductions.

7.12 EMIL NOLDE: *The Three Kings.* 1913. Color lithograph,
25 1/4 × 21″ The Museum of Modern Art, New York

7.13 Contemporary Color Lithography: A gallery of lithographs printed at Tamarind illustrating various contemporary approaches

a. SAM FRANCIS: *Untitled.* 1963. Color trial proofs *a* and *b*; completed lithograph. 22 × 30". Tamarind Impression (T–859)

The completed lithograph is printed in four colors from one stone (green) and three zinc plates (blue, red, and yellow). Acid biting has been used on the stone to achieve a tonal range. Strong tusche has been used on the plates to make simple, positive images. Trial proof *a* shows an early proof of the green stone, overprinted in black by the plate that will ultimately be printed in blue. Trial proof *b* shows these two plates reversed, the stone printed in blue and the "blue" plate printed in green; the red plate has then been added. The procedure followed by the artist is an entirely characteristic way in which some complex color images are developed

b. NICHOLAS KRUSHENICK: *Untitled.* 1965. Color lithograph, 29 × 21″. Tamarind Impression (T–1366)

Four-color lithograph printed from three aluminum plates (yellow, orange, and blue) and one stone (black); images drawn with brush and tusche

c. PAUL BRACH : *Silver Series.* 1965. Color lithograph, 21 × 21″.
Tamarind Impression (T–1507)

Multicolor lithograph printed from three stones in four printings.
A solid gray was printed first ; the nine circles were then printed in
two runs using blended roller techniques ; the third stone carried
a crayon drawing

Three-color lithograph printed from a single stone in three runs (black, light blue, orange-red)

d. NORMAN ZAMMITT: *Untitled*. 1967. Color lithograph, 29 1/2 × 42 1/2″. Tamarind Impression (T-2154)

The dimensional properties and optical shimmer of this print have been produced by slightly shifting the positioning of the paper on the stone for each printing

e. ED RUSCHA: *Annie.* 1969. Color lithograph, 17×24″. Tamarind Impression (T–2530)

Two-color lithograph printed from an aluminum plate (yellow) and a stone (brown). The key image was drawn with rubbing crayon over a gum arabic mask

f. WILLIAM BRICE: *Two Figures.* 1966. Color lithograph, 22×30″. Tamarind Impression (T–1810)

Five-color lithograph printed from stones, drawn with tusche, rubbing crayon, and lithograph crayon, and with the color printed in the following sequence: yellow, red, blue, purple, black

g. IRENE SIEGAL: *Zippy Linnae, or The Collector.* 1967. Color lithograph, 40 × 29 3/4". Tamarind Impression (T–2132)

Three-color lithograph, two aluminum plates and one stone; drawn with brush and tusche and lithographic pencils

h. NATHAN OLIVEIRA: *Hommage to Carrière.* 1963. Lithograph, 30 × 22″. Tamarind Impression (T–923)

The drawing was made in tusche on stone.

i. BILLY AL BENGSTON: *Royal Viking Dracula.* 1968. Color lithograph, 10 1/2 × 9 3/4". Tamarind Impression (T–2273)

Five-color lithograph printed from four zinc plates and one aluminum plate. The images were drawn principally with air brush and tusche spatter over gum masks

TECHNICAL CHARACTERISTICS

The successful color print is a composite of complex parts, which, by various means, must be brought together to complete the tonal work. Unless these are well planned from the outset and carefully executed through the cycles of the work process, the completed print cannot achieve those qualities which are essential to its aesthetic potential. Hence the craft and techniques of printing exert as much influence as the art of the drawing on the aesthetic merit of the work. Poorly printed ink films, imperfect impressions of the image, careless color registration, and soiled margins are indelibly recorded on the print paper as obvious errors of craftsmanship.

It is usually possible to make slight variations in inking lithographs to achieve lean or rich impressions. Lean impressions convey a dry quality that may be aesthetically desirable for some images; the opulence of a rich impression may be more desirable for others. Once a decision is made, a skilled printer can maintain identical impressions having either quality throughout the entire edition. The subtleties of such differences are extremely important for some artists and less so for others. Nevertheless, they are worth considering within the total context of each artist's aesthetic intent.

The color lithographs of the German Expressionists illustrate the relative importance of impression quality. On the whole, the prints by Kirchner, Nolde, Heckel, and Otto Mueller were poorly printed; there are a limited number of impressions, and these are generally not identical in color or print quality. Although the impressions seem primitive and have properties akin to monotypes, their appearance seems entirely appropriate for each artist's direct and forceful intention. The character of the printing (soiled margins and all) appears in complete accord with the brutality of the imagery. The aesthetic properties of these lithographs reveal qualities that are a direct outgrowth of the work process. These same prints would undoubtedly appear sterile and artificially engendered if visualized with clean margins and faultless printing.

Similar attitudes of appropriateness might not apply to other lithographs. For example, prints with Hard-Edge or Optical imagery could not tolerate the imprecision of the Expressionist printing methods. Instead, they require expert and very precise printing techniques in order to convey their pure or optical properties.

In summary, aesthetic considerations in color lithography vary from individual to individual and from one historical period to another. The serious lithographer would do well to study the evolution of aesthetic concepts in the history of the medium for an understanding of more subtle factors than those briefly mentioned here.

7.3 PSYCHOLOGICAL DIFFICULTIES IN MAKING COLOR LITHOGRAPHS

Some artists who are accustomed to the direct involvement and immediate decision-making of drawing, painting, and sculpture encounter psychological difficulties in color lithography. Problems are first encountered when the color study of the intended print is separated into individual color plates. Another series of problems occurs when the desired color for each plate is being translated into a black-and-white drawing. Unless each drawing is properly executed on its plate, the hue mixtures, tonal effects, and surface modulations of the print cannot function as intended. A time lapse is unavoidable between the completion of the color plates and the achievement of a satisfactory print impression. The inexperienced artist will seldom know whether his preparations were satisfactory until the final plate has been proofed. Further interruptions must be tolerated if the separate color plates require corrections or modifications. In such cases additional processing and proofing are required. During this period, the artist must also adjust to a collaborative work sequence, in which the printer functions as an intermediary between the artist's drawing, the color plates, and the printed impressions.

The critical evaluation of the completed print can also be difficult for an artist inexperienced in lithography or having limited experience with the use of color. Unless he has some knowledge of prints in general, it is difficult to relate the aesthetic merits of the print to his works done in other mediums. His subjective response to the work process and to the completed print may be so indeterminate that he cannot form a positive opinion regarding the significance of either. In some cases an indecisive artist may take several days to decide whether to alter the work, go on to print the edition, or abandon the project altogether. Gradually, as he does other prints, the artist will become accustomed to the kinds of judgment and decisions involved. An experienced printer can be invaluable to an artist beset with the psychological difficulties just described. Through tactful guidance, advice, and thoughtful scheduling, the printer can provide the assurances that many artists need during such difficult periods.

7.4 BASIC CONTROL FACTORS IN COLOR LITHOGRAPHY

It is assumed that anyone seriously contemplating work in color lithography has had prior experience with color in other mediums and that he has at least a funda-

mental knowledge of color principles and their practical applications.

There are five basic factors that govern the outcome of a color lithograph. Each can affect creative as well as technical decisions made by the artist and by the printer during the planning and execution of a color print.

1. Color Structure and Composition. Both the artist and the printer must have a sound knowledge of color theory and structural organization. The artist must understand how to use a limited number of colors for maximum effect. The printer must understand color theory sufficiently to prepare ink mixtures that correspond to the artist's requirements.

2. The Character of the Drawing. The separate plates must be so drawn that each will contribute its intended hue, value, and surface characterization to the completed print.

3. Sequence of Printings. Color plates must be printed in a planned sequence so as to form intended intermixtures and tonal modulations with one another.

4. Transparent and Opaque Inks. The visual characteristics of transparent and opaque ink films should be understood so as to incorporate them both for chromatic and expressive nuance.

5. Registration. A system of registration is necessary so that successive overprintings will strike exactly into the positions intended.

CHARACTER OF THE DRAWING

The Black Drawing and Its Relation to Color Value. The drawing materials used in color lithography are the same as for black-and-white lithography. The artist must translate his color image into separate black-and-white drawings, one for each color to be printed. This is one of the most disconcerting problems for the inexperienced. Nothing can be more discouraging than to produce a handsome black-and-white drawing that, when proofed with color ink, loses all of its beautiful modulation and appears weak and lifeless. All color hues are lighter in value and shorter in tonal range than the full black, gray, and white scale. The lighter the hue to be printed, the shorter will be its tonal range. The comparison of a proof in black ink with a proof of the same image in yellow ink will illustrate how severely the tonal range is altered (see fig. 7.14). The value scale of the yellow print is compressed, and the full range of values of the original drawing cannot be shown to advantage on the print. This reduction of value is usually misinterpreted by the beginner, who views it as the manifestation of an overetched image, or of an image that is not carrying a sufficient amount of ink. In an effort to compensate, he overinks the image, quickly

destroying its printing stability without appreciable gain to the impression. *Color cannot be made to print darker than the value of the basic ink mixture.*

As the hue to be printed is darkened by mixing with other inks to a deeper yellow, ocher, or tan, a correspondingly greater range of values can be achieved. Colors such as dark blue, dark green, dark gray, or dark brown, which approach the value of black, will offer even greater opportunity for reproducing tonalities close to the original drawing.

In view of this principle, the artist should execute rather simple and bold drawings for images to be printed in light hues. Although effects of depth will be minimized, the primary objective is to enable the light hue to maintain its identity in comparison with the other colors in the print. It is impossible to darken the color value without changing the basic hue for drawings that have been made too light. It is well to remember, however, that color inks can be lightened in value for drawings that have been made too dark.

Effect of the Drawing on the Chroma Range. A comparison of the yellow impression with a proof of the same image printed with a bright red ink will provide another important illustration. The red print will not only show more detail than the yellow impression, it will appear more brilliant and contrasting. Being darker than the yellow, it offers a broader value range, and, because it is also more intense, its chromatic range is increased as well. The additional intensity of the red permits it to stand out against the surrounding whites of the paper, whereas the yellow image is optically absorbed and weakened by its surrounding whites. If the red is not overly dark, its degree of value change will be small, and the difference between the red and the yellow print will be mostly a difference of intensity. Further observation will reveal that those areas which are maximum in intensity will correspond to the strongest areas of the original black-and-white drawing, those which are weakest in intensity will correspond to the palest values of the drawing.

Viewed in another way, it can be seen that the original drawing is printed with a color ink that contains a predetermined value and intensity. The greatest concentrations of the ink will correspond to areas that were full black in the drawing. Maximum color saturation will occur only in these areas, since virtually no white paper will show through. Weaker values in the drawing receive correspondingly less ink and at the same time permit greater amounts of white paper to show between the ink dots. There is a lessening of hue intensity in these areas, and the effect of the original ink mixture becomes a tint of itself. Although there is also some lessening of color

7.14 JAMES McGARRELL: *Portland I*. 1963. Lithograph, 35 × 25″. Tamarind Impression (T–702)

value in this instance, the predominating factor is the reduction of color intensity. *Value changes in the black-and-white drawing are perceived as intensity changes in the printed color. Images that are to carry the maximum intensity of the ink mixture should be drawn very dark or solid.*

The Value Range of a Color Lithograph. Two approaches are possible for developing the over-all value range of a color lithograph. The traditional method utilizes a rather complete tonal image which is printed in a semidark neutral color, either at the beginning, midpoint, or end of the sequence of color printing. Serving as an understructure of tonality, it can be heightened chromatically, as well as modulated by lighter and darker transparent color veils printed above or below it. The second approach is based on a selection of colors that in their combination will produce the value range desired. In some cases, an increase of value depth and intensity that is beyond the capacity of a single hue may be desired. In such instances, several additional drawings and printings in modified hues, values, and intensities are printed over parts of the basic color area. These will considerably enrich the hue beyond the capabilities of any single printing. *The tonal range of a finished print is developed through successive overprintings of transparent hues on a neutral substructure or with a succession of hues of different values.*

SEQUENCE OF PRINTINGS

Most of the previous paragraphs apply to the development of one single color plate. When two or more images are printed against one another, there are additional factors to consider. These involve the positioning of the hues with respect to one another and to the sequence in which they are printed.

Suppose it is decided to print red as one printing, followed by yellow for the second printing. There are three basic alternatives for the positioning of these colors:

1. The red and yellow may be positioned separately. Their interplay within the print will depend on the relations of shape, size, surface appearance, and proximity to one another and to the remaining white of the paper.

2. The red may be completely printed over the yellow. This will produce a resultant hue that is a mixture of the two. It should be noted that the mixture of the overprinting is somewhat different from a premixed orange achieved in a single printing. Overprintings of this type are somewhat less pure, but contain more substance than individually printed mixtures.

3. The red can be printed partially over the yellow, so that some of the red and yellow remain as independent hues. The area of their overprinting produces a third hue,

orange, which interacts with these and with the white of the paper. The greatest possibility for hue extension is permitted by this approach, for three hues can be obtained from two printings. Although one would expect this approach to be preferred, it is not always so. An artist's decision should depend on the concept of the work. In actual practice (particularly when there are many printings) the artist may wish to use all three approaches during the development of the work.

The sequence in which the colors are printed can alter their effect considerably. If the tonality of the two images is essentially the same, and the red is printed over the yellow, the resultant mixture is red-orange. If the yellow overprints the red, the mixture is yellow-orange. *All other factors being equal, mixtures of overprinted hues lean in the direction of the topmost color.* Exceptions to this principle occur when the first color is darker and is printed with a more intense ink: it then overcomes the topmost color and dominates the mixture. Similarly, if the top color is more transparent than the bottom color, it permits the latter to assert its identity. Actually, the sequential relations of colors in the printing can affect the value and intensity as well as the hue of the overprintings. This is another means by which the color range of the lithograph can be increased.

The nineteenth-century concept of color sequence was to print the lighter and brighter colors first and the darker, contrasting colors last. This permitted maximum freshness and luminosity in the lighter colors, because they lay closest to the white paper. The darker colors, because they were printed last, were used to cover up earlier errors while enriching the work and pulling it together.

An example of this type of color sequence is documented in David Cummings, *Handbook of Lithography*, 1904. His description follows:

1. Pale yellow: any shade most suitable for the subject in hand.

2. Deep yellow or orange: The discriminating use of pink over parts of the pale yellow will often enable the artist to do without the second yellow printing, which will allow another color to be used instead, if required.

3. Pink or rose color: This, with a little yellow underneath, will give agreeable flesh tints, and may be used pretty freely.

4. Pale blue: This, worked over the pale yellow, will give a pale green and over the pink a pale violet. It is a useful color, and the artist will obtain general toning by using it freely.

5. Red: For picture work it is generally advisable to use a madder or crimson ink, as by having yellow underneath, a vermilion tone is obtained, while with the blue

worked over it, a purple tone is produced, thus obtaining a variety of reds with one printing.

6. Black or outline color: Gives the form or drawing of the picture.

7. Dark blue: To be worked as required to give best effect and fullest value.

8. Brown: On top of the blue will give deep shadows.

9. Dark gray: Will give shadows and tone positive color where required.

10. Light gray: Used to tone generally.

Today, such elaborate color sequences are seldom used because they recall the undesirable characteristics of reproductive art. The same principles, however, can be applied advantageously to more abbreviated printing sequences. Current approaches not only use fewer colors but often reverse the sequence by printing the dark colors first. Lithographs developed in this manner, even though less luminous, are often weightier and more resonant.

OPAQUE AND TRANSPARENT INKS

Only a thin deposit of ink can be printed on the paper because of the chemical and mechanical principles of the lithographic process. Lithographic inks have limited opacity and do not have the covering power of similar inks used in other printing processes. Semitransparent and transparent inks permit greater amounts of undercoloring to show through their printed films. Further additions of a transparent nonpigmented ink (transparent white) to the color ink allow still greater degrees of transparency. Mixtures of this type can be used to print very weak tints comparable to pale transparent watercolor washes. A wide range of color effects can be developed by transparent overprintings following the principles of color glazing in oil paint. In this way, additional hue gradations can be produced whose tonalities are considerably more luminous than those obtained by printing a single color. *Modifications of transparency or opacity of the printing ink will affect both value and chroma of the image in the resultant overprintings.*

REGISTRATION

Color registration is perhaps the most important factor of all, for the accurate placement of one printing over the other makes it possible for the colors to function as intended.

7.5 THREE BASIC APPROACHES TO COLOR LITHOGRAPHY

The three principal approaches by which color lithographs are developed are: (1) the additive system, (2) the subtractive system, and (3) the evolutionary system.

THE ADDITIVE SYSTEM

In this approach, the artist draws at one time a number of plates. Each plate carries an appropriate color and image area; when the plates are printed in succession, the multiple effect of the sequence produces the complete print. Work developed in this manner permits all the plates to be drawn and proofed before the actual edition printing is undertaken. Sometimes the last plate is not drawn until all the preceding colors have been proofed. In this way, the artist can use the final color plate to correct unforeseen problems resulting from the earlier plates.

The advantage of the additive system for the beginning lithographer is that it offers unlimited opportunities for proofing and correcting. The importance of trial proofing in the making of black-and-white lithographs has been stressed above (see sec. 4.4). Separating this process from the actual printing of the edition allows greater freedom in bringing the print into final form.

Another advantage of the additive approach is that all the plates can be saved after the edition is printed. Additional alterations and supplementary plates can be incorporated to produce a variant or even a totally different lithograph if desired.

THE SUBTRACTIVE SYSTEM

The subtractive system also depends on successive printings. These may issue from the same plate, part of the image being eliminated after each printing. The possibility of subtracting elements from a rather complete starting image could conceivably produce a total print from only one plate. More often than not, however, several supplementary plates are required. These may be developed by using either additive or subtractive approaches.

The element of risk involved in the subtractive approach is obvious. All impressions of the edition must be printed in the first color before the image can be altered for the following color. Decisions as to the exact mixing of the color inks must be made as the printing progresses; there is no possibility of reviewing a set of progressive proofs (as in the additive system) before the edition is printed. When the subtractive system is used, both the artist and the printer must know precisely what they are doing, particularly in the beginning. All judgments are final. Such judgments are precarious when the image is only partially formed and color relations incomplete.

The subtractive system has its compensating benefits. It offers a freedom and flexibility that the additive system

7.15 An example of a color sketch, separation sketches, and key drawing

does not provide. The work remains fluid until the last color has been printed. The artist can easily respond to unforeseen developments.

The sequential printing of two or more variants of a base color can often yield a substantial tonal richness, far greater than could be obtained in a single printing. Color lithographs developed through use of the subtractive system often require a large number of printings. Since less time is spent in drawing images, however, the total time (for artist and printer combined) is not greatly prolonged.

The lithograph need not be developed only "subtractively." After the original plate has gone through a series of deletions, new work may be added to it. Alternatively, entirely new plates may be drawn to add other colors to the image.

THE EVOLUTIONARY SYSTEM

When there is no preconceived plan for the color print, the evolutionary approach is necessary; each step evolves from a preceding phase. This occurs when a print is developed by processes of automatic imagery or when an image originally intended for black-and-white purposes suggests color potentials. In either case, actual planning cannot proceed until proofs of the image have been examined. If the proofs have been printed with black ink, the artist must consider the following:

(1) whether the plate should be printed with black or color ink;

(2) whether additions or deletions should be made before printing;

(3) whether supplementary plates should be developed by additive or subtractive approaches;

(4) whether the initial plate should be printed at the beginning or end of the color cycle.

In many cases, color studies can be developed with pastel, crayons, or paint over trial proofs of the original or supplementary plates. Provision must be made for adequate registration of all succeeding drawings as well as printings. Sometimes it is possible to make a key drawing from proofs of the first plate; at other times, separate key tracings must be made after each successive printing before drawing the next plate.

It can be seen that complex decisions and great risks are involved in using the evolutionary system. However, the artist is offered a greater latitude of approach as well as a more continuous creative involvement than when using the other systems.

7.6 PLANNING THE COLOR LITHOGRAPH

It is sometimes mistakenly believed that thorough preparation will dull the artist's creative momentum and thus reduce work to a reproductive exercise. This need not be so; the faculties engaged in conceptual planning are different from those involved in execution. The technical and theoretical problems encountered in making a color lithograph are such that orderly planning is required. This is particularly true for the beginning lithographer. As the artist becomes more proficient, he may eliminate one or more of the steps described below provided that he has learned how to compensate for their absence. Preparations for a color lithograph usually include the following:

(1) preliminary drawings and color sketches,

(2) determination of the dimensions of the print paper,

(3) determination of the dimensions of the image format and its positioning on the print paper,

(4) color-separation sketches,

(5) a key drawing,

(6) determination of the registration system to be used, and

(7) determination of the number and size of the stones or metal plates to be used.

A number of relations between the size of the image and the size of the printing element must be considered. Preferably, the paper should not be larger than the printing element. The size of the image and the margins of the print depend on the system of registration and the location of the register marks. Marks to be printed on the paper should not be visually distracting. Moreover, they must be placed at least ¾ inch inside the edges of the

printing element, so as to prevent the press scraper from running over the end. Thus, if the printing element and the paper measure 16 by 20 inches, the size of the image should not be larger than 15½ by 18½ inches. (See secs. 7.3 to 7.11.)

7.7 COLOR STUDIES AND SEPARATION SKETCHES

Preliminary drawings and color studies are useful for resolving the basic color and structural organization of a color lithograph. The studies can be executed freely with transparent or opaque watercolors, colored pencils, pastels, or wax crayons. To a certain extent, the character of the intended image will suggest the materials and treatment best suited for the studies. One should understand that the studies need not be definitive. However, they should be sufficiently clear to allow for easy translation into the lithographic medium. The completed print will look quite different from the sketch.

Studies of this type are extremely helpful if the artist is working in collaboration with a printer. They allow the printer to visualize the artist's intention from the outset. He can offer valuable technical advice on the number of colors and printings that may be involved as well as on procedures that might enhance the artist's concept.

Color-separation Sketches. Further clarification of a color study is often necessary. Separate diagrammatic sketches outlining the major color areas can be made on tracing paper placed over the study. Drawings conforming to these separations must eventually be placed on each color plate. Additional notations on each tracing can detail the technical considerations for that particular plate. These may refer to overprinting nuances or surface effects that require specific treatment when the plates are drawn. The separation sketches will also help the artist and the printer to determine the sequence and number of printings necessary to produce desired color mixtures. The key drawing is made after the separation sketches are completed. Before the key drawing is described, it is necessary to examine the various systems of color registration used in color lithography.

7.8 SYSTEMS OF COLOR REGISTRATION

Many systems are used in color lithography to ensure accurate color registration. From these, three have been selected that are simple as well as efficient. Two of these systems position the edge of the print paper to

registration marks on the printing element. The third uses a set of pins pierced through register marks printed on the impression. Each of these systems has advantages and disadvantages. The character of the artist's work should determine selection of the system used.

7.9 REGISTRATION FROM THE PAPER EDGE

In the simplest method of color registration the outer corners of the print paper are keyed to corresponding marks on each color plate. The process is similar to that used in positioning sheets for black-and-white prints so that their image is centered within the margins of the paper. (See sec. 4.5.)

Register marks corresponding to the corners of the print paper are located first on the key drawing, so that they can be traced to each color stone or plate in correct alignment with the separate images. The marks are carefully drawn on the dampened stones or plates with a printer's lead or strip of brass rule.

This system of registration can be employed successfully only if each sheet of print paper has 90-degree corners and is cut to exactly the same size. Furthermore, each sheet must be positioned exactly on the register marks or just inside them. Variations of positioning will be inevitable if the register marks are too thick or if the corners of the papers have uneven deckles. In view of these variables, it is essential that each sheet of paper be guided first to the nearest left-hand register mark before its alignment with the other marks. This approach should be followed for each impression throughout all successive printings. Thus, variations in the size of the sheets will occur only at the opposite end of the print and can be visually absorbed by the margin rather than within the image.

From the above description it can be seen that misregistration of as much as 1/16 inch (either vertically or horizontally) may often occur when this system is used. Consequently, it is recommended only for lithographs of loose and open configuration where color alignments are not critical. For works having this character its speed of execution is unsurpassed.

Alternative Method. A variation of this system permits greater control with slight additional effort.

1. Register marks are drawn with tusche on the stone or metal plate carrying the first color.

2. The print paper is cut larger than the register marks; these are printed on each sheet when the first color is printed.

3. The sheets are trimmed with a sharp edge to conform to the register marks. Thus the positioning of the first color and of the contours of each sheet matches.

4. The sheets are then positioned, as before, with respect to the identical corner marks placed on each color stone.

NOTE: The precise mechanical qualities of cut edges convey an entirely different aesthetic character from that of deckle edges. Therefore, this system should be used only for prints that can be enhanced by a crisp, sharp edge.

7.10 THE CENTER-MARK SYSTEM

The center-mark system of color registration requires that penciled register marks be put on every sheet of printing paper before printing. The marks on the paper are then aligned to positioning marks on each of the printing plates. As in the method previously described, paper is positioned from the edge of the sheet, but in this system there is greater control and accuracy.

The paper is prepared by first tearing each sheet to the same size and with right-angle corners. All the papers are then piled with their printing surface down and with their watermarks facing in the same direction. Pencil marks are lightly ruled on the reverse side of each sheet. These marks should be approximately $\frac{3}{8}$ inch in length and in the center of each end, parallel to the vertical of the sheet. The line at the left end of the sheet of the sheet is crossed vertically with a short line called the *T-bar*. This enables the printer to tell one end of the sheet from the other and ensures that each sheet will be identically placed on the printing surface.

The printing plate is prepared with register marks similar to those on the paper. These may either be scratched and etched in the stone or precisely drawn with a printer's lead. The left side of the stone at midpoint should carry a vertical line $\frac{3}{8}$ inch long put in the place where the edge of the print paper will be laid. A horizontal line of the same length is butted to the vertical, forming a T the reverse of the T on the print paper. A similarly positioned horizontal is drawn on the right side of the stone starting where the right-hand edge of the print paper will lie.

The paper is positioned by aligning the left edge of the sheet with the T-bar on the printing surface and by lining up the horizontal lines at both ends of the sheet and printing surface to form continuous lines. Figure 7.16 illustrates the positioning marks on the paper and printing surface.

The accuracy of this excellent system of registration depends on several factors. Because the positioning of the

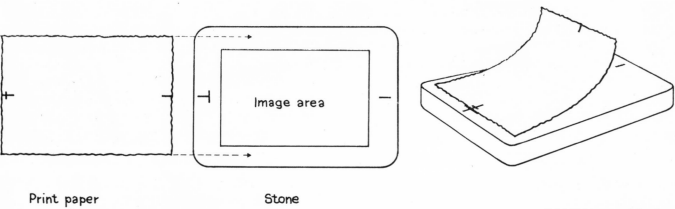

Print paper Stone

sheet is controlled only by visual means, it is important that marks on the paper and printing surface be in exact alignment. All registration marks should be extremely fine and absolutely accurate in measurement and positioning on each sheet of paper and on each color plate. The printer should lean over the plate when positioning the paper to avoid distorted or foreshortened views of the alignment. Slight errors in the positioning can seldom be detected until the next color is printed. (The following paragraph describes corrective measures for realigning impressions that have been misregistered.) Another problem results from the irregularity of the deckle edges of handmade papers. These prevent a tight butting of the sheet against the T-bar on the printing surface. For absolute accuracy, the deckle for each sheet should be slightly trimmed with a razor blade to offer a $\frac{3}{8}$ inch straightedge at this point. Properly executed, the deckle trim is imperceptible against the irregularity of the sheet edge.

Transparent Overlay System. Transparent sheets of Mylar are used at Tamarind for positioning drawings accurately on color plates when using the center-mark system of color registration. (Clear acetate sheets can also be used for this purpose, although they are prone to slight stretching when printed. Consequently, they are less reliable for checking extremely precise registration.) Key drawings for tracing color plates are placed on sheets of Mylar .005″ thick. Thinner sheets .003″ thick are used as overlays for checking the alignment of printed impressions with the next color to be printed.

Misregistration in color printing can occur through (1) faulty drawing of the color plate, (2) improper positioning of the sheet, or (3) stretching of paper during printing. Each of these problems can be corrected or compensated for by use of the transparent-overlay system after all impressions of the first color have been printed.

1. A Mylar impression is taken from the second color plate (and all subsequent color plates). The registration marks of the printing element are scratched onto the Mylar before it is removed. The impression must be carefully dusted with talc and cleaned with cotton, because the ink will not dry rapidly on its surface.

2. The Mylar impression is taped along its top edge to a chipboard base with its image side down.

3. Before printing, each impression of the previously printed color is positioned under the Mylar proof until both images are exactly aligned. The penciled center mark of each impression should be lightly marked on the image side of the paper in order to check against the register marks of the overlay. In some cases it is more desirable to prick the horizontal line of the T-bar through the overlay and the edge of the paper with a pin. In this way the overlay is used to check whether the colors of the two images meet and overlap correctly and whether the registration marks are accurately related. With some images, a light box will make such checking easier.

4. If the overlay shows the need for correcting the new image or its register marks, the correction can be marked on the Mylar proof and traced from it to the printing element. More often, the overlay will show that the paper has stretched during printing. Hence realignment on the horizontal or the vertical axis of either or both ends of the sheet may be necessary. The pin-pricking technique of step 3 enables the printer to see from the back of the sheet the degree of compensation necessary to secure alignment for the new printing.

With this approach each impression is checked against an overlay of the following color before being printed. Thus, accurate registration is assured throughout the printing of the edition, regardless of faulty placement of the paper on previous colors.

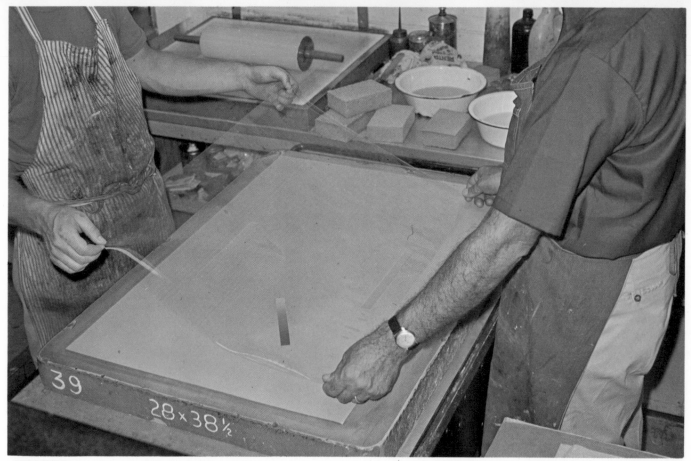

a. Positioning the Mylar sheet

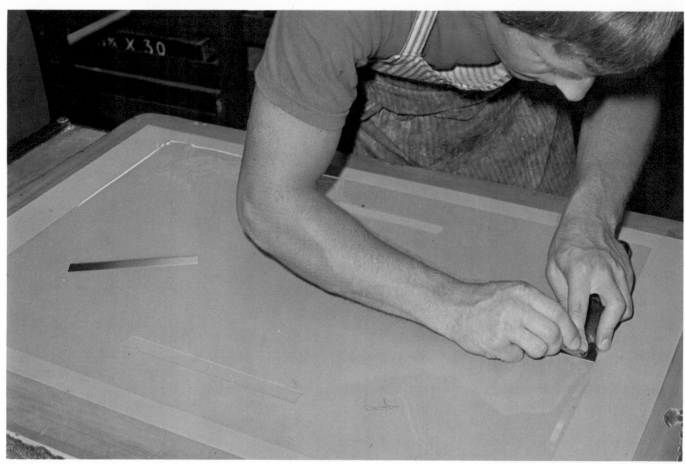

b. Scratching register marks on the Mylar

7.17 Making an impression on Mylar

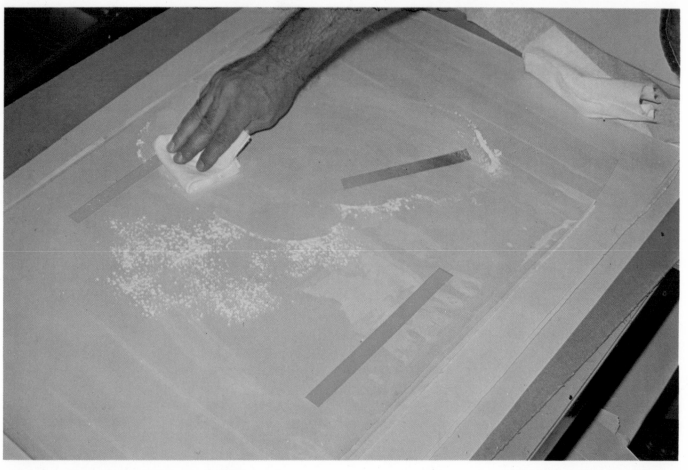

c. Dusting the impression with talc

d. Removing the Mylar impression

7.11 PINHOLE SYSTEMS OF REGISTRATION

Traditionally, the most commonly used system of color registration utilizes two pins, or wire shafts, which pierce two printed register marks on the impression and then fit into corresponding minute holes in the stone. The printer lowers the paper along the pin shafts until it falls into place on the stone. He then removes the pins, using them again as he prints the next impression.

The chief advantage of pin registration is the accuracy it offers. The paper goes only where the pins lead it, and the pins engage register holes whose position on the stone has been carefully determined beforehand. Accuracy is aided by simple mechanical means rather than by variables of hand and eye as in the methods described above. Pin systems, however, are not infallible. Misregistration can occur because of carelessly drawn register marks, inaccurate piercing of the impressions, or inaccurate locations of the holes in the stone.

Pin registration requires delicate manipulation and considerable practice before it can be used with precision or speed. It should not be attempted by one person if the distance between the two register marks is greater than twenty inches. Larger sheets of paper require the assistance of a second person. Pins are especially difficult to use on thin or fragile papers. These tend to pull and tear at the pinholes, creating a condition which is aesthetically undesirable and which impairs the registration of subsequent colors because of the play of paper around the enlarged holes. Despite these problems, a great number of American and European color lithographs are produced by pin registration. The high skill of fine color printers can be truly admired here. Even upon close examination the pinholes are all but invisible in a printed edition.

Procedure. The register marks for this system consist of very fine cross hairs or dots which are placed outside the image format and equidistant from top and bottom along the left and right margins of the first color plate. The exact location of these marks is a matter of individual preference. Images with narrow margins require marks set close to the format. Some printers use the diagonal corners of the image itself for the positioning of register marks. These are eventually covered by the edge of the image and cannot be detected on the finished print. One should remember that these marks are intended to print on the first color impressions. Hence they must be sufficiently inside the outer edges of the stone to permit the press scraper to pass over them. Furthermore, they should print as near to the outer edge of the print paper as possible in order to permit easy handling of the sheet with the register pins during subsequent printings.

The register marks may either be drawn with a fine pen and Autographic Tusche or put on the stone after it has been processed. This is done by scratching through the dried gum coating on the stone with a stiff and finely pointed tool. Only the coating should be scratched to expose the stone. Deeper scoring will produce an intaglio line which will hold ink but will not print satisfactorily because the pressure of the press cannot push the paper into the crevice. Thin oil or asphaltum is rubbed on the stone through the scratches while the gum coating remains. After the stone is washed out and rolled up, the greasy scoring will accept ink and will print very fine register marks on each impression.

Each color stone should have its register marks carefully traced from the key drawing. On all stones except the first (whose marks are made to print), a minute hole is bored at the exact intersection of each mark so as to accommodate the register pin. The boring instrument is a thin awl-like tool, steel punch, or stout etching needle which has been ground to a very fine point. The point is rotated carefully with slight downward pressure on a wet stone. Undue pressure or wobbly rotation will chip or shale the stone around the edges of the hole, causing faulty or loose pin engagement. The hole need be only deep enough to permit the pin to click into place and remain engaged. Unnecessary drilling only increases the task of grinding the hole away after the printing is completed.

The register pins should be very thin and reasonably stiff. Fine sewing needles or specimen-mounting pins are excellent for this purpose. Very efficient instruments can be made by inserting the pins into balsa wood or Plexiglas holders, as shown in fig. 7.22. The lighter the holder, the easier will be its balance for handling. A set of two pins is necessary for the registration process. (A well-equipped shop should have at least six sets of register pins in case of breakage or dulling.)

Once all impressions of the first color have been printed, the intersections of the register marks are precisely pierced with one of the pins. When the second color stone is ready for printing, the register pins are inserted in the holes of the print paper (from the back) and carried to the stone. The paper is lowered on one side until the first pin is engaged in its proper hole in the stone. The opposite side is then lowered until the second pin is in its place. The sheet is lowered along the pin shafts until it touches the stone; it is lightly held as the pins are carefully removed and set aside for the next print.

These procedures may prove useful:

1. Each sheet of paper (with pins inserted) is carried to the stone image side down. Which end of the paper will

Location of register marks for one-man registration using pins

Location of register marks for pin-and-rod registration

Location of register marks for two-man pin registration

7.18 Location of register marks

a. Piercing register marks on the printed impressions

b. Inserting the register pin through the back of a printed impression

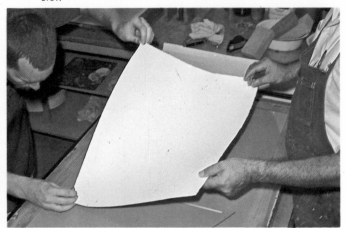

c. Boring a register hole in the printing plate

d. Two-man registration with pins

e. The proper method of gripping the pin and paper

f. One-man registration with pins

g. Removing a printed impression

h. Examining a printed impression

7.19 Techniques of pin registration

be led to the stone first should be determined beforehand in order to prevent its being printed in reverse. The pierced sheets of the first impression are then piled face down, with the image facing in the same direction for all sheets. Further inspection during printing is unnecessary.

2. After the paper is on the printing surface, the register pins should be removed with care. If the paper slips during the removal of the pins the image will print out of register. The paper is lightly held after the pins are removed until the backing sheets and tympan are in position. (Sometimes the rush of air caused by the lowering of the backing sheets can lift the print out of position.) A small sponge can be used on the press bed as a pincushion to hold the register pins after removal from the print. The pins are then easy to locate and pick up for the next impression.

3. When working alone, some printers find it easier to set the first pin in a register hole located in the upper left corner of the stone, and then to swing the paper in a quarter arc to engage a pinhole located in the near right corner of the stone.

4. Pin registration is simplified if a press assistant is available to help. Sometimes it is his task to pierce the impressions and carry each to the press. He grasps and positions one pin while the printer positions the other. In such cases, the register marks should be located in the diagonal corners of the sheet for easier handling.

5. Some papers will tend to stretch after the first and second printing and thereafter remain reasonably stable. A slight flexibility in the pin shafts can accommodate minor stretching and still permit engagement with the pinhole in the stone. In such cases the paper should not be pushed all the way down the pin shaft. Instead, the pin should be removed the moment the paper binds against the shaft. The paper is permitted to drop free for the remaining distance. Unless this is done, the hole in the paper will become torn or enlarged, thus making subsequent registration of that sheet impossible.

Pin-and-Rod Register Device. The system of pin registration described above can be used by one man for positioning medium-size sheets of paper but requires two men for positioning larger sheets. Another system using a pin-and-rod device enables the printer to register papers up to 40 inches long without assistance.

The instrument used in this system is fabricated from brass or aluminum rod and tubing. It consists of a rod approximately $\frac{3}{8}$ inch in diameter and about 32 to 34 inches in length. (The general rule is to make the rod several inches longer than the width of the largest stone to be printed.) Two sleeves of .020 gauge tubing of close

7.20 Technique for registering large-size paper

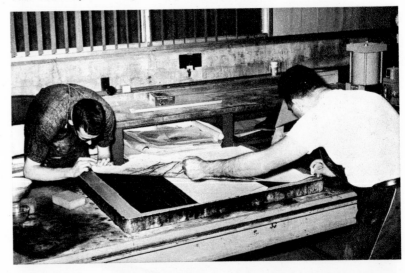

a. Lowering a large sheet of paper: note the newsprint slipsheet to prevent smearing

b. Aligning the pin to the register mark

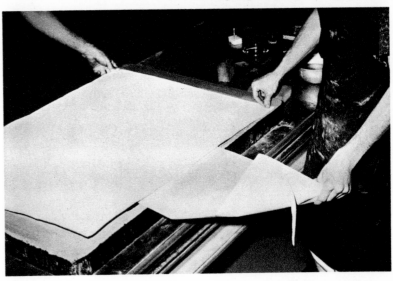

c. Removing the slipsheet

7.21 Register pins and pin-and-rod device

Two sets of register pins and the pin-and-rod device; a small block of styrofoam is an effective pincushion

tolerance are slipped over the rod. Each sleeve measures 1 ¼ inches long and has a hole ⅛ inch in diameter drilled and tapped to hold a small set screw in its center. In addition, each sleeve has a pin fashioned from fine piano wire soldered on the opposite side from the set screw. The pin should be 1 ¼ inches long and sharply pointed at one end. The pin and set screw should appear on center to the circumference when viewed from the end of the sleeve (fig. 7.23).

If the pin-and-rod device is to be used, the register marks must be put at the top and bottom along the left side of the stone. These may be in the margin or at the corners of the image.

All impressions of the first color are printed carrying these marks. The marks are then pierced with a register pin. The sleeves of the register device are adjusted to conform to the pinholes in the paper and are secured in position on the rod with the set screws. Care should be taken that the pins in both sleeves are in line with each other. The pins are inserted into the holes in the paper from the reverse side of the print. Both the register bar and paper are picked up with the left hand; it will be noted that the rod forms a natural support around which

the projecting margin of the paper may be lightly curled. The right side of the sheet is held up by the right hand while the left hand lowers its side of the sheet until the pins meet previously drilled register holes in the stone. The sheet is lightly shaken until it slides down the pin shafts and touches the stone. The right side of the sheet is lowered to the stone and lightly held while the register rod is carefully removed. The process is repeated for each sheet to be printed.

The register rod may also be used for prints of smaller dimensions. Rods of different lengths may be used for prints of different sizes, although the chief virtue of the rod lies in its ability to facilitate the handling of large sheets by one person.

Like all hand-registering systems, the pin-and-rod device has its shortcomings. Because both register marks appear on one end of the sheet, there is some risk that slight variations in the positioning of the pins will produce misregister at the other end of the sheet. It is necessary that the pins be inserted into their holes in a vertical position and that the rod be held securely until the paper is down. In this method of registration the pins should not be too flexible, for this prevents steady positioning.

5/8 × 1/8" Plexiglas drilled for needle
or piano-wire, pin cemented in shaft

2 – 1/8 × 5/8" balsa strips
glued and wrapped with thread

5/8" 1/8" 5/8" 1/8" 1/8"

1 1/2" 1"
1 3/4"
3" 1/4"
2 1/2"
1 1/4" 1 1/4"

A B

7.22 Two types of register-pin construction

Cut to required length

Aluminum or brass rod
approx. 3/8" diameter

1/2" Set screw

Tap-and-thread sleeve wall

Sleeve to fit snug over rod, needle or piano-wire pin
set in sleeve with epoxy cement

1 1/4"

7.23 Construction of adjustable pin and register rod

7.12 THE KEY DRAWING

After the artist has prepared preliminary drawings and color sketches for his proposed print, it will be necessary to prepare a larger line drawing showing the layout of the image, register marks, and print paper in actual size. This is called the *key drawing*, and it is used as the master pattern from which the color separations and register marks can be traced onto the separate printing plates. Because the key drawing is the definitive guide for the entire work, it is essential that it be accurate in every way.

The key drawing is usually placed on heavy, smooth drawing paper or tracing paper. It is sometimes more practical to place each color area on a separate tracing paper taped to the key drawing. The tracing of these keys must be very accurate so that register marks and image alignments are exact. For prints with abutting colors, it is necessary to provide 1/32-inch overlap for the topmost image to ensure a minimum tolerance for misregistration during printing. If desired, this overlap can be shown on the tracings. Images that are symmetrical are seldom mechanically exact. It is therefore advisable to mark the top of the image and the top face of the tissue with an arrow or appropriate indicator to avoid errors of tracing upside down or in reverse. The key drawing or separate tracings are turned over, and the register marks and color areas are traced onto each stone by using the red-chalk tracing method. (Reversing the tracing ensures that the left-to-right relationships of the finished print will appear as originally intended.)

It is sometimes necessary during the development of a color lithograph to print additional colors not planned at the outset. Colors may be added either to enhance the work aesthetically or to correct errors in drawing or registration in earlier printings. In such cases, the original key drawing can seldom be relied upon to ensure accuracy. A new tracing should be made either from a proof of the print in its current state or from the image on the last printed stone, whichever is the more convenient or reliable. If the tracing is made from a printed impression, it must be turned over before retracing to a new stone. (Tracings from the printing surface are retraced right side up on the new stone.)

Alternative Methods for Keying Drawings. In some cases‡, it will be impossible for the artist to diagram his intentions before actual work. In other cases, a print originally intended as a black-and-white lithograph may be further developed in color. In both cases, the first

‡ Subtractive and evolutionary approaches (sec. 7.5).

image will most likely have been made without a key drawing. It is sometimes necessary to modify this image after proofing to accommodate the paper size and register marks required for its development as a color print. A key drawing is made after the proofing of the first color to guide the development of the following plates.

Usually the procedure involves printing a dozen impressions on proof paper (with predetermined register marks, when possible) in an approximation of the contemplated color. The stone is then rolled up with black ink and gummed down. The proofs are examined, and decisions about the next drawing and color are made. If the artist is flexible in his intention, he may draw directly on one of the proofs with colored chalk or oil crayons until he arrives at a satisfactory solution. This proof sketch is then placed under a clean tracing paper, and the new color area, as well as its register marks, is drawn. This constitutes the key drawing for the second color. The drawing is turned over and traced onto a new stone, which, upon completion, is printed in the appropriate color and registered against the rest of the proofs of the first color. This stone is also rolled up with black ink and gummed down before decisions about the third color are made. In this way, the work progresses from one drawing and proofing session to the next until the total image is completed. The purpose of the original dozen proofs is now evident; they will have served as color sketches of the evolving concept as well as a series of progressive trial proofs. It is usually necessary to run a second series of progressive proofs in order to refine each color mixture as well as to make minor corrections on the printing plates. After this, all stones are touched up, cleaned, and put away until the edition is to be printed.

A further refinement of the above system requires pulling Mylar proofs of each color plate as described in sec. 7.10. Because Mylar is more stable dimensionally than tracing paper, it ensures greater accuracy for tracing and for registration alignment.

7.13 KEY IMPRESSIONS AND CHALK OFFSETS

A variant of the foregoing keying procedures eliminates the necessity of hand-tracing each color plate and ensures that the image layout and register marks are identical for each plate. It is somewhat more time-consuming than the other methods, but is an excellent approach for certain types of work, such as Hard-Edge prints, which require extremely precise drawing and registration.

First a linear key drawing, showing the major color

areas and register marks of the print image, is made. This is turned over, traced onto a stone, and carefully drawn in outline with Autographic Tusche. The stone is processed for printing, and a number of impressions are pulled on a smooth, hard paper such as bond, vellum, or tracing paper. There should be sufficient proofs for each color stone contemplated, plus a few extra sheets, in case the print requires additional colors beyond those already envisioned.

The freshly inked impressions are lightly dusted with red chalk, which clings to the tacky ink. The excess chalk is flicked off the paper, which is then placed on a dry stone and run through the press with moderate pressure. Each key impression is transferred to a different stone. The pressure of the press will offset the chalked image and its register marks on the printing surface with crisp and clean definition. In this way, the impressions serve as exact guides in the development of drawings for each plate. The original key stone may also be counteretched and drawn upon as one of the color stones. Unwanted areas remaining from the key outline can be deleted by honing or scraping with a blade as necessary.

7.14 DETAILS OF DRAWING AND PROCESSING

Color lithographs are drawn and processed in the same way as black-and-white lithographs. Most of the tools and drawing techniques described in the early part of the text can be employed in color lithography (see secs. 1.1 to 1.10). The stone or metal-plate printing surfaces are also processed for printing in the usual way. Even so, because the drawings are to be printed in colored inks rather than in black, the artist soon learns that he should do his work in a slightly different way than he might for black and white. The following suggestions may be helpful:

1. Multiple color work depends on a series of drawings and printings to produce the complete print. There is less necessity to utilize a broad range of effects in any one plate. Hue, value, intensity, and textural modulation should be carefully planned to occur through the successive printings.

2. An overly complex variation in drawing techniques in the early color plates of the print may result in a fussy final image.

3. The greater the number of tonal and textural changes in any single plate, the weaker its printed hue will appear. The value and color saturation of the printing will have become too broken to assert themselves against the other colors. This characteristic is difficult for the novice to comprehend, because he cannot visualize the cumulative effect produced by the total number of printings.

4. Individual plates should be firmly drawn. Tonal passages will be more effective if contrasts are slightly exaggerated; otherwise passages that are extremely delicate or have subtle tonal transitions may disappear during successive overprintings.

5. Drawings made with medium to soft grades of crayon or medium to dark tusche washes and scumbles produce the best results.

6. Darker drawings may be more strongly etched to ensure clean printings. This will prevent color ink from filling in the image.

7. Sometimes the drawings for the first few plates of a color work are kept rather loose and open so as not to fix the image too quickly. Rubbing crayon and tusche scumbles are useful for this purpose. Subsequent color plates can then be drawn more carefully to give firmness to the image.

8. Often the early printings will have produced poorly related passages whose contours do not properly merge. Subsequent overprintings with drawings made with rubbing crayon can greatly improve these harmonies.

9. The use of deletions as a means of developing the image should not be overlooked; it is a method of particular value in color lithography. Total removal of drawing areas permits the lower colors to appear clear and unmodified; partial removal produces blends and broken mixtures of the upper and lower colors. Such modifications are useful to soften or heighten the total color quality of the print as well as to produce the tactile interplay necessary for certain graphic statements.

7.15 CHARACTERISTICS OF COLOR INKS

Certain characteristics of color inks should be understood by both the artist and the printer during the planning and printing of color lithographs.§

From the artist's viewpoint the range of color in inks is infinitely greater than is usually encountered in painting. The hues are purer and often more intense than artists' pigments, although care must be taken to select colors that offer resistance to fading. Most inks for color lithography print semitransparent films. Greater transparency can be achieved by adding varying amounts of nonpig-

§ Because the subject of color inks is complicated by many interrelated factors, a further discussion of their properties and use is included in chapter 11.

mented transparent ink to the basic mixture. Few truly opaque color inks are available, although a limited range of opacity can be developed by printing several colors over one another. Most of the pigments used in color inks exhibit properties of both mass tone and undertone; that is, a single color will appear to be of a different hue in the masses and in the tints of the same drawing (see sec. 11.8). Through careful planning of both drawing and color selection, the artist can utilize this characteristic of inks to increase the color range of his print while at the same time restricting the actual number of colors employed.

From the printer's viewpoint, all color inks are softer in body and greasier than roll-up black ink. During manufacture, each color pigment requires a different balance of vehicles and modifying agents to produce satisfactory coloration and printing properties. As a result, the consistency and behavior of the ink will vary from one color to another and from one manufacturer to another. More often than not, the printer will need to further modify the ink mixtures in order to satisfy requirements for a particular work. Various materials may be incorporated to make the ink less greasy, firmer, more or less viscous, faster drying, etc. (See sec. 11.3.)

Color ink is generally distributed on the printing element with a smooth roller made of rubber or synthetic materials (see secs. 14.9 and 14.10). Such rollers are somewhat less maneuverable than the leather roller used for black ink. Consequently, the beginning printer is more likely to encounter filling in of the image during color printing than during black-and-white printing.

Most of the colors will dry sufficiently overnight to permit subsequent overprinting on the following day. Methods of control, which can assure the printing of the entire color sequence for a lithograph without unnecessary delay, are described in the following sections.

7.16 MIXING COLOR INKS

Color ink is mixed in much the same way as paint is mixed. The correct procedure is to place small amounts of the inks to be used around the perimeter of a small glass mixing slab. (See secs. 11.13 and 11.14.) Each color is taken from the ink can with a clean spatula. The colors are brought together in the center of the slab with an ink knife and mixed to the color desired. The mixture is periodically tested by lightly dipping the forefinger in it and tapping the deposit on a clean swatch of the type of paper that will carry the print. The color tap-out must be carefully made to approximate the density of the ink when actually printed. In this way, adjustments of hue, value,

intensity, and transparency can be made until a satisfactory mixture is achieved. Once established, larger proportions of the same color can be mixed (with periodic matching against the approved tap-out) until the necessary volume of ink has been prepared. One should always mix a somewhat greater volume of ink than anticipated for the actual printing, since it is very difficult to compound a second mixture with exactly the same hue and consistency as the original.

After the desired volume of ink has been mixed thoroughly, it is checked for consistency. Where necessary, modifiers such as varnish, reducing oil, or magnesium carbonate are added and mixed in so that the ink has satisfactory working properties. It may then be distributed on the main ink slab in long ribbons and rolled into a smooth, even layer, like black ink.

The ink slab, roller, mixing knives, etc., are cleaned with rags and kerosene after the completion of printing. Surplus ink may be kept in clean cans with tight lids or wrapped in aluminum foil for prolonged storage.

7.17 PROOFING AND PRINTING COLOR LITHOGRAPHS

Proofing and printing color lithographs are more difficult and prolonged tasks than proofing and printing black-and-white work; and the attention of both artist and printer is focused on a much more complex series of interrelationships. Although the steps for printing remain essentially the same, the procedure becomes more complicated as the number of color plates increases. Each color plate must not only print satisfactorily but must also combine accurately with the other color plates. Ink color and consistency must be mixed specifically for the printing requirements of each plate. In addition, the plates must be printed in proper sequence and in alignment with one another. The proofing process is even more important in color printing than it is in black-and-white printing. If the cumulative result is unsatisfactory, proofing must be repeated. The colors for each plate may need to be modified or the order of printing changed. Sometimes the images on each plate must be corrected to improve the expressive properties, to allow improved color orchestration, or to permit closer registration with the other plates. Like that of a black-and-white lithograph, the image of a color print is considered to be in a fluid state during the proofing process.

The printer must also determine which of several proofing procedures to use and whether proofing can be completed in one day or over a period of successive days.

He must decide whether a complete set of progressive proofs is required or whether it would be better to print the edition immediately after proofing each plate.

7.18 PROCEDURES IN PROOFING

The correct approach to color proofing is determined by the color sequences chosen during the planning of the work or by the sequence in which the plates are actually drawn and processed (see sec. 7.4). Because of the additional steps involved in color work, the printer's efficiency during the proofing operation depends on carefully calculated work schedules. Through experience, the printer determines the variables involved in each job so as to schedule its completion with the greatest economy of time, money, and effort.

1. Simple Proofing. Simple color lithographs require little effort in proofing. These often contain few colors and are so drawn that few or no changes are required during the proofing process. If the plates are drawn in sequence, using the additive system, they should be proofed in the same progression. Lithographs that have been planned with explicit color sketches do not need lengthy proofing. Instead, the printer mixes a very accurate color ink, pulls a few impressions until the plate is printing satisfactorily, and then prints all of the edition without interruption. This procedure saves much time, since only one set-up for the job is necessary. Scheduling in such cases depends more on the time estimated for printing the edition than on the time involved in proofing.

2. Proofing by the Subtractive System. The subtractive system requires that each plate be proofed and the edition printed before the plate is permanently altered for the next color. If the edition is small and the artist and printer have retained their energy and enthusiasm, the image can be altered for the next day of printing. Otherwise the work is altered the following day. After preliminary proofing, the entire edition is printed with the second color. The work proceeds through successive image alterations, proofings, and printings until the edition is completed. The actual process will seldom flow as smoothly as suggested by this description. Sometimes the plates will require additional time to alter or stabilize the image. There is always the possibility that supplementary plates may need to be designed as the proofing progresses. Because of the variables involved, additional proofing and edition papers should be printed from the beginning.

3. Complex Proofing. Prints that have a number of complex color relationships should be proofed progressively. This type of print usually requires modifications of both color and drawing during the proofing process; final results are difficult to foresee during the early stages of the work. Corrections and color refinements for each plate cannot be undertaken until a finished impression of the final plate has been printed. Consequently the work may require progressive proofing more than once before the edition can be printed. Prints developed by the evolutionary process usually require the most prolonged proofing because the concept for the print evolves as each plate is printed. The original sequence in which the plates are drawn and proofed may not be the best. Several proofing sessions may be necessary to perfect images, select colors, and determine printing sequences. Considerably more proofing and edition papers should be provided for complex proofing procedures, inasmuch as the variables involved usually require much more printing. To estimate total proofing time is very difficult for this type of work, for a number of unknown factors are likely to be encountered. Generally, the first sequence of proofing can be accomplished within a four to eight-hour period, if the work is of medium size. Corrective and final proofing during subsequent sessions may take twice as long. The work schedule should be set up in half-day sessions, for shorter work periods may prove wasteful of time.

Collaborative proofing requires the presence of the artist during all critical phases of the process. He must approve the color and quality of the printed impressions in a preliminary way even during the first proofing cycle. During the second sequence, he must be present to correct the plates, to approve more critical color mixtures, and finally to approve the *bon à tirer* impression. Accordingly, the printer should notify the artist of the planned printing schedule for each phase of work.

PROOFING PAPERS FOR COLOR LITHOGRAPHY

The same types of proofing paper used for black-and-white work are used for proofing color lithographs. However, a greater number of sheets must be prepared to allow for modifications of each plate throughout the proofing sessions.

1. Rough Proofing. Each color plate is proofed on newsprint until the image is stabilized and printing dependably. These proofs can be destroyed immediately after they are examined.

2. Intermediate Proofing. A paper of intermediate quality, more nearly like edition paper in color, weight, and printability, is employed for a more critical appraisal of the image and its color effect. During this period the color and consistency of the ink are refined, the registration techniques are perfected, and the corrections of the image are made. If corrections to the image are extensive,

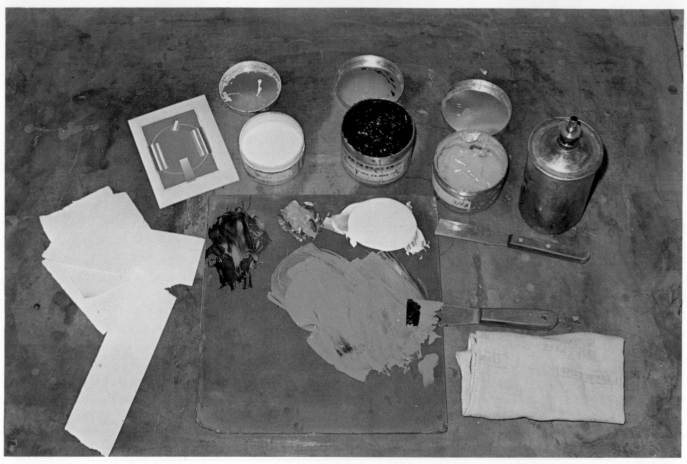

a. The materials for mixing color ink

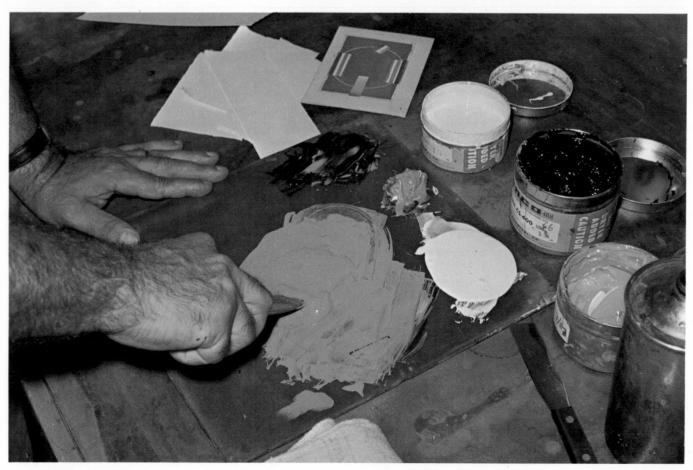

b. Mixing the ink

7.24 Mixing color ink

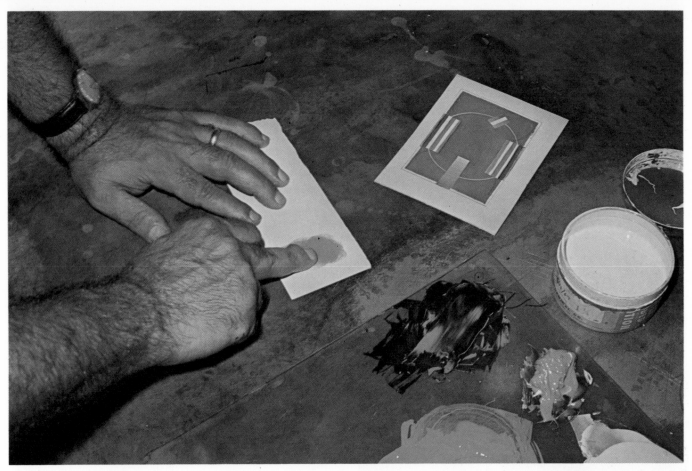

c. Making the color tap-out

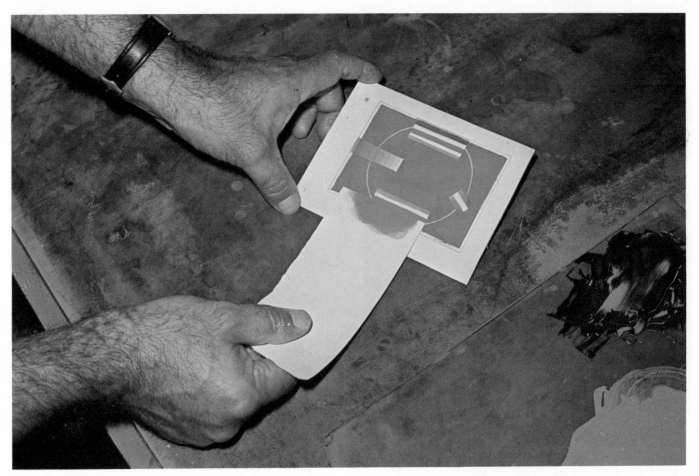

d. Comparing the tap-out to the color sketch

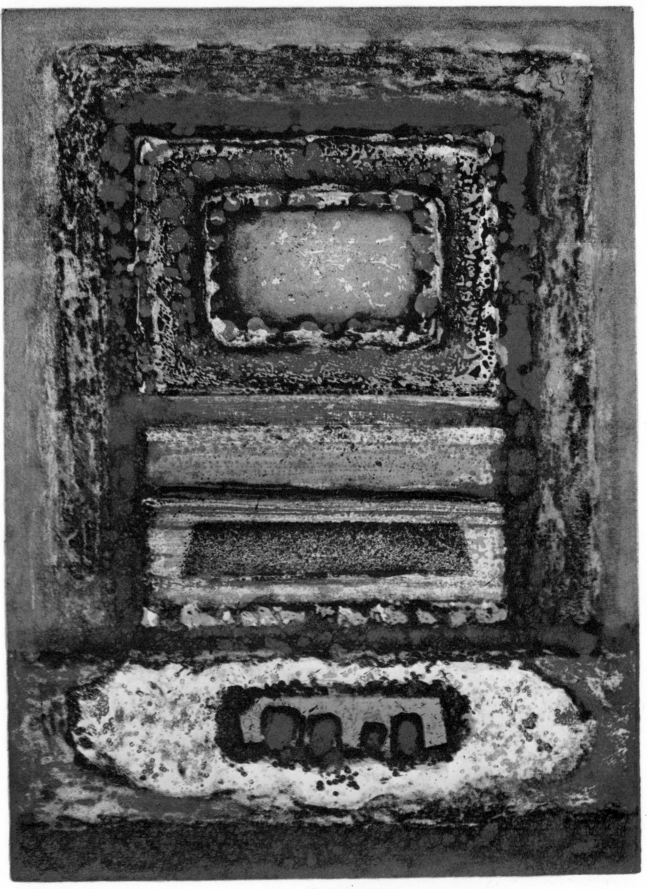

7.25 CLINTON ADAMS: *Untitled* (Plate IX from *Window Series*). 1960. Color-separation plates and definitive lithograph, 18×15". Tamarind Impression (T–103A, 1–4)

the first few proofs are printed on newsprint until the plate is printing satisfactorily. The proofs on intermediate quality paper are saved for proofing the balance of the plates in the color sequence.

3. Critical Proofing. Final decisions for each plate are made from proofs pulled on paper identical to that which will be used for printing the edition. Professional shops will usually print one complete set of progressive proofs on clean, unused edition paper. For example, a print having red, blue, brown, and black plates would require the following progressive proofs printed on the same paper as the edition:

(a) the red plate alone

(b) the blue plate alone

(c) the blue plate printed over the red plate

(d) the brown plate printed alone

(e) the brown plate printed over the red and blue plates

(f) the black plate alone

(g) the black plate printed over the red, blue, and brown plates.

The last impression constitutes the *bon à tirer*. This and the impressions for each color plate are initialed by the artist as verification of his approval to proceed with the printing of the edition.

It can be seen that seven sheets of paper (plus a few extra to allow for spoilage) are necessary for one set of progressive proofs on fine paper. The total amount of all proof papers necessary for the above procedure could be as follows:

	For each plate:	For four plates:
Rough proofing	4—6 (newsprints)	16—24 (newsprints)
Intermediate proofing	4—6	4—6
Critical proofing	7—10	7—10
Slip Sheets	14—20 (newsprints)	14—20 (newsprints)
Total	29—42	41—60

Prints with fewer color plates will require less paper, while those with more color plates or with plates that require complex proofing procedures will require correspondingly more paper of each kind.

PRECAUTIONS WHEN PROOFING

The following precautions are listed especially for the student printer:

1. Repetitive handling and registering of the paper during the entire proofing sequence subjects the stock to continual risk. All the problems of careless craftsmanship in black-and-white printing are multiplied by the number of color plates to be printed. All problems of paper handling and registration should be overcome during the proofing operation, so that the edition printing can proceed with minimum spoilage.

2. Though it is true that the proofing implies trial printing, its underlying objective is to "set up the job." It is essential for the printer to familiarize himself with all the special problems of a particular work so that these can be overcome before the edition is printed.

3. Normally, printed impressions are sufficiently dry after twenty-four hours to permit resumption of proofing. Some slow-drying inks or inks that contain modifiers such as magnesium carbonate require longer periods to dry. When progressive proofing is undertaken immediately or shortly after the first color has been proofed, there is some danger that the wet ink from the impression will set off against the second color plate. The ink that is offset will gradually overcome the gum-etch barrier of the new plate and cause a thickening or filling in of the image. Several methods are employed to overcome this during proofing as well as during the printing of the edition.

a. The printing surface is very lightly sponged with water after its final inking and just before the print paper is registered. The slight moisture film between the paper and the printing surface prohibits the transfer of ink from the paper to the stone, while permitting the fresher and heavier ink film on the printing surface to impress the paper.

b. If this method is unsuccessful, each impression should be lightly dusted with magnesia (using a cotton swab) before being positioned on the printing surface. All excess powder is shaken off before the sheet is registered. The powder has almost no tinting strength, and very little color change will be detected when the new image has been printed. This process may be repeated for each new color printed if the same conditions prevail.

c. Very small additions of ink drier can be incorporated in the ink mixture to hasten drying time between colors during progressive proofing. This approach is of particular advantage for proofing of impressions that carry large areas of solids.

THE STEPS IN PROOFING

The layout of equipment and materials for color proofing is similar to that for black-and-white printing.

1. The proofing papers are cut and stacked along with newsprint slip sheets on a chipboard flat. (See sec. 12.16.)

2. The backing sheets, press tympan, and scraper are

prepared. The water bowls, sponges, and press equipment are set out, and the first color plate is centered on the press bed.

3. The color ink is mixed, and, when everything is ready, the printing plate is washed out and rolled up.

4. Proofs are printed on newsprint until the press pressure and inking patterns are adjusted to print a satisfactory impression. Initial decisions regarding corrections to the image are made, and the image is then printed on intermediate proofing paper.

5. The printer must observe that his registration system is operating satisfactorily. If using the pin register system, he must be sure that the register marks are printing satisfactorily on each impression. He must also check the printing ink for color and performance. Sometimes these matters necessitate numerous modifications, with trial impressions taken for each. At other times very little modification is necessary after the initial set-up. After satisfactory impressions have been printed on the intermediate proof papers, the proofing is completed on samples of the edition paper, and final decisions are made.

6. Pairs of impressions (including those printed on newsprint) are placed back to back between the slip sheets until the proofing is completed.

7. The printing image is washed out and rolled up with black ink; next it is cleaned, gummed, and stored. The ink slab, roller, and printing equipment are cleaned.

8. The printed impressions are examined, and if they are to be pin-registered, they are carefully pierced through the register marks and repositioned in the paper kit. Where T-bar registration is used, the impressions are aligned against a Mylar impression when the next color is proofed.

9. The successive color printings follow in the same way as for the first color.

10. Often a surplus of ink will be left after each color is proofed. This may be saved by wrapping it in aluminum foil, provided it has no drier added. Ink mixtures containing drier should be discarded, since they will be useless after twenty-four hours. The surplus ink is very useful for matching when a larger quantity of the same color and consistency must be compounded for printing of the edition.

7.19 PSYCHOLOGICAL FACTORS RELATIVE TO PROOFING

Certain psychological problems during proofing have great bearing on the outcome of the work. Despite their importance, these are seldom documented in print literature.

First to be considered are the problems encountered when corrections must be made to the image. These fall into two categories: (1) corrections to stabilize the lithographic properties of the work so that it prints accurately and easily; and (2) corrections in the image made for aesthetic reasons. The first category is largely the responsibility of the printer. If the image has been poorly processed or if unusual conditions prevail, it will be difficult to control the work. Thickening of the image, scumming of margins, faulty paper laying, and incorrectly drawn registration marks are vexing problems which can delay the proofing process and tax the printer's patience.

Corrections in the drawing are the responsibility of the artist. In consultation with the printer he must determine whether work is to be added or deleted, and which tools and techniques are best to use. The printer must then decide how the image should be reprocessed to sustain these corrections. If the proofing continues unsuccessfully, the corrections must be repeated until the artist and the printer are both satisfied with the results.

A problem of even greater magnitude occurs if the artist discovers that his basic concept is not satisfying. More often than not, he discovers this only in the last stages of progressive proofing, and he can correct it only by major reworking of each printing plate. As each plate is corrected, it must be reprocessed and proofed again. In this event, the proofing process becomes intermittent, exhausting, and extremely time-consuming.

Successful recovery from such difficult proofing problems hardly leaves either the artist or the printer in a frame of mind conducive to the orderly printing of an edition. Whether the proofing is successful or not, it is usually better to delay the work until the next day, when both partners, refreshed, can resume their labors.

Difficulties of this type are usually attributable to a weak collaborative relationship. They often result from inaccurate planning, indecisive judgments, or lack of communication between artist and printer. The subject of collaboration should be reviewed for a greater understanding of how such problems can be avoided or overcome.

7.20 PHYSICAL PROBLEMS IN PROOFING

The burden of proofing and printing, which is often great, falls upon the printer. The extent of this burden depends on the amount of proofing necessary and the size

a. Inking the first plate with two colors; note blended inking

b. Removing the proof impression

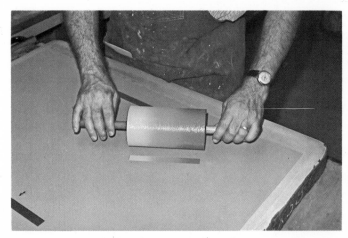

c. Examining an impression of the first color plate

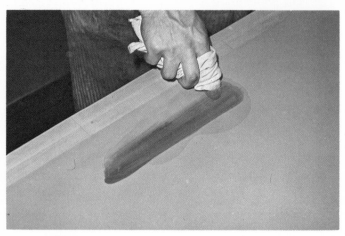

d. Establishing a printing base with thin color ink on the second plate

e. Inking the second plate with two separate colors

f. Removing the proof impression

g. Examining an impression of the second color plate

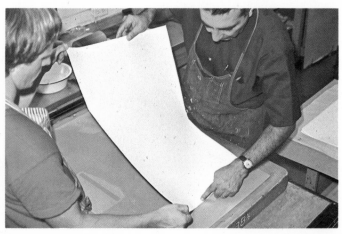

h. Registering the near edge of the paper to the T-line

7.26 Printing a multicolor lithograph with five plates

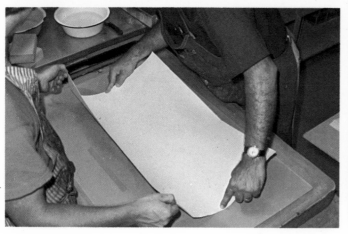

i. Registering the far edge of the paper

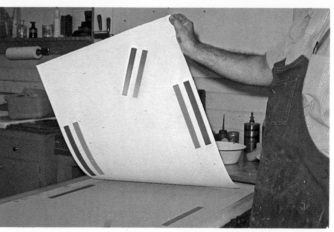

j. Removing the proof impression

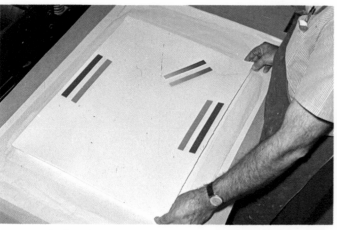

k. Examining an impression of the first and second color

l. Preparing to print the third color plate

m. Removing a proof of the third color

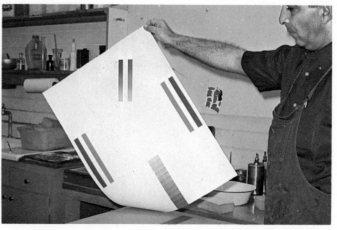

n. Removing a proof having the first three printings

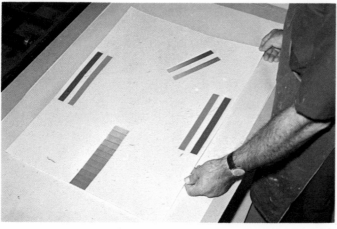

o. Examining the impression showing the first three printings

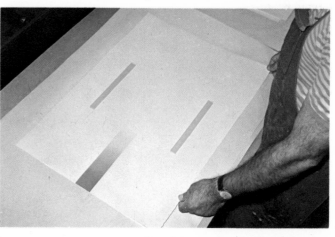

p. Examining a proof of the fourth color

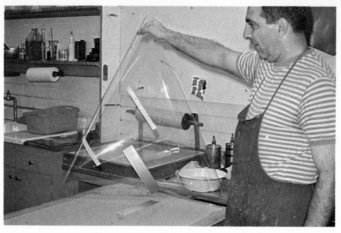

q. Removing a Mylar impression of the fourth color

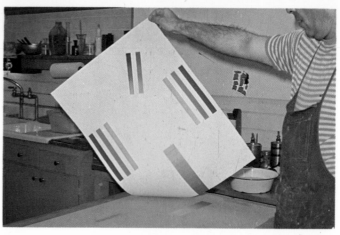

r. Removing a proof showing four printings

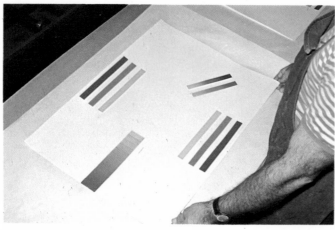

s. Examining a proof having four printings

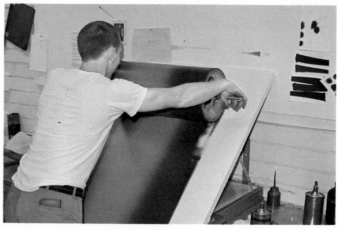

t. Charging the large-diameter roller with blended ink

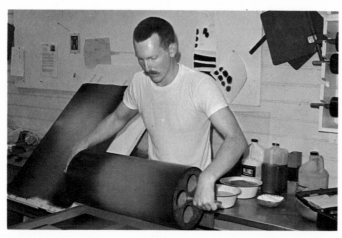

u. Inking the fifth color plate

v. Removing a proof of the final color

w. Examining an impression from the fifth color plate

x. Checking the registration of previous impressions

y. Registering the paper for the final color

z. Removing the proof

aa. Examining an impression of the completed print

of the edition to be printed. If the proofing is extensive and entails many image corrections and color changes, the printer may be operating the press more often than he will for the actual printing of the edition. In such cases, the work pattern is physically exhausting, because its movements are intermittent rather than rhythmical. And the psychological involvement during the development of the print can be equally fatiguing for both printer and artist. Both factors constitute a drain (seldom recognized until too late) that impairs keen judgment and negatively affects the progress of the work. After a complex proofing project, the printer's physical and emotional state is such that it is hard for him to adjust his pace to the regulated rhythm of edition printing. Therefore it is advisable that work schedules be organized with sufficient flexibility to permit the delay of edition printing when necessary.

The printer's physical energy may be conserved by employing a press assistant. In some cases the artist can function also as assistant (with some prior instruction) without interfering with his function of judging the merits of the proofs. His near presence and involvement with the total development of the work may, in fact, be most beneficial.

7.21 THE CHOICE OF PAPER FOR EDITION PRINTING

Edition papers for color lithography are the same as those used for black-and-white lithography. The reader is advised to study secs. 12.2 to 12.17 before preparing the paper kit for proofing and printing.

Several technical matters should be kept in mind when fine papers are selected for edition printing. Calendered papers that have heavily compressed fibers, or a hard surface or heavy sizing, will prevent the ink from penetrating their surfaces. Successive overprintings will tend to pile on top of the paper, creating an unpleasant sheen. As a general rule, the more the printings contemplated, the heavier and softer the paper should be. It is well to remember that repeatedly passing the paper through the printing press compresses it. The heavier papers will be reduced in bulk by almost fifty per cent after the second or third printing. Thereafter, further compression is negligible. As well as compressing the paper, the pressure of the press will stretch some papers considerably. This produces serious problems of registration for the first few colors printed, but not thereafter. The elongation of the

paper will be apparent from midpoint to the trailing edge of the sheet as it passes through the press. In other works, the image may be in register near the leading edge and out of register at the trailing edge. Through experience, the printer should select those papers for color work which offer minimum stretch. Otherwise, he should advise the artist to design the image and registration system to compensate for paper stretch.

The surface appearance, coloration, and weight of the paper are usually the most important aesthetic factors for choosing fine paper. Open and loosely scattered images may appear more attractive if the texture of the paper and its coloration actively participate in the total orchestration. Prints that carry complex overprintings depend less on the nuances of paper surface; here the more neutral the paper surface, the better will be the result.

A factor often overlooked in color printing is the relationship of the paper coloration to the colors carried in the printed image. Contrasts of hue and purity can be heightened or modified by printing on cold white, warm white, or buff papers. In addition, the same colors, printed on coarse papers, will have soft hue and intensity; printed on smoother papers, they will appear crisper and more brilliant.

Papers for color printing should have sufficient substance and weight to support the number of colors anticipated. Thin papers are undesirable for color work, because they absorb a minimum amount of ink. Overprintings lie on top of the paper and dry with a sheen, thus destroying their integration with the paper surface. Thin papers are also difficult to handle when using the pinhole system of registration. One must constantly guard against enlargement of the pinholes. Moreover, thin papers may appear fragile and unsubstantial for color works whose visual characteristics require substance to support their weight.

Of the fine papers listed in Part Two of the text, the following are recommended as the most reliable for color printing:

Rives BFK	Arches Cover
Crisbrook Waterleaf	German Etching Paper
Copperplate Deluxe	Magnani Italia

7.22 PRINTING EDITIONS OF COLOR PRINTS

The actual edition of a color lithograph should be printed following the guidelines established for printing black-and-white editions. Although most of the individual technical problems of the color print should have been solved during proofing stages, they may recur during edition printing.[‖] The single most important source of faulty impressions is the ever-present factor of human error. For example, poor inking, poorly cleaned margins, slipping of paper during registration, and the dropping of a sheet while it is being removed from the press are common occurrences which can result in the loss of an impression. These are but four hazards that can threaten the impression during the printing of any one color. If five colors are to be printed, the risks for each sheet become even greater. In actual practice, it is more usual for one sheet to be spoiled during the printing of one color and another sheet during the printing of another color. Therefore two to four extra sheets per color beyond the desired number to be printed in the edition should be included in the paper kit. The objective of any serious printer should be to control the elements of risk through concentration and disciplined practice. Such control constitutes one of the major differences between a competent professional printer and a student printer.

I. PROBLEMS AFFECTING IMAGE STABILITY

Problems that affect the stability of the printing image are the most serious and demand priority in corrective procedures. Otherwise the fidelity of the printed impressions cannot be maintained, and worse, the entire plate may deteriorate to the point where it must be abandoned. Even though the image may have appeared relatively secure during proofing, the cumulative process of printing can produce conditions that affect its lithographic stability in the following ways:

A. Image Filling by Overinking. Excess ink may accumulate gradually on the ink slab and roller and be transferred to the printing element. The extra amounts of ink, having nowhere to go, are forced beyond the image dots and are impressed between them by the pressure of the press. In time the excess ink will chemically replace the nonprinting areas of the gum-etch barrier and produce permanently enlarged image dots and eventual filling in. A similar problem occurs when the ink on the slab is overgenerously replenished because the impressions seem to be printing too lightly. In both cases, steps must be taken to compensate for overinking and ensure that a constant amount of ink is maintained on the slab, the roller, and the color plate throughout the printing.

Remedy: Plates that are only slightly overinked can be corrected by pulling a few proofs on newsprint without further inking. This will remove the excess ink on the image surface; after the ink supply on the slab and the

‖ It should be noted that the warnings in secs. 7.19 and 7.20 apply to final printing as well as proofing.

roller has been reduced, the printing can continue as before. Excessively overinked plates should be gummed, dried, washed out, and carefully rolled up with lesser amounts of ink on the roller and slab. Little can be done for plates whose images have become permanently filled. Sometimes it is possible to gum and wash out the image and to roll it up with black ink, to be followed by a mild cleaning etch. This will at least protect the current image boundary from further filling, but will seldom return the image to its original condition.

B. Image Filling because of Faulty Ink Properties. Color printing inks are usually both softer in consistency and greasier than black ink. Both properties can produce image filling by grease, which gradually accumulates during the extended period of printing. This effect may not have been noticeable during the shorter period of proofing. This explains why an ink which appeared satisfactory during the proofing may gradually cause filling during the printing of the edition.

Remedy: The ink should be stiffened and made less greasy by additions of magnesia or stiffer varnishes and modifiers (see chapter 11).

C. Image Filling due to Underetching. Lithographic images that are underetched can become filled because their ink-rejective areas have been insufficiently desensitized. This is a less common occurrence in color printing than is usually supposed. If the image can be inked again with black ink and is capable of producing an accurate series of impressions, the problem is probably due not to underetching but to improperly compounded color ink. It sometimes does happen that the image is slightly underetched. In this condition cumulative inking with soft color ink can eventually destroy its stability.

Remedy: The plate is gummed, washed out, and rolled up with black ink, given a weak gum-acid etch, and dried. It can then be washed out and rolled up with color ink, and printing can be resumed.

D. Image Spreading by Relief. Etching images on soft stones sometimes produce a slight relief effect, in which each ink dot is slightly raised above its surrounding nonimage area. The moisture-bearing, nonimage areas will tend to dry most rapidly around the shoulders of this projection. Meanwhile the ink film (especially if it is heavy) will be squashed beyond the image dot by press pressure. In addition to producing ragged image boundaries, the extra ink will gradually attach itself to the dry shoulders of the projection and produce a permanently enlarged image dot.

Remedy: If the relief effect is only slight, it can sometimes be controlled by inking the plate with black ink and gumming it several times. The plate is wiped dry between each application. The purpose of this is to build up a strong adsorbed gum film along the walls of the relief, so that the moisture film will adhere tightly to the periphery of each ink dot without being slightly thrown aside. This should be supplemented either by using less ink or by formulating a more viscous ink that has less of a tendency to be squashed. The press pressure should also be reduced slightly.

II. PROBLEMS OF INK FORMULATION

Problems of ink formulation are next in importance to those of image filling. Most ink problems should be solved during proofing, but occasionally they return during edition printing. Apart from their effect on image stability, described above, several other problems are worth mentioning.

A. Roller Lap Marks. Roller lap marks are usually produced by inks of such consistency that they release from the roller surface too rapidly on the first revolution and not rapidly enough on the following revolutions. The problem is most pronounced with inks that have too little tack and are too short in consistency. After the first revolution has released the major amount of ink, the roller will have picked up a certain amount of moisture from the plate, which slows down the release of the remaining ink. Inks that are too short are more susceptible to moisture blockage than inks that are more viscous.

Remedy: The ink should be made somewhat more viscous by adding a small amount of a heavy #5 or #7 varnish. The longer the roller can be passed over the work with equal discharge, the more opportunity there will be to regulate the ink film.

Unfortunately, the printer can modify the ink only within narrow limits. If the ink becomes too viscous or too greasy, it may not transfer satisfactorily or it may fill the work. Another remedy for this problem is to employ an inking roller with a larger circumference, which, in one revolution, can completely span the work (see sec. 14.13). Still another solution is to double-print the image. The second printing will almost always obliterate the imperfections of the first printing, although the effect will be of a heavier and somewhat more opaque ink film.

B. Lack of Color Richness. Inks that are too stiff or too short will not transfer well onto the printing image. Consequently, they appear dry and mealy when printed. The condition sometimes worsens progressively during the printing of large editions.

Remedy: The ink should be somewhat thinned and softened with reducing oil, Setswell compound, or Vaseline. (See sec. 11.9.) Progressive development of this condition is brought about by a gradual emulsification of ink on the slab with moisture from the printing plate; this

stiffens and shortens the ink and inhibits its ability to transfer. One should scrape the old ink from the slab more often before replenishment with fresh ink.

C. Color Changes during Printing. The color of the ink may gradually undergo changes of hue, value, or intensity as printing progresses. This is usually an indication of a poorly mixed ink. The more the ink is distributed on the slab and roller, the more thoroughly its components become amalgamated, gradually producing a change in its appearance.

Remedy: The mixture should be thoroughly blended by hand on the small mixing slab before distribution on the ink slab. Large quantities may require five to ten minutes of mixing before complete homogeneity results.

D. Color Change due to Change of Printing Paper. The same ink may have an entirely different appearance on one type of printing paper than on another, because of differences in absorbency and printability. Such variations sometimes occur on different sheets of the same type of paper which have come from separate shipments.

Remedy: It is always advisable to print the entire edition on paper from the same shipment. Considering the variables inherent in the hand-forming process, it is not surprising to find slightly different qualities from one shipment of handmade paper to another. This is less a problem of ink than of paper. It can still be handled, however, if it does occur, by slightly modifying the original ink mixture, so as to match the original color on the new paper.

III. PROBLEMS OF PAPER REGISTRATION

The problems that occur during and after registration of the print paper are mechanical and can be prevented through practice.

A. Enlarged Pinholes. If the edition is to be printed by the pinhole method of registration, the printer must manipulate the pins very carefully each time the sheet is printed so as not to enlarge the holes in the paper. If these do become enlarged, there will be too much play around the shaft of the pin to ensure accurate positioning. In such cases it is sometimes wiser to mark all the sheets and substitute the centerline system of registration for the succeeding printings.

If the pinholes in a color plate are too large, or if a corner has been chipped, accurate registration is imperiled. Here, too, it is better to substitute a centerline system of positioning to ensure greater accuracy.

It sometimes happens that the print paper becomes stretched after the first printing. This will throw the pinholes in the paper out of alignment and also misalign those of the succeeding color plates. It is advisable in such cases to realign and bore fresh holes in the successive plates rather than risk enlargement of the paper holes by forcing the sheet against the shaft of a misaligned pin.

B. Misalignment of Centerlines. Since centerline systems of registration depend on visual judgments, it frequently happens that a novice slightly misjudges the lay of the sheet. This can be easily checked after the sheet is passed through the press. At that time a corrected centerline can be placed on the sheet before it is removed from the printing plate. An over-all check can then be made before the next color is printed by aligning each impression to the acetate proof of the new plate to confirm the position of the corrected centerlines. (See sec. 7.10.)

C. Slurred Impressions. If the print paper slips or shifts during positioning or printing, the impression will be slurred. Slurring occurs most frequently while the sheet is being lowered onto the inked plate and being maneuvered to align the registration. The nearer the image is to the outer edges of the sheet, the less room one has for maneuvering without ink smear. There is no alternative but to estimate alignments before the sheet is down and then to lower the sheet without further shifting.

Slurring on large sheets of paper sometimes occurs if the sheet becomes bowed in the center and drags on the printing plate during positioning. This can be avoided by holding the sheet taut until both sides are positioned. Another method is to use a four- to six-inch-wide strip of newsprint laid across the center of the inked plate. This functions as a slip sheet and prevents the bow of the print paper from touching the inked plate surface. After the print paper is in position, it is held tightly at both ends while the slip sheet is pulled out from between the paper and the plate. The service of a press assistant is usually required for either of these methods, or whenever large sheets of paper are to be positioned. Slurring can also occur if an onrush of air shifts the print paper on the plate surface, either while backing sheets and tympan are being lowered before printing, or when they are removed after passage through the press. The remedy is to hold the print paper lightly in place while placing or removing backing sheets and tympan.

D. Finger Marks. Finger marks on the front or rear face of the printed impression are a sign of sloppy printing. They should be avoided at all costs. Hands should be washed periodically with solvent as well as with soap and water, and then dusted with talc before handling each sheet of paper. Impressions that carry bleed images are difficult to manage without getting ink on the fingers. These may be lifted from the printing plate by carefully inserting a razor blade between the sheet and the plate and grasping the sheet by its edges (like a phonograph record)

for removal to the slip sheets. These prints can also be safely handled with paper grips. Hands should not be dusted with talc when carrying bleed prints; the residue of white powder will stick to the ink film of the print and usually cannot be removed.

7.23 METAL PLATES IN COLOR PRINTING

Zinc or aluminum plates are often used in color lithography to supplement work on stone. Procedures for color printing are virtually the same as for black-and-white work.#

Probably the strongest reasons for the use of metal plates in color printing are ready availability, simplicity in processing, and easy portability. These advantages increase as the number of color plates for a lithograph becomes greater. Large prints require laborious grinding of a number of heavy stones; the substitution of metal plates for at least part of a color sequence saves much time and effort. Another advantage can be seen for professional shops which have a limited supply of stones in any one size. Such shops must carefully plan production schedules so that all stones of one size are not tied up with work in progress. Otherwise new work cannot be undertaken, nor will stones be available for unforeseen requirements of the work at hand. The use of metal plates can relieve production schedules and permit a more efficient use of stone or metal for particular types of work. Although emphasis is directed toward the advantages of metal plates as an auxiliary for stone, it should be evident that characteristics of the metal surface also provide unique properties for drawings, thus extending the aesthetic potential of color lithography.

7.24 ADVANTAGES AND DISADVANTAGES OF METAL PLATES FOR COLOR PRINTING

Drawings done on the printing surface, flat-tint plates, simple tonal areas, scumbled tusche washes, and most transfers can be controlled easily on metal plates. In general practice, those print images which require extensive reworking either before or after proofing are best executed on stone. Methods that rely on surface biting with acid or on extensive scraping and scratching, or those which necessitate numerous additions and deletions after proofing, should be avoided on metal plates.

Metal-plate lithography has been fully discussed in chapter 6. Only those matters which are specific to color printing are discussed here.

Vigorous and repeated manipulations of this sort will only jeopardize the sensitive barrier between the printing and nonprinting areas of the metal plates.

Elaborately drawn key plates are usually executed on stone, thus permitting latitude for additional drawing and processing that may be necessary as the work progresses. When a key plate is used, the subsequent plates are usually drawn with tonal and textural overlays for the key drawing. These can easily be executed on metal plates.

The simplest and most often used technique for printing color on metal plates is the solid-tone technique. Solid-tone plates are used to print transparent or semiopaque films of color over large areas of the print; they can also provide dense opaque grounding layers on which the major image can rest. Tone plates are made by the following simple and quick procedure:

1. A clean zinc or aluminum plate is prepared for drawing. (See sec. 6.3.)

2. The area to be printed is lightly laid out with a red conté pencil. The shape or shapes should be carefully traced from the key drawing if close registration of subsequent colors is required.

3. The nonimage (negative) areas of the plate are painted in with cellulose gum, hydrogum, or gum arabic. The solution should be brushed out and dried into a thin, even coating.

4. A film of liquid asphaltum or Triple Ink is wiped on the plate and dried to an even layer.

5. The plate is sponged with water, releasing the gum coating and asphaltum film from the nonimage areas.

6. The plate is carefully and evenly rolled up with the black roll-up ink until the printing area is solid.

7. The plate is fanned dry, dusted with rosin and talc, and given a mild second etch; it is then ready for proofing or storage. (See sec. 6.15.)

7.25 REGISTRATION TECHNIQUES ON METAL PLATES

All the methods used for color registration on stone may be used for metal plates. (See sec. 7.8.)

Centerline marks and other registration marks are placed on metal plates by drawing with a silver wire mounted in a pencil holder. The plate must be moistened with water before this is done, or the indelible marks will accept ink.

Drilling holes in metal plates for registering with pin systems is easily accomplished, in the same manner as for stone. It is unnecessary to drill the holes completely through the plates. Their depth should be just sufficient to

7.27 GARO Z. ANTREASIAN: *Untitled* (Plate IV from *Quantum Series*). 1967. Color lithograph, 30×22". Tamarind Impression (T–1522)

Laying out the ink slab for blended inking

The roller and ink slab after use, showing the ink blend

7.28 Roller alignments for blending

engage the pin securely and no more. The drilling must be done before the final etch; otherwise it will destroy the etch barrier and produce a printing dot. Furthermore, if the holes are too deep they will physically accept ink and make it necessary to clean before printing each impression.

7.26 PRECAUTIONS FOR COLOR PRINTING ON METAL PLATES

Printing color work from metal plates is essentially the same as printing with black ink. The chief difference is that Triple Ink should not be used as a plate base for color work. Because of its dark color, it can strike through the ink film, dirtying the color or staining the print impression. Instead of Triple Ink, the color ink, thinned with lithotine, is wiped in an even film over the image. Like all plate bases, the mixture should have the consistency of thin cream, and it should be applied after the image is washed out but while the dry film of gum etch is still on the plate.

Light colors and transparent mixtures of ink do not show up well on metal surfaces, especially on the darker-colored zinc plates. One cannot rely on the color effect as it appears on the printing surface. Ink mixtures must be carefully matched for color before the job is run, and critical color judgments can be made only by examining the printed proofs. Similarly, the proofs must be examined to determine whether the image is underinked or over-inked, and whether it is filling in. The printer must rely more on touch and rhythm than on the appearance of the plate as he adjusts his inking pattern to the requirements of the printed impressions.

It should be recalled that color inks are usually softer and greasier than black inks. Too greasy inks can gradually overcome the nonprinting areas of metal plates and cause filling. In other cases the greasy ink particles can separate from the vehicle and float on the moisture film of the plate, producing a veil-like scum. When scumming occurs, work usually halts, while the plate is cleaned and a less greasy ink is mixed. If the scumming is severe, the plate should be dried, gummed, and washed out; it should then be inked with roll-up ink and given a mild etch, followed by regumming. The color ink should be made stiffer by adding magnesium carbonate. It is sometimes necessary to supplement these steps by employing a fountain solution until the scumming is overcome. In difficult cases the fountain solution should be used throughout the entire printing.

Difficulties experienced in metal-plate work, if thought-fully controlled, can be overcome, whereas careless handling will ruin both the plate and the job. It must be remembered that the relations between printing and non-printing areas on metal are more susceptible to displacement through chemical and physical action than those on stone. In extreme cases, where nothing seems to help, it is often necessary to wash the plate out, roll it up with stiff roll-up ink, and then clean, etch, and gum it dry. The plate is left under the gum, at least overnight, before printing is resumed. The main reason for this approach is psychological, for it offers the printer an opportunity to begin anew with a fresh and determined outlook on the work, rather than feeling harried. Secondly, a new start with clean materials and equipment is in all cases advantageous. Finally, the re-etching and regumming of the plate can help to fortify additionally the nonprinting areas of the image against the encroachment of the printing ink.

7.27 PRINTING MORE THAN ONE COLOR SIMULTANEOUSLY

It is possible to print more than one color at a time from the same printing plate (whether stone or metal), provided that the areas to be inked are sufficiently separated to permit individual inking with small hand brayers. This procedure is most practical if the print requires a number of small isolated areas of different color. Instead of being placed on separate plates, these can all be drawn on the same plate and printed at one time. Considerable time and effort are saved with this technique if the images are simple. But it should not be used for complex images or for images that require unusual roller manipulation, for it would then lead to greater time loss during the over-all printing of the edition than would occur with separate plates for each color.

The work should be planned so that the size of each color area is not appreciably greater than the width or span of travel for one revolution of the roller. The character of the individual drawings should be firm and relatively simple, to allow for easy rolling and ink distribution.

The different color ink mixtures are laid out in separate swatches on the large ink slab, or, if the large roller is also being used during the operation, they may be placed on separate, small sheets of glass. After the individual colors have been deposited on the plate surface and the print paper positioned, the work is passed through the press to make the impression.

The combinations of color distribution by this method are infinite. Often the plate can be designed to carry a

major large image (inked with the large roller), around which several small spots of color can be inked with the small rollers. In other cases, only the small rollers may be used. It is usually impractical to use more than four rollers at one time because of the extra time necessary for handling. Nevertheless, the actual number of colors that can be used for one print can be considerably extended with this technique, since each plate can be designed to carry up to four separate colors.

Color Blending. Another procedure that employs more than one color during a single printing is called *color blending*. In this process, several colors of ink are distributed side by side in a regulated pattern on the ink slab, parallel to the direction of travel for the ink roller. The roller is passed over these with a controlled traverse to blend the juncture between ink swaths. The pattern of the blended inks carried by the roller can then be transferred to the printing surface, and, by regulated rolling, it can be controlled to produce identical blended color impressions.

The character of the blended ink film is extremely uniform, and, depending on color, it can produce very beautiful, continuous tonal harmonies. The nature of the process is limited to parallel bands of color pattern, although these can be varied in proportion by the width of the individual ink swaths on the slab. Maximum benefits can be achieved by careful planning. For example, it is conceivable that a single plate could be drawn to carry a series of parallel bands of striated and blended colors which in one printing could produce a complete multi-colored print.

PROCEDURE

1. After the individual inks have been mixed, they are distributed in parallel bands on the ink slab in the direction of the roller traverse; separate ink knives are used.

A system of alignment is devised beforehand, so that each time ink is replenished it will conform to the original swath of the individual colors. Small pieces of tape or pencil marks at the near and far ends of the ink slab can be utilized for lining up the width of each swath.

2. Each ink swath is placed in a continuous ribbon on the slab, starting at the extreme left edge. Various widths of ink knives are used to distribute an even layer of ink. Each swath is placed just adjacent to the one which preceded it, until a pattern just the width of the inking roller has been set out.

3. The roller is carefully placed on the ink so that its left edge corresponds to the left edge of the slab. It must be controlled to roll back and forth without shifting its alignment in relation to this edge, so that, as the edges of the ink swaths become blended, the pattern will remain uniform throughout each inking.

4. The printing plate is inked after the roller and slab have been prepared. The image must be planned beforehand so that a desirable pattern of roller traverse and paths of alignment can be achieved. Again, it is important that the left edge of the roller be guided back and forth along these alignments so that the inking for each impression will be identical. It can readily be seen that one has little opportunity for complex roller maneuvering in this system; the maximum size of the image must be limited to the width of the roller and the span of its traverse in one revolution.

5. Periodically, the ink slab must be replenished as the ink supply becomes exhausted. This is carefully done following the same procedure used at the beginning. A certain amount of practice is necessary to control ink distribution and replenishment in a uniform inking system. The success of this method depends on the skill and ingenuity that the artist and the printer bring to it.

Transfer Lithography

8.1 THE TRANSFER PROCESS

When a lithograph is drawn on one surface and transferred to a second before printing, it is called a *transfer lithograph*.* Such drawings are usually done on paper using lithographic crayons or tusche, although it is also possible to transfer impressions from intaglio plates or woodblocks and print them as lithographs.

The transfer process has been known and used since the early days of lithography. It was perfected during the nineteenth century and was used extensively in commercial printing of posters, labels, and certificates, becoming the forerunner for photographic reproduction processes.

The first artists to use the transfer process were motivated by its convenience. The lithographic stone was cumbersome and difficult to use in many situations. The transfer process permitted the artist to draw on paper; the printer could then shift this drawing to a stone by running it through the press. Although the freedom was attractive, the full range of effects made possible by the transfer process remained unexplored by artists until the late nineteenth century.

Many of the lithographs of Fantin-Latour, Redon, Toulouse-Lautrec, and Bonnard were (at least in their initial states) produced by the transfer method. Subsequently, the process was employed with skill and imagination by Picasso, Braque, Matisse, Chagall, and Miró, among others.

Until recently few American artists had recognized the potential of transfer lithography. Through lack of knowledge they have failed to exploit a process which is particularly well adapted to contemporary imagery and which makes it possible to create lithographs that cannot be produced by any other means.

8.2 ADVANTAGES AND DISADVANTAGES OF THE TRANSFER PROCESS

Before transfer techniques are described here, it will be useful to consider both the advantages and disadvantages of the process.

1. Many artists find it easier and more natural to draw on paper rather than on stone. The stone inhibits them, preventing a normal fluency.

2. Unsuccessful drawings on paper may be easily discarded. Unsuccessful drawings on stone require a regraining of its surface.

3. There are no problems having to do with reversal of the image. The artist who draws on paper sees his work just as it will appear in the final print. It will be reversed once when transferred to the stone and a second time when printed, thus returning it to its original position. In many drawings, particularly those which reveal the "handwriting" of the artist, this can be an important advantage.

4. When scraping techniques are used on a stone or plate, the grain of the printing surface is disturbed or destroyed. When used on transfer paper these techniques tend to print more reliably, as the adsorbed films of the desensitizing etches achieve a firmer foothold on surfaces that retain their original, crisp grain.

5. Because of the absorbency of the transfer paper, tusche washes dry somewhat differently on paper than on a stone or plate, without the characteristic hard or heavy edge.

* Transfers may be made either to stones or to metal plates. Throughout this chapter reference will usually be made to stone. Unless a distinction is specifically made, the processes described are equally applicable to metal plates.

6. Economy of time can be effected through transfer of several smaller images to a single large stone, all to be printed at one time. This is possible either with drawings done on transfer paper or with inked transfer impressions from smaller stones. It can be a particularly valuable method in the printing of certain kinds of suites and *livres de luxe.*

7. A single drawing may be used to develop a series of variations on a theme. Several inked transfer impressions may be taken from a stone or plate, altered through additions or deletions, and transferred to new printing surfaces, each of which may then be developed separately.

8. Inked impressions from other surfaces such as woodcuts, intaglio plates, and type faces can be transferred for lithographic printing. It is assumed that the reason for such transfers will not be mere reproduction, but rather the modification of the images through subsequent reworking.

9. If difficulties due to deterioration of an image arise during printing, it is sometimes possible to bring about improvement by transferring the image to a new surface. This technique will also be useful if the original stone develops a hairline crack. A transfer impression may be taken to avoid loss of the image in the event that the stone should break.

10. The tonal range of transfer drawings is affected both by (1) the surface tooth of the paper and by (2) the surface ("underlay") on which the paper is placed before the drawing commences. Because of the pliability of the paper surface, transfer drawings seldom have the crisp tonal definition of works drawn directly on the printing element. During transfer, drawings are further blurred (microscopically) because the tooth of the transfer paper can never exactly correspond to the grain of the printing surface. In addition, a certain amount of squashing is an inevitable consequence of the pressure necessary for the transfer. Cumulatively, these factors, though minute, make transferred images broader, coarser, and somewhat less alive than work drawn directly. Hence, for drawings that require precise and crystalline definition, the transfer process is not advisable. It is relatively easy for the trained observer to differentiate between transferred and directly drawn lithographs, upon the basis of their characteristic visual differences.

Many additional advantages (and some disadvantages) of the transfer process will become apparent as the individual modifies the basic techniques to suit his individual requirements. It should be evident that the process is not intended as a substitute for direct work on the printing surface, which has its own unique characteristics. Rather, the transfer procedure should serve as an extension of lithography, providing additional means through which the artist may develop his work.

8.3 TRANSFER PAPERS

Transfer papers fall into two categories: coated and uncoated. The coated papers assure the most perfect transfers by virtue of their water-soluble coating. When this type of paper is transferred to the printing surface and its back is dampened with water, its coating and the drawn or inked impression leave the paper and attach themselves to the printing surface. In this way the performance of coated papers is similar to that of commercial decalcomanias. All traces of the lithographic image and its fatty contents, which were originally attached to the transfer paper, become affixed to the printing element; after processing, these become more firmly established, just as when drawings are done directly.

Any reasonably soft paper that is acceptable for drawing can be classified as uncoated transfer paper. Such varieties as bristol, bond, vellum, tracing, or charcoal paper can be employed with equally satisfactory results. Because each type of paper produces different visual effects in the drawing, a certain amount of individual experimentation is necessary to determine the best paper for specific types of work. The fatty contents of the drawings on uncoated papers are transferred to the printing surface only by the pressure of the printing press. Although the greater part of the drawing will remain on the paper, enough of its grease content is impressed into the printing surface to permit careful processing into a permanent lithographic vehicle. When fully processed, it is also capable of printing an image possessing the full tonal range of the original. Transfers from uncoated papers perform dependably only for simple, direct approaches in drawing. They are less reliable than coated papers for works having delicate tonalities, and they should never be used for drawings employing tusche washes or for transfers from stone to stone.

8.4 TYPES OF COATED TRANSFER PAPER

Many different types of coated transfer paper are used in lithography; the coating formulation and paper stock for each are designed to function with maximum efficiency for specific types of work. For example, transfer papers for writing are less satisfactory for intaglio transferring, and papers for transferring from one stone to another are not suitable for drawing color separations.

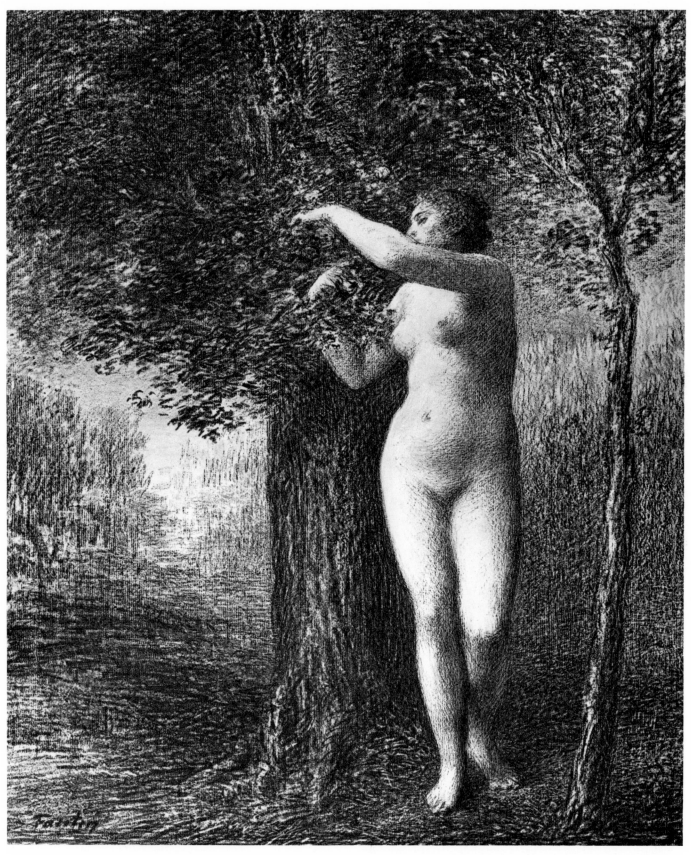

8.1 HENRI FANTIN-LATOUR: *Eve*. 1898. Transfer lithograph·
18 3/8 × 15 1/2". University Art Museum, The University of New
Mexico, Albuquerque

Hence, several different types of transfer papers should be stocked in shops where a great variety of transferring work is undertaken. Machine-coated transfer papers are no longer manufactured in the United States, although they can be obtained from distributors listed in Appendix A, *Sources of Supply*.

It is also possible to hand-coat transfer paper using simple coating solutions. It should be noted that hand-coated papers are seldom as uniform in surface coating or as efficient in performance as machine-coated varieties. However, hand-coated papers allow a greater latitude for various kinds of transferring than do papers that have no coating.

The basic factors that affect the behavior of transfer papers are listed below. Descriptions of the more common machine-coated varieties follow. Typical formulas and coating procedures for hand preparation are also given. Although machine-coated transfer papers other than those listed can be obtained, they find little use in hand lithography today.

BEHAVIORAL FACTORS

1. The coatings must not be so thin or so weak as to prevent effective release from well-dampened papers.

2. The coatings must not be too soft or too absorbent, because the greasy drawings will then penetrate the papers, leaving little grease to be transferred from their outer surface.

3. The coatings should have an adhesive quality when slightly dampened. This permits the paper to adhere with intimate contact on the printing surface as the work is passed through the press many times. The slightest shifting would slur the transfer, causing a doubling of the impression, and spoiling the work.

This is just one reason why uncoated papers are relatively unsatisfactory for transferring. Without adhesive properties, they can grip the stone only through the tackiness of the grease image. The sparser the drawing content, the less opportunity for the uncoated paper to adhere without slipping.

4. The coatings must be water-soluble, so that the process can be accomplished rapidly and efficiently without prolonged soaking, which would be injurious to the water-soluble drawing materials.

5. The coatings should not be composed of materials that will desensitize the printing surface during transference. Hence, gum arabic should never be employed in transfer coating solutions.

6. The coatings must not be composed of materials that contain fatty acids, since, in addition to the drawing, these would transfer other unwanted ink-receptive properties to the printing surface.

TYPES OF COATED TRANSFER PAPER

1. Writing Transfer Paper. This, the simplest kind of transfer paper, is designed for writing, for linear drawings, and for solids with pen, brush, and tusche. It should have the following properties:

a. The coating composition must be hard and smooth, so that it may be written and drawn upon with ease.

b. The coating should be strongly adhesive when slightly damp.

c. The paper should be sufficiently absorbent so that the moisture from dampening will penetrate its surface and easily dissolve the coating. The work should leave the paper completely after the transference.

The coating solution is prepared as follows:

Gelatine	6 ounces
Hot water	2 quarts
Finely ground white pigment	6 ounces

The gelatine is dissolved in the hot water; the white pigment, mixed in a little water, is added to the mixture; and the entire solution is strained through cheesecloth to remove lumps. A smooth-surfaced, medium-weight, wove paper is covered with the warm solution using a broad, soft brush. The damp sheets are hung to dry, using paper clips fastened to a line. After drying, the sheets may be plate-glazed by placing them on a clean finely ground stone and then passing them one at a time through the printing press under moderate pressure.

2. Stone-to-Stone Transfer Paper. This paper is designed primarily to receive inked impressions from one stone for transfer to a second stone. Because of its rather hard smooth surface, it can also be used for drawings and writings in crayon and tusche. An excellent machine-coated variety, produced by the French firm M. Charbonnel, is called *Papier a Report*. The coated side of this paper is easily identified by the term *Coté Collé* stamped in the corner of each sheet. Stone-to-stone paper is perhaps the best transfer paper for all-purpose shop use. It should have the following properties:

a. The coating should be thin, hard, and very smooth, so as to accept printed impressions with clarity.

b. The hardness of the coating is produced by the quantity of gelatine in the coating solution. Too much gelatine will produce excessively hard coatings. which are incapable of accepting clear impressions, Such prints will appear gray and broken in tone. If the coating is too soft, its composition will separate from the paper and adhere to the viscous transfer ink on the printing surface. Soft coatings also absorb grease from the ink more rapidly. Transfer impressions on soft coated papers cannot be kept over-

night; they should be transferred onto the second stone immediately.

The coating is prepared as follows:

Flour	18 parts
Finely ground dental plaster	12 parts
Gelatine	1 part
Starch	1 part

The plaster is slowly sprinkled and stirred into the water. More water is added if the mixture is inclined to thicken or set. A satisfactory mixture will stand for some time without setting. Excess water rising to the surface of the mixture should be poured off. The flour is made into a smooth paste by mixing with cold water and then boiling; the plaster mixture is slowly added when the paste is smooth and free of lumps. The starch and gelatine are boiled in water and added to the solution. After thorough mixing, the solution is strained through cheesecloth before application. The creamy liquid is applied with a soft, flat brush onto a medium-weight, smooth, and slightly absorbent wove paper and is then hung to dry. After drying, the paper may be plate-glazed by passing through the printing press on a clean stone.

3. Grained Transfer Paper. Grained transfer paper is prepared with toothy surface for crayon and pencil drawings. Although its toothy surface cannot duplicate the properties of a grained stone or metal plate, its granularity permits the development of drawings unlike those on any other transfer paper. Sometimes the coating solution is applied to charcoal paper which, because of its laid surface, can provide a particular type of luminosity for drawings.

Grained paper usually requires a very thick coating in order to produce granular surface properties and also to enable the artist to scrape cleanly any lights required in the drawings. Coatings that are too hard will smudge the drawing during transfer, and those which are too soft will absorb excessive fatty content from the drawing materials. In either case the transfer will be ineffective.

The coating composition is similar to that for stone-to-stone paper and is prepared identically:

Flour	9 parts
Finely ground dental plaster	12 parts
Starch	2 parts

Unless charcoal paper is used, the paper to be coated should be smooth, somewhat absorbent, 120- to 150-pound weight, with wove surface. The composition is spread evenly over the paper with a sponge or flat brush. Sometimes the paper is coated twice, in order to provide sufficient coating thickness. Grained transfer paper should not be plate-glazed. The graining of commercially prepared paper is produced by laying the paper (slightly dampened) on a grained copper or zinc plate and passing it through an etching press under very heavy pressure. However, the natural granularity of hand-prepared coating solutions is often sufficient to produce a less regulated tooth formation, which many artists prefer.

4. Plate Transfer Paper. This paper is used for pulling impressions from an etching or other intaglio plate for transferring to stone. Ideally its properties lie between those of stone-to-stone paper and grained paper. Stone-to-stone paper is, however, sometimes used for plate transferring. Generally more starch and less paste is used in the coating composition. Starch is the ingredient that enables the paper to rise from the plate after the impression is pulled. If stone-to-stone paper sticks to the intaglio plate, the proportion of paste in its formulation must be reduced.

The coating solution is prepared the same way as stone-to-stone paper; its ingredients are as follows:

Flour	12 parts
Finely ground dental plaster	12 parts
Starch	1–2 parts

The warm solution is brushed on a smooth, soft, wove paper, approximately 40-pound weight.

5. Transparent Transfer Paper. This is a very important paper for making drawings that are to be used for color separations. Printed impressions can be clearly seen through it, and the drawing of new colors can easily be positioned in relation to the previous work. Coating compositions for transparent transfer paper may be the same as those used for writing transfer paper; they should be applied, however, on the thinnest, most transparent paper available. Absorbent tracing paper and onionskin paper are suitable. A few drops of alcohol in the solution will permit the liquid to be brushed more smoothly. The mixture should be applied hot; therefore, a double boiler is used for its preparation.

6. Everdamp Transfer Paper. This paper is excellent for stone-to stone transferring, for image transposition, and for certain kinds of drawing. It has a semimoist, hygroscopic surface, due to the glycerine and gelatine in its coating. By absorbing moisture from the surrounding atmosphere, the paper becomes limp and slightly tacky. This permits excellent adhesion without the need to dampen the printing element before the first pass through the press. It is important that Everdamp paper be well protected while in storage, so that its moisture content will remain constant during atmospheric fluctuation.

The semimoist surface of Everdamp paper is less satisfactory for drawings executed with lithograph crayons or pencils; however, it accepts tusche drawings with brush and pen very favorably. Furthermore, sharper and cleaner

impressions can be printed on it (using less ink) for stone-to-stone transfer than on any other variety of transfer paper.

The coating is prepared as follows:

Irish seaweed or carrageen moss	2 ounces
Water	2 quarts
Glycerine	¾ pint
Glucose	1 ounce
Gelatine	½ ounce

The seaweed or moss is placed in a pan with the water and brought to a boil. The remaining ingredients are added while stirring; the mixture is strained through cheesecloth. Two coats of the warm solution are applied to a smooth, slightly absorbent wove paper, which can be plate-glazed by passing through the printing press, if desired. The prepared papers should be protected from change in moisture content by wrapping in plastic film or aluminum foil. The paper should be stored in a cool, dry area. Warm and humid atmospheric conditions can promote excessive tackiness of the surface coating; the weight of the paper pile can cause the sheets to stick together.

7. Experimental Transfer Papers. Recent experimentation by individual artists in the United States has resulted in some use of transfer papers with coatings other than those traditionally employed. Coatings composed of polymerized acrylic or vinyl resins in water emulsions have been employed with some success. Although such coatings are not water-soluble in the usual sense, their dried films can be activated and softened with applications of moisture to induce transfer. It appears reasonable to expect continued refinement of techniques for use of these more modern materials within the near future.

Commercially prepared gummed papers for label and decalcomania printing have been employed successfully for transferring. One such paper (somewhat like Papier a Report is prepared with a dextrin coating. Its extremely smooth and glossy surface permits excellent stone-to-stone transfer following standard procedures. Another type having a matte gummed coating is called *dry gum paper*. This paper is best for crayon, pencil, and tusche drawings. The usual procedures for the traditional transfer papers are used. Label and decalcomania papers are widely distributed and can be obtained from many of the large suppliers of printing paper.

8.5 DRAWING ON TRANSFER PAPER

Virtually all the drawing processes suitable for direct application on stone or metal can be used for drawing on transfer paper. Since these processes have already been described in secs. 1.8 to 1.20, attention here is directed toward those approaches of particular consequence to the transfer process.

The surfaces of coated transfer papers are very sensitive to grease and foreign matter; therefore, they must be handled as carefully as the surface of the stone. The drawing procedure should be planned so as to minimize overhandling of the paper. Overhandling can be avoided by taping the corners of the transfer paper to a clean, smooth working surface before beginning to draw. The paper should be slightly larger in size than the drawing, but smaller than the stone or plate upon which it is to be transferred. The work is drawn on the coated side of the paper (so marked by the manufacturer). Drawings on uncoated papers can be placed on either side of the paper.

The image format and registration marks (if necessary) are lightly drawn in with conté crayon or hard lead pencil. The general layout of the image may also be lightly sketched with conte crayon, or it may be carefully traced, using a red chalk tracing sheet. Pressure during the laying-in should be avoided, because it will indent the paper coating and will be difficult to obscure during the drawing.

The drawing can be developed over a period of several days if necessary; it is advisable to complete its transfer as soon as possible, however, while the fatty content of the drawing is fresh. Incomplete drawings should be covered with a soft clean cloth or sheet of paper to protect them from contamination.

8.6 RUBBINGS OR FROTTAGE

One of the unique techniques possible in transfer drawing is rubbing or frottage. This technique is impossible when drawing directly on stone. When the transfer paper is placed on any underlying surface and rubbed with a lithograph crayon, the texture of that underlay will determine the character of the drawing. Many evocative surface qualities can be thus achieved, ranging from diaphanous effects of extreme delicacy to a coarse and heavy granularity, depending on the character of the surface beneath the transfer paper. The degree of surface definition is conditioned by the thinness of the paper and the grade of lithographic crayon or pencil being used. Tests should be undertaken with scraps of transfer paper, using several grades of crayon or pencil to determine the best approach for the desired effect.

Additional work may be added over the rubbings, with interplay between the major image and its surroundings.

It is sometimes desirable to transfer only sections of a rubbing. This is accomplished by cutting the desired shapes with scissors or razor blade and positioning them on the stone before passing them through the press. Sometimes torn or cut shapes are objectionable because of their hard edges. Hard edges may be avoided by placing the cut shapes on the stone and transferring them by burnishing their backs with a spoon or similar smooth instrument. Variations in the pressure and pattern of hand-burnishing will produce effects quite different in value and edge quality from those of transfers passed through the printing press. By extending this approach, it is possible to transfer several layers of work to produce complex tonal and spatial effects.

Negative surface effects (white on a dark ground) are obtained by covering the transfer paper with a solid layer of solvent tusche or transfer ink. When dry, the paper is secured over the surface to be rubbed and then scraped with a blade, exposing the texture of the underlay through the dark ground. Linear work, when scraped over a rough surface, appears very nearly like original white chalk drawings made on a dark ground.

8.7 OTHER TYPICAL DRAWING TECHNIQUES ON TRANSFER PAPER

Other techniques that may be used successfully while working on transfer paper are described below.

SCRAPING AND SCRATCHING

A certain amount of scraping and scratching to remove crayon and tusche is possible on coated paper, but it is less successful on uncoated paper. Care must be taken not to destroy the coating completely or roughen or tear the paper. Heavy tusche drawings and those made with soft crayon lend themselves to the most successful scraping.

Parts of the image that appear to have been completely removed by scraping nevertheless retain minute amounts of grease; when transferred and processed, these roll up as very faint gray tones. As such, they appear more closely related to their surrounding surfaces than the brilliant white lines that would be produced by scraping the stone after the transfer has been made.

TUSCHE TECHNIQUES

Solvent tusche is required when using liquid drawing materials on transfer paper. Water tusche cannot be used, because its aqueous vehicle will dissolve the surface coating of the transfer paper, allowing the fatty components of the tusche to be absorbed into the paper. As the surface deposits of grease are diminished, their transfer becomes less reliable. Autographic Tusche, however, does not react in this manner. Although containing an aqueous vehicle, this material can be used safely on transfer paper for linear work, small solid areas, and stipples, provided that single applications are employed without overworking.

Stippling with brushes, sponges, or pieces of facial tissue may be used, as may techniques of spattering, splashing, dripping, and air-brushing. Fine linear work can be done with pens or pointed sticks, provided that the tusche is of the proper fluid consistency and the drawing instrument does not dig into the paper. Steel pens that tend to pick up the transfer paper coating should be cleaned repeatedly or they will not dispense the tusche evenly.

Heavy brush drawings with thick, viscous mixtures of solvent tusche resemble oil paintings in which the passage of each brush stroke retains clear definition. This is particularly pronounced when brushes with coarse and stiff bristles are used.

Blended tusche washes and flowing gradations can be employed on transfer paper, using techniques previously described for drawing on stones. Gasoline, benzine, or lithotine solvents can be used to blot or further modify wet or dry films of tusche. Another method for controlling the tonality of tusche drawings on transfer paper is to use full-strength viscous mixtures in a scumbling technique. The tusche is applied in a scrubbing motion, and the brush is used to remove as well as to apply the mixture. Filmy grays and rich darks can be achieved with this rather broad painting technique.

Qualities similar to the brutal characteristics of woodcuts can be obtained by totally covering the transfer paper with tusche or transfer ink and scraping away the negative areas of the image. Scraping tools are used to remove the greasy coating up to the edges of the lines and forms of the image, as in the making of woodcuts.

CHEMICAL SEPARATION

Mixtures causing chemical separation of the tusche may be employed on transfer paper, in the manner described for drawing on stone. For example, lithotine tusche modified by additions of water will produce a mottled separation when drawn across the paper. (See sec. 1.15.)

TRANSFER RESISTS

Various resists can be used to prevent portions of the grease drawing from transferring to the stone. In this way, areas of the drawing can be completely masked or partially modified. Lines and masses can also be reshaped or sharpened for crisper definition before transfer occurs.

The areas of the drawing that are to be masked are

8.2 KÄTHE KOLLWITZ: *Self-portrait*. 1934. Transfer lithograph, 11 1/4 × 8 3/4". Grunwald Graphic Arts Foundation, University of California at Los Angeles

8.3 JEAN DUBUFFET: *Stone with Tracks* (Plate I from *L'Elémentaire*). 1958. Transfer lithograph, 12 5/8 × 16 1/8". The Museum of Modern Art, New York. Gift of Mr. and Mrs. Ralph F. Colin

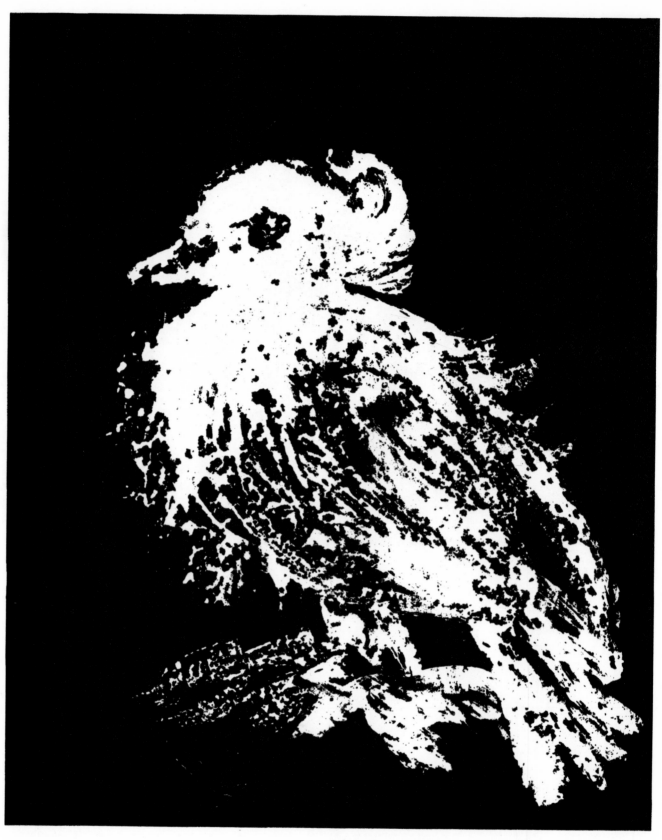

8.4 PABLO PICASSO: *La Petite Colombe* (*The Little Dove*).
1949. Transfer lithograph, 10 3/8 × 8 1/8″. The Museum of
Modern Art, New York

Picasso painted the image of the dove with thin white gouache
over transfer paper that was first covered with transfer ink

painted over with white casein paint. This material is used in a creamy consistency when total masking is desired. Chinese white watercolor paint is sometimes used over heavy tusche drawings. Because of the thin liquid consistency of this less opaque paint, it cannot completely resist the greasiness of the drawing. By separating from the image it forms globular white patterns against the dark background which are comparable (though reversed in value) to solvent tusche and water mixtures. Further variations in texture are offered by altering the liquid consistency of the resist. It is possible for small areas of the drawings to be masked out and then drawn over with lithograph crayon, although this procedure is not recommended for extensive image alteration.

Various physical resists can also be employed to prevent parts of the drawing from transferring to the stone. Materials such as paper, open-weave cloth, string, horsehair, etc., produce effective resists, providing they are reasonably thin. Bulky resists can damage the stone, scraper bar, and press tympan when pulled through the press. Items having some bulk, such as cloth and string, require soft backing sheets or a rubberized blanket to compensate for their irregularity during transfer.

MONOTYPE TRANSFERS

Monotype rubbings from glass, marble, slate, Formica, or metal surfaces can be made with transfer ink and paper for transfer to the printing element. The monotype image is produced by brushing or rolling transfer ink (somewhat thinned with lithotine or varnish) on the bearing surface. The drawing can be scraped with blades, or it can be softened and blotted with solvents. When it is completed, the coated face of the transfer paper is carefully placed over it and held with one hand, while the back of the paper is burnished with a smooth block of wood, metal, or plastic. The character of the monotype impression depends on the pressure and pattern of the rubbing process. The completed monotype can be immediately transferred to a stone or metal plate, or it can be reworked further by the direct application of drawing processes already described.

Monotype processes are particularly useful for the development of automatic imagery. By producing rapid and often unpredictable effects, they provide great flexibility for artists whose creativity is heightened by suggestive imagery. Because the process functions as an intermediate stage of transferring, a series of drawings and impressions can be made and discarded, until, through calculated chance, a desirable effect is achieved. The nature of the monotype process is such that it obscures the techniques employed to a greater degree than do most other image-forming processes.

8.8 COLLAGE PROCESSES

The transfer process makes it possible to use the techniques of the collage in the making of images. Technically, the process is called *patching* or *imposition*, and it has further uses in book and folio production. The separate pieces of the collage are drawn and cut from transfer paper and then positioned on a larger backing sheet of transfer paper. Additional drawing may be included on the supporting sheet before the whole is passed through the press. It is important that the individual pieces be attached to the backing sheet so that they will not shift during transfer. The layers of the collage should not be bulky, to avoid an unevenness of surface that impairs the accuracy of the transfer.

PATCHING OR IMPOSITION OF TRANSFERS

Many types of book and folio printing require a combination of forms printed on the same sheet. It may be desirable or even necessary to print drawings and typography simultaneously from the same sheet, the sheet being torn and folded after the printing.†

Complex arrangements of image and type forms cannot be successfully printed without a comprehensive and detailed layout. Positions of the various printing forms, registration marks, folding marks, and tearing marks must be shown on the layout. Individual items (drawings, typography, and halftone plates) are drawn or printed on transfer paper. They are then trimmed and affixed to a larger backing sheet of transfer paper in positions corresponding exactly to the layout. After registration, folding and tearing marks are drawn on the supporting sheet; the entire unit is transferred en masse to a large press stone or metal plate.

STICKING DOWN TRANSFER IMPRESSIONS

Individual transfers are affixed in one of two ways, depending on whether the supporting sheet is Everdamp transfer paper or stone-to-stone paper. Transfers are affixed to Everdamp paper by dabbing into position with a blunt, pencil-like metal point, such as a mechanic's center punch. This should not strike into the drawn or printed areas of the image, but only around its edges and in enough spots to secure a firm hold.

An adhesive is necessary for sticking down impressions on stone-to-stone or other types of dry coated paper. Flour and water paste with a little glycerine or table syrup added is an excellent material for this purpose. A strong adhesive for heavy transfer paper is made by mixing

† Only the basic technical matters of page imposition for transferring purposes are briefly described here. Ample information on this subject is contained in standard texts on commercial printing.

two parts flour paste with one part syrup and then evaporating the bulk of the moisture by heating.

Transfer paper adhesives should be water-soluble, so that their hold is released rapidly when moisture is applied to the back of the paper during the transfer. Gum arabic should not be used as an adhesive; by dissolving, it would desensitize the printing surface on contact, and this could spoil the transfer. Only a minimum amount of adhesive is necessary to affix the various transfer impressions; every effort should be made to apply it in places where it is not likely to soak through to injure the work on the face of the transfer. Individual transfers must be very carefully handled with clean hands so as not to smear the freshly inked or drawn surfaces.

When all impressions are in place on the supporting sheet, it is carefully positioned on the freshly ground stone; it is then transferred and processed in the usual manner. Often the supporting sheet will be quickly released from the stone as dampening progresses, although the separate impressions will remain affixed to the stone. These must be individually dampened and covered with a protective sheet before continuing the transfer. The process is repeated until these can be easily removed from the stone to complete the operation.

8.9 THE STEPS IN MAKING THE TRANSFER

The steps in making the transfer are listed sequentially below. Each of the steps will be described in greater detail in topics that follow. It should be understood that this sequence of steps is essentially the same whether the transfer is to stone or to metal plates.

1. The stone is grained, and, if desired, it is treated with chemicals to make it even more receptive to grease. (For preparation of metal plates, see sec. 8.18.)

2. Transfer papers with dry surface coatings are positioned on dampened stone surfaces. Transfer papers with moist surface coatings (such as Everdamp) and dampened papers without coated surfaces are positioned on dry stones.

3. The work is passed through the press under pressure to obtain the transfer. Coated transfer papers require repeated passes through the press with continued redampening of the sheet to dissolve its coating. Uncoated transfer papers are passed through the press only once.

4. The transfer paper is peeled from the stone.

5. The stone is fanned dry and dusted with talc.

6. The first etch is applied and dried. In most cases only gum arabic is used for the first etch.

7. The image is washed out and rolled up with ink, either with or without a printing base.

8. Minor corrections are made, and the borders of the stone are cleaned.

9. The inked image is dusted with rosin and talc.

10. The stone is given the second etch, using gum and acid mixtures in accordance with standard etching procedures.

8.10 DAMPENING UNCOATED PAPER FOR TRANSFERRING

Uncoated transfer papers require dampening, to obtain greater pliability before being transferred. These papers should never be dampened directly, because of the water solubility of crayon and tusche drawings. Instead, they should be placed between moist blotters in the damp box. (See sec. 15.33.) Thin papers require only a few minutes to absorb sufficient moisture; heavier and harder papers require longer periods of absorption. Correctly moistened papers feel soft and limp, and their surfaces will appear matte. A shiny surface is an indication that the paper is too wet. Such paper must be permitted to dry partially before transferring. Weights should not be placed on the damp box, because undue pressure will cause the moistened drawing to offset onto the dampening sheets.

As stated before, uncoated papers rely on the inherent tackiness of the drawing to adhere to the stone. Since the drawing materials are softened when the paper is dampened, there is some danger that the drawing will slide or shift under the pressure of the press. Heavily drawn works on too moist papers are particularly subject to this problem.

The reader is reminded that coated transfer papers are not dampened before transferring. With the exception of Everdamp paper, these are simply placed on a dampened stone for the first pass through the press. The complete transfer of images from coated papers occurs by passing the paper repeatedly through the press. Dampening the stone before the initial pass enables the paper coating to become partially dissolved and securely attached to the stone. In this way the transfer can be dampened and passed many times through the press without danger of shifting.

8.11 ARRANGING THE BACKING SHEETS FOR TRANSFER

The arrangement of the backing sheets for transferring is essentially the same as for printing. Either a single

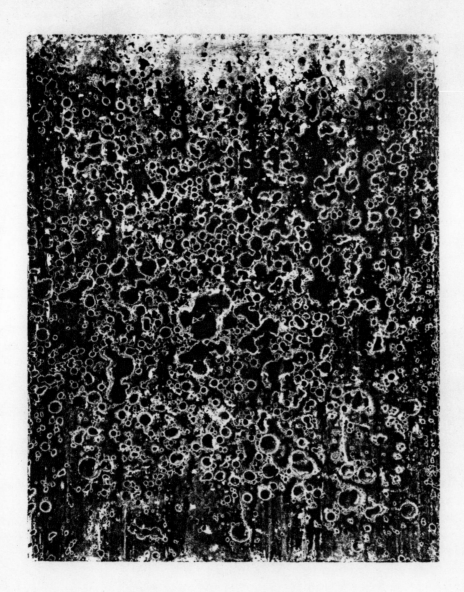

5. La danse du gaz

8.5 JEAN DUBUFFET: *La Danse du Gaz* (*The Dance of Gas;* Plate V from *L'Elémentaire*). 1958. Transfer lithograph, 15 3/4 × 12". The Museum of Modern Art, New York. Gift of Mr. and Mrs. Ralph F. Colin

This is a typical example of a transfer drawing made using the monotype technique. Dubuffet has ingeniously employed this process in many different ways to intensify the automatic and highly evocative imagery of his lithographs

blotter, a four-ply newsprint, or one or two sheets of smooth proof paper are used for cushioning between the transfer paper and the press tympan. Overly soft backings produce mushy transfers; these should be employed only if the surface of the transfer is irregular (see Transfer Resists, sec. 8.7). The backing should be either the same size as or slightly larger than the outer dimensions of the stone or metal plate.

Because coated transfer papers require repeated dampening between passes through the press, a waterproof barrier is required between the saturated transfer paper and the backing sheets. Besides protecting the backing, this barrier forces the moisture film downward through the transfer paper, while preventing its absorption by the backing. A thin sheet of aluminum foil cut to the same size as the printing element provides an excellent waterproof barrier. Wax paper and thin plastic film are other materials that can be employed for this purpose, although they perform less satisfactorily. The transfer paper can be dampened either by direct application of the water sponge or by placing an evenly saturated newsprint over it. This is followed by the waterproof interleaf, the backing sheet, and the press tympan.

8.12 PREPARING THE STONE TO RECEIVE THE TRANSFER

Only fine-textured level stones should be used for transferring. Although it is possible to transfer work to coarse stones, the more finely grained surface assures more intimate contact between the paper and stone. The stone should be sufficiently large to accommodate the entire sheet of transfer paper and provide ample clearance at both ends of the image for the scraper bar of the press.

The stone is usually grained with several cycles of #220 grit carborundum. If desirable, an even finer tooth can be achieved by grinding with several cycles of #320 grit aluminum oxide or by using fine pumice powder and water. A thin lithograph stone measuring approximately $1\frac{1}{2} \times 6 \times 8''$ should be used for final surfacing instead of the steel levigator.

The freshly ground stone is highly sensitive to the transfer of fatty particles from the transfer drawing. Even greater sensitivity can be achieved by treating its surface with a weak solution of alum, nitric acid, and water. This treatment polishes the stone surface slightly and cleanses it of remaining foreign matter. The solution is prepared as follows:

Potassium alum	3 ounces
Water	80 ounces
Nitric acid	¼ ounce

Add two parts of this mixture to sixteen parts of water. The stone is flooded with the solution, which is allowed to remain for one or two minutes before washing away with clean water.

It must be noted that this alum sensitizing treatment is not suitable for all classes of transfer. It is best used for drawings that have a limited grease content or have suffered grease loss during storage of several weeks or longer. This treatment can also be used advantageously for drawings on uncoated papers.

When the stone is treated with the alum solution, an adherent crystalline film, soluble in the acid etch but insoluble in water, is formed on its surface. This film is highly receptive to the adsorption of fatty acid particles. Transfer impressions from stone, metal plates, halftones, and type forms take a very firm hold when applied to this sensitive surface.

Drawings on uncoated papers are sometimes transferred onto a warmed stone. The heat permits deeper absorption of the fatty drawing particles into the pores of the stone. A stone may be warmed either by exposing it to the rays of an infrared heat lamp or by flowing hot water over its surface. The application of heat should be gradual and it should be evenly diffused; otherwise the stone may fracture as a result of rapidly changing temperatures within it. A properly heated stone should feel warm, but not hot, to the touch.

8.13 MAKING THE TRANSFER ON STONE

Materials used for making the transfer are laid out as follows:

1. If the transfer is to be made from coated paper, a water bowl and sponge are placed near the press. These are not needed if the transfer is from uncoated paper.

2. The backing sheets and waterproof barrier are cut to size and positioned on the paper table or near the press tympan.

3. The freshly ground stone is centered on the press bed, and the scraper bar (well lubricated) is lined up and installed. The scraper wood and leather must be free of imperfections to produce a flawless transfer.

4. The traverse limits of the press bed are determined and marked.

5. If desired, the stone is treated with the chemical sensitizer just before the actual transfer.

TRANSFERRING FROM UNCOATED PAPERS

1. The previously dampened transfer is centered on the dry stone. Alignment marks are lightly scratched on the

stone with a blade, if positioning is critical. The transfer paper should not be shifted after it is positioned.

2. The backing papers and tympan are carefully lowered, and the press bed is moved to the starting traverse position.

3. The press pressure is adjusted, either to the same degree or slightly firmer than for regular printing (necessary because the complete transfer must be accomplished in a single pass through the press).

4. The pressure is released after the stone has been passed through the press, the bed is returned to the starting point, and the tympan and backing sheets are removed.

5. The transfer is carefully lifted from the stone. A considerable amount of drawing will still remain on the paper. This should not be viewed with alarm, since a reasonable amount of its fatty content will have been transferred to the stone. Through careful processing the transferred image will print with the same detail and range of tonality as the original.

TRANSFERRING FROM COATED PAPER

1. The stone is lightly and evenly dampened with water to the same extent as when printing (except when Everdamp paper is employed).

2. The transfer is centered on the stone followed by the backing sheets, but without the waterproof barrier. The tympan is lowered, and the bed is positioned for the adjustment of pressure. Coated papers require only enough pressure to enable them to adhere firmly to the stone while moisture is squeezed through their backs. Therefore, press pressure should be slightly less than for normal printing.

3. The stone is passed through the press to the trailing traverse mark, and without hesitation or disengagement of the pressure, it is returned to the starting position. This forward and return passage under pressure is called one full pass. The press motion is continued without hesitation for a total of three full passes, constituting one complete cycle.

4. The pressure is disengaged, the tympan and backing are removed. The transfer is now firmly attached to the stone.

5. The back of the transfer paper is lightly and evenly sponged with water. (If desired, a well-saturated newsprint can be laid on the transfer in lieu of sponging.) This is followed by the waterproof barrier, the backing sheets, and the tympan.

6. The whole is passed through the press without hesitation for another complete cycle of three full passes.

7. The procedure is repeated, alternately dampening and passing through the press for three to five full cycles, depending on the properties of the paper coating and whether the drawing can withstand extended passage through the press. Gradually, as the paper absorbs the dampening water, it will become quite transparent, and the work will show through it very clearly. After the third cycle, one corner of the paper is carefully peeled back; if it parts readily from the stone, it may be stripped completely. If it tends to adhere, it should be dampened with warm water and passed through the press with reduced pressure one or two more times. For a successful transfer, the paper should leave the stone easily and in one piece; there should be virtually no trace of work left on its surface.

8. After the transfer has been accomplished the stone is fanned dry. *Under no circumstances should the stone be sponged to remove the residual transfer coating at this time.* This would in effect dissolve the materials of the drawing, causing them to spread. This is true for transfers from uncoated paper as well. One should recall that the grease image is only tenuously attached to the stone's surface; it must be carefully processed for the image to become firmly established.

8.14 TYPICAL PROBLEMS AND DIFFICULTIES

There are several problems that can occur during the transfer process. These faults and their probable causes are as follows:

1. The transfer paper may slip, tear, or double its impression as it passes through the press. One of the following is usually the cause:

 a. There was excessive press pressure.

 b. The stone was too wet before the coated transfer paper was laid on.

 c. The stone was too dry before the coated transfer paper was laid on.

 d. With uncoated transfer paper, the stone was passed through the press more than once.

 e. The scraper bar and tympan sheet, not being well lubricated, induced excessive friction during the passage of the stone.

Coated transfer papers are likely to tear or double toward the end of the transferring cycles, for at that time the dampness permeating the paper increases in amount and dissolves the coating. This produces a slippery surface on the stone, which, compounded by the friction of the process, can cause the paper to slip or tear. Thus the work should proceed very carefully during the last cycles

a . Dampening the stone

b. Positioning the transfer drawing on the damp stone

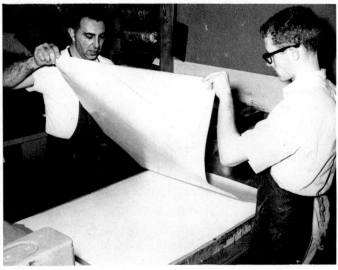

c. Positioning the backing sheets

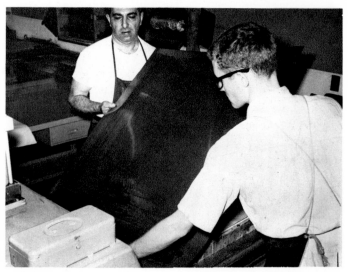

d. Positioning the tympan sheet

e. The press in operation

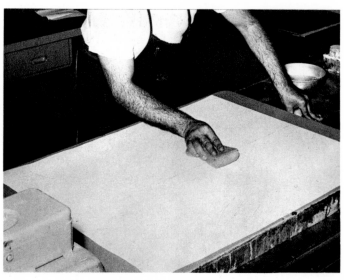

f. Dampening the back of the transfer drawing

8.6 Making a transfer lithograph

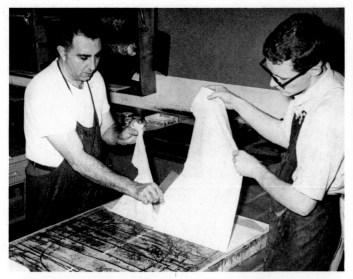

g. Removing the transfer paper after the transfer is completed

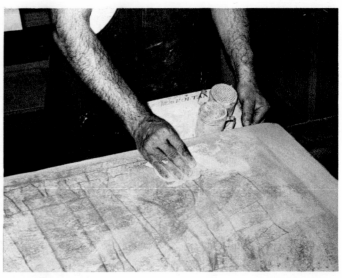

h. Dusting the stone with talc

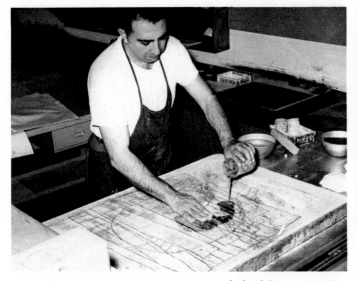

i. Applying gum arabic

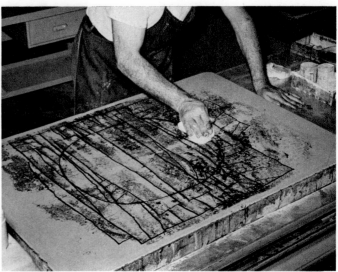

j. Wiping dry the gum film

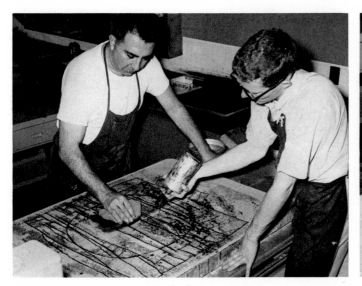

k. Applying lithotine to wash out the image

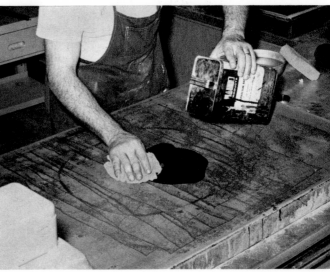

l. Applying asphaltum printing base

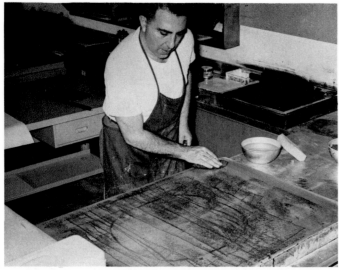

m. Distributing the asphaltum evenly

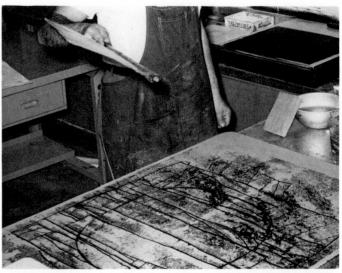

n. Fanning the asphaltum film dry

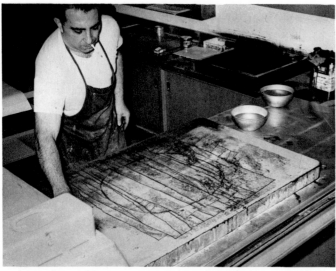

o. Removing the gum film and excess asphaltum with water

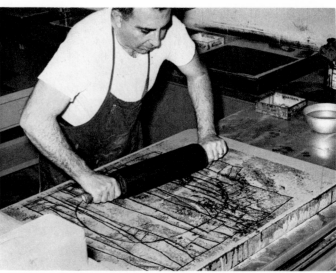

p. Rolling up the image with ink

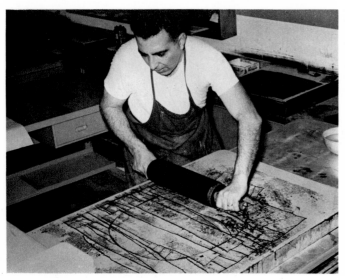

q. Changing the direction of the inking pattern

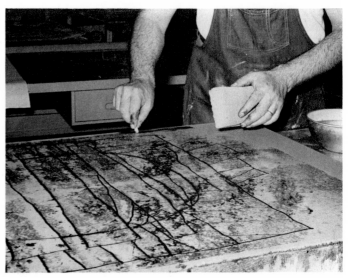

r. Cleaning the margins with a hone

s. Dusting the image with rosin (to be followed with talc)

t. Mixing the second etch

u. Applying the etch

v. Drying the etch

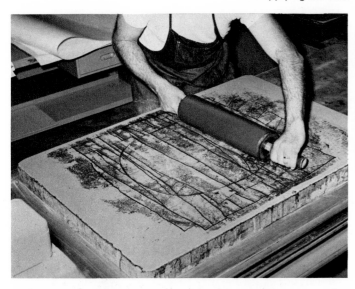

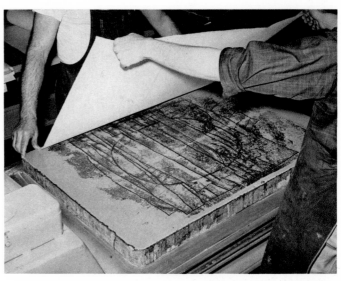

w. Inking the image in preparation for proofing

x. Positioning the proof paper

through the press. When in doubt, it is advisable to lessen the pressure slightly.

 2. Heavy drawings appear squashed after transfer.

 a. This may be a result of too much pressure, especially for coated papers. Drawings on which the crayon materials are piled up excessively will invariably squash to a certain extent; very little can be done to overcome this condition except to make the drawing in a different manner.

 b. The uncoated paper was too wet, causing the drawing materials to soften excessively.

 3. The transfer paper sticks and pulls apart as it is peeled from the stone.

a. This is sometimes caused by home-made transfer coatings that are too hard and insoluble. Warm or hot water may permit a more reliable release, but care must be taken that this does not dissolve the drawing materials.

b. The transfer paper may be soft, porous, or laminated. The dampness may strip the paper lamination before the transfer coating is ready to part. When the paper is peeled away, a very fine layer of paper can stick tenaciously to areas of the image. One must carefully pick off each particle until the work is exposed. This is a tedious procedure, and there is some danger that the drawing may be rubbed off or

displaced during the process. Sometimes a watery gum solution is used to soak through the paper layer and desensitize the stone in the nonprinting areas. After most of the pieces have been removed, the rest is left for safer removal during the processing that follows. Transfers that have undergone excessive removal of this sort seldom ink up to their full tonality, since a certain amount of their fatty contents will have been rubbed away.

8.15 PROCESSING THE TRANSFERRED IMAGE ON STONE

After the transfer is completed, the stone is fanned dry and is then ready to be processed. Corrections of the image are inadvisable at this time because a certain amount of coating from the transfer paper remains on the surface of the stone. The coating will prevent newly added work from making contact with the stone surface. Likewise, particles of paper fiber remaining after the transfer of an uncoated paper can prevent the attachment of new work. Because of the solubility of the drawing materials, the stone cannot be washed to remove the residue of transference; this residue should not be removed until the image has been safely processed.

Exceptions to the above are stone-to-stone transfers or other types in which transfer ink has been used. Because the transfer ink is insoluble in water, these can be lightly sponged to rid the stone of the transferring residue. When the surface of the stone is thoroughly clean, new work can be added before processing.

THE FIRST ETCH

The processing of transferred images differs slightly from that of drawings placed directly on stone. Because the fatty products of the transfer are in less intimate contact with the printing element, the first desensitizing etch must be very weak. Transfers from uncoated papers are especially susceptible to injury during the first etch, since they do not have a firm foothold on the stone.

Procedure

1. The dried stone is dusted with talc.

2. For most drawings, the first etch is composed only of pure gum arabic. Excessively fatty images, such as those made with heavy solvent tusches, soft rubbing crayons, and very soft drawing crayons, may require from two to six drops of nitric acid added to the gum solution. The volume of the etch remains the same as in the processing of other types of work.

3. The etch is brushed evenly over the stone and then carefully dried to a thin, smooth film with cheesecloth

wiping pads. Transfer drawings that have areas of gouache resist may smear during the wiping process. This is seldom damaging, because the etch will have completed the initial desensitization of the stone. After etching, the partially desensitized stone is ready for the washout and roll-up process.

WASHOUT AND ROLL-UP

During the processing, the printer's efforts should be directed toward firming up the fatty image deposits. The usual procedure is to employ an asphaltum printing base during the washout to reinforce the image before rolling it up with ink.

CLEANING AND CORRECTING PRIOR TO THE SECOND ETCH

A certain amount of cleaning and correcting may be necessary during the processing operation. The techniques used are similar to those already described for drawing directly on stone. Only minor and obvious corrections should be made between the first and second etches.

Full-strength solids, stipples, and lines can be added at this time without counteretching. Autographic or other maximum-strength tusche is used for this purpose.

Deleting work with blades, hones, and points can be done in the same way as in other types of work. Images that have been rubbed up usually require a greater amount of cleaning because of the accumulation of surplus ink during the process.

THE SECOND ETCH

As with drawings made directly on stone, the strength of the second etch for transferred work is determined by the character and response of the image to the roll-up. The procedure is like that for other types of work, except that in principle the second etch is stronger than the first. The extent to which this applies depends on how rapidly and fully the image accepts ink. Drawings that accept ink slowly are etched more weakly than those which accept ink rapidly. Judgments of image formation and roll-up characteristics follow guidelines previously described. (See sec. 2.5, procedures for the control of etches.)

8.16 PROCESSING WEAK TRANSFERS ON STONE

The procedure for processing weak transfers on stone is as follows:

1. Roll-up black ink is reduced with #0 varnish and a small amount of lithotine until it becomes quite soft and workable. It should still have good body and not be merely varnish with a little ink in it.

2. The ink is worked up on the ink slab with a soft sponge. It should be smooth and of the consistency of heavy cream.

3. The image is washed out with lithotine through the dried etch coating before the ink is rubbed in. If preferred, the rub-up can proceed immediately on top of the transferred image and dried etch coating; this is advisable if one feels there will be some grease loss during the washout.

4. The ink is rubbed carefully and evenly over the entire image, to produce a thin uniform film of grease. Images that are rubbed up too fully may be endangered by becoming permanently thickened.

5. The finished rubbing is cleaned with a second sponge carrying gum arabic slightly thinned with water. This dissolves the etch mask and carries along with it all unattached ink. The work is fanned dry and is carefully examined. If parts still appear weak, the stone is gummed, and the entire process is repeated. If the image appears satisfactory, the work is ready to receive the first etch.

6. The stone is dusted with rosin and talc and given a weak etch (4 to 6 drops of nitric acid and 1 ounce gum arabic). The solution is applied liberally, and within a few minutes it is dried to a thin even coating. The work is then ready to be washed out with lithotine and rolled up firmly for the final etch, using standard procedures.

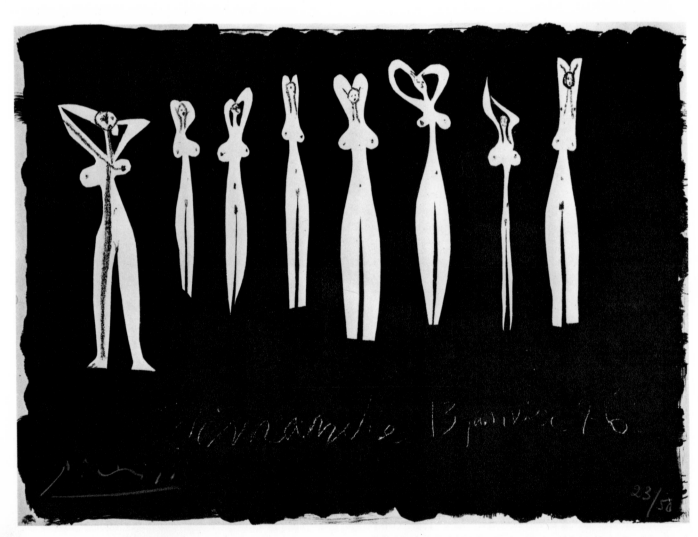

8.7 PABLO PICASSO: *Eight Nudes.* 1946. Transfer lithograph, 12 5/8 × 17 3/8". The Museum of Modern Art, New York. Curt Valentin Bequest

The figures are cut from transfer paper and affixed to a second sheet of transfer paper covered with transfer ink. In addition, Picasso drew on the figures with crayon before the work was transferred

8.17 SPECIAL CONSIDERATIONS FOR METAL-PLATE TRANSFERS

Autographic writings, drawings, type transfers, and inked impressions from other surfaces may be transferred also to metal. In addition, images can be transferred from stone to metal plates or from one metal plate to another.

Although work is transferred to metal plates in much the same manner as to stone, there are certain limiting factors that must be taken into consideration when transferring to plates. First, the chemical separation between image and nonimage areas on metal plates is much less stable than on stone. Second, as with stone, transferred images are less securely attached to the printing surface than are images drawn directly. Because these two factors combined create greater risks when transferring to metal plates, it is advisable that the beginner perfect the techniques of transfer to stone before proceeding to metal.‡

A problem that is inherent in metal-plate transfers is the tendency of water films to induce oxidation, especially on zinc plates. The transferring of coated papers requires the presence of a certain amount of moisture during the process. There is some danger that undue amounts of water will produce plate oxidation while the transfer is taking place. The image, affixed to the oxide film, will have a faulty grasp on the metal and consequently will produce an unstable printing element. It is advisable to use the minimum amount of moisture necessary to secure the transfer and afterwards to fan the plate dry and process immediately. Whenever possible, the transfers should be made using Everdamp transfer paper. This paper permits initial positioning on a dry plate surface and requires less dampening during subsequent passes through the press.

Metal-plate transfers are more susceptible to scumming during the roll-up than stone transfers are. One reason for this is the greater sensitivity of the metal to the transfered image. Another is that coating particles and other superfluous material remaining after transfer will tend to attract ink. Transfer-paper coatings seem more difficult to remove from plates than from stones. Their resistance is due to the firmer footing offered by the sharper metal-plate grain. As with stone, inked transfers can be thoroughly sponged with water after the paper has been removed; however, crayon and tusche transfers cannot. Even then, the plate is sometimes subject to scumming, although this is easy to prevent by using Lithpaco plate cleaner or the rubber hone before the final etch.

‡ General problems related to transferring are discussed in sec. 8.14. These problems are equally applicable to metal plates.

Weak metal-plate transfers may be rubbed up using procedures similar to those recommended for stone. (See sec. 8.16.) The plate is gummed with a solution having a little plate etch in it. After washing out, the image is rubbed up with the ink sponge and thinned roll-up ink. The fully charged plate is then sponged with one-fourth strength plate etch (diluted with gum arabic), washed with water, and regummed. Upon drying, the plate is again washed out, asphaltum or Triple Ink is applied, and the image is fully rolled up. In this condition it is cleaned, given minor corrections, dusted with rosin and talc, and given the final desensitizing etch.

8.18 PREPARING THE PLATE FOR TRANSFERRING

The procedures for transferring work to zinc and aluminum plates are exactly the same, except that the processing chemicals are different. In both cases, it is essential that the printing surface be perfectly clean before the transfer is made.

Zinc plates must be counteretched before transfer in order to rid their surfaces of oxides. Counteretches that contain alum in their mixture are especially good for the transference of tusche and crayon drawings or writings because of the excellent grease receptivity of their adherent films.

Aluminum plates need not be counteretched if they are treated with a sub-base (Imperial LP-8 plate). Freshly grained, uncoated aluminum plates should be counteretched, using one of the listed aluminum plate counteretches. (See sec. 6.6.)

8.19 MAKING THE TRANSFER ON METAL PLATES

Transferring on metal plates proceeds in the following manner:

1. The prepared plate is secured on the plate support, which has been previously centered on the press bed.

2. All press adjustments are made.

3. The plate is lightly dampened, and the coated transfer paper is positioned on it. (Note that the plate is not dampened for uncoated papers.) The backing papers and tympan are positioned, and the work is passed through the press.

4. The press cycles for transferring on metal plates are identical with those for transferring on stone. (See sec. 8.13.)

8.20 PROCESSING THE TRANSFERRED IMAGE ON METAL PLATES

The procedure for processing the transferred image on metal plates is as follows:

1. After the transfer is completed, the plate is fanned dry, dusted with talc, and gummed down. Either gum arabic or cellulose gum may be used for this purpose, and the procedure is identical for zinc and for aluminum. Transfers that are unusually fatty should be etched with the appropriate plate etch diluted 50 per cent with gum arabic. (See secs. 6.15 and 6.16.)

2. After the etch is dried, the image is washed out with lithotine, and a printing base such as asphaltum or Triple Ink is applied and dried to a thin, even film.

3. The plate is washed with water and immediately rolled up with stiff ink used sparingly on the roller. From this point on the procedure is exactly like that on any work drawn directly on metal plates.

4. Cleaning, touching up, and minor corrections proceed in the usual way, and these are followed with the appropriate second etch for the type of metal used.

8.21 SPECIAL TRANSFER PROCESSES

In addition to the basic transferring process, there are other, more complex methods for the transferring of images, either to stone or to metal plates. As with other techniques, inexperienced printers are advised to perfect the basic procedures before exploring these more specialized methods. The techniques described here are applicable to both stone and metal surfaces.

TRANSFERRING FROM ONE STONE TO ANOTHER

Stone-to-stone transfers have been described earlier but without details as to purpose and procedure. The following are some of the advantages:

1. When a large and important edition is contemplated, the transfer of an impression from the first stone to a second offers insurance against the deterioration of the original during printing. If necessary, the second stone (being nearly a duplicate of the original) can be quickly substituted for the first without jeopardizing the edition. The transferring of the original image *after* its deterioration would be questionable. In this case the transferred work would only reflect the damage.

2. If several transfer impressions are made from the original and one is transferred to another stone, the others can be stored for auxiliary purposes. The two stones may be printed simultaneously on separate presses to reduce the printing time of large editions. If either image deteriorates, the auxiliary transfers can be put to use.

3. A series of inked impressions from a smaller "key" stone may be transferred on a larger printing stone in such a way that duplicate images will be printed on one sheet of paper. The paper is cut or torn after printing into a number of separate prints.

4. Variations of a motif may be developed by printing a series of transfer impressions from one stone. These may then be reworked before and after transferring to other stones for the serial development of a theme.

5. Line drawings from a key stone may be transferred to other stones for very precise positioning and registry of drawings in color lithography. (See sec. 7.13.)

Procedure

1. Any type of work that has been completely processed and stabilized may be used as the original image for stone-to-stone transfer.

2. Lithographic transfer ink, rather than regular printing ink, is used for taking the impression, since the working properties of transfer ink differ from those of roll-up ink. Some trial experience will therefore be required before ideal control is obtained. The ink is modified by small additions of #0, #3, or #5 varnish or reducing oil, or black roll-up ink to suit the requirements of the particular job. Because of its greasy nature, less ink is used on the roller than under normal printing conditions. The stone is inked sparingly so as not to produce overinked impressions that will tend to squash during transfer.

3. Proof impressions on newsprint are taken until the image is printing satisfactorily with transfer ink.

4. The stone is again inked, and the water film on it is fanned dry. A sheet of stone-to-stone paper is carefully positioned and printed. Several impressions on transfer paper should be taken and interleafed between newsprint to prevent offsetting against one another.

5. The stone is dusted with talc and is gummed before washing out and inking with roll-up ink for final gumming and storage.

6. A fresh stone is positioned on the press and set up for transferring one of the printed impressions. From this point on the process duplicates the steps for standard transfer.

REVERSE OR END-FOR-END TRANSFERS

In the past, reversed transfers were often required when designs drawn for direct printing were later run on the offset press. The process is described here for another reason. It is sometimes useful to reverse the image, end for end, in order to improve its composition. It also offers opportunity to print an impression from one stone and then, by reversing and transferring it to another stone, to

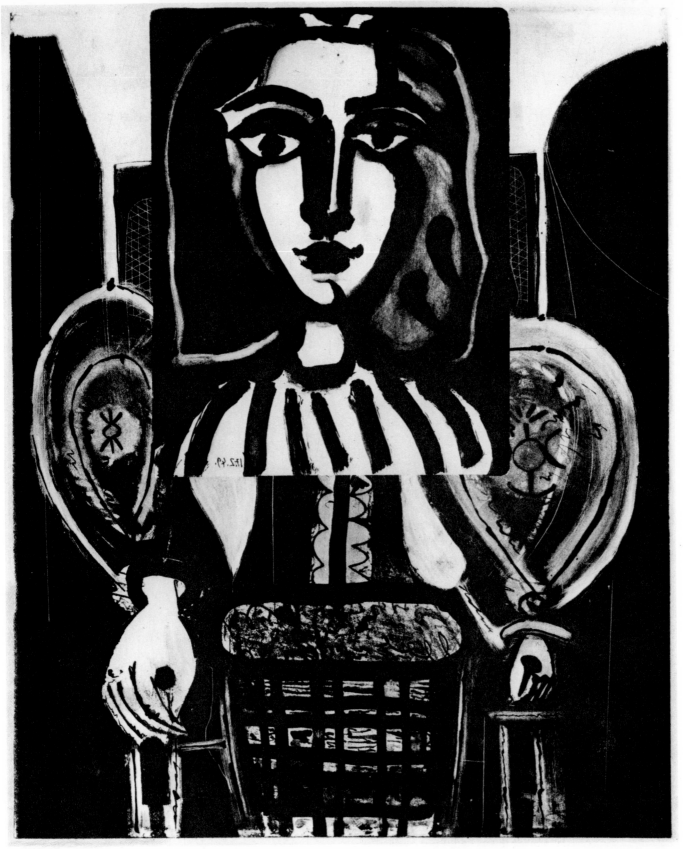

8.8 PABLO PICASSO: *Woman in an Armchair* (variant). 1949.
Transfer lithograph, 25 5/8 × 19 3/4″

Impressions on transfer paper from two separate prints by Picasso
have been pasted together and transferred to a fresh stone to form
a unique new image

carry forward two separate prints, providing visual and psychological interplay.

Care must be taken to avoid loss of detail in this method of transferring. A fairly full impression is printed on stone-to-stone paper with transfer ink. This is placed inked face down against the coated face of a sheet of Everdamp paper and pulled through the press. Dry coated paper is preferable for the first impression because it will lift a fuller body of ink, an important matter in reverse transfers, which are usually printed too lightly. There is also less trouble in the two papers sticking together or stretching. A strip of aluminum foil between the edges of the transfer papers will prevent sticking; furthermore, if the Everdamp paper is cut slightly larger all round, the overlap will be useful when the papers are peeled apart. After the two papers have been separated, the reversed impression is transferred to a fresh stone and processed in the normal manner.

TRANSFERS FROM TYPE AND WOODCUTS

Transfers can be made from type, woodcuts, and other surfaces used for relief printing. Impressions from these surfaces in combination with standard lithographic drawing techniques offer additional aesthetic possibilities, particularly in the field of book and folio production.

This type of transfer is best when printed on stone-to-stone paper using ordinary letterpress ink (without drier) to which a small amount of transfer ink has been added. The transfers should be clean and sharp, and as dense as possible. The impressions should be printed on a letterpress proof press whenever possible. Impressions from woodcuts may be printed by spooning the back of the paper or by using a Japanese baren or other burnishing instrument. Tonal variations can be obtained by varying the pressure of the rubbing instrument. The impression is then transferred immediately to a fresh stone and processed in the usual way.

TRANSFERS FROM INTAGLIO PLATES

In the nineteenth century, transfers from intaglio plates to lithograph stones were often made for reproductive purposes. The process is described here to bring attention to its creative possibilities. Since each medium offers unique and independent characteristics, it is possible that combining two or more can produce qualities otherwise unobtainable. To date, only a few artists have combined intaglio and lithographic imagery in their work; however, the results have been promising and are worthy of further exploration.

Procedure: The impression from the intaglio plate is printed on plate transfer paper or stone-to-stone paper. This is carefully dampened in the damp box or between moist blotters until quite limp. Regular etching ink is mixed with lithographic transfer ink (30 per cent by volume). This mixture produces an ink capable of being easily wiped from the plate surface and yet sufficiently fatty to form a strong printing image when transferred to stone. Excessive transfer ink in the mixture will prevent easy or clean wiping; too little ink will produce a weak transfer.

The intaglio plate is warmed and inked in the traditional way; wiping is completed by using whiting so as to reduce plate tone. The limp transfer paper is laid on the plate, followed by the normal complement of printing blankets. It is run through the etching press several times to secure a rich impression. If there is danger that the paper will be stretched or doubled, it should be run through the press only once with rather firm pressure. The plate and paper are then removed to the hot plate and carefully heated until the moisture in the paper has evaporated. With a little gentle assistance, the paper may be lifted from the plate without interference. The completed impression may then be transferred to a fresh printing element and processed in the normal way.

One must recognize that the image of the intaglio impression will be in relief. Herein lies one difficulty in making this type of transfer. There is some risk that the pressure of the lithographic press will squash the relief during the transference, thus resulting in a coarse and filled-in image. In order to minimize this problem, the ink on the intaglio impression should be permitted to dry somewhat before transfer is attempted. It is also helpful to place the impression face down against a smooth sheet of paper and pass both through the lithograph press with light pressure. This will tend to flatten the relief while at the same time pulling off excess amounts of ink. The work may then be transferred more safely.

CHALK OFFSETS FROM KEY IMPRESSIONS

Frequently, color lithographs require complex and extremely precise relationships of color positioning. In such cases it is impractical to hand-trace each color area and register mark, particularly if many stones are involved. More reliable color separation can be obtained by employing a key stone or plate on which the over-all image, including the register marks, is drawn in outline form. Impressions printed with tacky ink are taken from the key stone, dusted with red chalk or offset powder, and transferred to the separate color stones. In this way each stone supports an identical chalk impression, which can then be drawn in the proper areas for the particular color that will be printed from it. The steps of this process are detailed in sec. 7.13.

TRANSFER FROM PHOTOGRAPHIC REPRODUCTIONS

Standard procedures for the direct reproduction of photographic images on stone and metal plates are described in secs. 15.29 to 15.32. There is, in addition, an indirect method by which reproductions can be transferred to a stone and processed to form a printing image. The success of the process depends on the degree of fatty content in the ink film of the particular reproduction. Only certain reproductions can be used, because a fair percentage of commercial printing today does not employ fatty inks. Furthermore, even though the reproduction may be in color, all its fatty contents are transferred simultaneously; hence these can form only a single unified tonal image.

Various releasing agents with solvent bases have been employed to soften the ink films of reproductions so that they can be transferred. Choice among them depends on the condition and type of ink film contained in the reproduction. A certain amount of individual experimentation is required if one is to develop controllable working methods.

The following is a procedure developed by Tamarind Artist Fellow Francis Noel in 1965. Although reference here is made to transferring to stone, the procedure remains essentially the same for transferring to metal.

1. After the reproduction is selected and cut to size, its reverse side is evenly covered with a pasty solvent used as a release agent. (Naz-Dar silk-screen transparent base ink is one such material.) Solvent agents that are too liquid will run and will smear the softened ink films. The releasing agent is permitted to remain on the reproduction from three to five minutes, to permit penetration of the paper and softening of the ink film. When activated, the ink film will appear shiny.

2. The softened reproduction is carefully positioned on the stone, inked side down. It should not be shifted after positioning, because the softened ink will smear.

3. Backing sheets and tympan are positioned, and the work is passed through the press only once with firm pressure. If considerable squashing has occurred, the work is likely to be ruined. This would indicate that the release agent was applied too liberally, or that it was permitted to soften the ink excessively before transfer.

4. The transfer is fanned dry, dusted with talc, and gummed.

5. The transferred impression is washed out and reinforced with asphaltum before rolling up in the usual way.

6. After the image is fully inked and minor corrections are made, it is given a second etch, following procedures for other types of transfer work. In this condition it is ready for proofing.

PART TWO

The Chemistry of Lithography

9.1 THE CHEMISTRY OF LITHOGRAPHY

Although it is possible to draw and print lithographs without a clear understanding of the theory and chemistry of the process, in the absence of such knowledge the printer's effective control of the medium is likely to be extremely limited. He will find it difficult to advance beyond routine techniques and procedures. This limitation will impose a severe handicap upon the printer who wishes to collaborate with genuinely creative artists, for such artists can seldom realize their objectives through limited or pedestrian technical means. The serious lithographer must therefore have every aspect of the process fully at his command. Only in this way can he become a master of his medium.

This chapter examines separate but interrelated facets of lithographic chemistry to show the how and why of the materials and processes of the medium. Each topic is discussed as simply as possible for the benefit of those readers who have not had previous experience with the general subject of chemistry. One should understand, however, that knowledge of chemistry is highly desirable, especially if experimental research in the medium is undertaken. For more extensive information about specific chemical phenomena, the reader should consult appropriate references.*

*Paul J. Hartsuch, *Chemistry of Lithography*, 2nd ed. (New York, Lithographic Technical Foundation, 1961).
Dull, Metcalf and Williams, *Chemistry* (New York, Holt, Rinehart & Winston, 1958).
Nebergall, Schmitt, Holtzclaw, *General Chemistry* (Boston, D. C. Heath & Co., 1963).
Encyclopaedia Britannica

9.2 THE ROLE OF WATER IN LITHOGRAPHY

Water is used throughout the lithographic process. It is a basic constituent of gum arabic and etch solutions, counteretch solutions, and antitint solutions. It is also used to dilute tusche and to dampen the surface of the stone or metal plate during printing. Various problems associated with water are described to illustrate its influence on lithographic behavior.

THE CHEMICAL CONTENT OF WATER

The content of the water used is very important in lithography. Hard water (containing high percentages of calcium, magnesium, and iron ions) should never be used. When the local water is hard, the printer should use distilled water in all major functions of the lithographic process except stone grinding. Hard water can produce problems in the following:

1. Tusche Dilutions. Tusche, like soap, depends on water to suspend its fatty constituents. In mixtures with hard water, the fatty particles of tusche are converted into insoluble soaps even before they reach the printing surface. The quantity of free fatty particles that can unite with the printing surface is thus considerably diminished, weakening the ability of the tusche to form a firm printing image. Tusche suspensions in hard water usually display a curdled appearance.

2. Counteretch and Antitint Solutions. Hard water affects these solutions by a buffering action. The minerals in the water react with the acids in the solutions, thus weakening their ability to react with the printing element.

Consequently, greater amounts of the solutions are required to produce mixtures of a given strength. This problem is even more serious for metal plates than for stone, since the acidity of solutions used on zinc and aluminum must be more critically controlled.

ACIDITY OF WATER

During printing, the water will tend to increase in acidity and fatty content as the dampening sponge picks up free fatty particles from the inked printing surface. These are transferred to the water bowl when the sponge is dampened. The accumulation of fatty acids in the dampening water can be detected by the gradual formation of a greasy film which becomes attached to the walls of the water bowl. Overly acidified dampening water can weaken the etch barrier of the printing image, retard the drying of ink, and, in severe cases, stain the print paper. It may be necessary to clean the bowl and add fresh water every twenty to fifty impressions, depending on the degree of fatty acid present.

SURFACE TENSION

A frequent, although seldom recognized, problem is produced by the surface tension of the printing ink and the wettability of the printing element. Overly greasy images tend to repel the dampening-water film. Instead of staying in immediate juxtaposition to each printing dot, the water film is repelled to a microscopic distance from it. The dry area around each ink dot then attracts ink, producing a spread that distorts the image if unchecked and produces image growth. Problems of this sort usually result from poor adhesion of the gum and etch film. Gum films must be evenly adsorbed and in intimate contact around each ink dot; this can be accomplished only by careful application and wiping down. Even though an inked image is well dusted with talc, it can reject aqueous solutions of gum or etch during the process of their application. To prevent this, the gum or etch should be kept in motion during the entire period of application. The excess solution should be removed with a wiping cloth; another wiping cloth should be used to dry and buff the remainder.

Wetting agents are not recommended as additives to the dampening water to reduce surface tension. They tend to reposition the ink-attractive molecules of the fatty particles constituting the printing image. Additionally, the water-receptive molecules of the gum film become oriented toward the image-forming particles. As both become receptive rather than rejective, the chemical definition between image and nonimage areas is lessened, and the stability of the printing is sharply reduced.

INFLUENCE OF ATMOSPHERIC CONDITIONS

Unusual atmospheric conditions can affect the moisture films on the printing surface, either by inducing rapid evaporation or by preventing moisture from drying fast enough. With skillful manipulation, the printing roller can usually control the distribution of the moisture film in such circumstances. Less water and longer rolling are needed for slow drying conditions; shorter rolling cycles are used for rapid drying conditions. In unusual circumstances, small amounts of glycerine or table salt in the dampening water will reduce the evaporation of the moisture film on the printing surface.

9.3 THE ROLE OF FATS, OILS, AND WAXES IN LITHOGRAPHY

Natural and animal fats, oils, and waxes play a central role both in the formation of the lithographic image and in the inks with which impressions are printed. Chemically, fats and oils are the same; fats are solid at room temperature and oils are liquid. Both are found in lithographic materials.

Fats and oils are fatty-acid esters of glycerol. The term *fatty acid* refers to any organic acid that occurs in a fat. The importance of fatty acids in lithography lies in their greasy properties: they are soluble in solvents but not in water. Drawings made with materials containing fatty acid form strongly adherent films on the printing surface, repellent to water but attractive to inks, which are also composed of materials containing fatty acids.

The more common fats, oils, and waxes high in fatty-acid content are olive oil, palm oil, linseed oil, cottonseed oil, lard, butter, and mutton tallow. Any one of these is a mixture of several different kinds of fat molecules. When perfectly clean, the printing surface (stone or metal plate) is extremely sensitive to fat molecules. A few drops of olive oil or a smear of butter or lard will immediately be adsorbed or attached to its surface. It is obvious, however, that olive oil, butter, and lard are not very practical materials with which to produce lithographic drawings. Lithographic crayons, pencils, and tusches must be composed of other substances, which, in addition to containing a high percentage of fatty acids, provide pigmentation as well as variable working properties to accommodate a wide range of drawing techniques.

The particular properties of some of the fatty materials used in the manufacture of lithographic crayons, pencils, and tusches are described below.

Soap. Soap is a chemical compound formed by the reaction of fats and fatty oils with an alkali. Its chemical

nature allows it to change readily from a solid gel to a dilute colloidal suspension of fatty particles in water or solvent. Soap in lithographic crayons produces a smooth, slippery texture and stroke. It is used in tusche to make the other ingredients sufficiently dispersible to form liquid emulsions. Soap has a significant role in lithography; it is treated in greater detail in sec. 9.5.

The amount of fatty acid varies in different soaps. The more fatty acid, the better the soap serves lithographic purposes.

Tallow. Tallow is a pure fat and is used to give greasiness and softness to crayons and tusches. It also reduces the proportion of effective alkali in the soap.

Beeswax. Although greasy by nature, beeswax is much firmer when cold than tallow is. It is used to alter the consistency of crayons containing soap and tallow.

Carnauba Wax. This vegetable wax is found in the form of coating on the leaves of the Brazilian palm. It imparts hardness to the crayon and enables it to be highly resistant to acid etches.

Spermaceti. This is a crystalline wax obtained from the oil of the sperm whale. It is now largely replaced by beeswax, whose properties are similar.

Stearine. Addition of stearine rather than soap to the crayon renders the crayon insoluble in water and reduces its stickiness.

Shellac or Mastic. Obtained from trees, these are natural resins that are hard although easily melted by heat. They are used to harden the crayon as well as to bind its ingredients together.

Lampblack. Carbon-black pigment is used in varying quantities to color tusche and crayon materials. It is also used to give body and gliding properties to the crayons. It has no chemical effect upon the finished product. Although it is theoretically possible for pigments other than black to be used, nothing would be gained by using them.

TYPICAL CRAYON FORMULAS:

Engelmann's Crayons

Yellow wax	640 grams
Tallow	80 grams
White soap	480 grams
Saltpeter (in 140 grams of water)	20 grams
Lampblack	140 grams

Bolton Brown's Insoluble Crayons

Grade:	5	4	3	2	1	0	00	000
Quantities by proportionate parts:								
Carnauba Wax	50	45	40	35	30	25	20	18
Stearine	50	44	38	38	26	20	14	10
Mineral Oil	—	10	20	20	40	50	60	70
Paraffin	—	—	1	2	3	4	5	6

Lemercier's Crayons

Grade:	Copal	1	2	3	4	Rubbing
Quantities by proportionate parts:						
Yellow wax	500	500	500	500	500	250
Mutton tallow	60	50	50	70	70	340
Shellac	60	25	25	70	70	340
White soap	350	350	350	360	360	200
Copal	175	350	350	360	360	200
Saltpeter	15	15	15	15	15	200
Water	75	75	75	75	75	200
Bitumen of Judea	25	10	10	20	75	200
Lampblack	100	100	100	105	105	200

TYPICAL TUSCHE FORMULAS:

Type	Wax	Shellac	Tallow	Soap	Lampblack
Quantities by proportionate parts:					
Senefelder	12	—	4	4	1
Senefelder	12	4	—	4	1
Senefelder	8	4	4	4	1
Hullmandel	4	4	4	4	1/2
Lemercier	4	4	4	4	1

Tusche must have the following properties:

1. It must be capable of being reduced with water or solvent to a liquid state. The inclusion of soap gives it this quality.

2. It must contain the necessary amount of fatty acid to combine with the printing surface even when used to draw the finest line. The tallow and soap provide this quality.

3. The tusche must not wash away either while being transferred to stone or during etching or gumming. The shellac and wax provide this property.

4. The tusche must be visible in the tiniest line and dot. The lampblack provides this quality.

Transfer Ink and Printing Ink. Both transfer ink and printing ink are composed of fatty-acid materials in the form of oils and waxes; the vehicles of these inks are varnishes made of boiled linseed oil which are graded by acid number and degree of viscosity. A varnish is combined with a pigment and a waxy modifying agent to

produce the necessary fatty properties and body for a particular type ink. (See chapter 11.)

Other Fatty Materials. Miscellaneous materials containing fatty acids are used from time to time either as drawing materials for special techniques or as image intensifiers. (See secs. 2.11 and 10.4.) Asphaltum is the most important of these, followed by oleic acid.

9.4 THE CHEMISTRY AND BEHAVIOR OF TUSCHE WASHES

The successful control of tusche washes is one of the most difficult techniques to master in hand lithography. The artist's methods of diluting and applying the tusche are as important to the final outcome of a lithograph as the printer's methods of processing the drawing. Too often artists have mistakenly believed that an expert printer can produce dependable results regardless of how a wash drawing is made. When such matters are left to chance, the outcome of the work is unpredictable. Although many systems of control are possible, they cannot be employed without some understanding of the chemistry and behavior of tusche washes.

Chemically, liquid mixtures of tusche are emulsified solutions of fatty particles and pigment particles suspended in a water or solvent vehicle. Only the fatty particles produce the printing image. Strong mixtures of tusche contain a maximum concentration of fat and pigment particles, which appear black when drawn or printed. When strong mixtures are diluted, however, the pigment and fat particles in the suspension are divided unequally. Thus a wash drawing may appear light gray owing to the displacement of a large number of pigment particles and yet print dark gray because the fatty particles were divided to a lesser extent. Sometimes, a dark drawing prints light because the concentration of pigment particles is greater than that of fat particles.

The effects of differences between pigment concentration and fat concentration are increased when the appearance and behavior of equal dilutions of water tusche and solvent tusche are compared. Solvent vehicles tend to dissolve and divide the fat particles, thus increasing the grease concentration of the solution and permitting the fats to penetrate deeply into the pores of the stone. As a result, drawings with solvent tusche tend to print much darker than drawings with water tusche of the same tonality.

It can be seen that these characteristics of tusche dilution can cause difficulty when the artist draws and the printer processes the work. Both artist and printer must learn to take into account the difference between the way the drawing looks and the way it will print. Familiarity with these differences and the ability to control them can come only through experience and periodic testing. A simple method of testing the behavior of tusche dilutions will be described later.

Because liquid suspensions of tusche are generally unstable, they should be applied as soon after preparation as possible. Commercially prepared liquid tusche should be well shaken in the bottle before dilution or application. Bottled tusches are usually unreliable for wash techniques after storage of six months. Mixtures from stick tusche should be freshly prepared daily. Concentrated mixtures of stale tusche are used only to fill in solid black areas of drawings.

During application, tusche washes flow over the peaks and valleys of a grained stone or metal plate, following paths of least resistance. The pattern is not unlike that of rivulets flowing down irregular slopes. Fat and pigment particles are deposited on the printing surface as the vehicle evaporates. Pattern formation and wash tonality are influenced by the fluidity and concentration of the

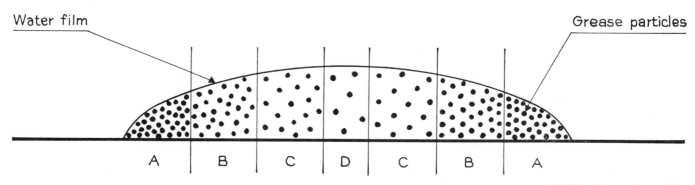

Water film Grease particles

A B C D C B A

9.1 Tusche wash puddle

Magnified section of tusche wash puddle

solution. In this respect, the drawing characteristics of solvent tusches are also quite different from those of water tusches. As the wash dries, fat and pigment particles settle in and on the printing surface in a minute granular pattern, which to the naked eye appears as a finely textured continuous tone.

Figure 9.1 illustrates a magnified cross section of a diluted puddle of tusche. The heaviest concentration of grease particles gathers at the outer edge of the puddle at A, with lesser concentrations at B, C, and D. In very dilute washes, section D will consist mostly of pigment stain, with few fatty particles present. Unless carefully reinforced with a top dressing of rubbing crayon, this section will disappear after etching, thus destroying the continuous tone of the wash. This phenomenon is known as the *halo effect*: the wash formation dries with a dark outer band and a light center. It occurs because the outer perimeter of the wash dries more quickly than the interior. As it dries, even more fatty particles from the interior are drawn to the outer edge by capillary action and are added to the original concentration. "Halo" effects can be avoided by brushing the wash puddle until it is almost dry. This ensures equal drying and settling of grease particles throughout the entire wash.

The application of one layer of tusche over another produces other characteristics which are often puzzling for the inexperienced.

1. When the second layer of tusche has the same concentration as the first layer, the wash will not appear appreciably darker, although it will print approximately twice as dark. A certain proportion of fatty particles from the second wash layer will settle on the printing surface in between the particles of the first layer, thus increasing the grease content of the entire formation without appreciably changing its pigmentation (see fig. 9.2).

2. Heavy concentrations of dried grease particles in the first layer of tusche will partially stop out weak concentrations of grease in the second layer. In such cases, pigment and grease accumulations, instead of making contact with the printing surface, gather over the first wash and darken it. Since little grease is added to the printing surface, the wash will print slightly lighter than it appears.

3. When the second layer of tusche is very fluid and great in quantity, it can dissolve and slightly displace dried fats from the first layer and add grease to the original formation.

4. Washes applied wet into wet will mutually disperse their grease particles and behave like a single wash. Nevertheless, the concentration of grease will have increased beyond that of either wash alone.

MAKING A TEST CHART FOR TUSCHE WASHES

1. A lithograph stone is ruled with conté crayon into three separate rows, each containing eight rectangular compartments measuring $1'' \times 2''$ (see fig. 9.3).

2. A stock solution of stick tusche is prepared with distilled water to a full-strength, free-flowing consistency. (Bottled tusche can be used if desired.) With an eye dropper, 5 drops of stock solution are mixed in 1 ounce of distilled water. This is called a 1:5 solution. Successive dilutions measuring 1:10, 1:15, 1:20, 1:25, 1:30, and

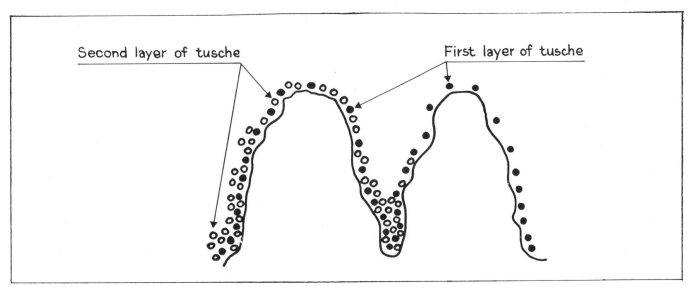

9.2 Double layer of washes

Relationship of two layers of tusche wash
Note: Some particles of second layer are unable to contact the stone; others subdivide the spaces between particles of the first wash

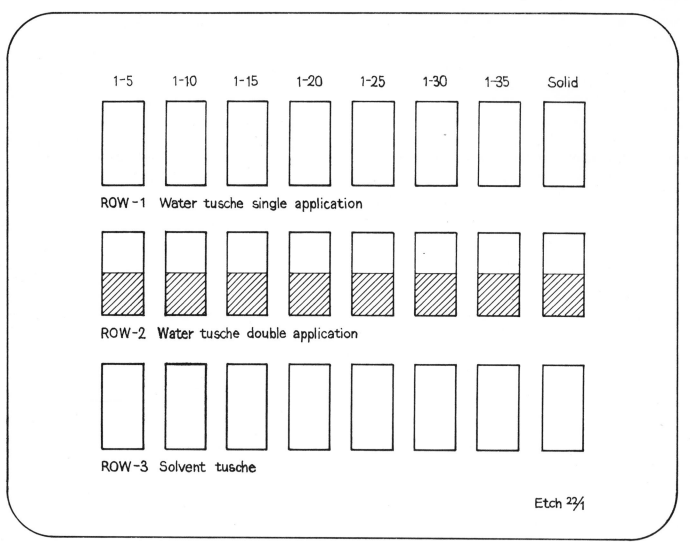

| 1-5 | 1-10 | 1-15 | 1-20 | 1-25 | 1-30 | 1-35 | Solid |

ROW-1 Water tusche single application

ROW-2 Water tusche double application

ROW-3 Solvent tusche

Etch 22/1

9.3 Tusche wash test chart

Layout for testing tusche washes

1:35 are mixed in separate containers.

3. The first rectangles in rows 1 and 2 are painted with the 1:5 mixture. The mixture is applied with a single sweep of a well-saturated, soft-hair brush. The wash should be permitted to dry naturally without further brushing.

4. The second rectangles are painted with the 1:10 solution, the third rectangles with the 1:15 solution, and so on until all compartments in the first two rows are completed with graduated dilutions. The last compartments in rows 1 and 2 are painted with full-strength stock solution.

5. While these washes are drying, the compartments in the third row are painted with solvent-tusche gradations comparable in ratio to the first two rows.

6. After drying, each compartment in the second row is half-covered with a second layer of water tusche having the same dilution as the first layer. This row will demon-

strate the cumulative increase in value produced by two layers of the same strength of tusche.

7. Tusche ratios should be noted in the margin of each compartment with a lithograph pencil.

8. The stone is dusted with rosin and talc and etched in the standard way. The etch strength should be arbitrary: for example, 16, 18, or 22 drops of nitric acid to 1 ounce of gum arabic. Special steps for protecting weak washes should not be taken.

9. After the etch is dried, the image is washed out and rolled up with ink. It is cleaned, dusted with rosin and talc, and given a slightly weaker etch.

10. Proof impressions are printed. The proofs will reveal some compartments either partially or totally destroyed: etch strength was too strong for these particular washes. Several washes may appear much darker: for these, the etch was too weak. Between these extremes, there should exist a measurable series of gradations from

black to pale gray. These represent the ratios of tusche dilution most suitable for the particular strength of etch used. Future drawings made with identical dilutions and etched in the same way can be expected to produce approximately the same results. Because of their added grease content, the layered washes in the second row will be much darker than those in the first row. The solvent-tusche washes in the third row will appear somewhat darker than the layered washes, because they contain even heavier saturations of grease.

By observing results from this test the lithographer can determine methods of control for future work. In some cases he may wish to increase or decrease ratios between tusche dilutions to allow for a greater or lesser difference between tones. In other cases he may wish to strengthen or weaken the etches to correlate them with the relative grease contents of the various washes. Additional, similar tests are advisable, to refine the relationships of etch strength and tusche dilution for other brands of tusche and for different application techniques.

When the test charts have assured the lithographer's basic understanding of wash phenomena, he should print up several test drawings in order to practice the techniques of tusche application. Additional control in processing can then be introduced by localized spot etching with several different etching solutions and by using protective pools of gum arabic to dilute etches over weak passages of tusche. (See sec. 2.5.)

9.5 THE ROLE OF SOAP IN LITHOGRAPHY

Soap is an important chemical component for use in lithography. It is made by boiling natural fats and oils with strong alkali bases such as sodium or potassium hydroxide. Soap is a mixture of the sodium salts of fatty acid radicals present in the particular fats used. Glycerine is the by-product of this reaction. The cleansing property of soap depends in part upon its ability to change readily from a solid gel to a dilute, colloidal suspension. The dispersed particles of soap adsorb fine particles of dirt and form a protective film about them. The dirt particles are thus held in suspension in the water and are washed away. Soap also acts as an emulsifying agent in the formation of stable emulsions of oils and greases in water. It is this particular property which has significance for lithography.

We have seen that lithographic drawing materials such as crayons and tusches are composed of similar fatty substances and may even include soap. Chemically, these may be considered to be soaps, and, as such, most of them are miscible in water to some degree. Thus the soap

present in the solid state of tusche permits it to be mixed with water to form an emulsion of suspended fatty-acid particles. Since most lithographic crayons and pencils are miscible in water, they also are subject to dispersion in the presence of aqueous solutions. These characteristics have several effects on stone and metal plates, some of which can be harmful. For example, crayon drawings on the printing surface can be softened and dispersed with water; however, they may not be entirely washed away because a certain quantity of their fatty particles will remain adsorbed on the printing surface. The washing action will tend to disorient the bulk of the particles from their original position, although a small percentage will remain. In such cases, it becomes impossible to determine their exact pattern or degree of ink receptivity until the work is processed and rolled up with ink. Thus, it is not advisable to attempt to remove crayon drawings by washing the surfaces with water.

These properties of miscibility in water attributable to the soap content can be put to good use:

1. Portions of a crayon drawing may be slightly softened and broadened by moistening them carefully with brush and water so that their fatty contents partially dissolve but remain generally oriented. Meanwhile other softened areas can be carefully blotted to remove a portion of their grease content. Manipulations of this sort require some practice to gain image control.

2. It is also possible to use drawing crayons to make a tuschelike material. The shavings of crayon particles mixed in distilled water form liquid tusches whose fatty contents are equivalent to the grade of crayon hardness. Solutions made with #4 crayons, for example, are weaker in grease content than those made with #1 crayons. A graduated series of tusche strengths can be formed by using mixtures of the various grades of crayon.

3. Because a certain amount of water is always present in gum and etch solutions, there is some danger that the aqueous solution can disperse crayon particles and weaken parts of the drawing. The release and conversion of the fatty drawing particles into insoluble soaps on the printing surface is practically instantaneous upon contact with the acids in the etch. However, as the upper surfaces of heavily clotted soft-crayon drawings dissolve slightly, it is possible for the etch to penetrate these areas and weaken their conversion. Etches should be gently brushed so as not to displace softened crayon drawings. In addition, gum films must be carefully wiped so as not to smear the softened drawing, which can still be injured even though most of the etching action has already taken place. Since the etch film must be reduced to a thin, even film, the cloths must be used with gentle pressure at first

to absorb most of the fluid; the pressure should be gradually increased as the film begins to dry.

Soaps, detergents, and cleansing powders are frequently used to clean dirty sponges, water bowls, and gum cloths in the workshop. Since most of these cleaning materials contain fatty-acid particles, any object washed with them must be thoroughly rinsed with water. Any remaining particles of fatty acid could be transmitted to the printing surface, where they could produce serious problems.

9.6 THE LITHOGRAPH STONE

Although many materials—such as glass, marble, onyx, slate, and stainless steel—can be conditioned to print lithographically, none perform with such reliability or range for artistic purposes as does limestone quarried from the district of Franconia (near the town of Solnhofen, Germany). It is significant that this region was the birthplace of lithography, and, until recently, it supplied the entire world with stone for lithographic printing. Although plentiful deposits of limestone exist in other parts of the world, virtually none have yielded products equal in chemical purity, fine granularity, and excellent printing quality to Solnhofen stones.

The Solnhofen quarries, extending over an area of approximately fifteen square miles, are situated in the Franconian Jura mountains at an elevation of 2,500 feet above sea level. The towns of Solnhofen and Pappenheim border the Altmühl River (a tributary of the Danube), and together they form the center of the lithographic stone district. Before it is explained why Solnhofen stone is the best limestone for lithography, the manner in which it was formed will be briefly described.

Formation of Lithographic Stone. Geologists inform us that most limestone was formed during the Jurassic middle period of the Mesozoic era, between 136 million and 190 million years ago. Limestones used for lithography are described as being nonclastic, i.e., not composed of fragments of existing stone. Instead, they contain microfragmentations of various forms of marine life (minute crustacea, protozoa with calcite shells, and certain coral-forming organisms) deposited in calcareous mud (micrite) on the sea floor. Pressure, heat, and chemical reaction compacted the calcareous deposits. In the formative cycle, one stratum of sediment was deposited over another, further compacting the earlier layers. During diastrophic periods, the earth's crust was deformed, and the sediments of the sea floor were elevated and subjected to subatrial erosion. During the periods of elevation, rivers and streams intermixed other chemical components with these deposits. After formation, the limestone strata in most other parts of the world were subjected to additional cyclic subsidence and uplift. Each such disturbance produced joints and faults in the normally horizontal stratum, permitting the formation of other minerals by hydrothermal alteration and weathering.

Two major geologic factors seem to be responsible for the unique properties of the Solnhofen deposits. First, owing to unusual regional circumstances, only a very small percentage of mineral impurities combined with the calcareous deposits during their formation. Second, the horizontal strata of the deposits of limestone remained relatively stable during the various epochs of cyclic upheaval. According to Maurice Gignoux:

> Massifs of coral limestones correspond to the position of ancient reefs and are in juxtaposition with well stratified, fine grained limestones, exploited as lithographic stone. The famous quarries of Solnhofen (Franconia) have provided rare but precious impressions of swimming and flying animals (fish, crustaceans, flying reptiles), fallen on the muddy bottom and fossilized with an extraordinary delicacy of detail. There existed at that point, no doubt, tranquil lagoons in the middle of atolls or protected by reef barriers.†

Thus a uniform deposit of limestone was created with limited faults and fewer chemical impurities than deposits in other regions. Consequently, purer stones of the rather large dimensions necessary for lithography could be cut with relative ease and economy.

Quarrying Lithographic Stone. Solnhofen stone was quarried by the process of gadding or channeling. First the surface soil and weathered debris were removed, exposing a stratum of common Jurassic limestone of variable thickness. The lithograph stone was located below this in perfectly horizontal strata up to 10 inches thick; it could be worked to a depth of 100 feet. Being moist and rather soft, the stones were not difficult to quarry; however, considerable skill was required in marking and raising large slabs of fine quality. Though soft when quarried, the stone soon became very hard through exposure to air.

Availability of Solnhofen Stone. The Solnhofen deposits, never plentiful, have, within the past ten years, been virtually depleted of lithographically usable stone. The depletion was in part due to the heavy exportation of stone to printing centers throughout the world during the nineteenth and early twentieth centuries. Depletion

†Maurice Gignoux, *Stratigraphic Geology* (San Francisco, W. H. Freeman & Company), p. 348.

was also the natural result of the quarrying process. Thin strata, broken slabs, and waste from cutting stones to rectangular shape all contributed to depletion. Ironically, even though limited quantities of stone are still available, most of what is now being quarried is sold for paving and construction—purposes for which the stone was originally used before the invention of lithography.

By 1930 metal-plate lithography had universally replaced stone printing for commercial purposes. Even before that time, most of the stones in the United States had either been exported to other countries or destroyed to provide space for more sophisticated printing equipment. It is estimated that fewer than 5,000 lithograph stones from Solnhofen exist in the United States today, most of these having been salvaged by schools and individual artists interested in hand printing. A limited number of stones are still owned by a few printing firms; and occasionally small stones can be purchased from suppliers of printmaking equipment. Somewhat larger quantities of used stones are known to exist in other parts of the world. Together these reserves are probably sufficient to sustain demand for another fifty years.

Today the prices of used lithograph stones are computed on the basis of size, thickness, weight, quality, and scarcity. The following table gives a comparison of sizes and prices for quarried stones in 1900 and 1961. The more recent prices are based on a quotation to Tamarind from the Solnhofen quarry. Since that time, the Solnhofen firm has advised Tamarind that stocks of fine quality lithograph stone in large sizes have been nearly exhausted. Nevertheless, the prices shown constitute a guideline for the current evaluation of existing lithograph stones.

Other Natural Sources for Lithographic Limestone. At the turn of the century, other limestones for lithography were quarried in Canada, Turkey, Italy, Spain, and France, although these were usually softer than Solnhofen stone and were used only for the simplest types of commercial lithography. Limestones from Brandenburg, Kentucky, and Mitchell County, Iowa, were also considered for lithographic use. Although the chemical analysis of stones from both locations was said to compare favorably with that of Solnhofen stone, it is unknown whether stones for lithography were actually quarried from these sources. It now appears that an extensive exploration of American sites for lithographic stone was never undertaken, inasmuch as the lithographic industry was rapidly converting to printing from metal plates during this period.

Physical Properties. Lithograph stones have a close and compact, yet porous texture. They should be handled with care, because they are very hard and brittle; when they break, they part cleanly with a conchoidal fracture.

Stones must have a certain thickness, depending on over-all size, to withstand the pressures of the printing press without breaking. Small stones up to $9'' \times 14''$ should have a minimum thickness of 2 inches. Larger stones require 3 to 4 inches of thickness for safe printing. Thinner stones are often backed with slate to provide sufficient bulk to withstand printing and to prolong their usefulness.

The color of a stone indicates its hardness and quality. The following seven grades of color are recognized for lithographic purposes:

1. Blue Stones. These are the most ancient, most compact, and darkest of all the lithographic stones. They were subjected to the greatest pressures and heaviest infusions of mineral pigmentation during their formation. Being denser, purer, and rarer than other grades, these stones were in the past highly prized for engraving purposes. They are generally too dark for artists' drawings and are too heavy for general lithographic use today.

2. Dark Gray Stones. These stones also are rare; they are somewhat lighter in color than blue stones, but usually too dark for the artist to develop tonal gradations with ease. They are excellent stones for engraving, for solids, and for linear work.

3. Medium Gray Stones. These are the most desirable stones for use in lithography. The tonal range of a drawing can be clearly seen. Though less hard than the previous categories, these stones are of ample density to withstand strong lithographic etches evenly and without coarsening. Today, stones of this quality are rare (particularly in large sizes) and are highly prized. They make possible the printing of very large editions with remarkable stability.

4. Light Gray Stones. These stones are a light, cool

Prices of Lithograph Stones

Quality	Size in inches	Average Wt. in pounds	Thickness in inches	Price per lb. ($) 1900	1961
	16×22	100	3	.035	—
	18×24	130	3 1/4	.045	.39
Blue-gray	24×32	264	3 3/4	.08	.48
	26×36	319	3 3/4—4	.09	.51
	28×38	336	3 3/4—4	.10	.64
Yellow	28×38	362	3 3/4—4	.07	.31
	30×40	422	4	.09	.33
Gray	30×40	440	4	.12	.57
	42×64	1,000	4 1/2	.18	—

One Side Polished, Planed Front and Back

9.4 Quartz crystal vein in stone

9.5 Iron pyrites in stone

gray. They are the youngest and softest of the limestones in the gray category. These are found in greater numbers than the medium gray stones and can be used with excellent results for all varieties of work. Occasionally, marine fossils are found imbedded in stones of this color.

5. Hard Yellow Stones. These stones have a warm, tan color. They are less dense than the gray varieties, although they are still capable of producing a satisfactory range of work. Most of the large stones brought to this country were of this quality. Being relatively soft, stones of this quality cannot withstand strong etches without some coarsening. In addition, the sharp granularity that is characteristic of gray stones cannot be produced on hard yellow stones; crayon drawings with fine tones and delicate tusche washes executed on such stones therefore appear somewhat less crisp.

6. Soft Yellow Stones. These stones are lighter in color and even softer than the previous category. They usually have an uneven density and are composed of greater percentages of silica, ferrous oxide, and other impurities. Some of these impurities will resist the action of the etch more than others, thus roughening the surface of the stone and undermining parts of the image. Soft yellow stones are suitable only for the coarsest type of drawings and are not recommended for processes that require extensive corrective procedures. Linear work and autographic transfers print fairly well from soft yellow stones.

7. White Stones. These are the most recently formed, the softest, and the least desirable of all the grades of lithographic stone. They are chalky white and invariably contain large percentages of impurities. White stones are generally incapable of producing dependable results for any type of lithographic use. They are used only because of the general shortage of all grades of stone, and only for the simplest types of printing.

In addition to color, lithograph stones display other physical characteristics that govern their quality and performance:

Iron Marks. These may appear on the surface of the stone as bands, ribbons, or streaks of dark gray, bluish gray, or pale reddish brown. They result from iron oxides in differing states of oxidation reduction which were present during the formation of the stone. Though sometimes visually distracting, they seldom interfere with the lithographic properties of the stone.

Quartz Crystals. These are shiny clusters of small quartz or gypsum crystals. They are unreceptive to grease, and, being much harder than their surroundings, they produce uneven etching. Fortunately, most stones were cut in such a way as to avoid such formations. When they are present, however, the artist has no alternative but to plan his work to avoid them.

Iron Pyrites and Copper Pyrites. These appear as crystalline hairlines resembling cracks across the surface of the stone. The copper pyrites are usually accompanied by a yellowish stain on either side of the line. Like quartz particles, these are harder than their surroundings. They are tolerated because of their thinness. In some cases they will accept ink and print as a fine crack, and in other

9.6 Marine fossils in stone

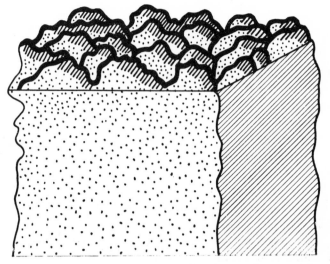

9.7 Magnified section of stone showing grain structure and porosity

cases they will reject ink and print as white lines.

Marine Fossils. The unassimilated exoskeletons of marine crustacea appear as small whitish flecks and blossomlike patterns in the surface of the softer stones. In some stones, the entire surface is covered with these defects. Such stones can be used only for very simple work; their mottled surfaces, besides being visually distracting during drawing, respond unpredictably to etches.

Mechanics of the Physical Properties. Because of their hardness and compact texture, lithograph stones can be ground with abrasives to a remarkably fine grain or polished to a glasslike surface. Grained or polished stone functions in the following way:

1. The natural porosity of the stone permits the penetration and deep seating of the fatty-acid particles and of the adsorbed films of gum and etch, which, when wet, constitute the ink-rejecting barrier.

2. The surface grain of the stone divides drawing material placed on it into minute dots of varying size and shape, which attach themselves along its peaks and valleys. The size, proximity, and pattern of the grease-dot formation is instrumental in the development of optical textures and tonalities. Dot patterns that are close together and nearly the same size produce darker values and smoother drawing textures than those which vary in size and are farther apart.

Varying amounts of light which appear between the dots determine the particular texture and tonality of the passage. This granularity of the stone surface provides unique possibilities for the development of deep and rich tonalities of light, delicate, and luminous tones; this quality distinguishes lithography from other print mediums. The grain also produces an increase in the surface area of the stone by creating a great number of reservoirs that offer improved foothold for the materials that form the image and nonimage areas. These reservoirs are especially important to the nonimage areas of the work, for they increase their capacity for water retention.

3. Polished stones, because of their grainless surface, cannot be used for tonal drawings. Linear work and solids, however, appear much denser and snappier than they do on grained surfaces, because granular lights cannot penetrate the solid to reduce optical density. Polished stones can also be used for photographic halftone reproduction. The principles of this process also are dependent on full-strength patterns.

The image and nonimage materials adhere to the polished surface of the stone because of its natural porosity. Theoretically, they attach less securely and are more subject to displacement during the etching process than formations on grained stones; actually, displacement seldom occurs.

Chemical Properties. Chemically, lithograph stones of the finest quality contain approximately 94 to 98 per cent calcium carbonate and carbon dioxide. The remaining 2 to 6 per cent of foreign matter is mostly composed of silica, iron, manganese, and aluminum oxide. Because

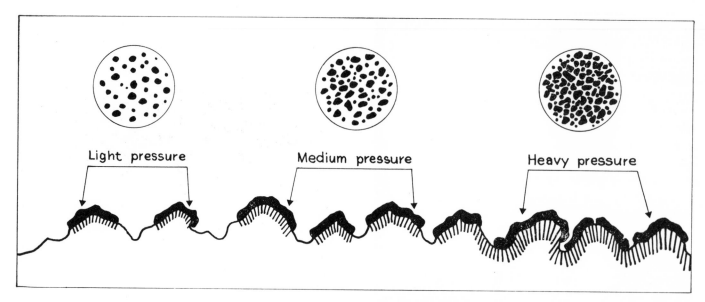

Light pressure Medium pressure Heavy pressure

9.8 Magnified crayon formation and particle proximity on a grained lithograph stone

of its extremely small percentage of chemical impurities, the stone can absorb grease or water with equal affinity; meanwhile it responds to the chemicals used in lithography with maximum sensitivity. The following table is an analysis of a typical Solnhofen stone:

Analysis by Steiger

SiO_2 (silica)	1.15%
TiO_2	—
Al_2O_3 (alumina)	.45
Fe_2O_3	—
FeO (ferrous oxide)	.26
MO	—
CaO (lime)	53.80
MgO (magnesia)	.56
K_2O (potash) ⎫	
Na_2O (soda) ⎭	.07
Li_2O	—
H_2O (−) (hygroscopic water)	.23
H_2O (+)	.69
P_2O_5	—
CO_2 (carbon dioxide)	42.69
S	—
SO_3	—
Cl	—
Organic	—
	99.9%

When the stone is etched with solutions of gum arabic and nitric acid, its chemical composition enables the printing image to be established in the following two ways:

1. The fatty bodies of the drawing materials are converted by chemical action into fatty acids; these combine with the calcium of the stone to form insoluble lime soaps that are highly receptive to greasy printing ink.

2. The surfaces without grease drawing are changed from calcium carbonate to calcium arabinate by virtue of the adherent gum arabic film produced by etching and drying the stone. The adsorbed gum has the property of keeping the stone surface moderately damp when moistened with water. In this way the stone's natural affinity for water retention is increased considerably by the etching process. When the residue of the drawing components is washed away with water and lithotine, the latent lithographic image can be faintly seen like a photographic negative. The difference in color between the image and nonimage areas is the result of the calcium oleate image formation and the calcium arabinate nonimage formation.

The reliability of these lithographic functions is related directly to the chemical composition of the stone itself. Both image and nonimage formations are impaired if high percentages of foreign impurities are present. For example, concentrations of silica, alumina, magnesia, or quartz, being less porous than calcium carbonate, will resist somewhat the absorption of fatty image particles as well as the chemical reaction of desensitizing etches. Thus, image formation in areas containing such impurities will be weak or nonexistent, and the tonal gradations of the drawing will be coarsened or disrupted. These conditions are particularly evident when working with

soft yellow and white stones, which are high in impurities. It should now be evident why other types of limestone, which have even greater percentages of impurities, are unsatisfactory for lithography. Other chemical characteristics of lithograph stones will become evident in later discussion of the chemistry and behavior of lithographic etches. (See sec. 9.12.)

Substitute Stone for Lithography. Because of the shortage of lithograph stones in the United States, some exploration of usable substitutes is under way. Working under a grant from Tamarind, Robert Evermon is testing the lithographic properties of Pedrara onyx. Results to date, though not conclusive, show some promise.

Pedrara onyx is of calcareous composition; in its purest state it contains even smaller percentages of silica, iron, and manganese than Solnhofen stone. It is very closely grained and is one and one-half times harder, and much denser than the average marble with which it is classified. The stone is quarried near Marmol, in Baja California, about 300 miles south of San Diego and 50 miles inland from the Pacific Ocean. It is imported and distributed in the United States by the Southwest Onyx and Marble Company, San Diego. This beautiful and finely textured stone ranges in color from translucent white to fleecy cream; it is veined in tints of green, rose, yellow, gold, and brown. Clear slabs, without veining, are also quarried, and these are more desirable for lithographic use.

Evermon purchases the slabs in 1-inch thickness to reduce weight and cost. The stone is then laminated with epoxy adhesive to a 2-inch thick unit of aircraft aluminum having honeycombed cellular construction. This provides an extremely strong, lightweight, and uniform base for the stone, although, if the stone is carelessly laminated, fracturing can occur during printing.

The onyx is grained, drawn, and processed in the same manner and with the same materials as Solnhofen stone. Preliminary observations indicate that this stone has a slightly different granularity than the traditional lithograph stone, and hence crayon drawings produced on it are somewhat coarser. Tusche washes react very well with the onyx, and to date printing performance has been reasonably dependable.

9.7 THE PHYSICAL AND CHEMICAL PROPERTIES OF ZINC PLATES

Zinc lithograph plates are manufactured from native ores, principally zinc carbonate and zinc sulphide, and are alloyed with small amounts of cadmium, lead, and iron. The zinc is heated and rolled into sheets, which, upon cooling, retain toughness and pliability. Finished plates are bluish gray, much darker than aluminum, and about two and one-half times heavier. The alloy and manufacturing process of American zinc plates is somewhat different from that of European zinc plates. The chemicals and processing techniques for American plates are thus unsuitable for European plates; similarly, the chemicals and processing methods of European plates are unsatisfactory for American plates.

Zinc dissolves quickly in strong solutions of nitric, hydrochloric, and sulphuric acids. Cold solutions of caustic soda or caustic potash have no effect on it, although a slight decomposition results if these solutions are warmed. Untreated zinc plates will oxidize in the presence of atmospheric moisture. Oxidation occurs in the formation of a tightly adherent film on the plate surface, which, if unchecked, will eventually pit and corrode the plate, rendering it unfit for further service. The relationship of the oxide film on zinc plates to the lithographic process is not clearly understood, although it is universally agreed that the film must be removed to permit good image formation and printability.

Before being drawn upon, zinc plates must be sensitized (counteretched), with weak solutions of nitric, acetic, or hydrochloric acid. The products of counteretching are instrumental in the removal of oxide films and other chemical and physical impurities left on the plate surface after graining. (See secs. 6.6 and 9.15.)

The chemical formation of image and nonimage areas is somewhat different on metal plates than on stone. Both areas on metal are entirely dependent on the adsorption of their chemical constituents on the plate surface, and this occurs without basically changing its chemical composition. The fatty deposits of the image areas on stone are chemically converted to become part of the basic chemical composition of the stone, while the nonprinting areas, though mainly dependent on the principles of adsorption, are also chemically oriented to the composition of the stone. The significance of this difference is that both image and nonimage areas are "in" rather than "on" the stone surface. Being more firmly established, they are less likely to be displaced during the course of printing.

Since the image and nonimage areas cannot penetrate the nonporous surface of the metal plates, they must secure themselves mostly through adhesion. Therefore, the processing chemicals for metal plates must provide the tightest possible adsorption bonds. In this respect the desensitized areas of the metal plates may be considered to be more important than the image areas. As long as

they function as a strong, stable, water-receptive, ink-rejective mask, they can confine and localize each image dot, protecting it from spread or displacement. The desensitizing etches for zinc plates are composed of gum arabic or cellulose gum, and contain inorganic salts such as nitrates, phosphates, and bichromates. (See secs. 6.4 and 9.14.)

9.8 THE PHYSICAL AND CHEMICAL PROPERTIES OF ALUMINUM PLATES

Aluminum is extracted from the ores of bauxite and cryolite. It is malleable when hot or cold and may be drawn, cast, or rolled. Lithograph plates are formed by rolling. The metal is lightweight and light in color, and is preferred by some lithographers for the ease with which drawn work can be seen on it.

Aluminum is not damaged by nitric acid, but it is vigorously attacked by hydrochloric acid and dilute sulphuric acid (although concentrated solutions of sulphuric acid will not damage it). Phosphoric, acetic, citric, and oxalic acids show little or no reaction with aluminum. Additions of common salt to these chemicals will, however, set up a slight decomposition in the metal. Caustic soda and caustic potash react strongly with aluminum, and steady decomposition results.

Aluminum plates are inherently covered with a tightly adhering film of aluminum oxide. Although this oxide film can be removed with weak solutions of hydrofluoric acid, present evidence suggests that its presence may be advantageous to the adherence of desensitizing etches. In this respect, oxide films on aluminum plates affect performance quite differently from oxide films on zinc.

Aluminum plates are grained in the same general manner as zinc plates, although their grain structure is somewhat different. Drawings and tusche washes on aluminum look more like those on stone than do those on zinc.

Aluminum plates that are not provided with special surface coatings should be sensitized by counteretching with weak solutions of nitric or hydrochloric acid and water. Counteretching aluminum is less to remove oxide films than to establish adsorbed salts helpful to drawing and etching.

Desensitizing etches are usually simpler for aluminum plates than for zinc plates. They are basically composed of phosphoric acid and either gum arabic or cellulose gum. (See secs. 6.16 and 9.14.)

9.9 THE ROLE OF pH IN LITHOGRAPHY

The pH of a chemical solution is a measure of its relative acidity or alkalinity, analogous to the measurement of temperature by degrees of Fahrenheit or Centigrade. Given the information that a certain solution performs with maximum efficiency in lithography at a specific pH, one can use pH measurement to match solutions reliably, regardless of volume. This is particularly important in metal-plate processing solutions, where tolerances of relative acidity or alkalinity are much more critical than for stone.

The pH system of measurement relies on measurement of the *dissociation constant* of water; a numerical value (pH value) is assigned to a given solution by mathematical equations on the basis of its hydrogen (positive ion) and hydroxyl (negative ion) concentration. In pure water the hydrogen and hydroxyl concentrations are equal, and the solution is neutral (pH 7, neither acid nor alkaline). Acids, bases, and salts will also ionize in a water solution to form positively and negatively charged ions. The hydrogen ion is the basis of acidity and the hydroxyl ion is the basis of alkalinity. If the solution contains a high concentration of hydrogen ions, it is acidic; if it contains a high concentration of hydroxl ions, it is alkaline.

A scale of pH values has been established from 0 to 14, with the neutral point at 7 (the pH of pure water). Values from 0 to 6 indicate acidic solutions, and values from 7 to 14 indicate alkaline solutions. The lower the pH numbers, the more hydrogen ions are in concentration and the more strongly acid the solution. A pH value of 8 indicates a relatively weak alkaline base, and progressively increasing numbers indicate stronger bases:

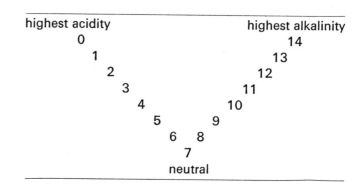

The following table indicates where some lithographic solutions fall on the pH scale:

	pH
Hydrochloric acid counteretch (1 fl oz/1 gal)	1.2
Aluminum-plate etches	
(gum arabic/phosphoric acid)	1.8—3.0

Zinc-plate etches	2.5—3.5
Acetic acid counteretch (6 fl oz/1 gal water)	3.0
Cellulose gum (acidified)	2.9
Gum arabic (nonacidified)	4.2—4.3
Cellulose gum (nonacidified)	5.0
Ammonium hydroxide (ammonia)	11.2
Trisodium phosphate (TSP)	12.0
Sodium hydroxide (lye)	13.0

The mathematical relationship between pH values is logarithmic, to the base 10. Thus a solution that measures pH 2.0 is ten times more acidic than one measuring pH 3.0 and one hundred times more acidic than one measuring pH 4.0. The following table illustrates the logarithmic comparison of pH values with active units of acidity in etch solutions:

pH value	Active units of acidity
1.0	1,000,000
1.5	320,000
2.0	100,000
2.5	32,000
3.0	10,000
3.5	3,200
4.0	1,000
4.5	320
5.0	100
5.5	32
6.0	10
6.5	3
neutral 7.0	1 or 0

The implications of logarithmic progression are of great importance when increasing or decreasing the volume of an etch for stone or metal plates, as shown by the following examples:

I. 1. Assuming that one had one ounce of acidified gum arabic etch (pH 2.0) and wanted to make it half as acidic, one would normally add one more ounce of pure gum arabic (pH 4.0). This would appear, in acidic units:

Quantity	Active units of acidity	pH
1 oz acidified gum arabic	100,000	2.0
1 oz pure gum arabic	1,000	4.0 approx.
2 oz total volume	101,000	2.0 approx.
50% total volume	50,500	2.2 approx.

2. The introduction of an equal measure of pure gum arabic, in addition to doubling the total volume of the solution, actually increased its total acidity by 1,000

units. Thus, one ounce of the new mixture is slightly more than one-half as acidic as the original mixture.

II. Etch solutions for stone lithography are usually formulated on the basis of one ounce volume of gum arabic per variable number of drops of acid. Theoretically, if each drop of acid was considered to be 100 acidic units, ten drops of acid would equal 1,000 acidic units.

1. Thus ten drops of acid (1,000 acidic units) plus one ounce of gum (10,000 acidic units) would produce an etch mixture containing a total of 11,000 acidic units measuring approximately pH 3.0.

2. Although one ounce of etch solution is sufficient to desensitize a small stone, at least two ounces of solution are necessary for large stones. Doubling the formula (two ounces gum arabic to twenty drops of acid) would produce the following:

Quantity gum arabic	Quantity nitric acid	Active units of acidity	pH
1 oz	10 drops	11,000	3.0 approx.
1 oz	10 drops	11,000	3.0 approx.
2 oz	20 drops	22,000	2.8 approx.

3. Doubling the etch formulation lowered the pH factor by increasing the acidity in the total volume of solution. Thus, *as the total volume of an etch formula is increased, its acidity multiplies, and, unless modified, the excessively strong etch can be injurious to the work.*

The usefulness of pH values in lithography depends on a quick and accurate means of measuring the pH of a specific solution. Two methods are commonly used: colorimetric and electrometric. The electrometric system records changes of voltage in an electrical cell as the pH of the solution of the electrical cell is altered by the solution being measured. The colorimetric system depends on the ability of certain organic compounds to function as color indicators when immersed in the solution being measured. Bromothymol blue, chlorophenol red, and phenophthalein each change color over approximately two pH units and are useful as indicators only within that range. Different color indicators must be used for measurements outside these limits.

The most practical type of colorimetric system for pH determination in hand lithography is called Hydrion Short Range Papers (see Appendix A). This is a kit of rolled paper strips, each impregnated with a color indicator dye. The pH is measured by tearing a short strip of paper from one roll and immersing it for two to three seconds in the solution to be tested. The color developed in the paper is compared with a color chart supplied with the kit, which has a pH value corresponding to each color

shown. When the color developed on the test strip is the same as the color at either end of the color chart, the solution should be retested with a strip from another roll containing a different indicator. The process is repeated until an indicator is found that is between the extremities of the particular color chart. Short-range colorimetric papers are useful for approximate pH measurements such as for gum, etch, and antitint solutions. Their accuracy is usually not better than 0.3 to 0.5 pH units; however, these are satisfactory tolerances for hand lithography.

9.10 THE ROLE OF LITHOGRAPHIC ETCHES

Drawings on stone or metal plates must be chemically processed in order to establish the printing and non-printing areas of the bearing surface. Various combinations of gums and acids are used for processing. When the acids are combined with the gums they are called *etches*. The process of etching and gumming performs a double function: (1) It converts the fatty constituents of the drawing materials into firmly established and insoluble ink-attractive particles. (2) It desensitizes the printing surface by forming a tightly adhering water-receptive and ink-rejective filmlike barrier around each of the image particles and the rest of the nonprinting surface.

The gum used in the etch or gum solutions contributes mainly to the desensitization. It must be *hydrophilic*, or water-loving, and it must be capable of holding tightly to the nonimage areas of the printing surface. Inasmuch as the printing surface must be continuously dampened during the course of printing, the adherent gum film must not completely dissolve, or the nonimage areas would be exposed to ink. Although many natural and synthetic materials are hydrophilic, they vary widely in their ability to adhere tightly to the printing surface. At present the most efficient materials for this purpose are gum arabic and carboxy methyl cellulose (CMC), the latter having proved slightly superior for adherence to zinc plates. Even though both gums are water-soluble, their dried films cannot be completely washed away, owing to a certain principle of adhesion called *adsorption*. Thus, after dried gum or etch coatings are washed away, a microscopic layer of their substance remains to function as a water-retaining film covering the nonimage areas of the printing surface.

The acids incorporated in etch solutions enable the gum constituent to desensitize the printing element more effectively. This function is somewhat different on stone than on metal plates. Before detailing the chemistry of etches for lithography, it is necessary to examine the mechanics and some of the implications of adsorption.

9.11 THE MECHANICS AND IMPLICATIONS OF ADSORPTION

Adsorption is a surface phenomenon that affects the adhesion of a solid or liquid (such as gum arabic) to another solid by molecular attraction. The adsorbed layer of material is usually held so strongly that it cannot be washed away with a liquid that would ordinarily dissolve it. The atoms, molecules, or ions that compose a surface such as a lithographic stone or metal plate differ from those in the interior body where they are surrounded on all sides by particles having equally attractive forces. The particles on the surface are surrounded only on their inner side by such cohesion; they have a certain amount of attractive force that is unsatisfied. These unsatisfied forces are called *residual valence forces*, and they are largely responsible for adsorption.

When matter is subdivided to the extent that its particles become colloidal in dimension, there is a tremendous increase in the surface exposed to the surrounding medium. Because colloidal particles have a very large surface area for a given volume of material, they are good adsorbers. Gum arabic and cellulose gum are both colloidal materials that are good adsorbers. The fatty-acid constituents of lithographic drawing materials are also good adsorbers.

Present theory states that only matter whose molecules arrange themselves in certain patterns will form adsorbed films. The molecules of such matter have parallel axes and are pointing in the same direction. In this condition they are said to be *oriented*, or *polarized*. The degree to which the molecules of the desensitizing solutions can be oriented is a measure of the effectiveness of the adsorption. When certain acids are added to the gum solutions, the ability of the gum to form tighter adsorption bonds is improved. Moreover, it is believed that smoothly wiping and drying gum and etch coatings improves the polarization of the molecules. Coatings that are washed off without drying will also form adsorbed films, although the molecules are thought to be less polarized and, hence, provide less firm image desensitizers.

Adsorption in itself is not a chemical action, but it usually depends upon some chemical reaction. For example, the chemical reaction of acids in metal-plate etches releases the fatty constituents of the drawing materials, permitting them to be adsorbed on the plate surface; at the same time, the gum contents are forming

adsorption bonds on the nonimage areas. Thus, two separate and distinctly different adsorbed layers exist side by side on metal plates, one grease-receptive and the other water-receptive.

Even though adsorbed films are tightly adhering, they can be displaced by either physical or chemical means. For example, a certain amount of friction and physical abrasion can occur on the printing surface through the movements of the dampening sponge, inking roller, and press scraper. The repetitive friction of these movements can eventually disorient or displace the molecules of an adsorbed film. Another case, seldom recognized by the novice, results from cleaning ink-smudged margins by rubbing with the fingers. This procedure, while temporarily cleaning the surface, will actually subject it to increasing ink accumulation as the adsorbed gum-desensitizing film is gradually destroyed by the friction of rubbing.

Various mixtures containing acids, gum, water, or solvents also destroy adsorbed films. A few of these are:

1. Too strong mixtures of nitric acid in gum or water, instead of desensitizing the surface, will produce sensitization by weakening or destroying the previously adsorbed image and nonimage areas. Instead of etching the work, such solutions will function as counteretches. The chemistry of this phenomenon is explained in sec. 9.13.

2. Strong mixtures of phenol and gasoline can dissolve and destroy adsorbed fatty-acid image areas.

3. Weak solutions of acetic acid and water (counteretches) can dissolve and destroy adsorbed desensitizing films of gum or etch.

4. Too acidic antitint solutions can weaken adsorbed fatty image deposits and eventually cause their destruction.

Last—and perhaps most significant—is the characteristic of adsorbed films composed of dissimilar materials to displace one another, depending on which material is in greater concentration. Displacement occurs in many forms in lithography, and it is most often the underlying reason for loss of stability between the ink-receptive and ink-rejective areas of the printing surface. This happens most frequently when overly greasy printing inks are used. The excessive concentration of fatty ink molecules will gradually overcome the adsorbed gum molecules on the nonprinting areas. Unless this condition is quickly corrected, the ink molecules will replace the gum with freshly formed deposits that will accept ink. Similarly, weak image deposits can also be overcome and displaced by repeated gumming either with or without acid.

9.12 THE CHEMISTRY OF GUMS AND ETCHES ON LITHOGRAPHIC STONE

The process of desensitizing (etching) the stone after the drawing has been made secures the image and nonimage areas simultaneously. The major material for desensitizing the stone is gum arabic. Combining the gum with nitric acid or mixtures of nitric, phosphoric, and tannic acid provides an etch with greater desensitizing properties than if the gum were used alone. Inasmuch as both image and nonimage areas are formed at the same time during etching, it is necessary to review their separate chemistry in order to clarify their relationship to each other.

Formation of the Image Areas. During the process of drawing, the fatty constituents of the lithographic crayons and tusches are partially absorbed into the porous surface of the stone. It should be remembered that the drawing materials are composed of various combinations of fats, soaps, and pigments, which, by their nature, have some penetrative capacity. The granular surface of the stone separates the drawing materials into microscopically separate particles that attach themselves in varying patterns around the peaks and crevices of the grained surface.

The drawing particles cannot completely unite with the stone until the fatty-acid molecules of the fats in the drawing materials have been chemically released to combine with the stone in gumming or etching. The soaps in the drawing materials hydrolyze in the presence of the aqueous gum or etch solution. Acids in the mixture assist in the liberation of the fatty-acid molecules and drive them farther into the pores of the stone. The product of the reaction converts the fat molecules into insoluble calcium soaps whose fatty groups gravitate to the outer surface of the stone. The calcium soap molecules, being greasy, attract greasy printing ink and repel water.

When the physical components of the drawing materials are removed from the surface of the stone with a solvent such as lithotine, the ghostlike trace of each drawing particle will remain as an integral part of the stone; no amount of washing with solvent will remove it. When the cleaned stone is dampened with water, the image areas will repel the moisture film on the nonimage areas (between each drawing particle) of the stone. If ink is applied to the stone with a sponge or printing roller, some of the greasy film will be transferred onto the image areas, and the moisture film on the nonimage areas will reject the ink.

Without the chemical reaction produced by the etching solution, only the free (unconverted) fats of the drawing

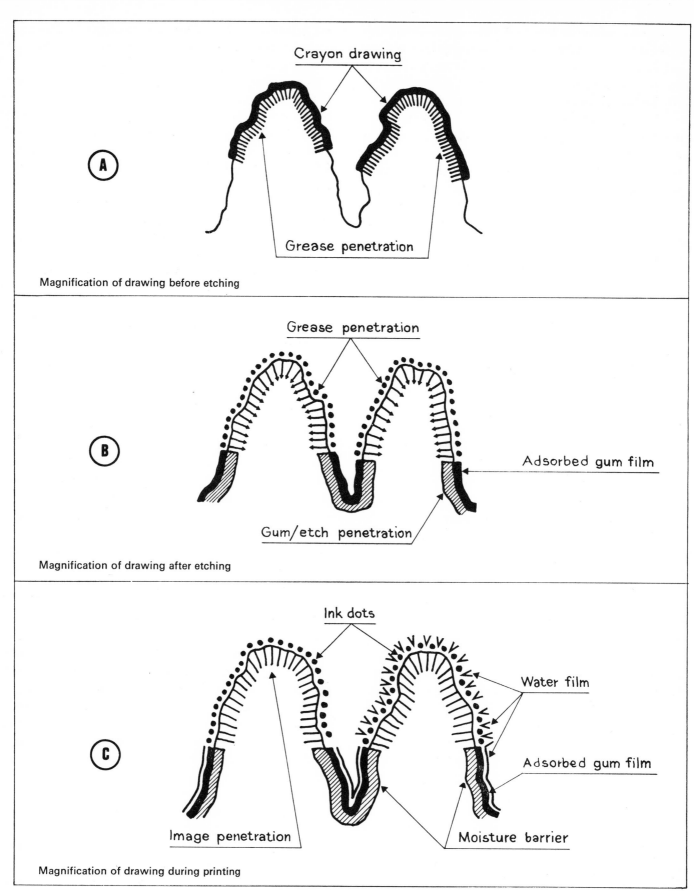

A — Magnification of drawing before etching

Crayon drawing

Grease penetration

B — Magnification of drawing after etching

Grease penetration

Adsorbed gum film

Gum/etch penetration

C — Magnification of drawing during printing

Ink dots

Water film

Adsorbed gum film

Moisture barrier

Image penetration

9.9 Relative magnifications of the image

components are absorbed into the porous limestone. Unconverted fats create poorly adhering, impermanent particle formations, which are not molecularly oriented with the molecules of the stone. Although some of the fatty content adheres to the stone by adsorption, it is usually an insufficient quantity for dependable printing performance. This explains why portions of a drawing can be totally removed by a benzine wash (a procedure for correcting drawings) only before the etching process, and not afterwards.

Formation of the Nonimage Areas. The nonimage areas comprise all the minute spaces between the image particles, as well as the surrounding undrawn surface on the stone. In the etching process, a tightly adherent hydrophilic surface is created between image particles which retains a film of moisture longer than it would be retained by the untreated stone. As long as these areas remain moist, they reject further establishment of grease. In this condition the stone is completely desensitized and is ready for the printing of multiple impressions.

Whereas the image formation is produced only through chemical change, the nonimage areas undergo chemical as well as physical change during the process of etching. Gum arabic, the basic constituent of the etch, is a mixture of the various salts of arabic acid. When combined with nitric or phosphoric acid, the salts of the gum are converted to a free-acid form; in this condition their molecules are better able to adhere tightly to the nonimage areas of the stone surface. This complex action, which is partly chemical and partly physical, is brought about in the following way:

1. The inclusion of nitric acid in the gum etch produces an effervescence of carbonic gas upon contact with the limestone. If examined closely, this effervescence will appear between image particles as well as on the undrawn areas of the stone. The drawing components, greasy in quality and protected with rosin and talc, are *physically* resistant to the aqueous etch solution. Hence, even though the image particles are *chemically* converted by the etch reaction, effervescence can be detected only on the undrawn areas of the stone.

2. During effervescence, the converted salts of the gum are driven deeper into the porous structure of the stone grain, where, upon drying, they form tightly polarized bonds with the molecules of the stone between the greasy image dots.

3. The free acid gum salts, upon contact with the stone, partially convert the nonimage areas to calcium arabinate; the rest of the molecules orient themselves within the pores and outer surface of the stone to form an adsorbed film. It is believed that the hydroxyl (hydrogen and oxygen atoms) groups within the adsorbed film are oriented outward from the stone and are responsible for the hydrophilic nature of the desensitizing film.

Thus, during the process, the stone has undergone a partial chemical change, becoming calcium arabinate in the nonimage areas. At the same time, an adsorbed film has been physically formed over these nonimage areas; this film will receive and retain water longer than would be possible for the natural unprocessed stone.

The Relationship between Image and Nonimage Areas. In considering the relationship between the image and nonimage areas on the stone, the following points should be kept in mind:

1. The nonimage areas after desensitization are less firmly established than the image areas, because they depend on a physically adsorbed film slightly supplemented by a chemically converted stone just below and compatible with it. This adsorbed film is susceptible to physical and chemical displacement, whereas the image areas, having been transformed chemically, are considerably more durable.

2. It is significant that most problems in stone lithography relate to the nonimage areas of the work. The printer's efforts are more often than not focused on keeping these stabilized throughout the processing and printing, in order to prevent the image from spreading, filling in, or scumming.

3. Mixtures of phosphoric and tannic acid are sometimes incorporated with nitric acid and gum arabic for greater control between image and nonimage areas. Upon reaction with the stone, the phosphoric acid in the mixture is converted to calcium phosphate salts, which are considered to offer tighter adsorption bonds in the nonimage areas. The tannic acid toughens the adherent gum film to further resist the abrasive action of printing. The inclusion of both of these acids permits a proportionate lowering of the percentage of nitric acid in the etch without loss to the total pH of the solution. Because of its reduced nitric acid content, the corrosive properties of this type of etch are less threatening to the image deposits.

Additional Factors that Govern the Chemistry of Etching. A number of additional factors govern the eventual establishment of the image and nonimage areas on the stone. As such, they affect the chemical principles just described, in one way or another. These have been described in detail in Part One of the text but are briefly summarized here in order to provide continuity to the present subject. (See sec. 2.2.)

1. The Character and Grease Content of the Drawing. Drawings with weak grease content need less acid in

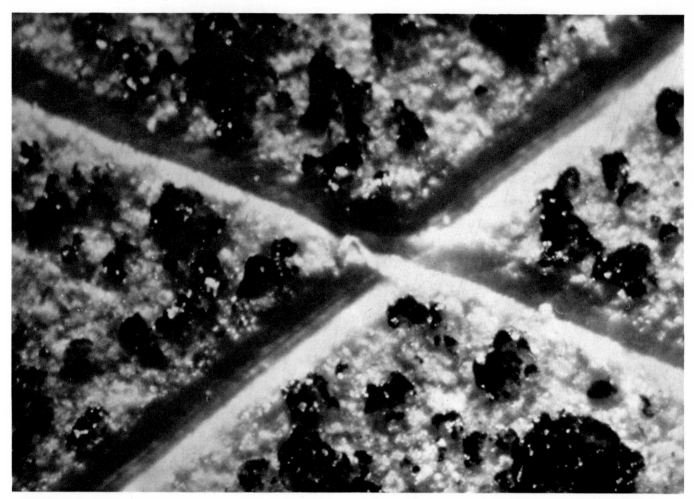

9.10 Relationships of the image deposits before and after etching and inking

a. Magnified view of a drawing before etching showing the grain of the stone and particle formation made with a #5 crayon. Diagonal scratches were made with a razor blade. 50X magnification

the etch to liberate their contents for unification with the stone. Drawings with heavy fat concentration need greater proportions of acid in the etch to enable a total release of their fatty acids.

2. The pH Factor as Related to Etch Volume. Increases in the total volume of an etch formula will logarithmically multiply its degree of acidity. (See sec. 9.9.)

3. The Cumulative Factors of Etching. There is an ideal etching amount that will establish perfectly the image and nonimage areas of a particular drawing on a particular stone. Sometimes this amount will be high and sometimes low, depending on the nature and fatty content of the drawing and on whether the stone is hard or soft. One must determine how to divide the amount into stages of etching in order to establish both image and nonimage areas effectively. The usual procedure is to provide two stages of etching: (1) for totally converting the image areas and partially stabilizing the nonimage

areas, so that the drawing components can be removed and replaced with ink, and (2) for reinforcing and totally establishing the nonimage areas. If the cumulative result of the etching is excessive, the image areas will be partially weakened or totally destroyed; if it is insufficient, the nonimage areas will be poorly formed and inadequately desensitized to reject ink.

4. The Hardness of the Stone. Lithograph stones that are hard or dense may require slightly stronger etches to achieve chemical desensitization. Softer stones require proportionately weaker etches.

5. Atmospheric Conditions. The chemical reaction of etching solutions is accelerated by high temperatures and dry atmospheres, and retarded by low temperatures and humid atmospheres.

6. The Reaction Time for Chemical Conversion. Present evidence suggests the reaction time for the chemical establishment of the image and nonimage areas

b. The same drawing after processing with a standard etch and rolling up with ink. Note the reduction of stone grain and loss of crisp definition in the image areas caused by the corrosive properties of the etch. 50X magnification

is fairly short. The principle reaction occurs between one-half to three minutes (while carbonic gas is produced by the etch). During this time the image and nonimage areas will have been chemically converted. After the etch coating is wiped dry, further chemical reaction is believed to cease. Some further chemical conversion occurs in image areas each time the stone is etched, although subsequent etches mainly serve to increase gum adsorption on the nonimage areas.

Antitint Solution. Antitint solutions for stone are composed of watery mixtures of gum arabic containing a very small percentage of phosphoric acid. (See sec. 4.13.) The phosphoric acid in the mixture functions as a mild cleaning etch, and its salts assist the gum arabic constituents toward replenishment of the adsorbed gum barrier on the nonimage areas of the stone. It is important that the acidity of the solution be very weak, or it will endanger the image deposits by undermining the grain of the stone.

9.13 THE CHEMISTRY OF COUNTERETCHES ON STONE

Counteretching chemically resensitizes the stone so that its previously etched surface will receive, rather than reject, new work. Before counteretching can be done, the adsorbed gum film of the nonimage areas must be removed by chemical means.

Counteretch solutions for stone are weak mixtures of alum, acetic acid, or citric acid with water. The two most popular solutions are alum and water and acetic acid and water. (See sec. 4.9.) The action of the counteretch on the stone is twofold: first, it dissolves the adsorbed gum layer on the nonimage areas, and, second, it deposits salts from its own chemical reaction onto the stone. When the counteretch solution is washed from the stone with water, it leaves a thin film of grease-attractive salts adsorbed on the nonimage areas in place of the grease rejective gum film. The stone

is thus sensitized to receive additional drawing with crayons or tusche.

The reader is cautioned that overacidified mixtures of counteretch can be harmful when applied over previously drawn work. Even when the image is well protected with rosin and talc before application, the corrosive properties of strong counteretches will slightly dissolve the grain of the stone. The image particles attached on the upper peaks of the grain become undermined and destroyed, resulting in coarser and weaker tonal qualities in the drawing. Repetitive cycles of counteretching, even with standard-strength solutions, will also erode surface grain. As the grain becomes progressively smoother, it provides less of the original crispness of tonal and textural definition for new drawings placed over it. Corrective drawings placed over such areas will not correspond in surface appearance to previously existing adjacent passages. When spot corrections to match adjacent areas are required, they should be counteretched and executed once only to minimize differences of surface appearance.

After the new work has been added, the stone must be desensitized so that the new fatty drawing constituents can be united permanently with the stone. At the same time, a freshly adsorbed gum film is established between the image particles. Desensitizing etches for counteretched work must be very weak solutions. Pure gum arabic is most often used for this purpose. For extremely fatty drawings, a few drops of nitric or phosphoric acid are added. But note that overacidified etching solutions dissolve the salts that the counteretch deposits, undermining the new drawing resting on them. In such cases the new work will disappear during the washout and roll-up. An inexperienced lithographer may think this problem is the result of faulty counteretching, but it is actually a sign of faulty etching.

It may seem that weak desensitization of new work would be insufficient to stabilize it effectively, since far stronger etches are necessary to stabilize an original drawing. The success of the procedure is due partly to the ability of the molecules of the counteretch salts, under the action of pure gum alone, to be activated into strong adsorbing bonds with those of the stone. In addition, the fatty-acid image particles attached to the salts eventually penetrate through these, resulting in firm, permanent chemical union with the molecules of the stone during printing.

Sometimes, drawings added after counteretching will print with a fresher appearance than the original areas of work, thus destroying the total integration of the image. This is particularly characteristic of images that have been counteretched and re-etched locally. This condition, which is usually temporary, is due to inability of the original and the new desensitizing gum films to accept equal amounts of moisture when the stone is dampened. If the problem persists after six impressions have been printed, the entire stone should be regummed, dried, washed out, and rolled up for reproofing. Usually the redistribution of fresh gum over the entire surface will equalize water retention. If the problem is not overcome by this procedure, the overly rich areas can be spot-corrected by scraping, picking, and etching. In such cases, it is likely that the fatty constituents of the corrective drawing were excessive.

9.14 THE CHEMISTRY OF ETCHES ON METAL PLATES

Although the functional principles of image and nonimage areas on zinc and aluminum plates are the same as for stone, the chemistry of their formation is quite different. The greatest single difference between plates and stone is the relative lack of natural porosity of the metal surfaces. In consequence, the image-forming materials and the chemicals for desensitization cannot penetrate below the outer surface of metal plates, and the desensitizing chemicals do not transform the basic chemical composition of metal plates. Both image and nonimage areas depend on the establishment of adsorbed films that adhere tightly to the outer surface and do not become an integral part of the metal. In addition, zinc is hydrophobic (water-repellent) and aluminum hydrophilic (water-attractive), whereas stone is equally receptive to either fat or water.

All this has enormous consequence when metal-plate and stone lithography are compared. It means that image and nonimage areas on metal plates are more tenuously attached, that the demarcation between image and nonimage areas is dependent on extremely thin (unimolecular) adsorbed films, and that these films, resting on the outer surface of the plate, can be easily disoriented or destroyed through the cumulative hazards of chemical action and physical abrasion. In practice, the image areas on zinc plates are easy to establish and the nonimage areas are difficult to stabilize. The opposite is true for aluminum: the nonimage areas are easy to stabilize and the image areas are difficult to maintain.

Gum arabic and cellulose gum are the two desensitizers most often used for metal plates. Cellulose gum is somewhat preferable for gumming zinc plates, because its larger molecular structure is capable of absorbing greater amounts of moisture than gum arabic. Gum arabic is

more effective for aluminum plates, although it can also be used on zinc. Cellulose gum should not be used on aluminum plates because it creates a pit-type corrosion on the metal surface and leads to ink-dot scum. Plate etches are composed of one of these gums plus certain inorganic salts, such as nitrates, phosphates, or bichromates. Most of these materials contain negatively charged ions (hydroxyl groups, —OH) in their molecules, and it is believed that such groups are at least partly responsible for the hydrophilic nature of the desensitizing solutions.

Both gum arabic and cellulose gum are classified as salts of high molecular weight, weak organic acids. Many organic acids have the general formula R-COOH. The letter R stands for an organic radical.‡ The —COOH group is called a *carboxyl group*, and it is present in all organic acids.

Present theory suggests that the carboxyl groups contained in the desensitizing etches are responsible for the adsorption of these agents to the surface of the metal plate. It is reasoned that the —COOH groups adhere tightly to the metal surface, and so the whole molecule of which they are part is held to the metal. By comparison, other hydrophilic materials such as starches, dextrins, and methyl cellulose, which do not contain carboxyl groups in their molecules, are usually poor desensitizers.

Experience has shown that good desensitizing agents such as gum arabic or cellulose gum are even more effective when their solutions are acidified with phosphoric acid. The addition of the acid converts the salt form of the gum into the free-acid form. This conversion has important bearing on the effectiveness of the desensitizing solution. For example, when the pH of the etch is on the alkaline side or as low as 6.0, most of the gum is in the salt form. This etch will produce poor desensitization, especially on zinc plates. The addition of more phosphoric acid, lowering the pH to 3.0, will provide much better desensitization, for more of the salt form of the gum is converted to the free-acid form.

The addition of still more phosphoric acid in the etch solution after most of the gum has been converted to its free-acid form will produce serious problems. Having nothing left in the solution to react against, it remains in the etch as excess phosphoric acid. The excess acid will attack the surface grain of the plate, undermining the drawing and reducing the effective adsorption of the desensitizing gum film. Accordingly, *a gum etch that is too acidified will perform like a counteretch; instead of*

‡Some groups of elements act like single atoms in forming compounds. These groups are called radicals. The bonds between radicals are predominantly covalent, but the groups of atoms have an excess of electrons when combined and, thus, are negative ions.

desensitizing the plate, it will sensitize it. The nonimage areas, instead of rejecting ink, will begin to accept it; and the result will be a badly scummed or filled plate.

Etching formulas for metal plates often call for the inclusion of other chemicals, such as ammonium bichromate, magnesium nitrate, zinc nitrate, ammonium nitrate, tannic acid, or chrome alum. The role of these materials in the etch solution is still unclear. Unproved theories suggest that they permit tighter adsorption bonds or tougher film formation. It is generally accepted that ammonium bichromate and zinc or magnesium nitrate salts are effective corrosion inhibitors. For example, a gum arabic and phosphoric acid etch of pH 3.0 will react with a zinc plate, producing an evolution of hydrogen gas that can corrode the plate surface and reduce its ability to hold desensitizing films tightly. By adding ammonium bichromate to the solution, the evolution of gas can be greatly reduced. Similarly, the addition of magnesium nitrate can arrest the evolution of hydrogen gas produced by acidified cellulose gum etches. If the etch contains enough of these buffering salts, it will not attack the plate surface, even though the solution may contain a certain amount of excess phosphoric acid.

Formation of Image Areas on Zinc and Aluminum. The establishment of image areas on either zinc or aluminum plates is governed by the strength of etch used and the length of time it is left on the plate. Drawings with heavy grease deposits require relatively strong etches applied for relatively long times. The strength and duration of the etch must be sufficient to permit total conversion of the fatty constituents of the drawing materials and adsorption of their fatty-acid molecules on the plate surface. Meanwhile the acid strength of plate etches must be limited; otherwise the etches can corrode the surface, undermine the grain, and prohibit effective image and nonimage formation. Accordingly, there is somewhat less latitude in the use of the etching process to control the image areas on metal plates. Because the plates cannot tolerate the corrosive types of etch used on stone, image control must be accomplished by limiting the fats deposited by the drawing materials. This is particularly true for tusche washes, which are applied to metal plates in a weaker concentration than is used for stone.

Formation of Nonimage Areas on Zinc. The desensitization of nonimage areas on both zinc and aluminum occurs during etching at the same time as the formation of the image areas. Etches for zinc plates, however, are somewhat less acidic than those for aluminum. The most effective desensitizing solutions for zinc fall within the following pH ranges (see sec. 6.16):

Desensitizing gums and weak etches pH 4.0 to 4.5

Moderately weak etch	pH 3.5
Moderately strong etch	pH 3.0
Strong etch	pH 2.5

The application of an etch solution on zinc will produce a chemical response decreasing the acidity of the solution as much as one full step on the pH scale. Tests have shown that an etch of pH 3.5 increases to pH 4.5 after a 1 1/2-minute application on the zinc surface. The significance of this phenomenon is that the etching solution becomes weaker the longer it remains on the plate. Hence, a large plate, which requires a long etching time, may become unevenly desensitized. This can be avoided by giving the plate two applications of etch. The excess of the weakened solution of the first application is wiped away before a second application of fresh solution is put on.

Formation of Nonimage Areas on Aluminum. Etch solutions for aluminum plates are basically composed of gum arabic and phosphoric acid and are more acidic than etches for zinc. (See sec. 6.17.) It is believed that the inherent film of aluminum oxide carried on the surface of aluminum plates reacts very slowly with these stronger etches and apparently can tolerate them much more effectively than zinc. Desirable pH ranges are as follows:

Desensitizing gums and weak etches	pH 4.0 to 4.5
Moderately weak etch	pH 2.3
Moderately strong etch	pH 2.0
Strong etch	pH 1.8

Drying Gum and Etch Films. As with stone, the desensitizing solutions for either zinc or aluminum plates should be wiped dry after processing. This holds for gum solutions as well as etch solutions. Tests have proved conclusively that drying th solution permits a heavier concentration of the desensitizing material to be adsorbed on the plate than mere application and washing off. Drying ensures longer-lasting protection for the nonimage areas of the plate, hence a more stabilized printing element.

Some lithographers prefer to etch the plate, mop up the excess etch, and then apply a solution of pure gum on the moist plate before wiping dry, on the theory that the two films will form a tougher adsorption bond than the bond formed if only the etch coating is applied and dried. Etching followed by separate gumming is particularly desirable for zinc plates, owing to their lack of natural attraction for hydrophilic materials. As long as a properly adsorbed desensitizing film remains on a metal plate, it can continue to receive water and reject printing ink.

Sometimes during the course of printing this film is weakened or ruptured by the physical abrasion of the press scraper, by the printing roller, by the use of overly greasy inks, or even by chemical impurities in dampening water. When the gum film has been only slightly weakened, the plate can either be given a weak etch followed by gumming or simply gummed to reinforce its ink-rejective properties. But occasionally the printing conditions are such that, even though the plate is properly desensitized, its ink-rejective properties must be continually fortified while it is being printed, for example, when heavy amounts of somewhat soft and greasy printing ink must be employed to produce a satisfactorily rich printing impression. It then becomes necessary to employ an antitint (fountain) solution throughout the printing in order to prevent scumming and filling. (See sec. 6.28.)

The Mechanism of Scumming. Scumming is described as the adherence of ink to the nonimage areas of the plate. This may occur between minute image dots or over broad undrawn areas throughout the plate. Gradually, the image dots and scummed areas will expand, closing the spaces in between; and the plate is said to be "filled."

Upon reviewing the chemistry of desensitization, we recall that the nonimage areas are covered with an adsorbed layer of hydrophilic gum arabic or cellulose gum. The carboxyl groups in the gum molecules are oriented toward the surface of the metal, and are believed to be responsible for the adsorption bond. The rest of the gum molecules stick outward from the metal, and, because these contain —OH molecules, they are receptive to water rather than ink.

It may happen that there are molecules in the ink that also contain carboxyl molecules capable of forming an adsorption bond on the metal. The rest of the ink molecules may be ink-receptive instead of water-receptive. If these molecules displace the gum molecules and become attached to the metal, the plate will become ink-receptive in that area. Experience has shown that certain ink pigments have a greater tendency to scum the plate than others. The same is true for some modifiers and reducing varnishes. Excessive use of ink driers can also produce scumming.

When a plate begins to scum, something must be done at once. If the ink is at fault, the only remedy is to modify the ink. When the ink becomes attached to the nonimage areas of the plate (especially on zinc), it is very difficult to reverse the process and make these areas water-receptive again. Some lithographers add more acid to their antitint solution. This is not the best method, for any excess acid in the solution can attack the gum film, thus causing increased ink receptivity and sensitizing the plate rather than desensitizing it. It is much better to get to the

root of the problem by encouraging the scummed areas to become water-receptive again.

Ink-dot Scum. Sometimes aluminum plates develop a peculiar type of scum called *ink-dot* or *oxidation scum*. (See sec. 6.28.) This consists of thousands of tiny sharp dots of ink on the nonimage areas of the plate. The areas between these dots will still appear to be well desensitized.

Normally, aluminum is covered with a thin, tightly adhering film of aluminum oxide. The surface is easy to desensitize with a good plate etch. It is believed that ink-dot scum occurs when the oxide film becomes ruptured. Aluminum plates covered with water that has been permitted to dry slowly develop ink-dot scum. It is theorized that the scum occurs in spots where the metal is just starting to corrode. Aluminum characteristically corrodes in many separated spots, resulting in the formation of pits. The printing ink seems to penetrate these pits or openings in the oxide film, and attach itself to the bare metal.

Ink-dot scum can be eliminated if it has not progressed too far. A solution of five ounces of oxalic acid per gallon of water is usually an effective treatment. The scummy areas are gently swabbed with a cotton swab saturated with the solution; the plate is then washed with water, gummed, and dried.

From the above, it becomes further apparent that the maintenance of the oxide film on an aluminum plate is of paramount importance. Counteretches and desensitizing etches for aluminum plates should be chosen with this in mind.

Fountain Solutions. Fountain solutions for metal plates are composed of a watery gum solution containing an acid, usually phosphoric acid, gallic acid, or tannic acid. Sometimes an acid salt such as ammonium phosphate or a nitrate salt such as ammonium, zinc, or magnesium nitrate is also included as a corrosion inhibitor. (See sec. 6.28.)

Although the ingredients of fountain solutions for metal plates are similar to those in etching solutions, their concentration is considerably weaker. The pH range for fountain solutions should be between 5.0 and 5.5. Repeated application of a solution with acidity below pH 5.0 can weaken the adsorption bonds of the image areas of the plate. Strong fountain solutions will also destroy the desensitizing gum film and render the nonimage areas of the plate sensitive to the encroachment of ink.

The fountain solution may be applied locally to troublesome spots with a soft, lintless pad (Webril Wipes) or with cotton swabs. The solution can also be employed in the dampening water and distributed with the dampening sponge. Over a period of time the solution will tend to become neutralized through contact with the printing plate, the printing ink, and the print paper. Therefore, its pH should be checked periodically and readjusted as necessary.

Two side effects produced by the prolonged use of antitint solution are the tendencies (1) to accelerate the emulsification of printing ink, and (2) to retard the drying time of ink. Both conditions can be tolerated in hand printing, since it is more important to keep the job printing cleanly; emulsified ink can easily be replaced with fresh mixtures, and drying time can be extended for twenty-four hours if necessary.

9.15 THE CHEMISTRY OF COUNTERETCHES ON METAL PLATES

A new or freshly grained zinc or aluminum plate usually has a tightly clinging film of zinc or aluminum oxide on its surface. The longer the plate is stored after graining, the heavier the oxide film is likely to be. The surface oxide prevents a secure foothold for drawing and desensitizing materials. The purpose of counteretching metal plates before drawing is to clean their surfaces of oxides or other impurities that might interfere with the adhesion of drawing materials and desensitizing etches. Plates whose surfaces have been specially protected after graining, however, or plates with oxide-resistant precoated surfaces, do not require counteretching before drawing.

Counteretch solutions are weak concentrations of hydrochloric, acetic, or nitric acids (with or without alum) in water. These mildly acidic solutions remove oxides on the plate surface by chemical action. For example, when a hydrochloric acid counteretch is applied on a zinc plate, the acid reacts with the water-insoluble zinc oxide on the plate surface. The oxide is converted into water-soluble zinc chloride in approximately one minute. The zinc chloride is easily washed off when the plate is flushed with water after counteretching. Meanwhile the metallic salts deposited on the plate surface by the counteretching solution are good adsorbers. Once adsorbed, they are highly receptive to the establishment of fatty drawing particles and gum-desensitizing films.

Counteretching solutions are also used when additional drawing is to be incorporated on a previously etched plate. In such cases, the counteretch dissolves the adsorbed, nonimage gum deposits, leaving an adsorbed film of grease-attractive metallic salts in their place. If too acidic, the counteretch will rupture sub-base treatments of precoated plates and may produce localized scumming over the corrected work during printing. Thus,

counteretching for corrective purposes on precoated plates is somewhat hazardous and must be carefully carried out.

It is important to understand that metal plates exhibit approximately 8 to 10 per cent reduction in the size of surface grain every time they are counteretched. If the counteretching solution is too acidic or applied too long, grain reduction can be even more pronounced. Accordingly, foothold for image- and nonimage-forming materials is reduced, and the ability of the plate to retain water is slightly impaired. Thus, plates that have been counteretched after graining or corrected after etching usually display a slight tendency to scum during the inking and printing. Although such plates can be controlled effectively by the use of a fountain solution during printing, they do not perform so cleanly as plates that have not been counteretched.

As stated, a plate does not require counteretching before drawing if its surface is free of oxides. Unfortunately this is seldom possible for newly purchased plates or for plates that have been stored for long periods. The formation of oxides can be prevented, however, or at least minimized, by carefully regulated procedures when used plates are regrained. (See sec. 6.5.) This problem should be discussed with the plate grainer, although some firms are either unwilling or unable to provide plates without oxidized surfaces. To ensure reliability, Tamarind grains its own plates. In most instances the plates are drawn and processed immediately after graining to minimize further oxide formation. The following procedure for treating metal plates without counteretching before drawing was perfected by Tamarind Master Printer Serge Lozingot.

Lozingot Treatment of Metal Plates:

1. Before drawing, the plate is lightly dusted with a cotton wipe to remove dust and fine residue from graining.

2. The plate is drawn; the finished work is dusted with talc.

3. The plate is etched, using standard procedures.

4. Thereafter, it is treated in the normal manner, except that each time the plate is used (before and after printing) it is treated with cellulose gum or gum arabic.

5. Corrective work can be added to plates treated in this way by using standard counteretching procedures. In normal circumstances the counteretch is less harmful at this point because the image and nonimage areas have been firmly established on the plate surface.

CHAPTER **10**

Materials and Equipment

10.1 GUM ARABIC

Gum arabic is one of the most important image desensitizers used in lithography. It displays two very important properties: (1) it is hydrophilic (water-loving); hence, its coatings are more receptive to water than to the fatty contents of printing ink; (2) its dried coatings, although water-soluble, hold tightly to the nonimage areas of the printing surface. A good desensitizing agent should be capable of dissolving in water and leaving a microscopic water-receptive layer on the printing surface. This layer cannot be removed even with further additions of water. Many other natural and synthetic materials are hydrophilic, and some are capable of adsorption on the printing surface. Some of these are gum tragacanth, cherry gum, larch gum, mesquite gum, carboxymethyl cellulose (CMC), dextrines, alginates, oxidized starches, polyvinyl pyrolidone, and polyvinyl alcohol. With the exception of carboxymethyl cellulose, none is so effective a lithographic desensitizer as gum arabic. Carboxymethyl cellulose is a synthetically produced gum whose performance for metal-plate desensitization is slightly superior. This material is described in the next section.

Gum arabic is obtained from the dried gummy substance of the acacia tree, which grows in Arabia, Senegal, Egypt, India, and the Sudan. Today most of the gum used in lithography comes from the Sudan. This particular variety seems to have superior properties for lithography. The gum exudes naturally from the trunk and branches of the tree in the form of tears, which harden when exposed to air. These tears are separated from the bark and sand, and, after being sorted and graded for quality, are packed for shipment.

Gum arabic falls in the class of noncrystalline carbohydrates that form colloidal solutions. Chemically, gum arabic is usually considered to be a mixture of calcium, potassium, and magnesium salts of arabic acid with some free arabic acid. When nitric or phosphoric acid is added to gum arabic to make lithographic etches, most of the salts of the arabic acid are converted to the free-acid form. In this condition the solutions produce the most effective desensitization.

Gum arabic solutions (with or without acid) act so powerfully on stone or metal plates that it is impossible to wash the printing surface completely clean after they have been applied. Furthermore, a previously gummed stone or plate will not accept drawn or transferred work; the film of gum prevents the greasy image from uniting chemically with the plate surface. The gum can be removed only by chemically dissolving it with counter-etching solutions or by physically destroying it by polishing with pumice powder or scraping with blades.

Pure gum arabic can be obtained from lithographic suppliers in powdered, crystalline, or liquid form. The liquid form is formulated particularly for offset lithography; it is, however, by far the most efficient for hand-printing purposes as well. Research has shown that gum arabic solutions perform best for all-round use when they are low in viscosity and high in solid content. Consequently, liquid gum arabic is supplied in either 12° or 14° Baumé readings. That of 14° Baumé is somewhat preferable for hand lithography because of its heavier solid content. The advantages of commercially prepared liquid gums are many. These gums are clean and free from residue, are of controlled formulation (which ensures that each batch is exactly the same), and, more important, they are nonsouring, so that stock solutions can be kept for indefinite periods of time.

Powdered and crystalline forms of gum arabic can be liquefied by mixing with water. Although hand-prepared solutions of gum arabic rarely have the same consistency from one batch to another, it is well to know how they are made.

PROCEDURE

Either the powdered or crystal variety of gum arabic is first mixed with water to form a solution. A handful of the powder or crushed crystals is placed in a quart jar. Water is added until the jar is three-quarters full. The mixture should stand overnight and then be stirred well and strained through muslin or cheesecloth to filter out lumps and impurities. The solution, having a consistency of thin honey, is kept in a tightly sealed jar.

Sometimes it is necessary to prepare gum arabic for immediate use. The powdered variety is best for this purpose because it dissolves readily in hot water. The mixture should be stirred slowly with a wooden paddle, so that air bubbles are not entrapped. The larger lumps can be broken down with the fingers; when nearly dissolved, the mixture is filtered through cloth.

Hand-prepared gum solutions tend to sour in eight to ten days in winter and in less time in summer. Soured gum, which can be detected by its pungent odor, must be discarded, because its increased acidity and transformed chemical structure are harmful to the lithographic process. The addition of two to four drops of phenol or a pinch of talc per quart of gum will prolong its useful life for a few extra days. It is much safer to mix only a few days' supply at a time, thus ensuring clean and pure gum solutions.

Commercially prepared gum arabic is sold in 1-gallon, 5-gallon, 30-gallon, and 54-gallon quantities. A 30-gallon drum is an efficient and economical size for a reasonably active shop. Gum arabic drums are usually stored along with drums of solvent on a specially constructed rack adjacent to the work area.

10.2 CELLULOSE GUM

Cellulose gum is a synthetic derivative of cellulose. Originally introduced in commercial lithography as a substitute for gum arabic, it has since proved its superiority as a desensitizing agent for metal plates. On metal the adsorbed films of gum or etch containing this material seem to offer tighter bonds and permit smoother coating without streaks than gum arabic films. The performance of cellulose gum on stone is acceptable, but, for reasons which are presently unknown, it is somewhat less satisfactory than gum arabic.

Cellulose gum is formed by modifying a side chain on the basic cellulose ring structure, converting it to carboxymethyl cellulose. Although basic cellulose is not soluble in water, cellulose gum is; hence its attractiveness as a desensitizing agent. The gum may be considered a sodium salt of high molecular weight, weak organic acid. In this respect it is somewhat similar to gum arabic. When the salt form of the gum is acidified by the introduction of phosphoric acid, the free-acid form is produced. (See sec. 9.12) The best desensitization occurs when most of the gum is converted to the free-acid form. In order to produce the conversion, enough phosphoric acid must be added to lower the pH to about 2.5. Etches with such low pH will react unfavorably with zinc plates by producing an evolution of hydrogen gas. More satisfactory plate etches have been produced by keeping the pH between 3.0 and 3.5, and by adding a sufficient amount of magnesium nitrate to the formula to act partly as a corrosion inhibitor.

Cellulose gum is available from lithographic suppliers in powder or liquid form and in pure solution or in acidified formulation. The liquid form, like that of gum arabic, is nonsouring and by far the most efficient for all-round use. One popular brand of the pure solution is Hanco Pure Cellulose Gum MS-448 (see Appendix A). It may be used for gumming plates or, with additions of phosphoric acid, modified for etching plates. Hanco Acidified Cellulose Gum MS-571 is a prepared plate etch, and thus saves formulation in the shop. Both the pure and acidified types of cellulose gum are advisable for inventories in shops where a reasonable amount of metal-plate activity is undertaken. The desirable quantities may vary from as little as 1 gallon of each type to 30 gallons of each. The formulas for gum and etch solutions for metal plates are given in secs. 6.16 and 6.17.

As with gum arabic, the powder form of cellulose gum is easy to prepare into solution. Although it dissolves in cold water faster than gum arabic, care must be taken lest it form clumps. Clumps are partly dissolved on the outside and dry on the inside. Once formed, they are extremely difficult to break down. The Lithographic Technical Foundation has devised a process to prevent this sort of clumping. The cellulose gum is first suspended in 91 per cent (or 99 per cent) isopropyl alcohol. When the water is added to this suspension, the gum will not form clumps and, hence, will dissolve very rapidly. It is said that the presence of the alcohol in the gum solution has no effect on the desensitizing properties of plate etches and, if anything, tends to improve the etch slightly.

10.3 HYDROGUM AND LOVISGUM

Hydrogum is a natural product derived from the mesquite plant. It was originally introduced during World War II when restrictions had been imposed by the government on sale of gum arabic and cellulose gum. Since hydrogum is less satisfactory as a desensitizing agent than either of the other two gums, its chief use today is in the offset industry in the fountain solutions of power printing presses.

Hydrogum has some limited application in hand lithography as a masking medium in place of cellulose gum or gum arabic. Because of its thin, nonviscous consistency, it can produce very sharp-edged and thin linear gum masks. It may be used with brushes, pens, or ruling instruments with greater ease than either of the other gums, and it has sometimes been employed with the airbrush as a masking liquid to reduce the danger of the instrument's clogging or spitting.

Lovisgum is a synthetically produced gum of low viscosity used in offset printing. Its chief virtue lies in its ability to produce thin, unstreaked coatings when buffed dry. It has no particular advantages for hand printing, however, and is seldom used.

10.4 ACIDS

Most of the acids used in the lithographic process are highly corrosive; hence precautionary measures are required for their handling and storage. The following commonly used acids should be considered essential shop supplies. Brief descriptions of the use and handling of each are given.

ACETIC ACID (GLACIAL)

Acetic acid is a distillate of gases produced by the decomposition of wood heated in the presence of air. It is sold in several different grades. Pure anhydrous acetic acid is a liquid boiling at 118.1°. It freezes at 16.6° forming a solid which resembles ice; for this reason the pure acid is usually called *glacial acetic*. It is approximately 99 1/2 per cent pure and is the standard on which all formulas have been based.

Dilute solutions of acetic acid and water are called *counteretches*. These are used to sensitize the surface of lithograph stones and metal plates to receive fresh deposits of fatty acids. (See secs. 4.9, 6.6, 9.13, and 9.15.)

Acetic acid is usually purchased in 8 1/2-pound, plastic-capped bottles. Stock solutions of counteretch for stone (1 part acetic acid to 10 parts water) are prepared in 1-quart bottles and stored, to be used as necessary. A stock solution for counteretching metal plates is usually prepared in a 1-gallon bottle, for larger amounts of the solution are necessary for plate preparation. To keep the stock solution free of contamination the desired volume of counteretch for a particular work should be distributed from a shallow glass bowl.

Acetic acid has a penetrating odor, much stronger than vinegar, and produces painful burns on the skin. Prolonged inhalation of the acid vapors of even diluted counteretch solutions should be avoided. Some individuals react with greater sensitivity to this chemical than others, but in any case, it should be used only in well-ventilated areas.

NITRIC ACID (C.P., APPROX. 69 PER CENT)

Nitric acid is one of the most important chemicals in the lithography workshop. Today it is manufactured mostly by the Ostwald process, which oxidizes ammonia through a series of conversions from nitric oxide to nitrogen dioxide, and then to nitric acid. The concentrated chemical is a colorless liquid, commercially available in several grades. The grade listed as "C.P." (chemically pure) is preferable for lithography, although "A.R." (analytical reagent) grades are also satisfactory.

Nitric acid by itself or in solutions of water, gum arabic, or other chemicals chemically prepares stones by stabilizing or altering their printing images. Mixtures of the acid and gum are called *etches*, and, when applied and dried on the lithograph stone, they desensitize its surface to resist additions or encroachment of grease. Concentrated mixtures of the acid in either gum arabic or water attack the stone most energetically and set free carbonic gas in violent effervescence. These strong mixtures physically attack the surface of the stone and its grease content as well and thus can alter the image quality and its tonal values by eroding the grain of the printing surface. (See secs. 2.2 to 2.9 and 2.16 and 2.17.) Today, nitric acid is seldom employed for metal-plate lithography unless it is in very weak dilution or is buffered with other chemicals. Its contact with zinc or aluminum surfaces produces harmful oxides detrimental to the lithographic process.

Nitric acid is a highly corrosive chemical which must be kept in glass- or plastic-capped bottles. For shop use it should be purchased in 7-pound quantities; it should always be handled with great caution. It should be stored along with the other acids in a specially designed acid cabinet whose wooden construction and open shelving will withstand the corrosive action of acid fumes. (See sec. 16.6.) For daily use the acid is funneled with a glass

funnel into a 4-ounce, glass-stoppered laboratory drop bottle. (See sec. 10.7.) When this acid is being mixed with water, the water must always be poured first; the acid is added afterwards. Because of the lower specific gravity of water, a violent splashback would occur if the acid were poured first and the water added. Painful burns can result from such a splashback. Care should be taken to prevent contact of acid solutions with the skin and clothing and to avoid excessive inhalation of the vapors. In the event of contact, the area involved should be quickly and thoroughly flushed with water. Minor skin burns can be treated by an application of household baking soda (which should always be on hand in the acid cabinet). Serious injuries should always be attended to by a physician.

OLEIC ACID (U.S.P.)

Oleic acid is an ester that is a liquid, unsaturated fatty acid of glycerol. Esters are produced by the reaction of acids with alcohols. Because of its extreme greasiness, oleic acid is sometimes employed to restore images on stones that have been weakened by too strong etching. One-pint quantities are kept in the shop for this purpose. The acid is soluble in organic solvents but not in water. Since it is not corrosive, its handling does not require special safety precautions. It must be applied to the work carefully, however, or it will create a greater problem than the one it solves.

Oleic acid permits concentrated fatty acids of the chemical to penetrate the stone and fortify latent grease deposits of the weakened image. A little acid is placed on a clean cloth and carefully applied to the parts to be strengthened. It may also be applied with a brush, but should then be worked into the surface rather firmly. The solution should be prevented from making contact with other parts of the stone; otherwise its concentration of fatty acid can overcome desensitized areas, and, by attachment, produce ink scum in the nonprinting areas. The usual procedure is to apply the solution locally over the image, which has already been dampened with water. The stone is immediately redampened and rolled up with ink. Another method is to apply the solution locally over an image that has been previously gummed and dried. The stone is then washed out and rolled up in the usual way. In either case a certain amount of ink scum may occur, which can be tolerated as long as the image has become strengthened. Scummed areas can usually be cleaned and re-etched as a second operation.

OXALIC ACID (TECH., CRYSTALS)

Oxalic acid is a dicarboxylic acid whose molecule consists of two carboxyl groups bonded together. The acid is a colorless crystalline solid made by fusing sawdust with sodium or potassium hydrate. Undiluted, it is poisonous. Today it is seldom used in general lithographic work, but it has interesting properties, which can be exploited in experimental work with metal plates and stone.

Saturated solutions of oxalic acid and water, when rubbed on stone, form glazes that effectively repel ink and are virtually insoluble. This glazing was employed by early commercial lithographers to block out printed titles temporarily or to keep the borders of stones clean during the printing of large editions.

The process is most effective on stones having fine-grained or polished surfaces. Promising results have also been achieved on 240 grainings.

The inked portions of zinc plates can be altered or totally removed by the biting action of oxalic acid on their ink film. The crystalline acid is dusted on the areas to be bitten and is activated by a water-saturated blotter or newsprint placed over it. The moistened particles bite the ink in a crystalline pattern, and the amount of image removed depends on the duration of the biting. When sufficiently bitten, the plate is flushed with water, dried, spot-etched, gummed, and wiped dry. It is then ready for proofing.

Oxalic acid is also used for one type of image transposition on metal plates. (See sec. 15.26.) This process is rather difficult and not recommended for the novice. Its chief attraction is its extension of the creative methods available in lithography; it makes possible results not obtainable by the more orthodox processes.

PHENOL (LIQUEFIED, U.S.P., APPROX. 90 PER CENT)

Derivatives of benzene containing one or more hydroxyl groups attached directly to carbon atoms are called *phenols*. The hydroxyl group in these compounds is markedly acidic in character, and phenol itself is commonly known as carbolic acid. It is an important constituent of coal tar, and is produced synthetically from benzene. When pure, phenol is a colorless crystalline substance melting at 42–43° F and boiling at 181.4° F. Unlike other acids, it does not respond to acid tests; rather it is allied to alcohol as an oily-feeling solvent. It has a very corrosive action on tissues, and on skin it rapidly causes blisters. If taken internally, phenol causes irritation and necrosis of the mucous membranes. It may also paralyze the central nervous system, causing death.

Phenol is purchased in liquid form for shop use in 5-pound or 1-gallon bottles with glass or plastic caps. It should be stored in the acid cabinet and used only in well-ventilated areas.

The most valuable lithographic property of phenol, not generally recognized, is its powerful effect as a grease solvent. The addition of two or three drops to a pint of lithotine can be very helpful in washing out very old images on which the ink has become extremely dry and hard. When used in greater proportions it will permanently weaken the chemically formed image in stones. This particular property can be put to excellent use in color lithography. Images on color stones can be permanently destroyed with solutions containing phenol and then chemically resensitized to receive fresh work without the necessity of regrinding the stone. (See sec. 15.19.) Mixtures of 1 part phenol to 1 part gasoline are used for this purpose. These are pre-mixed in 1-quart- or 1-gallon-capacity glass- or plastic-capped jars and kept in the acid cabinet for use as needed. The solution should be shaken well before use and should be applied with a rubberset acid brush or a brush having nylon bristles. (See sec. 10.8.)

It should be noted that phenol and gasoline mixtures are extremely volatile and corrosive. They are perhaps the most dangerous solutions in the shop and should be handled with extreme caution. They should be stored and handled away from heat and flame, and the solution should not be permitted to touch skin. Accidental skin contact should be immediately treated by washing with large amounts of soap and water. Rubber gloves and shop aprons are strongly recommended when mixtures of phenol are used. Adequate ventilation is imperative.

PHOSPHORIC ACID (A.R., 85 PER CENT, SYRUPY)

The purer grades of phosphoric acid are manufactured by oxidizing phosphorous from the electric furnace and dissolving the product in water. Its form, as used in lithography, is known as *syrupy phosphoric acid*. It is usually stocked in 1-pint quantities, and in daily use it is dispensed like nitric acid from laboratory drop bottles.

Phosphoric acid is incorporated with gum arabic and sometimes water in desensitizing etches, antitint, and fountain solutions on stone, zinc, and aluminum plates. It is believed that its presence in these solutions results in tighter adsorption bonds on the printing surface through the inherent films of calcium phosphate (on stone), zinc phosphate (on zinc), and aluminum phosphate (on aluminum). (See sec. 9.1.) Phosphoric acid reacts on stone less violently than nitric acid and is therefore more useful in the formation of milder etches for delicate drawings. (See sec. 2.3.)

SULPHURIC ACID (A.R., APPROX. 95 PER CENT)

Pure sulphuric acid is a colorless oily liquid which freezes at 10.5° F and boils at 338° F. Its use in lithography is mostly confined to aluminum plates. It can be used either full strength or diluted with water to permanently remove parts of an inked image that has already been processed. The acid must be added slowly to the water so as to distribute safely the heat generated by the reaction.

TANNIC ACID (TECH., POWDERED)

Tannic acid is not a pure substance, but a mixture of acids of which some are similar to gallic acid and others have unknown structures. It may also be extracted from gall nuts. The acid is a poisonous astringent chemical available in powdered form, and is stocked in the shop in 1-pound cans.

Tannic acid is most often used in gumming and etching solutions for stone and metal plates. Coatings containing small amounts of tannic acid will form tough absorbed films. Present evidence suggests that these are more durable against the frictions of lithographic hand printing than solutions that do not contain tannic acid. (See secs. 2.3 and 6.16.)

Being in powdered form, the chemical is usually added last to liquid gum and etch solutions in order to prevent lumping. The solution must be thoroughly mixed with a glass stirring rod before use. Tannic acid has a certain amount of biting power; hence its incorporation into gum or etch solutions should closely follow recommended proportions. Otherwise it is possible that the fatty contents of the lithographic image will be weakened.

10.5 OTHER CHEMICALS OFTEN USED

The following is a list of other chemicals regularly used in the lithographic process.

ASPHALTUM LIQUID

Asphaltum is a bituminous product of petroleum cracking. It is manufactured in crystalline and liquid form and is particularly noted for its resistance to acids. The liquid form is used in lithography primarily as an ink base for stones and metal plates. (See secs. 2.11 and 6.18.) It is available either in heavy viscous consistency which must be diluted with benzine or lithotine or in thin consistency especially compounded for ordinary use as an ink base. The heavier consistency of asphaltum can be employed for special drawing techniques. Some shops find it practical to keep both types on hand in 1-gallon quantities. (See sec. 15.10.)

DEXTRIN, POWDERED

Dextrin is a water-soluble substance formed from cornstarch by the action of heat, acids, or ferments. It is useful in lithography for its adhesive properties, which are somewhat like those of gum arabic. Solutions mixed with water are sometimes incorporated in transfer paper coatings or employed for sizing thin oriental papers used in papier collé work. Dextrin is also useful for gumming out airbrush work, because it can form cleaner and sharper masks than gum arabic.

GLYCERINE

Glycerine is a colorless, syrupy by-product of soaps and fatty acids. It is very hygroscopic and so is employed in the manufacture of Everdamp transfer papers. A very small quantity may be used in the dampening water, when printing from stone, to keep the stone moist with a minimum quantity of water. This is particularly useful in color printing to prevent the offsetting of color from previous printings onto the stone. Glycerine must not be used on metal plates because it readily dissolves oxides on their surface, breaking down printing stability and producing scumming.

MAGNESIUM CARBONATE

Magnesium carbonate is a fluffy white powder produced by the precipitation of mineral magnesite. It is used as an additive to color lithographic ink to stiffen and shorten its body. (See sec. 11.9.) It may also be used to dust over printed work that is drying too slowly. Usually 5-pound lots of this lightweight powder are sufficient for routine purchasing.

MUTTON TALLOW

Mutton tallow is a pure nondrying fat containing a large proportion of fatty acid. It was once used as a tympan lubricant but has largely been replaced by more efficient commercial greases. Its chief use today is in coating leather printing rollers before prolonged storage to prevent their surfaces from drying.

POTASSIUM ALUMINUM ALUM, POWDERED

Potassium aluminum alum is a double sulphate of aluminum and potassium. It dissolves easily in cold water and, in saturated solution, is sometimes used as a counteretch for weak transfers, such as fine writings or stone-to-stone retransfers. The salts of alum counteretches form an adherent crystalline film on stone or metal plates. The film is soluble in acids but insoluble in water and is highly sensitive to the action of fatty acids. Alum is usually purchased in 1-pound quantities.

RED OXIDE, POWDERED

Powdered red oxide is an inert mineral pigment and is used as a tracing substance. A little of the pigment is evenly wiped onto a sheet of newsprint or tracing paper with a tuft of cotton. After it is well worked in, the excess powder is blown off. The sheet is then used like carbon paper, placed face down between the original drawing and the printing element. Traces drawn over it will produce crisp light-red lines that will not interfere with either the drawing or lithographic functions.

One-pound quantities can usually be obtained from the larger commercial paint stores.

ROSIN, POWDERED

Powdered rosin, sometimes called *rosin flour*, is produced as a distillate of turpentine. It is used in lithography as an acid resist to protect drawn and inked images from the corrosive action of acids used in gum arabic etches. Although other materials have been used for this purpose, none function with the over-all properties of rosin. (See sec. 2.6.) Rosin powder is available in several different qualities. The finely ground powder is the best for lithographic use. Coarser grades contain gritty particles that can scratch drawings and metal plates during application. Rosin is most economically purchased in 25- to 50-pound drums. Like talc, it can be dispensed from large metal salt and pepper shakers, and distributed over the printing surface with a tuft of cotton.

SODIUM HYDROXIDE (CAUSTIC SODA)

Sodium hydroxide is often referred to as *caustic soda* or *lye*. It saponifies fats (converts them into soaps) and renders them easily soluble in water. It is used on zinc plates to delete portions of inked images by converting their insoluble fats into soap. Plate grainers sometimes subject used zinc plates to sodium hydroxide baths to destroy the lithographic images before passing them through the graining cycle. Sodium hydroxide readily dissolves aluminum, hence is never used for that metal. It is seldom used in stone lithography, but it can be employed to polish the stone grain chemically. (See sec. 15.2.)

Solutions of sodium hydroxide and water react with considerable generation of heat. They should be mixed only in glass or ceramic receptacles and applied with sticks, toothpicks, cotton swabs, or glass bristled brushes. They have a very corrosive effect upon the skin and can produce painful burns. This material should be handled with extreme care, and it is advisable to use rubber gloves and apron as protective measures.

TALC, POWDERED (FRENCH CHALK)

Talc, sometimes called *French chalk* or talcum powder, is a dehydrated magnesium silicate. It is used, like rosin, as an acid resist on stone and metal plates, although it is less resistant than rosin. When used with rosin, talc lessens the surface tension of the printing element in the presence of watery solutions of gum arabic or acid. Talc can sometimes be used alone as an etch resist on metal plates, because the acid etches employed on metal are relatively weak. It is also employed throughout the shop as a cleaning agent, to dust the hands, press box, paper table, ink slab, or color roller after use. Powdered talc is usually stocked in 25- to 50-pound drums and is dispensed as described for rosin.

VASELINE (PETROLEUM JELLY)

Vaseline is occasionally used as an ink compound to soften and shorten color inks. Although greasy in feel, it contains no fatty acids and, therefore, will not make the inks more oily. It can also be used to create temporary masks on the lithograph stone during the drawing process. These can easily be removed during the processing and washout without producing ink receptivity.

10.6 SOLVENTS

Among the most commonly used solvents in lithography are acetone, alcohol, benzine, gasoline, kerosene, and turpentine or lithotine. Each solvent has particular advantages for specific processes, as briefly described below.

Most of the solvents are not pure compounds, but are mixtures of several kinds of molecules, each mixture, therefore, having its own specific boiling point and flash point. For reasons of safety, every lithographer should be familiar with the relative flash points of the solvents in his shop.

Solvent	Flash point, degrees F
Gasoline	60
Benzine (V.M. & P. naphtha)	53
Lithotine	60—100
	(depending on composition)
Turpentine	93
Mineral Spirits	105
(Stoddard Solvent)	
Kerosene	130

The solvents with low flash points are highly evapora-

tive and those with high flash points are slow evaporators. The table shows that kerosene, mineral spirits, turpentine, and lithotine are relatively safe to use, but that benzine and gasoline are much more rapidly combustible, hence hazardous for general use in the workshop. Some lithographic processes require rapidly evaporative solvents. Slowly evaporating solvents can be used for other processes. The printer can more easily choose the solvent best suited to his purpose if he consults the table.

The hazardous and sometimes toxic nature of solvents requires appropriate storage and handling procedures in the shop. These will depend on the quantities kept in stock. In productive shops, it is most economical to purchase the commonly used solvents, such as kerosene and lithotine, in 30-gallon drums. Solvents that are used less are usually purchased in 1- to 5-gallon containers.

Solvent drums are usually stored either horizontally in a rack, with a spigot attachment for drawing the liquid, or vertically with a more elaborate pumping attachment. The solvent is drawn from these into 5-gallon, fireproof solvent containers, which, along with the smaller quantities of the other solvents, are kept away from heat sources in a closed metal solvent locker. From this storage, amounts can then be distributed in jiffy cans as needed.

All the solvents used in the shop tend to dry the skin after a period of time. Prolonged contacts may result in active dermatitis for persons having sensitive skin. Wearing gloves or protective creams during working hours would be impractical; however, one should use skin creams periodically. Any of the following is acceptable and not cosmetically unpleasant: *Cetaphil Lotion* (Texas Pharmaceutical Co.), *Lubriderm* (Texas Pharmaceutical Co.), *Neutraderm* (Owen Laboratories), and *Keri Lotion* (Westwood Pharmaceuticals, Los Angeles).

ACETONE

Dimethyl ketone, commonly called *acetone*, is an organic solvent obtained as one of the products of the destructive distillation of wood. Chemically speaking, ketones are secondary alcohols (such as isopropyl alcohol) that have been oxidized. Methyl ethyl ketone (MEK) is another member of this family which is sometimes used as a solvent for vinyl plate lacquers.

Acetone is a colorless liquid, boiling at 133° F and possessing a characteristic pungent odor and sweet taste. Although it is infrequently used in hand lithography, it is capable of producing unique results when combined with mixtures of water tusche. Minute quantities of acetone, when added to water tusches, will destroy the emulsion balance between their fatty-acid particles and vehicle. The grease particles are thrown out of the solution in the

form of clotted globules. The substance, when drawn with a brush, will produce a coarse and blotchy appearance that cannot be obtained by other means. It is sometimes useful to create powerful and primitive drawing effects.

METHYL ALCOHOL

Alcohols represent the first stage of oxidation of hydrocarbons in which one or more hydrogen atoms are replaced by hydroxyl groups. This methyl alcohol is derived from methane by synthesizing carbon monoxide or carbon dioxide. Ethyl alcohol is derived from ethane by fermentation of corn, potatoes, rye, and molasses.

Methyl alcohol, methanol, or wood alcohol is a colorless liquid boiling at 150° F. It is very poisonous when its vapors are breathed in quantities; however, because of its low cost, it is used as a thinning agent in shellac coatings employed in techniques of image transposition. It may also be used in place of acetone for destroying the emulsion balance of water tusches. Inasmuch as this solvent is infrequently used, quantities greater than one gallon are unnecessary. Ethyl alcohol, ethanol, or grain alcohol is seldom necessary for use in hand-printing processes.

BENZINE

Benzine, or V.M. & P. naphtha, as it is sometimes named, is an aromatic hydrocarbon produced by fractioning petroleum. It is a colorless solvent with a mild odor and a boiling point of 243° to 293° F. Benzine should not be confused with benzene, which is a weaker hydrocarbon ring compound. Benzine evaporates rapidly, and, because of its excellent capacity to dissolve grease, it is employed as a corrective solution for lithographic drawings.

Drawings on stones or metal plates may be corrected before etching by washing out the offending area with benzine. Brushes, cotton swabs, or clean soft cloths may be used to carry the liquid. Repeated applications of the solvent are required to ensure its penetration into the printing surface. All traces of fatty drawing deposit must be destroyed. Each application of the solvent should be removed with small pieces of clean blotting paper or cotton swabs so that the surrounding areas of work will not be contaminated by the residue. Since benzine evaporates rapidly, the new drawing may proceed immediately over the dried areas that have been deleted.

GASOLINE

Gasoline is another hydrocarbon product of petroleum fraction. It is very volatile, with a boiling point of 140° to 375° F, and has an even more rapid evaporation rate than has benzine. Grades of white gas or regular gas are preferable for lithography. The more expensive premium grades of gasoline are less desirable because of added tetraethyl lead.

Gasoline may be used instead of benzine as a rapidly evaporating drawing eradicator. Mixtures of gasoline and tusche produce solvent tusches that rapidly dry. Because water is miscible with the solvent, its incorporation into the tusche mixture provides additional possibilities for control and extension. Gasoline is also used as the chief solvent for washing out the plate in processes of image transposition that utilize shellac masks.

KEROSENE

Kerosene is among the least expensive petroleum distillates. It has a mildly offensive odor, greasy feel, and a high boiling point of 350° to 520° F. Because of its oily nature, this solvent is unsuitable for any of the lithographic processes, but because of its low cost, it is an excellent cleaning solution in the press room. Kerosene is used to clean ink knives, mixing slabs, ink slabs, and color rollers. In fact, inking rollers with synthetic surfaces should be cleaned only with this weak solvent, which is least injurious to them. Because kerosene evaporates slowly, surfaces cleaned with it are often wiped with talc, which absorbs the oily residue of the solvent and hastens drying.

LITHOTINE

Some persons are sensitive to the irritant properties of turpentine. Repeated contact with turpentine can produce dry cracked skin and itching rashes or dermatitis. A turpentine substitute called *lithotine* was developed by the Lithographic Technical Foundation in 1933 to overcome skin problems produced by the former solvent. Lithotine is composed of a mixture of pine oil and a small amount of castor oil and ester gum added to a larger quantity of some petroleum distillate such as benzine or mineral spirits. The pine oil and petroleum distillate approximate the solvent qualities of turpentine; the castor oil and ester gum leave a tacky nonvolatile residue when the solvent evaporates. This residue, like that of turpentine, is water-resistant, ink-receptive, and nondrying. Lithotine, because of its superior all-round behavior, is, thus, preferable to turpentine, and is highly recommended for all lithographic uses for which turpentine is normally used. References to it throughout the text should be considered as synonymous to turpentine.

Lithotine may be purchased from most lithographic-material suppliers. In view of its constant use, purchases in 30-gallon drum lots will be economically advantageous for an active shop.

TURPENTINE

Until the introduction of lithotine, turpentine was the chief solvent used in the lithography workshop. Gum spirits of turpentine is a slightly oily liquid obtained by the dry distillation of natural resins of southern pines. Steam-distilled turpentine is obtained by the steam distillation of the resinous wood from the trees. Either type is satisfactory for lithography, although the gum spirit is preferable because of its less objectionable odor.

Turpentine is an excellent grease solvent and evaporates reasonably quickly. It may be used for washing out work on stone or metal plates and may be incorporated in tusche mixtures for drawing purposes. Upon aging, it absorbs oxygen, forming a resinous substance that remains in the solution but is not volatile. Most commercial turpentines contain 1 to 4 per cent of this resinous substance, which is beneficial to lithography. When the printer washes the ink from the printing surface with turpentine, most of the solvent evaporates, but the nonvolatile resinous part remains as a thin coating on the image areas. This allows them to accept ink readily, which they do not do when petroleum solvents such as benzine or gasoline are used for the washout.

10.7 LABORATORY EQUIPMENT

A minimum amount of laboratory equipment is necessary for the formulation and handling of chemicals in lithography. The following items are considered essential in a well-organized shop and may be purchased either from general lithographic suppliers or from laboratory-equipment supply houses.

ACID DROP BOTTLES

Lithographic solutions containing nitric or phosphoric acid are generally formulated in drops. The most efficient instrument for dispensing and counting these is the acid drop bottle. Two bottles of 4- to 6-ounce capacity are required, one labeled "nitric acid" and the other "phosphoric acid."

The drop bottle has a hooded glass stopper. Two opposite channels in the lower half of the neck and corresponding grooves in the upper half of the stopper allow a drop or series of single drops of fluid to be delivered from the projection on the side of the stopper. A slight turn of the stopper seals the bottle. The bottle is filled up to its neck from the acid in bulk storage by using a glass funnel. The stopper is fitted and the bottle is tipped over the sink with the water running. Slight adjustments of the stopper in one direction or the other will control the rapidity of acid

delivery for easy counting. The water flow in the sink should be continued for a short time after the drop bottle is adjusted to permit total dissolution of the acid in the drainage system. Once positioned, further adjustment of the drop bottle is unnecessary until the level in the bottle becomes so low that the acid escapes too rapidly. At such time, the stopper can be turned slightly more to reduce the flow, or the bottle can be refilled.

BOTTLE BRUSH

A laboratory flask brush is a useful instrument with which to clean all glassware. This is a specially designed brush whose configuration permits easy cleaning of hard-to-reach places in bottles and graduates.

FUNNELS

One long-stem glass funnel is necessary for filling the drop bottles from the bulk acid storage. The diameter of its bowl and length of its stem should be selected to conform to the requirements of the drop bottle. Additionally, several larger enamel or Teflon funnels are necessary for drawing solvents and gum arabic from bulk stores.

GLASS BOWLS

Solutions of gum, etch, or counteretch are transferred from the mixing graduate to glass bowls before being applied to the printing element. Four smooth-surface glass bowls, approximately 5 inches in diameter, are reserved for use only with various gum and etching solutions. Two bowls, approximately 4 inches in diameter, are reserved for counteretches only. In this way the receptacles for these opposing solutions can easily be identified by size and can prevent any risk of chemical contamination.

GLASS GRADUATES

Two glass graduates are necessary for measuring liquid volumes of lithographic solutions. The first and more important is a pharmaceutical conical graduate, with a double scale graduated to 8 fluid ounces and 250 cubic centimeters. It should be of the heaviest type available so as to withstand constant use without breakage. This graduate is used for mixing etch solutions and counteretches. A second glass graduate of cup type, with markings up to 1 quart and 1,000 cubic centimeters, is useful for formulas of greater volume than can conveniently be measured in the smaller graduate.

GLASS STIRRING RODS

Several heavy glass or other acid-resistant stirring rods are necessary to mix formulas in the graduate. Metal rods cannot be used for this purpose in view of their adverse reaction with many lithographic chemicals. Both gradu-

ates and stirring rods should be thoroughly washed after each use. It is advisable to keep several inches of water in the graduate at all times during storage. The stirring rod is kept in the graduate and is prevented by the water from sticking to adsorbed films on its surface.

BARTENDER SHOT GLASSES

Several bartender shot glasses are useful for mixing strong gum and acid solutions for spot etching at the press. Mixtures of 30 drops of nitric acid to 3/4 ounce gum arabic (a standard press etch) are easy to compound and handle in these glasses, since they have a 1-ounce capacity.

LABORATORY SCALE

A simple, inexpensive, but reasonably accurate beam balance calibrated in grams is a very useful instrument for weighing quantities of the dry chemicals sometimes used in stone and metal-plate etches. This scale can be either one with a simple platform or one fitted with a removable brass scoop for easy handling of powdered materials.

HYDRION pH TEST PAPER

Hydrion pH test paper is a convenient and easy-to-use material for testing the pH of lithographic gums, etches, and antitint solutions. Test papers are available in a wide variety of pH ranges. Wide-range test papers, measuring from 1 to 11 pH units, are satisfactory for routine lithographic work. Short-range papers with color change for each 0.5 pH unit may be purchased for critical readings from 2.0 to 6.0. The test papers are inexpensive, and refills are available for the dispenser.

10.8 OTHER MATERIALS AND SMALL EQUIPMENT

The following materials and small equipment are necessary to the over-all operation of a well-planned hand-printing establishment.

ABRASIVES

The chief abrasives in use today for grinding the surface of lithograph stones are Carborundum grits of various size. Quartz grit and sand abrasives, formerly used in lithography, are less expensive but inferior. They require greater quantities of material and longer grinding cycles. Carborundum particles are sharper and tougher; hence, they break down more slowly during the grinding operation and at the same time produce a crisper and more conical graining conformation.

Stones are generally grained using a sequence of three different particle sizes: coarse, medium, and fine. Carborundum particles of 100 grit, 180 grit, and 220 grit correspond to this sequence. Particles coarser than 100 grit remove the previous image on the stone more rapidly but require longer cycles of intermediate and fine grinding to remove the pits produced by their larger size. Although the final surface tooth produced by grindings of 240 grit is satisfactory for most lithographic drawing, some artists prefer even finer graining. It must be remembered, however, that the finer the particle size, the more difficult it becomes to grain without producing scratches. For this reason the finer grades of abrasive are usually aluminum oxide optical graining powder of 320 grit, rather than Carborundum. These break down more rapidly during the grinding process, and, since their cutting action is used more for final surfacing than for the destruction of the previous image, they are employed only for cycles of short duration. Still finer grindings can be achieved by employing smaller grits of pumice powder; however, at this point the stone surface will have lost most of its grain definition and will begin to approach a polished condition. Pumice powders are also useful for spot-grinding an image after proofing to reduce its tonality or to remove it completely before adding other work.

Abrasives are usually purchased in 50- to 100-pound drum lots and are stored, when possible, with other bulk materials outside the immediate work areas. The abrasives used at the grinding sink are dispensed from small containers; and these are refilled from the bulk stores as needed. A certain amount of care is necessary to prevent particles of one grit from being mixed with those of another when the dispensers are refilled. Small metal kitchen scoops, one for each abrasive drum, are ideal for this purpose.

ABRASIVE CONTAINERS

Abrasives at the graining sink may be dispensed from 1-quart mason jars having lids with a series of punched holes that allow a controlled sifting of the contents. Each jar should be labeled to identify its particular particle size and should be reserved only for that size. It is essential that the handling and refilling of these containers prevent any mingling of their contents; otherwise scratches will surely result during the graining.

BRUSHES

Various types of brushes are used for drawing, etching, counteretching, and spot etching:

Drawing Brushes. An assortment of soft and stiff bristle brushes of various sizes and styles is necessary.

A very small and pointed brush for touch-up and corrective work should be included as well as a 1 1/2-inch flat sable for applying gum arabic masks or tusche solids.

Etch Brushes. These brushes are constructed of special camel's hair bristles set in rubber or an acid-resisting substance. They are highly resistant to the various acids used in preparing stone and plate etching solutions. Several brushes of 3-inch width are adequate even on large stones and plates. Etch brushes may be obtained from the larger lithograph-material suppliers. The brushes are washed with soap and water after use and hung to dry in the vicinity of the processing table. Unless they are thoroughly rinsed, absorbed films of gum will cause their bristles to stick and become brittle.

Spot-etching Brushes. Japanese brushes of varying sizes are used for spot-etching solutions. The cheaper varieties composed of white bristles appear to be more resistant to acidified solutions than those having brown bristles. A very small brush with a fine point should be included among these for critical touch-up etching.

Counteretch Brushes. One counteretch brush is sufficient for shop operations. This should be of the rubberset variety previously described. Since it must be used only with counteretch solutions, it should be readily identifiable, either by being slightly smaller in size than the etch brushes or by carrying a color band on its handle.

FANS

Various phases of lithography require rapid drying of moist surfaces. Tusche washes, gum and etch coatings, counteretched metal plates, and grained stones are usually fanned to hasten their drying. Generally hand fans of simple construction are employed for this purpose. Their design dates back to the beginnings of lithography, but despite their simple construction they are remarkably efficient. The instrument is twirled like a flag on a stick, creating a rush of air produced by the flapping vane. One hand fan should be located at each press station, processing table, and drawing area. More rapid drying can be induced by hand-operated electric hair dryers or low-capacity air jets. Outlets must be provided at suitable locations for these instruments.

FELT

Lightweight surgical felt of the type used for thin etching blankets is used for the application of antitint solutions on stone. Its slightly coarse and absorbent surface is ideal to carry the solution while picking up unattached particles of ink from the printing surface. The felt is cut into small pads approximately three inches square. These must be thoroughly washed with water after each use and should be discarded when they become stiff, worn, or clotted with ink. They are usually located in the shop near the antitint solution bowls.

10.1 The hand fan

A felt pad should not be used to carry fountain solutions onto metal plates. Being of protein material, the pad is primarily ink-receptive, and will tend to remove the greasiness from the image areas. Fountain solutions may then overcome the impoverished image and weaken it further. This is less of a problem with work on stone, where image and nonimage areas are less tenuous than on metal.

Lintless cotton pads called Webril Litho Pads are used with fountain solutions on metal plates. These may be obtained by the roll from most lithographic-material suppliers.

FIRE EXTINGUISHERS

The risk of accidental fire is considerably less in the hand-printing profession than in the automated high-production field. Nevertheless, a certain number of chemicals and solvents used in lithography are flammable and necessitate preventive measures to minimize fire hazard. Adequate fire-extinguishing apparatus will depend on the size and configuration of the workshop space and may range from small, hand-operated pump extinguishers to large portable fog apparatus.

FIRST AID KIT

A small first aid kit of the type used in schools and laboratories should be located near the sink and processing station in the workshop. It should include standard disinfectants, burn ointments, bandage supply, and tapes for minor injuries.

GUM-WIPING CLOTHS

Gum arabic and etch solutions are dried on stones and metal plates by wiping with special cloths reserved for this purpose. The gum-wiping cloths are composed of fine, closely meshed cheesecloth sold by lithograph-material suppliers. The cloths are cut to a length of 36 inches and folded into soft pads just before use. (See sec. 2.9.) Two pads are required each time a solution is to be wiped dry, the first to pick up the excess liquid and the second to effect smoothing and drying. Four to six gum cloths should be available for such use at all times. After use, they are thoroughly washed in tap water, wrung out, unfolded, and hung without wrinkles to dry over rods located near the sink and processing table. It is important that all gum and etch residue be dissolved from the cloths, or they will dry hard and stiff. If they are folded into pads in this condition and used on the printing surface, they may produce scored or streaked coatings. Cloths that become coarse and torn should be replaced from fresh stocks.

HONES

Various types of hones are used for smoothing the edges of the stone after grinding and for deleting parts of an image on stone and metal plates.

Lump pumice is used for smoothing the edges of the stone after these have been beveled with the stone rasp. Only one piece is needed.

Carborundum blocks, which are like bricks of compressed grit, may be used either for smoothing the stone edges or for polishing the top surface. Only one is needed.

Scotch hones (snake slips) are compressed pumice sticks, flat or round, about six inches long and three-eighths of an inch wide. These are used with water as abrasive instruments to delete passages of an inked image or to clean unwanted scum and ink from nonimage areas of the stone. Orders should be placed per dozen or per gross, for they are used constantly and exhausted rapidly.

Tam-O-Shanter sticks are similar compressed sticks in 1/8 inch, 3/16 inch, and 1/4 inch cross section. These are of hard composition but their abrasive action is slow. Their chief value rests in their small cross section, which permits easy deletion in tiny areas. Quantities of one dozen are sufficient for a shop of average size.

Weldon and Roberts Retouch Transfer Sticks are hones of rubber composition approximately 1/4 inch in diameter which are used to delete work on metal plates. Being made of rubber, they are less injurious to the plate grains than pumice hones, although they are capable of polishing. The transfer sticks can be sharpened to fine points in a pencil sharpener for very fine erasures, and they may also be used for deletion on stones if desired.

JIFFY CANS

Jiffy cans are specially designed fireproof metal containers used in the printing profession to hold solvents. Two types are required. The first type is a brass container, 1-quart capacity, called a "Justrite Benzine Can." It has a self-closing nozzle with spring action and is used only for lithotine. The second type is a "Justrite Underwriter Labeled Safety Can," and has a short-valved spring spout for pouring and filling. The 1/2-gallon size is recommended, and it is used only for kerosene. Thus, each solvent is readily identifiable by its container; because kerosene is used in greater volume, it is kept in the larger container. One container of each solvent should be positioned near the processing table and at each press station. These cans are filled from the larger metal drums by using metal funnels reserved for this purpose.

KNIVES

The *mat knife* should be sturdy and have replaceable blades for cutting chipboard, corrugated cardboard, mats, and other items in the shop.

The best *ink knives* are actually putty knives with blades 2 1/2 inches wide. These should be of high-quality spring steel with a reasonable amount of flexibility. Knives that are broader are awkward to use and narrower ones require too much time to lay out ink. One ink knife should be located at each press station and at the processing table.

Stainless steel *laboratory spatulas* with semiflexible blades approximately 3/4 by 6 inches are ideally suited for mixing color ink. Six to twelve knives are ample for this purpose. They should be kept in a can located by the ink shelves.

Kitchen spatulas with 10-inch blades that are broad, flexible, and have rounded ends are used to scrape old ink from the surface of leather rollers. There should be one at each press station and at the processing table. (See sec. 14.5.)

LUBRICANTS

Several types of lubricants are necessary in the lithography shop.

Tympan Lubricant. Darina-AX is an excellent lubricant for plastic press tympans. At least six 1-pound cans should be stocked at all times. (See sec. 13.6.)

Press Lubricants. Various types of cup grease, bearing grease, or gear grease may be utilized to lubricate points of friction on the lithograph press. Most brands are satisfactory. The grease should be of middle weight and should not contain graphite particles which can ruin the work process upon contact with the press. One to five pounds should be stocked.

Lubricating Oils. A good grade nondetergent machinery oil and a dispensing can are required for frequent oiling of the bed wheels on the press. Oils 30 S.A.E. are satisfactory for this purpose as well as for periodic replacement in press gear boxes. One-quart quantities are sufficient.

MARKING PENS

Felt-tip marking pens are useful for labeling supplies, equipment, ink cans, etc.

PAPER-TEARING DEVICE

Heavy steel straightedges $1/4 \times 2 \ 1/2 \times 48''$ with one side beveled are useful for tearing printing paper as well as for testing the plane of a lithograph stone for traverse. (See secs. 12.7 and 1.4.) These precision instruments are usually quite expensive. They may be obtained from drafting-equipment suppliers or from the larger art-material suppliers. Another type of paper-tearing device which performs excellently can be made inexpensively. It consists of a true-edged piece of galvanized metal (20 gauge) measuring $4 \times 48''$. One edge is crisply bent into two 45° angles whose width is 3/8 inch each. This can be done easily by most sheet-metal shops. The width of the instrument permits ample hand hold to prevent slipping when paper is being torn. The angled edge, in addition to minimizing slippage, is also useful as a guide for the knife when the instrument is used for cutting beveled mats. One end of the device should be drilled with a hole so that it may be hung in the vicinity of the paper-cutting table.

PRESS KIT

The press kit consists of a small box (a cigar box is satisfactory) in which various materials used at the press during proofing and printing are kept. These may include printers' leads for marking paper lays on the stone, various types of hones, masking tape, chalk, razor blades, and an awl for drilling register pinholes in the stone.

NOTE: A similar box is usually kept near the processing table.

RAZOR BLADES

Single-edged razor blades are used constantly in the lithographic process. It is important that they be sharp and free from nicks if crisp and clean corrections are to be performed. They are rapidly dulled by contact with the stone, and consequently must be replaced frequently. Razor blades for industrial use may be obtained in gross lots from lithographic suppliers at reasonable cost. A minimum of one gross is essential for an active workshop.

ROSIN BOXES

Powdered rosin is dispensed from large salt and pepper canisters. The dispenser and a large tuft of cotton are kept in a cigar box. After the rosin is dusted onto an inked image, the excess is wiped off the surface and into the cigar box with the cotton tuft. This keeps the surrounding work area free from accumulated rosin. Although the rosin in the box can be re-used, it is usually discarded after a time, for impurities will have been introduced. The rosin box is kept at the processing table.

TALC BOXES

Powdered talc and tufts of cotton are kept in these small containers similar to rosin boxes. A talc box should be located at the processing station and at each press station. (See sec. 16.6.)

SCISSORS

A large pair of scissors is useful for miscellaneous shop purposes.

SHOP RAGS

Shop rags are probably the most often used and, in many ways, among the more important materials in the entire process. They are used for washing out images, cleaning ink slabs and rollers, shop maintenance, etc. They must be clean, of ample substance, and always available in sufficient quantity to fulfill their many tasks. Mechanics' industrial cloths are ideal in this respect. They are of heavy substance, convenient size, and sufficient softness for all-round use. Firms that specialize in supplying industrial cloths can arrange to deliver a specified number of rags at regular intervals and to pick up and launder the dirty rags that accumulate between deliveries. The rates are not excessive, and, considering the efficiency and dependability of such service, the convenience is well worth the expense. The best procedure in this type of arrangement is for the shop to reserve or buy a certain number of rags. The quantity is estimated at 2 1/2 to 3 times the number expected to be exhausted in one week's production. Thus, during the second week, while the rags from the first week are being laundered, the rest of the original stock is being used. There remains sufficient reserve to satisfy unusually heavy production or tardy deliveries. The arrangements should ensure that the rags purchased or reserved by the shop are being laundered and returned in loads separate from those of other clients. This prevents any contamination of the rags by the chemicals of other industrial firms.

Used rags are kept in 5-gallon metal waste containers that are fireproof and have spring-lever lids operated by a treadle. One container is used only for rags that have been used with nongreasy solvents such as lithotine, gasoline, alcohol, etc. The other receptacle is used for rags containing greasy materials such as kerosene, oil, grease, etc. Thus, rags that are not too dirty can be re-used for similar purposes without fear of contamination.

SPONGES

Sponges occupy another important position in the lithographic process. They are used to dampen stones and plates, apply liquid solutions, prepare printing paper, and maintain shop equipment. For these purposes, they must be soft, firm, close in texture, and capable of freely absorbing and discharging water. In recent years cellulose sponges have largely replaced the sheep's-wool sponges formerly used for these purposes. They are of rectangular, bricklike shape and, because of their smoothness, they tend to deposit a thinner and more even moisture film than the sheep's-wool sponges.

Cellulose sponges measuring $2 \times 4 \times 6''$ are available from lithographic-material suppliers in fine and coarse porosity. The fine-pore sponges are used for dampening the stone, and the coarse-pore sponges are used for washing-out processes, spot etching, antitint solutions, and for shop maintenance.

Considering the chemical sensitivity of the lithographic process, sponges used for one type of activity should never be used for another. Sponges can be identified for specific tasks by their texture, size, color, or location in the shop. The sponges are thoroughly washed with water following each use. All traces of soap or solvent used during the clean-up must be removed by copious rinsings with water. Household detergents should never be used, for it is difficult to rinse them from the sponge completely; and any residue is injurious to the process. The following is a list of sponges required for the various lithographic processes:

Full-size coarse-pore sponge for washing out images. One is required for each press station and for the processing station.

Full-size fine-pore sponge for dampening the stone or plate. One is required for each press station and one for the processing station.

Full-size fine-pore sponge for counteretching stones. One is required with the materials of counteretching.

Full-size coarse-pore sponge for shop maintenance. Worn sponges from other processes may be used for this purpose before being discarded. The clean-up sponge is usually located by the shop sink.

Half-size coarse-pore sponge for spot etching. One is required for each press station.

Half-size coarse-pore sponge for antitint solutions. Spot-etching and antitint sponges may be used interchangeably if thoroughly cleaned.

Half-size fine-pore sponge for use with thin ink in rubbing processes. This sponge should be stored in a separate sealed can containing a little solvent so as to remain constantly soft.

Half-size coarse-pore sponge for gumming the stone. This sponge is optional and is not essential to the process.

Full-size fine-pore sponge for dampening paper. This sponge is optional; stone-dampening sponges may be used for this purpose.

STONE RASPS

A heavy stone rasp is necessary for beveling the edges of the lithograph stone after it has been grained. Stone rasps may be purchased at sculptor's-material supply houses. Medium-grade metal files may also be used for this purpose. One type, called a fender file, is used in the auto-repair trade and has a convenient handle for easy manipulation. Another type of rasp that performs satisfactorily is a Carborundum block of coarse grit that has a

handle and is used in stonemasonry. It is important that the stone rasp be kept sharp. It will frequently clog with stone dust and should be periodically brushed with a wire brush and washed.

STRAIGHTEDGES

Several metal straightedges with measured calibration are necessary for planning, layout, drawing, and paper-measuring activities. Those made of aluminum are much more efficient, inexpensive, and durable than are wood rules. Instruments measuring 18, 24, 36, and 48 inches will be adequate for all the shop activities.

TAPES

Various types of gummed tapes are useful in the lithographic process: masking tape for drawing, tracing, etc.; labeling tape for drawers, shelves, inks, etc.; white holland tape for hinging print mats; and brown kraft tape for sealing packages of prints, etc.

TOOL KIT

A small kit of tools is necessary for periodic maintenance of shop equipment and machinery. Items that should be included are as follows: saw for cutting scraper bars, etc.; 24-inch spirit level for testing the level of press beds, etc.; hammer for general construction and repair; screw drivers in several sizes; pliers in several sizes; wrenches in several sizes for various press fittings; metal shears for cutting metal plates; hex keys for various equipment fittings; crowbar for opening crates of paper; and miscellaneous tools, such as drills, punches, chisels, sanders, etc.

WATER BOWLS

Water bowls are an essential item of equipment for processing, proofing, correcting, and printing. Two bowls are usually employed: one for washing out images and for other processes that gather greasy accumulations of dissolved crayon, ink, solvent, and water; and the other, carrying only clean water, for dampening the printing element. One set of bowls should be available for each press station and the processing table, with an additional set in reserve for special occasions when it is impractical to interrupt work in order to clean bowls in use.

The bowls should be approximately 8 inches in diameter and of smooth-faced aluminum, stainless steel, or enameled metal. These materials facilitate cleaning and minimize the danger of breakage. The bowls should have sufficient volume to carry an ample amount of water without taking up too much space on the press counter.

Two smaller bowls of the same type accompany the water bowls at each press station. One bowl, 4 inches in diameter, is used to carry antitint solutions; the other bowl, 6 inches in diameter, carries clean water and the half sponge for mopping up antitint solutions and spot etches. Thus, two water bowls, an antitint-solution bowl, and a bowl for mopping up are necessary for each press set up for proofing and printing. Their differing sizes offer a ready means of identification.

All bowls must be kept immaculate following each use. It will be noted that scum will have been absorbed on their surfaces. This scum is largely of fatty content; and there is always some danger that the substance, if left, will contaminate the sponges and be transferred to the printing element. The bowls are easily cleaned with some scouring powder and the soiled washout sponge. A little lithotine added to the soap will quickly dissolve stubborn accumulations. The bowls and sponges must be thoroughly rinsed with water to rid them of all remaining traces of soap. (See sec. 9.5.)

WASTE CONTAINERS

Several fireproof metal waste containers are essential to the shop operation. At least two 5-gallon containers are used for storing oily shop rags. Larger containers are necessary for the accumulation of waste paper during daily shop production. To lessen fire hazards, waste paper should be removed daily.

10.9 HEAVY EQUIPMENT

A certain amount of heavy equipment is required in any lithography workshop. Printing presses, stone- and metal-plate-graining machinery, and carting devices for heavy stones fall within this category. Presses and plate grainers are described in separate sections (see secs. 13.2 and 6.5); the other items of heavy equipment are briefly described below.

Stone Levigators. The stone-graining levigator is simply a heavy metal disc, 10 inches to 12 inches in diameter; an upright tubular handle is fitted around a heavy shaft that is connected at the outer edge of the disc. The instrument is swung in a rotating motion that is augmented by its weight and eccentric movement.

Levigators can be easily fabricated by most machine shops. The types illustrated have ball-bearing handles which, although expensive to construct, provide the greatest maneuverability with the least physical effort. The grinding disc should be a hard alloy of stainless steel in order to resist the abrasion of the graining particles. The face of the disc should have a smooth, true plane in order to ensure even grinding; the edge should be slightly beveled and free of burrs in order to prevent scratches.

10.2 The hand levigator

Powered Levigators. Various types of powered stone-grinding devices have been designed by lithographers to minimize the labor of stone grinding and to produce an accurate level surface.

The two most important factors relative to the designing and fabrication of powered levigators are the necessity for limiting rotary speed and for providing controlled leveling. Ideal disc rotation is approximately 80 to 120 rpm. Higher speeds induce excessive torque vibration, which jeopardizes the evenness of grinding as well as control of the tool. Power grinding is considerably faster and easier than hand grinding; consequently the operator must guard against removing excessive amounts of stone.

Type "a" (fig. 10.4) is powered by an air compressor

capable of delivering a minimum of 150 pounds of pressure. The speed of disc rotation is controlled by a reduction valve on the handle of the instrument. Because this type of levigator can be operated at varying speeds, it works very smoothly and needs no leveling guide.

Type "b" (fig. 10.5) is a rotary graining disc which is surrounded by a stationary metal outer frame. The disc is powered by a flexible shaft connected to a motor which is located safely away from contamination by water and abrasive. The outer frame functions as a guide and prevents the torque of the disc from grinding the stone surface unevenly.

Type "c" (fig. 10.6), the Fox I Levigator (Fox Graphics), is an electrically powered contemporary version of

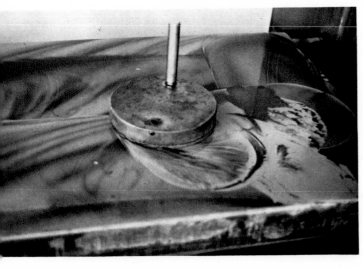

The levigator in use

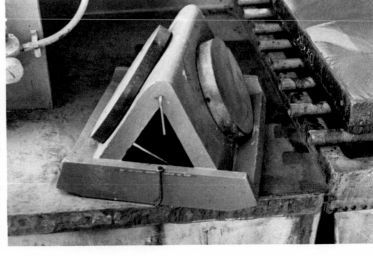

Storage stand for hand levigators

10.3 The hand levigator

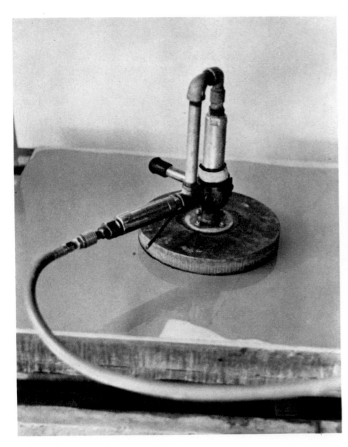

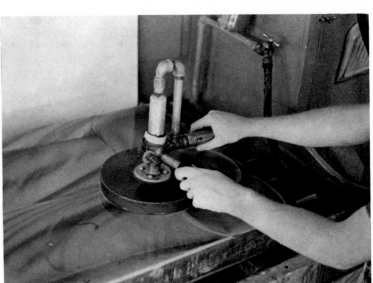

10.4 The air-powered levigator

10.5 The electric-powered levigator

10.6 The Fox I Levigator

10.7 The hydraulic lift truck

earlier commercial stone-grinding machinery. The machine consists of vertical center posts from which adjustable swinging arms support a belt-driven, fluted graining disc of cast iron. Construction is of rigid lightweight aluminum with lubricated sealed bearings. The operation of the levigator is said to be quiet, efficient, and remarkably trouble-free.

Stone Cartage. Various types of hydraulically operated lift devices have been utilized in recent years to cart heavy lithograph stones from one work station in the shop to another. One excellent heavy-duty machine is the Big Joe Lift Truck, Model 9957, manufactured by Big Joe Manufacturing Company. (See Appendix A.) The lift is a battery-operated fork that can be raised or

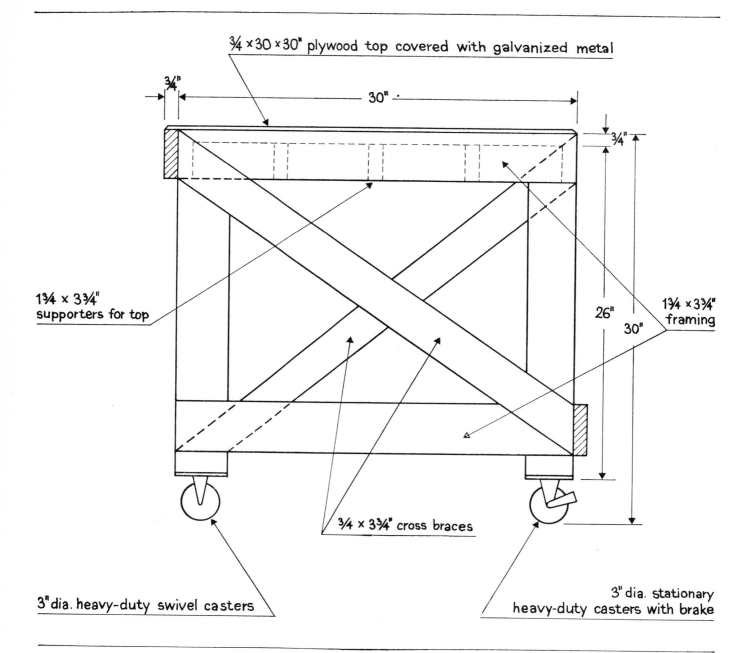

¾ × 30 × 30" plywood top covered with galvanized metal

¾"

30"

¾"

1¾ × 3¾"
supporters for top

1¾ × 3¾"
framing

26"

30"

¾ × 3¾" cross braces

3" dia. heavy-duty swivel casters

3" dia. stationary
heavy-duty casters with brake

10.8 Stone-cartage device

lowered by a clutch control. The machine is manually wheeled on heavy-duty casters that can be locked when loading heavy items.

A sturdy plywood platform approximately 30 × 30 × 2″ is bolted over the forks of the lift in order to provide support for the stones. Ball-bearing casters, 1 inch in diameter, are fastened to the top surface of the platform in a gridlike pattern about 6 inches apart. The ball bearings provide easy movement of heavy loads on and off the platform.

The hydraulic lift is an extremely useful and versatile machine in an active shop. It should be regularly main-

tained following manufacturer's instructions in order to provide long-lasting service.

Other mechanical lifting devices can be made by modifying various types of manually operated heavy-duty automobile jacks. A more simple carting device can be constructed from wood or angle iron. This consists of a sturdy platform supported by four legs on which heavy-duty casters are fastened. The height of the stationary platform should conform to the standard height of work tables, press bed, and graining sink in order to eliminate the lifting of stones to different heights.

CHAPTER **11**

Lithographic Inks

11.1 LITHOGRAPHIC INKS

Three different types of ink are used for lithographic hand printing. These are (1) roll-up ink, used in processing the image, (2) black or colored ink, used in proofing and printing of editions, and (3) transfer ink, used to transfer impressions from one surface to another. Each ink must have special working properties to function dependably, and the printer must understand the factors that govern the choice, behavior, and control of the inks he uses. Inks which are manufactured with the wrong properties or which are improperly altered by the printer may either destroy the printing stability of a work or produce impressions of poor quality.

Inks for hand lithography were still offered as standard products by a few ink manufacturers until the 1940s. Today, however, inks are produced to meet the requirements of a complex, automated printing industry. Inks for offset lithography are formulated for high-speed production and for maximum efficiency on presses and printing papers totally unlike those used in hand lithography. Whereas inks for automated printing dry rapidly, are relatively thin, and are formulated for economical mass production, inks for hand lithography must dry slowly, must be thick, and often require costly ingredients to ensure maximum color permanence.

An insufficient market potential was the major reason most manufacturers discontinued the mass production of hand-printing inks. However, a few of the ink producers have continued to supply individual printers with modified offset inks for hand lithography on a custom-order basis. It is likely that this practice will continue until a greater market can again support volume production of ink for hand printing. Until that time, the hand printer should expect to pay higher prices for his inks and should

also be prepared to work closely with the ink manufacturer in order to perfect ink formulas for his special requirements.

In 1960, Tamarind, with the cooperation of the Sinclair & Valentine Ink Company, initiated an ink research and testing program to develop a standardized group of inks for hand lithography. A series of black and colored inks was formulated to perform reliably within a broad range of processing and printing requirements. These tests also provided performance factors against which inks by other manufacturers could be measured. Some of the inks that qualified in the testing program are described later. (See sec. 11.11.) It is reasonable to suppose that inks produced by other manufacturers could also qualify within the standards of the inks used at Tamarind. It is hoped that more hand lithographers will work closely with ink manufacturers, thus encouraging the expansion of future ink resources. The printer should understand that the development of a special ink or the controlled alteration of an existing variety requires the technical services of an ink chemist. This is another reason why it is important for the printer to understand basic ink technology. Unless he can communicate his ink problems meaningfully to the chemist, experimentation will be costly, time-consuming, and probably fruitless.

11.2 PHYSICAL PROPERTIES OF LITHOGRAPHIC INK

The behavior of printing ink is usually related to its physical properties. The hand printer should become familiar with such terms as viscosity, thixotropy, tack, length, and body. Each term describes some physical aspect of ink.

Viscosity. Viscosity is the amount of resistance of the

ink to flow. Comparatively, inks for hand lithography should be more viscous than inks for offset lithography. The vehicle (lithographic varnish) is the chief material governing the flow characteristics of ink. Since this is introduced during the manufacturing process, the viscosity of the ink is determined beforehand so that the ink meets certain basic requirements. Modifications of this viscosity by the printer are often necessary for special tasks. For example, inks of low viscosity flow too readily and cannot be easily controlled during inking. Inks with high viscosity may not transfer readily from the printing element to the paper. Roll-up ink requires greater viscosity than printing ink so as to prevent excessive build-up of ink during the critical stage of processing. Edition printing usually requires a less viscous ink which can penetrate the paper easily and which will not pluck the fibers of the paper when the impression is removed from the printing surface.

Ink viscosity can be modified by adding varnishes with different flow characteristics or by using one of the modifying agents. These will be more fully described later. Temperature change can also affect ink flow. Warm temperatures tend to lower the viscosity and cold temperatures to increase it. Hence somewhat thinner varnishes are used in winter than in summer months.

Thixotropy. Lithographic ink may appear rather firm when first removed from the can. It becomes looser and smoother after being worked on the ink slab for a few minutes. The ink is like a plastic material; its internal forces break down when it is worked, and they gradually re-form when left standing. This phenomenon is called *thixotropy.*

Because lithographic ink is thixotropic, the volume to be used for printing must be thoroughly agitated on the slab before it is distributed. During prolonged printing, the remainder of the ink pile must again be worked (for it will have re-formed) before the slab is replenished. Meanwhile the film of ink distributed on the slab will remain in its looser state, since it is under continual agitation from the rotation of the ink roller.

Occasionally ink in the can will form a gel-like structure that cannot be broken down on the slab. Ink in this condition is no longer usable and is described as being "livered." Livering is most often caused by inferior materials and careless manufacturing.

Tack. Tack is the measure of the stickiness of ink. Tack can be roughly estimated by the pull on one's finger when it is rapidly lifted from the ink. When the finger taps the same ink on a sheet of paper, the pull will be even greater because some of the ink vehicle is absorbed into the paper.

Tack manifests itself in printing in the following way. Both the printing image and print paper are wet with ink during printing. When the paper is removed from the printing surface, the film of ink splits between the two surfaces, with the greater amount being affixed to the more absorbent.

A certain amount of tack is necessary in lithographic ink if the sharpness of the image is to be retained when the ink is rolled on. Excessive tack, however, prevents the penetration of ink into the paper and may even pluck fibers from the surface of soft papers.

During printing there will be a gradual reduction of tack as the ink becomes emulsified with water from the printing surface. Overly emulsified inks become rubbery and cannot produce crisp impressions. Hence, the distribution of water on the printing surface and the tack of the ink are closely related to each other and require careful control.

Length. The length of an ink is determined by the distance it can be pulled into a long string without breaking. A long ink may stretch 5 to 6 inches without breaking; a short ink may break within 1 inch. Ink length is important because it affects the distribution of ink on the paper. Long inks are more desirable for offset printing; they must travel a greater distance from the inking ducts and over the inking rollers before reaching the printing surface, the offset blanket, and finally the paper. Shorter inks are preferable for hand printing because of the shorter distance of travel between the ink roller and the printing surface. Being more compact, they are easier to control on the inking roller and the printing surface, whereas a longer ink has a tendency to overink each printing dot.

The length and the tack of an ink are different properties, although often related. Each or both may be affected by changes of varnish or pigment ratios, or by additions of modifying agents. For example, adding a stiff varnish will make the ink tackier and shorter, whereas adding magnesium carbonate may only shorten the ink without affecting its tack. If the ink manufacturer used the same varnish but increased the pigment ratio, the tack would increase but the length would decrease. Like tack, length is reduced when the ink becomes emulsified with water during printing. It will be noticed that the printing ink on the slab is considerably shorter at the end of a job than it was at the beginning.

Body and Consistency. Ink body and consistency are generic terms usually referring to the over-all physical properties of the ink. Inks for hand printing should be heavier in body than those used for offset printing. This means that they should be compounded with greater

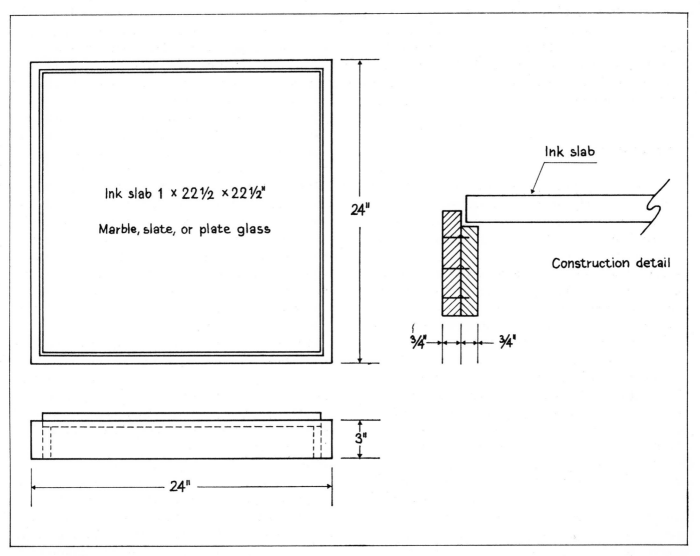

11.1 Portable ink slab

One for each press station

Ink slab 1 × 22½ × 22½"

Marble, slate, or plate glass

24"

3"

24"

Ink slab

Construction detail

¾" ¾"

loadings of pigments, varnishes, and modifiers, and that their consistency should be short and tacky.

11.3 MATERIALS OF LITHOGRAPHIC INK

All lithographic inks are composed of three basic parts: (1) the varnish or carrying vehicle; (2) the pigment or coloring matter; and (3) various modifying agents that impart special properties.

The vehicle for lithographic ink is a heat-treated, linseed-oil varnish that contributes the fatty qualities necessary for the ink to perform lithographically. The vehicle also provides viscosity and binding properties that enable the ink to flow properly and to bind the pig-

ment particles to the paper on which the ink is printed.

Today pigments are produced from both organic and inorganic substances. Their physical and chemical properties exert a strong influence on the behavior and permanence of inks in which they are used.

Modifying agents such as special greases, waxes, solvents, driers, or adulterants can be added to the ink during manufacture or by the printer just before printing. Modifiers contribute additional working properties to inks for specific tasks.

It should be noted that ink technology, in keeping with other areas in the printing industry, has advanced very rapidly in recent years. Raw materials, manufacturing techniques, and finished products undergo constant modification, often without preliminary notification to

the client. Frequently the reason for change is affected as much by economic necessity as by technical advancement. The printer should therefore maintain close contact with his ink supplier to keep informed of current trends that may render a previously satisfactory product useless for hand lithography.

11.4 VEHICLES

The vehicles used in present-day lithographic inks include drying oils, resin-solvent varnishes, alkyd varnishes, and gloss varnishes. Drying oils (chiefly linseed-oil varnishes) are by far the best vehicles for hand-printing inks.

Linseed-oil Varnishes. Linseed-oil varnishes are made by heating the oil to approximately 600° F and maintaining this temperature for varying lengths of time. The length of boiling determines the grade and body of the varnish produced. The longer the oil is boiled the less greasy and the more viscous it becomes. Shorter boiling periods produce varnishes that are thinner, less tacky, and much greasier. A numerical grading system identifies these differences, which range from #0000 varnish (extra thin and very greasy) to #10 (extremely stiff and viscous). Varnishes carrying numbers from 7 through 10 are usually called *Body Gums* by ink manufacturers. The thinner varnish may be boiled for less than an hour, whereas the stiffer varnish may require 16 to 24 hours of boiling.

Different grades of lithographic varnish produce variations in the working properties of ink. They can change its viscosity, reduce its consistency, or affect its greasiness. An adequately equipped shop should stock 1-pound cans of #0, #3, #5, and #7 varnish. This range will satisfy almost any requirement for ink modification.

All lithographic ink has a certain combination of varnishes incorporated during its manufacture. Additional amounts of varnish introduced by the printer to modify the ink will increase its greasiness unless balanced by other ingredients. Inks that are too greasy can cause scumming and filling-in of the image. Such inks contain a high percentage of fatty-acid particles. Under certain conditions a number of free fatty-acid particles can separate from the ink and be drawn toward the nonimage areas of the printing element. If the migration is of sufficient concentration, it can overcome and destroy the adsorbed gum protecting these areas. Ink scum will then develop, and the image will begin to fill in. Overly greasy inks should be modified with magnesium carbonate. (See sec. 11. 9.)

A mixture of several grades of varnish in the ink will often perform more satisfactorily than one grade alone. For example, #0 varnish added to the ink, while thinning its consistency, may reduce its tack excessively. It is then necessary to readjust its tack by adding small amounts of #3 or #5 varnish.

A satisfactory hand-printing ink should permit easy inking of solids and permit halftones to stay open. A large percentage of ink is expended in rolling solids. Inks slightly softened with #3 or #5 varnish will distribute over solid areas more easily. Inks in this condition can also penetrate denser and heavier papers more effectively. If the ink is softened too much it will tend to close in the half-tones. The properties of the ink must be carefully balanced so that both half-tones and solids can be printed satisfactorily. Depending on the control factors involved, it is sometimes necessary to compound the ink mixture to favor slightly either the solid or the half-tone areas.

The very stiff varnishes (#7 or #8) are mostly used for occasions such as bronzing and gold-leafing, which call for an extremely tacky ink. Gloss and overprinting varnishes, which are also stiff, find greater application in commercial printing. Gloss varnishes are incorporated with the ink to impart more sheen to the dried-ink film. Overprint varnishes produce scuff-resistant films over color work or bronze printings.

It is believed that at least two processes are at work in the drying of inks containing linseed-oil varnishes. The first is oxidation. The chemical reaction of oxygen with the drying oil helps to convert it into a solid. The second is polymerization, wherein a number of varnish molecules become bound together by cross-linking. Held together in this way, they are unable to move; in this condition the ink is considered to be dry.

Other Vehicles. Varnishes made from substances other than linseed oil are sometimes used in offset inks, but are not recommended for inks for hand printing. China wood oil (tung oil) varnish dries very rapidly into a tough, flexible, and highly glossy film that is more waterproof than other vegetable drying oils. The raw oil is more viscous than linseed-oil varnishes.

Alkyd resins are also employed as part or all of the vehicle in other types of ink. Inks containing alkyd varnishes dry fast and have great toughness and scratch resistance. Because of these properties, they are used mostly for printing on metal.

Resin-solvent varnishes (quick-set) are made by combining one or another type of resin with a petroleum hydrocarbon solvent that has a high boiling point. Inks using these varnishes dry primarily by the evaporation of

the vehicle solvent or by its absorption into the printing paper. Because quick-set inks dry very rapidly, they are not satisfactory for hand printing. The solvent in the vehicle evaporates on the ink slab and roller, and the viscosity of the ink increases sharply. Such a large loss of solvent can reduce the binding properties of the ink even before it reaches the paper.

Inks for printing on plastic materials must be formulated for the particular kind of plastic to be used. Inks of this type usually contain a binder similar to the resin incorporated in the plastic. A volatile solvent is also required, to soften the surface of the plastic, thus permitting the resin binder to become fused with ink. The use of standard printing inks on plastic sheets is not recommended because, when dry, they will often smear, scuff, or flake off.

11.5 PIGMENTS

Pigment is the coloring matter in ink. Some of the requirements for a satisfactory pigment in lithographic ink are:

High Color Strength. Ink films deposited during the lithographic process are considerably thinner than those of other printing processes. Inks for lithography, therefore, require high color strength in order to produce brilliant color impressions.

Clean Color Tone. Although many pigments used for making artists' paints can also be used for satisfactory inks in full-strength mixtures, they are seldom capable of providing clean color tones in reduced strength. A totally different group of pigments is required; these provide clean color tones in full strength as well as in reduced mixtures.

Nonbleeding Pigments. Ink pigments must be insoluble in water or dilute acids, such as those contained in antitint and fountain solutions. Otherwise the pigment particles would separate from the vehicle and float on the surface of the dampened printing element. The result would appear as a tinted halo around each image dot of the printed impression.

Nonsubliming Pigments. Pigments that change from a solid to a vapor in the presence of heat or moisture are said to *sublime*. In this condition, the vaporous color can be transmitted from the front of one sheet onto the back of another in the edition pile, and upon condensing it can tint the sheets. This is a condition that can occur at any time, even after the inks are dry. Inks made from such pigments are totally unsatisfactory for hand printing.

Nonflocculating Pigments. Pigment particles are evenly dispersed through the varnish vehicle when the ink is ground on an ink mill. During printing, if the pigment particles tend to coagulate in the presence of moisture from the printing surface, the condition is called *pigment flocculation*. As a result, the ink becomes very short and pasty. Up to a certain point, shortness of hand-printing ink is desirable. If the ink becomes too pasty, however, it will not distribute properly on the roller or printing image. In severe cases, the ink will strip from the roller or pile up on the printing image unevenly.

Although most pigments today do not flocculate (the chrome yellows are the worst offenders), those with high specific gravity tend to do so. High percentages of modifying agents in the ink, particularly magnesium carbonate, can also encourage flocculation.

Good Oil-wetting Properties. The ink pigments must have good oil-wetting properties in order to be thoroughly ground with the lithographic varnish. Pigments with limited oil-wetting properties produce inks with poor flow and weak binding properties.

Small Particle and Nonabrasive Pigments. Certain types of pigments are hard and gritty. When incorporated in ink, they have abrasive properties that can physically erode the image and nonimage areas during the repeated process of printing. This is one reason why earth pigments such as umbers, siennas, and ochers are not used today. Even though such pigments are extremely fade-resistant, their gritty properties and relatively poor tinting strength have rendered them obsolete. Other types of pigments, when too coarsely ground, can also produce abrasive inks. In addition, the incorporation of sizable amounts of magnesium carbonate will result in an abrasive ink. Although improving certain properties, this ink modifier can create other problems when used carelessly.

Fade-resistant Pigments. Pigments that are highly resistant to discoloration or fading in the presence of light are essential for quality hand printing. Lithographs printed with fugitive inks will eventually lose their original appearance, and in so doing will defeat the aesthetic or technical objectives of the artist. By comparison, standards for color permanency are much less demanding in commercial printing. Thus the term "permanent ink" as used by ink manufacturers refers to commercial usage; it has no correlation with standards of permanency required for fine art. The inks tested at Tamarind were subjected to accelerated periods of exposure to light in a Fadeometer. Colors that could withstand between 50 and 100 hours of exposure without discoloration were considered acceptable. It is worth noting that comparable colors from the three most widely used brands of European hand-printing inks could not qualify within this exposure requirement. Each of these inks showed marked

fading or discoloration within 5 to 12 hours of accelerated exposure.

Factors other than pigmentation can also affect the permanence of inks:

1. Some lithographic varnishes and modifying agents are more resistant to light than others. Incorporation of the less resistant types in an otherwise satisfactory ink can reduce the ink's resistance to light.

2. Heavily concentrated ink films are more resistant to fading than weakly concentrated films.

3. Maximum concentrations of color intensity are more resistant than weak tints of the same hue.

4. Inks that are deeply absorbed into the paper are more resistant than those which lie mostly on its surface.

Because these factors can occur in innumerable combinations during ink formulation, ink mixing, and printing, it is virtually impossible to select an index of permanence applicable to all printing requirements.

The commercial printing industry often requires inks with other special properties, such as resistance to alkalis, resistance to solvents, resistance to food products, resistance to heat, etc. Because no one pigment can meet all these demands, the ink manufacturer must compensate as well as he can with pigments that he has available. Through economic necessity, his standard line of pigments (from which many hand-printing inks are also made) is geared to meet as many of these all-round requirements as possible. This is one reason why an ink-testing program can establish only relative guidelines.

It is ironic to note that certain pigments are available today from which even more permanent inks could be manufactured. Because these are relatively expensive and since no volume market for more permanent inks exists, the ink manufacturers make no attempt to stock these materials. Consequently the hand lithographer must make do with permanent inks that are currently available and hope for improvements in the future.

11.6 INORGANIC PIGMENTS

Ink pigments may be inorganic or organic. The inorganic pigments will be discussed first.

Inorganic pigments are composed of substances that are chiefly of mineral content, either in natural or manufactured form. The majority of the natural pigments (barytes, umbers, and siennas) are no longer used for lithographic inks because of their large and abrasive particles.

Most inorganic pigments are opaque or semiopaque. They usually have good resistance to light; they do not sublime; and they have good oil-wetting properties. On the other hand, they have only fair color strength; the reduced tints are often muddy; and, because many varieties are of high specific gravity, they tend to promote ink flocculation. Hence, the list of satisfactory inorganic pigments is quite short.

COLORED INORGANIC PIGMENTS

Chrome Yellow. Chrome yellow is available in several warm colorings; it is a very useful pigment for hand-printing inks because of its heavy body, its opacity, and its rapid drying characteristics.

Primrose and Lemon Chrome Yellow. These are paler and greener shades of chrome yellow.

Chrome Orange. This pigment is a neutral orange hue. Like chrome yellow, it is heavy and opaque, and inks made from it have excellent body for hand printing.

Molybdate Chrome Orange. This pigment is a deep reddish orange. Molybdate oranges are excellent pigments of intense coloration. Their characteristics are like those of the other chrome colors, although they are somewhat more expensive.

Iron Blues. The iron blues are used extensively in lithographic inks. They include Prussian blue, bronze blue, milori blue, and Chinese blue. The many different hues of iron blue are produced by subjecting the chemical to variations of acidity, temperature, and length of heating. These pigments have high tinctorial strength and reasonable light-fastness, but they will turn brown in the presence of alkalis. They may be mixed with most other colors, except those which are reducing agents or those which are alkaline. Iron pigment is soft and greasy; hand-printing inks made with it are prone to scumming and tinting. For this reason, additions of magnesium carbonate are often required.

Chrome Green or Milori Green. This pigment is an intimate mixture of iron blue and chrome yellow. It is a dark, fairly opaque dull green and is reasonably resistant to fading. Its working properties, like those of most of the chrome pigments, are considerably improved when mixed with other pigments and extenders. Because it has strong drying properties, inks made from it tend to skin rather rapidly in the can.

Cadmium Pigments. The cadmium yellows, oranges, and reds are sometimes made into lithographic inks, but they are very costly pigments. Although the cadmiums have excellent opacity and resistance to fading, they have relatively low tinting strength, and their reduced mixtures do not produce clean tints.

Other inorganic pigments, such as red lead, ultramarine blue, vermilion, and zinc chromate, are not used in lith-

11.2 The materials for mixing ink

ographic inks because of their low color strength or poor distributing properties. Mixtures approximating these colors are made by combining other inorganic pigments with certain organic pigments.

Titanium Dioxide. Mixtures of titanium dioxide pigment and lithographic varnish produce the most opaque white inks presently available. These are called *cover white* inks. Nevertheless, it must be noted that cover whites are incapable of producing totally opaque films because of the fundamental thinness of ink films printed lithographically. Occasionally this ink is printed two or three times over itself to increase its covering capacity, although even this is insufficient to produce a strongly opaque white. Transparent inks are often given more body and are made more opaque with small additions of cover white. This ink can also be used alone over dark printings to produce unusual milky grays. Inks made with titanium dioxide are heavy-bodied and similar in

working properties to the chrome pigments. They tend to emulsify rather rapidly in the presence of moisture, and they require constant attention in order to maintain their smooth working properties during printing.

Other inorganic white pigments such as lithopone, zinc oxide, zinc sulphide, and white lead are not usually used in lithographic inks because of inferior working properties.

NONCOLORED INORGANIC PIGMENTS

The noncolored inorganic pigments are employed in mixtures of other colors as extenders, to produce tints, and, sometimes, to improve the working properties of the ink. Mixtures containing as much as 75 per cent extender and 25 per cent colored pigment can be made to print effects not unlike delicate watercolor washes. Small amounts of extender will usually improve the working properties of heavily pigmented ink mixtures. When in-

corporated with a varnish vehicle, noncolored pigments produce semitransparent or totally transparent inks. If the pigment and the varnish have the same light-refractive index, the extender becomes transparent; if they are somewhat different in refractive index, they form a semitransparent extender. Transparent white ink is an example of a transparent extender. Ink mixtures that contain large percentages of extender usually need to be further modified with additions of magnesium carbonate to shorten the length and reduce the tack. This will also help to reduce the tendency of the transparent color to gloss.

Alumina Hydrate. When mixed with lithographic varnish, alumina hydrate produces a colorless, transparent extender. It is a desirable pigment which helps to give the ink both length and flow.

Barium Sulphate. This semiopaque white pigment is better known as *blanc fixe*. It is an inexpensive pigment of high specific gravity and low oil-wetting properties. Therefore, it produces inferior extenders which are chalky when dry and are easily scratched. Blanc fixe is sometimes used in the cheaper grades of ink.

Gloss White. This pigment produces a semiopaque extender. It consists of about 25 per cent alumina hydrate and 75 per cent blanc fixe. Gloss white is a fair extender, but is seldom used today in hand printing because of the superior properties of alumina hydrate.

Magnesium Carbonate. This transparent white extender is a mixture of hydrated magnesium carbonate and magnesium hydroxide. The substance, in the form of an impalpable white powder, has virtually no coloring capacity. Chemically neutral, it will react with the free acid in a vehicle, forming a magnesium soap. As such, it can increase the body of an ink and at the same time reduce its length and tack. Magnesium carbonate is employed more as a modifying agent in hand-printing inks than as an extender. It produces flat, nonglossy inks and is often employed in color lithography to print ink films that trap succeeding colors very effectively. More will be said about the properties and use of magnesium carbonate in the section on ink modifiers (sec. 11.9).

11.7 ORGANIC PIGMENTS

Organic pigments are synthetically produced from carbon-ring compounds of complex chemical structure. They are used far more extensively in lithographic inks than inorganic pigments because they offer greater color range. Most organic colors have high color strength, low specific gravity, small particle size, and low abrasive properties. The chief disadvantage of organic pigments is their transparency. Most inks using these pigments

need further modification by the printer to adjust their tack, length, or body to meet the requirements of hand printing. The principle categories of organic pigments with some of the familiar pigments in each are listed below.

Azo Pigments. Pigments that fall in this class are hansa yellow, benzidine yellow, permanent orange, para red, toluidine red, and the naphthol AS pigments (of which there are over thirty varieties). Most azo pigments have good to excellent light-fastness.

Azo Dye Pigments. Some azo pigments are true pigments, and are insoluble in water without further treatment. Others are dyes, and require precipitation onto a neutral base to form pigments insoluble in water. Azo dye pigments are used in "toners" and "lakes," which have highly intense, transparent coloration. Lithol red and red lake are important members of this class of pigments. Although many toners and lakes have great tinting strength, some varieties are sensitive to alkalis and others have poor resistance to light. Peacock blue is an example of this type of pigment. Individual toners and lakes should be thoroughly tested before being employed for professional production in hand printing.

Basic Dye Pigments. These pigments are made from dyes that are basically alkaline. As stated, they are soluble in water, although they can be precipitated into insoluble toners and lakes by chemical action. The resulting pigments have brilliant coloration and are reasonably fast to light. The more familiar pigments are made from these dyes: malachite green, methyl violet, Victoria blue B, and rhodamine.

Phthalocyanine Pigments. Copper phthalocyanine is called *thalo blue* or *cyan blue*. The introduction of chlorine into the molecules of thalo blue produces a brilliant green pigment called *thalo green* or *cyan green*. Thalo blue is available in two shades, called R (red) shade thalo blue and G (green) shade thalo blue. There are also two shades of thalo green. These pigments are very fast to light and find great use as strong tinting colors. Because they are hard to grind, they are often manufactured as inks of loose consistency, and must be stiffened either with heavier-bodied pigments or with additions of magnesium carbonate.

Carbon Blacks. Today nearly all black printing inks are made from carbon-black pigment. Carbon black consists mostly of elementary carbon, a small percentage of ash, and a higher percentage of "volatile matter." Because of their finely divided pigment particles, carbon-black inks are used for the roll-up and etching process and for transferring. Roll-up inks offer maximum protection of the image from the action of the acid in the etching

a. Removing ink from the can

b. Working the ink on a corner of the slab

c. Distributing the ink with the knife

d. Removing the excess ink bead

e. Distributing the ink with the roller

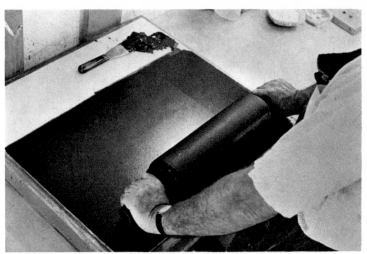
f. Evening the ink on the slab and roller

11.3 Ink preparation

solution. Because the carbon pigments are slow driers, black inks are also employed for rolling up color stones or plates before gumming and storage. When a stone or plate is prepared for reprinting, the semimoist ink on the image can be quickly and easily washed away. Color inks, because they dry rapidly, are extremely difficult to wash out after the printing element has been in storage for even a few days.

Most of the black-and-white lithographs of the nineteenth century were made with inks containing Frankfort black pigment. Frankfort black is made from various vegetable substances of a woody and fibrous nature which are charred and ground into a fine powder. Because only about 70 per cent of the material could be reduced to carbon (the rest being mineral impurities), Frankfort blacks have lower tinting strength than present-day blacks. Their softer tone and warmer color were attractive qualities in artists' lithographs. Unfortunately, the requirements of the commercial printing industry necessitated stronger and purer blacks. Today the carbon pigments have virtually replaced all other types for black printing inks. When softer blacks are desired for hand printing, the carbon pigments can be reduced and modified with other colors to approximate somewhat the qualities of Frankfort black.

11.8 OTHER PIGMENT PROPERTIES

Three important visual characteristics of color ink are: (1) degree of opacity or transparency, (2) tinting strength, and (3) mass tone and undertone. Relative properties of transparency and opacity have been noted briefly in the preceding sections. It is well to remember that, with the exception of carbon black, all the inorganic pigments have less tinting strength than the organic pigments but greater opacity. Chrome yellow is an example; it is perhaps one-fifth as intense as benzidine yellow, which it resembles in hue. It is a considerably more opaque pigment, however, and thus has much greater hiding power.

Mass tone is the appearance in hue of a thick mass of ink. It is the result of the reflection of light from the ink pigment. *Undertone* is the hue of a thick, transparent, or translucent veil of ink produced by the reflection of light from the print paper through the ink film. For example, a red ink may exhibit a very cool or bluish top tone in its mass, but, when reduced to a thin transparent tint, the same ink will reveal a decidedly warm or yellowish cast. Most pigments used in color inks appear different in mass tone and undertone; and these shifts of pigment coloration can be used advantageously to extend the color range of a print. Their appearance depends on the tonalities in the artist's drawing. For example, the solids and heaviest part of the drawing will accept greater amounts of ink and will produce the appearance of its mass tone. The lighter parts of the image will accept less ink, and the resultant tint of the ink will reveal its undertone. If the value range of the drawing is sufficiently exaggerated, the print will have the appearance of separate printings in two hues. Even black ink can be employed to produce this phenomenon; when mixed with small amounts of color, it will appear neutral in mass tone and show a distinctive chromatic cast in the tints. Extremely subtle coloration can be achieved by use of this principle for either single or multicolor lithographs. Furthermore, the number of colors for multiple printings can be reduced by making fuller use of the dual characteristics of each color used. Obviously, a certain amount of planning is necessary if drawings are to be developed so as to exploit the particular characteristics of each color.

When the printer comprehends the relationships of ink transparency, opacity, tinting strength, mass tone, and undertone, he is better qualified to select a basic assortment of color inks that can provide a balanced range among all these properties, and so is assured of the broadest possibilities for undertaking color printing. The selection of the basic ink palette is discussed later. (See sec. 11.11.)

11.9 INK MODIFIERS

Some lithographic inks can be used directly from the can, but others require modification to improve certain working properties. The various materials which are added to inks to improve these properties are called *ink modifiers* and include reducers, bodying agents, antiskinning agents, and driers.*

Although ink modifiers are very important, they should be added to the ink with some caution. It must be remembered that printing ink is manufactured with a carefully balanced selection of ingredients. Indiscriminate addition of modifying agents can destroy this balance and create greater problems than those they are meant to solve. Moderation is advised; one should never add modifiers to the ink unless absolutely necessary, and then only in small amounts until the desirable working properties are achieved.

*The drying principles of ink films and the use of driers in printing inks are discussed separately in sec. 11.10.

Ink Reducers. It is sometimes necessary to thin an ink. The preferable approach is to employ a reducing oil (Sinclair & Valentine Reducing Oil #470 or Hanco Reducing Oil #V318). Reducing oils are highly refined petroleum solvents of low fatty-acid content. A few drops are sufficient to thin a stiff ink without increasing its greasiness. Lithographic varnishes may also be used to reduce ink, although, as well as thinning, they modify tack and viscosity. At the same time they substantially increase the total fatty content of the ink. In some cases, a small amount of varnish is added only to modify tack and viscosity; reducing oil is used to thin the ink. In this way, less varnish is necessary and the increase of grease content in the ink is lessened.

Tack Reducer. Occasionally it is necessary to reduce the tack of ink without changing its body or fatty content. This usually occurs when the printing image requires a stiff ink in order to print sharp and clean; if not reduced, the tack plucks the fibers of the paper when the paper is removed from the printing element. A number of nonfat waxy compounds that are designed to overcome this problem are available from ink suppliers. Petroleum jelly (Vaseline) is another substance that can reduce tack satisfactorily because it does not contain fatty acids. Reducing oil can also be used for tack reduction, but, being more liquid than petroleum jelly, it will also lessen the ink body somewhat.

Bodying Agents. Inks that are too thin require stiffening to allow controlled inking of delicate tonal passages. Sometimes a color ink can be stiffened by mixing it with another color (cover white, chrome yellow, chrome orange, or black) that has heavier body. Ink may also be stiffened by adding a heavy grade of varnish. This will tend to increase the tack, viscosity, and greasiness of the ink. A small addition of Vaseline or reducing oil can balance the increase in tack and viscosity.

The material most often used for bodying inks is magnesium carbonate. It is especially useful for stiffening soft and greasy inks made with organic pigments. Although this material is one of the most important modifiers for hand-printing ink, it must be used with some caution. Quantities used should not exceed one-third the total volume of the ink mixture. Greater amounts impart to the ink abrasive properties that can permanently weaken the lightest areas in the printing image. High concentrations of this modifier will also produce ink films which dry much too slowly and which have poor binding properties. Accordingly, magnesium carbonate (magnesia) should be mixed with the ink in small amounts until the desired body is obtained.

Antiskinning Agents. Antiskinning agents are used mostly in commercial printing. They serve to prevent skinning in the ink fountain and on the press rollers of high-speed offset presses. The best-quality antiskinning agents will reduce the tendency toward skinning without retarding greatly the drying time of the printed ink.

Another type of antiskinning agent is supplied by some ink distributors in a pressurized can. The agent is sprayed over the ink remaining in the can before it is stored. The protective film will prevent the ink from skinning in the can. When the ink is used again, the coating is simply mixed with the contents of the can and a new coating is sprayed on before storing.

The table below summarizes uses of ink modifiers:

1.	To thin ink, add:	a.	*#470 reducing oil* (does not affect greasiness or viscosity).
		b.	*thin varnish* (#1 or #3· increases greasiness, reduces viscosity).
2.	To soften ink, add:		*Vaseline* (reduces tack without increasing greasiness).
3.	To stiffen ink, add:	a.	*magnesium carbonate* (decreases greasiness, shortens ink, and increases viscosity).
		b.	*stiff varnish* (#5 or #7), increases body, as well as greasiness and viscosity.
4.	To increase tack, add:		*stiffer varnishes* (#5 or #7).
5.	To decrease tack, add:	a.	*#470 reducing oil.*
		b.	*magnesium carbonate.*
		c.	*thin varnish* (#1 or #3).

11.10 INK DRIERS

Under normal conditions the oil varnish in an ink vehicle dries rather slowly. The drying rate accelerates somewhat with the addition of certain pigments and is retarded by the addition of others. Drying rates for all inks can be rapidly increased by incorporating a drier in their mixture.

The drying rate of ink films for both color and black-and-white printing has the following significance from the printer's viewpoint:

1. The ink film on the paper surface must be sufficiently dry to prevent offsetting onto the printing element from which the next color is to be printed.

2. Each successive printing should lie on a previously printed film of ink which is not completely dry. This permits the fresh ink to be trapped by the underlying ink

film. If the underlying ink were too dry, it would tend to reject the new color, thus resulting in poor impressions.

3. The drying rate of ink is also vital to the production schedule of an active lithography shop. The printer must be thoroughly familiar with the natural drying properties of all his inks in order to forecast his daily printing output. Generally lithographic inks are dry enough in twelve to twenty-four hours to allow for safe overprinting. Unless the printer accelerates his slower-drying inks (for example, milori blue and black), he may be forced to delay printing for several days until the previously printed color is sufficiently dry. An ink drier is particularly useful when printing two or more colors in one day, as during progressive proofing.

4. Inks with too much drier are difficult to control during hand printing. The rapid alteration of their viscosity and tack can endanger the printing image as well as the quality of impressions. Therefore ink drier should be incorporated judiciously, and only when absolutely necessary to control adverse drying conditions.

5. In multicolor printing, inks for the first few colors should contain proportionately less drier than the topmost colors in order to assure ideal ink entrapment.

Principles of Drying of Ink Films. The usual lithographic inks dry in two stages. The first stage is "setting" or absorption of the ink vehicle in the paper.

The second stage of drying is oxidation. This chemical reaction hardens the ink vehicle and renders the ink rub-proof. Oxidation usually requires twelve to thirty-six hours and is conditioned by the nature of the pigment employed in the ink, the moisture content of the paper stock, and the climatic conditions during the printing. Certain pigments, such as the chrome yellows and oranges, some blues, and certain browns, dry rapidly by oxidation. The black inks are the slowest driers of all. Modifying agents in the ink, such as lithographic varnish or magnesium carbonate, will retard drying even more, because of their slower rate of oxidation.

Heat accelerates the oxidation rate of ink; cold slows it down. Ink dries approximately twice as fast at 85° F to 90° F as it does at 70° F (provided the relative humidity remains constant). High humidity retards the drying time considerably. Moisture in the paper or on its surface also retards ink drying. Ink dries faster on absorbent papers and slower on hard-sized, nonabsorbent papers.

Types of Driers. Ink driers are available in both liquid and paste form. The liquid types are usually derivatives of cobalt siccative; these are noted for their powerful drying action which functions by drying from the top of the ink film downward. Cobalt driers tend to form glossy elastic ink films.

Paste driers usually contain lead and manganese; they tend to dry the ink throughout, and form tough, leathery films that have less surface gloss than films produced by cobalt driers. They are somewhat preferable for hand printing, inasmuch as their drying characteristics are more suitable to the problems of color trapping.

Driers have little effect on color permanency. Pigment reaction is negligible because of the small percentage of drier used per volume of ink.

Amount of Drier Needed. All driers should be used in accordance with the manufacturer's directions. However, proportions should seldom exceed 1/16 ounce of drier per pound of ink. Since the basic volume of ink for any one printing session is considerably less than 1 pound, only a minute amount of drier is actually used. Even so, the ink will become rubbery on the slab and the roller during prolonged periods of printing. This problem can be avoided by mixing smaller proportions of ink and drier, rather than mixing the drier in the entire amount of ink at one time. In this way, ink that starts to dry on the slab can be scraped away before a fresh mixture is added.

11.11 BASIC INK PALETTE

Once the fundamental characteristics of lithographic ink are understood, the printer may select a basic assortment of inks that can accommodate a wide spectrum of work. The choice should be governed by the factors discussed in this chapter. Variety should be provided; not all colors need be intense and transparent or dense and opaque. Ink palettes that are too restrictive will severely limit the character of professional work.

With this in mind the following series of inks tested at Tamarind is recommended for professional use. Several brands of black inks are listed. The color inks are grouped by manufacturer into two separate but complete lists; both are comparable in quality. A selection of fifteen to twenty colors will provide a satisfactory range; and the total series of colors can accommodate the most discriminating color printing.†

BLACK INKS

The black inks are listed in three categories: (1) roll-up ink, (2) printing ink, and (3) transfer ink.

†The inks are listed with the manufacturer's name, stock number, and a short description of their properties. The stock numbers are those of specific regional plants where these inks are produced. Orders placed with branch plants from another region should refer to the locale of the formulation. Manufacturers' addresses are listed in Appendix A.

Roll-up Ink. This ink must be stiff and capable of withstanding the etching treatment when the image is processed. The ink should have a minimum amount of grease to ensure crisp and clean inking during the roll-up. It should also be reasonably nondrying, to protect the work in storage, and yet be easy to wash out when printing is resumed. Roll-up ink is the most important ink in the shop. In addition to its use in processing, it is often employed as a bodying agent in mixtures of printing ink or transfer ink.

Sinclair & Valentine Company
S & V Rolling Up Black LA-72437
S & V Stone Neutral LA-76823

General Printing Ink Company (Los Angeles Branch)
GPI Rolling Up Black SF-63-313
This heavy-bodied ink has a somewhat colder coloration than the Sinclair&Valentine inks. It has a slight tendency to scum, but can be controlled by additions of magnesia.

Charbonnel Ink (Paris, France)
Noir Monter
This is an excellent heavy-bodied ink of short consistency. Because of its soft and somewhat greasy properties, this ink is usually employed for images that require a fatty ink for rolling up.

Graphic Chemical Company (Villa Park, Illinois)
Senefelder Crayon Black Ink M-1803
Rolling Up Black M-1921

Printing Ink. The ink for printing impressions on paper is usually softer than roll-up ink. This permits easy inking of the image and permits good penetration into the printing paper. Sometimes roll-up ink is modified with small amounts of varnish and used as a printing ink. These inks often require minor modification with magnesia to print satisfactorily.

Charbonnel Ink (Paris, France)
Noir Velours No. RSA
This ink is soft and short in consistency. Its warm, sooty coloration and excellent printing properties produce very velvety impressions.

Graphic Chemical & Ink Company (Villa Park, Illinois)
Black Printing Ink M-1796
This ink produces hard, dense blacks of good printability.

Transfer Ink. This ink is composed of various waxy or tallowlike substances which, in addition to providing firmness, also increase greasiness and nondrying properties. Transfer ink must be capable of printing clean impressions on transfer paper without scumming and must contain sufficient fatty acid particles to form a firm impression when transferred on a clean stone or metal plate.

Sinclair & Valentine Company
S & V Stiff Transfer Ink FL-61173
This ink is usually modified with additions of roll-up ink or lithographic varnish to produce varying consistencies for different types of transferring.

Charbonnel Ink
Charbonnel Re-Transfer Ink

WHITE INKS

Handschy Chemical Company (Indianapolis Branch)
Opaque Cover White CS-850
This ink has good light-fastness, heavy body, and excellent covering capacity; it usually does not need modification.
Opaque Cover White W-220-X
This ink has good light-fastness, very stiff and heavy body; because of extra stiffness, it is usually reduced with #3 varnish or reducing oil before use.
Transparent Tint Base W-191-X
This ink has fair light-fastness, which improves in mixtures of other stable colors. Because of long body and high tack, the ink is usually shortened with magnesia.

Sinclair & Valentine Company
S & V Opaque White LA-69622
This ink has good light-fastness, good body, and printability.
S & V Flat Transparent Base LA-68294
Good light-fastness, which improves in mixtures with other stable colors, good body, and printability are characteristic of this ink.

COLOR INKS

Handschy Chemical Company (Indianapolis Branch)
Primrose Yellow (Y-271). A cold opaque yellow with greenish mass tone and undertone. Fair light-fastness.

Chrome Yellow (Y-2716). A heavy, warm, middle-value, opaque yellow with orange undertone. Fair light fastness.

Policy Orange (OE-1347). An opaque, heavy-bodied middle-hue orange. Good to excellent light-fastness.

Standard Orange (CS-200). A semiopaque reddish orange. Good to excellent light-fastness.

Sun Orange (Cr-1349). A semitransparent, brilliant red-orange with yellowish undertone. Useful for transparent-tint overprinting. Good to excellent light-fastness.

Sun Red (R-6706). A warm, intense, semitransparent red, with yellowish undertone. Fair light-fastness.

Fire Red (CS-360). A strong, fiery, semitransparent color with good light-fastness.

Flag Red (R-6710). A semiwarm, intense, and semi-transparent red. Fair light-fastness.

Valentine Red (R-6716). A deep, semiopaque red with bluish undertone. Fair light-fastness. Usually needs some addition of magnesia to control its tendency to scum.

B. Shade Magenta (R-6721). A deep, intense reddish violet with bluish undertone. Fair light-fastness. Usually needs addition of magnesia to control its tendency to scum.

Deep Magenta (P-685). A deep, transparent, reddish violet with reddish undertone. Good light-fastness. Usually needs addition of magnesia to control its tendency to scum.

Reddish Purple (P-686). A deep, intense, bluish violet with blue undertone. Fair light-fastness. Usually needs addition of magnesia to control its tendency to scum.

Ultra Blue (B-7497). A medium-dark, semiopaque blue with warm undertone. Good light-fastness.

Thalo Blue (Red) (CS-420). A very intense, deep, semitransparent blue with warm undertone. Excellent light-fastness. Usually needs some magnesia to control tendency to scum.

Thalo Blue (Green) (CS-400). Similar to above except for cool greenish undertone. Excellent light-fastness. Usually needs some magnesia.

Yellow Shade Green Toner (G-8720). A deep, transparent green with yellowish undertone. Excellent light-fastness. Usually needs addition of magnesia.

Christmas Green (G-4996). A heavy-bodied, opaque olive green. Good light-fastness. This ink tends to liver in the can.

Trophies Brown (BN-3428). A deep, semiopaque brown with cool undertone. Good light-fastness. Usually needs some magnesia.

Chocolate Brown (BN-3429). A deep, semitransparent reddish brown with violet undertone. Useful for transparent-tint overprinting. Good light-fastness.

Pheasant Brown (NB-3432). A middle-value, semitransparent, warm brown with yellowish undertone. Good light-fastness. Usually needs some magnesia.

Leaf Brown (BN-3434). A light-value, semitransparent, yellow brown with yellowish undertone. Excellent light-fastness. Usually needs some magnesia.

Richtone Grey (T-3023). A transparent gray with greenish undertone. Good light-fastness.

Opaque Flat Grey (CS-872). A semiopaque bluish gray with good light-fastness.

Sinclair & Valentine Company

Stone Permanent Yellow (#404 LA-58013). A cool yellow with excellent light-fastness. Has tendency to emulsify rapidly in presence of excess water.

Special Chrome Yellow (LA-71986. Medium-warm yellow. Good light-fastness.

Stone Orange (LA-68958). Medium orange. Good light-fastness.

Stone Permanent Rose Red (#325 LA-67477). Good light-fastness. Addition of magnesia necessary.

Stone Permanent Vermillion Red (LA-60177). Excellent light-fastness. Usually needs some magnesia.

Stone Purple (LA-62549). Excellent light-fastness. Some magnesia necessary.

Stone Monastral Blue G.S. (LA-62626). Good light-fastness. Addition of magnesia sometimes necessary.

Stone Royal Blue (LA-75390). A good, heavy-bodied color, resembling ultramarine blue. Good printability.

Stone Monastral Green (LA-62629). Excellent light-fastness. Usually needs some magnesia.

Stone Permanent Oriental Green (#619 LA-67473). Excellent light-fastness. Warm, brilliant, semitransparent coloration.

Stone Green (LA-69760). Excellent light-fastness.

Stone Permanent Autumn Brown (#803 LA-67474). Good light-fastness. Addition of magnesia and varnish usually necessary.

Stone Silver (LA-67796). Excellent light-fastness. Requires heavy loadings of magnesia because of its loose consistency.

11.12 OFFSHADE COLOR MIXTURES

On request, most ink manufacturers can formulate inks with hues other than those listed in their catalogs. Sometimes one may require a color of such hue or intensity that it cannot be mixed from the colors in the basic palette. At other times an offshade mixture is necessary in large amounts for volume production. It may then be far more economical to have such colors mixed by the manufacturer than to spend the time in laborious hand-mixing. Machine mixtures are usually cleaner and purer than those made by hand. Within this category, such colors as gunmetal gray, olive brown, bister, sanguine, and emerald green can be useful additions to the basic shop hues. There is some question regarding the light-fastness of such mixtures. However, if their formulation is based on the more reliable colors listed in the basic palette, the color chemist can provide a reasonably dependable ink.

Process Colors. The reader will notice that no mention has been made of the process inks used in commercial reproduction. Colors such as process yellow, process

blue, process red, and process black are very intense transparent inks. They are employed in the printing of halftone reproductions and are formulated to give a balanced spectrum range of hue when properly printed over one another.

Because of the complexity of controlling techniques, the four-color printing principle is not an advisable approach for the creative artist. For sucessful results the artist must draw four separate plates with meticulously controlled tonal balances approximating those produced with photographic halftone screens. The tonal range of each plate must coincide exactly in order for the proper percentage of each overprinted color to combine and produce a given nuance of hue, value, and intensity. Since the techniques of control in this procedure are antithetical to the natural processes of drawing, the work produced will usually appear brittle and reproductive.

11.13 MATERIALS FOR INK MIXING

Special materials are necessary for mixing ink, and these are laid out in a certain relationship to facilitate the work.

Ink Slab. Ink is distributed from the ink slab to the printing roller and then to the printing image. The slab should be wide enough to accommodate the widest inking roller comfortably and long enough to permit an arm's-length traverse of the roller. Ink slabs approximately 24 inches square are ideal in size. (The slabs for special large-diameter rollers must be designed to accommodate the distance of travel in one revolution of the roller.) The surface of the slab must be smooth, flat, and strong enough to withstand the impact of ink rolling.

The most commonly used ink slabs are made from marble, slate, heavy plate glass, or discarded lithograph stones. It is important for the inking surface to be elevated several inches above the counter that supports the slab so as to permit easy roller maneuverability. If possible, the slab should be portable, so that it can be moved to other press locations in the shop in case two ink slabs are necessary for the inking of special work. At the same time it should remain firmly anchored once it is positioned; otherwise it will slide about during ink rolling. Figure 11.1 illustrates the construction of a typical ink slab.

Ink Knife. The ink knife is used to remove stiff roll-up ink from the container and to mull it on the ink slab. It is also used for mixing color ink. The best tool for this purpose is a good-quality, semiflexible putty knife with a blade from 2 inches to 2 1/2 inches wide. (Narrower blades make extra work in laying out ink, and wider blades are awkward to use.) At least one such knife should be located at each ink-slab station.

Color-ink Mixing Slab. Color ink should be mixed on a separate surface before distribution onto the inking slab. Distribution will then be smooth and free from the conglomerate of the mixing operation. Glass or white marble, cut 12 inches square and 1/4 inch thick, is excellent for this purpose. One or more mixing slabs should be located at each inking station.

Color-ink Mixing Knife. Color inks are removed from their cans with spatulas having narrow flexible blades. A knife used to remove ink from one can should never be used to remove ink from another without first having been cleaned. Since a number of colors may be used in making one mixture, the presence of an ample supply of clean knives eliminates the need to stop and clean a knife each time a new color is added. Needless to say, the knives must be thoroughly cleaned with solvent after the ink-mixing operation is completed. Color-ink knives are usually positioned upright in a can in the immediate vicinity of the ink-mixing station.

Tap-out Papers. The salvage from torn proofing and printing papers is ideal for making color tap-outs of trial ink mixtures. The scraps are usually torn into rectangles approximately 4 by 6 inches and stored near the ink-mixing area.

Clean-up Materials. All the materials of the ink-mixing operation are thoroughly cleaned after the job has been printed. The inking and mixing slabs are first scraped of surface ink with the ink knife. Kerosene solvent and heavy rags are then used to wash down the slabs, mixing knives, and ink knives. Usually, the color-ink roller is washed with kerosene at the same time. It is important for all surfaces to be cleaned immediately after use; otherwise the dried ink is extremely difficult to remove. The best rags for this purpose are industrial towels or mechanics' cloths.

11.14 INK PREPARATION AND COLOR MATCHING

Black ink is placed on the upper right-hand corner of the ink slab. There it is worked vigorously with the ink knife. The ink pile is scraped up, turned over, and squashed, with rapid and repeated motions. These are interspersed with agitated up-and-down patting motions. Within a short time the ink will become smoother and somewhat thinner. When it is quite smooth and free of lumps, it is ready for distribution on the ink slab.

The ink is distributed as evenly as possible in a series

of overlapped ribbons, each the width of the ink knife. The knife, carrying a generous load of ink, is held perpendicularly and dragged firmly across the full width of the slab at midpoint. It is then turned over and used as a shovel to scrape up the excess-ink bead left on each side of the ribbonlike swath. After the bead is scraped up, a second swath is laid down, slightly overlapping the first, and the surplus beads of ink are again scraped up from each side of the swath. From four to six ribbons of ink are sufficient to charge the slab initially.

It is important for the ink ribbons to be relatively thin and smooth, or the ink roller will become unevenly charged and require prolonged rolling to equalize ink distribution on its surface and on the slab. The inking of the image can proceed when the ink is evenly distributed on the ink slab and the roller. When the ink becomes exhausted on the slab, it is replenished from the stock mixture in the upper corner. Care should be taken that this mixture be well out of the way of the roller traverse when inking commences.

Ink replenishment will depend on the nature of the work; it is usually determined by the number of full ribbons laid out for a given number of printed impressions—for example, one ink ribbon for every five impressions or three ink ribbons for every two impressions, etc. Every time fresh ink is set out, it must be evenly distributed throughout the existing ink on the slab. Periodically the ink pile is reworked before distribution in order to maintain its smooth consistency.

The printer must determine by experience the quantity of ink to be prepared for a given job. Works that are only to be processed require very little ink, whereas the printing of large editions requires considerably more. This is no problem if the black ink is unmodified; one simply returns to the can and prepares another batch. To simplify matters, proof printing is usually done with small amounts of unmodified ink. If ink modification is indicated, additional proofs are printed until the desired ink properties are present. After that time, a volume of ink matching these properties is mixed in sufficient quantity to print the edition.

When the work is completed, the excess ink is scraped from the ink slab with the knife and discarded. The remainder of the original mix may be returned to the ink can, provided it is reasonably free of dust and contamination. The slab and ink knife are washed and wiped clean with kerosene, and all materials are returned to their proper location.

COLOR MIXING

In principle, mixing color inks is not greatly different from mixing paints. The printer should have a reasonable familiarity with the basic range of colors in his shop, since these differ in pigmentation, intensity, and transparency from the usual artist's paints. Color mixtures that are general in character will not be too difficult. More specific mixtures that must match a color sample exactly require much more skill and experience. The most practical procedure for the beginner is to mix small amounts of the inks he has on hand in as many different combinations as possible. Tap-outs of these mixtures on white paper will familiarize him in a general way with what the inks will do. Identification of those inks which are warm or cool, transparent or opaque, and subdued or intense will quickly follow. Further, he will perceive how these properties are affected by varying the proportions of the same colors within the mixture.

Because color matching depends on visual factors, it is essential to set up working procedures from which efficient and accurate observations of color can take place. Mixing techniques and equipment should be as clean as possible. Small amounts of the inks to be mixed are distributed around the mixing slab with clean ink-mixing knives. Small proportions of the inks are thoroughly mixed with the ink knife and tapped out on a scrap of white paper. Tapping is accomplished by lightly dipping the forefinger in the mix and tapping the ink charge onto the paper. The density of the ink film transferred to the paper should approximate the density that would be transferred from a printing image. Generally the maximum concentration of the tap-out is at its center, with less ink transferred to the outer edges. This produces variations of hue, value, and chroma comparable to the variations that occur in printing images having tonal differences. Corrective adjustments of the color mixture can be more easily made after examining the tap-out. When the trial mixture is approved, a larger volume of ink may be prepared using similar proportions of this color.

The printer should make certain that sufficient ink is prepared to complete the entire printing. It is usually very difficult and time-consuming to duplicate the exact proportions of ingredients in any given mixture of ink.

Colors requiring up to 50 per cent transparency should be mixed and tested by tapping out before the appropriate amount of transparent white ink is added to them. Colors requiring more than 50 per cent transparency are mixed by using the transparent white as the base color and adding minute amounts of the other colors until the desired result is achieved. Surprisingly small amounts of colored ink can dramatically alter transparent white. If too much color is added, correspondingly greater quan-

tities of transparent white are necessary to provide the desired transparency. This yields more ink than necessary for the job and is wasteful. Because transparent extenders have no coloring properties, they will pick up any traces of dirt, dust, or color stain from the ink slab, the color roller, or the printing surface. Clean and delicate colors, therefore, must be mixed with immaculate equipment.

Lithographic ink is considerably more intense than paint. A corresponding reduction of chroma in the ink mix may be necessary to meet the needs of an artist, whose standards of color purity are usually different from those of the commercial printer. Clean hues are obtained by combining hues adjacent on the color spectrum. A lemon yellow, for example, can be made warmer by adding chrome yellow. This results in a purer hue than would occur by adding red or orange. A warm red is made colder by adding one of the related bluer reds rather than a blue. The neutralizing of chroma by addition of hues that are nearly complementary will produce cleaner colors than using mixtures of black and opaque white.

When the desired volume of ink has been mixed, the pile is worked over with the ink knife (as with black ink) and checked for consistency. The proper modifiers, such as varnish, reducing oil, and magnesium carbonate are added and thoroughly mixed with the ink. The ink is then carried from the mixing slab for distribution on the ink slab in ribbons similar to those described for black ink. If the printing is carried over to the next day, the surplus ink mixture is saved by being placed on a scrap of clean proofing paper. Ink mixtures that are to be stored for longer periods may be wrapped in aluminum foil or placed in clean, empty ink cans purchased from the ink supplier.

The lids of all ink cans should be replaced after the final ink mixture has been made. This minimizes contamination from dust and air. Mixing knives and ink slabs are cleaned with kerosene and rags. Kerosene is more efficient and considerably more economical than lithotine for this purpose.

Cleaning ink slabs during progressive proofing requires additional steps. The greasy residue of kerosene on the ink slab and color roller will ruin the next ink mixture unless it is completely removed. The easiest method is to dust both ink slab and roller with talc, which absorbs the oily film remaining from the kerosene and dries the surfaces. The talc is wiped off with a clean, dry cloth, after which fresh ink can be immediately distributed.

CRITICAL COLOR MATCHING

Preparing ink mixtures to match color sketches or color samples requires a precise technique. All surrounding colors in the sketch or color sample must be masked out so as not to interfere during comparisons with the ink mixture. Ideally the entire sketch or color sample should be masked with opaque white paper. A small circle approximately 3/4 inch in diameter is cut out of the mask, exposing the hue to be matched. In this way very accurate comparisons with the ink mixture can be made without visual interference from the adjacent hues in the original example. Comparison of hue, value, and intensity become easy to assess because both the original and the tap-out are surrounded by white paper.

It is imperative for the color tap-out to approximate the density of a printed film of ink. This is especially critical for pale or extremely transparent tints. Excessive density in the tap-out will give a false impression of the color effect. When the work is printed it has a totally different appearance from what was anticipated. Beginners often misinterpret this error and look for the fault in the printing image. In an effort to compensate, they overink, underink, or alter the image, without realizing that the fault is essentially in mixing technique.

In the final analysis, color mixing and color matching can be refined only through practice and experience. Nothing is more deceiving to the untrained eye than to witness an ink mixture that appears different on the ink slab, the ink roller, the printing image, and, finally, the printed impression. As the problems of color matching are observed, the virtue of sound techniques quickly becomes apparent.

11.15 SPECIAL INK PROBLEMS

Although some of the ink problems that beset stone and metal-plate printing and their remedies have been discussed in Part One (see sec. 4.12.), the following ink problems need special attention:

Waterlogged Ink. During the process of printing, a certain amount of moisture is lifted from the printing surface by the roller and becomes distributed on the ink slab in the form of microscopic droplets. Eventually the droplets become entrapped in the ink and form a *water-in-ink* type of emulsion. In this condition, the ink becomes short in consistency; it loses its tackiness, and, when the condition is pronounced, becomes difficult to distribute. The ink is described as being *waterlogged*, and its properties resemble those of inks suffering from pigment flocculation.

Waterlogged inks dry very slowly on the print paper, and their dried films form poor bonds with the paper fibers. To remedy, (1) scrape the ink roller and slab, (2) lay out fresh ink, and (3) maintain a better balance be-

tween ink and water distribution on the printing element.

Tinted Ink Scum. Occasionally an ink, particularly of the soft-pigment variety, will produce a tinted scum over the entire surface of the image. The scum is usually loosely affixed and can easily be removed with antitint solution or fountain solution, although it immediately reappears when the image is inked again.

The condition results from minute ink particles separating and becoming emulsified in the dampening film. This is an *ink-in-water* emulsification and is the opposite of the type responsible for waterlogged inks. Although authorities disagree about the exact cause of this problem, a number of remedies have been used successfully to overcome it. These should be undertaken in the following order:

1. Reduce the amount of surface moisture on the printing element. Theoretically, the less the moisture, the less the opportunity for emulsification.

2. Regum the image in order to provide an even sounder foothold for the moisture film.

3. Reformulate the ink mixture into a stiffer and shorter consistency by using a stiffer varnish along with a small amount of magnesium carbonate.

4. If the above procedures do not solve the problem, the ink should be discarded and a different combination of inks should be used to make a fresh mixture.

Chalking of Ink. Ink films that can be rubbed off the print paper after drying are said to have *chalked*. This problem is produced by ink mixtures that have insufficient binding vehicle. Since most inks are manufactured with a balanced content of pigment and vehicle, the problem usually occurs when large proportions of modifying agents introduced by the printer destroy this balance.

Unusually large proportions of magnesium carbonate (unless balanced with small additions of varnish) can produce chalked ink films. Even when used in small amounts, this particular modifier must be mixed thoroughly with the ink because of its highly oil-absorbent properties.

11.16 BRONZING AND METALLIC LEAFING

Bronzing, gold-leafing, and printing with metallic inks are processes generally associated with the commercial printing industry; they are mentioned here briefly because of recent interest in their application to hand lithography.

Tremendous improvements in the performance and appearance of metallic inks have been made in recent years. Today inks with considerable brilliance are available. The hand printer should realize, however, that maximum luster can be achieved only by printing on smooth papers. The soft, absorbent, and somewhat toothy handmade papers diminish the reflective properties of these inks. In addition to using commercially available metallic inks, the printer can mix his own. Very finely ground metallic powders can be combined with regular lithographic inks to produce unusual metallic hues that cannot be duplicated in any other way.

Metallic inks, because of their bronze or aluminum pigments, are fairly opaque. Their films seal the pores of the paper in printing and form smooth and hard surfaces. Silver ink (because of its opacity) is sometimes employed when printing white or an extremely light color over a darker color. The silver is printed first, thus hiding the darker color, and the same image is printed over it with the lighter color. Such printings produce a heavy clean color body.

Identical methods are used for hand-bronzing and metallic leafing. First, a ground color with a viscous vehicle (#5 lithographic varnish) is printed. The traditional ground color for silver or aluminum is gray or black. Earth red, ocher, and yellow are the usual ground colors for bronze or gold printing; other colors can be used provided their appearance through or around the edges of the work is attractive. Before drying, the tacky ink of the ground color is dusted with a tuft of cotton carrying the bronze powder. If desired, gold or silver leaf may be applied to the ground color instead of bronze powder. Metallic leafing adds much more luster than can be achieved by bronzing. After drying for several days, the individual prints are gently dusted with a clean tuft of cotton to remove bronze powder or leaf from all areas unattached to the ground color. The success of this process requires that all previously printed colors be dry; otherwise the powder or leaf sticks to these areas as well.

When dry, some types of bronzing powders can be hand-polished with a bone burnisher for added luster; often a final overprint varnish is printed over bronzed or leafed areas to protect them from scuffing and tarnishing.

11.17 INK INVENTORIES AND STORAGE PROCEDURES

Total quantities of ink to be stocked for on-hand inventories will depend on the particular workshop and its estimated production rate. The following table shows the quantities of ink used at Tamarind during two separate years of its operation.

	July 1960- June 1961	July 1966- June 1967
Color	Quantity in pounds	Quantity in pounds
Yellows	5	40
Reds and Oranges	4	37
Blues	3	21
Browns	3	15
Greens	2	10
Cover White	9	107
Transparent White	12	60
Blacks	9	75
Number of editions printed	200 approx.	370 approx.
Impressions per edition	35 average	35 average

The difference between these two periods reflects increased printing of color editions by a larger staff of printers, as well as a marked acceleration of training and research programs. As a consequence, greater waste of ink undoubtedly resulted.

Other differences are evident from comparisons of production ratios of school shops with those of professional shops. Although the number of impressions in student editions is usually smaller, a greater number of participants are involved and ink waste is considerably higher. In all cases, very accurate forecasting can be achieved by maintaining a regulated inventory-checking system. Depleted stocks should be reordered at scheduled intervals to prevent delays in production caused by a shortage of ink.

Inks for hand printing are generally purchased in 1-pound cans for easy handling and storage. Colors that are more rapidly consumed, such as cover white or transparent white, may be ordered in 4-pound cans if desired.

Substantial expenditures are required to maintain an adequate supply of ink. The prudent printer will protect his investment by sound handling procedures, for drying begins as soon as the protective seal is broken on a can of ink. Depending on the type of pigment, some inks will skin rapidly and others not at all. Skinning can be controlled by maintaining an even level of ink within the can. The ink should never be dug or gouged from the container; instead, it should be gathered along the edge of the ink knife as the blade is slowly revolved. Ink skin can be removed easily from level surfaces; removal from gouged surfaces leaves broken particles of skin that inevitably mix with and contaminate the remaining fresh ink. Inks in this condition are unfit for fine printing, and the entire can must be discarded.

Additional methods can be employed to control ink skinning. Greasing the collar of the can and the lip of the lid with Vaseline will retard the skinning process and at the same time facilitate easy opening and closing of the can. A disk of oiled or waxed paper placed over the leveled ink is also recommended. Protective films of lithographic varnish or water should never be used in ink cans to prevent skinning. The presence of either liquid is damaging to the ink consistency as well as to its chemical properties. Water rusts the interior of the can and releases metallic oxides that are harmful to the drying behavior of the ink and can also damage the consistency. Previously described pressurized antiskinning agents are safer and more efficient for this purpose than either varnish or water.

Color rub-outs for each can of ink are a helpful means of color identification. These are placed on a sheet of white paper about 1 1/2 by 2 inches and affixed to the back of each can with transparent tape covering and protecting the entire swatch. The cans of ink are placed on the ink shelves with the swatch facing outward for ease of identification.

Paper for Lithography

12.1 PAPER FOR LITHOGRAPHY

Paper is the supporting ground upon which most prints rest. It has more than just a passive function in the total lithographic process. Its presence as part of the finished work is always more explicit than are the supporting grounds in painting. In consequence, the relationship between paper and printed image is of great importance to the lithographer, for the final print is judged in terms of the entire sheet and not simply by the impression printed on it.

Three primary factors must be considered in the selection of papers for fine prints. First, the sheet must have excellent printability so as to record a faultless impression from the printing surface. Second, its surface, color, or over-all character should complement and further enhance the aesthetic qualities of the image printed upon it. Third, it must be as permanent as possible, in keeping with high standards for preservation as works of art.

Although the above criteria may appear fairly obvious, they have particular relevance because of the planographic printing principle of the medium. To meet these criteria papers must have special properties, which will be discussed later. (See sec. 12.9.)

Despite the tremendous array of paper products and the wealth of technical information available on the subject of paper, very little authoritative information exists regarding appropriateness, proper usage, or present-day availability of paper for lithographic hand printing.* In view of the important role that paper plays in the making of a fine lithograph, this lack has been a serious handicap to the advancement of the medium.

The novice, assuming that most papers have similar properties, attempts to print his work either on whatever is inexpensive and easily obtainable or, if he is somewhat more knowledgeable, on the few traditional papers that have been popularly associated with the medium. With inferior papers, he will seldom attain the ultimate print quality that is potentially possible from his image. Further, he may endanger printing stability by overloading the image with ink in order to print acceptably on paper that is altogether unsuitable to the process. With traditional papers, although he may obtain acceptable impressions, he may also fail to achieve expressive possibilities of his image that could be obtained through a more discriminating selection of paper. Both kinds of failure reflect limited understanding of the subject and have occurred frequently in American printmaking.

Systematic research on the subject of paper as it relates to lithography has been undertaken at Tamarind. During the course of Tamarind's existence, the basic properties of many types of paper have been studied. Numerous tests have been made, and the behavioral characteristics of paper for particular types of lithographic printing have been recorded. Paper-handling procedures have been examined and refined. Discussions with paper manufacturers concerning the upgrading of existing papers and the development of new ones have taken place. Meanwhile, there is a continuing effort to locate and determine the availability of little-known papers which might offer additional breadth to the medium.

12.2 THE EVOLUTION OF THE PAPERMAKING INDUSTRY†

Authorities trace the beginnings of papermaking in

*Although not definitive in its discussion of fine paper, E. J. Labarre's *Dictionary of Paper and Papermaking* (Amsterdam, 1947) identifies the various types of paper products and provides useful, basic information about them.

†A standard reference is Dard Hunter, *Papermaking: The History and Techniques of an Ancient Craft* (New York, Alfred Knopf, 2nd ed. 1957).

Egypt to about 2000 B.C., at which time writing material was made from the papyrus, a reedlike plant of the bullrush family, from which our term *paper* is derived. The plant stems were cut into fine threadlike strips which were laid side by side with another layer crossing at right angles. The layers were glued together by the muddy waters of the Nile or with a wheat-flour paste. The formed sheets were then hammered or rolled flat and dried in the sun. Papyrus was the universal writing material in the world for about 2000 years. Gradually during the Middle Ages parchment and vellum made from animal skins replaced papyrus as a base for permanent records and scholarly writings.

Modern papermaking was born in China about 200 B.C., where the fibers of native plants such as bamboo, cotton, and the bark of the mulberry tree were used. The process in the Orient was first carried to Korea and then to Japan. The Arabs were responsible for carrying the techniques to Europe after the conquest of Samarkand in A.D. 712. By the twelfth century this knowledge had reached Spain, whence it passed to Italy, France, and Germany. Papermaking started in England about 1500 and in the Netherlands about 1600. It is recorded that a paper mill was established in North America as early as 1690, in the vicinity of Philadelphia.

Today the manufacture of printing paper, a worldwide industry, embraces numerous production methods and products designed to meet the requirements of the many printing professions. Although most paper today is manufactured by complex machinery, a certain amount of paper is still hand-formed in Europe and Asia. Thus, we speak of machine-made and handmade papers, both of which play a part in hand printing. By varying basic raw materials or manufacturing procedures, papers having many different properties of surface appearance, weight, strength, durability, and sheet size can be produced. Different combinations of these properties result in paper types suited to one or another of the commercial or artistic printing processes. Handmade papers from Europe differ considerably in appearance and working properties from those made in Japan, China, and India; all handmade papers are greatly different from those made by machine either in this country or abroad.

The ever-increasing use of printed matter in the world has so revolutionized the products and production methods of papermaking that today's industry and its products have little in common with earlier papermaking methods. Although a respectable quantity of paper is still produced by hand in Europe and Asia, the commercial production of handmade paper in the United States ceased long ago. The many varieties of handmade paper for the nineteenth- and early twentieth-century lithographer are no longer available. Today the variety of acceptable papers is extremely limited, despite a ready demand created by the resurgence of printmaking in general. At least part of the reason for this limitation lies in the gradual decline of the hand-papermaking craft during the past one hundred years.

Beginning with the period of the Industrial Revolution and the introduction of papermaking by machine, the products of hand-papermaking simply could not compete in a mass market that depended on high production volume and low costs. Demands for the development of numerous kinds of paper suitable to new printing processes, together with the need to increase production and lower costs, contributed to the obsolescence of the old craft. Unable to compete, many mills were forced either to discontinue production or, more often, to convert their resources to machine processes. Only the larger manufacturers survived, some of whom devoted a small fraction of their new operation to the continued production of handmade papers. These papers were generally sold to a limited and discriminating market of printers who were willing to pay a considerable premium for paper having unique or superior qualities. Basically the same situation exists today. Handmade papers command very high prices and are used mostly by artists for drawing or by printers who specialize in fine limited-edition printing.

Other recent developments have affected the making of paper by hand. The basic raw materials of European handmade papers have always been cotton and flax, either in pure substance or in the form of rags. Neither, in a world clothed in synthetic fabrics, is so plentiful as it once was. Shortages, restrictive priorities, and high tariffs on these raw materials have often forced the adulteration of traditional formulas with mixtures of less desirable products, in order to continue production and keep prices down. This in turn has gradually resulted in the production of inferior paper. Additionally, the making of fine paper by hand is a highly skilled craft requiring long years of experience. Although many of the older generation of craftsmen have found jobs in the newly mechanized paper mills, relatively few new workers have been attracted to the profession of making paper by hand. The craft does not have a promising potential as a vocation for youth.

Faced with a dwindling labor force, limited production, and raw materials both costly and hard to obtain, the handmade-paper mills are one by one closing down. Only a few of the largest remain in Europe, and their productive quality seems as uneven as their future is uncertain. Their future survival is a matter of conjecture;

their loss would be deeply felt by all persons who use fine paper.

12.3 THE MATERIALS AND MANUFACTURE OF MACHINE-MADE PAPER

Most of the paper produced in the world today is made from plant fiber. Although papers can be made from the cellulose fibers of any plant, only those fibers which can be easily and cheaply processed are used for commercial manufacture.

Until about 1880 paper was most often made from cotton and linen rags. These materials impart strength and durability and are still used in varying proportions to form the best machine-made papers. The use of groundwood pulp began gradually to replace rag stuffs as the basic substance of papers, and today more than two-thirds of all paper is made from wood pulp. Other substances such as hemp, jute, straw, cornstalks, the waste from sugar cane, and, lately, synthetic fibers are commonly used in the making of commercial papers. Approximately one-fourth of all new paper is made from reprocessed waste paper.

The fundamental steps in forming paper are: (1) to separate the cellulose fiber from the raw material, (2) to make a watery pulp of the fiber, (3) to beat the pulp until the separate fibers have reached a necessary fineness and have been thoroughly mixed with certain other materials which go into the stock to impart special properties, (4) to form a web of paper on a fine sieve that lets the water run through but holds the solids in a thin, even layer on top, and (5) to dry, smooth, and finish the paper web in various ways.

Linen and cotton rags, being nearly pure cellulose, are carefully sorted, cut into small pieces, and cooked with caustic soda and lime to make pulp. After washing and bleaching with chloride of lime and sulphuric acid, they are ready for the beaters.

The processing of wood fibers is more complicated because they are only about 50 per cent cellulose. Four major types of wood pulp can be produced in varying combinations. The first is *groundwood pulp*, with all the impurities left in it. Newsprint paper is approximately 75 per cent groundwood. The second is *sulphite pulp*, so named because the wood chips are treated under pressure with the fumes of bisulphite of lime. This treatment removes gums and resins from spruce and fir or other woods and purifies the cellulose. Most book papers are made from sulphite pulp. The third is humus or *soda pulp*, so called because the chips are boiled under pressure with caustic soda. Soda pulps are often composed of poplar or cottonwood fibers, which produce soft, bulky

mixtures that are used to impart mellowness to some book papers. The fourth is called *sulphate pulp*, so called because sodium sulphate, along with other chemicals, is used in its production. It produces strong, dark fibers and is used for kraft and wrapping papers.

The composition of paper is determined in the beater machine; varying proportions of different pulps are mixed with other materials and subjected to a macerating process. The beating machine consists of a giant tub in which a wheel covered with knives turns against a large iron bed plate, also covered with knives. The beating process shreds and roughens the fibers, fraying the ends so that they interlock tightly during the forming operation. Part of the fibers react with water to produce a gelatinous material called *hydrocellulose*, which acts as a glue to bind them together when the paper is formed. The formation of hydrocellulose is called *hydration*. The longer the pulp is beaten, the more it becomes hydrated. Highly hydrated pulps have greater strength but less dimensional stability than those of weak hydration. The significance is twofold: papers that are dimensionally unstable expand and contract in accordance with the presence or absence of moisture in the air or in the printing process. They present problems in registering color work and often do not stay flat after printing. Papers with little or no hydration, although dimensionally stable, have little internal strength. Blotting paper is an example. Relatively speaking, dimensional stability is of greater importance than internal strength in papers for hand printing.

Additive materials such as colorants, fillers, and size are introduced into the pulp during the beating process. These enhance appearance, strength, and ink receptivity when the paper is completed. By varying the composition of these materials and using different combinations of pulp the manufacturer modifies the character of the paper, its color, finish, and printability. For example, fillers such as clay, chalk, gypsum, or titanium dioxide can impart differing degrees of opacity, brightness, or surface smoothness to the finished paper. Pigment or dye colorants are used even in white papers, to create delicate shadings from warm to cool whites; they are used as well to create a full spectrum of other colors. Size, in the form of rosin or synthetic resins, acts as a further binder for the fibers and can reduce or increase the degree of ink absorbency of the paper. Commercial offset-printing papers are usually surface-sized; this enables the inner substance of the paper to retain pliability and the outer surface to stay firm and resist picking.

After the pulp fibers and additives have been hydrated sufficiently in the beater, they are passed in a broad,

continuous stream into the papermaking machine, called the Fourdrinier (named after Henry and Sealy Fourdrinier, who in 1840 perfected Louis Robert's invention of 1799). The wet pulp is first led along a continuous vibrating band of wire screen, which permits a large amount of water to fall through and leaves a film of interlocked fibers on top. In this unformed state the pulp is passed onto a thick soft blanket which delivers it between pressing rolls that squeeze out more water. The paper then passes between heated drying cylinders and calendering rolls that give it a smooth surface. Finally, the continuous roll of paper is wound on a reel at the end of the machine, ready for cutting and stacking.

During this process, when the wire cloth receives the pulp, the surface pattern and watermark of the paper are formed. (See sec. 12.4.) The wove or laid patterns of handmade paper may thereby be simulated or other surface textures may be impressed into the pulp by wire-gauze skeleton cylinders called *dandy rolls*, which have the pattern worked in relief on their surfaces. One can distinguish machine-made papers from handmade papers most easily by the appearance of the watermark. The compression of fibers renders the paper denser around the watermark, and when the sheet is held up to the light, the watermark will appear darker than its surroundings. The reverse is true of handmade papers, where watermark and wire lines from the paper-forming displace the pulp fiber; these show lighter than the surrounding areas of the sheet. (See sec. 12.4.)

Another process for dressing up machine-made paper is the formation of a deckle along the edge of the sheet to simulate the naturally formed edges of handmade paper. A feathery deckle is produced by jets of water cutting the edges of pulp as it moves along the web of the paper-making machine. Since the pulp is moving in a continuous stream, only two edges can be deckled. Such papers can be differentiated from those made by hand, which have deckles on four sides. Sometimes machine-made papers are deckled by ripping the sheets after they have been formed; these can be identified by a characteristic mechanical hardness of edge.

Heavier-weight papers and paperboards are made on a cylinder machine. Rather than have the pulp flow onto the wire of the Fourdrinier, a cylindrical sieve revolves in the vat of pulp. This sieve may consist of several cylinders which form webs to be pressed together into a single heavy paper or board. Paper laminations of this type are often called *mould-made*, although confusion with the term as it is applied to handmade papers should be avoided. Laminated papers seldom have the smoothness necessary for hand printing.

Many types of paper are given additional treatment after leaving the papermaking machine. Supercalendered paper is given an extra-smooth finish by being passed through a series of metal and fiber rollers. Coated papers receive surface preparations of china clay, casein, glue, or synthetic resins to give them extremely smooth and glossy surfaces.

The fibers that form machine-made paper have length but little breadth. Although the web is given a side-to-side vibrating motion to cross and interlock the fibers, interweaving is limited because the fibers flow along the surface of the wire cloth in line with the flow of water. As a result the fibers lie mostly in the direction of flow, referred to as the *grain* of the paper. Papers tear more easily in this direction, and, since the fibers are loosely woven from side to side, the paper is dimensionally unstable along the grain. In atmospheric change, it is susceptible to buckling and expansion across the direction of the grain. Grain direction can be determined by moistening one side of the finished paper or by floating it in water. The paper will curl toward the dry side, and the axis of the curl will always be parallel to the direction of the grain.

It is important for the printer to know the grain direction and expansion characteristics of whatever machine-made paper he may employ. This is particularly necessary when a large-size sheet is being torn. In order to minimize paper stretch when the job is run, each piece must be torn from the larger sheet in the same way, so that grain direction will be consistent.

12.4 THE MANUFACTURE OF EUROPEAN HANDMADE PAPER

The materials of the best European papers are linen and cotton fibers and, occasionally, fibers of the esparto plant, a type of grass prevalent in southern Europe and North Africa. As with machine-made papers, the raw materials are sorted, cut into small pieces, bleached, and then macerated in the beater. Before the 1800s, beating was laboriously done by hand, using paddles or pestles in mortars or vats. The pulp was vigorously pounded and sometimes trod until sufficiently hydrated. This system of beating the pulp is still practiced in the Orient.

The period of time necessary to macerate the pulp varies depending on the nature of the materials and the length of fibers desired. For example, new linen and cotton stuffs require longer beater action than old rag stock, and, by adjusting the settings on the beater machine, the modern papermaker can chop the pulp fibers

into shorter or longer lengths. Coloring matter for toning the paper is added during the beating process. Pulp adulterants may also be added to the slurry in order to reduce costs in cheaper grades of paper. Some of the pulp is run into a reservoir beside which the paperworker stands. Each sheet of paper is formed separately in a wooden tray, called a *mould*, of appropriate sheet size. The mould is composed of a grid of very fine wires and contains within it a slightly smaller thin frame, which is removable. This is the *deckle*, from which the edges of the formed sheet are named.

When the mould is dipped into the pulp reservoir and lifted, the water in the mixture drains through the wires, leaving a thin layer of pulp deposited on its surface. The mould is given a brisk two-directional shake which controls the thickness and uniformity of the sheet and also serves to interlock the pulp fibers thoroughly in many directions. The thoroughness of this interlocking gives handmade papers the characteristic of being stronger and more dimensionally stable than their machine-made counterparts.

The skill of the papermaker can be appreciated when one considers the large sizes of some sheets of handmade paper. The weight of the mould containing a layer of wet pulp is considerable. Each sheet must be shaken in one skillful motion to ensure uniformity of thickness within the sheet; the process must be repeated again and again in precisely the same way. Obviously, mechanical uniformity of sheet thickness is impossible in hand forming, although it is surprising how critically tolerances are controlled. The slight variations in hand-formed paper, of course, add to its intrinsic charm, for each sheet is unique in a way that machine-made paper can never be.

After the deckle frame is removed from the mould, releasing the pulp from its perimeter, it is turned upside down to deposit the formed sheet upon a heavy felt. Another felt is then placed over it. This operation, called *couching*, is repeated until a pile, or *post*, of pulp sheets and alternating felts has accumulated. The pile is then placed in a press and squeezed to remove water from the pulp. The sheets of paper are stripped from the felts and are usually placed upon a drying loft. This is a large rectangular frame covered with a netting material which allows both sides of the paper to dry evenly.

Paper in this condition contains no sizing material and is sometimes referred to as *waterleaf*. Upon drying, it may be passed through a weak bath of animal glue (*tub-sized*). Papers sized once are *soft-sized*, and those passed through twice are *hard-sized*. Soft-sized papers are the most suitable for lithographic printing. After sizing, the paper is lightly pressed in blankets and stored in an airing room, after which its surface may be further finished. Surface finishing (*hot-pressing*) consists in passing alternate sheets of paper and thin zinc plates between heated rollers under great pressure. This smooths and glazes the paper surface. Cold-pressed papers are subjected to the same treatment except for the heat; these too are smooth but somewhat less glazed. Neither process produces ideal paper for lithography because the pressing compacts the fibers of the paper and tends to render them less ink-absorbent. This condition can be overcome in some degree by dampening before printing.

The configuration of the wire grid in the paper mould determines whether the paper is to be of the wove or laid variety. When the wires are very closely spaced and diagonally woven across the mould in both directions, they produce *wove paper*. The two sides of a sheet of paper are sometimes referred to as the *wire side* (the side of the pulp as it lies against the wire mesh in the paper mould) and the *felt side*. The pulp is slightly displaced and more open as it lies against the wire mesh; it is smoother and more dense on its upper surface. For this reason the preferable side from which to print is usually the felt side of the sheet. The determination of wire and felt side of the paper is, perhaps, more important for machine-made than for handmade papers. Either side of handmade paper will probably print well, although there will be some slight difference in the character of print quality.

The moulds for *laid paper* have one set of wires about 2 inches apart running along the short side of the frame. These are called the *chain lines*. Another set of wires crossing these at right angles and spaced from sixteen to forty wires per inch are called the *laid lines*. The earliest handmade papers were of the laid variety, following Oriental tradition, and it was not until the middle of the eighteenth century that J. Whatman, the English papermaker, introduced the manufacture of wove paper to Europe.

Laid papers are sometimes considered more interesting in texture and appearance than wove papers, and, indeed, a number of nineteenth-century lithographs were printed on this type of paper. Although some of these prints have great subtlety, in most instances the unevenness of surface due to linear patterning interferes with lithographic printing. The wove variety of paper, having a smoother surface, receives the inked impression more uniformly. This is of considerable advantage when delicate continuous tones are printed. Laid papers are best employed if the work is broad and open or linear in character and if the particular beauty of the paper or its antique connotation contributes to the expressive qualities of the work and offsets the slight loss of tonal qualities.

Watermarks are usually woven or soldered into the wires of the paper mould, and their designs or letters will appear as light configurations when one looks through the finished sheet. The watermark wires displace the pulp when the paper is formed, leaving it thinner in the pattern of the design. As mentioned before, this is the reverse of the condition produced by watermarks on machine-made papers. The side from which the watermark can be properly viewed is considered to be the right, or *felt,* side of the sheet.

A good deal has been written about watermarks from the historical point of view as well as with respect to the romantic charm of their designs. They serve to identify paper types, mill names, and regions in which the paper is produced. In addition, their presence in present-day papers, through association, links these with the great papers of the past. The watermark, as such, represents a hallmark of quality. By appearing on watermarked paper, prints thus convey the air of special and precious items. It should be remembered, however, that poor prints placed on fine papers, although having good impression quality, are not improved as works of art. Moreover, poor-quality papers do not improve simply by being watermarked, particularly not machine-made papers that are intended to simulate handmade papers. The resemblance in appearance and printability is no more than superficial.

Usually watermarks are discreet and very beautiful in size, design, or positioning in the sheet. Occasionally, however, one sees papers with gross and pretentious watermarks which not only deface the sheet but, because of their position, interfere with the printing and show through the image, destroying its continuity. Papers of this type should be avoided.

12.5 MOULD-MADE PAPER

Papermaking by the mould machine was introduced at the turn of the twentieth century in order to increase the productive capacity of the European handmade paper industry. The process permits the formation of individual sheets of paper having four sides deckled as compared to the two-sided deckle of paper formed on the Fourdrinier machine. The better grades of mould-made paper very closely resemble handmade papers. They are usually composed of similar high-grade pulps, and their production techniques are rigidly controlled to produce only papers of superior quality. Except to the trained eye, the difference between handmade and mould-made papers is difficult to perceive. Generally the mould-made papers are slightly stronger in the direction of their grain and somewhat more regular in their surface appearance as well as in the character of their deckle.

Today, the great majority of European papers best suited for hand lithography are mould-made. These include such varieties as Rives BFK, Arches Cover, German Copperplate, and German Etching Paper.

The papermaking apparatus is called a *cylinder mould* or cylinder-and-vat machine. Basically it consists of a large cylinder composed of brass ribs which support a coarse-laid covering. This in turn supports a removable outer covering on which the watermark designs are fastened. The outer edges of the cylinder are covered with a waxed waterproof cloth on which the paper pulp cannot form. Thin strips of waterproof cloth or tissuelike threads are drawn between the end cloths at regulated intervals around the cylinder. The exposed face of the cylinder between these boundaries determines the dimension of each sheet of paper.

By rotating in the vat, the cylinder gathers the pulp on its outer surface between the cloth boundaries. The individually separated pulps that are formed are next transferred to a felt web and subsequently must be removed by hand for piling in the hydraulic press to squeeze out the remainder of water. The drying and sizing procedures of mould-made papers from this point onward are identical with those of handmade paper.

12.6 THE PAPERMAKING INDUSTRY IN THE ORIENT

Social and economic pressures have had less effect on the evolution of papermaking in the Orient than in Europe. Even though machine-made paper was introduced into the Orient at the turn of the century, the making of paper by hand has continued much as it has for centuries. Papermaking is promulgated by family heritage and village tradition; and the raw materials are native wood and vegetable fibers. Inasmuch as the craft of papermaking by hand is a deeply rooted and highly respected part of Oriental culture, it is unlikely to be completely abandoned in the foreseeable future.

The chief Asiatic countries in which considerable paper is still made by hand are Japan, Korea, China, and India. Of these, Japanese papers enjoy the greatest output and variety and are best known in this country.‡ Although most Oriental papers are made with similar techniques, the papers of each country differ in subtle ways because of differences in natural ingredients. It is interesting to note in this respect that one of the most

‡The making of Japanese papers is described in *Papermaking by Hand in Japan* by Bunsho Jagaku (Tokyo, Meiji-Sho, 1959).

highly esteemed lithographic papers is made in China. It is misnamed *India paper* (probably because it was exported by the East India Company) and is not to be confused with commercial machine-made paper carrying the same name. The paper is fairly thin and of lovely pale-gray appearance. It was used extensively for lithography in this country and in Europe in the late nineteenth and early twentieth centuries chiefly for the printing of small works and for collé printing. (See sec. 15.34.) Impressions printed on India paper are noted for their freshness and clarity coupled with a subtle tonality contributed by the paper color. Unfortunately, India paper is no longer available in this country because of trade restrictions. It is unlikely that India paper can be produced successfully on Formosa because of the absence of natural resources that would exactly duplicate those found on the Chinese mainland.

Some Korean paper is still made by hand, although in recent years production has been sporadic and the products uneven in quality. Korean papers exhibit some of the appearance and properties of papers from both China and Japan.

The art of papermaking has been practiced in India since about A.D. 1200. By the middle of the nineteenth century there was a general deterioration of the craft because its major supporter, the government, was ordered to buy paper supplies from Great Britain. The revival of papermaking was promoted in 1934 by the All India Village Industries Association, which encouraged the development of useful cottage industries and enabled remote villages to provide their own paper.

Today, the technological center for the craft is the Handmade Paper Research Center at Poona.§ The productive capacity of the industry is relatively limited, and the output, like that of Korea, is mostly for consumption within the country.

Some of the papers from India have shown interesting possibilities for lithographic printing but are generally less attractive than either Japanese papers (which they somewhat resemble) or handmade papers from Europe.

12.7 THE MANUFACTURE OF JAPANESE HANDMADE PAPER

The present-day manufacture of Japanese handmade paper follows closely the traditions brought from China by way of Korea circa A.D. 610. Procedures are essentially

§See *Papermaking (as a Cottage Industry)* by K. B. Joshi (Poona, The All India Village Industries, Ltd., 4th edition, 1944).

the same as for handmade papers produced by other Asiatic nations. The basic process, moreover, is somewhat like that employed in Europe. The essential difference is that Oriental papers are composed chiefly of vegetable fibers (instead of linen or cotton) which give them great strength and durability, and impart unique working and visual properties. Papers made from these fibers are still in excellent condition after hundreds of years, as evidenced by the many existing Japanese historical documents.

Kozo, gampi, and mitsumata are the three most commonly used deciduous plants for making Japanese paper pulp. The best of the three varieties of kozo *(Broussonetia kazinoki)* is popularly known as the *paper mulberry.* Papers made from kozo pulps are noted for their tough and sinewy fibers and forceful character. Some types of paper made with kozo are even resistant to water and are used in the manufacture of shoji, raincoats, and umbrellas. Mitsumata, which comes from the *Daphnis adora* family, has three branches issuing from an upright stem and is popularly called *three forks.* Its fibers impart softness and fine texture, and are used for papers recognized for their gentle and graceful expressive properties. Gampi is often referred to by the Japanese as the king of papers. The plant is scarce because it resists cultivation, and papers made from it, apart from being very expensive, are extremely durable, lustrous, and of superlative beauty.

The basic preparation of the raw materials before the paper is formed consists in cutting shoots of the kozo or mitsumata, tying them into faggots, and subjecting them to a steaming process that softens and removes their bark. The bark of the gampi is stripped without being steamed. This can be done only in the spring, when the shoots are soft and green, thus further limiting the production of this paper. After the bark is removed, the materials are ready for beating and immersion for long periods in running streams, to remove all knots and imperfections. The *white bark*, as it is now called, is again subjected to boiling in lye solution made from ashes, buckwheat ashes, or slaked lime. After the boiling, the lime is removed by immersing the bark in water for as long as three days. This is so thoroughly accomplished that free chemicals are virtually absent from this point onward; this is one of the chief reasons for the remarkable stability of Oriental papers. After the water immersion, the material is vigorously beaten by hand with mortar and pestle or mallet to macerate the fibers. The Oriental craftsman feels that this time-honored method is superior to the mechanized European method because it permits greater control in producing fibers of correct

length. Balls of macerated pulpy fiber are next placed in vats of water. Pulps have ratios of 30 to 70 per cent water, depending on the type of paper to be formed. The pulp is thoroughly mixed by means of a comb-shaped agitator, after which it is ready for forming.

Tami-Zuki, the first and older of the two methods used to form Japanese paper, is quite similar to the European method. The mould is dipped into the pulp vat, lifted, and shaken in two directions so that the pulp will be evenly distributed and firmly intermeshed. The deckle is lifted and the wet, newly formed sheet is removed from the mould. In the Orient, sheets of newly formed paper are simply piled one upon another without the use of interleaving felts such as are used in the West. Heavy weights are placed upon the pile of wet sheets, removing about 8o per cent of the water. In the last stage of the drying process, the damp sheets are usually brushed onto long boards and permitted to dry in the sun. This is the most ancient method of drying and is entirely dependent on the caprices of the weather. Another method of drying is steam-heating, but it is said that this does not produce the finest papers. Sometimes, as in China, the damp sheets are placed on the ground (uncultivated burial grounds are customarily choice spots) or simply brushed onto the walls of a cottage to dry.

Nagasi-Zuki, the second and relatively new method of Japanese paper-forming, is distinguished by the fact that the mould is not dipped into the vat. Instead, the pulp is poured upon the surface of the mould to make the sheet. A type of mucilaginous substance derived from the tororo-aoi (*Hibiscus manikot* or "paste tree") is added to the pulp as a binder and size. The mould is manipulated in the same manner as in *Tami-Zuki* when the sheet is formed.

The materials and methods described are used in varying combinations to form a very wide variety of papers having different properties and surface appearances. Most of these are used for drawing and printing processes other than lithography, which was not introduced in Japan until very late in the nineteenth century. There are, however, several superior papers that perform excellently. (See sec. 12.11.) Moreover, it is likely that many other special types that are not known in this country are available or can be fabricated. Further exploration in this area would be worth while, for, in view of their unique properties, such papers could add to the rather limited selection of Oriental papers presently available.

12.8 BASIC PROPERTIES OF LITHOGRAPHIC PAPER

The best papers for lithographic printing must have the following basic properties: (1) pliability, (2) firmness of surface, and (3) relatively high degree of ink absorbency. Many other properties are also necessary and will be described later, but the three listed above are of major importance and are the basis for separating lithographic papers from those used for other types of printing. Pliability of the paper is necessary because of the unique press motion necessary in printing the impression. Since this is a sliding rather than a rolling or stamping type of pressure, the sheet must be very flexible if it is to lie in intimate contact with the printing surface when fed through the press.

The outer surface of the paper must be somewhat firm so as to resist picking of its fiber by the printing ink. Lithographic inks are of heavier body and greater viscosity than inks for other types of printing and therefore exert a pull on the surface fiber of the paper. If the paper is too soft, fibers will pluck off and stick to the printing surface when the sheet is removed, marring the paper surface and, more serious, jeopardizing the printing image. The offending whiskers of paper must be removed, which usually demands a complete washing out and re-inking of the printing surface. (See sec. 2.10.) Soft-finish, antique-finish letterpress, book papers, and certain Japanese papers are especially susceptible to picking.

It is desirable for lithographic papers to be somewhat more ink-absorbent than papers for other types of printing, essentially for aesthetic reasons. Preferably the printed image should appear couched *in* the sheet rather than on its top surface, as with hard-surfaced, less absorbent papers. Ink deposits should appear soft and matte, not crisp and brittle like the ink films on the coated nonabsorbent papers used in commercial printing.

12.9 TECHNICAL CHARACTERISTICS OF PAPER AND THEIR SIGNIFICANCE

The technical nomenclature used in describing paper should be familiar to all printers. The following paper characteristics are especially important for lithographic hand printing:

GRAIN
The grain is the alignment of fibers during the formation of the sheet. The better handmade papers have little grain because of the thorough crossing of the pulp fibers

during formation. Machine-made papers tend to have their fibers aligned in the direction in which the wire of the papermaking machine travels. This directional alignment is increased somewhat as the finished paper is dried. Because of the grain, paper (1) tears more easily in the direction of the grain, (2) is less strong and stiff in the grain direction, (3) absorbs or releases moisture in the presence of atmospheric humidity, so that expansion and contraction are greater across the grain direction.

DENSITY

Density is the degree of compactness of the paper fibers. Dense papers are made from strongly beaten or hydrated pulp. Compacted fibers, because they are closely interwoven, subject the paper to relatively great distortion in the presence of moisture. Soft, porous, and less dense papers can swell and shrink without so much change in the over-all dimensions of the sheet, because the distance between their fibers permits more tolerance for expansion or contraction. Paper density is related to dimensional stability and the tendency to curl.

DIMENSIONAL STABILITY

Almost all papers will stretch or shrink in the presence of moisture. Since the lithographic process is dependent on the presence of water, effects of moisture on the performance of paper must be taken into account. Papers that are dimensionally stable and thus least subject to expansion and contraction are preferable for lithography. Such papers are formed by limited beating action and weak hydration. Papers with too little fiber hydration are weak, porous, and linty.

STRETCH

Paper is stretched by (1) moisture in the air or contact with the wet printing surface, (2) the pushing squeeze of the press action as it is being printed, and (3) the pulling of the ink as the sheet is lifted from the printing surface. Because lithographic inks are viscous, their heavy concentrations can exert a good deal of pull on the paper surface. In the presence of moisture, paper can be stretched beyond its elastic limit by press action, ink pull, or a combination of the two. In this condition it is permanently deformed and will not return to its original state. Because paper stretches or shrinks most across its grain, the registering of close color work requires that the paper be positioned so that its grain aligns itself in the direction of the movement of the press bed.

WAFFLING

Waffling is caused by stretching of the paper and is evident along the edge of a printed sheet. It is most noticeable when a band of solid color extends the length of the paper, parallel with the grain. The pull of the ink stretches the paper in the solid area while the rest of the sheet remains unstretched.

RELATIVE HUMIDITY

Paper is hydroscopic; it absorbs or gives off moisture with changes in relative humidity of the atmosphere. Too much humidity will cause formation of brown spots in the paper, called *foxing*, which is a type of mildew. Too little moisture in the air, although less of a problem, is said to make the paper fibers deteriorate by rubbing together. The ideal relative humidity for lithographic printing papers is about 50 per cent. In commercial printing, it is recommended that paper be from 5 to 8 per cent more moist than the pressroom. Humidity control is a major factor in commercial printing, where high-speed production and very critical color registration are imperative, but it is less critical to hand printing unless one is printing in a very hot tropical climate. In such cases the lowering of surrounding atmospheric moisture is necessary.

CURL

Curling can be seen along the edges of the sheet when piles of paper are exposed to a very dry atmosphere. Its occurrence is most common in the drier months. Paper can also be cockled or bumpy, owing to uneven distribution of moisture throughout the sheets. These problems occur most often when paper is manufactured in one region and shipped to another with a different relative humidity. It can also happen in places that have great fluctuations of humidity.

Curling can develop when the paper makes contact with the wet printing surface. The paper tends to curl away from the moistened side and with the grain. Generally, the thinner and denser papers are more subject to this condition, although they return to a flatter position upon drying.

PICKING

Picking is the lifting of fibers from the paper onto the printing surface after an impression has been pulled. Picking occurs through (1) lifting of separate fibers out of the paper surface, (2) lifting of large areas of surface fibers—the paper sometimes tearing and splitting—and (3) blistering or delamination of the paper. The affected impression area (usually a solid) is ruptured internally and looks and feels rough. Picking can be an indication

of poor paper foundation or bad size, but it is more often caused by tacky inks.

ACTIVE CHEMICALS

Some chemicals from the papermaking process stay with the paper even though it is thoroughly washed. These are principally the acid and bleaching agents used in pulping the raw materials and the precipitating chemicals employed during the sizing process. Active chemicals within the paper can affect its condition and performance in two very important ways:

1. They can shorten the life of the paper by causing its fibers to deteriorate. Newsprint is an example, for it quickly turns brown and brittle. Papers of this type can contaminate other papers through contact and transmittal of free chemicals, which are mostly acidified. Therefore the measurement of relative acidity (pH) of the paper is very important. Fine printing papers for lithography should not contain pH factors below 4.5 or above 5.8. (See sec. 9.9.)

2. An active water-soluble chemical in the paper can damage the printing image when it touches it during printing. This occurs less frequently these days than it used to, but instances have been known where active chemicals released from the paper surface have counter-etched the printing plate and caused scumming.

Machine-made papers are more prone to these problems than those made by hand. It has been demonstrated that the deterioration of paper is more likely to be due to the presence of active chemicals in its surface than to the raw materials from which it is made. For example, some Japanese handmade papers made from wood fibers are extremely durable and of proven long life; whereas American newsprint, also made from wood fibers, is both fragile and impermanent. In general, all handmade papers are more permanent than those made by machine, because the process of their manufacture limits the use of chemical agents to such an extent that their presence in the finished paper is negligible.

LINT, POWDER, AND DUST

Linting is the presence of loose surface fibers that are only partially bonded to the sheet. Linting is usually more pronounced on the wire side than on the felt side of the paper. Loosely attached paper fibers and powders such as talc, magnesium carbonate, or dust act like resistants against the printing image. These prevent the ink from reaching the paper surface. When the impression is pulled off the printing surface, white unprinted marks will show in a pattern corresponding to these particles. More important, such particles will remain stuck to the inked image, where they will sometimes receive or reject the next application of ink and, if not removed immediately, cause eventual damage to the plate or stone. Machine-made papers of poor quality, particularly the softer types, are susceptible to linting. One may also find this problem in some handmade paper. In all cases, the printer should carefully examine his paper before printing an edition and lightly brush or remove all loose particles.

RESILIENCE

Successive printing through the lithographic press will gradually press the printing paper thinner. The sharpest reduction in paper thickness occurs after the first printing, with minimal reduction thereafter. After four or five printings, the paper thickness will remain constant. The degree of fiber compression during the process of printing is an inverse indication of the paper's resilience. Very soft papers, even though bulky, will flatten considerably after the first impression; the compression of other types may be more gradual. The resilience of the fibers has some relationship to the paper's pliability; it also has significance for the aesthetic appearance of the finished print. Lithographs on paper with a flattened and heavily burnished look are less appealing than those on paper whose surface is not so compacted.

12.10 THE EXPRESSIVE PROPERTIES OF PAPER

Each type of printing paper has its own expressive characteristics. The color, surface, thickness, and "feel" of papers evoke subtle associative responses that can increase or diminish the total expressiveness of a lithographic print. Not only serving as the supporting ground, an individual paper can enhance the aesthetic properties of the printed image by contributing its own character. Far too often this matter is left to chance. The printer and artist, intent on obtaining good fidelity from the printing image, neglect the expressive qualities of the paper. They consider one kind of paper to be as good as another so long as it prints well. Yet, if comparisons were made, it would be noted that although several different kinds of paper might receive the image equally well, each would convey a different expressive connotation. For example, a small, delicately drawn image will appear quite different if placed on a paper of robust character rather than on a paper of subtlety and refinement. Even though both impressions have printed beautifully, the interplay of paper and image will evoke totally different visual responses. Judgment as to which is the more ap-

propriate combination depends on the artist's aesthetic beliefs and intent.

Aesthetic judgments of this type are clearly subjective and develop from individual experience and sensitivity. The development of such sensitivity can be hastened through first-hand study and appraisal of the great lithographs of the past and present and of the papers upon which they have been printed. It will be apparent that, in the finest examples, there is a certain delicate point at which color, surface, character, and weight of the paper seem to be a fitting complement for the printed image.

The basic differences between handmade and machine-made papers are obvious. Machine-made sheets are uniform in surface and hard in "feel"; even when simulating the appearance of handmade paper, they do so in a mechanical way. Offset machine-made papers of the vellum and bristol types are perhaps the closest in surface appearance to certain handmade papers; but, because they are not permanent, they are useful only for proofing. It is conceivable that certain all-rag machine-made papers of proven permanence could be used in hand printing where the uniformity of their surface and their over-all mechanical character would contribute to the expressive properties of some lithographs. To date such papers are not known.

Just as we associate the character of fine wines with the country of their origin, so we do with fine papers. Oriental papers are characteristically delicate and sensuous and display a native ruggedness. English papers, on the whole, appear tough, dry, and staunch, as do certain early twentieth-century Dutch papers. Italian papers look coarse, rich, and warm-spirited; and French varieties display reserve and elegance. These, to be sure, are extremely broad associative terms, but even such generalizations may be useful as a guide to selection of paper.

The color, surface, and feel of handmade papers have further expressive properties. Papers called "white" are available in numerous shadings from pale warm to brilliant cool whites. No two white papers are exactly alike in nuance of tone. Similarly, colored papers may range from light creamy grays to buff. In this respect, Japanese papers are especially noteworthy for their wide range of natural, unbleached off-white hues. Although stronger-colored papers are available, they seldom are used in lithography except for folio covers, interleaves, title pages, and posters.

The color quality of paper is often used either to intensify or to diminish the impact of the image. Bright, cool-cast, white papers set up a startling impact for black-and-white lithographs; pale and warm-toned papers present a soft and more subdued appearance.

The paper tonality may further complement the image when printed with slightly toned black inks. Very handsome effects can be produced on either toned or white papers by printing greenish, brownish, or bluish blacks. In this way, the chromatic relationships established between the paper and the ink offer striking possibilities. Additional expressive differences result if the paper is dampened before printing: black ink and color inks as well are drawn deeper into the softened fibers of the paper surface and so produce much softer and mellower impressions. By comparison, impressions on dry paper display snap and brilliance unobtainable on damp paper.

The surface appearance of paper may range from a toothy softness to a smooth sleekness, with other expressive qualities in between. It must be remembered, however, that, for lithography, choice of exaggerated surfaces is somewhat limited by the nature of the printing principle involved. The feel of the paper is closely related both to its surface appearance and to its substance or weight. Some papers will seem supple, others limp. Some may feel thick, strong, and coarse; others thin, tender, or fragile. Each of these characteristics can arouse limitless visual as well as tactile associations.

As the individual characteristics of a specific paper are recognized, their interplay within the lithograph can be more meaningfully explored. The following theoretical examples of paper and image relationships further describe this interplay:

1. **The image:** Of large size; bold and frank in connotation.

 The paper: Should be ample in substance and weight to give sufficient support to the subject. Thinner papers, by not supporting the image, convey a lack of substantiality for the total projection. In such cases, the image overcomes the paper and rests "outside of it," rather than becoming an integral part of the sheet.

2. **The image:** A delicate, lyrical work with open spaces and mostly linear motifs.

 The paper: A refined Oriental paper with fine silken fibers might heighten the lyricism of the image and contribute to its sense of preciousness. The discreet silken fibers of the paper substance could provide visual interplay against the linear forms by appearing in the open spaces of the image. If, on the other hand, the fibrous content of the paper were too obtrusive, it could cheapen the concept by drawing undue attention to itself.

 Quite another response would be engendered by printing on an elegant European paper of

cool and pristine purity. Papers that are too weighty or primitive in appearance would be likely to overcome the delicacy of the image.

3. **The image:** A work having a full range of tonal values with fine washes and extensive close shadings.

 The paper: In many cases the interplay of tonality within the image is so demanding that only a fairly refined and neutral surface can display this to advantage. White papers will convey a sense of purity and directness; toned papers and inks may add modifications of overtone to the basic image.

 Complex multicolor lithographs also require conditions of paper neutrality. Hence the weight of the paper is important, for it must carry the weight of the many printings both physically and by visual implication.

4. **The image:** Strong, hard-edged, and with vivid, solid colors.

 The paper: A stout, rather smooth paper that is cool white in color will permit the printed colors to appear more brilliant than a warm, soft, toothy paper. In addition, the smooth surface and resiliency of the sheet, by relating to the mechanical hardness of the image, can heighten these properties. Images and colors that convey too much hardness can be somewhat tempered by using softer and coarser papers, although their impression may thereby take on a romantic connotation.

Still another way in which the expressive characteristics of paper play an important part in lithography is in the publication of folio editions, lithographic suites, and *livres de luxe.* The European tradition in this field of publishing is to print portions of the edition on different types of paper. The work is offered at different prices according to which type of paper is used. The very finest and most precious papers (usually Chinese or Japanese) are printed in small number, sometimes by the papier collé method (see sec. 15.34), and command a high price. The balance of the edition is printed on a second paper also of fine quality; and a third, less expensive paper may be used for printing some of the works for advertising and gallery display. Two examples of this practice in publications are:

BONNARD, *Les Pastorales, ou Daphnis et Chloé.*[‖]
Published by Vollard in 1902, it lists the edition of

250 copies as follows:
 200 copies on Holland Laid, with watermark "Daphnis et Chloé"
 10 copies on Japan, with two extra sets of lithographs in rose
 40 copies on China, with two extra sets of lithographs in blue
PICASSO, *Lithographs for Tristan Tzara, de Memoire d'Homme*[#]
Published in 1950 in an edition of 350 copies
 30 copies on Holland with an extra set of lithographs on Japan
 300 copies on Arches
 20 copies *hors commerce* on Alta Mouse Wove

Although in one sense the prints are identical, the subtle effect on print quality of differences in paper can be identified by the connoisseur.

This practice in publication is growing in the United States as greater numbers of American artists and publishers are undertaking more ambitious printing ventures. As the choice of papers will strongly condition the intrinsic character of the total suite or *livre de luxe,* the serious student of lithography will do well to explore the entire subject of paper in order to utilize its properties to the greatest advantage.

12.11 FINE PAPERS FOR PRINTING

The following fine papers have been selected for use at Tamarind because of their superior properties for lithographic printing. Some are well known, others less so. All may be ordered from Andrews, Nelson, Whitehead, Inc., a division of Boise Cascade Corporation, the chief importer of fine foreign papers. (See Appendix A.) Given below, in order of country of origin, are data regarding these papers, together with comments on their individual characteristics.

Rives BFK

Mill:	Arjomari S.A.
	3 Rue du Pont de Lodi
	Paris 6, France
	Rives Mill
	Rives (Isère), France
Manufacture:	Mould machine
Raw Material:	100% rag
Size:	19 × 26"
	26 × 40"

‖*The Artist and the Book, 1860–1960* (Boston, Museum of Fine Arts; Cambridge, Harvard College Library, 1961), p. 26.

#Fernand Mourlot, *Picasso, Lithographe* (Monte Carlo, André Sauret, Editions du Livre, 1956), vol. III, pp. 45–47.

	22 × 30"
	29 × 41"
Weight:	230 grams per square meter;
	110 pounds per ream (22 × 30")
	250 grams per square meter;
	220 pounds per ream (29 × 41")
	NOTE: The weight of the larger sheet is 10 per cent greater per square inch than that of the smaller. This is perhaps an attempt to compensate for the fact that a smaller sheet will seem to have greater density than a larger sheet that is actually of the same density.
Color:	White
Sizing:	Half sized
Deckles:	4 deckles (those along length are fuller)
Watermark:	BFK (left bottom) and RIVES (right bottom)
Availability from Abroad:	Occasionally available from mill in following weights and sizes (minimum of five reams):
	180 grams per square meter;
	67 pounds per ream (19 × 26")
	240 grams per square meter;
	100 pounds per ream (19 × 26")
	260 grams per square meter;
	240 pounds per ream (29 × 41")
pH:	5.4

This classic lithographic paper is relatively versatile, dependable, and quite stable to light. It is a good paper for washes, crayon, and single-color work of all kinds. It has limited absorption qualities, making it less reliable for multicolor printing. Flat areas of color that require heavy inking may dry to a shiny finish. The paper erases well. It stretches slightly in printing and tends to curl somewhat after printing. Lighter-weight Rives papers are available that do not carry the BFK watermark. Although these display acceptable printability, they are not listed here because they are in no way comparable to or as versatile as BFK.

Arches Cover

Mill:	Arjomari, S. A.
	3 Rue du Pont de Lodi
	Paris 6, France
	Arches Mill
	Arches (Vosges), France
Manufacture:	Mould machine
Raw Material:	80 to 90% rag
Size:	22 × 30"
Weight:	250 grams per square meter;
	120 pounds per ream
Colors:	White and Buff
Sizing:	Half sized
Deckles:	4 deckles (those along length are fuller)
Watermark:	ARCHES (2 1/4 × 5/8")
Availability from Abroad:	Occasionally available from mill (minimum of five reams) in sizes:
	19 × 26"
	25 × 36"
	29 × 41"
pH:	5.0

With time and exposure to light the buff paper fades to white and the white paper darkens. In comparison with Rives, the tooth of the paper is coarser, and its heavier weight sometimes requires slightly softer ink and greater pressure to print successfully. This paper is particularly recommended for multicolor printing. When viewed over a light box, Arches will occasionally show a streak down one edge, along which the surface density of the paper appears to be disturbed. Flat tones will not print properly over such streaks, although printing on the reverse wire side of the paper sometimes alleviates the problem.

J. Green Waterleaf

	(Also called English Etching Paper)
Mill:	J. Barcham Green Ltd.
	Hayle Mill
	Maidstone
	Kent, England
Manufacture:	Handmade, hot pressed
Raw Material:	100% rag
Size:	23 1/4 × 31 1/4"
Weight:	300 grams per square meter;
	140 pounds per ream
Color:	Cool white
Sizing:	None
Deckles:	4 deckles (those along width are fuller)
Watermark:	None (Embossed "J. Green" 1 1/4 × 1/8" in corner)
Availability from Abroad:	Made only twice a year

This is a very cool white paper. It prints well for delicate washes and open crayon work. Overlaid flats print well with some inks and not others. Overprinting with more than three colors is not advisable in view of the limited absorbency of its hot-pressed fiber compression. This paper, like Crisbrook Waterleaf, contains occasional small luminous flecks. The paper erases poorly.

Crisbrook Waterleaf

Mill:	J. Barcham Green Ltd. Hayle Mill Maidstone Kent, England
Manufacture:	Handmade, hot pressed
Raw Material:	100% rag
Size:	22 × 30"
Weight:	139 pounds per ream
Color:	White
Sizing:	None (Waterleaf)
Deckles:	4 deckles (those along length are fuller)
Watermark:	CRISBROOK in left bottom. Special markings may be obtained in orders of ten reams or more
pH:	5.6

This very cool, white paper is good for crayon work, but, because of its limited ability to absorb ink, it is less receptive to washes, flats, and multicolor printing. It contains dark flecks in random distribution, which may disturb the aesthetic of pristine images. It does not erase well. The paper stretches slightly in printing.

Copperplate Deluxe

Mill:	Papierfabrik Zerkall Renker & Soehne, Zerkall Ueber Dueren, Germany
Manufacture:	Mould machine
Raw Material:	75% rag, 25% high grade alpha (wood pulp)
Size:	30 × 42 1/4"
Weight:	250 grams per square meter; 200 pounds per ream
Color:	Warm white
Sizing:	None
Deckles:	4 deckles (those along width are fuller)
Watermark:	None
pH:	5.0

This paper is considerably more robust than either Rives or Arches. Its coarse surface quality and warm cast are useful for strong heavy work and it is especially commendable for multicolor printing, where its absorbent properties permit matte drying of the ink films. Copperplate Deluxe should not be confused with German Copperplate; the latter is identical in appearance and printability, but has 42 per cent less rag content and therefore cannot be recommended for permanence. The warm yellowish cast of this paper bleaches to white in time. The paper erases well.

German Etching Paper

Mill:	Buettenpapierfabrik Hahnemuehle G.m.b.H. Dassel, Kr. Einbeck Germany
Manufacture:	Mould machine
Raw Material:	75 to 80% rag
Size:	31 1/4 × 42 1/2"
Weight:	300 grams per square meter; 220 pounds per ream
Color:	Warm white—yellow cast
Sizing:	None
Deckles:	4 deckles (those along width are fuller)
Watermark:	None
pH:	5.4

German Etching Paper is very close to the general color and appearance of Copperplate Deluxe. It performs equally well, and its slightly softer feel conveys a rich associative response for work printed upon it. Occasionally speckles of dirt that originate in the rag can be seen in the paper, and its surface should also be checked for loose fibers. It does not erase well.

Laga Velin Blanc Narcisse

Mill:	Moulins à Papier du Val de Laga Richard de Bas Ambert (Puy-de-Dôme), France
Manufacture:	Handmade
Raw Materials:	100% rag
Size:	20 × 25"
Weight:	240 grams per square meter
Color:	White
Sizing:	None
Deckles:	4 deckles
Watermark:	"1326," a heart, and "Richard de Bas" (3 1/3 × 3 1/2") in one corner; "Auvergne à la Main" (4 1/2 × 1/2") in opposite corner
pH:	4.6
Availability from Abroad:	Occasionally available in limited quantities

This somewhat rare paper is rather expensive but strikingly beautiful. Because of its coarse texture, it does not accept ink uniformly and in consequence is not recommended for washes. Solid black and colored printings may reveal pinholing effects of the uninked surface due to the limited pliability of the paper. Best for single colors, it is very effective for those images which relate to rich, antique, warm-spirited, and bold papers.

Italia

Mill:	Cartiere Enrico Magnani
	Magnani, Pescia, Italy
Manufacture:	Mould made
Raw Material:	66% rag, 34% high grade alpha (wood pulp)
Size:	14 × 20"
	20 × 28"
	28 × 40"
Weight:	300 grams per square meter;
	220 pounds per ream
Color:	Cool white
Sizing:	Lightly sized
Deckles:	4 deckles (those along length are fuller)
Watermark:	Harp and cross in one corner (1 × 5/8")
pH:	5.4

Italia is an excellent light-fast and dimensionally stable paper, somewhat heavier than Rives. Its surface is considerably softer than Arches. It is suitable for all types of work, although some care should be taken that its surface fibers are not disturbed when printing with stiff inks. Heavy ink layers may dry shiny or mottled on the finished impression.

Basingwerk

Mill:	Grosvenor, Chater & Co. Ltd.
	68 Cannon Street
	London E.C. 4, England
	Abbey Mills
	Holywell
	Flintshire, North Wales
Manufacture:	Fourdrinier machine
Raw Material:	45% esparto pulp
Size:	26 × 40"
Weights:	77 pounds per ream (26 × 40")
	88 pounds per ream (26 × 40")
	115 pounds per ream (26 × 40"; weight recommended for lithography)
Color:	White
Sizing:	Weak
Deckles:	Trimmed 4 sides
Watermark:	None. Special markings may be obtained in orders of 2000 pounds or more.
Availability from Abroad:	Occasionally available from mill in following sizes and weights:
	20 × 30"—38, 45, *50, 60* pounds
	30 × 40"—60, 76, 90, *106,* 120 pounds
	22 1/2 × 35"—*40, 50, 60, 70, 80* pounds

35 × 45"—80, 100, 120 pounds
17 × 27"—*40* pounds
27 × 34"—30 pounds
20 × 25"—38, *45,* 50 pounds
25 × 40"—*64,* 76, *90,* 100 pounds
Italicized weights are available in toned papers. Some are available in colors.

Basingwerk is a machine-made paper that has been traditionally used for lithography in this country since the 1920s. It is a very reliable paper in durability and printability, largely because of its esparto grass–fiber content. It is of very smooth, somewhat mechanical surface appearance, which permits the printing of brilliant impressions although these tend to have a hardness about them. Because of its characterless appearance, this paper seems unable to contribute to the total orchestration of the print and, therefore, should be reserved for very special circumstances in which its lifeless purity can be used to advantage. Basingwerk is not recommended for strong multicolor work because of its inability to absorb many heavy layers of ink.

Umbria

Mill:	Cartiere Miliani Fabriano
	Fabriano, Italy
Manufacture:	Handmade
Raw Material:	100% rag
Size:	20 × 26"
Weight:	60 pounds per ream (20 × 26")
Color:	White and Cream
Sizing:	Softly tub-sized and air-dried
Deckles:	4 deckles
Watermark:	"Umbria Italia" with crown in top left corner; "C. M. Fabriano" in bottom right corner
	Special markings may be obtained in orders of ten reams or more.
Availability from Abroad:	Occasionally available from mill in size 20 × 28" (minimum of five reams)

Umbria is a soft, pulpy, and robust paper having a decidedly coarse surface appearance. It is a durable paper capable of accepting delicate as well as strong work. Because of its fibers, which are short in length and somewhat lacking in pliability, it does not adapt to a wide range of nuances.

Inomachi (Nacre)

Mill:	Shiota Mill
	Kochi, Japan

Manufacture:	Handmade, *Tami-Zuki*
Raw Material:	100% kozo
Size:	20 × 26"
	22 × 30"
	29 × 41"
Weight:	45 pounds per ream
	(17 1/2 × 22 1/2")
	70 pounds per ream (22 × 30")
	152 pounds per ream (29 × 41")
Color:	White and Natural
Sizing:	Weak sizing
Deckles:	4 deckles
Watermark:	None
	Special watermarks can be obtained in orders of 1000 sheets or more. Special markings can be obtained in papers of other sizes, shades, and weights.
pH:	5.4

This handmade parchmentlike paper produced from the fibers of the kozo and mitsumata trees equals or surpasses rag papers in strength and permanence. It has often been considered the "queen" of handmade papers and is normally reserved for special deluxe editions in which its magnificent texture gives a rich silken surface to the finished prints. Considerable experience is necessary for successfully printing from Nacre because of its dense, heavily fibered content. It takes black and color inks beautifully when these are slightly softened with varnish. Multicolor overprintings are difficult because of the paper's limited absorptive capacity and its tendency to stretch under press pressure.

Suzuki

Mill:	Etchu Mill
	Japan
Manufacture:	Handmade, *Nagasi-Zuki*
Raw Material:	60% kozo, 40% wood pulp
Size:	36 × 72"
Weight:	83 pounds per ream (36 × 72")
Color:	White
Sizing:	None
Deckles:	4 deckles
Watermark:	None
	Special markings can be obtained in orders of 1000 sheets or more

Suzuki is a very strong, silken-fibered sheet of cool white appearance. It is suitable only for black-and-white work and on special occasions, where its large sheet size can be economically subdivided, for smaller prints.

12.12 PAPERS FOR PROOFING

The preparation of a stone or metal plate before an edition is printed from it always involves a certain amount of test printing, called *proofing*. During the proofing, ink mixes are refined, inking patterns determined, printing pressure adjusted, and minor corrections applied to the image. A certain number of impressions need to be printed, all of which will be imperfect in one respect or another, before all preparations have been completed. Such trial proofs are necessary for the start-up of any job and are usually destroyed after the edition is printed. The printer, in order to minimize paper cost, must rely on inexpensive papers for proofing rather than risk expensive sheets of fine paper for eventual discard. To further the economics and the efficiency of papers for proofing, the process is separated into several stages with appropriate paper types for each stage as follows:

ROUGH PROOFING

Newsprint is the best paper for rough proofing. Usually from three to six impressions must be taken before printing pressure can be adjusted and the image reasonably stabilized so as to print satisfactorily. Newsprint is also used in quantity for slip sheets, to interleave between freshly printed impressions as a guard against offsetting. Other uses, as tympan backing sheets, set-off paper, and makeready, make newsprint one of the most useful and necessary papers in the shop. It is most useful in the 30 × 40"-size, from which smaller sizes can be easily cut. Quantities from 500- to 1,000-sheet lots are a necessity for shops engaged in steady activity. The newsprint should be of medium weight and medium surface finish in order best to perform its many functions.

CRITICAL PROOFING

Following the rough proofing, a more critical type of proofing is undertaken in which the color mixture and ink consistency are adjusted, minor corrections in the image are made, paper positioning marks are resolved, and the quality of the printed impressions is assessed. The paper for critical proofing should be closer in color, weight, and surface to that of the final edition paper. Shops in which many different types of edition paper are used employ a semismooth proofing paper, neutral in surface, preferably of a cool white cast, in order to serve as an all-purpose paper for critical proofing. Whenever possible, the type of paper should be of the offset, uncoated variety in order to ensure pliability and firmness of surface. The following excellent papers have been used

from time to time for critical proofing at Tamarind and at the University of New Mexico:

Radar Vellum Bristol	35 × 46″, 251 pound, basis 100, Moraine Paper Company (Kimberly-Clark Corporation)
Energy Vellum Bristol	26 × 40″ and 35 × 46″, 80 pound, 130–260m, long grain (Kimberly-Clark Corporation)
Winston Wedding Bristol	22 1/2 × 28 1/2″, 80 pound stock (Rising Paper Company)
Patina White Cover; smooth, used for chalk transfer and set-offs	35 × 46″, 65 pound, 402m (Simpson-Lee Paper Company)

FINAL PROOFING

In many cases, edition printing is undertaken immediately after the critical proofing indicates that everything is ready. Theoretically, the next impression is taken on a sheet of edition paper and, if perfect, it is designated as the *bon à tirer* impression. This impression, when approved by the artist, is used as a guide to the printing of the entire edition. Occasionally the nature of the work is such that results from the critical proofing are still indeterminate, either because of color subtlety or print quality. In such cases, additional proofs must be taken on fine edition paper until an approved impression can be achieved.

12.13 PAPER SIZES, WEIGHTS, AND QUANTITIES

Printing papers are sold by size, weight, and quantity. The standard American system records a quire as 25 sheets of paper and a ream as 20 quires, or 500 sheets. The bulk or density of paper is usually described by its weight per ream. Thus a 140-pound stock would be considered a thick, bulky paper weighing 140 pounds per 500 sheets. European papers often list substance weight in grams per square meter of paper. Relating paper weight to sheet thickness can sometimes be misleading. For example, a very dense paper could conceivably be thinner and yet heavier in weight than another paper that is much thicker though less dense. In comparing one paper to another it is better to regard paper weights as only generally relative to paper thickness.

The standard sizes of machine-made papers seldom coincide with those of handmade papers; and the European handmade papers do not correspond in size to Oriental ones. The following are the most popular sizes of American machine-made papers:

19 × 24″	26 × 40″
22 × 34″	35 × 45″
24 × 38″	40 × 60″

Machine-made papers up to 22 × 34″ print satisfactorily on the hand press in weights from 65 pounds to 85 pounds per ream. Papers of lesser weight tend to buckle or present a flimsy appearance. Larger impressions are better taken on sturdier stocks, from 100 to 140 pounds per ream, depending on the paper type. These heavier-weight machine-made papers are often referred to as *cover stocks*.

Some popular sizes of European handmade paper suitable for lithography are as follows:

14 × 20″	26 × 40″
20 × 28″	29 × 41″
22 × 30″	30 × 42 1/2″

The most useful Japanese paper sizes are:

17 1/2 × 22 1/2″	29 × 41″
22 × 30″	36 × 72″
27 1/2 × 37 1/4″	

Size variations of as much as 1/2 inch in either direction of the sheet are not uncommon in handmade papers. Irregularities of the deckled sides, corners, and surface thickness are particularly noticeable in Japanese papers; and their presence must be accepted as an intrinsic part of the character of handmade paper. These differences between sheets must be taken into account by the printer during the printing of work, so that each impression will be uniformly centered. (See secs. 4.5 and 7.8.)

The selection of suitable weights, sizes, and quantities of paper stocks depends on anticipated usage, storage facilities, and budget allowance. (See secs. 12.14 and 12.15.) Larger and heavier papers are more expensive than smaller and lighter papers; they may, however, be more economical in the long run, since they can always be torn into smaller sizes. The heavier weight of the larger papers affords additional luxury for smaller works, especially for multicolor printing. There are considerable savings per sheet cost when ordering in carton or ream lots, rather than in smaller quantities.

12.14 BASIC PAPER SUPPLIES FOR THE SHOP

There are usually practical limits that govern the number of papers one can keep on hand. Obviously, a

sizable inventory of varied expensive papers would require considerable investment. Unless the printmaking activity is assured of immediate profitable return or is subsidized by publishing or institutional funds, few independent shops can afford to carry large paper inventories. From a practical point of view, therefore, they should stock those papers which can best serve in the broadest possible way the types of work contemplated. The ordering of special types of supplementary stocks, whether large or small in quantity, must be planned well ahead of anticipated usage. Delivery schedules for all types of paper, especially those of the handmade variety, are variable and depend on current demand and available transportation.

Four excellent handmade papers are recommended for all-purpose stocks: Rives BFK, Arches Cover, German Etching Paper, and Copperplate Deluxe. (See sec. 12. 11.) Any one of these papers can serve as the staple shop paper. Although these papers have distinctly different characteristics, each is capable of producing superb impressions under the most varied lithographic conditions. Each paper, with the exception of Arches Cover,

is available in sheets of large dimensions. It remains for the individual to select from these papers the one most useful for his purpose. Although the basic shop paper should be white, a smaller quantity of toned paper will be a useful investment. Buff Arches Cover is most versatile.

University and art-school print shops must consider the limited financial resources of their students, many of whom cannot afford regular purchase of the finest papers. An ideal and economical paper in such a circumstance is German Copperplate paper, which is available in large-sheet size at a substantially lower cost than Deluxe Copperplate. Educational shops should also keep several of the finer papers in stock, so that a part of each student's work may be undertaken on papers of the highest quality. This will further his experience and will generate attitudes of professionalism.

The quantity of paper to be ordered depends on budget capacity and storage facilities. Inventories should include at least one ream or more of several types of paper for shops contemplating serious printing activity. It is always surprising how rapidly the steady printing of even small editions can deplete paper stocks. It will be found that

ordering less frequently and in greater quantities will lower the cost per sheet by reducing both paper and freight charges.

In addition to fine papers, the shop inventory should include several other types of paper stocks. Both newsprint and critical proofing papers should always be available. Newsprint, because of its all-round use and rapid consumption, should be ordered in at least 1,000-sheet lots, unless local availability assures rapid delivery. Critical proofing paper of the types listed earlier is usually available in cartons of 300 sheets. One or two cartons are sufficient for shops of average size. Here again, those papers which are the largest in sheet size will prove to be the most economical.

Additional papers, although not absolutely essential to the basic printing process, should be available in any well-equipped lithography shop. These include blotting paper, tissue papers, and paperboards such as chipboard and corrugated cardboard.

White porcelain-finish blotting paper is available in $22 \times 28''$, $24 \times 38''$, and, on special order, $30 \times 40''$ sizes. It is sometimes used as a backing cushion under the press tympan during printing, but more often it is necessary for paper dampening and collé printing. It should be ordered in 100-sheet lots for shops of average productivity.

Chipboard, sometimes referred to as *bindery board,* is a low-quality gray pulpboard available in a variety of caliper sizes. Eighty (0.80) gauge is a relatively stiff heavyweight board measuring $28 \times 38''$. It is sold in bundles of twelve to fifteen sheets depending on gauge size. Several bundles should be stocked. This sturdy board, which has many uses in the shop, is employed chiefly as a flat on which to pile, carry, or store editions of prints in progress.

White tissue papers are used as protective interleaving between finished printed impressions. They are also used to protect the face of mounted prints during shipment. Many types of commercial tissue papers are available on today's market. Those of the highest quality are preferable. Because of their high sulphite content, the inferior grades of these papers can transfer damaging chemical impurities after prolonged contact with the impression. For this reason, many professionals prefer glassine-type papers, which are thin semitransparent glazed sheets of better substance than tissue. Their glazed surface permits somewhat easier handling in the covering or uncovering of prints. Either glassine or tissue should be ordered in the largest sheet available, and because of their relatively low cost and rapid consumption, ream lots should be kept on hand.

Corrugated cardboard of the sturdiest variety available is extremely useful in the shop, for temporary work surfaces, protective covering over paper-storage areas, and particularly as protective wrapping for the shipping of prints.

12.15 PAPER HANDLING AND STORAGE

Scrupulous care in the handling and storage of paper is an integral part of the lithographic craft. The printer must know how to work with paper without sullying it. In addition to the objectives of craftsmanship, there is the practical necessity of protecting an expensive investment. Nothing is more costly and wasteful to the shop operation than damaging a package of fine, expensive paper through neglect, careless handling, or improper storage.

Printing paper, as it comes from the dealer, is sealed in stout wrappings. It should remain in these wrappings throughout its storage. Only the edge of the package need be opened to remove sheets for use. The remainder of the sheets may thus remain protected from dirt and dust. Each package of paper should be stored absolutely flat on stout shelving or in drawers especially allocated for this purpose. It is best to house the bulk storage of paper in a room or closet adjacent to the print shop. If this is not possible, a protected area within the shop can be designated strictly for the handling and storage of paper. Some papers, particularly those of heavier weights and larger sizes, may reveal a slight curling at their corners when received. These packages should be stacked top to bottom, reversing the faces of alternate packages in order to even them. Periodically, the packages of paper stores should be inspected, shifted in the pile, and turned end for end to further flatten the paper. The storage facilities should be dry and clean, with ample circulation of air. For certain installations, further protective measures may be advisable, such as placing corrugated cardboard sheets on top of the paper package, or covering it with plastic film to insulate against dirt or water damage.

12.16 PREPARATION FOR EDITION PRINTING

The preparation of paper for proofing and edition printing should be undertaken before the job is set up on the press. At this time the user's hands are clean, and his attention is not divided between the printing of the stone and the preparation of the paper.

One table or cabinet surface should be reserved for paper preparation; it must be kept immaculate for this

12.2 Ripping European paper against a straightedge

purpose. The papers to be printed are sorted, counted, and torn to size. After it is determined which side of the sheet will be printed, the papers are placed face down, with watermarks aligned so that the watermark position on each sheet will be consistent in relation to the printed image. Two sheets of chipboard are cut slightly larger than the printing paper, to serve as top and bottom support for the paper stack; the entire stack can then be easily transported to and from the press. Editions that are completed or in process can be stored one over the other, with complete protection provided by the chipboard covers.

A sample paper grouping for edition printing might consist of the following: first, a chipboard base; next, a sheet of newsprint (to assure cleanliness); then ten sheets of Japan, thirty sheets of Arches, four sheets of critical proofing paper, and four sheets of newsprint, followed by a chipboard cover. In this position the sheets of paper are stacked in the order of their printing, with the proofing papers on top and the edition papers on the bottom. Each variety may be separated by inserting a thin tab of newsprint as a means of rapid identification when printing. The printer can thereby determine how soon he will

have exhausted his proof paper and when he is approaching one or another of his paper types.

A quantity of newsprint sheets cut to the same size as or slightly larger than the printing paper accompanies the paper stack to the press table. These sheets will serve as slip sheets, or interleaving, to prevent the wet ink of one impression from offsetting onto the clean back of another. The slip sheet can be used over and over from one edition to another; a sufficient quantity in the most frequently encountered print sizes should always be available in the shop. When the paper stack is moved to the press table for printing, the chipboard cover is removed and placed alongside the pile. A slip sheet is placed on this, and the first print taken is laid face down on the slip sheet. The second impression is placed face up on the first print, and this is followed by another slip sheet. The sequence is repeated, with the printed impressions placed back to back, between slip sheets, until the edition is completed. Finally, the finished stack of impressions is topped by the chipboard that was originally on the bottom of the first pile.

12.17 PAPER TEARING

It is often necessary to reduce a standard-size sheet of printing paper to a smaller dimension. Paper is most often torn by hand so that the edge of the tear approximates the natural deckle of the other sides. Tearing is accomplished in several ways, depending on the type of paper. Before describing these methods, it is important to consider the planning of paper dimensions.

Whenever possible, it is advisable to plan sheet sizes so as to eliminate undue waste. (See sec. 1.1.) For example, Arches Cover paper ($22 \times 30''$) may be torn economically to sheet sizes such as $22 \times 15''$ and $11 \times 15''$. Inevitably, however, some paper will accumulate in the form of strips. These strips should be saved for testing color-ink mixes and for use as paper grips or insert tabs in edition stacks.

The simplest method for tearing paper is to rip the sheet along a broad straightedge. The straightedge must be firmly gripped so that the tear will be true. Several sheets may be torn at one time; however, if too many are torn at once, the torn edge will appear coarse. A more serious danger is the appearance of an undesirable impression of the straightedge just inside the torn edge; the deckle will have to be burnished to remove this mark.

Another paper-tearing method, more traditional in Oriental printmaking, is to cut the paper along a soft fold by means of a paper knife. The knife, which is long and thin-bladed like an envelope opener, is drawn along

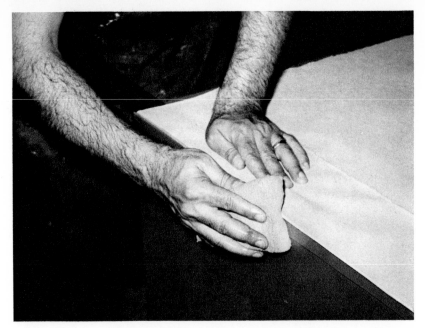

12.3 Dampening Oriental paper against a straightedge

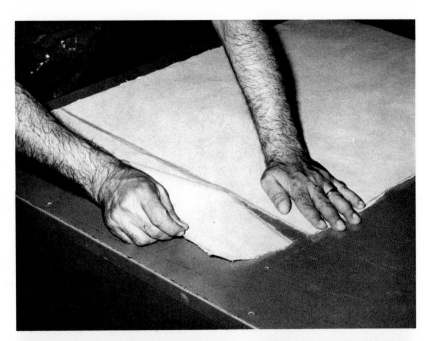

12.4 Pulling paper apart

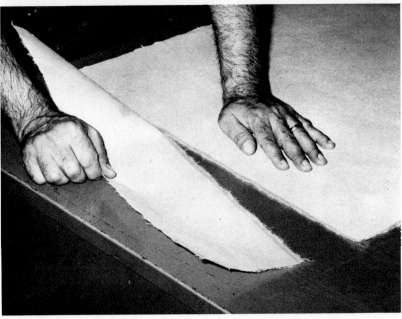

the inside edge of the fold, slitting the paper unevenly. Deckles formed in this manner are considerably more irregular and lend an antique quality to the sheet.

Tough-fibered Oriental papers are torn in a different manner. First, they are folded along the line to be torn, and the edge of the fold is carefully dampened with a clean sponge and water. Dampening may be more easily controlled if a metal straightedge is held against the inside of the fold. The sponge need only touch the paper against this reinforced edge. After it has set for a few moments, the paper may be flattened out and pulled apart along this wet edge. The moist and softened filaments will part easily, presenting a handsome and fibrous edge.

The Printing Press

13.1 THE LITHOGRAPHIC HAND PRESS

The flatbed hand press (sometimes called the hand transfer press) is the traditional machine for printing lithographs directly from stone and metal plates. American presses, such as the Fuchs-Lang, Robert Mayer, and Rutherford, were first manufactured in the mid-nineteenth century. They were of simple, cast-iron construction and were patterned after English lithograph presses manufactured several decades earlier. It is interesting to note that the pressure leverage and scraper-box suspension (as well as the all-metal construction) in the British and American presses were a distinct departure from the European wooden presses, which adhered closely to the design of Senefelder's original presses. There is little doubt that these changes in press design have been responsible for the numerous differences in pressmanship technique between American and European hand printers.

American hand presses of this type have not been manufactured or used commercially for the past forty years. They were last used for commercial purposes in the transferring departments of the larger poster, decalcomania, and label printing establishments during the 1930s. With the rapid development of photo-reproduction techniques, motorized transfer presses, and high-speed offset presses, the slower hand presses were phased out of industrial use and often sold as scrap metal. A small number of presses were salvaged by schools and individual artists during the 1930s; many of these remain in excellent operating condition and perform dependably.

Today the discovery of old, unused hand presses is mostly a matter of luck, although a few may still exist in forgotten storage rooms of the older lithography firms. Despite their simple construction, they command ex-orbitant prices when they appear, infrequently, on the market. Until recently, the scarcity of these presses had been a serious detriment to the advancement of artistic lithography. Moreover, when damage occurred on existing presses, parts could not be replaced except through expensive custom fabrication.

Fortunately, the current revival of interest in hand lithography has encouraged the manufacture of new presses, which will alleviate the shortage of adequate machinery.* Among these are the following:

THE AMERICAN GRAPHIC ARTS PRESS

The American Graphic Arts, Inc., of New York, has announced the manufacture of new presses built on the same patterns and dimensions as the old hand presses. Not only will these new machines be available; it would appear that parts for the older presses may once again be easy to obtain.

THE CHARLES BRAND PRESS

A new press has been designed and manufactured by Charles Brand Company of New York. This is essentially a modern version of the early hand presses, but it has many new design and construction features that assure easier and more efficient press operation. The Brand press is available in two standard sizes; it can also be custom fabricated in other dimensions. Although this press can be motorized, hand operation is remarkably easy because of its powerful gear ratio. Several Brand presses were tested and modified over a two-year period at Tamarind. These modifications, designed especially for heavy duty and professional work loads, resulted in improvements of the press bed, pressure cam box, and roller clutch. Further

*Inquiries regarding these presses should be directed to the manufacturers, whose addresses are given in Appendix A.

modifications are to be expected as this relatively new machine is tested more extensively by printers throughout the country. In view of its excellent performance, the Brand press is likely to be one of the standard lithography presses (particularly in school shops) at least through the next decade.

THE GRAPHIC CHEMICAL AND INK COMPANY

This company has designed two presses along traditional lines but with all-steel construction, modern roller, and self-aligning bronze bearing supports. These presses are unique in that the pressure lever operates through the top crossbeam assembly, as it did in early German hand presses. A special knuckle-locking device is utilized after final pressure is applied. Model LP-3 has a bed size of 30 × 48″ with special safety stops. The bed is constructed of laminated wood reinforced with steel and with battleship linoleum padding. A 6:1 enclosed gear-reduction drive is used to crank the press. Model LP-4 has identical features, except that the bed is 36 × 60 × 1″ steel construction, and the gear ratio is 10:1. Both presses are modestly priced.

THE GRIFFIN PRESS

This recently designed press is constructed of welded, rectangular-section steel tubing and has a cam-operated pressure system activated by a side-arm lever. The pressure system provides a full inch of movement at the scraper, greatly facilitating the handling of the tympan and its lubricant. The press bed is moved by chain drive with variable gear ratio; both manual and motorized drives are available. The press bed can be disengaged from the lower roller by means of a bed-lifter: a pair of small wheels on eccentric axles mounted just behind the lower roller. When disengaged, the bed may be drawn forward or backward with one hand. Additionally, this press is designed for rapid and easy conversion for intaglio and relief printing, by replacing the scraper arbor with an upper roller unit. This roller can be stored on fittings attached to the lower frame when the press is used for lithography.

THE GERALD MARTIN PRESS

This privately constructed press is available on custom order only. Several sizes are offered. The general design is based on that of traditional hand presses, although all construction is of heavy-duty steel, machined with expert precision. Because of fine workmanship and careful alignments, the operation of this press is said to be remarkably easy and trouble-free.

THE S & H HYDRAULIC PRESS

This is a completely automatic printing press consisting of a 1-horsepower, worm-gear-driven motor, which activates the bed on a rack-and-pinion device. Pressure is applied hydraulically by a motor connected to a hydraulic pump. An electrical control system, protected by overload switches, operates the press from a push-button panel connected to the press frame. This permits extremely easy application of pressure, as well as forward and reverse bed travel under power. The press construction is specifically designed for heavy-duty use and consists of a steel press bed, linoleum cushions, and galvanized steel top surface. A sturdy and clean framework contributes to the efficient operation and easy maintenance of this press.

Several other presses have been built recently. Each has an advanced design that departs radically from that of the traditional hand press. These are prototype experimental models designed for heavy-duty professional use. For the present time, they are not mass-produced, but they can be constructed on special order. A description of these newer models follows. Inquiries with respect to these presses should be directed to the individual manufacturer.

THE TYLER PRESS (GEMINI G.E.L., LOS ANGELES)

This press is a variation of an earlier mechanized press designed by Kenneth Tyler, Director and Master Printer of Gemini G.E.L. The new machine is electronically operated by hydraulic pistons for pressure regulation and bed drive. Pressure can be very precisely regulated by means of a pressure gauge. The press has an extremely long bed, allowing the printing of very large works. Design and construction include very sophisticated engineering details which make possible further refinement of the precision printing for which this shop is already noted. Several slightly smaller models of this press, which have recently been constructed, offer additional improvements on the basic design.

THE ANTREASIAN PRESS

This press, designed by the author, has been in dependable operation at the Herron School of Art in Indianapolis since 1963. The machine has a stationary bed over which a movable arbor carries the scraper box. Pressure is applied automatically by a hydraulic piston and is set and recorded by means of a pressure gauge. Like the Tyler press, the entire mechanism is motorized and electronically controlled.

Before the construction and operation of the hand press is described in the following sections, mention should be made of serviceable press sizes and drive systems. The most useful presses have printing beds measuring 26 × 41″, 32 × 49″, 30 × 50″, and 34 × 53″. The size of the press bed determines the maximum dimensions

a. Overall view of the press

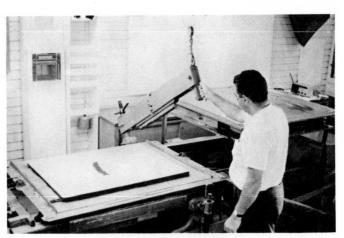

b. Preparing to engage the scraperbox

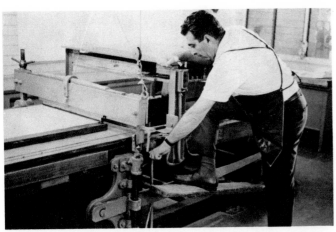

c. Detail showing the scraper engaging mechanism

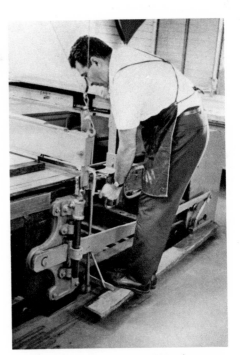

d. Engaging and locking the scraper

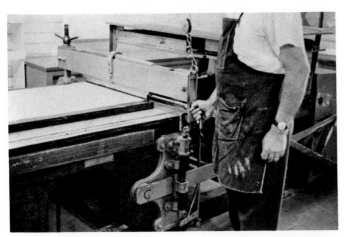

e. Disengaging the scraper

13.1 The mechanically powered French press

a. End view of the Brand press

b. Side view

c. The gear box, clutch and crank

d. The clutch lever engaged

e. The pressure cam engaged

13.2 The Charles Brand press

of work that can be printed; it must be remembered that additional clearance must also be provided for the press tympan, which is always larger than the printing element. Press beds wider than 36 inches present difficulty for the printer in the inking of large stones.

All hand presses should have compound gearing to reduce the manual effort required to crank the bed. The larger presses can be motorized if desired; although manual exertion will be reduced somewhat by this means, there will be little gain in production speed.

13.2 PRESS CONSTRUCTION AND OPERATING PRINCIPLES

The construction and operating principles of the traditional hand transfer press are essentially the same for all makes and sizes. (See fig. 13. 3.)

1. Two cast-iron frames are bolted together and held rigidly by cross bars at the front and back.

2. A cast arch is bolted between the uprights of the frame.

3. A screw that regulates pressure passes through the arch and is attached at its lower end to the scraper box. The screw is turned by a key or pin inserted through its top. This permits the regulation of pressure by raising or lowering the scraper box.

4. The scraper box is a heavy metal cross bar channeled along its underside for housing the scraper bar. A set screw for securing the scraper bar is positioned at the center point of the box. The box, free at each end, is self-aligning to the stone when pressure is applied.

5. The scraper bar is a wooden blade with a beveled contour along its lower edge. A strip of leather is stretched tightly along this edge to serve as a resilient cushion when pressure is exerted between the scraper and the tympan sheet. Because the scraper is not an integral part of the press, it will be described separately in sec. 13.3.

6. The press bed is constructed of heavy maple planks. These are held together by cast-iron end frames. A series of thin iron straps is screwed along the length of the bed on its underside to provide traction and to prevent frictional wear when the bed is moving. It is essential for the press bed to have a true plane without indentation or warp. A sheet of battleship linoleum is fastened on the upper side of the bed as a cushioning. Over this sheet, a thin sheet of zinc, aluminum, or galvanized metal is secured to provide a durable and easy-to-clean work surface. The long sides of the bed are protected by metal slides, which reduce friction as the bed moves within the rails of the press frame. Its movement is sup-ported by a series of wheels called *bed runners*, which rotate in shafts that are an integral part of the frame.

7. The operating mechanism consists of three basic units: (a) the pressure lever, (b) the connecting rod and cams, and (c) the bed roller, gears, and handle.

a. The pressure lever is a heavy steel rod connected to the cams. When the rod is lowered, it rotates the cams, thus raising the bed roller into contact with the press bed.

b. The cams rest on bearing blocks which are seated in slots on the lower part of the frame uprights. The connecting rods rest on the cams, and the ends of the rods support the shaft of the bed roller. The bearing blocks are fitted with turn screws for adjusting the level of the bed roller and press bed.

c. The bed roller is a steel cylinder of large diameter which carries the press bed forward and backward when the press is engaged. A turning handle, or crank, is attached on one end of the bed roller, and a gear train is attached on the other end.

When the pressure lever is upright, the press is disengaged. In this position, the cams do not permit the bed roller to make contact with the press bed. This permits the bed to be pulled or pushed by hand along the bed runners. When the pressure lever is brought down, the actions of the cams and connecting rods raise the bed roller into contact with the bed.

Thus engaged, the bed may be cranked forward or backward by means of the handle and gears. The movement is produced by the friction of the bed roller turning against the metal strapping on the underside of the bed.

8. Tympans were originally an integral part of the hand press; they consisted of an iron frame hinged to the leading edge of the bed. The frame was covered with a thin sheet of zinc or leather, lubricated on its top surface. The tympan frame was lowered over the printing stone and paper, serving as the bearing surface over which the scraper would glide when the press was in operation. This system was heavy and cumbersome, and was eventually replaced by simple, removable tympans that could be easily positioned by hand. Since these are no longer an integral part of the press, they are described separately later. (See sec. 13.5.)

13.3 THE SCRAPER BAR

The scraper bar is a bladelike attachment on the press which passes over the tympan sheet, impressing ink on the print paper. It is made of seasoned, straight-grained maple. Other woods, such as birch, boxwood,

13.3 Graphic Chemical and Ink Co. press

13.4 The Griffin press

and poplar, may be substituted; however, these are less durable. The scraper is cut from stock measuring 7/8 × 3 3/4″. One edge is beveled with a slightly round contour so as not to cut the leather strap that is tightly stretched across it.

The crispness and fidelity of the printed impression greatly depends on the design of the scraper contour. The bevel must not be excessively thin, and the edges should not be too sharp; otherwise, the leather strap will be indented when pressure is applied, and the blade edge will deteriorate rapidly. If the blade edge is too broad, it will produce coarse impressions; at the same time, the friction produced will cause difficulty in operating the press. The scraper wood should be milled to contour and a supply of 6- to 8-foot lengths should be kept in the shop for periodic replacement of worn bars.

Irregularities along either the beveled edge of the bar or its leather covering will produce faulty printing. Surface nicks, gouges, and rough spots must be sanded smooth; worn leather should be discarded. The beveled edge of new, as well as old, scrapers should be dressed by running the wood back and forth against a lithograph stone onto which sandpaper has been attached.

The length of the scraper bar to be used depends on the size of the printing element. A well-equipped shop should have scrapers with length conforming to the width of each stone in the shop. Additional bars of intermediate length (graduated from the standard set by decrements of 1/2 to 2 inches) offer even greater opportunity to accommodate every conceivable image width. When possible, it is advisable to have a set of scrapers for each press in the shop. It will then be possible for works of similar sizes to be printed simultaneously on all presses. The length of each scraper should be indicated on its side, and the centerline should be marked on both sides to ensure correct positioning in the scraper box.

Leather straps for scraper bars are made from 1-inch wide cowhide or horsehide belt blanks (purchased from leather-goods shops or saddleries). The belt blanks are soaked in water or neat's-foot oil and then stretched (smooth side outward) as tightly as possible over the beveled edge of the scraper. The leather is fastened with nails to each end of the scraper, and the ends of the leather are shaved to conform to the thickness of the bar. The surface of the leather should be dressed with cup grease or similar lubricant to keep it soft. Occasional washing with solvent will be necessary to remove the accumulation of tympan grease. Periodic tightening of the scraper leather may also be necessary. If the leather is too loose, it may produce slurred impressions.

The scraper is fitted accurately into the channel of the scraper box by means of the centered thumb screw, which locks it into position. Care should be taken that the bar fits snugly along the length of the scraper box, that it is centered, and that the screw is firmly tightened so that the scraper will not vibrate when the press is operated. Sometimes the channel of the scraper box is wider than the width of the scraper, so that the blade, when secured, is not perpendicular to the printing element. This will produce a faulty impression, because the contour of the beveled blade is not in accurate contact with the stone surface. This condition may be corrected by gluing a thin strip of Masonite to the scraper bar, so that it will fit snugly and perpendicularly into the scraper box.

13.4 THE PRESS BOX

The press box is located astride the rear of the press frame and functions as a storage compartment for scrapers and tympan sheets. It is a simple wooden box with two shelves. The two sides rest on the rails of the press frame, and the rear of the box fits securely against the arch of the press. The top of the box is level with the top of the arch, so that the tympan and backing sheets can be laid on it during printing. For easier cleaning the top of the box may be covered with plastic film, sheet metal, or oil cloth. It is important that the press box be clean at all times, so as not to soil the bottom surface of the tympan and backings.

Scraper bars are stored on edge, leather side uppermost, in slotted compartments located on one shelf; the other shelf can be used for storage of small tympan sheets.

13.5 THE TYMPAN SHEET

The press tympan is a thin, smooth sheet of plastic or metal that is used to cover the printing element and print paper during printing. Its lubricated top surface travels in contact with the scraper bar when the press is in operation.

The best and most serviceable tympans are made from plastic sheets of high-impact glass epoxy (Panelyte 161, type Gee., .031 gauge). They are lightweight and easy to clean; with reasonable care, they are remarkably durable. Until a few years ago, pressboard was the standard material for press tympans. It deteriorated rapidly, however, necessitating frequent replacement, and it was hard to clean. Some printers used zinc or aluminum

Overall view of the press

Detail showing the control panel and hydraulic pressure gauge

13.5 The Antreasian hydraulic press

sheets (both subject to curling under heavy pressure). Nylon-impregnated phenolic sheets have also been used. To date, the glass epoxy sheet, although somewhat more expensive, has proved to be superior to all other tympan materials.

Different sizes of tympans are needed to correspond to the various sizes of stones in the shop. To ensure easy handling, they should be several inches larger, all round, than the stone or plate supports. For example, stones 16 × 20″ require tympans 20 × 26″, stones 22 × 30″ require tympans 24 × 36″, and stones 30 × 40″ require tympans 32 × 48″.

Tympan sheets should carry lubricant on their top surfaces (see sec. 13.6, below) to reduce friction and to provide a smooth traverse as the printing element is carried under the scraper. The bottom surface of the sheet must be kept very clean; any trace of ink, dirt, or lubricant grease will be transferred to the backing sheets, and, in a matter of time, it will invariably find its way onto the print papers and printing element. Dirty tympans should be washed with lithotine or gasoline. Kerosene is never used for this purpose because its greasy content would stain the backing sheets. The underside of the tympan is periodically wiped with talc to ensure cleanliness.

Attention should always be given to the condition of the tympan. In addition to being clean and well lubricated, the tympan should be free of dents and irregularities, for these will lead to faulty printing. Damage of this sort is most likely to occur when the traverse of the scraper overrides the trailing edge of the printing element. The impact of pressure along this edge can split or crease the tympan, ruining it. Damaged tympans cannot be repaired; they can, however, sometimes be cut to a smaller size.

It is worth noting that tympan sheets (especially those made of plastic) induce static electricity when passed through the press under heavy pressure. The drier the surrounding atmosphere, the stronger will be the charge. Although this is not dangerous, it can produce an unexpected and mild shock. Anti-static liquids (applied to the underside of the tympan from pressurized containers) have been used with some success to minimize static charges. Special handling procedures for the removal of the tympan and backing are necessary; these will be described later.

Large tympan sheets are hung from the ceiling or wall near the press station. To facilitate hanging, a small hole is drilled through the sheets at the extreme outer corners of one end.

13.6 TYMPAN LUBRICANT

Fresh lubricant is placed on the tympan sheet at the beginning of printing and as often as necessary thereafter to provide a smooth press action. The correct amount depends on the size of the tympan. Several ribbons of grease, of the width of the scraper, are usually enough. Too much grease will spread beyond the scraper traverse, and prevent clean handling. On the first pass through the press, the ribbons of lubricant will level and collect in a

bead at the trailing end of the traverse. At the start of the next pass through the press, the tympan is reversed end for end, so that the scraper can be brought down on the collected bead of grease. In this way, the tympan is alternated for each printing pass, so that the scraper can start under a fresh bead of grease. Unless the tympan is carefully aligned for each pass, the lubricant will become gradually dispersed. The grease should be periodically redistributed or replenished on the tympan in order to maintain constancy in press action. Care must be exercised to avoid pushing the lubricant bead over the edge of the tympan sheet; otherwise, the grease may drag under and spoil the impression. The tympan must then be touched up with talc, so as not to stain the backing sheets. Careless handling of the tympan by beginning lithographers is common. The printer must practice keeping the lubricant in a steady pattern on the tympan in order to minimize hazards to the work.

In the past, the traditional tympan lubricant was mutton tallow. Although this is a satisfactory lubricant, it has a tendency to collect dust, and when rancid, it has a particularly offensive odor. Today, most professional printers favor commercial lubricating greases. *Cup grease* is one such lubricant; it performs very well on metal and pressboard tympans. Plastic tympans require another type of lubricant. The press pressure tends to squash the lubricant on these smooth, nonporous sheets; the grease bead is pushed along in front of the scraper, which is then forced to ride on a relatively dry surface. Specialized industrial greases are now available, which, through their plating action, can overcome this problem on plastic surfaces. Even when pushed ahead of the scraper, they leave a thin, tenacious, and slippery film that is reinforced each time the press is operated. Thus, the lubrication of the tympan progressively improves, and the need for continual relubrication is decreased. One such commercial lubricant is Darina-AX, produced by the Shell Oil Company.

A can of tympan lubricant should be within easy reach at each press station. The grease is dispensed on the tympan with a spatula that has a broad flexible blade. Rubber or plastic mixing spatulas, sold as kitchen utensils, are excellent for this purpose.

13.7 BACKING SHEETS

Backing sheets are placed between the tympan and the print paper to provide resiliency and to keep the back of the impression clean while the work is passed through the press. The type of backing material used will have a definite effect on the character of printed impressions.

Soft and thick backings produce soft impressions because of their greater cushioning properties. Thin backings provide less cushioning, thus producing hard and crisp impressions.

Several different types of paper are used to make backing sheets. Soft backings are made with single-thickness blotting paper (white porcelain finish). Even greater cushioning can be obtained by taping two layers of newsprint to the covers of the blotter. This system is satisfactory up to the maximum blotter size of 26 × 38″. Soft backings for larger works are made with three to five sheets of newsprint taped together at their four corners. Backings made from blotter paper are excellent for small works, because their rigidity permits easy handling. In larger sizes, however, they tend to be somewhat awkward to manipulate; moreover, because of their size, they cannot be laid on the press box alongside the tympan.

Large backing sheets of newsprint are handled in the following way:

1. As the pressure of the press is released, the press assistant raises the trailing edge of the tympan, while the printer holds down the backing sheet against the action of static electricity.

2. While the tympan is being removed by the assistant, the printer pulls back the press bed with one hand; as it is returning, he grasps the left edge of the newsprint backing and lightly doubles the sheet against itself. The doubled sheet may then be lifted from the print and placed on the press box by the time the press bed has reached its starting position.

3. Folding, wrinkling, and creasing of the newsprint backing sheet during printing should be avoided, because such imperfections will impress the back of the print paper and cause faulty impressions.

Thinner and somewhat tougher backing sheets can be made from smooth vellum proof paper. Radar vellum is one such paper. Either one or two sheets may be used, depending on the degree of resiliency desired.

Backing sheets are cut to the same size as the printing element or slightly larger. Backing sheets that are smaller than the printing element cannot fulfill their protective function. Backings should be immaculate at all times, and should be replaced as often as necessary to ensure cleanliness during the course of printing.

13.8 MAKEREADY

Occasionally, a stone will print impressions that are lighter at one end than at the other. If the problem cannot be attributed to uneven inking, it is likely that the surface

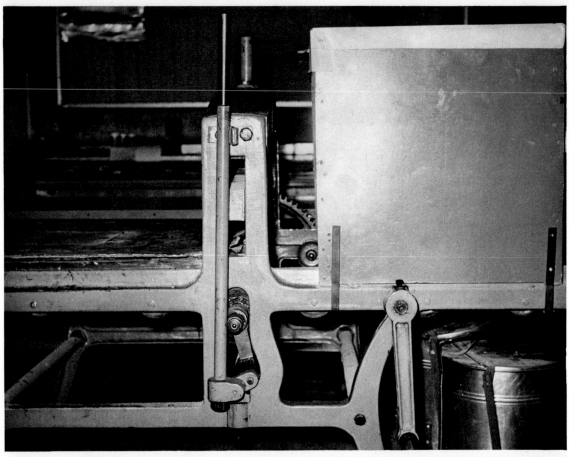

The pressure lever disengaged

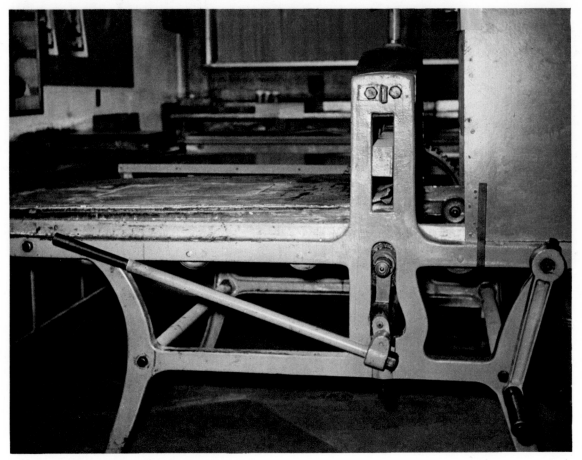

13.7 Side view of the traditional hand press

The pressure lever engaged

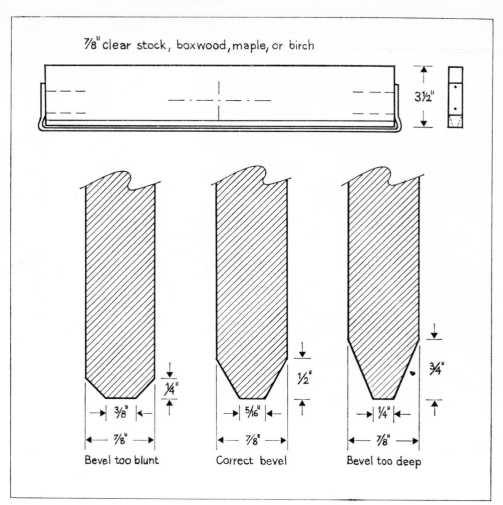

7/8" clear stock, boxwood, maple, or birch

3½"

13.8 Scraper bar detail

Bevel too blunt Correct bevel Bevel too deep

3/8" 5/16" 1/4"

7/8" 7/8" 7/8"

1/4" 1/2" 3/4"

of the stone is lower at the light end of the print than at the dark end. In this condition, the surface cannot receive equal scraper pressure along its length. One can usually feel this difference (produced through careless stone grinding) while cranking the work through the press.

This problem, if it is not too pronounced, can often be corrected by positioning a staggered layer of newsprint strips cut to the width of the stone underneath its low end. This procedure, called *makeready*, must be taken with care; if the strips are too sharply staggered, the stone may fracture as a result of unequal pressure.

13.9 OPERATION OF THE PRESS

The press is operated according to the following steps:

1. A scraper is selected just slightly smaller than the width of the printing element, but larger than the image. The scraper is centered and locked in the scraper qox by means of a set screw.

2. The printing element (lithograph stone or plate support) is centered on the press bed and aligned to travel evenly under the scraper.

3. The press bed is pushed until the leading margin of the stone or plate (but not its image) is just under the scraper. This position is determined by sighting through the opening of the press frame. A piece of masking tape is affixed to the edge of the press bed, in line with the frame; this indicates the starting point of the press traverse.

4. The press bed is pushed until the trailing margin of the printing element is just under the scraper. A second piece of tape on the press bed, in line with the frame, indicates the stopping point of the press traverse.

5. The press bed is returned to its starting position; the stone or plate is washed out and rolled up with ink. The print paper is positioned, then the backing sheets and tympan.

6. The pressure-regulating screw is adjusted until the scraper just touches the tympan. The screw is then loosened in half revolutions until the pressure lever can be brought down smartly. The press is in gear when the pressure lever is all the way down.

NOTE: The Brand press has a small clutch pin near the crank, which must be pushed in before the bed roller is engaged.

7. The press is cranked steadily, permitting the work to be passed under the scraper, which functions like a squeegee blade. The cranking is stopped when the trailing traverse mark is aligned with the frame upright. The speed of the press traverse is less important than the

Scraper bars, covered and uncovered Stretching and nailing the leather on the scraper

13.9 Scraper bar construction

smoothness of its passage. Press operation should be steady and constant, rather than halting and jerky.

8. The pressure lever is released; the bed, now disengaged, is returned to its starting point.

NOTE: The Brand press requires the disengagement of the clutch pin, after the pressure lever is released; this enables the bed to be freewheeled back to its starting position.

9. The tympan is carefully removed so as not to slur the work. It is placed with its lubricated side up on the press box. The backing sheets are carefully removed and placed clean-side up alongside the tympan.

10. The print is removed, the printing element is dampened, and the impression is then examined before being placed between the slip sheets of the paper pile.

11. The entire sequence, from step 5 onward, is repeated for each impression to be printed. Step 6 is eliminated after the correct press pressure has been achieved.

13.10 ADJUSTMENT OF PRESS PRESSURE

The correct press pressure necessary for printing fine impressions will vary from one work to another.

Crayon drawings and handwritten texts require somewhat less pressure than do wash drawings. Printing large solid areas requires very firm pressure; papers that are printed dry require considerably more pressure than those which are printed damp.

Unfortunately, there is no instrument on the traditional hand press by which press pressure can be easily determined. Engineering tests on old hand presses have shown that pressures varying from 9,000 to 13,000 pounds per square inch are necessary for printing most lithographs on dry paper. By comparison, pressures approximating 6,000 to 10,000 pounds per square inch are sufficient for printing works on dampened paper. Within these ranges, the printer must rely on past experience to determine the correct degree of pressure for each work. Descriptions based on the feel of muscular strain necessary for bringing down the pressure lever are subjective and often misleading. Pressure leverage feels different on each press and is further conditioned by individual physique. In addition, greater exertion is necessary for pressure application on large works than on small ones. This is so because the pressure load is distributed along a greater span of the longer scraper bar. Because of these factors, correct pressure adjustment is difficult to describe.

13.10 View of press box

End view of the press box showing storage of scraper bars

NOTE: The Tyler and the Antreasian hydraulic presses have automatic pressure gauges, by which very precise pressures can be regulated. As other presses are manufactured, the incorporation of such instruments will provide a reliable system of pressure regulation.

In the final analysis, the quality of the printed impression is the most reliable determinant of correct press pressure. If a satisfactory impression of the printing image is obtained, the pressure can be assumed to be correct. However, the printer should understand that an impression that appears weak may be as much the result of faulty inking as it is of insufficient press pressure. Similarly, too strong impressions can result from overinking, as well as from too much pressure. As described in Part One, printing pressures that are too strong, or too weak, can be hazardous to the printing image. Generally, image deterioration from weak press pressure is more

prevalent than deterioration from strong press pressure.

Press pressure should be regulated during the proofing process. Moderately firm pressure is advisable at the outset of proofing on newsprint. The pressure is gradually adjusted, when necessary, after careful checking of the inking of each successive impression. Modifications of pressure should not exceed one-eighth of a turn on the pressure-regulating screw at any one time. Increments in this amount are estimated to alter the pressure by 1,000 pounds per square inch. Pressure adjustments that produce satisfactory newsprint impressions should be increased by one-eighth of a turn before printing on intermediate-quality proof paper. Sometimes an additional eighth turn is necessary in proceeding from intermediate proof paper to the fine edition paper. These increases in pressure are required because the edition papers are considerably heavier and somewhat less pliable than

newsprint. Final adjustments of pressure must be made before the *bon à tirer* impression is printed. Thereafter, the pressure should remain unchanged throughout the printing of the edition.

It is worth noting that many older presses have loose pressure regulators. The bushings through which the pressure screw passes become worn and cannot hold it firmly in position. When the pressure lever is released, the vibrations in the press frame can shift the position of the screw, resulting in changed pressure for the next impression. Either the worn bushings should be replaced, or the screw should be marked with an alignment on the press arch. In this way, it can be periodically checked to prevent shifting.

13.11 PRESS INSPECTION, ASSEMBLY, AND MAINTENANCE

The hand press is the most costly item of equipment in the lithography shop and one of the most important. It requires careful installation and frequent cleaning if it is to give efficient and dependable service. Improperly maintained presses are not only strenuous to operate but (more important) incapable of producing good work. In addition, when an older press breaks down as a result of improper care, repair is frequently expensive and time-consuming. Consequently, all hand printers should become familiar with the important aspects of press installation, and should establish regular periods for press maintenance in the over-all operating schedule of their shops.

INSPECTION AND OVERHAUL

Older hand presses which have seen hard use or which have received poor care should be completely dismantled for inspection and overhaul. The following items should be examined:

Press Bed

1. The bed should be stripped of its cushioning, so that the wooden planks can be examined for warp, splits, and separation. It is essential that a smooth and true plane exist along the entire length and breadth of the bed.

2. The metal straps beneath the bed should be wire-brushed and examined for dents and loose screws. The metal guides along its sides should be burnished and greased.

3. Worn cushioning should be replaced by new battleship linoleum or other tough resilient material. If the outer covering of the bed is dented or worn, it should be replaced with aluminum or galvanized metal.

Bed Roller

The bed roller should be checked for worn and uneven spots, as well as for severe pitting. Worn rollers must be remachined. Dirt and corrosion should be removed by wire-brushing and washing in solvent. The roller shafts should be burnished clean and greased again.

Cams

The cams and connecting-rod pins should be carefully examined for wear. Since these parts support the entire press pressure, they are most susceptible to wear if poorly greased. Worn cams and pins can produce uneven lifting action on the bed roller, which results in unequal pressure loads on the stone. Such cams or pins should be replaced by new parts.

Cam Blocks

The cam blocks must be clean, unworn, and well greased if they are to support the cam action effectively.

Gears

The gears should be thoroughly cleaned and greased again.

Pressure Screw

The pressure screw, as well as the fittings that secure it to the scraper box, should be cleaned and greased.

Press Arch

1. The upper fitting for the pressure screw is below the center point of the press; it is reached from underneath the press arch. The fitting is attached by means of long bolts through the arch; the bolts are fastened to the top of the arch on either side of the pressure screw. A series of leather washers on each bolt provides cushioning action to protect the arch from breaking under severe pressure. These washers should be replaced if they become badly worn. Old presses on which these washers are missing can be damaged, unless cushioning is provided at this critical stress point.

2. The press arch should also be examined for cracks and flaws. The brittleness of the cast-metal frames of old presses is a frequent cause of breakage, which can occur along numerous stress points. The press arch is one of the most common locations of breakage.

Bed Rider Wheels

The riders should be examined and replaced if they are worn. Their spindles on the press frame should be well burnished and greased. The rider wheels vary in circumference and strength on some press models; the wheels are usually numbered in sequence, so that, if removed, they can be put back into position correctly. It is essential that the riders be replaced in the proper sequence and matched on both sides of the press. The purpose of the bed riders is to provide proper support and planar travel for long press beds.

a. Centering and locking the scraper bar

b. Aligning the stone and scraper

c. Positioning tape to indicate the starting point of the bed traverse

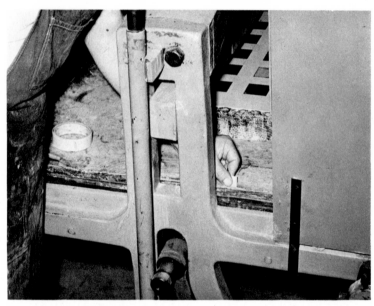

d. Positioning tape to indicate the end of the bed traverse

13.11 Operating the hand press

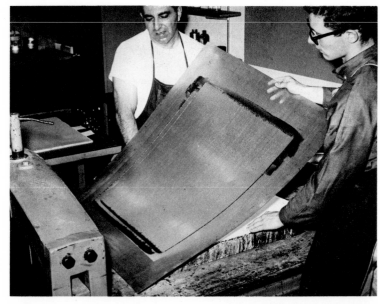

e. Positioning the tympan sheet

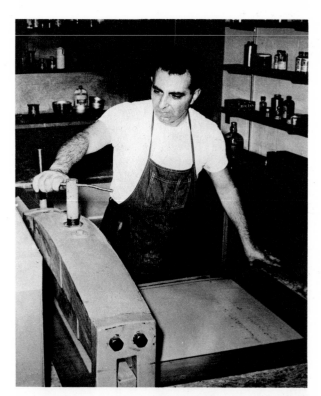

f. Adjusting the pressure screw

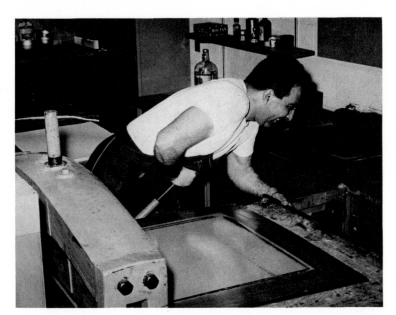

g. Applying pressure to engage the press

h. Cranking the press

Press Frame

1. The press frame and its connecting rods should be inspected for flaws and fractures. A broken frame can usually be repaired either by brazing or by attaching welded or screwed reinforcements. The frame is wire-brushed to remove scale and dirt; after having been washed with solvent, it should be painted with several coats of machinery enamel.

2. All exposed points of friction should be lightly oiled or greased, depending on their function. Medium-weight machinery oils, cup grease, and gear lubricants are most frequently used.

ASSEMBLING THE PRESS

The most important part of the assembly process is ensuring that the press is level and stationary. The leveling should be checked at several points:

1. A spirit level should be placed along the length of the bed roller to determine whether it is on a truly horizontal axis. If it is not, either the legs of the press frame must be raised, or the appropriate cam block must be raised to lift the low end of the roller.

2. The bed is cranked through the press after the pressure is applied. The bed roller should maintain even contact along the underside of the bed throughout its maximum traverse. If it does not, the bed may be warped, the roller worn, or the press frame twisted.

3. When the bed and bed roller rest true, but the bed does not travel evenly on the riders, the press frame may be twisted. The problem can also be caused by bed rider wheels that are worn or that have been replaced into position in an improper sequence of sizes.

4. Problems of leveling usually result from a combination of the above factors; furthermore, they can be aggravated by an uneven floor. These problems can be eliminated only by trial-and-error adjustments; unless they are overcome, the press will be subjected to severe strains, and its ability to function will be impaired.

5. It is advisable that the press be firmly anchored to the floor, once its permanent location has been determined. Unsecured presses will slowly creep out of position under the vibration of pressure leverage and bed movement. Such movement is annoying and detrimental.

MAINTENANCE

A strict program of press care should include the following:

1. The press bed should be washed with solvent or soap and water, after the completion of every job. It should especially be free of all traces of dried gum arabic. Even the smallest dried crust can produce an unevenness under a lithograph stone that can cause its fracturing under pressure.

2. Care should be taken that no oil or grease drops onto the bed roller when the press is in operation. A greasy bed roller will slip and lose traction against the press bed. When grease does touch the roller, the bed roller and the metal bed straps should be thoroughly washed with a nongreasy solvent; after being dried, they should be wiped with a little talc.

3. The shafts of the bed rider wheels should be oiled as often as necessary. Oiling should be done from once every few days to once a month, depending on the extent of press operation. It is important that the outer rims of the wheels be clean and dry, to reduce slippage against the press bed.

4. The gears, cams, connecting-rod pins, and pressure-regulating screw should always be well greased and relubricated as often as necessary. Gear keys should be inspected and tightened at the same time.

5. The inner sides of the press frame and metal guides of the bed rapidly collect rosin, talc, and dust particles during the work process. The gummy residue thus produced is a hindrance to smooth press action. Every two weeks, the accumulation should be removed with steel wool and solvent. After being dried, the metal surfaces should be lightly regreased.

6. The servicing of motorized presses and of presses with other special features will require additional steps in the maintenance schedule. These should be incorporated according to the manufacturer's instructions.

Professional maintenance practice requires that presses that are used regularly be dismantled every two years. They should be thoroughly washed, inspected, repainted, and regreased before reassembly, following the procedures already given.

CHAPTER **14**

The Inking Roller

14.1 THE INKING ROLLER

There are two basic types of hand rollers used for distributing ink onto the printing image. One type has a leather covering and is used mostly for printing with black ink; this roller will be discussed in secs. 14.2 to 14.8. The other type of roller, composed of synthetic or rubberized material, is used for color and specialized printing. Both rollers are designed to operate like a rolling pin. The rollers, along with the hand press, are among the most important and expensive items of equipment in the shop. They should be cared for accordingly, so as to provide continually good service.

The number of rollers used will depend on the size of the shop and the scope of its operation. One leather and one synthetic roller are minimum equipment for black-and-white as well as color printing. A larger and better-equipped shop should have several of each type of roller, in different lengths, to serve each press. In addition, one leather roller should be set aside to be used only for processing; another, perhaps, should be reserved for use with transfer ink. To ensure that he can meet any situation that may arise during printing, the printer should also stock an 8-inch hand brayer and several 2- and 4-inch rubber brayers for localized inking.

14.2 THE LEATHER ROLLER

Leather rollers are made in lengths from 12 to 18 inches. Larger sizes can be made on special request, but they are impractical because of their weight and awkwardness. The 12-, 14-, and 16-inch lengths are the most efficient sizes for both large and small works.

The roller is formed on a round wooden core, the ends of which are shaped to form spindlelike handles. A heavy felt or flannelette sleeving is fitted over the core; a very finely tanned calfskin is pulled over this sleeving. The sleeving and calfskin are drawn tight and sewn at each end. The outer covering of leather has a very fine seam along the length of the roller. This seam is sewn from the inside with hidden stitches to preserve the smoothness of the outer surface. For functional reasons that will be given later, the grained surface of the leather is outermost.

Two leather washers slip over the handles and rest against the ends of the core, acting as guards. They are followed by two leather grips, by which the roller is held. These permit the wooden handles to revolve freely without burning the hands from friction.

Rollers, as supplied by the manufacturer, cannot be used until properly conditioned. They may be conditioned by some manufacturers at extra cost; nevertheless, the printer will find that additional breaking in is necessary before the rollers are capable of producing satisfactory work. The process of breaking in usually requires several months of intermittent work on the roller to make the surface smoother and more pliable.

Once it is properly broken in, the leather roller must be kept in good condition. The performance of the roller depends on its porous surface, which should receive and discharge both ink and water equally well. The roller thus simultaneously applies ink and maintains the dampness of the printing element. (See sec. 14.8.) Furthermore, if it is carefully handled, the roller may distribute more or less ink and may lift off excess ink when necessary. Rollers in poor condition can perform none of the above functions satisfactorily and can permanently damage the printing image.

14.3 CONDITIONING NEW LEATHER ROLLERS

The purpose of conditioning is to prepare the leather so that its surface will be soft and pliable and its excess hairy nap removed. When properly broken in, the surface of the leather becomes almost like smooth velvet. In this condition, the roller becomes a sensitive instrument, capable of undertaking inking of the most delicate and demanding nature.

The following materials are used in conditioning the roller (see fig. 14.1): ink slab and roller rack, neat's-foot oil, #0 lithographic varnish, #5 lithographic varnish, #7 lithographic varnish, stiff roll-up ink, ink knife, and a broad spatula for scraping the roller.

PROCEDURE

1. As much of the neat's-foot oil as possible is rubbed into the leather surface. This requires a series of applications over several days, after which time the leather will be fully saturated and remain shiny. After each application has been absorbed by the leather, the roller should be lightly scraped before the next application.

2. The roller is rolled up in #0 lithographic varnish several times a day, being lightly scraped between applications, for approximately one week.

3. The roller is lightly scraped and rolled in #5 varnish for one week, according to the procedures in step 2.

4. The roller is lightly scraped and rolled in #7 varnish for several days, again according to the procedures in step 2. The successively stiffer varnishes will exert a pull on the longer and looser fibers of the roller; these fibers will be deposited on the ink slab. As the roller and slab are scraped for each new application, more and more loose fibers will be pulled away. At the same time, the excess thinner and softer oil and varnishes used for softening the leather will also be removed.

5. The roller is charged with rolling-up black ink several times a day for another week, during which time the slab and roller are scraped after each workout. By this time, the roller will have a very soft, velvety appearance. It can be gradually brought into service and, for another period of several weeks, used only for broad, coarse work. Roller nap will continue to be pulled off for some time after printing is begun. This will be observed each time the ink slab and roller are scraped. Separation of nap will continue for another six months, depending on the properties of the leather and the extent of use. This separation should not be viewed with alarm, since it will gradually lessen and finally disappear if the roller is constantly used.

Once it is started, the conditioning of the roller should be continued without interruption. If it is interrupted, there is some danger that the varnishes or inks absorbed on its surface may harden and stiffen the leather again. If prolonged interruptions (one week or more) are foreseen, the roller should be covered generously with mutton tallow before being put aside. This nondrying fatty substance will continue to keep the leather soft for indefinite periods of time. Because tallow is extremely greasy and will produce scumming, it must be thoroughly scraped out of the roller before the conditioning is resumed.

14.4 MAKING THE LEATHER HAND GRIPS

Leather hand grips for the rollers are easily made from smooth leather blanks, which can be obtained from either the roller supplier or leather-goods shops. The blanks measure approximately $4 \times 6''$. Two of these are soaked overnight in water; they are then formed over the handles of the roller and loosely secured in position, by tape or cord, until dry. Since many roller handles are tapered, the blanks may need to be shaped with a razor blade before they are formed. As the leather dries, it will permanently assume a tubular shape that should loosely correspond to the roller handle, at the same time permitting its easy rotation. Some printers prefer the grips to be sewn with a fine stitch along the seam. Sewn grips can also be obtained from some roller suppliers.

As the roller is used, the inner surface of the grips will gradually become worn from friction. The heat thus produced can dissolve the shellac on the roller handles. Dislodged flakes of shellac and worn bits of leather drop onto the ink slab or image and eventually find their way onto the printed sheet. Reducing the friction, by frequent dusting of the roller grips with talc, can prevent this from happening. Excess talc must be shaken or blown from the grips before the roller is used, so that the talc also does not drop on the inked image and spoil the impression. Many professional printers, whose hands have been toughened by long use of the ink roller, disdain the use of hand grips and avoid the problems resulting from their wear.

14.5 SCRAPING THE LEATHER ROLLER

The leather surface of the roller must be scraped during the time of its conditioning and periodically during its use. After conditioning, the frequency with which scraping must be done will vary (daily to once a week).

Rollers should always be scraped under the following

circumstances: (1) when changing from soft ink to stiff ink (but not necessarily when changing from stiff ink to soft ink); (2) when changing from transfer ink to printing ink; (3) when carrying an excess charge of ink; (4) when the leather nap is matted with emulsified ink and water, becoming flat and lifeless in appearance; (5) immediately after use with inks containing drier or color; and (6) when the surface is contaminated with dirt, dust, or lint particles. Scraping must be done with care so as not to gouge or mar the leather surface. First, the leather hand grips and washers are removed. The roller is either placed in chocks or held with one handle against the ink slab and the other resting against the abdomen. The broad scraping spatula is used on edge (see fig. 14.2); the printer grips it with both hands, pulling it from the far end of the roller toward himself, as he would pull a drawknife. A certain amount of ink will be scraped up with the first draw. The knife is wiped on a cloth, the roller is turned slightly, and a second draw is made. The process is repeated by turning and drawing, until the total surface of the roller has been evenly scraped.

One must be careful, while scraping, to apply an even pressure. The slackening of pressure will cause the blade to skip and bounce, which, in turn, may produce a series of nicks in the leather. As the pattern of scraping is completed, the roller is reversed end for end, and the process is repeated. The final scraping is done in the direction of the grain of the leather.

The direction of the grain of the leather is important in roller-scraping. When one scrapes against the grain of the leather, the nap of the leather will appear to rise. Vigorous scraping against the grain tends to cut off the longer fibers of the leather. When the roller is being conditioned, this cutting off is useful, since the fibers are usually too long. However, once the roller is in good working condition, further reduction of the length of fiber is not desirable. Thereafter, one should use only a light touch in scraping against the grain. When the scraping is in the direction of the grain, the nap will tend to lie down. This produces a somewhat smoother roller surface; the final scraping is done, therefore, in this direction. Some printers paint a color band on one handle

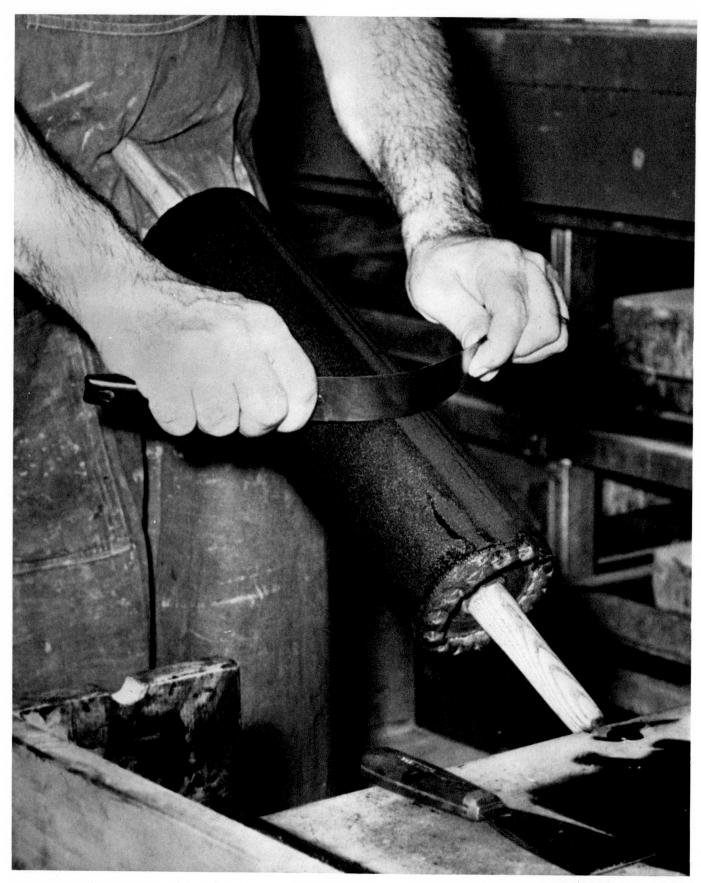

14.2 Scraping the leather roller

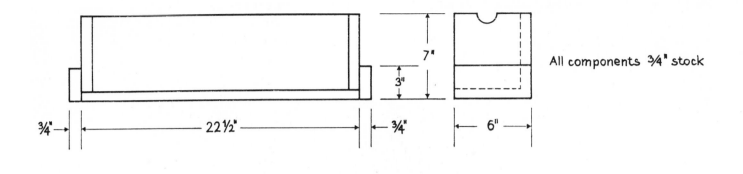

All components ¾" stock

of the roller to identify the direction of the grain. The usual procedure in scraping a roller consists of (1) initially going with the grain, (2) then going against the grain, and finally (3) once more going with the grain.

Some attention should be given to the seam that runs along the length of the roller. The seam, on old rollers, will often become filled with ink, which tends to force it open. Widened seams will cause welt or seam marks in the printing. Scraping should clean the seam, but it must be done carefully so as not to endanger the sewing cords. Difficult cases may require cleaning with a stiff suede brush.

14.6 STORING THE HAND ROLLER

It may be that more harm is done to rollers by improper storage than by improper use. Sound storage practices are necessary, not only to ensure the condition of the rollers, but also to protect a costly investment.

Rollers that are not in use should never be left lying on the slab, for, if this is done, they will tend to flatten on one side. They should always be placed either on special chocks or in a rack built for this purpose. Rollers should be covered with aluminum foil or plastic sheeting before storage to protect their surfaces from dust and dirt. Rollers that are to be stored for long periods of time should be scraped clean and covered with mutton tallow, lard, or some other nondrying grease before they are wrapped and put away. When the roller is to be used again, this coating must be thoroughly removed. After the coating is scraped off, the roller is washed with lithotine, scraped again, and immediately rolled up with ink.

14.7 RECONDITIONING OLD LEATHER ROLLERS

Dry and hardened ink films found on rollers that have been improperly used can be removed only with solvents and "elbow grease." Either kerosene or lithotine may be used for this purpose. Because of its oily content, kerosene will soften the leather while cleaning off the old ink. The roller must be well scraped after completion of this task; if it is not, the oily content of the kerosene will contaminate the printing ink and cause greasy proofs. If lithotine is used, on the other hand, the roller must be inked immediately afterwards; otherwise, this solvent will dry the leather.

Stubborn clots of dried ink must be well soaked with a stronger solvent, such as paint remover. A suede brush can be used for dislodging these dried ink particles; table salt is a good abrasive agent for roughening the dry matted leather.

14.8 TECHNIQUES OF HANDLING THE LEATHER ROLLER

In the hands of an expert printer, the roller is a delicate instrument through which every nuance of the lithographic image may be realized in the print. The printer's touch with this instrument will vary from one print to the next, just as the handling of the roller will vary from one printer to the next. An uninitiated observer, viewing the rolling techniques of several printers, would find it difficult indeed to discern a pattern of standard practice. Actually, the rolling techniques must vary from one individual to the next, since factors of

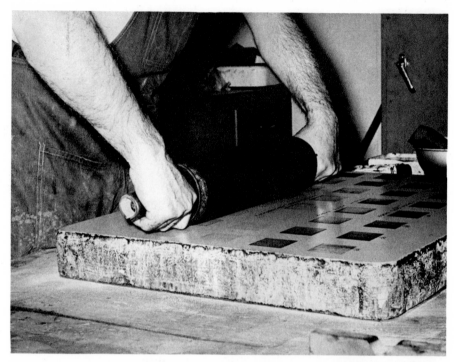

a. Position of hands and wrists at the beginning of the roll

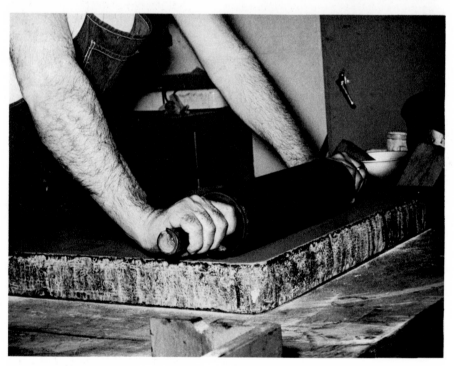

b. Position of hands and wrists at the end of the roll

14.4 Ink-rolling techniques

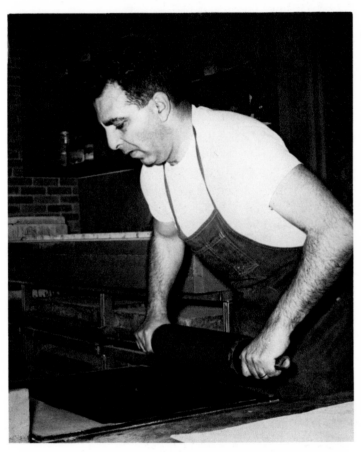

c. Charging the roller with ink

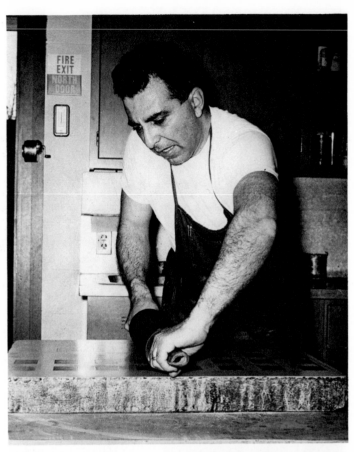

d. Rolling pattern, end to end

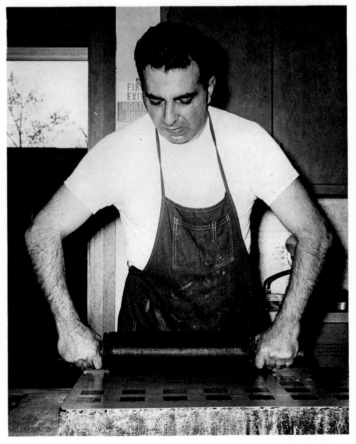

e. Rolling pattern, top to bottom

height, physique, pressure, leverage, and reach all play a part in the manipulation of the inking instrument. In the final assessment, each person must find his own method for achieving his own best results. The following principles, however, are fundamental to the proper control of the roller:

1. Heavy downward pressure on the roller deposits more ink. If one holds one's arms like an arch, maximum pressure may be applied over long periods of repeated inking, without undue strain.

2. The more tightly the grips are squeezed, the more ink will be deposited. Squeezing the grips increases both the friction and the movement of the roller.

3. Slow rolling produces heavier ink deposit, whereas rapid rolling produces lighter ink deposit.

4. Loose handling of the grips lessens friction and increases rolling speed; hence, less ink is deposited.

5. Rapid rolling may tend to fan the stone dry; one should guard against the ink attaching itself onto the dried surface.

6. Quick rolling, with light pressure and stiff ink, tends to lift off attached ink from areas where it does not belong.

7. Sluggish and slow rolling techniques can overload an image with ink. Many printers give a brisk, final pass of the roller over the image to lift excess ink and sharpen the image.

The roller grips are held with the backs of the thumbs toward the body and the fingers turned away from it. The roller is pushed away from the body to arm's length. The grip is slightly tightened, and the roller is pulled back to the starting point on the ink slab. The roller is slightly lifted from the slab and rotated one-quarter turn; the grips are relaxed, and the cycle is repeated. Pushing the roller away and returning it constitutes one full pass. A number of passes are necessary to fully charge the roller with ink. Lifting and turning the roller every few passes enables all of its surface to receive ink. Brisk rolling on the ink slab is beneficial, since it tends to pull up the nap of the leather and open its reservoirs, thus improving both its inking and dampening properties.

Several characteristic problems may often occur during rolling. Sometimes, the operator, without realizing it, may have a tighter grip with one hand than with the other. By squeezing the roller grips unequally, he may deposit a greater amount of ink from one end of the roller than from the other, thus producing uneven inking. Often the tensions resulting from inking will cause the novice to squeeze the roller grips inadvertently, thus slowing the revolutions of the roller; because of the increased pressure, greater amounts of ink will be deposited. Occasion-

ally, an uncoordinated printer will permit one end of the roller to engage the work slightly before the rest of the roller touches the stone. Since the forward movement of the inking pass is under way as this occurs, a slight skidding takes place, which produces ink marks at the first point of contact. These marks are sometimes difficult to roll out. In such cases, the stone should be gummed and washed out before inking is undertaken again. It is important to approach the inking in a relaxed state and to coordinate the movements so that equal pressures are exerted along the axis of the roller at all times.

One of the most mystifying problems for the novice is the development of light bars, or stripes, in the inking. These are usually most noticeable in the darkest passages, parallel to the axis of the last rolling. They are produced by the depletion of ink from the roller, the circumference of which is insufficient to span the breadth of the inked passage. If the roller is recharged with ink and the rolling pattern is repeated, the light bar will continue to appear in the same position. If this phenomenon occurs during printing, the novice may assume that it is the result of a faulty scraper bar (which produces a similar effect). When the problem continues even after a new scraper is put in position, the novice is completely puzzled and cannot comprehend that the light bar could be caused by faulty inking. This problem can be solved by manipulating the rolling patterns from many different directions, to equalize the ink deposit. Several types of rolling patterns that can be used to overcome this problem and to assure even ink distribution are illustrated in fig. 14.5.

The friction from the roller handles can be hard on tender hands. As the skin toughens, calluses will eventually develop between the thumb and forefinger. Pieces of tape, worn at these points, will help prevent blisters when one is beginning work.

During long runs of printing, as the roller's pores become clogged with water, it loses its capacity to pick up and deposit ink. A light scraping of the ink slab and roller is necessary. Fresh ink is laid out, and the roller is vigorously passed over the slab, being banged down solidly at the outset of each pass. This operation, called *knocking up* the roller, helps to restore its pliancy and ink receptivity by roughening its nap.

14.9 ROLLERS FOR COLOR PRINTING

Ink rollers for color printing fall into five basic categories, listed here in the order of their evolution in the printing industry: (1) leather, (2) gelatin or composition, (3) rubber, (4) vulcanized oil, and (5) plastic. All color hand-printing rollers, the synthetic varieties included, are

shaped much like the previously described leather rollers and are available in comparable sizes. The following general comments concern the various methods of fabrication for each type of roller and indicate characteristics of their performance.

Leather Color Rollers. Leather rollers may be used for color printing and are capable of excellent performance. A set of three to five rollers, however, is necessary to assure clean ink mixes for multicolor printing. Because leather rollers are a costly investment and require time-consuming procedures of conditioning, cleaning, and storage, they are not so widely used in color printing as they are in printing toned blacks. Leather rollers for color printing are discussed more fully in sec. 14.11.

Gelatin or Composition Rollers. For many decades the classic color-printing roller was of glue-glycerine composition. The covering material was reclaimable, and the rollers were cast in steel molds by a simple, inexpensive process.

Although composition rollers are sometimes still used in hand printing, they are not recommended because of their inferior performance. They are adversely affected by temperature change and by moisture, becoming hard in cold weather and very soft in hot weather. Gelatin rollers distribute ink less effectively than other types of rollers because they pick up excessive amounts of water from the stone. This results in a problem called *stripping*, wherein the roller rejects ink from its surface and refuses to accept a fresh supply. Composition rollers have low resistance to physical damage; hence they must be handled with great care to avoid denting or rupturing.

Rubber Rollers. Natural rubber rollers were introduced in the printing industry in the 1920s. These were an improvement over the composition rollers in dimensional stability and durability. They had one basic defect, however: they were subject to deterioration in the presence of oily inks and solvents. The problem remained unsolved until the introduction of synthetic rubber in the 1930s under the trade name Duprene, later improved and called Neoprene. Still later the German product Buna N was introduced in this country and is today the standard oil-resistant synthetic-rubber roller covering.

The manufacture of synthetic-rubber rollers is a complex process still largely done by hand. Essentially, the synthetic composition is calendered into thin sheets and spiraled onto the roller core under high pressure. Afterwards, it is vulcanized under steam pressure for about six hours at 300° F. After curing and cooling, it is ground on a lathe to final tolerance and surface finish. The many intermediate steps of the process are critical and time-consuming. Hence rubber rollers of fine quality are

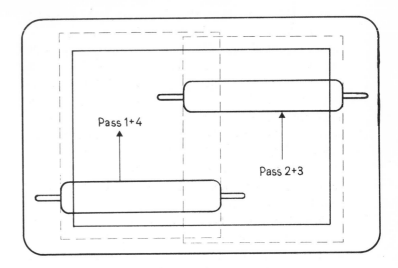

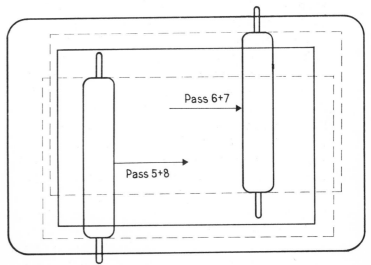

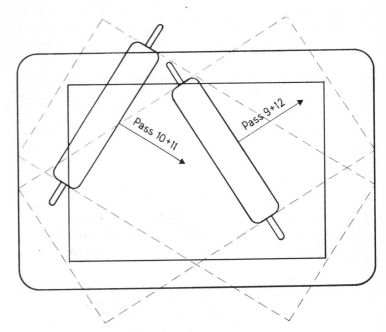

14.5 Rolling patterns

considerably more expensive than glue-glycerine types.

Rubber rollers are perhaps the most durable of all the rollers except plastic. They have excellent resistance to abrasion and are not appreciably affected by temperature or humidity change. Their principal disadvantage is that they are somewhat heavier than other types of rollers. They are more difficult to wash, because of the absorbency of their surface. They also deposit ink somewhat less sensitively than vulcanized-oil rollers. Rubber rollers tend to harden somewhat after prolonged service, because of the extraction of their plasticizers by the ink vehicle and wash-up solvents.

Vulcanized-Oil Rollers.* Vulcanized-oil rollers are made from various natural drying oils such as linseed, soy bean, or corn oil. The oils are rendered solid at room temperature by the addition of such curing agents as sulphur monochloride. The mixture is poured into a hollow tube, slightly larger in diameter than the desired roller. The partially filled tube is placed in a high-speed lathe and rotated until solidification is complete. During rotation, all foreign material is thrown to the outside of the tube, where it will be ground off. After solidification the roller core is inserted and the intervening space is filled with a similar, though softer, oil-chemical mixture. After the roller is thoroughly set, it is removed from the mould and ground to size and concentricity in a lathe or grinder. After it is capped with brass end plates, it is ready for delivery.

Vulcanized-oil rollers are slightly lower in cost than rubber rollers, perform more sensitively, and are easier to clean. Their principal disadvantage is that they are not durable. Although more resistant than glue-glycerine types, they must be handled with great care to avoid pits, scratches, and bruises resulting from careless cleaning or from dropping on the edges of the ink slab or stone.

The Plastic Roller. A number of plastic rollers have appeared on the market in recent years. These are chiefly composed of polyvinyl chloride or polyurethane. Although they have yet to reach the popularity of the other types of rollers, it is reasonable to expect that they will be improved appreciably in the future and that they will gradually replace the older rollers.

Polyurethane rollers are manufactured by casting in moulds in an even less complicated process than the original glue-glycerine method. Although raw materials are currently quite expensive, the consequent reduced

*Until recently, vulcanized-oil rollers (known by their trade name, Ideal Rollers) were the most popular type used for color lithography. Although still purchasable in Great Britain, their sole American fabricator has discontinued manufacture; hence the future availability for this type of roller remains uncertain.

labor costs permit them to compete in cost with rubber and vulcanized-oil rollers. It is expected that future volume production will reduce costs even more.

Although still undergoing testing at Tamarind, the polyurethane roller suggests very promising performance. It can be supplied in a wide range of densities (a durometer reading of 20 is comparable to that of the standard vulcanized-oil roller and is the hardness of surface most commonly used). The roller is extremely durable and resists denting and scoring to a remarkable degree. Plastic rollers are easy to clean and, being of solid construction, are dimensionally very stable.

14.10 THE CLEANING AND CARE OF SYNTHETIC COLOR ROLLERS

Color rollers must be carefully cleaned and stored. In all cases it is advisable to follow the manufacturer's instructions, if these are available. The following are general comments on roller care.

Color rollers should be washed immediately after each use. Inks that are permitted to dry not only are difficult to remove but in some cases can be injurious to the roller surface. The standard procedure is to wash thoroughly both the roller surface and its end plates with soft rags and kerosene. Stronger solvents such as lithotine, benzine, or gasoline should never be used, for these can injure the roller surface.

When first received, the rollers have a smooth, slightly tacky surface. In this condition they are highly receptive to ink. After repeated cleaning, a hard glaze will form on the roller surface; this glaze is difficult to remove without the use of special solvents, called *blanket and roller washes*. These washes can be obtained either from the roller manufacturer or from general lithographic suppliers. Roller surfaces that are excessively glazed either release ink too quickly or accept excessive amounts of water from the printing surface and refuse to attract ink properly. Glue-glycerine rollers are particularly susceptible to this problem of stripping. Rollers that become stripped must be washed with solvent and dried before being used with a fresh supply of ink.

Composition and vulcanized-oil rollers have a longer life if used constantly. This is due to their semigelatinous inner fabrication. When they are stored on chocks for long periods of time (particularly in hot weather) the weight of the inner mass exerts downward pressure, distorting the surface and concentricity. During storage, the roller should be rotated once a month to equalize gravitational pressures. Similarly, the roller should not be permitted to rest on the ink slab for periods longer

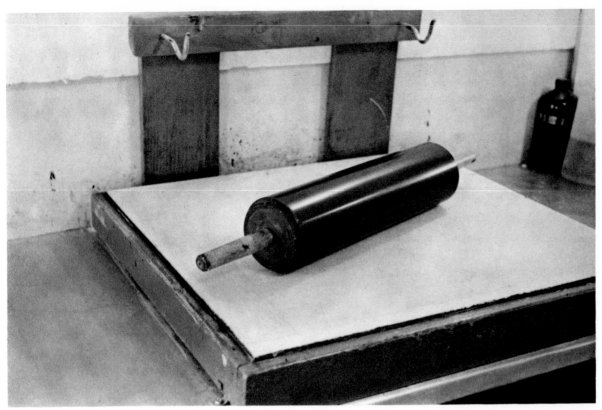

14.6 The vulcanized-oil roller

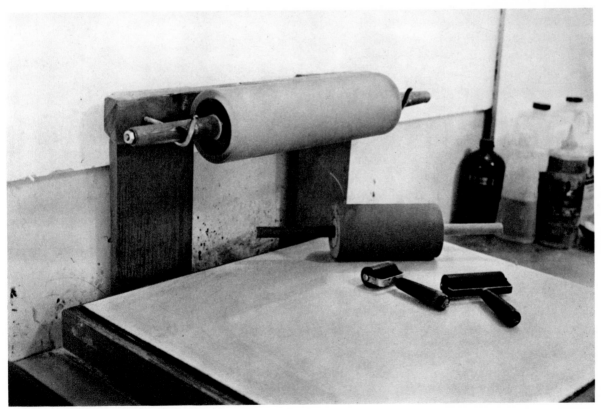

14.7 Other color-printing rollers

A polyurethane roller is in the rack; also shown are small rubber
brayers and a short rubber roller

than one hour, for this may subject it to flattening. Although rubber rollers are less prone to this problem, they also can become deformed.

The beveled ends of vulcanized-oil rollers are coated with a protective sealer. On older rollers this sealing tends to wear away, to crack open, or sometimes to sustain cuts and gouges. The pressures of rolling can open such crevices, so that the softer inner material seeps out. Damage of this sort can sometimes be repaired by a roller manufacturer. Constant inspection of the roller edges and periodic sealing with shellac or clear lacquer can help to prevent damage of this sort.

Sometimes a heavily glazed roller surface develops a network of fine cracks. These will impress their pattern upon printing images that contain large unbroken solid areas. If the condition is pronounced, the roller should be returned to the manufacturer to have its outer surface reground.

It is advisable to dust all color rollers lightly with talc after washing them with kerosene. This helps to absorb the oily residue of the solvent and prevents the build-up of glaze.

14.11 THE LEATHER COLOR ROLLER

If leather rollers are used, a set of three to five is necessary for color printing. One roller is usually reserved for opaque whites, yellows, and transparent light tints. Another may be used for middle tones, another for blues and greens, one for oranges and reds, and one for very dark colors. A simpler arrangement would be to use one roller for the whites and tints, another for blues, greens, and dark colors, and one for oranges and reds.

When used for color printing (as opposed to black-and-white printing), leather rollers must be thoroughly washed with lithotine after every printing. Otherwise the ink will dry, sealing the nap of the roller and quickly rendering it unsatisfactory for delicate inking. After the roller is washed, it must be covered with mutton tallow or lard so that the cleaning solvent will not harden the leather. The coating of fat must be scraped out before the roller can be used for the next color. If the roller is to be used immediately for a second color, the coating of fat is omitted after washing, provided the dried surface does not remain uninked longer than one-half hour. Because leather rollers are expensive as well as laborious to prepare and clean, they have largely been replaced by synthetic rollers for color printing.

Sometimes a leather roller used for black ink is used for printing single colors having dark chromatic hue. In this case, the roller should first be well scraped to remove as much of the black ink as possible. Then the color mix, which is usually composed of a certain percentage of black ink, should be made slightly lighter and brighter than the effect desired, in order to compensate for the residue of black ink remaining in the roller. The roller must be scraped again after printing and immediately rolled up in black ink (if no longer to be used for color printing) or coated with mutton tallow to keep it soft. It is not necessary that it be washed with solvent when used for this type of inking.

Sometimes a very old leather roller that has hardened and lost most of its nap is converted into a color-printing roller by sealing its outer surface. The roller is given several coatings of shellac or white lacquer. When dry, these produce tough glazed coatings that can easily be washed with kerosene to remove ink. Rollers of this type have none of their original virtues. Although they are closely related to synthetic types, their performance is nevertheless inferior.

14.12 BRAYERS FOR COLOR PRINTING

It is sometimes useful to supplement the hand roller with several brayers for intricate color printing. This makes it possible for several separate colors to be inked and printed simultaneously. (See sec. 7.27.)

Brayers should vary in size from 2 to 8 inches in length, and several should be available in a well-equipped shop. Color brayers should be composed of solid, high-quality rubber or polyurethane plastic. The diameter of each roller should be as large as possible, to permit the maximum inking span in a revolution. Inasmuch as a certain amount of pressure is applied during inking, the frames and handles should be sturdy and permit easy revolution of the roller. The popular type of small-diameter, cheaply constructed brayers for woodcut printing are unacceptable for this purpose. They cannot pick up and distribute ink satisfactorily, nor will their meager circumference accept enough ink for anything but the smallest passages.

Brayers are cleaned with kerosene in the same way as the large synthetic rollers. They should hang freely suspended from hooks when not in use, so as to preserve their contours. A light dusting of talc after washing will prevent surface glaze.

14.13 THE LARGE-DIAMETER ROLLER

One of the most difficult types of color printing involves the inking of large spans of absolutely flat solid areas. These require great skill in roller manipulation if

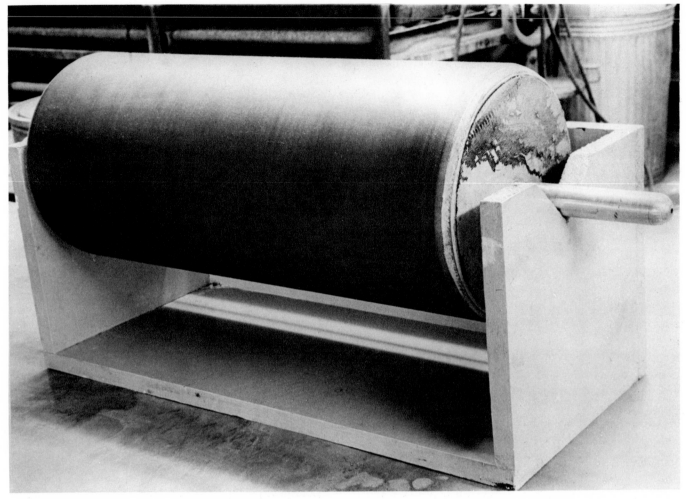

the ink is to be distributed evenly and not show roller laps. Experiments to reduce the problems involved in this type of printing have resulted in the development of several special inking rollers at the Tamarind and University of New Mexico workshops.

These custom-fabricated rollers are long and large in circumference. In one revolution they can deposit an even film of ink over the entire printing surface. For example, a roller measuring 12 inches in diameter and 30 inches in length can, in one revolution, deposit a continuous film of ink measuring about 38 by 30 inches.

The roller, because of its large size, must be lightweight yet very sturdy. Several models have been built with hollow stressed-aluminum cores; one has a solid core of lightweight Styrofoam. The outer covering of these rollers is a carefully machined sleeve of high-quality rubber or polyurethane plastic, 1/4 inch thick.

The roller requires a special, large inking slab commensurate with its inking span. Two types of slabs and storage chocks have been developed for this purpose.

One slab, inclined from the wall to the inking counter, reduces the amount of space necessary for the equipment and at the same time permits somewhat easier maneuverability in inking the roller. It should be noted that these rollers require a considerably greater amount of ink than standard rollers; therefore, a larger volume of ink must be mixed before printing begins.

The ink is rolled in much the same way as with the standard roller. The roller is permitted to sustain its own weight, and, with little or no downward pressure, it is moved back and forth across the image or ink slab only a few revolutions per inking. This is sufficient to distribute the ink very evenly. Several returns to the ink slab may be necessary for recharging the roller; the number will depend on the density of the desired ink deposit. Because this type of roller is bulky, handling it might be thought awkward. Since it is only slightly heavier than a standard roller, however, and since complicated maneuvering is unnecessary, the strain of inking is not appreciably greater than with a standard roller. The roller is cleaned

in the usual way by using soft rags and kerosene solvent. Its surface is lightly dusted with talc before the roller is stored.

The remarkable success of the large-diameter roller suggests increased use in the future. Newer models with refinements of construction will provide even greater latitude in handling and simplicity of upkeep. Although these rollers are quite expensive to fabricate, it is anticipated that greater demand will eventually lower their cost.

14.14 USING THE SYNTHETIC ROLLER

The synthetic roller is seldom used in black-and-white printing. It is different in construction from the leather roller, and so must be manipulated differently. Its surface, unlike that of the leather roller, is smooth and without nap or absorbent reservoirs with which to pick up and deposit ink or water during the distribution process. Because synthetic rollers are heavier than leather rollers, there is danger of overloading of the image or scumming; so excessive pressure during inking should be avoided. Since color ink is softer and less tacky than black ink, it has a tendency to release rapidly from the roller surface, thus further complicating the problem of controlling distribution. The larger and more solid the area, the more difficult will be the distribution problem.

For example, if the area to be inked is wider than the length of the roller and longer than the span of one of its revolutions, most of the ink charge is dispelled from the roller surface in the first revolution. Meanwhile a certain amount of water has collected on its face. The following revolution deposits a much weaker film of ink from the depleted surface and at the same time leaves a light bar between the end of the first revolution and the beginning of the second. The amount of water that the roller has collected is doubled. Rolling back and forth will somewhat improve ink distribution, but never to the extent possible with a leather roller. The water accumulated on the surface of the synthetic roller prevents the gathering and release of ink during the course of many revolutions, whereas the reservoirs of the leather roller permit an extended control of ink and water accumulation and distribution. At this point, after two or more revolutions, only one band as wide as the roller has been inked. Repositioning the roller to complete the passage will result in a dark lap mark where the edge of the second pass lies over the first.

Overcoming the light bars and lap marks will test the ability of even the best of printers and will require con-

siderable patience and experience. One should calculate a pattern of rolling that will equalize the light bars and lap marks: the ink on the roller should be replenished more often than ordinarily; the ink consistency may even have to be changed to permit slower release. Some printers prefer to ink images of this sort with very short passes that are not complete revolutions of the roller. A great number of these are crisscrossed over one another, producing a sort of herringbone pattern that equalizes the distribution of ink. This is called a *feathered* type of inking. It is worth noting that broken-toned images are relatively easy to ink with a synthetic roller, since their separated patterns disguise light bars and lap marks. Good control of ink distribution is always difficult for very large images, whatever the roller; it can be accomplished only through practice and perseverance.

Another problem, somewhat less troublesome, arises from the lack of natural porosity in the synthetic roller. Because this roller cannot absorb water like the leather roller, moisture is collected on its surface from the dampened stone. The excess water mixes with the ink and changes its consistency, thus affecting its working properties. The ink becomes emulsified and rubbery, losing its snap and refusing to distribute on either the roller or the printing image. It then becomes necessary to freshen the ink on the slab frequently. In aggravated cases, both roller and slab become stripped. When this happens, both must be washed and dried before fresh ink is set out.

In view of the basic problems of synthetic color rollers, the following handling techniques are recommended:

1. Use little pressure. Let the weight of the roller accomplish the distribution of ink.

2. Roll moderately fast or very fast in order to even the ink film.

3. Use a minimum amount of dampness on the stone so as not to collect excess water on the roller.

4. Freshen ink on the slab often. This may mean after every two or three impressions or as often as after every impression. One to three ribbons of ink drawn across the slab should be sufficient. If the ink becomes rubbery and emulsified, scrape it from the slab before applying fresh ink.

5. Determine the rolling patterns for a particular image beforehand in order to minimize lapping problems. These problems should be solved and the lapping overcome during the proofing operation, before the edition is printed.

6. Adjust the ink consistency to suit the existing conditions. In general this will mean shortening the ink body and perhaps reducing its tack.

CHAPTER 15

Special Processes

15.1 VARIATIONS IN THE GRAINING OF STONES

The surface grain of a lithograph stone directly influences the appearance of a drawing placed on it. Surfaces that are rough and toothy break up the crayon particles, thereby producing drawings that are coarse and granular. Smoother grains produce finer and more delicate tonalities. Prolonged and slow graining cycles produce "flat" grain definition, resulting in lifeless tones. For this reason, the last cycles of graining should usually be short and brisk, so as to produce a crisp tooth on the printing surface.

The practical limits of surface grain for lithograph stones range from 100 grit particle size for coarse graining to 320 grit or FF (double fine) for fine grainings. Grainings using coarser grit tend to produce a mechanical texture, and grainings using grit finer than 320 mesh lack surface definition. Drawings that contain large areas of solids should not be placed on coarsely grained stones, because the granularity of the surface would prevent the print paper from making contact with those portions of the printing image lying in the valleys between the teeth of the grain. The finer the teeth, the richer and more vibrant the solid areas will appear. The firmest solids and linear works are drawn on polished surfaces that contain no grain whatsoever. It should be remembered, however, that there can be no crayon gradations on polished stones. Medium to coarse surface grainings are sometimes used for the separate stones of a color lithograph. The broken color tonalities of each stone can then interact with one another to produce luminosities like those found in Pointillist paintings.

It is also possible to vary the surface tooth on the stone by spot grinding with different sizes of abrasive.

First the stone is ground, using the standard sequence of abrasives. Next, a small muller or broken stone with flat surface (measuring approximately $4 \times 6 \times 1/2''$) is used to grind the desired areas locally with the appropriate grit. An even less regular surface can be achieved by scraping the stone with coarse grades of sandpaper after it has been grained in the usual manner.

15.2 POLISHING THE SURFACE OF LITHOGRAPH STONES

Before the surface of a stone can be polished, it must be prepared in the usual way by grinding with Carborundum grit abrasives (see sec. 1.5). After the grits are washed off, the stone is rubbed with a pumice block (Schumacher brick) and water until the granular surface begins to be polished in appearance. More water and less pressure are used at this stage than at any time previously. The rubbing stone is slowly passed in a circular motion, first up and down, and then side to side, covering the wet lithograph stone in a calculated and even pattern. It will leave a series of extremely fine scratches. These are removed by polishing with Water of Ayr stone or block charcoal and water in an even pattern until the surface of the stone becomes glasslike and grainless. After a thorough washing and drying, the stone is ready for use.

In the early days of lithography, stones were sometimes polished by chemical means. This method is less desirable than grinding and polishing, but it is considerably more rapid. The chemical polish is formulated as follows:

caustic soda	1/2 pound
water	6 pounds
phenol	1/2 pound

The soda is dissolved in the water; the phenol is then added.

The solution is flowed over a normally ground lithograph stone while it is lightly polished with Ayr stone or charcoal.

NOTE: The solution is highly corrosive, hence rubber gloves should be worn.

After the stone is washed with water, it is treated with an alum counteretch. It is washed again, dried, and is then ready to receive work. Sometimes finely ground pumice powder may be used with the solution and rubbing block to achieve an extremely fine surface grain.

15.3 PRINTING FROM POLISHED STONES

Stones with polished surfaces are generally used for stone engraving and relief printing. They may also be used for type transfers, handwritten text, linear work, and solids. Polished and grained surfaces respond differently to the inking roller. The roller tends to operate more freely on a polished stone. Hence it must be handled with a lighter touch, and each inking should involve fewer passes over the image. If the surface of the stone is too moist, the roller will tend to slip and will therefore be more difficult to control.

Polished stones usually dry more rapidly than grained stones because they lack reservoirs that retain moisture. Scumming and overinking are more likely to occur. Sometimes a small amount of salt or glycerine is added to the dampening water to retard the rate of evaporation.

15.4 STONE ENGRAVING AND RELIEF PROCESSES

The lithographic processes of stone engraving and relief printing are as old as lithography itself. In fact, it was Senefelder's quest for a less costly substitute for metal-plate engraving that led to his discovery of the lithographic medium. From that time until the 1920s one branch of the lithographic industry specialized in the production of complex intaglio and relief printings. Such images—of stock certificates, diplomas, business forms, and commercial labels—are still to be seen on the backs of lithograph stones in use today.

Although cheaper and easier to produce, these intricate works unfortunately never equaled the fine intaglio or relief metal plates that they tried to emulate. Close comparison will show that the lithographic engravings have a characteristic flatness of surface due to the printing process.

American printmakers have had little interest in such processes because of their commercial connotation and their inferiority to metal-plate engraving. Consequently, there are very few contemporary lithographers who know how to process lithographic engravings. In view, however, of the reawakened interest in all aspects of lithographic technology today, stone engraving and relief printing should be re-examined with a view toward application to contemporary imagery.

STONE ENGRAVING

Polished stones are used for stone engraving. The stone is given a mild etch, which is lightly wiped to a thin film. Finely powdered red-oxide pigment is dusted on the wet film and is wiped dry, to form a thin, smooth coating. The pigment provides a colored ground through which the engraving is drawn. Lithographic needles and engravers' burins are used to score lines that appear crisp and bright against the ground. A fatty substance such as asphaltum, machine oil, cup grease, or mutton tallow is wiped into all the lines and allowed to remain a short time so that it may penetrate the exposed stone. The ground is dissolved with water, and, while the surface is kept damp, soft lithographic ink is pushed into the lines by means of the traditional etcher's dabber. The polished surface of the stone is wiped clean with a dampened sponge or tarlatan pad, and the printing is begun, using damp printing paper and very soft backing sheets. Sometimes a rubber blanket is employed with the backing sheets to provide additional pliancy.

The lithographic roller may sometimes be used instead of the etching dabber to distribute ink. For this approach, the drawing lines must not be incised so deeply as before; otherwise, the roller will not deposit ink in them.

A polished stone is prepared with a mildly etched colored ground, as before. The drawing is made in the same manner, except that much less pressure is exerted, so that the etch coating is incised but not the stone. Upon completion, the lines of the drawing are filled with a fatty substance.

It will be apparent that this second method offers additional opportunity to use blades, sandpaper, and other devices with which to expose the etch coating. When greased, these exposed areas will produce effects different from pure engraved work. Such approaches, used either separately or with other drawing processes on grained stones, offer possibilities far beyond the traditional techniques of lithographic engraving.

THE RELIEF PROCESS

The lithographic relief process is the direct opposite of the engraving process. Where the engraving method

produces dark lines against a light ground, the relief process presents light lines against a dark ground. Although they appear to be in relief, the white lines are actually incised in the surface of the stone. A polished stone is prepared by etching its border only. When dry, the surface is greased with cup grease, thinned lithograph ink, or asphaltum. The drawing is cut crisply through this thin, even coating. When it is completed, the stone is dusted with rosin and talc and given a mild Kistler etch (12 drops nitric, 5 drops phosphoric, 6 grains tannic acid in 1 ounce of gum arabic). (See sec. 2.3.) After the etch is dried, the image is washed out and rolled up with ink, using a color roller with a smooth surface. (See sec. 14.9.) This type of roller is preferable to a leather one because the nap of the leather has a tendency to push the ink into the incised lines.

For this method of printing, the lines must be cut fairly deep and clean to produce image clarity. With some experimentation it is entirely possible to utilize both relief and intaglio methods in a work that also includes other traditional drawing techniques using crayon and tusche.

ETCHING FOR ACTUAL RELIEF

It is sometimes beneficial when printing on dry, heavy, or coarse papers to have the image on the stone slightly embossed in actual relief. Linear formations produced in this way impress themselves into these papers and produce crisper results. This process is beneficial primarily for linear and open work; it is not advised for solids, which require heavy inkings, because the press scraper will drag the films of printing ink over the trailing edge of the relief formation and produce a slurred impression.

Stones are etched in relief following the standard etching procedures; however, the cumulative etch strength (whether in two or three stages of etching) should be greater than usual. The work must be well protected, therefore, to resist the corrosive properties of the stronger etching.

The first etch is applied at normal strength. The stone is washed out and rolled up with ink and dusted with rosin and talc in preparation for the second etch. If the second etch functions as the final etch, the dusted stone is dampened and again rolled with ink. The process is repeated several times until an amalgamation of rosin and ink produces a highly acid-resistant, protective film over the image. The stone is given the second etch, which is either formulated stronger than usual or used in a volume twice that normally employed. If the stone is to be etched three times, the first and second etches are given

at normal strength and dried. The third etch is given at slightly reduced strength. With either approach, the relief should approximate the thickness of a playing card. Sometimes nitric acid and water mixtures are flowed over an inclined stone to produce the relief. Such procedures must be followed immediately by gumming and drying to ensure maximum desensitization. It should be noted that the strength of etching solutions for relief work largely depends on the hardness of the stone. Soft yellow stones must, of necessity, be etched with weak solutions so as not to undermine the work.

15.5 AVOIDING BREAKING STONES

In view of the scarcity and high cost of stones, it is important that every precaution be taken against breakage. In school shops the two most frequent causes of breakage are improper storage and careless handling. The details of proper storage are set forth in sec. 16.6. The shop supervisor must impress upon his personnel the importance of handling stones carefully. All stones should be set down gently, so that corners and edges are not chipped. Wet stones should not be lifted, nor should stones be carried with wet hands. Stones larger than $18 \times 22''$ should be carried by two men or carted. (See sec. 10.9.)

Breakage also occurs when stones that are too thin fracture under the heavy pressure of the press. To prevent such breakage, a thin stone should be cemented to another stone or slate slab of the same size.

Stone breakage can also occur at the press whenever the normal smoothness of press traverse or equality of pressure breaks down. The following are examples of how such breakage can occur:

1. The stone has not been ground to a level surface plane. Such a stone can break if subjected to heavy press pressures, particularly if it is high at the midpoint of the top surface or low at the midpoint of the bottom surface.

2. The press bed is worn or warped. The bed then exerts uneven stresses as the stone is passed under the scraper bar under pressure. Worn bed rollers can cause the same problem.

3. The press bed is not clean. Clots of dried gum or ink lying underneath the stone can subject it to unequal pressures.

4. A faulty scraper bar or tympan sheet contains lumpy matter on its surface, producing unequal pressure.

15.6 CEMENTING THIN STONES

Thin stones are likely to be broken under the pressure of the press. Such stones can be reinforced against breakage and preserved for further use by being joined to a backing: either two thin stones can be cemented together, or a thin stone can be cemented to a slab of slate or cast concrete. Considering the ever-increasing shortage of good stones, the backing of thin ones is essential to the preservation of a lithography shop's stock. For effective preservation, stones must always be cemented before the danger of breakage becomes acute.

The stone and its backing must be as nearly the same size as possible. The thickness of the backing will vary from 1 to 2 inches, allowing an over-all thickness of 3 inches for small stones and 4 inches for large stones. The surfaces to be joined are first grained against one another with # 100 grit Carborundum so that a close bond will be assured. Various commercial bonding cements of latex or waterproof epoxy may be used (one such adhesive is Upoxy Grouting Compound, made by Upco of Cleveland, Ohio). The cement is spread on one of the freshly ground slabs, and the second slab is placed against it. The top stone is then moved about until the cement has been spread evenly and thinly on both surfaces and the stone can be moved only with difficulty. The two slabs are carefully aligned, and the excess cement is cleaned away from the edges. Weights are placed on the upper stone, and the cement is left to dry.

15.7 DRAWING WITH TRANSFER INK

Lithographic images can be drawn directly on stone or metal plates with transfer ink. The chief advantage of this substance as a drawing material lies in its high viscosity and rich fatty content. Being much more tacky than either tusche or asphaltum, it can give very coarse, dragged, and scumbled qualities to drawings.

The transfer ink can be thinned with lithotine, benzine, or litho varnish, depending on the degree of desired fluidity, or it may be used in its normal consistency. Transfer ink can be applied with coarse brushes, sticks, or knives, or can be dabbed and wiped with rags. Care should be taken not to pile up the work, for only those grease particles which make contact with the printing surface print. The completed drawings should be carefully dusted with rosin and talc and given a moderately strong etch for the first etch; the second etch is determined by the character of the roll-up. Some care is necessary in dusting with rosin and talc, so as not to smear the non-drying transfer ink.

15.8 MANIÈRE NOIRE

The *manière noire* or "black method" is one of the most interesting and oldest techniques of drawing. It takes its name from the procedure in which a drawing is scraped from a solid black image in a series of gradations toward white. Working procedures and aesthetic properties are not unlike those of mezzotint engraving. Overstatement should be avoided; otherwise, the rich, smoky values produced become too soft, monotonous, and melodramatic. In the hands of the early masters of lithography, such as Calame, von Menzel, and Bresdin, this technique offered a vast range of tonality and surface interplay. Some of Redon's lithographs were initially developed with this technique and subsequently enriched by the use of other processes in later states. The evolution of the techniques within this process can be seen if one compares the works of the above nineteenth-century artists with works done in the same manner by Picasso and Rouault. Such a comparison will reveal the tremendous range of possibilities within the process.

One begins work in *manière noire* by forming a solid black printing image with tusche or asphaltum. (See sec. 15.10.) The stone is processed with a weak etch, rolled up with ink, and dusted with talc. The purpose of the talc is to dry the topmost layer of ink so that one can work over it without smearing. After the talc is washed off with sponge and water, and the surface is dry, the stone is ready for the development of the drawing. Various blades and points are used to scrape, scratch, and pick the ink from the grain of the stone. The approach is similar to that of a painter working against a dark ground and forming his image by working light passages over dark. Like such paintings, lithographic drawings of this type tend to be low in key, and their passages convey a "built-in" structure instead of seeming to lie on top of the drawing.

Finished drawings in the *manière noire* should be given moderately strong etches after being carefully reinforced with rosin and talc. The scraping process tends to leave latent fatty deposits, which must be adequately desensitized so as to resist filling in during the printing.

15.9 ACID-TINT TECHNIQUE

A unique process called *acid-tint technique* has been developed at Tamarind for the controlled formation of continuous-tone gray values on stone. These tones resemble somewhat those of extremely fine aquatints. The procedure offers great flexibility. The process is capable

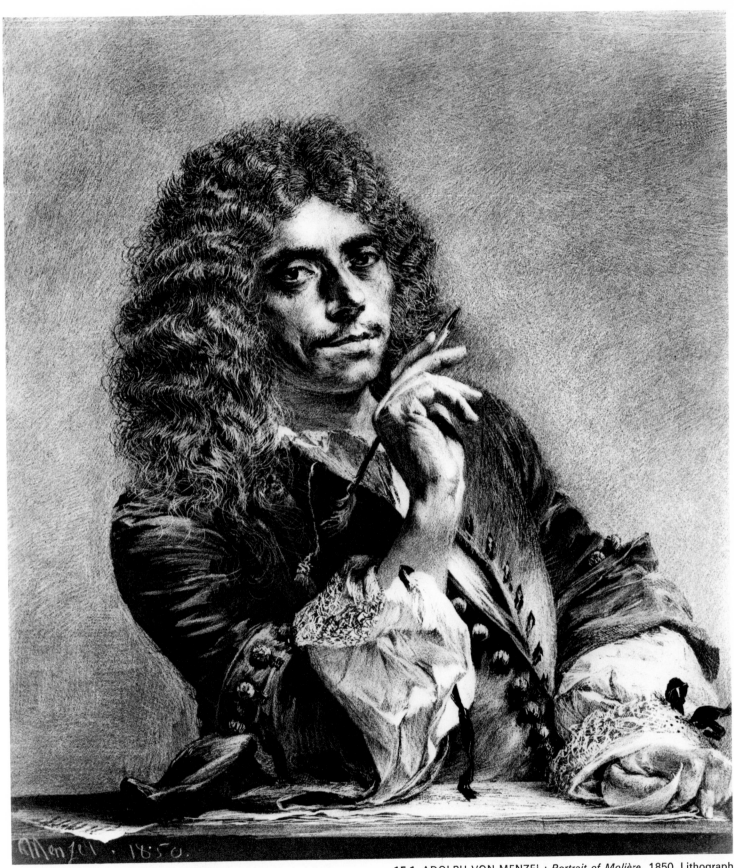

15.1 ADOLPH VON MENZEL: *Portrait of Molière*. 1850. Lithograph with tone plate, on mounted China paper, 8 1/2×7″. University Art Museum, The University of New Mexico, Albuquerque

of producing either wash or flat-toned values extremely subtle in their gradation and capable of aesthetic effects quite different from those produced by crayon and tusche. The process may be used either separately or in combination with the more traditional drawing techniques, to provide an additional dimension to the art of lithography.

The process involves developing the image in a manner similar to the *manière noire*. Starting with a black ground, the artist develops his drawing by applying weak formulas of nitric acid in gum arabic or water, thereby reducing the tonal values. The control of value reduction depends on the degree of resistance of the image ground to the acid strengths employed. A very weak ground should be used so that very weak etches can be applied. If the ground were overly resistant, strong acid etches would be necessary to reduce it, and these would partially destroy the tooth of the stone. Coarse tonalities would result, such as those developed by acid spot biting. (See sec. 4.8.)

The basic steps in the acid-tint process are listed below; for purposes of clarity they have been separated into stages. In actuality the work can proceed from one step to the next without interruption. It should be noted that acid-tint techniques should be used only on the finest-quality gray stones. Soft stones or stones with uneven or mottled composition do not react dependably to the acid etches.

STAGE 1.
FORMATION OF THE BASIC IMAGE GROUND

1. The basic image is formed as a lithographic solid area by either (a) drawing with full-strength liquid tusche or (b) applying an asphaltum solid. (See sec. 15.10.)

2. The borders of the stone and all image areas to remain white can be masked out with a slightly acidified solution of gum arabic (4 drops nitric acid to 1 ounce gum arabic). If a gum mask is employed, the asphaltum method (b) should be used.

3. The image is processed by appropriate methods (depending on whether it is formed with tusche or asphaltum). In either case the processing etches should be very weak (4 to 6 drops of acid to 1 ounce gum arabic).

4. At the termination of this stage, a firmly inked, solid-black image with a dried-etch coating has been formed.

STAGE 2.
ESTABLISHMENT OF THE ACID-TINT GROUND

1. The image is washed out with lithotine through the dried etch film.

15.2 ROBERT HANSEN: Pages 26 and 27 from the *livre de luxe Satan's Saint*. 1965. Color lithograph, 13 × 28". Tamarind Impressions (T-1251A, T-1251B). And detail

The lettering was printed in red from an aluminum plate; it was written in tusche on transfer paper and transferred to the plate. The drawing was made on stone using the acid-tint technique

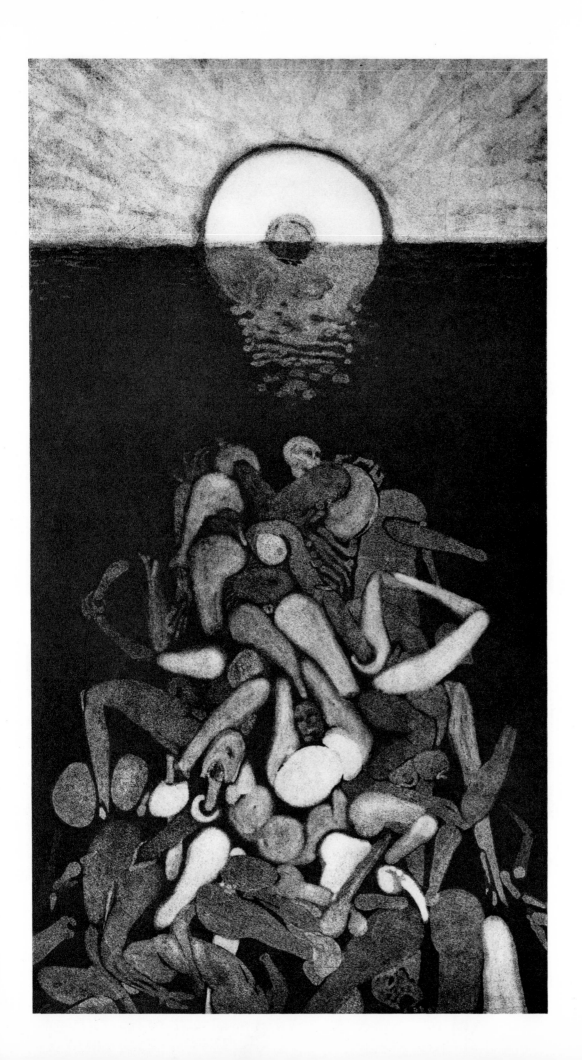

a. The layout of materials for the process

b. Masking the margins and internal parts of the image with gum arabic

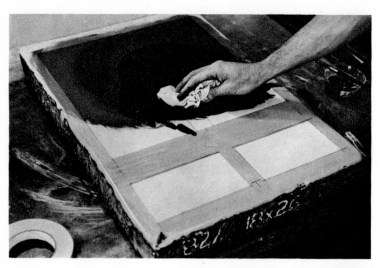

c. Applying asphaltum to make a flat solid

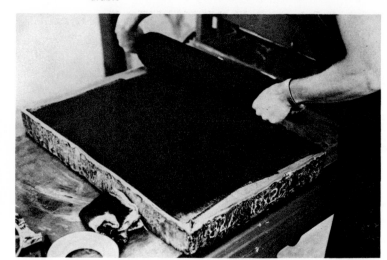

d. Rolling up the solid with ink

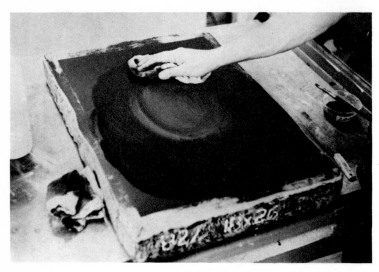

e. Washing out the image with lithotine

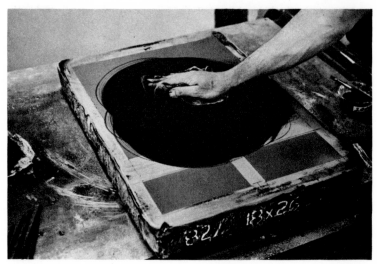

f. Applying a thin film of Triple Ink

15.3 The acid-tint technique

g. The prepared ground, showing the polished layer of Triple Ink and the gum arabic mask

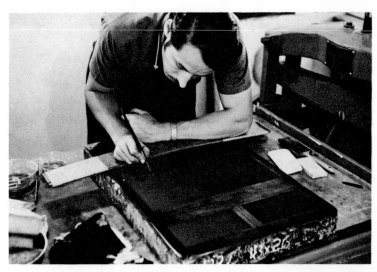

h. Forming the image by biting the ground with a weak acid etch

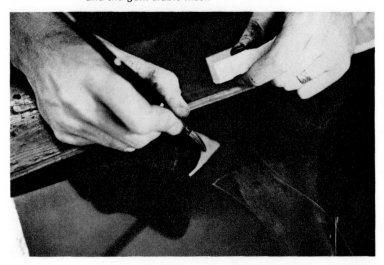

i. Close-up showing removal of ground by acid biting

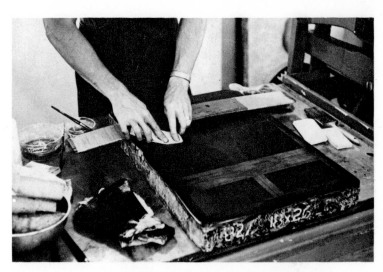

j. Arresting the biting action with the water sponge

k. Close-up showing blotting with the water sponge

l. The completed drawing after acid biting

m. Rubbing up the image with ink

n. Cleaning the rub-up with gum sponge

o. Washing out the image with lithotine

p. Rolling up the image with the leather roller

q. Cleaning the margins with a hone

r. The completed image prior to etching

s. Etching the image, which has previously been dusted with rosin and talc

t. Wiping the etch dry

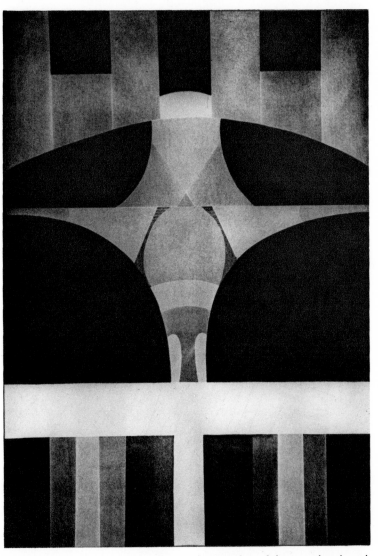

u. A printed impression of the completed work

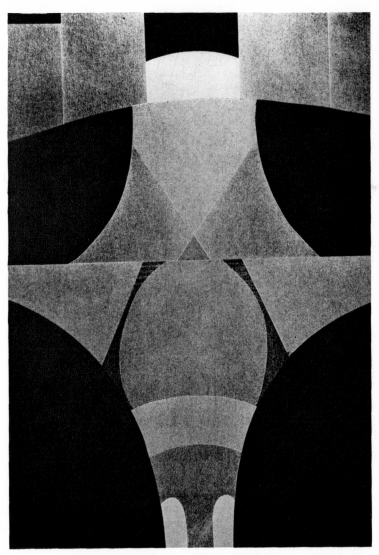

v. Detail showing the fine textural quality and great tonal range of grays produced by this technique

2. A thin film of Imperial Triple Ink is applied to the washed-out stone and wiped into a thin, even film. (See sec. 6.18.)

3. The Triple Ink ground must be properly established. Applications that are too heavy should be washed away with lithotine and re-applied. A certain amount of experimentation may be necessary in order to establish the correct grounding film. A properly formed ground should have a smooth, pale gray appearance.

STAGE 3.
THE BITING PROCESS

The artist creates the desired values by drawing with one or more etch solutions that penetrate the thin ground and desensitize the stone in varying degrees. The solutions should be extremely mild, even though varying in strength with the density of the grounding film. They should never exceed 12 drops of nitric acid to 1 ounce of gum arabic for even the strongest etch. Often only one strength of solution is employed, which, by repeated application over some areas, can produce the desired scale of values. Etching solutions that contain water instead of gum arabic produce somewhat different biting patterns because of their greater fluidity. The biting proceeds as follows:

1. The etch is applied with a brush to the area to be lightened. The greater the number of applications over one area, the lighter the tone will be.

2. The reaction of the etch is arrested by sponging with water. The water also helps lift the grounding film. Hence, the etching process can be controlled by the length of time the solution is left on the stone as well as by the strength of its formula. Moreover, the amount of grounding film removed will offer some indication of the resulting tone.

3. The cleaning water must be changed periodically and the sponge cleaned; otherwise acid residue will over-etch the stone. The sponge should be used in a mopping or lifting motion, so as to prevent the arrested etch from making contact with other areas of the stone.

4. It should be noted that each stage of biting produces an exaggerated effect on the final values of the image. The artist must continually bear in mind that the pale grounding tint will actually print solid black. Thus, only the slightest modifications of the ground can produce a series of clearly articulated grays. The artist will need a certain amount of experience to learn to produce the broad range of tonalities that are possible with this technique. One may first etch all the areas of the image, arresting the etch to form a value just removed from full-strength black, and then apply the next etch over all the

areas except those which are to remain off-black. The image patterns can thus be developed by repeatedly etching for progressively lighter values, with the greatest number of applications over those areas which are to be just removed from white.

STAGE 4.
THE FINAL PROCESSING

The completed drawing is given a final cleaning with fresh water. It is then ready for the final processing, which entails a rubbing-up procedure. The steps of the thinned rub-up are briefly enumerated here. For a detailed description of the process, see sec. 15.14.

1. The ink sponge is used to saturate the image with thinned roll-up ink.

2. A second sponge saturated with gum arabic is used to clean the residue of scum left by the inking sponge.

3. The process is repeated a number of times; inking and wiping are alternated until a firm deposit of fatty ink is in the pores of the stone.

4. After the final inking, the entire stone is washed with a sponge and water. It is dried and then dusted with rosin and talc in preparation for a complete etch.

5. A mild etching solution (12 drops acid to 1 ounce gum arabic) is applied, and dried to a thin, smooth film.

6. The image is washed out and firmly rolled up with ink, with the leather roller. A printing base may be used before the roll-up if desired.

7. The margins and white areas of the image are thoroughly cleaned. Minor deletions can be made following standard procedure. Solid black areas may be touched up with Autographic Tusche.

8. The stone is again dusted with rosin and talc, and is given the final etch, following standard procedure. After this etch, the stone is ready for proofing and printing.

STAGE 5.
CORRECTIONS AFTER PROOFING

Corrections on acid-tint work after proofing can be made in several ways.

1. The acid-tint biting technique can be repeated: the image is washed out, and a thin Imperial Triple Ink ground is applied before additional biting.

2. Traditional methods of deletion, such as honing, scraping, and acid biting, can be used.

3. Traditional techniques for adding work can be used; one counteretches and then proceeds in the usual way.

15.10 ASPHALTUM DRAWING TECHNIQUES

Both liquid and powdered asphaltum can be used to produce drawings on a lithograph stone. The liquid asphaltum should be of heavy consistency, not like the thinner variety used as an ink base. Being of greater viscosity than liquid tusche, the heavy asphaltum is useful for drawing coarse, linear works and vigorously scumbled passages. The liquid can be applied with stiff brushes, rags, or pieces of wood. It dries fairly quickly and, because it is highly acid-resistant, it can withstand moderately strong etches.

Although asphaltum is greasy, it does not have the strong fatty content of tusche or crayon materials. Images drawn with it do not have the penetration needed for the development of deep-seated lithographic formations. Therefore, after the original drawing is etched and washed out, it should always be reinforced with an asphaltum ink base before it is rolled up with ink. (See sec. 2.11.) The image will eventually become firmly established after a certain number of impressions have been printed. Until that time, the image deposits are close to the surface of the stone and attract ink more through their tackiness than through their fatty content.

Thin liquid asphaltum is often used instead of tusche for producing large areas of solids. These areas are easier to execute with asphaltum, and their formations are usually smoother and flatter throughout. This process requires that all areas of the printing surface that are to remain white be gummed beforehand. A few drops of nitric acid are added to the gum solution, to allow it to function as the first etch. After the gum mask is dry, thin liquid asphaltum is applied with a rag over the total area of the stone and wiped to form a smooth and streakless film. Upon drying, the stone is washed with sponge and water, which dissolves the gum mask and carries away any asphaltum gathered on it. The stone is dampened with fresh water and immediately rolled up with ink, which adheres rapidly and firmly to the remaining tacky asphaltum. The inked stone is dusted with rosin and talc and given a mild second etch; it is now ready for printing.

Asphaltum is soluble in gasoline, benzine, lithotine, or mineral spirits, and can therefore be used in another way for drawing. When one of these solvents is dispensed through an eye dropper onto a wet film of asphaltum, it will disperse the material into blossomlike formations. Successive droplets will produce a number of expanding formations that will merge and coalesce with one another in ever-changing patterns. These can be blown for directional control even while they are changing formation.

The organic, crawling formations will appear to have a life of their own. Their movement can be arrested, however, by using a hair dryer to evaporate the solvent vehicle, thus allowing the pattern to settle to the surface of the stone. Pattern formations that are unsatisfactory can be painted over with fresh asphaltum and re-formed with solvent.

In a reversal of the above approach one may force droplets of asphaltum onto a stone previously dampened with solvent. This produces dark coalescing formations instead of light ones. Powdered asphaltum or Gilsonite may also be sprinkled on a stone dampened with solvent to form a printing image. The grains dissolve slightly and settle on the stone to form a granular image quite unlike those produced by any other drawing process.

Some experience is necessary in learning to etch drawings made with asphaltum and solvents. Since the asphaltum is a good etch resist, fairly strong desensitizing solutions should be used. However, since much of the asphaltum film has been weakened by solvent removal during the image formation, these areas should be either protected by pools of gum arabic or treated with weaker localized etching.

Solvent lift-offs can be made on wet or dry asphaltum films in much the same way as with tusche. For example, a raggedly torn piece of newsprint laid on a dried asphaltum film and brushed with solvent can lift the softened film and leave its impression behind. If this is carefully done, each minute fiber of the torn edge will show with remarkable fidelity against the surrounding dark asphaltum. If the asphaltum film is wet, the edges of the lifted pattern will have a slightly softer appearance. Very complex torn and cut patterns can be lifted in this way. These are totally different from gummed-out formations.

15.11 WORK ON HEATED STONES

Lithographic crayon will melt in the presence of heat; and, by this means, drawings with unusual "halftone" tints can be produced. This very old technique is mostly used for covering large areas with a continuous halftone effect.

A finely grained lithograph stone is heated by placing it near an oven, an infrared lamp, or small blowtorch. The heating must be slow, so as to permeate the stone surface evenly. If the temperature of its surface rises too rapidly or unevenly, there is some danger that the stone will fracture. The heating process may take from fifteen minutes to an hour, depending on the heat source and on

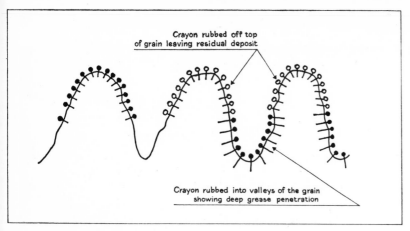

15.4 Displacement of rubbed crayon

Effects of particle displacement on rubbed crayon drawings

the size and thickness of the stone. When the surface is quite hot to the touch, it is ready for application of the crayon tint.

Medium or soft rubbing crayon is firmly drawn over the areas to be tinted. It will melt readily and can be pushed around with ease. Next, a soft cloth is used to rub the tone evenly while the crayon is pushed over the surface and into the pores of the stone. Because of its softened condition, a considerable amount of crayon can be removed during the wiping process. One can remove as much or as little as desired. The object is to produce an even expanse of tone by the manipulation of the wiping cloth. Since the stone will retain heat for a long period of time, this toning process can be repeated if the first application of crayon is unsatisfactory. The more the surface cools, the less crayon can be removed.

It is possible to establish additional drawing over the halftone with soft crayons, tusche, or scraping tools after the stone has cooled. All drawings on heated stones require moderate to strong etching solutions, so as to desensitize their rich grease deposits, which are characteristically located in the lower areas of the stone grain rather than on the upper tooth.

15.12 OTHER ETCHING APPROACHES

In Part One of the text it was stated that there is a theoretically correct etch strength to desensitize perfectly a given drawing on a lithograph stone. (See sec. 2.2.) Various etching approaches have been employed over the years to achieve etching of the exact strength required. Any given approach, however, even if suitable for many classes of work, is unsuitable for other types. In consequence, each printer will have his own preferences for certain etching techniques, which his experience has shown to be effective in processing specific types of lithographic drawings.

Today, three basic approaches to etching are most commonly used. The first employs a single etch to desensitize the stone totally and prepare it for printing. The second, which is by far the most popular approach, employs two stages of etching. The third employs three stages of etching and includes a supplementary process called *rubbing up*, which fortifies the image deposits and enables them to resist the cumulative factors of the processing.

Because the etching approach standard today is the two-stage method, this has been fully detailed in chapter 2. The following sections describe single-stage and triple-stage etching.

15.13 SINGLE-STAGE ETCHING

Theoretically, drawings that are etched only once are more likely to (1) preserve their original freshness and (2) resist value distortion. The essential problem is to assess the correct etch strength to preserve these properties without impairing the printing stability of the stone.

In actual practice single-stage etching is seldom used except for the palest lithographic drawing. Drawings made with #4 and #5 crayons, in which little other manipulative rubbing or scraping has occurred, will fall in this category. These can be etched successfully with very mild etches. (See sec. 2.5.) After the washout and roll-up they are given a pure gum arabic coating in lieu of a second etch and are ready for printing.

Heavier and more fatty drawings require stronger than usual formulas if their fat constituents are to be converted totally and their nonimage areas desensitized in one etching. The acid content in the standard etch tables may be increased by one-third for single-stage etchings. For example, an etch calling for 18 drops of nitric acid may be increased to 24 drops. At this point, however, two problems may arise. First, the 24-drop formula may be too strong for many of the image areas; unless protected with pools of gum, these may be overbitten. Second, the cumulative total of desensitization provided by the 24-drop etch in one stage is considerably less than that of the 18-drop etch in two stages. The significance here is that single-stage etching often threatens the stability of the image deposits, yet is inadequate for the total desensitization of the nonimage areas.

Experience has shown that stones that have been processed by the single-etch method usually require additional fortification of their desensitized zones during printing. With the exception of very pale and delicate

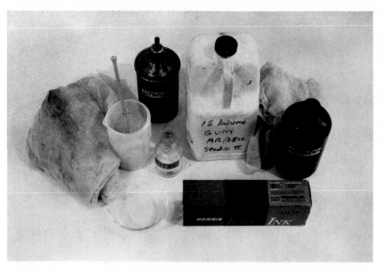

a. The materials used for rubbing up the image

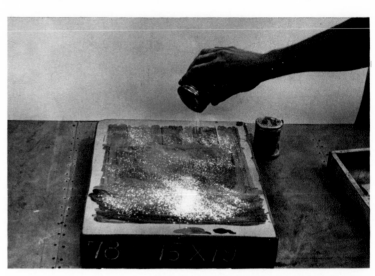

b. Dusting the completed drawing with talc

c. Removing excess talc with a pad

d. Mixing the first etch: 4 drops nitric acid to 2 ounces gum arabic

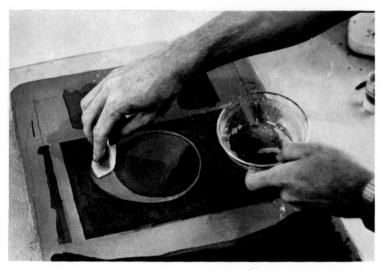

e. Applying the first etch

f. Wiping dry the first etch

15.5 Three-stage etching: the rubbing-up method

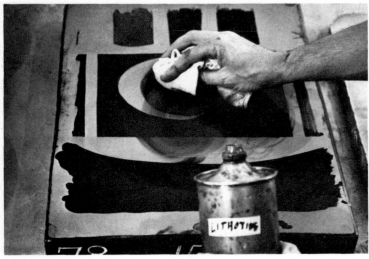

g. Washing out the image with lithotine

h. The layout of equipment prior to the rub-up

i. Applying the rub-up ink with a small sponge; note the use of rubber glove for cleanliness

j. Cleaning the image with the gum sponge

k. Re-applying the rub-up ink

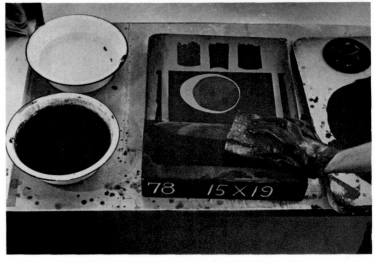

l. Cleaning the image with the gum sponge

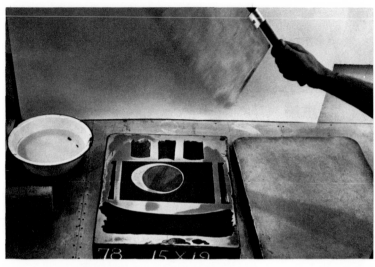

m. Fanning the stone dry after cleaning with the gum sponge

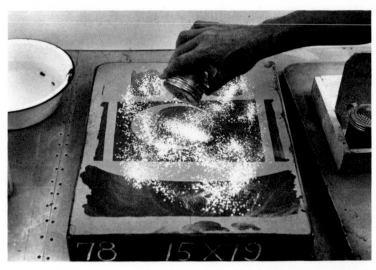

n. Dusting the image with talc

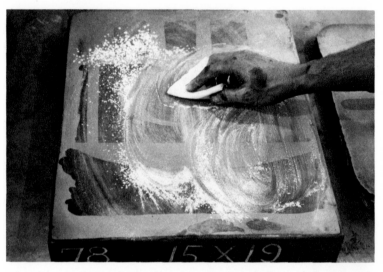

o. Removing excess talc

p. Mixing the second etch: 6 drops nitric acid to 2 ounces gum arabic

q. Applying the second etch

r. Drying the etch

s. Washing out the image

t. Rolling up the image firmly with the leather roller

u. Changing the rolling pattern

v. Cleaning the margins with a hone

w. Applying rosin

x. Applying and removing excess talc

y. Applying the third etch: 24 drops nitric acid to 3 ounces gum arabic

z. Wiping dry the third etch

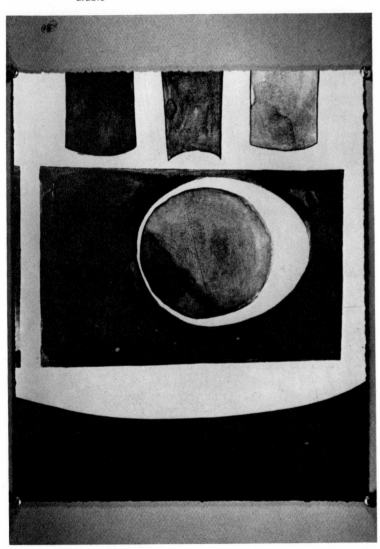

aa. A printed impression of the stone

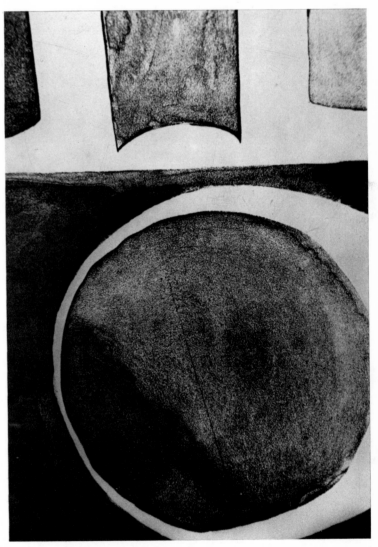

bb. Detail showing the unusually clear and unbroken quality of the tusche washes

drawings, most works receiving a single etch will require the following supplementary procedures to control image stability:

1. During the printing, the entire surface of the stone is sharply slapped with a sponge containing gum arabic. This drives the gum deep into the pores of the stone and supplements periodically the meager deposits provided by the single etch. The gum may be fanned dry in order to form stronger film adsorption. Upon drying, the surface gum is washed off with water before printing is resumed.

2. Antitint solution is sometimes added to the dampening water to keep the work open. In extreme cases, the image may need to be gummed, dried, washed out, and re-inked periodically during the printing.

Despite the hazards involved in the single-etch process, some printers prefer it because of the lively quality of impressions it can produce.

15.14 THREE-STAGE ETCHING: THE RUBBING-UP METHOD

The three-stage method of etching is recommended for the more experienced lithographer. Because of its complexity, it requires somewhat greater judgment and skill of application than the other etching approaches. The process is particularly useful for etching very delicate drawings that contain subtle nuances as well as an extended range of values. Tusche wash drawings and rubbed crayon works most often fall within this category. The standard etching approaches for works of this type present certain problems. If the etches are compounded to desensitize the palest areas of the drawing, they will be insufficient to desensitize fully the heaviest fatty constituents of the dark parts. On the other hand, the stronger formulas necessary to desensitize the darker areas of the image will either weaken or destroy the paler areas. To a certain extent this problem can be solved by etching locally with several different strengths of etch. However, these are awkward to manipulate at best. Moreover, the cumulative total of this method of application is difficult to assess by the time it is carried through the second stage of etching.

Theoretically, complex tonal drawings can be more effectively desensitized by three-stage etching than by any other approach. First, only mild etches are employed for the early stages of processing. These will not endanger the pale areas of the drawing. Second, the fatty contents of the original drawing are supplemented with thinned lithographic ink during the rubbing-up process and thus fortified and driven more deeply into the stone. Third, the enriched deep-seated fatty contents of the image, which can withstand a stronger final etch without risk of being weakened or destroyed, are given such an etch. Thus, the image becomes firmly established without loss of its subtle tonalities. At the same time the nonimage areas are further desensitized by three separately adsorbed gum etch films. Stones treated by the three-stage etching method will receive ink easily on their images and permit exceptionally long and stable printing runs.

The steps of the process are as follows:

STAGE 1.
THE FIRST ETCH
1. The completed drawing is dusted with talc only.
2. A mild nitric acid and gum arabic etch is prepared by assessing its strength against the palest passages in the work. Often 2 to 3 ounces of total etch volume are mixed for use both in the first and in the second stage of etching.
3. The etch is applied with brush or cotton swab in the usual manner, taking care that all areas of the stone receive liberal amounts of the solution.
4. The etch is dried to a thin smooth film with the gum-drying cloths. It is essential for the film to be sufficiently thin to permit the work to be washed out through its dried coating.

STAGE 2.
THE WASHOUT, THE RUB-UP, AND THE SECOND ETCH
1. The drawing is thoroughly washed out with lithotine through the dried etch film. It is important that no water make contact with the stone at this time.
2. The materials needed for the rub-up are: (a) a bowl of very watery gum arabic solution and a sponge, (b) a second small sponge to dispense the rubbing-up ink, and (c) roll-up black ink thinned with lithotine to a smooth semiliquid consistency.
3. The thinned rubbing-up ink is evenly distributed over the washed-out image with the inking sponge. This is immediately followed by an even wiping with the gum-water sponge. With one sponge in each hand, the printer alternately inks and gums the stone. The object is to work the ink deep into the pores of the stone while keeping it localized on the image areas with the gum-water sponge. The entire stone must be kept wet with the gum water throughout the rub-up process, or the fatty contents of the ink will overcome the nonimage areas, which until now have been only partially desensitized.

During the rubbing up, the image will appear very smeared from a mixture of gum arabic and thin ink, but

this is not harmful to the work. The most important factors at this stage are the skill used in manipulation and the amount of ink applied to the image. Determining amounts of ink is largely a matter of experience, since visual appearances are not reliable. It should be remembered that the rubbing-up ink is fairly thin. Even though it enables the work to appear black, a number of applications will be necessary to fortify the image completely. If the ink is insufficiently or unevenly applied, the image will be meagerly protected and its value range will be distorted or impoverished by the final etches. If the ink is applied too heavily, its tonality will become too rich after etching.*

4. The fully inked work is given a final cleaning with the gum sponge to clear the stone of unattached ink. The stone is fanned dry in preparation for the second etch. In this condition it will have a faint gray film over its surface that is mostly the remainder of the gum-water stain. This is not harmful to the work.

5. The stone is etched for the second time with the remainder of the solution from the first etching. Dusting the image with rosin and talc is unnecessary for this etch; however, it can be employed if desired. The second etch is dried with the gum cloth as before.

STAGE 3.
THE FINAL WASHOUT, ROLL-UP, AND THIRD ETCH

1. The image is washed out with lithotine in the usual way.

2. The dried etch film is removed with sponge and water. The stone must be kept damp from this point onward.

3. The image is firmly rolled up with ink, with the leather roller. The roll-up proceeds in the same manner as for any other process. If the preceding steps have been executed correctly, the roll-up will produce a rich image containing a full range of the tonal nuances of the original drawing.

4. The fully charged image is dried and dusted with rosin and talc in preparation for cleaning. The rubbing-up process activates all latent grease deposits in the stone. Consequently, finger marks, dirt particles, fallen hair, and lint will attract greater amounts of ink than they would if other methods were used. Such foreign particles must be thoroughly removed by honing, scratching, and picking before the final etch.

*To a certain degree heavy inking may be used advantageously by an experienced printer. By calculated manipulation he can employ the rub-up technique to interpret the potential of the artist's drawing even beyond that of its original appearance. Such works, although faithful to the value relationships of the original, exhibit a fullness of tone unobtainable by any other means.

5. A moderately strong final etch is formulated. This provides maximum desensitization for the strongest values. The palest tints of the image will have received sufficient fortification during the rub-up to withstand the stronger etch solution. Rosin and talc must be applied at this time to provide additional protection to the inked image against the action of the etch. The final etch is applied and dried in the usual way; the stone is then ready for proof printing. From this point onward it may be treated in the same manner as work processed by more standard procedures.

In conclusion, it should be stated that the rub-up-and-three-stage etching process is advisable only on hard stones of fine quality that have even coloring and composition. Soft, mottled, and veined stones give uneven results, often inferior to the effects produced when these stones are etched by standard methods. Finally, it will be noted that stones having rubbed-up images require considerably more regraining to rid them of the deep-seated formations in preparation for new work. Though arduous for the grainer, this is perhaps the most meaningful evidence of the firm images produced by this process.

15.15 SURFACE PRINTING

Images can be formed on a previously desensitized stone by materials that are capable of physical (rather than chemical) union with the stone. The process of producing impressions from these images is called *surface printing*. Strictly speaking, this is not a true lithographic process. The nonimage areas, being desensitized, receive water and reject printing ink according to the usual lithographic principles. The image areas, however, are nonlithographic and can be completely dissolved with solvent after printing. Therefore a number of drawings can be executed and printed without the usual graining and processing of the stone between printings.

The drawing materials used for surface printing must be capable of forming tough dried films that remain insoluble in the presence of water during the course of printing. They must also be easily removable with an appropriate solvent after printing is completed. The three most popular materials for this purpose are lithographic plate lacquer, shellac, and liquid etching ground (as used by intaglio printmakers). Liquid etching ground is a mixture of waxes, asphalts, and volatile solvents that dry rapidly. The three materials work equally well, but they each display their own drawing and printing characteristics.

Images made with these materials are quite different from those produced with the usual lithographic drawing substances. Being liquid, they are most appropriately used for linear or flat passages. Limited tonal effects can be obtained by drybrushing and stippling. Because the materials dry rapidly, brush marks tend to overlap one another rather than to blend together. Such lap marks, because of their different layer levels, will print in relief, conveying effects similar to impasto painting. The effect can be sustained for one impression after another by controlled inking. The image will tend to flatten somewhat, however, under the pressure of the press during the printing of a large edition. Therefore impasto effects are better suited for small editions. With some exploration, perhaps, tougher synthetic resin coatings will be found that can provide longer runs without flattening.

Besides offering obvious advantages for minor corrective techniques (see next section), surface printing is also useful in the making of color lithographs. Since images can be drawn, printed, and dissolved with relative ease, it is possible to make a multicolor lithograph without regrinding the stone between printings and, in fact, without reprocessing or removing it from the press bed. However, limiting characteristics of the drawing materials will more often relegate surface printing to the auxiliary functions of modifying and enhancing passages made by other means.

Ink films printed by the surface process display two distinct characteristics that can be used advantageously. First, heavier and somewhat more opaque ink deposits can be printed; thus denser and more resonant color passages can be obtained than could be achieved otherwise. Second, the impasto passages produce an especially pronounced variation between the mass tone and bottom tone of the color ink (like that of impressions printed from intaglio plates). Color rollers with smooth surfaces should be employed to realize fully these characteristics.

PROCEDURE

1. A freshly ground stone is given a medium-strength etch over its entire surface and is wiped dry.

2. The etch is removed with sponge and water, and the stone is fanned dry. It is imperative that the grain and the pores of the stone be completely dry before the drawing materials are applied; otherwise they will be incapable of obtaining a firm hold on the surface.

3. The image is drawn with the desired drawing material (lacquer, shellac, or liquid etching ground).

4. After the image is completely dry, the stone is dampened with water and fully charged with printing ink. Images made with liquid etching ground should be proofed and printed immediately. After the edition is completed, the ink and image are dissolved with lithotine, the stone is then washed with clean water and dried, in preparation for receiving the next drawing.

5. Shellac or lacquer images are dampened and rolled up with ink for printing as above. Sometimes they are also dusted with talc and given a second mild etch for further desensitization. The ink film is washed out with lithotine in the traditional manner, and, after the etch film is washed away, the stone is inked up and printed. These images can be gummed and washed out repeatedly with lithotine without loss to the surface film, which is insoluble in this solvent. Drawings made with liquid etching ground, however, are soluble in lithotine, thus should not be washed out until the edition is completed. After the edition has been completed, shellac images are removed from the stone with alcohol solvent. Lacquer images are removed with lacquer thinner. The stone is washed with clean water and dried. In this condition it is ready to receive the next drawing.

15.16 MINOR ADDITIONS DURING PROOFING

During proofing it is often necessary to make minor corrections on the image, such as filling in tiny white pinholes, repairing broken lines, or touching up irregular edges. Such minute corrections can be made at the press as an integral part of the proofing operation without interrupting the work flow for the more time-consuming techniques of counteretching, retouching, and re-etching.

The materials used for surface printing (plate lacquer, shellac, or liquid etching ground) are excellent for making these corrections, because they (1) dry rapidly, (2) are capable of firm attachment to the printing surface, (3) are insoluble in the dampening water, and (4) are attractive to printing ink. (See sec. 15.15. It should be recalled that images corrected with liquid etching ground cannot be washed out after storage and must be printed immediately.)

Two other materials are available that are capable of forming ink-receptive areas on desensitized stones or metal plates without counteretching. Korn's Autographic Tusche can be used for solids and for linear corrections, and an offset reproducing pencil (A. B. Dick # 4-3221 Hard) can be used for minor corrections of crayon work. Both materials (because of a high percentage of fatty content) are capable of overcoming desensitizing films and of establishing firm, ink-attractive deposits. Unlike the materials of surface printing, these two substances

are capable of producing actual lithographic formations.

The printing surface must be thoroughly dry before corrections are made. The stone or plate should be fanned for at least five minutes to ensure removal of moisture from its granular surface. The slightest trace of moisture will prevent the corrective materials from attaching firmly to the printing element and will lead to their eventual breakdown during printing.

The liquid materials are applied with a small pointed brush or pen either by stippling or by laying a continuous film; the application should be as smooth as possible. After the correction is completely dry, it is carefully dampened with water and rolled up with ink in preparation for the resumption of proofing. Several proofs may be required before the corrected area accepts the necessary amount of ink; once stabilized, it should continue to print dependably throughout the balance of the edition.

The reproducing pencil does not have the adhesive properties of the liquid materials, so correction of crayon work with this instrument is a somewhat more delicate task. The pencil should be applied firmly and precisely so that its fatty content can penetrate and overcome the desensitized areas of the printing element over which it is drawn. It is a good idea to exhale over the printing surface a number of times, leaning closely over the area to be retouched. Condensation produced by the warm breath softens the desensitizing film and so permits more effective penetration by the fatty contents of the pencil.

The stone should be carefully dampened after the retouching; a little ink may be dabbed with a rag on the corrected area before the roll-up is begun. This reinforces the correction and enables it to accept ink from the roller more easily, without being dislodged from the printing surface.

15.17 OXALIC ACID MASKS

When a saturated solution of oxalic acid and water is rubbed over the surface of a lithograph stone, it forms a glasslike film of calcium oxalate. The glazed film is receptive to water, rejective to printing inks, and virtually insoluble. Its toughness is such that it can be removed from the surface of the stone only with delicate physical abrasion.

Commercial lithographers at the turn of the century used films of oxalic acid to keep stone borders free of ink during the printing of large editions. More important, they sometimes used these films for temporarily masking out titles, publishing inscriptions, and other documentation in the margins of special publications. For example,

a limited edition of a print might be pulled without inscriptions; when this was completed, the temporary mask would be removed, and the balance of the works would be printed with the original lettering included.

This traditional use of oxalic acid has suggested other possibilities of use, such as temporary masking in color printing. It would appear entirely possible to print several different colors from the various areas of one master drawing by alternately masking and re-exposing separate areas of the image as the different colors are printed. For example, one area of the drawing could be covered with the mask, and all impressions of the first color printed from the exposed remainder of the image. After the first printing, the mask could be removed and a new mask put over the previously printed areas; the second color would then be printed in areas that had been blocked out during the first printing. The process could be repeated a number of times.

It will be apparent that the nature of the drawing will determine the effectiveness and efficiency of the masking system for color lithography. Some motifs are better suited than others to this approach. Furthermore, it is doubtful that the procedure would enjoy more than occasional use because of its intricate technology. Nevertheless, the theoretical possibilities of the masking technique are such as to warrant further exploration.

PROCEDURE

1. A drawn stone is processed by etching and rolling up in the usual way for printing.

2. The stone is dried and dusted with talc.

3. The areas to be blocked out are painted with a saturated solution of oxalic acid and water. Several applications may be needed to seal effectively the pores and grain of the stone. The solution is gently rubbed with a soft cloth to facilitate the sealing and the formation of surface glaze. Polished stone surfaces are the easiest to mask; coarse-grained stones require a number of applications before an effective mask can be produced.

4. After the mask is thoroughly dry, the stone is dampened and rolled up with ink. The blocked-out areas gradually refuse to accept ink, even though the original image can be seen below the mask. Sometimes additional applications of the oxalic solution may be necessary if the blocking out is insufficient.

5. Rough proofs are taken until the blocking out becomes effective. The edition is printed as soon as the image is performing satisfactorily. Either the original ink may be used or the stone may be washed out and printed with another color.

6. The stone is rolled up with black ink after each

color of the edition has been printed; it can then withstand the abrasive action involved in the removal of the mask.

7. The oxalic mask is gently rubbed with a bone burnisher and water or with a mixture of fine pumice powder and water applied with a felt pad. Care must be taken not to injure the image deposits lying below the mask.

8. After the mask has been removed, the image areas that were covered are carefully rubbed up with the gum and ink sponges, in order to restore their original ink-receptive properties.

9. The fully restored image is dried and dusted again with talc; another area is then masked out with the oxalic acid solution.

10. The steps of the process are repeated; the image is alternately masked, printed, and restored as many times as necessary.

15.18 LACQUER PRINTING BASES FOR METAL PLATES

The use of a lacquer printing base on metal plates instead of asphaltum or Triple Ink offers certain advantages during the printing of editions. First, the lacquer film provides a tough protective mask over the image areas. Upon drying, the mask is impervious to the usual solvents and chemicals used in hand printing. Nonimage areas that become ink-receptive during printing can be cleaned easily with solvents that would normally dissolve other printing bases and endanger the plate image. One highly recommended lacquer base is Lith-Kem-Ko Deep Etch Lacquer "C" # 3001-C (Litho Chemical and Supply Company, Inc., see Appendix A). Lacquering is performed as follows:

1. The plate is etched, washed out, and rolled up; Triple Ink is used as the printing base before the second etch. After the second etch, the plate is proofed and corrected following standard procedure.

2. When ready for edition printing, the image is washed out thoroughly, first with lithotine and then with lacquer thinner, until all traces of ink have been removed. The plate is dried.

3. Lacquer is poured in a small puddle and rubbed gently into the image with a clean, dry rag. A second rag is used to buff the lacquer into a smooth, dry film.

4. Asphaltum is applied over the lacquer and buffed until it is smooth and dry.

5. The plate is sponged with water to lift the gum mask, excess lacquer, and asphaltum from the nonimage areas.

6. The dampened plate is rolled up firmly with printing ink. If the lacquer refuses to lift completely from the nonimage areas, the plate is dampened with water for several minutes and rolled briskly to remove attached particles.

7. When the plate is fully inked, the printing of the edition can begin, according to standard procedures.

8. Once established, lacquer printing bases will remain on the image areas of the plate surface indefinitely throughout subsequent re-etching, gumming, and washing-out processes. After the plate has fulfilled its printing function, the printing base is removed with lacquer thinner and the plate regrained.

If the nonimage areas must be cleaned or re-etched during printing, the following procedure is recommended:

1. The image is inked freshly over the lacquer base.
NOTE: Talc should not be dusted over the ink.

2. The areas to be cleaned should be treated with Plate Conditioner F 602–71–502 or 50 per cent NGN Non-Tox Solution (Lithoplate Company, see Appendix A) and 50 per cent gum arabic. Either solvent will remove ink scum and unattached excess fatty deposits without harming the lacquered image areas.

3. Depending on the extent of desensitization necessary, the plate can be re-etched or gummed by standard methods.

4. The plate is left to dry thoroughly for at least thirty minutes.

5. The gum is washed off, and the dampened image is inked for printing without washing out.

15.19 REMOVAL OF IMAGES WITH CARBOLIC ACID AND GASOLINE

It is possible to employ chemical means to efface images that have been processed on stone and to prepare the surface to receive new work without regraining. An effacing solution consisting of 1 part carbolic acid (phenol) and 1 part gasoline is used to destroy the image deposits.† The stone is then counteretched to dissolve the nonimage gum deposits; in this sensitized condition it is ready to receive a new drawing.

The components of the effacing solution serve two functions. The phenol is a very powerful grease solvent and, as such, can weaken or utterly destroy the most durable fatty images. The gasoline serves to carry the phenol into the pores of the stone to attack the most deeply seated image deposits. Curiously, the stain of the

†Phenol-gasoline solvents should be used with extreme care and *only* where there is adequate ventilation.

a. Applying talc to the freshly inked image

b. Counteretching the stone

c. Removing the counteretch with water

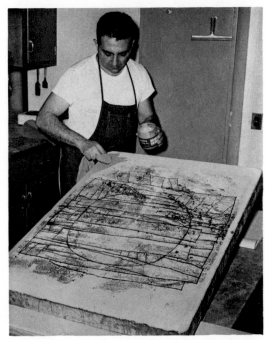

d. Masking the borders with Vaseline

15.6 Transposing by the shellac method

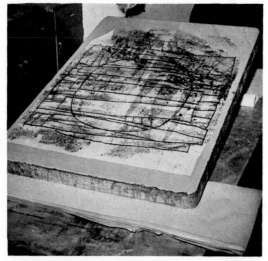

e. Pouring shellac over the inclined stone

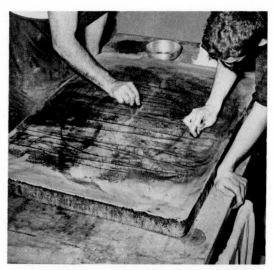

f. Washing out the positive image with lithotine

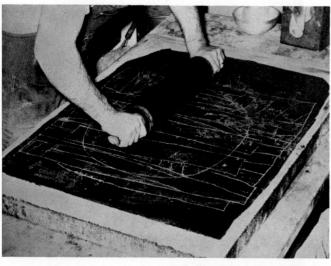

g Rolling ink on the shellac film

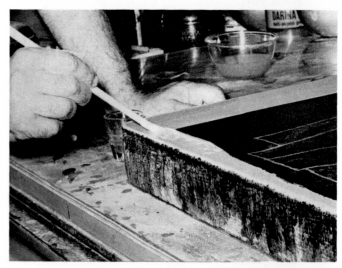

h. Etching the margins of the image

i. Removing a proof impression of the transposed image

j. Removing an impression of the positive and negative images combined

k. The positive image

I. The negative image

m. The negative image superimposed over the positive image

effaced drawing will remain on the stone even though its ink receptivity has been arrested to a great extent.

The chemical action of the phenol-solvent solution on the grease image and the stone is not completely understood. One theory suggests that the solution arrests or dissolves the fatty-acid radicals that are the ink-attracting components of the etched drawing. Another theory suggests that the radicals become disoriented by the solution, which drives them deeper into the pores of the stone. Since the radicals are no longer pointing outward toward the surface, they cannot accept ink. The latter theory is supported by the fact that in certain cases effaced images have been known to reappear, not in the next printing, but several printings later. That is to say, several drawings can be printed safely without the previous image's returning. Drawings processed by the rubbing-up method have been known to activate old images sometimes three drawings removed. Apparently, the penetration of the rubbing-up process re-orients the old image deposits and permits them to attract ink once again.

Effacement by chemical means has a number of advantages for color lithography. The stain left from the chemical effacement of one drawing can often serve as a reliable guide in aligning the next drawing. It is also possible to print several colors from the same stone without having to regrain between printings, thus reducing the problems of misregister due to faulty tracing. Although the process can be used for almost any work, it is particularly attractive for large prints where grinding and handling of stones can become burdensome. A number of images can be drawn and printed without the stone's being removed from the press bed.

Chemical effacement can be safely employed for any number of separate printings. It is well to know, however, that excessive effacement with subsequent counteretching and re-etching gradually destroys the grain of the stone. The original grain is slowly replaced by another grain produced by the chemicals of the process. The chemically produced grain is less crisp and produces less attractive tonal nuances in successive printings. For this reason, drawings after the first printing should be designed to carry simple nuance and surface character. It is sometimes desirable, however, to grain the stone freshly in order to obtain crisp tonal definition for the final printings.

PROCEDURE

(Before proceeding it is advisable to review the storage and handling of the effacing solution in view of its volatile and corrosive properties. See sec. 10.4, Phenol.)

1. The first drawing of the color lithograph is placed on a freshly ground stone, and register marks are indicated. The stone is processed, proofed, and printed in the normal manner. It should be noted, however, that the process is essentially subtractive, and, once effacement has been made, there is no opportunity to return to an earlier image. Therefore, sufficient extra proof papers should be printed to allow for a good deal of testing and error as the work progresses.

2. After all impressions of the first color have been printed the printing image is washed out with lithotine. The stone may remain in this condition until the work is next taken in hand, or it may be chemically effaced immediately.

3. The phenol-solvent solution is applied over the entire stone surface, and the image areas are gently scrubbed with a brush used only for this purpose. The agitation should be carried on for several minutes, to remove all traces of color ink from the pores of the stone.

4. The residue of the effacing fluid and ink is wiped from the stone with a clean cloth. The stone is washed thoroughly with water and fanned dry. The brush is washed with soap and water after each use.

5. The stone is counteretched in the usual way. After it is washed with water and dried, it is ready to receive new work.

6. The new drawing should be processed as if on virgin stone, but with a slightly weaker etch. The etching process completes the final destruction of the old image while it is preparing the fatty deposits of the new.

7. The new drawing is washed out and rolled up in the normal manner. The fully inked image is sometimes gummed in lieu of a second etch, or it may be given a moderate etch. Decisions regarding the second etch depend on the character of the drawing and its response to the rolling-up process.

8. The cycle of printing, effacing, counteretching, drawing, and re-etching is repeated as often as necessary.

15.20 THE TRANSPOSITION OF IMAGES

During the last century many technical innovations were introduced in commercial printing from stone, in an effort to compete successfully with letterpress printing. One such innovation was the process of transposing the original lithographic image so that it would print an exact duplicate in reversed tonal pattern. Areas that were white in the original would print black in the transposed version, and the relationship of the ink-receptive and ink-rejective areas of the stone would be exactly reversed.

The process was especially useful in label printing, where a client's order might call for a quantity of labels

white on black in design and another quantity in black on white. Drawing exact duplicates both ways would be difficult, time-consuming, and costly. The photo-litho process by which this could easily be done was not invented until much later.

Several different approaches were employed to transpose work. With some, the positive (or original) image was destroyed if the transposition was undertaken on the same stone. With others, both the positive and transposed (or negative) images could be retained through the use of the transfer process. Subsequently, it was found that, if the positive and negative images were printed against each other in minute misregister, a remarkable dimensional effect could be achieved. The optical illusion of such prints is not unlike that produced in intaglio printing when impressions are taken against each other from the relief and the intaglio levels of the same plate.

It is particularly in this capacity that lithographic transposition has significance for the creative artist of today. Its potential in color lithography for dimensional as well as optical illusion has received only limited attention in this country; its application to black-and-white work has been explored even less. Since a certain amount of technical manipulation is involved, transposition must be used with discretion; otherwise, it can easily degenerate into pointless technical superficiality.

Lithographic transposition can be undertaken both on stone and on metal plates. The processes on stone are somewhat easier to control and offer greater flexibility of use. However, metal plates, if carefully processed, offer equally accurate results. Five different approaches are described here. Of these, all but the last are adaptable for stone; only the last two are satisfactory for metal plates. Significantly, the processes most suitable for metal plates are also the most demanding in execution and the least tolerant of error.

15.21 GENERAL REMARKS REGARDING THE TRANSPOSITION PROCESSES

1. If transposition for color work is undertaken on one stone, the edition of the positive image must be completely printed before its image is reversed. Register marks must appear on the positive as well as the negative image, and, since there is no opportunity for progressive proofing, sufficient proof papers should be printed to allow for adjustments as the work continues.

2. Transposition of work on two stones permits progressive proofing if desired. Furthermore, each stone can be reworked after it serves its original purpose, and can be used again either to supplement the original printings or for an independent work.

3. The registration of the positive image against the negative image is of extreme importance. Pin registration is the preferred system; but the T-line system can also be used if correlated with acetate overlays. (See secs. 7.10 and 7.11.) Some experimentation will be necessary to determine the degree of misregister most suitable for a particular work. Misalignments greater than the width of a pencil line are usually unsatisfactory, because of the unpleasant optical distortions they produce. When the correct registration has been determined, each sheet must be laid in exactly the same way, or the dimensional effect produced will change radically from one impression to the next.

4. Some experience is necessary for planning appropriate colors to be carried by the positive and negative plates. If the two plates are printed in inks that are close in hue and value, the result will appear as a dimensional shadow of the positive image, and the over-all print will appear monochromatic and of local hue. Greater differences in hue or intensity between the two plates will impart slightly more chromatic properties when they are combined; contrasting hues and values will produce more vivid results. In all cases the visual effect of the print will appear as a mixture of the two colors, since they are completely interwoven throughout the image. To provide a broader color spectrum for a print, additional overprintings are usually needed.

5. The dimensional and optical effects of transposed printings are very subtle. Supplementary images printed over them should be carefully considered. If too opaque or too strong in color, they will tend to overcome the subtleties of the underprintings. The supplementary images must also be drawn in such a way as to become plastically integrated with the dimensional effect. The sequence of printing is sometimes more successful if the transposed images are printed last.

6. Although the process of transposition totally reverses the image values and patterns, they need not be printed in this way. For example, images processed by the relief method may be only partially transposed. (See sec. 15.22.) They are then capable of printing some of the negative and the remainder of the positive image at the same time. Transposed plates can also be altered by honing, acid biting, and scraping so that only portions of the image print against the positive; deleted sections permit parts of the positive image to show without interaction.

15.22 THE RELIEF METHOD OF TRANSPOSITION

The relief method of transposition transforms the original image by physical and chemical means into its negative duplicate. If the positive image from the original stone is transposed, its formation will be destroyed during the transformation. As stated before, all edition prints from the positive image must be printed before transposition. It is sometimes desirable to pull a transfer impression from the original and to lay this down on a second stone for transposition. Both positive and negative images are thus readily available for repeated progressive proofing sessions if necessary. The steps of the process are as follows:

1. The original image is drawn on the stone in the usual way. It is processed and proofed, and the entire edition is printed with appropriate register marks.

2. After the printing, the stone is rolled up with fresh roll-up ink.

3. The image is dusted with rosin; the stone is dampened and rolled up with ink again. The process of dusting with rosin and re-inking is repeated at least three times. The object is to develop over the work a tough coating of ink impregnated with rosin that is highly acid-resistant. The stone is dusted with rosin and talc after the last inking.

4. The stone is etched with a solution of nitric acid and water (80 drops of acid to 2 ounces of water). Repeated applications are brushed or flowed over the work until the design stands in low relief (about the thickness of a playing card). It is better to use an etch of moderate strength applied several times than a strong etch applied once, for the latter will tend to undermine the most tender passages of the work.

5. The stone is washed with fresh water when sufficient relief has been obtained.

6. The stone is counteretched with the standard acetic-acid-and-water counteretch.

7. The entire image is filled in with full-strength tusche, resulting in a solid black stone. After drying, the entire stone is gummed and wiped down.

8. The stone is washed out and inked with roll-up ink. The relief of the design may prevent the ink from getting in between lines; hence a generous amount of ink and firm rolling are required to obtain a solid black.

9. The surplus ink may be taken off the top of the design by passing the stone, with proof paper over it, through the press with moderate pressure. The background should remain richly covered with ink.

10. The stone is dusted with talc to dry the ink. The relief design is polished down to the surface of the stone by using snake slips or Carborundum hones and water.

11. When the positive image appears white against the black background and its relief has been honed level, the stone is washed with fresh water and dried. At this point the transposition should be complete and should contain the original register marks in reverse value.

12. The stone is dusted with rosin and talc and given a moderate-strength etch, which is wiped dry.

13. The stone is washed out, rolled up, and proofed according to standard procedures. When it is printing satisfactorily, the registration alignment is determined, and proofs are taken against impressions of the original image.

15.23 THE SHELLAC METHOD OF TRANSPOSITION

The shellac method is perhaps the simplest method of transposition known. With a little practice it can produce excellent results. As with the relief method, the original or positive image is destroyed during the process. The edition of the positive image must be printed before the transposition, or a transfer impression of the positive image may be placed on a second stone for transposing. The steps of the process are as follows (see photo sequence fig. 15.6).

1. The positive image is inked with roll-up ink, but is not dusted with rosin or talc.

2. The stone is counteretched with one of the standard solutions. The liquid should be brushed well over all the image; since no rosin or talc is present, extra care is necessary to make sure it lies in close contact with the image contour. The absence of the rosin and talc permits the counteretch solution to weaken the image deposits slightly. These will be completely destroyed during the course of etching (steps 6 and 7). The stone is washed with fresh water and dried.

3. If the borders of the transposed image are to remain white, they must be temporarily masked. Either Vaseline or liquid tusche is used for this purpose. It is important for a solid layer of the substance to cover the areas to be masked. Areas within the image can also be masked in this way, so that they will resist the formation of the negative image.

4. The stone is placed on an incline and flooded with a dilute solution of white shellac and alcohol (1 part shellac, 2 parts alcohol). The consistency of the solution is very important. It should be quite thin. It must flood the entire stone in one application and lie in an even film

over the total surface. Spray shellac from a pressurized can may be used; sometimes, however, this produces a crazed surface.

5. Just before the shellac film is dry (it should be slightly tacky to the touch), the inked image is carefully washed out with gasoline, using a cotton swab. Care must be exercised not to dislodge the shellac mask. This is the most critical phase of the process. If the shellac has been applied too heavily, the solvent will be unable to penetrate its film to wash out the positive image. If the shellac film is too thin or has not been permitted to dry sufficiently, it can be dislodged by the solvent. Ideally, the film formation will be slightly rejected by the inked image, on whose greasy surface it cannot completely dry. In this condition it is easily dissolved by the solvent, and so is the ink film under it. What remains is a tightly clinging shellac mask covering all the nonimage areas of the work.

6. The stone is washed with water and dried. It is next given a moderate etch (12 to 18 drops of nitric acid to 1 ounce of gum arabic) which destroys and desensitizes the exposed positive image. Because the shellac mask is acid-resistant, it will not be affected by the etch unless it was applied too thinly. The etch is wiped dry.

7. The etch is washed away with water, and the dampened stone is immediately rolled up with ink. The ink will attach itself quickly and firmly on the shellac mask, and will be rejected by the original image areas.

8. The fully inked image is dusted with rosin and talc. It is cleaned with scraper and snake slip if necessary, before receiving a weak final etching in preparation for proofing.

15.24 THE FALSE-TRANSFER METHOD OF TRANSPOSITION

In this method of transposition, an impression is transferred from the positive-image stone onto a second stone. The transfer must be of weak grease content, so as not to establish firm lithographic deposits. This positive image serves as a temporary resist around which much firmer fatty deposits can be formed. After these are formed, the temporary mask (positive image) is destroyed. During this procedure, the negative formation becomes ink-receptive.

PROCEDURE

1. An impression of the original image is taken with stiff roll-up ink either on stone-to-stone transfer paper or on a very smooth uncoated paper. The ink should be of minimum grease content; sometimes it is modified by additions of magnesium carbonate. Impressions from type or other relief surfaces should be taken with letterpress ink. The impression should contain as little fatty content as possible, yet permit a firm transfer.

2. The impression is transferred to a fresh stone, with slightly less pressure than usual so as to minimize deep-grease penetration into the stone.

3. The coating from the transfer paper is washed, and the cleaned stone is dried. Counteretching solution is sometimes applied at this stage to sensitize further the negative areas of the image as well as to weaken further the positive image. In such cases, talc should not be used to protect the image.

4. The entire stone within the borders of the image is coated with full-strength liquid tusche and dried.

5. The stone is dusted with talc and gummed down.

6. The image is washed out and rolled up with stiff roll-up ink. The areas that were filled in with tusche attract ink far more readily than do the transferred areas of the original positive image. The little that remains of the positive image will be totally destroyed by the final etch.

7. The firmly inked image is cleaned, dried, dusted with rosin and talc, and given a moderately strong etch, after which it is ready for proofing.

15.25 TRANSPOSING BY THE GUM METHOD

In transposition by the gum method, a gum arabic impression of the positive plate is transferred onto a second stone. This serves as a mask around which a lithographic image can be formed on the negative areas of the work. In principle this approach is simple; considerable skill and experience are needed, however, for the effective transfer and establishment of the gum mask.

NOTE: This process may be used on metal plates as well as on stone, provided that appropriate etches are substituted.

PROCEDURE

1. A proof impression of the positive image is printed on smooth bond, bristol, tracing, or other uncoated paper.

2. The fresh impression is dusted with finely powdered gum arabic. The gum powder should completely cover the tacky ink, but must be tapped off the paper everywhere else.

3. A clean stone is positioned on the press, and its surface is very slightly but evenly dampened. The gum-coated transfer impression is placed on the stone and pulled through the press with moderately firm pressure

only once. The degree of moisture on the stone is critical. If it is too damp, the gum powder will dissolve and run; if it is too dry, the gum will not adhere to the stone. The ideal transfer will produce on the stone a crisp gum mask that is a replica of the positive image.

4. The borders of the stone are gummed and dried. The entire surface is then coated with an even film of asphaltum printing base and is again dried.

5. The stone is washed with water, the gum mask is lifted, and the stone is rolled up firmly with ink.

6. The inked negative image and borders are cleaned and touched up as necessary according to standard procedures. The stone is dusted with rosin and talc and given a moderate etch. It is then ready for proofing.

15.26 TRANSPOSITION ON METAL PLATES

Another method of transposition is used only for metal plates and cannot be employed on stone. This process is somewhat similar to the gum method just described, except that a powdered oxalic acid impression is transferred to the plate. Instead of serving as a mask, the chemical bites its impression into a solid film of ink carried on the plate. Like the gum process, this method requires skill in the critical procedure of transfer.

1. A counteretched zinc plate or a clean aluminum plate is rolled up solid with transfer ink. The borders may be previously gummed if desired.

2. An impression of the positive image, whether from stone or metal plate, is taken on smooth bond, bristol, or other uncoated paper.

3. The impression is dusted with finely powdered oxalic acid. All excess powder must be tapped off the sheet.

4. The dusted impression is laid over the solidly inked plate. An evenly dampened newsprint cover sheet is placed on top, followed by the backing sheet and tympan. The work is passed through the press several times. The object is to transfer moisture from the cover sheet through the transfer paper in order to dampen the particles of oxalic acid, which in turn bite the transfer ink. Insufficient moisture in the cover sheet cannot activate these particles; too much moisture will cause spreading and overbiting of the image. The degree of dampness must be assessed against the absorbency of the transferring paper. Sometimes heavier papers are placed between damp blotters a few minutes before transferring in order to activate the acid particles.

5. The plate is washed thoroughly under the water tap, and the bitten work is gently sponged to remove the ink, which should come off in rubbery flakes, exposing the negative image.

6. The plate is fanned dry, dusted with rosin and talc, and given an etch appropriate for the particular metal that has been used. (See secs. 6.16 and 6.17.)

7. The image is washed out and rolled up according to standard procedures. After cleaning and touching up, the work is dusted with rosin and talc and given the final etch. It is then ready for proofing.

15.27 PRINTING THE ENTIRE SURFACE OF THE STONE

From time to time one sees lithographs on which the entire stone, edge to edge, has been printed. Many lithographs by German Expressionists were printed in this way. The natural irregularities of the stone's contour offer a tabletlike ground as well as positive encasement for certain types of imagery. The aesthetic validity of such approaches is unquestionable. The technical problems associated with them are worth examining.

In order to print the entire stone surface, the press scraper must engage the extremities of the stone at both leading and trailing edges during its traverse. Unless the stone is well anchored on the press bed, the heavy pressure at its extreme edges is likely to tip or shift the stone, thus slurring the impression. The precarious contact against the edges of the stone can damage the scraper bar by denting its surface. Pressure along these lines can also crease or split the tympan sheet. The printed impression will often show a strongly embossed plate mark as the sheet is forced against the edges of the stone. Finally, the stone itself can split or fracture along its edges, since these are subjected to unequal stresses.

Because the tolerances of scraper alignment are extremely small at both ends of the stone, the printer must check them carefully for each impression pulled. In short, edge-to-edge printing seriously reduces the factors controlling accuracy, increases the hazards to the printing equipment, and greatly magnifies the production burden. The prospects of printing a sizable edition with reasonable accuracy by this method are slender indeed.

Lithographs of this type require a special procedure to overcome the above hazards. The procedure recommended is to pull one or two inked impressions of the stone onto transfer paper and to transfer the best of these onto a larger stone allowing for comfortable margins. Although the same risks noted above are involved while the transfers are being taken from the original, greater time and care can be afforded, since only one or two are

necessary. Once the work is on the larger printing surface, it can proceed with less risk.

15.28 BLEED PRINTING

In recent years an increased number of lithographs are being printed with what are described as *bleed edges*. These are prints that have no margins whatsoever; the image is printed completely to the edges of the sheet. Images developed in this manner convey a characteristic increase of scale, and project forward from the sheet instead of being compressed into a recessive space by a surrounding unprinted margin.

It might appear that the most direct way of achieving a print without margins is to trim each print after the edition has been completed. This approach has one major disadvantage: edges trimmed in this way are void of ink and appear unprinted, particularly if the sheet is ripped to simulate a deckled edge. By comparison, if the sheet is cut to size before printing, the ink film will saturate the deckle and will appear as an organic part of the paper.

The following technical details should be considered before beginning bleed printing:

1. The printing paper must be smaller than the stone. The image must be drawn at least 1/4 inch larger on all sides than the size of the paper. This ensures that the variations of the deckle from one sheet to another will be printed.

2. The printing surface should be sufficiently large to permit the engagement of the press scraper in front of the leading edge of the sheet. In other words, the press pressure should be applied before the scraper reaches the print paper, and the printing traverse should be continued until the scraper passes the trailing edge of the sheet.

3. It is preferable, although not mandatory, that the printing surface be large enough to permit an uninked border outside the perimeter of the image. This keeps the ink from piling up along the edges of the stone, and contributes generally to cleaner printing.

4. Because at least 1/4 inch of the inked image will be exposed around the perimeter of the print paper, it is necessary to place a newsprint slip sheet (cut to the size of the stone) over it before positioning the backing papers and tympan. In this way, the backing sheets are protected against ink offset from the bleed areas. A separate slip sheet must be positioned for the printing of each impression and discarded thereafter. Slip papers are prepared at the same time that the paper kit is prepared and are separate from those which are used for interleaving between printed impressions.

5. Color lithographs printed by the bleed method and utilizing pin registration require white registration marks inside the perimeter of the inked image. These can either be formed with a gum stop-out before the drawing is made or scratched into the stone before etching.

6. The handling of bleed impressions requires greater care than do other types of printing. There is an increased tendency for ink smudging on the sheet as it is lifted from the surrounding ink film. Some printers employ a needle or razor blade to release the edge of the sheet from the printing surface. Thereafter the sheet is supported by its edges like a phonograph record, to prevent finger contact on its face or back while it is transported to the print pile.

15.29 PHOTOGRAPHIC REPRODUCTION IN HAND LITHOGRAPHY

Photographic imagery has become a popular form of artistic expression in recent years. Though more commonly employed in silk-screen and intaglio processes (because of simpler techniques), it is also being used in hand lithography. Although present achievements are crude in comparison to the remarkable virtuosity of commercial processes, it is probable that rapid improvements will be made through continued experimentation.

Three different approaches are used today for producing photographic imagery in lithography:

1. Impressions can be transferred from existing halftone plates (either letterpress engravings or offset plates) onto the printing element. This is by far the easiest approach; it utilizes standard transferring techniques and eliminates the necessity of using the more complex procedures for exposing and developing original photographs. The chief disadvantage of this method is that one's selection of imagery is limited by the choice of commercial plates readily available. Furthermore, the transferring must be executed faultlessly, or the halftones will thicken and coarsen the work.

2. Impressions can be transferred onto stone or metal plates from existing printed material. The printed ink films from magazine, newspaper, and poster reproductions (if sufficiently fatty) can be re-activated to produce an ink-receptive image on a fresh printing element. Processes for such transfers are given in chapter 8.

3. A lithograph stone or metal plate can be prepared by hand to carry a light-sensitive coating. Original photographic material can be exposed, developed, and processed to print impressions from this coated surface. The techniques of exposure require a thorough familiarity with photographic principles as well as specialized and

rather expensive equipment. Unless the printer has ready access to such knowledge and equipment, this phase of the process (if done on metal plates) is best executed by firms that specialize in lithographic photo-reproduction work. Unfortunately, such firms are equipped to expose work on metal plates only; reproduction techniques on stone must be carried out entirely by the printer. It should be noted that, after the photograph has been exposed on the plate, the image should be developed and processed by the printer since these techniques require special treatment, quite different from those used in the preparation of commercial offset plates.

Since professional services are readily available for exposing work on metal plates, one may wonder why photo reproduction on stone is even considered. The answer lies in the greater printing reliability that stone offers. Moreover, photographic images on stone can be modified to a greater extent once the image has been stabilized. Metal plates offer less flexibility for alteration.

The most practical procedure at present is to develop the photographic image on a metal plate with professional assistance. Impressions can then be transferred from the plate to a stone for the printing of the edition. It is to be hoped that continuing experimentation will either permit greater flexibility in metal-plate printing or provide a simpler, more reliable method for photographic reproduction on stone.

15.30 THE PRINCIPLES OF PHOTOGRAPHIC REPRODUCTION

The principles of photographic reproduction in hand lithography are briefly described below.

The Photographic Negative. The continuous tones of an original photograph must be divided into a series of fine dots in order to produce a dependable printing image. This is accomplished by photographing the original through a halftone screen of fine mesh wires. Screens in which there are 65 wires to the inch produce large dot formations. These are considered coarse halftones and are used for newspaper reproduction or for printing on soft pulpy stocks. Screens in which there are 150 wires per inch permit smaller dot formation and produce much finer tonal gradation. Although halftone screens that are even finer are used in commercial lithography, they are not recommended for hand printing. The finer the halftone dot and the softer and heavier the paper, the greater are the tendencies for the printed image to fill in.

The photographic negative should be very opaque in areas corresponding to the lightest parts of the original and should be transparent in the lines, solids, and halftone dots. To produce good work, the negative should be free from dirt and dust specks and should have sharp fidelity without fuzziness or halos around the halftone dots.

The Light-sensitive Surface Coating. A surface coating that is sensitive to light is applied to the lithograph stone or metal plate. Traditional coating solutions are composed of a water-soluble colloid such as fish glue, casein, or albumin and a bichromate. During exposure, the parts receiving light through the photograph negative become hardened and insoluble. The unexposed parts remain soluble and are washed away during the developing process. The insoluble parts of the surface coating form the ink-receptive areas of the image, whose tonal gradation is governed by the halftone dot formation. As with crayon and tusche drawings, the halftone dots are all full-strength dots that produce the optical appearance of continuous gradation through variations in proximity.

There are numerous coating solutions for lithographic reproduction work. Most require mechanical equipment for application; hence these are not practical for the purposes of hand printing. Recently, wipe-on coating solutions of the azo type have provided for the first time a reliable method of coating the printing element by hand. Although the wipe-on coatings were designed for use on metal plates, they also appear promising for use on stone.

The Exposure. The negative is exposed against the stone or metal plate under a carbon arc lamp. The exposure is accomplished either by placing the negative in close contact with the printing element (by means of a vacuum frame) or by projecting the negative onto the printing element with an enlarger. The vacuum frame is the most efficient method for exposure on metal plates; projection is the most practical method for exposure on stone.

The length of time for exposure depends on many factors, the most important being the density of the negative, the distance between the negative and the printing element, the distance of the arc lamps, and the thickness of the coating solution. A series of tests is usually necessary to perfect working procedures for various types of negatives. Correct exposure should provide sharp definition without distortion of the image dots.

Development of the Image. The exposed printing element is developed by covering its entire surface with a specially prepared developing ink. After this is dry, the work is flushed with water, which dissolves the unexposed, nonimage areas of the surface coating and all ink

attached to these. The image areas that have been hardened by light remain on the printing element, covered with a thin deposit of developing ink. This is a critical phase of the work and requires utmost care inasmuch as the surface coating is protected by only a thin layer of ink. All other traces of soluble coating and ink residue must be completely removed in order to assure effective desensitization of the image. Careless development techniques can endanger the image formation and threaten the printing behavior of the work.

Processing the Printing Element. After the image is developed, it must be chemically processed so as to establish firm ink-receptive and ink-rejective areas. The procedures for processing photographic images on stone are identical with those used to stabilize images produced on stone by other techniques. Procedures for processing photographic images on metal plates, however, are somewhat different from the usual plate-processing methods. Procedures for processing on both surfaces will be described in the following sections. After the printing element has been processed, it is ready for proofing.

15.31 PHOTOGRAPHIC REPRODUCTION ON STONE

The surface of the stone for photo reproduction must be perfectly level. It should either be polished or have a grain much finer than that usually employed for drawing. Thus the surface grain will not conflict with the dot formation of the halftone reproduction. The coating solution and procedure are as follows:

Solution

Powdered albumin	600 grains
Ammonium bichromate	150 grains
Water	20 ounces
Ammonia	1/2 ounce

PROCEDURE

1. A small amount of the solution is poured on the center of the stone and rubbed with a soft pad until it is almost dry.

2. The stone is tilted, and a little more solution is flowed over its surface; the surplus is drained off and the coating is fanned dry.

NOTE: Redi-Coat wipe-on coating solution and wipes‡ (Lithoplate Company, see Appendix A) can be applied for this purpose in the same way, if desired.

‡Described in the following section, 15.32.

3. For contact reproduction, the halftone negative is placed on the stone and covered with a sheet of clear glass; it may also be taped around the edges. Whatever the procedure, there must be intimate contact between the negative and the stone. Otherwise, the light from exposure will leak between the negative and the stone surface, causing halos and distorted dot formation. This is the major reason why contact reproduction is so difficult on stone. With a little ingenuity, however, it can be successfully accomplished.

4. Reproduction by projection is a more practical method of exposure. The negative is put in a photographic enlarger and projected onto the stone, placed some distance away. It should be understood that contact reproduction produces images that are the same size as the negative, whereas projected images are always larger than the negative.

5. The image is exposed with the arc lamp. Contact reproduction requires shorter periods of exposure than reproduction by projection. As previously explained, other variables such as the density of the negative, the thickness of the surface coating, etc., will also affect the length of the exposure. Tests will always be necessary to perfect exposure tables for specific types of work.

6. After exposure, the stone is covered with Triple Ink or rolling-up ink mixed with a small amount of transfer ink and lithotine into a thin, creamy consistency. If the Redi-Coat wipe-on coating is used, developing ink supplied for this purpose should be employed.

7. The stone is fanned dry and carefully washed with water until all traces of the unexposed light-sensitive coating and excess developing ink are removed.

8. The stone is dried, dusted with talc, and given a very weak etch (6 drops of nitric acid to 1 ounce of gum arabic). The etch is dried into an even coating; care should be taken not to disturb the inked image.

9. The image is washed out with lithotine; asphaltum printing base is applied and fanned dry. The stone is washed with water and firmly rolled up with rolling-up black ink.

10. The stone is dried. Dirt and blemishes are honed off. Broken dots and lines are retouched with full-strength tusche. When it is dry, the work is dusted with rosin and talc and given a mild etch, according to standard procedures, for final desensitization. This completes the processing; the stone is then ready for proofing. Corrections of the image are undertaken after proofing, following procedures for other types of work on stone.

15.7 ROBERT RAUSCHENBERG:
Booster, from the series *Booster and
7 Studies, RR 67-106.* 1967. Color
lithograph, 72 × 35 1/2″. Printed and
published by Gemini G.E.L. Copyright
Gemini G.E.L.

15.32 PHOTOGRAPHIC REPRODUCTION ON METAL PLATES

The following procedures for preparing photographic halftone images on metal plates have been developed by Kenneth Tyler, Director and Master Printer of Gemini G.E.L. They are an outcome of technical research that he began while at Tamarind in 1963.

Although photo reproduction on many different kinds of metal plates is feasible, references herein pertain only to the Imperial LP-8 ball-grained, aluminum sub-base lithograph plate and to Imperial developing chemicals. If other plates are used, it is advisable to employ the appropriate developing materials recommended by the distributor.

Tyler's usual procedure is to develop, process, and proof the image on the metal plate. Afterwards, transfer impressions are pulled from the plate and placed on a lithograph stone for printing. This allows additional flexibility and image control for artists who wish to extend the creative process by adding new work or by deleting portions of the original image.

The process is described in four stages: (I) coating the plate, (II) exposing the image, (III) developing and desensitizing the plate; and (IV) proofing the plate.

I. COATING THE PLATE

The plate is coated by hand with a wipe-on coating solution, following manufacturer's directions (Redi-Coat Sensitizing Kit, Lithoplate Company, see Appendix A).

1. The coating solution is prepared only for immediate use. A generous portion of powder in the kit is mixed with two-thirds of the accompanying liquid. The mixture is shaken well, then allowed to stand for approximately ten minutes.

2. The plate should be coated in indirect lighting; distant illumination is preferable. A generous amount of the solution is poured on the plate and wiped down in a circular rubbing fashion, with Redi-Coat wipes. The coating should be applied as evenly as possible. An electric fan may be used during the process to hasten drying. It is advisable that coated plates be exposed immediately. If not, they should be completely sealed from light or else handled under ruby light.

II. EXPOSING THE IMAGE

As stated before, photographic material should be prepared with 100- to 150-line halftone screens.

1. The plate and screened negative are locked in a vacuum frame for exposure. (Commercial lithographic plate-developing services are recommended for this phase of the work unless professional equipment is readily available.)

2. The work is exposed under an arc light positioned 3 feet from the vacuum frame. Depending on the nature of the negative, approximate time of exposure should be as follows:

a.	Solids	5 minutes
b.	Halftones	8 minutes
c.	Collage material	3 minutes

As with other lithographic techniques, test plates should be made to refine the above table for individual use.

3. A satisfactory exposure will appear dark blue on the image areas and pale yellow on nonimage areas.

4. The exposed plate should be processed immediately; it cannot be safely stored for longer than twenty-four hours.

III. DEVELOPING AND DESENSITIZING THE PLATE

This stage of the work is divided into two phases: (A) developing the image, and (B) the final desensitization of the plate. The necessary materials (all from Lithoplate Company) are Imperial 220 Developing Ink, Aluminum Plate Desensitizer, Gum Asphaltum Etch, Imperial Plate Conditioner, and Redi-Coat wipes. The work should be done in indirect illumination.

A. Developing the Image

1. The plate is positioned on the processing table, and a generous amount of developing ink is rubbed on the image areas and wiped dry.

2. The entire plate is flushed with desensitizer; a few moments are allowed for the solution to penetrate and loosen the light-sensitive coating. The excess solution is mopped up.

3. Desensitizer is applied again to the plate and carefully rubbed dry.

CAUTION: The solution should be carefully applied and dried, because the image areas covered with developing ink have very little protection and can easily become damaged during this stage of work.

4. Another portion of desensitizer is poured on the plate and mixed with one capful of plate conditioner. The plate is rubbed with this mixture until it is completely free of unattached developing ink and the floating residue of the dissolved surface coating. The wiping pads are changed frequently during this process because it is imperative that the plate be thoroughly clean.

5. Finally, a third application of desensitizer is poured on the clean plate and dried quickly into a rather thick coating. At this point the plate is fully developed

though only partially desensitized. It must undergo the following steps to achieve total desensitization:

B. Final Desensitization of the Plate

1. Gum asphaltum etch is poured on the plate and rubbed into the image areas to dissolve the existing coating. Care should be taken that the developing ink is not completely removed at this time. The plate is dried.

2. Gum asphaltum etch is applied again, and the entire previous coating is dissolved. A generous amount of fresh developing ink is applied to the image areas.

3. The plate is quickly flushed with clean water (to rid the surface of unattached material) and rolled up with rolling-up black ink.

4. Clean water should be used during the roll-up. When the image is fully inked, it should be cleaned rapidly with a brief application of fountain solution whose strength is pH 3.5.

CAUTION: Excessive amounts of fountain solution at this time can injure the image.

5. The plate is dried and dusted with talc.

6. A somewhat thick coating of cellulose gum is applied and dried. At this point the plate is completely desensitized and ready to be washed out for proofing.

IV. PROOFING THE PLATE

1. The plate is washed out using standard procedures.

2. Liquid asphaltum and Triple Ink are rubbed into the exposed image.

3. The gum coating is washed off with water, and the plate is rolled up with rolling-up black ink.

4. Proof impressions are taken, following standard procedures.

5. If the plate has a tendency to scum during proofing, it should be cleaned with a fountain solution of pH 3.5. If this treatment is unsuccessful, the plate should be etched with a 25 per cent mixture of cellulose gum etch and pure cellulose gum. If this or a subsequent treatment with a 50 per cent mixture of cellulose gum etch is unsuccessful, it is likely that the plate has been ruined, usually because of inadequate cleaning of the plate during development and processing.

NOTE: If a plate cleaner is employed at any time during the proofing or printing, it should be thoroughly flushed off with plenty of cold water. It is advisable to do this in the graining sink where a certain amount of water pressure can be exerted to ensure complete removal. The plate is then briefly treated with a fountain solution (pH 3.5), dried, and finally etched with a 25 per cent mixture of cellulose gum etch, which is allowed to dry in a thick coating. This coating is dissolved with water, and pure

cellulose gum is applied to the plate and buffed into a thin coating. After drying, the image may be washed out and rolled up for printing in the usual manner.

15.33 PRINTING ON DAMP PAPER

Today most lithographs are printed on dry paper; there are occasions, however, when superior impression quality can be achieved only by printing on damp paper. Some of the advantages and disadvantages of printing on dry and on damp papers are given below; procedures for working with damp paper follow.

PRINTING ON DRY PAPER

1. Stronger impression quality (both black and color) can be achieved because the inks are less deeply absorbed into the paper fibers. Impressions on dry paper appear crisper, have greater tonal contrast, and dry more rapidly than do those on damp paper.

2. Color registration is more reliable on dry paper because there is less tendency for the paper to expand and contract. Expansion and contraction are constant problems when dampened paper is used in color printing.

3. The fibers of dry paper are more resistant to the pluck of stiff printing ink. Fibers of dampened paper are more susceptible to plucking; by sticking to the inked image they can coarsen subsequent inkings. This problem, which is virtually imperceptible at first, is usually not detected until it is well advanced. By that time permanent thickening of the printing image may have occurred.

4. Although dry paper soils more easily when handled, a certain amount of surface dirt can be erased. Dampened paper, though less susceptible to surface soiling, is much more difficult to erase because the dirt is partially absorbed into the fibers.

5. Dry paper requires much less time for preparation and handling during printing than does dampened paper. Therefore, production costs for lithographs printed on dry paper are generally lower than for those printed on damp paper.

PRINTING ON DAMP PAPER

1. Dampening increases the pliancy as well as the absorbency of paper, enabling the paper to lie in intimate contact with the printing element. Very delicate tonal passages can be printed with greater ease on dampened paper.

2. Damp paper produces softer and more mellow impressions. The inks are absorbed more deeply by the dampened paper fibers, and they dry more slowly and with reduced tonal contrast.

15.8 The damp box Damp box for small and medium paper

Box lid ¾ × 35½ × 25½" o. d.

Handles

Sheet metal, oil cloth, or plastic film inner lining

Box 36 × 26" o. d.

3. To ensure satisfactory printing, hard-sized papers or papers with tough surfaces may be softened by dampening. Laid papers and papers with coarse surfaces also print better when dampened.

4. Damp paper requires less printing pressure to produce a fine impression. Hence stones that are too thin for the pressure of printing on dry paper may still print successfully on damp paper with reduced pressure. (Reduced press pressures are also less exhausting for the printer.)

PROCEDURE FOR DAMPENING PAPER

Paper is dampened in a shallow wooden box containing moistened blotters. This is called the *damp box*; it should be constructed of sturdy plywood and should be slightly larger than the largest paper to be dampened. A plywood cover with handles is fashioned to fit loosely inside the box; the inner surfaces of both the box and the cover are lined with oil cloth, plastic film, or thin galvanized metal. To prevent rusting, copper or aluminum tacks should be used.

Clean blotters, cut slightly smaller than the dimensions of the box to allow for expansion, are evenly saturated with water and are placed inside. Papers to be dampened are placed between the damp blotters. The number of sheets placed between each set of blotters will depend on the type and weight of the paper and the degree of moisture in the blotters. This may vary from three to five sheets of heavy stock to six to eight sheets of thin stock. A damp blotter is placed over the pile, which is then covered by the lid of the damp box. A small lithograph stone set on the lid will exert sufficient pressure to transfer moisture evenly from the blotters to the papers. Ten to twelve hours may be required for the papers to become

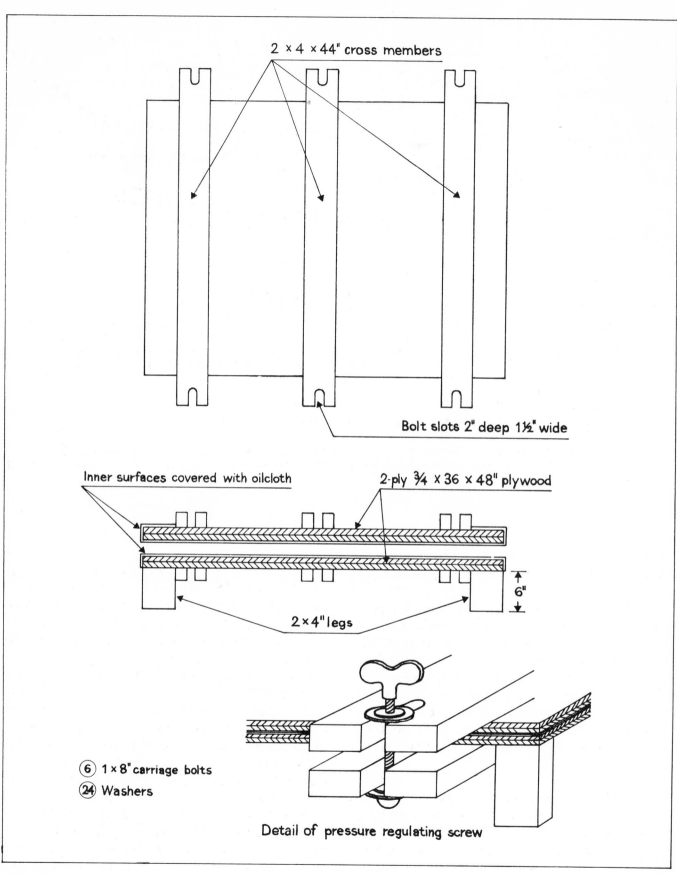

2 × 4 × 44" cross members

Bolt slots 2" deep 1½" wide

Inner surfaces covered with oilcloth

2-ply ¾ × 36 × 48" plywood

6"

2 × 4" legs

⑥ 1 × 8" carriage bolts
㉔ Washers

Detail of pressure regulating screw

15.9 Flattening press

Paper-flattening screw press

permeated with moisture. Unless the papers are evenly dampened, pliancy will vary, causing erratic printing. This is one reason why papers should never be individually sponged before printing.

It is difficult to describe the correct amount of dampness for any one paper. The proper degree of pliancy in the paper should be directly related to the character of the work, the ink consistency, and the printing pressure. Some papers must be damper than others when printed; each type will require experimentation to perfect dampening techniques. Beginners tend to print with papers that are too damp, producing ragged-looking, gray impressions. Generally it is better to think of the paper as being not quite dry rather than as being damp.

In very humid climates, paper will absorb sufficient moisture from the surrounding atmosphere; further dampening is usually unnecessary. Minimum dampening is also advisable for color printing, since the paper will absorb additional moisture from the printing element. After the second or third printing, the pliancy of the sheet will remain relatively constant as long as it is not permitted to dry. Papers that remain in the damp box for extended periods of time are subject to the formation of fungus. This condition is accelerated in warm, humid climates. Several drops of phenol (or other fungicide) in the blotter-dampening water will retard the formation of mold. Periodically the damp box should be washed with soap and water and then aired. The blotters should be laid out to dry or replaced before further paper-dampening is done.

PRINTING ON DAMP PAPER

Paper must be kept uniformly damp throughout the entire printing. Each sheet is taken directly from the damp box; the box is covered again after the sheet is positioned on the printing element. If the box were left uncovered, the uppermost sheets and blotters would dry, destroying the uniformity of paper moisture. Moisture constancy in color printing is preserved by transferring each sheet to a second damp box or plastic covering, after it has been printed. In this way problems of misregistration caused by dimensional variation in the paper are minimized.

Damp paper requires greater care in handling than dry paper. Thin Oriental papers are especially tender and likely to pull apart when damp. All papers with poor wet strength should be supported by both hands during handling. (When held by the corner with one hand, the weight can produce strains that will distort the interlocked fibers or even tear the paper.)

The surfaces of too damp papers will be injured if the ink is too stiff. Thin fibers are plucked from the surface and attach themselves to the printing image. Unless removed before further inking, these fibers can cause the image to thicken during the next inking. If this happens, the ink should be softened slightly and the paper permitted to dry somewhat before printing is resumed. Because modifications of the printer's work rhythm are required, printing with dampened paper usually takes extra time.

FLATTENING PRINTS ON DAMP PAPER

Finished prints on damp paper should be flattened to avoid curling. The impressions are interleaved between clean, dry sheets of newsprint or blotters and are flattened under pressure. Small prints may be flattened by placing the edition pile between heavy chipboard covers weighted with a lithograph stone of medium size. The following day, the moisture-saturated slip sheets are replaced with dry ones, and the process is repeated until the prints are dry.

Larger prints require a flattening press (which can be constructed as shown in fig. 15.9). This consists of a heavy base and top which are pressed together by means of screw bolts. The prints are placed between a stack of clean blotters positioned on the base of the press. The top of the press is lowered and screwed down tightly with equal pressure on all sides. After drying for several days, the prints are removed from the press, interleaved with tissue, and allowed to air-dry for another day, in order to balance the remaining moisture content with the surrounding atmosphere.

Impressions printed with heavy or tacky inks should be air-dried before being flattened in the paper press. Otherwise they will stick to the blotters when heavy pressure is applied. When the ink has lost its tack, the printed sheets can be carefully dampened on the back (if curling has occurred) and then placed in the flattening press.

15.34 PAPIER COLLE

Papier collé is the term given the process in which a thin sheet of paper is printed and mounted simultaneously on a larger and heavier backing sheet. The collé process is used for two reasons. First, the very thin sheets of paper (originally India paper) produce the finest printed impressions. In themselves, they are too fragile to provide either visual or physical support for a print. However, when backed by a heavier paper they offer the advantage of a superb impression and a substantial supporting ground. Second, most Oriental papers are slightly different in coloration from the supporting sheet. When cut

a. Moistening blotters in the damp box

b. Dampening a sheet of fine papaer

c. Placing the paper in the damp box

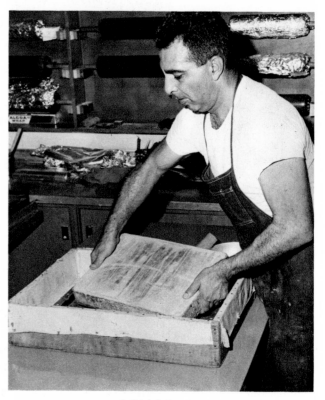

d. Weighting the damp box with a stone

15.10 Procedure for collé printing

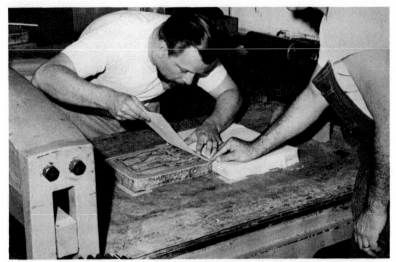

e. Positioning the thin Oriental paper

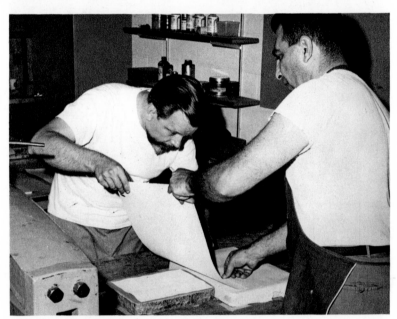

f. Positioning the damp supporting sheet

g. Removing the printed impression

h. The completed print by artist Robert Nelson. Note the contrast of tonality provided by the two papers

to the dimensions of the image, they provide a subtle plate tone separating the image from the surrounding margin of the backing sheet. For example, a snowy white paper provides a beautiful contrast when backed with a buff paper. Similarly, natural-colored varieties of Oriental paper harmonize handsomely when mounted on white paper.

The finesse of collé printing provides overtones of luxury and preciousness to most works. Hence, the process is best suited for intimate and small works printed in one or two colors only. Larger, bolder, and more intricately colored lithographs overpower the delicacy and expressive nuances of collé printing.

PROCEDURE

The printer must first select the two papers that will be combined to make the print. Only the thinnest paper should be used for the impression sheet. Since India paper is seldom now available, its nearest counterpart is a Japanese paper called Gasen Shi Rampo, which is available in either white or natural coloring. Cigarette tissue is another paper that has been used successfully, although it is composed of inferior fibers. Any of the heavier and softer handmade papers such as Arches, Rives BFK, German Copperplate, or Umbria are satisfactory as backing sheets.

The thin paper is cut with a razor blade exactly to the size of the image format. Papers that are to be printed against open or floating image formations are cut to any format selected. The backing sheets are torn to a size that will create handsomely proportioned margins. These are torn with deckled edges in contrast to the sharp, clean edges of the thin papers.

The principle of the collé technique depends on the presence of an adhesive on the back of the thin paper to allow adherence to the supporting paper as both are passed through the press during the printing. If the adhesive is too wet, the paper will not print a sharp impression. Adhesive coatings must be dry or semidry and yet be capable of becoming activated in the presence of moisture. This is accomplished in one of several ways.

Method I. Some thin Oriental papers contain a sizing that becomes tacky when slightly dampened overnight in the damp box. They should be barely moist when ready for use. The image is inked, and a dry sheet of the thin paper is placed over it with the sized side uppermost. (This is usually the rougher side of the sheet, and on some papers the marks left by the sizing brush can be clearly seen.) The damp backing sheet is centered over the thin paper by means of previously positioned lay marks.§ As the work is passed through the press, the moisture in the backing sheet will activate the sizing of the thin paper, thus mounting it permanently as the impression is printed. (See fig. 15.10.)

When the print is passed through the press, the paper surface is burnished by the pressure of the scraper as it passes over the tympan. This mark is clearly discernible on dampened papers. In itself the polishing of the paper surface is not objectionable. Many artists prefer the burnished appearance, which is complemented by the unburnished margins of the supporting sheet in the same way that an intaglio plate mark separates its image from the surrounding paper. To be truly effective, the burnishing should serve as a secondary margin just outside the thin appliquéd sheet. To accomplish this, the press scraper should be barely wider than the thin paper. Additionally, the traverse of the press should be marked to start just in front of the leading edge of the image and to stop just after its trailing edge. Such adjustments are made during proofing of the work and usually require several trials before ideal results are achieved.

Method II. Some thin papers do not contain a tacky sizing; Gasen Shi Rampo is of this type. Such papers must be hand-sized before printing. Sizing solutions for collé printing are composed of weak concentrations of rice paste, potato starch, or dextrin. A typical formula is as follows:

> 1 part rice paste flour
> 16 parts water
> A few drops of fungicide are added to prevent growth of mold after the sheets are mounted.
> The mixture is heated and stirred until free of lumps.

Each sheet of paper is carefully brushed on one side with the solution and then hung to dry. Sheets that are too fragile to hang should be laid out on a clean sheet of glass, Formica, or aluminum foil. When papers curl upon drying, the sizing mixture has been too strong. More water should be used; a few drops of glycerine in the

§When the printing image is truly rectangular and carries ink to its outer corners, the thin paper is carefully positioned to conform to these boundaries. If the image is of floating design, very small corner marks are scratched into the stone with a razor blade or pointed instrument. These must be etched so as to reject ink during the printing. A second set of lay marks for centering the larger supporting sheet is scratched with the blade or by using a printer's lead. It should be noted that the printer's lead should not be used for the positioning marks of the thin sheet. Although the marks will not accept ink they will offset against the supporting sheet, thus spoiling the impression.

solution, acting as a plasticizer, will also prevent curling.

When the thin papers are dried, they are placed in a pile with the coated side uppermost. Thereafter they are positioned and printed with the previously dampened supporting sheets, as in Method I.

Method III. This method is essentially the same as the others except that each supporting sheet is dampened just before being positioned over the coated (but dry) thin paper. The advantage of this approach is speed. The disadvantage is that hand-dampening each sheet individually seldom moistens the sheets evenly. This results in uneven printing and may also subject the mounted print to distortion upon drying.

When the edition has been completed, the mounted prints should be flattened by placing them between blotters and chipboard and weighting them with a stone for several days.

The Lithography Workshop

16.1 ORGANIZATION OF A LITHOGRAPHY WORKSHOP

The organization of a lithography workshop requires careful planning to ensure efficient and economical operation. The sections that follow describe some of the more important aspects of shop planning and organization. Three basically different types of workshop are described to illustrate certain correlations between shop design and shop function. These are: (1) the professional shop for free enterprise, (2) the school shop for training students, and (3) the private workshop for the independent artist-printer. Other sections offer general guidelines for shop construction and equipment acquisition. Because many variations in shop organization are feasible, descriptions of design and construction are confined to typical eaxmples; cost estimates are based on prevailing prices at the time of writing.

Preliminary Planning. During the initial phase of planning, it is advisable to outline the major requirements for the particular type of shop desired. From these, one can derive more precisely the operational procedures, the organization of staff, the details of shop construction, and estimates of cost. The outlines that follow list typical factors normally encountered during preliminary planning. Depending on the type of shop, some of the items listed may not be relevant; others more pertinent can be substituted until sufficient data have been assembled to formulate the major requirements anticipated. Some of these factors will be examined in greater detail during the description of the three basic types of workshop.

I. SHOP ORGANIZATION

1. The concept and objectives of the shop: professional, educational, or private

2. The operating schedule of the shop: full-time or part-time; regular or irregular hours

3. The organizational staff chart
 a. estimate of the number of supportive staff, including individual job classifications
 b. estimate of the number of printing artisans, including individual job classifications

4. Estimate of the number of artists or students capable of working during given periods of time

5. Estimate of the lead time necessary between construction and start-up of activity

6. Estimate of the time necessary after start-up to achieve peak productive or educational capacity

7. Will future modification of shop objectives be necessary?

8. Will future modification of shop equipment and facilities be necessary?

9. Other special considerations

II. SHOP CONSTRUCTION

1. Will the shop be newly constructed or remodeled from an existing structure?

2. Calculate the pattern and volume of work flow

3. Calculate the over-all configuration of the shop and placement of equipment

4. Calculate the traffic patterns of shop personnel

5. Calculate the number of work stations for graining, drawing, processing, printing, etc.

6. Calculate the amount and size of supplementary areas for office, conference room, curatorial activity, and storage of paper, supplies, maintenance equipment, and completed work

7. Calculate the over-all floor space required for all shop activities

8. Calculate the amount of equipment and supplies needed for peak production

9. Calculate the consumption rate of supplies

10. List factors affecting the health, safety, and efficiency of shop personnel

11. List factors affecting maintenance of the shop

12. List design factors that can provide flexibility for the future modification or expansion of the workshop

13. List other special considerations

III. SHOP COSTS

1. Estimate of basic construction costs

2. Estimate of the cost of interior fixtures, cabinetry, etc.

3. Estimate of the cost of equipment

4. Estimate of the cost of supplies for initial start-up

5. Estimate of the cost of replenishing supplies

6. Estimate of overhead and operating expenses: real estate, taxes, insurance, utilities, salaries, etc.

7. Estimate of the total capital outlay necessary for construction, installation, and start-up

8. Estimate of costs for various types of printing service

9. Estimate of expected annual revenue from sales, services, or other sources

10. List of other special considerations

16.2 THE PROFESSIONAL WORKSHOP

Between 1940 and 1960, no more than four lithography workshops in the United States could provide professional hand-printing services for artists who wished to make lithographs. Generally, these shops were not self-sustaining; they relied on financial support from another enterprise (often commercial offset printing). Each shop was the personal product of a single operator, whose enthusiasm, professional ability, business acumen, or responsibility to other commercial commitments determined the success or failure of his hand-printing activity. Several artists' cooperatives also existed in which equipment, labor, and operating expenses were shared by participating artists and interested lay members. The output of the cooperatives was periodic, uneven in quality, and restricted in breadth by the individual interests of their limited membership. Additionally, a few art schools and universities had small lithography shops in which valuable teaching and experimentation occurred, although there was virtually no professional printing undertaken.

During this period, there were neither guidelines nor an American tradition by which to organize or operate a profit-making enterprise to hand-print lithographs. Of equal importance, the corollary channels for the publishing and marketing of prints were virtually nonexistent in this country; hence there was little incentive for large numbers of American artists to commit themselves seriously to lithography.

In 1963, Tamarind published a study for the development of self-sustaining lithography shops in the United States. Material in the study was largely gathered from data compiled within the Tamarind Workshop operation. Since that time, several excellent professional shops have been organized by artisans trained at Tamarind; these have been operating successfully, following guidelines suggested in the study.* In view of the inevitable organization of other workshops in the near future, the Tamarind study was rewritten and enlarged by Calvin J. Goodman in 1968. The economic data have been updated, and the over-all presentation has been reoriented to address actual problems reported by artisans now operating hand-printing workshops in a free enterprise system. Goodman's comprehensive monographs are strongly recommended to anyone who contemplates organizing or operating a lithography workshop (See Bibliography). Although both studies primarily examine economic factors related to free enterprise, much of their content is equally pertinent to the function of school and private workshops as well.

Goodman describes several different concepts for a professional shop:

1. **The custom workshop** is designed to provide drawing facilities for artists and to offer printing services on a contract basis determined by the specific character and extent of work involved.

2. **The proprietary workshop** functions as a combined publishing organization and printing facility. Artists are commissioned to produce prints under the aegis of the organization, which assumes responsibility for their distribution and sale.

3. **The proprietary and custom workshop** is a combination of the two; this type of shop offers custom-printing services and also engages in proprietary publishing. Most present-day American workshops are of this type; the majority of the European workshops are the custom shops. Undoubtedly this difference is a result of the different publishing and marketing practices found in the United States and Europe. However, as a greater number of dealers and print distributors recognize the profit

*Gemini G.E.L., Los Angeles; Cirrus Editions, Los Angeles; Hollander Press, New York; Collectors' Press, San Francisco.

potential of publishing in this country, it is reasonable to expect an increase in the number of shops offering custom-printing service only.

The following are general observations from Goodman's study as they relate to some considerations of shop organization outlined in the preceding section.

1. Number of Personnel. Professional workshops may staff as few as four or as many as ten or more employees, including printers and supportive staff such as administrators, curators, typists, etc. A four-man organization (two printers and two supportive staff) can normally be expected to accommodate but one artist at a time. A shop with four printers can accommodate two artists simultaneously, although additional supportive staff is usually required to process the increased volume of work.

2. Equipment and Supplies. Shops designed to accommodate one artist at a time can function fairly well with one press, provided that the work flow is carefully scheduled. Shops that serve a greater number of artists

1. Desks, 30 × 60"
2. Work table, 30 × 60"
3. Work table, 36 × 72"
4. Sofa, 30 × 84"
5. Sign and chop table; print cabinets, 96 × 96"
6. Work table, 60 × 72"
7. Artists' work tables, 48 × 72"
8. Speed rack, 30 × 48"
9. Rolling table, 30 × 48"
10. Work space; storage, 30 × 72"
11. Work space; storage, 30 × 120"
12. Work tables; storage, 24 × 96"
13. Litho presses, 48 × 144"
14. Tympan storage
15. Graining table; stone storage, 42 × 120"
16. Hydraulic lift truck
17. Stone storage, 42 × 120"
18. Storage for zinc and paper supplies, 42 × 144"
19. Storage for supplies, 24 × 60"
20. Sink and hot plate, 24 × 72"
21. File cabinets
22. Print cabinets, 42 × 48"
23. Shower stall
24. Toilet
25. Sink
26. Hot water

16.2 Large professional shop

Typical layout for a large professional workshop 50 × 100 feet. 5,000 square feet. Six to eight permanent employees. Note that diagram is not drawn to scale

simultaneously may require from three to five presses and more supplies, printers, and supportive personnel in order to keep both artists and presses occupied full time.

An inventory of supplies and equipment should be provided to accommodate the rate of activity anticipated. Thus, a minimum of two dozen stones in varying sizes are necessary for a small shop, whereas a large shop may require seventy-five or more stones; metal plates should supplement the stock of stones if color work is anticipated.

The more productive the shop is, the faster the depletion of supplies. The rate of stock turnover must be carefully calculated so as not to cause delay in production

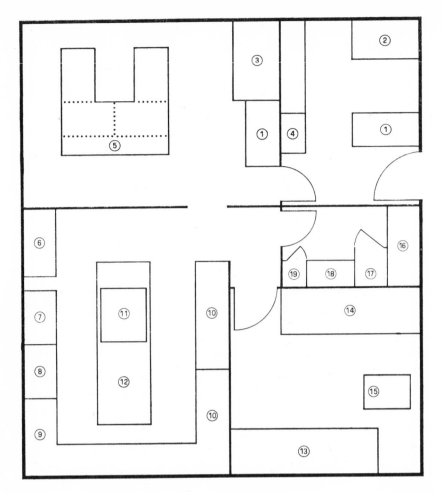

because of lack of material. There should be supplementary storage space for bulk items necessary for increased future production.

3. Space Requirements. Minimum space requirements for professional shops may vary from 1,800 square feet (40 × 45 feet) for a shop accommodating four employees to 5,000 square feet (50 × 100 feet) for a shop of six to eight employees. These square footages are approximate, and to a certain extent they depend on the actual proportions of the work space. Very long and narrow floor plans are sometimes less efficient because they limit traffic patterns and flexibility of shop configuration.

4. Pattern of Work Flow. The flow of work beginning with the stone graining and ending with the signing of the edition is of great importance to the efficiency of a professional shop. Flow patterns should be carefully planned to ensure against loss of time and profit, against fatigue, and against possible damage to prints because of poor storage.

5. Paper Storage. The most costly item in the shop inventory is printing paper. A productive, professional workshop can exhaust a sizable quantity of paper very quickly. Large inventories of paper are required for active shops unless supply sources are nearby. Ample storage is necessary for the paper; the design and location of storage should ensure maximum protection.

6. Edition Storage. Completed editions of prints should be removed promptly from the press room as a protective measure as well as to release space for new work. A separate area should be provided for the examination, collation, signing, and storage of the finished prints until such time as they are removed from the premises. (See sec. 5.4.) A sound curatorial procedure, including a system for documenting each print produced by the workshop, is a necessary responsibility of any professional shop. Curatorial duties are sometimes assigned to one staff member who is also responsible for other part-time duties in the shop or office.

7. Maintenance. Shop design should permit rapid and easy cleaning after jobs. Equipment and work areas should be fabricated of durable and easy-to-clean materials. There should be a rigorously enforced maintenance schedule; untidy shops are conducive to poor work, as well as loss of time and profit.

8. Capital Outlay. Capital costs for permanent equipment such as presses, ink, rollers, stones, and shop furnishings can vary from $10,500 for a small professional shop to $25,000 for a large shop. (See sec. 16.7.) These figures are exclusive of facility costs.

9. Operating Costs. Operating costs, including those

for staff salaries, expendable supplies, equipment maintenance, and all other accounts relative to the function of business, might typically be as low as $25,000 or as high as $60,000 annually, depending on the size of the enterprise. It is estimated that investments necessary for total capital outlay and operating costs may vary from $35,500 to $85,000 (with added funds required in subsequent years) for supporting a soundly planned professional workshop. The outlook for reasonably profitable return on less sizable investments does not appear favorable in the present American economy. It is recognized that the above figures have little meaning for the reader without the supplementary data contained in Goodman's studies. Nevertheless, they are included to provide general information and for purposes of comparison with the cost estimates for school and private workshops given in the next sections.

16.3 THE SCHOOL WORKSHOP

Many different types of workshops for teaching printmaking have emerged in American art schools and universities in the past twenty years. These range qualitatively from poorly equipped and poorly planned facilities to those of exceptional caliber in which highly concentrated, professional training is undertaken. Some institutions still teach all the mediums of printmaking in one course. Although this is perhaps justified as an introductory experience, such courses seriously handicap the progress of the more advanced student who wishes to specialize. When all print mediums are taught in one classroom, the equipment and work processes for one medium usually interfere with those of another. Few instructors possess a balanced knowledge of all the print processes. Students trained in such classes seldom exhibit a sound grasp of print fundamentals for any one medium.

Recently, the larger schools have begun to offer greatly improved programs in which each print medium is offered as a separate course of instruction. Ideally, the studios for such programs are adjacent to one another, thus permitting a cross-fertilization of ideas between students working with different print processes. Each course is taught by an instructor especially qualified in the particular medium, and the shops are excellently equipped to pursue the full potential of each process.

The design of a school lithography shop should begin with the concept of separation from the other printmaking mediums. The provision of ample space to accommodate student traffic should be given high priority. In comparison with professional shops, which rigorously regulate patterns of work flow, school shops require considerably more space to allow for less disciplined work patterns. Areas for drawing require the most space. One way to conserve space is to design a central drawing room for all the different printmaking courses to be taught. Separate access can then be provided from the drawing room to the individual processing and press rooms required for each printmaking medium.

1. Number of Shop Personnel. The number of students in a school shop depends on the size of the class, the method of instruction, and the extent of the equipment available. Ideally, a lithography class should consist of twelve to fifteen students working six to nine class hours per week. The workshop should accommodate several different classes during the week and still remain open to students who wish to work additional hours outside regular class time. Several classes of this size can be trained efficiently by one instructor and several student assistants.

2. Equipment and Supplies. Unlike the personnel of a professional shop, whose work is specialized, the students in a school shop are usually taught drawing as well as printing skills. Graining, drawing, and processing areas should be designed to accommodate more than one student at a time. A minimum of three presses (perhaps in varying sizes) should be provided, along with supplementary equipment for each. There should be at least fifty stones in different sizes and a sizable quantity of metal plates if color printing is also taught.

3. Space Requirements. Approximately 280 square feet (18 × 16 feet) is the least space necessary to accommodate the drawing requirements for a class of twelve to fifteen students. Additional footage will be required if the drawing room is separate from the press room and is to be shared by students from other printmaking courses.

Approximately 720 square feet (24 × 30 feet) are necessary to accommodate three presses and a processing station. Additional square footage is necessary for graining facilities, storage of paper, supplies, stones, and for traffic aisles.

4. Work Flow. Output in a school shop cannot be measured by the same criteria as for a professional workshop. Nevertheless, shop layouts and work schedules should be carefully organized to accomplish instructional objectives effectively.

5. Paper Storage. Sizable quantities of paper should be kept on hand for a school workshop. Although the rate of depletion may be lower than for a professional shop (because of the smaller editions printed), higher waste factors increase the paper consumption per student.

When possible, paper should be stored outside the

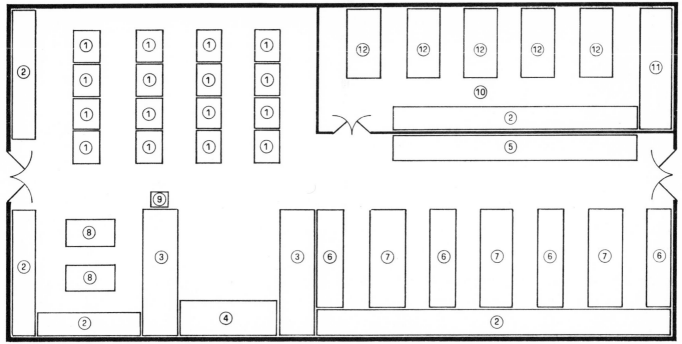

16.4 Typical school shop

Layout for a typical school workshop 75 × 30 feet. 2,250 square feet. Note that diagram is not drawn to scale

1. Student work tables with two-print drawers in each metal table, 48 × 60″
2. Storage cabinets with shelves above as necessary
3. Stone storage racks
4. Graining sink
5. Processing table with storage below
6. Movable press tables, 48 × 120″
7. Presses, 48 × 120″
8. Instructors' cubicles
9. Hydraulic lift truck
10. Curating and lecture room
11. Print storage cabinets
12. Curating tables

press room both to save space and to protect the stock. In some institutions it may be feasible to store paper along with other bulk lithographic supplies in the school supply store. From there, packages of a hundred sheets for work on hand can be kept in special drawers in the press room. The instructor or his assistant may sell these to the students, using methods that will assure control of the stock. There should be periodic inventory checks to determine rates of depletion and to permit efficient re-ordering.

6. Edition Storage. Space for examining and storing completed editions is less important in a school shop. A limited amount of storage space can be provided near the drawing areas. Blueprint cabinets are excellent for this purpose. It is assumed that each student is responsible for the care and housing of his own work after it is completed.

It is good practice to record each student's progress as well as to document the annual output of the workshop. Storage cabinets for this purpose can be located near the bulk paper supplies or in another area of the school where work from other studio classes is kept.

7. Maintenance. Shop maintenance is usually a severe problem in a school workshop in view of the inexperience of beginning students. The instructor and his assistants must maintain constant vigilance over the care of equipment, fixtures, and supplies such as inks, ink rollers, tympans, scraper bars, and presses. The replacement and repair of equipment are much higher in a school shop than in a professional shop; allowance for this should be made in the operating budget. Permanent installations, such as work tables, counters, and shelves, should be very sturdy, durable, and easy to maintain.

8. Capital Outlay. Depending on the size of the school shop, capital outlay for permanent equipment and installations may be higher or lower than for a professional workshop. Estimates of $15,000 to $25,000 (exclusive of building space) appear reasonable for school print shops, particularly when compared with installation costs for school science laboratories or other technical teaching facilities.

9. Operating Expenses. Because the over-all budget of the school can absorb a major portion of the overhead, operating expenses are considerably less than for a professional workshop. At some institutions a certain proportion of costs for expendable supplies may be re-

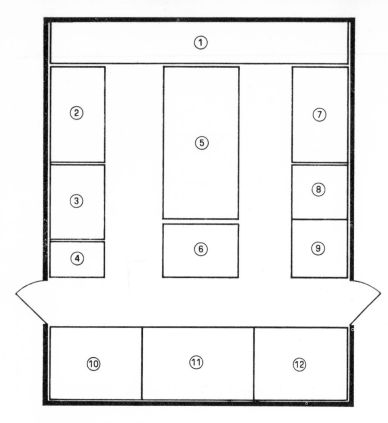

16.5 Private workshop

Layout for a typical private workshop 16 × 20 feet. 320 square feet. Note that diagram is not drawn to scale

1. Ink counter with storage above and below, 24 × 192"
2. Movable press table with storage below, 36 × 60"
3. Paper storage, 36 × 48"
4. Misc. bulk storage, 24 × 36"
5. Press area, 48 × 96"
6. Print storage, 36 × 48"
7. Movable table with storage below, 36 × 60"
8. Misc. bulk storage, 36 × 36"
9. Solvent storage, 36 × 36"
10. Graining sink and abrasive storage, 48 × 60"
11. Stone storage and misc. work area, 48 × 72"
12. Drawing and processing area, 48 × 60"

coverable through student fees. Paper stocks and drawing materials are usually sold at prices slightly above cost to defray freight and handling charges.

It is estimated that an excellent school lithography shop could function on an annual operating budget of $1,200 to $1,800 for expendable supplies, exclusive of student fees and recoverable costs for materials sold through the institution's supply store.

16.4 THE PRIVATE WORKSHOP

The private workshop is designed for the printmaker who prefers to draw and print only his own work. It is the smallest, the simplest to design, and the least costly of the three kinds of shop.

European etchers in the last decade of the nineteenth century introduced the concept of the independent printmaker to the United States. Thereafter, many etchers and wood engravers and a few lithographers maintained private workshops, which varied in size as well as quality of output. However, private print shops did not really become popular until mid-century. At that time, the great impetus of intaglio printmaking in schools created numerous talented artist-printers, each needing printing facilities after graduation. Although some found teaching positions, even so the burden of classroom activities usually prevented the use of school shops for the development of their own work. Consequently, many individuals constructed home workshops in which to work.

With the more recent revival of interest in lithography,

it is reasonable to expect the emergence of a limited number of private lithography workshops. Unfortunately, because of the high costs involved, it is unlikely that the number of such shops will ever equal those found for other print processes.

1. Equipment and Supplies. The basic equipment for a private workshop is minimal. One printing press, one leather roller, and one color printing roller are sufficient. A stock of twelve lithograph stones in various sizes and an equal number of metal plates would provide latitude for even the most ambitious work. The consumption of inks, chemicals, and supplies is considerably less than for the other types of workshop; hence much less storage space is needed.

2. Space Requirements. A completely equipped and very efficient small shop can be contained within 600 square feet (20 × 30 feet) of floor space. This is sufficient room to allow for all work stations and storage space (even for large works). A garage, basement, or room in a residence of modest size can be easily converted for this purpose.

3. Work Flow. The pattern of work flow, although less important than in professional or school workshops, should not be overlooked. Since the individual bears the burden of productivity (possibly with occasional help from an assistant), an orderly layout will save physical effort and may even help to improve the quality of production. The printing press should be positioned to serve as the core of shop design; all work stations should be located within a few steps of it.

4. Storage of Paper and Editions. Fine papers and

completed editions can be stored in cabinets having drawers designated for this purpose. Paper and edition storage should be farthest from the press area, to ensure cleanliness.

5. Maintenance. Maintenance problems are negligible in a one-man shop since the operator is responsible only to himself. He should recognize that careless maintenance not only is detrimental to production, but also creates safety hazards. Thoughtful designing and construction of facilities will reduce custodial chores and ensure the long life of both equipment and work quarters.

6. Capital Outlay. Capital costs for permanent installations can be reduced considerably if the owner constructs his own cabinets, shelving, graining sink, ink slabs, etc. (See sec. 16.7.) Estimates for equipment and installation for a small shop approximate $5,000 to $7,500, depending on whether new or second-hand equipment is purchased and on whether the individual undertakes part of the construction.

7. Operating Expenses. Operating expenses for supplies and replacement of small equipment will vary from $300 to $1,000 annually, depending on the amount of paper and color inks kept in stock as well as on the volume of shop production.

8. Total Investment. To start a modest private lithography shop, a total investment of $5,300 to $8,100 is estimated.

16.5 GENERAL ASPECTS OF THE PHYSICAL PLANT

Regardless of the type of shop, certain aspects of the physical plant must be considered in the early stages of design.

Ideally, work spaces should be free of supporting columns and other architectural encumbrances which might limit the configuration of the facilities. A certain amount of ingenuity is required for designing layouts in older buildings so that structural members do not interfere with the work and traffic patterns of the shop. When possible, floors should be cement and capable of sustaining heavy loads. Entrances and exits should be sufficiently wide to permit the passage of lift trucks, wide stones, and large packages of paper and prints. It is desirable that at least two walls be uninterrupted to permit installation of cabinets and shelving. There should be ample natural and incandescent lighting to allow comfortable and evenly diffused illumination in all work spaces both day and night. Special lighting conditions may be necessary for certain work stations (drawing, processing, ink mixing, and printing) where visual judgments are critical. Illumination that approximates natural north light is particularly important in the production of color lithography.

Utilities. The location of utilities is another important feature in the design of an efficient workshop. At least two separate sources of hot and cold water are desirable for all but the smallest one-man shop. One source is necessary for the stone-graining sink, and the other (coupled with a standard sink) is used for all other functions that require water. The latter should be near the processing station and chemical storage. All sinks should have heavy-duty draining systems connected to drum-type sink traps to catch heavy sludge. The sink near the processing station should be provided with corrosion-resistant drain pipes as a safeguard against accidental spilling of chemicals. The graining sink should be located near the stone-storage area and as far from the other work stations as possible. Additional water outlets and drainage facilities may be required if a metal-plate graining machine is to be installed.

Electrical outlets should be located at counter height near the drawing, processing, and printing areas. These are very useful when hair dryers and hot plates are used for special tasks. Motorized presses, power stone-grinding apparatus, and battery-charged lift trucks sometimes require 220-volt circuitry, in addition to the standard 110-volt circuits for the rest of the shop. Consultation with competent architects and electricians is advisable during this phase of planning in order to provide for future expansion or modification of electrical facilities.

Temperature and humidity controls must also be considered during the initial planning. Heating ducts should provide equalized temperature distribution; these should not be so close to the work in process as to harm crayons, drawings, inks, and chemicals. Air conditioning and humidity control are especially important for shops located in regions with great variations in temperature and humidity. Because exaggerated atmospheric conditions are harmful to the chemistry of lithography (particularly metal-plate work), it is especially important for a commercial shop to have adequate atmospheric control.

Fire and Accident Prevention. Although minimal in hand printing, fire and accident hazards must not be ignored. All the solvents and many of the chemicals used in lithography are combustible. Oily shop rags, scrap paper, and quantities of unused paper stock also present potential danger, unless adequately protected. A regulated schedule for disposal of soiled rags and paper should be a standard part of the shop routine.

Hand or portable fog-type fire extinguishers should be

16.6 Vertical stone storage racks

located at points that are easily and rapidly accessible. There should also be a small first-aid kit to treat minor cuts, chemical burns, and skin abrasions that occasionally occur during the course of work.

General Construction and Fabrication. All permanent fixtures should be as functional and durable as possible. Ideally, .020 gauge galvanized sheet metal should cover all counter and table tops. This material is relatively inexpensive, easy to fabricate, and able to withstand the abrasion from lithograph stones and the corrosion of chemicals to a remarkable degree. Steel wool, solvent, and cleansing powder will clean this type of surface with ease. A scraping tool and solvents or a dilute solution of lye will remove stubborn spots.

The graining sink, processing table, and drawing areas should be especially sturdy, absolutely level, and stable. For greater efficiency, all work counters and tables should be the same height, usually 30 to 33 inches from the floor, as determined by the height of the press bed. Such a standardized height can lessen fatigue by regulating the rhythms of work at the various stations.

16.6 CONFIGURATION AND CONSTRUCTION OF SHOP WORK STATIONS

The cycle of work followed to make a lithograph is as follows:

1. The lithograph stone is selected from storage.
2. The stone is grained.
3. The drawing is made on the stone.
4. The stone is chemically processed.
5. Paper is prepared for printing.
6. The stone is proofed and printed.
7. The image is cancelled after the edition is completed; the stone is regrained or returned to storage.
8. The completed prints are examined, signed, and documented.
9. The edition is stored or prepared for distribution. This completes one cycle and marks the beginning of another.

Each step in the cycle entails separate tasks and requires different materials, equipment, and shop fixtures. The work in each step is performed in separate but closely related areas of the shop, called *work stations*. The location of each work station should allow a smooth and sequential work flow; furthermore, the installation of materials and equipment at each station should permit efficient execution of all tasks required for that particular phase of work.

Various configurations for work stations are equally functional; choice is usually dictated by the size and proportion of the over-all space or by budgetary considerations.

STORAGE OF STONES

Storage facilities should permit easy and efficient handling of the stones and should provide maximum safeguards against breakage. Stones can be stored in three different ways:

1. **Vertical Storage.** Stones up to $18 \times 24''$ are best stored vertically. A stout unit containing several shelves capable of supporting the combined weight of the stones will provide excellent storage. The largest stones are placed on edge at floor level, the next largest stones on the bottom shelf, and the smallest stones on the top shelf. Shelves should have vertical spacers to prevent the stones from tipping.

2. **Horizontal Storage.** Stones larger than $18 \times 24''$ are usually stored horizontally, one above the other, on industrial roller racks. Welded metal framing or commercial structural components are used to support the roller frames.

NOTE: Storage areas for both large and small stones should be as near the graining sink as possible, to minimize the need for cartage. A large number of stones can be stored in a minimum amount of space if the areas below the graining sink and work counters are carefully utilized.

3. **Horizontal Storage—Reserve Stones.** Preferably, quantities of stones in reserve are stored in a protected

and relatively isolated area near the press room. The stones are stacked flat on wooden skids with corrugated cardboard in between the stones.

Various coding systems are employed in shops to ensure easy identification of stones. One such system uses a color code to distinguish the basic quality of the stone; for example, blue denotes first-quality (gray stones), orange identifies second-quality (buff stones), yellow is used for third-quality (soft, veined stones), and white for poorest quality (fossilized and mottled stones). The appropriate color band is painted with enamel or lacquer around the edges of the stone. The size of the stone is painted on its edge. Often a number or initial is added; corresponding numbers or initials on the storage rack identify a specific storage space for each stone. Coding permits rapid selection of stones for particular types of work and offers a systematic means by which the printing performance of every stone in the shop can be recorded.

THE GRAINING STATION

The graining station consists of (1) the graining sink, (2) a drying area for freshly grained stones, (3) shelving above the sink to store abrasive containers and graining equipment, and (4) horizontal or vertical stone storage below the sink. Hot and cold water outlets and a single faucet should be located just above the graining sink. A flexible hose with a rubber spray fixture (as used by hairdressers) is attached to the faucet. This permits ample water distribution and rapid removal of graining residue from the stone without splashing.

The graining sink should be custom-fabricated to ensure efficiency and durability. The sink is a deep tray of galvanized metal surrounded by heavy wooden framing; it is supported by a sturdy tablelike base fitted against a wall along its entire length. A standpipe protruding several inches above the bottom of the sink maintains the water level and prevents overflow as well clogging of the drain with graining sludge. The standpipe may be connected to a drum trap (an additional protection against clogging) or directly to a floor drain. A removable duckboard having galvanized-pipe cross members supports stones that are to be ground. The duckboard is periodically removed to permit disposal of accumulated graining sludge from the bottom of the sink.

The entire construction of the graining sink should protect against water leakage. With the exception of the pipes on the duckboard, all other components should be thoroughly waterproofed with heavy coatings of rubberized mastic. The coatings also prevent rust and wear from abrasion.

The base of the sink is extended at one end to provide a drying stand for freshly ground stones. Both the stand

16.7 Horizontal stone storage racks

and the wall behind the sink are covered with galvanized metal for protection and durability. An electrical outlet adjacent to the drying stand permits the use of electrical apparatus to hasten stone drying. Grinding levigators are usually kept on the drying stand when not in use.

A cabinet with heavy shelving above the graining sink provides storage for abrasive containers, files, pumice blocks, hones, and other materials used in the graining process. It may be desirable to design the cabinet and shelving to support several hundred pounds of abrasives unless other space for bulk storage can be provided nearby.

THE DRAWING STATION

The principal components of the drawing station are: (1) a suitable support for the largest stones, (2) ample natural or artificial light sources, (3) storage space for drawing materials, and (4) a nearby wall to pin sketches and proofs of work in progress on. When possible, the drawing station should be positioned near the processing station, particularly if stones are to be carried by hand in the shop.

Drawing facilities in a professional shop should provide privacy for each artist at work. For drawing in school workshops, stones can be supported by individual wooden or metal tables or by a long work table or counter on which a number of stones can be used by students sitting or standing side by side.

The drawing tables or counters must be very sturdy and capable of supporting weights of 400 to 500 pounds

16.8 Graining station

without swaying. Individual drawing areas in school shops should measure at least 36 × 50 inches; somewhat larger spaces are desirable for a professional shop. Galvanized metal should cover supporting surfaces to allow for easy positioning and removal of stones as well as for ease of maintenance. There should be storage shelves or drawers within the vicinity of the drawing area to house drawing materials, sketch papers, and proof impressions.

Illumination should be evenly distributed over the entire drawing station. In some cases, portable drawing lamps may be required for very close work. Electrical outlets in the vicinity of the drawing station are desirable for supplementary equipment such as hot-air dryers and hot plates.

The shop wall beside the drawing station can be covered with light-colored insulation panels; these serve as light reflectors and pinup surfaces for drawings and proofs.

THE PROCESSING STATION

Stones and metal plates are etched, washed out, and rolled up with ink at the processing station, in preparation for proofing and printing. Ideally, the station should be equidistant from the graining, drawing, and printing stations. It includes (1) an etching and roll-up table, (2) an ink slab, and (3) a sink with storage facilities for chemicals and laboratory equipment.

Like the other work stations, the etching table must be very strong and absolutely stationary. The top should be covered with galvanized metal, and it can have shelving below to carry processing materials such as cotton, rosin, talc, and rags.

The ink slab is located at one end of the etching table, along with a rack to support the inking roller, when it is not in use. (See secs. 11.13 and 14.6.) Shelving immediately adjacent to the etching table should carry the following processing materials: lithotine dispenser; kerosene dispenser; roll-up ink; asphaltum and Triple Ink; a box of correcting materials such as hones, razor blades, and pencils; the scraping spatula for the roller; and a hand fan.

A wash sink and counter top with cabinets above and below should be within a few steps of the etching table. The sink counter should be covered with a noncorrosive material to resist accidental spilling of strong chemicals. Wooden cabinets (without doors)† above the sink carry laboratory glasses, water bowls, sponges, gum jars, and chemicals. Larger cabinets (with doors) below the sink hold shop rags, soap powders, and miscellaneous maintenance materials.

Several sets of drying rods (like towel bars) are positioned near the sink and the etching table. These are necessary for drying the gum-wiping cloths after use. Etching and counteretching brushes are hung from hooks in a convenient location by the sink.

THE PAPER-HANDLING STATION

The paper-handling station must be the cleanest area in the entire physical plant. When possible, it should be located in an area adjoining the press room; otherwise, it should be farthest from graining, processing, and printing stations. If necessary, the area for paper handling can be subdivided and used partly for office and curatorial activities in a professional shop or for other storage facilities in a school shop.

Paper-handling activities include selecting, marking, and tearing papers for proofing and edition printing. The examination, collation, documentation, and storage of completed editions are done here, and in some shops bulk supplies of paper stocks are also housed within the area.

Large tables with smooth, clean surfaces (metal, Formica, or linoleum) are required for tearing paper and for examining editions. Metal straightedges and paper-tearing devices should be hung nearby.

Completed editions are stored in wooden or metal

†Cabinets for storing corrosive chemicals should be of wood and adequately ventilated; metal cabinets are not recommended because of their tendency to rust.

blueprint cabinets. Those having drawers measuring 35 × 55 × 3″ are sufficiently large to hold easily even the largest papers and cardboards. Special papers such as transfer paper and tissue can also be stored in this way. Often the cabinets are placed side by side to form a long counter for paper tearing and edition sorting.

Bulk paper stocks are stored on stout open shelving provided their wrappers are intact. Opened packages of paper are safer when they are stored in the blueprint cabinets.

THE PRINTING STATION

The printing station or press area contains (1) the press, (2) the paper table, (3) the press table, and (4) the ink slab and ink counter. Shops having more than one press should have duplicate printing stations; these stations should be adjacent in order to confine the printing activity to one area of the room and yet be as close as possible to a central processing station. Very productive professional shops might require individual processing stations for each printing station. In such cases duplicate processing equipment and materials would be necessary for each station.

The configuration of the printing station approximates a horseshoe pattern, with the press in the center butting against the ink counter and flanked by the paper table on the operator's side of the press and the press table on the other. (See fig. 4.1.)

The ink counter running along one wall of the shop may serve several press stations. It is used for mixing inks, and includes the ink slab, solvent dispensers, rags, sponges, and other printing paraphernalia. The counter surface should be covered with galvanized metal and should have shelving below for shop supplies and bulk storage. Ink slabs and individual roller racks are positioned on the counter adjacent to each printing press. Large pinup panels (4 × 4 feet) made of insulation board are positioned above each ink slab. These serve for examining proofs or for pinning up the *bon à tirer* for reference during printing.

An ink-and-roller cabinet containing many shelves is attached to the wall above the ink counter, equidistant from all press stations. The shelves are used to store printing inks, varnishes, and modifiers, and the cabinet is designed to carry extra leather and color-printing rollers that are not in immediate use.

In small shops, the paper table serves as the paper-handling station. Here the paper kit is prepared and laid out for feeding to the press. The press table located on the opposite side is for a two-man printing operation. It may be used for water bowls and sponges if the press assistant is responsible for dampening the stone, or it may be used for completed prints when this is the assistant's responsibility. The press table is unnecessary if all printing is done without assistance. In such cases, water

bowls and sponges are kept on the ink counter on the printer's side of the press.

The paper table and press table should be large enough to accommodate the largest sheets of paper to be printed and should be of the same height as the press bed and ink counter. Tables that measure $36 \times 72 \times 30''$ are ideal for large shops. Their top surfaces should be covered with metal, Formica, or linoleum, and should be immaculate at all times so as not to soil the print papers. Drawers and shelving below the tables are useful for storing color-registry needles, rulers, drawing materials, shop notations, and slip papers used during proofing and printing. Sufficient aisle space should be provided between the tables and the press to allow room for comfortable press operation and to permit passage of the lift truck when stones are transported.

Additional equipment for each press station includes:

1. A hand fan, which should be hung on or near the press.

2. A press kit containing proofing and correcting equipment. This is usually positioned on a shelf of the ink counter below the ink slab. (See sec. 10.8.)

3. Tympan grease and spatula. These are located near the press kit.

4. A talc box containing talc and cotton, next to the press kit. During printing the box is positioned on the ink counter or paper table, where it is convenient for dusting the hands before handling the printing paper.

5. Various sizes of tympan sheets for each press station. The most efficient arrangement for tympan storage is to hang the sheets from the ceiling or high on the wall near the press. Each sheet is pierced with an eyelet at the outer corners of one end for hanging. Small tympans can be stored on a shelf of the press box or on shelving built under the press. (Tympan lubricant should be removed from the sheets before this type of storage.)

6. An ink knife is essential for each press station and is usually hung below the ink counter near the ink slab.

7. Color-ink mixing knives are kept in a can located near the ink cabinet.

8. Color-ink mixing slabs are located on shelves below the ink counter near the ink cabinet.

9. A roller-scraping knife should be hung from the ink cabinet.

10. Fireproof waste containers for soiled rags and also for paper waste should be centrally located to service all the press stations. (See sec. 10.8.)

SOLVENT STORAGE

The various solvents used in the lithographic process are all inflammable. Procedures for their bulk storage have been previously described (see sec. 10.6). Smaller quantities in 1-gallon containers can be stored in a closed, fireproof, metal solvent locker. The solvent locker should be near the processing and press stations. Other materials,

such as press lubricants, tympan greases, and funnels, may also be stored in it. Fireproof waste containers are useful for the disposal of greasy shop cloths used in processing or printing. (See sec. 10.8.) It is advisable to have several such containers in various areas of the shop.

One container is labeled to carry only rags saturated with lithotine solvent; others are labeled to contain rags carrying kerosene, ink, or grease. In this way semiclean rags can be identified for re-use without endangering particular processes.

16.7 COST TABLES FOR THREE TYPES OF WORKSHOP

I. COMPARATIVE COST OUTLAY: BASIC FIXTURES AND EQUIPMENT FOR THREE TYPES OF WORKSHOP

ITEM	UNIT COST	PROFESSIONAL SHOP		SCHOOL SHOP		PRIVATE SHOP‡	
		QUANTITY	TOTAL COST	QUANTITY	TOTAL COST	QUANTITY	TOTAL COST
FIXTURES							
Stone-storage Rack	$ 500	2	$ 1,000	3	$ 1,500	1	$ 75
Graining Sink	350	1	350	1	350	1	75
Processing Table	100	1	100	1	100	1	35
Ink & Roller Rack	75	1	75	1	75	1	25
Print-drying Rack	200	1	200	—	—	—	—
Shelves & Cabinets	300	4	1,200	4	1,200	1	100
Paper Storage	300	1	300	1	300	1	75
Ink Slabs	20	4	80	4	80	1	20
Press Tables	75	3	225	3	225	1	25
Paper Tables	75	3	225	3	225	1	25
Drawing Tables	75	3	225	15	1,125	1	25
Chairs	12	3	48	15	180	1	12
Office Desk & Chair	100	1	100	1	100	—	—
Print Cabinets	200	4	800	4	800	1	200
Document Files	75	1	75	1	75	—	—
EQUIPMENT							
Lithograph Stones (Average Cost)	50	50	2,500	75	3,750	12	600
Hydraulic Lift Truck	350	1	350	1	350	—	—
Graining Levigator	75	2	150	2	150	1	75
Lithograph Presses	3,000	3	9,000	3	9,000	1	3,000
Tympan Sheets	20	5	100	5	100	3	60
Scraper Wood (6′ Units)	5	8	40	8	40	3	15
Scraper Leather (4′ Units)	2	10	20	10	20	4	8
Ink Rollers (Leather)	45	4	180	4	180	1	45
Ink Rollers (Synthetic)	50	3	150	3	150	1	50
Ink Spatulas	2	6	12	6	12	2	4
Color-ink Mixing Knives	2	12	24	12	24	6	12
Solvent Dispensers	10	8	80	8	80	2	20
Fireproof Rag Containers	25	2	50	2	50	—	—
Paper-waste Containers	10	2	20	2	20	—	—
Water Bowls	.50	8	4	8	4	4	2
Etch Bowls	.25	8	2	8	2	4	1
Etching Brushes	4	3	12	3	12	2	8
Laboratory Equipment	12		12		12	½	6
Straightedge (Stone Testing)	10	1	10	1	10	1	10
Straightedge (Measuring)	5	2	10	2	10	1	5
Paper-tearing Device	5	1	5	1	5	1	5
TOTALS			**$17,734.00**		**$20,316.00**		**$4,618.00**

‡The costs of various fixtures for the private shop are based on the assumption that these items will be built by the owner, or purchased second hand.

II. COMPARATIVE COST OUTLAY: BASIC SUPPLIES FOR THREE TYPES OF WORKSHOP

ITEM	UNIT COST	PROFESSIONAL SHOP		SCHOOL SHOP		PRIVATE SHOP	
		QUANTITY	TOTAL COST	QUANTITY	TOTAL COST	QUANTITY	TOTAL COST
ACIDS							
Acetic (glacial)	$ 3.00	1 gal.	$ 3.00	1 gal.	$ 3.00	1 gal.	$ 3.00
Nitric 70% USP	5.60	7 lb.	5.60	7 lb.	5.60	7 lb.	5.60
Phosphoric 85% syrupy	1.50	2 pt.	3.00	2 pt.	3.00	1 pt.	1.50
Tannic (powdered)	6.25	¼ lb.	1.56	¼ lb.	1.56	⅛ lb.	.78
Phenol	8.00	1 gal.	8.00	1 gal.	8.00	1 pt.	2.00
SOLVENTS & OILS							
Lithotine	1.15	55 gal.	63.25	55 gal.	63.25	10 gal.	11.50
Kerosene	.20	55 gal.	11.00	55 gal.	11.00	5 gal.	1.00
Anhydrous Alcohol	2.45	1 gal.	2.45	1 gal.	2.45	1 gal.	2.45
Gasoline	.33	5 gal.	1.65	5 gal.	1.65	1 gal.	.33
Tympan Grease	.45	10 lb.	4.50	10 lb.	4.50	5 lb.	2.25
Lubricating Oil	.55	1 qt.	.55	1 qt.	.55	1 qt.	.55
PROCESSING MATERIALS							
Gum Arabic 14° Baumé	3.50	30 gal.	105.00	30 gal.	105.00	5 gal.	17.50
Asphaltum	3.65	2 gal.	7.30	2 gal.	7.30	1 gal.	3.65
Rosin	.50	50 lb.	25.00	50 lb.	25.00	10 lb.	5.00
Talc	.25	50 lb.	12.50	50 lb.	12.50	10 lb.	2.50
Snake slips	14.00	1 gross	14.00	1 gross	14.00	½ gross	7.00
PLATEMAKING MATERIALS							
Cellulose Gum MS-448	2.35	4 gal.	9.40	4 gal.	9.40	1 gal.	2.35
Cellulose Gum (Acidified) MS-571	3.65	4 gal.	14.60	4 gal.	14.60	1 gal.	3.65
Non-Tox Fountain Solution	6.00	1 gal.	6.00	1 gal.	6.00	½ gal.	3.00
Counteretch Solution	3.75	1 qt.	3.75	1 qt.	3.75	1 qt.	3.75
Triple Ink	2.73	4	10.92	4	10.92	1	2.73
Aluminum Plates, 25½×36×.012″	2.35	25	58.75	25	58.75	10	23.50
Aluminum Plates, 32½×43×.012″	3.55	25	88.75	25	88.75	—	—
Zinc Plates, 25½×76×.012″	5.00	25	125.00	25	125.00	—	—
ABRASIVES							
Carborundum—100 grit	.40	100 lb.	40.00	100 lb.	40.00	25 lb.	10.00
Carborundum—150 grit	.40	100 lb.	40.00	100 lb.	40.00	25 lb.	10.00
Carborundum—220 grit	.40	100 lb.	40.00	100 lb.	40.00	25 lb.	10.00
INKS & MODIFIERS							
S & V Rolling-up Black	2.25	8 lb.	18.00	8 lb.	18.00	2 lb.	4.50
Charbonnel Noir Velour	8.50	4 kg.	34.00	4 kg.	34.00	1 kg.	8.50
S & V Transfer Ink	5.00	2 lb.	10.00	2 lb.	10.00	1	5.00
Color Inks (Average kit 12 colors, 1 lb. each)	50.00	4 kits	200.00	4 kits	200.00	1 kit	50.00

ITEM	UNIT COST	PROFESSIONAL SHOP		SCHOOL SHOP		PRIVATE SHOP	
		QUANTITY	TOTAL COST	QUANTITY	TOTAL COST	QUANTITY	TOTAL COST
Varnishes (4 grades, 1 pt. each)	$ 6.00	2 kits	$ 12.00	2 kits	$ 12.00	1 kit	$ 6.00
Reducing Oil	1.00	2 pt.	2.00	2 pt.	2.00	1 pt.	1.00
Cobalt Drier	5.00	1 pt.	5.00	1 pt.	5.00	1 pt.	5.00
Magnesium Carbonate	.30	10 lb.	3.00	10 lb.	3.00	5 lb.	1.50
DRAWING MATERIALS							
Lithographic Pencils (4 grades, 1 doz. ea.)	10.60	4	42.40	4	42.40	4	42.40
Lithographic Crayons (4 grades, 1 doz. ea.)	1.40	4	5.60	4	5.60	4	5.60
Rubbing Crayons	.50	12	6.00	12	6.00	1	.50
Charbonnel Paste Tusche	4.00	6	24.00	6	24.00	1	4.00
La Favorite Tusche	1.20	6	7.20	6	7.20	1	1.20
Korn's Autographic Tusche	3.75	6	22.50	6	22.50	1	3.75
Korn's Liquid Tusche	3.60	4	14.40	4	14.40	1	3.60
Red Oxide Powder	.75	5 lb.	3.75	5 lb.	3.75	1 lb.	.75
Red Conté Pencils	1.50	1 doz.	1.50	1 doz.	1.50	½ doz.	.75
MISCELLANEOUS							
Cotton	1.20	2 rolls	2.40	2 rolls	2.40	1 roll	1.20
Cheesecloth	12.00	60 yd.	12.00	60 yd.	12.00	20 yd.	4.00
Webril Wipes	2.55	8 rolls	20.40	8 rolls	20.40	2 rolls	5.10
Sponges (Fine Pore)	1.00	12	12.00	12	12.00	6	6.00
Sponges (Coarse Pore)	.75	12	9.00	12	9.00	6	4.50
Masking Tape	1.00	12 rolls	12.00	12 rolls	12.00	1 roll	1.00
TOTALS			$1,184.68		$1,184.68		$301.44

III. COMPARATIVE COST OUTLAY: BASIC PRINTING PAPERS FOR THREE TYPES OF WORKSHOP

ITEM	UNIT COST	PROFESSIONAL SHOP		SCHOOL SHOP		PRIVATE SHOP	
		QUANTITY	TOTAL COST	QUANTITY	TOTAL COST	QUANTITY	TOTAL COST
Rives BFK 29¾ × 41¼″	$ 300	1 rm.	$ 300	1 rm.	$ 300	½ rm.	$ 150
Arches Cover (white) 22 × 30″	180	1 rm.	180	1 rm.	180	½ rm.	90
Arches Cover (buff) 22 × 30″	180	1 rm.	180	1 rm.	180	—	—
Deluxe Copperplate 30 × 42″	280	1 rm.	280	—	—	—	—
German Copperplate 30 × 42″	190			1 rm.	190		
Proofing Paper	60	2 rm.	120	2 rm.	120	½ rm.	30
Newsprint	7	2 rm.	14	2 rm.	14	1 rm.	7
Chipboard	200	1 rm.	200	1 rm.	200	⅕ rm.	40
Tissue	15	1 rm.	15	1 rm.	15	½ rm.	7.50
Wrapping Paper (48″ wide)	15	1 roll	15	1 roll	15	1 roll	15
TOTALS			$1,304		$1,214		$ 339.50

GRAND TOTALS	PROFESSIONAL SHOP	SCHOOL SHOP	PRIVATE SHOP
Table I	17,734.00	20,316.00	4,618.00
Table II	1,184.68	1,184.68	301.44
Table III	1,304.00	1,214.00	339.50
	$20,222.68	$22,714.68	$5,258.94

Sources of Supply

(Listed alphabetically by material)

MATERIAL	SOURCE
ABRASIVES	The Carborundum Co. Niagara Falls, N. Y. (See also local Yellow Pages)
BRUSHES Etch brushes, rubberset Spot-etch brushes, Japanese Counteretch brushes, rubberset	(See Lithographic Suppliers, General)
CARTING DEVICES Big Joe Lift Truck (Model No. 9957)	Big Joe Manufacturing Co. Wisconsin Dells, Wis. 53965 (Local distributors in major cities)
Crown Lift Truck (capacity 1500 pounds, Model No. B57-Std.)	Crown Controls Corp. 40–44 South Washington St. New Bremen, Ohio 45869
CELLULOSE GUM ETCH (ACIDIFIED) MS–571	Handschy Chemical Co. (See Inks, Color)
CELLULOSE GUM SOLUTION MS–448	Handschy Chemical Co. (See Inks, Color)
CHEMICALS	(See Lithographic Suppliers, General)
FELT	Graphic Chemical & Ink Co. P.O. Box 27 Villa Park, Ill. 60181
FLANGES, PLASTIC PRINTMOUNTING	E. Joseph Cossman Dept. T 12502 Milbank St. Studio City, Calif. 91604
GRAINING MARBLES	Benton A. Dixon Co. 1270 South Dittman St. Los Angeles, Calif. 90023

HONES (See Lithographic Suppliers, General)

INKING ROLLERS, COLOR
Polyurethane plastic type and large-diameter roller custom
 fabrication

Spray Sales and Sierra Roller Co.
5001 Firestone Place
South Gate, Calif. 90280

Rubber type

Samuel Bingham Co.
201 North Wells St.
Chicago, Ill. 60606

Rubber type and large-diameter roller custom fabrication

Charles Brand
84 East 10th St.
New York, N.Y. 10003

Small brayers, rubber type

Dick Blick
P.O. Box 1267
Galesburg, Ill. 61401

INKING ROLLERS, LEATHER (Also repairing and
 re-covering service)

Roberts & Porter, Inc.
4140 West Victoria Ave.
Chicago, Ill. 60646 (Branches in principal cities)

L. Cornellisen & Son
22 Great Queen St.
London W.C. 2, England

B. Thornton
15 Mount Pleasant
London W.C. 1, England

Ets. Charles Schmautz
219 Rue Raymond Losserand
Paris 14, France 75

INKS, BLACK PRINTING
Graphic Chemical M–1796

Graphic Chemical & Ink Co. (See Felt)

Noir Velours No. RSA
Noir Monter

F. Charbonnel
13, Quai de Montebello Ct.
Rue de l'Hôtel Colbert
Paris 5e, France

M. Flax (See Printing Papers, Handmade)

INKS, BLACK ROLLING–UP
Rolling-up Black SF–63–313

General Printing Ink Co. (See Lithographic Suppliers,
 General)

Rolling-up Ink M–1921
Senefelder Crayon Black Ink M–1803

Graphic Chemical & Ink Co. (See Felt)

Rolling-up Black LA 72437
Stone Neutral Black LA 76823

Sinclair & Valentine
Division of Martin Marietta
14930 Marquardt Ave.
Santa Fé Springs, Calif. 90670

INKS, COLOR

Handschy Chemical Co.
528 North Fulton St.
Indianapolis, Ind. 46202

Sinclair & Valentine (See Inks, Black Rolling-up)

| INKS, MODIFIERS | (All companies listed above) |

| INKS, TRANSFER (stiff)
FL–61173 | Sinclair & Valentine (See Inks, Black Rolling-up) |

| KNIVES
Color ink-mixing spatulas
Roller-scraping spatulas
Stiff, ink-mixing type | Local hardware or paint store (See Laboratory Equipment)
Local hardware or department store (kitchenwares
 department) |

| LABORATORY EQUIPMENT
Glass graduates, stirring rods, water bowls, etch bowls, etc. | Local laboratory equipment or druggists' suppliers |
| Hydrion Short Range Papers for measuring pH | (See Lithographic Suppliers, General) |

| LACQUER BASE
Lith-Kem-Ko Deep Etch Lacquer "C" 3001–C | Litho Chemical & Supply Co. (See Lithographic Suppliers,
 General)
Roberts & Porter, Inc. (See Inking Rollers) |

LEVIGATORS	Fox Graphics Back Bay Annex P.O. Box 328 Boston, Mass. 02117
	Graphic Chemical & Ink Co. (See Felt)
	Rembrandt Graphic Arts Co. (See Lithograph Stones, Used)

| LIQUID ETCHING GROUND | Graphic Chemical & Ink Co. (See Felt) |

| LITHOGRAPH STONES, USED (When available) | Rembrandt Graphic Arts Co.
Stockton, N.J. 08559 |
| | Graphic Chemical & Ink Co. (See Felt) |

| LITHOGRAPHIC CRAYONS AND PENCILS
#00–#5 and rubbing crayons (Sole U.S. make) | Wm. Korn, Inc.
260 West St.
New York, N.Y. 10013 |
| Lemercier Crayons | Établissement OGE & Gauger
Malakoff
Seine, France |

LITHOGRAPHIC PRESSES, NEW The Antreasian Press Custom-made hydraulic pressure application, automatic and motorized	Garo Z. Antreasian Tamarind Institute University of New Mexico Albuquerque, N.M. 87106
Custom-made hydraulic pressure application, manual or motorized	S. & H. Manufacturing Co. P.O. Box 523 Sierra Madre, Calif. 91024
Custom-made new design, manual or motorized operation	Charles Brand (See Inking Rollers, Color)
	Graphic Chemical and Ink Co. (See Felt)

The Griffin Co.
2241 6th St.
Berkeley, Calif. 94710

Gerald E. Martin
3328 Girard Ave. South
Minneapolis, Minn. 55408

(New adaptations of the standard hand transfer-press design)

American Graphic Arts, Inc.
628 West 45th St.
New York, N.Y. 10036

The Tyler Press
Custom-made hydraulic pressure application, automatic and motorized

Kenneth Tyler
Gemini G.E.L.
8365 Melrose Ave.
Los Angeles, Calif. 90069

LITHOGRAPHIC PRESSES, USED
(When available)

Rembrandt Graphic Arts, Inc. (See Lithograph Stones, Used)

LITHOGRAPHIC SUPPLIERS, GENERAL
All general lithographic supplies, including chemicals, gum arabic, metal-plate etches, cheesecloth, asphaltum, rosin, talc, etc.

General Printing Ink Co.
Division of Sun Chemical Corp.
750 Third Ave.
New York, N.Y. 10017
Also: Box 3897 Terminal Annex
Los Angeles, Calif. 90054 and branches in other principal cities

Handschy Chemical Co.
2525 North Elston Ave.
Chicago, Ill. 60647
See also Inks, Color for their branch in Indianapolis; other branches exist in principal Midwest cities

Litho Chemical & Supply Co.
46 Harriet Pl.
Lynbrook, N.Y. 11563
Also: 335 South Pasadena Ave.
Pasadena, Calif. 91105

Lithoplate Co. (See Metal Plates, Aluminum)

Rembrandt Graphic Arts Co. (See Levigators)

Sinclair & Valentine
Division of Martin Marietta
14930 Marquardt Ave.
Santa Fé Springs, Calif. 90670
Also: 4101 South Pulaski Rd.
Chicago, Ill. 60632

LITHOGRAPHIC TUSCHE
La Favorite Tusche-Specialité

Sté. des Encres Françaises d'Imprimerie
Vitry-sur-Seine, France

Liquid Writing Ink

L. Cornellisen & Son (See Papers, Transfer)

Lithographic tusche (German)

Kast & Eteinger G.m.b.H.
Stuttgart-Feuerbach, Germany

Stick and liquid, also Autographic type	Wm. Korn, Inc. (See Lithographic Crayons)
Stick type and paste type (encre lithographique Dessinateur – Coverflex Zincographique)	F. Charbonnel (See Inks, Black Printing)

LUBRICANTS, PRESS — Local oil and grease dealers

LUBRICANTS, TYMPAN
Darina-AX — Local branch, Shell Oil Co.

MAT BOARD, 100% RAG — Andrews-Nelson-Whitehead (See Printing Papers, Handmade)

Colonial Paper Co.
102 Purchase St.
Boston, Mass. 02110

MAT BOARD, RAG–FACED — National Cardboard
11422 South Broadway
Los Angeles, Calif. 90061

METAL–PLATE GRAINING MACHINE
(Tamarind Design) — Tamarind Institute
University of New Mexico
Albuquerque, N.M. 87106

METAL PLATES, NEW ALUMINUM
Imperial Ball Grained — Lithoplate Co.
5200 East Valley Blvd.
Los Angeles, Calif. 90032
(See also Lithographic Suppliers, General)

METAL PLATES, ZINC, NEW AND REGRAINED — Chicago Litho Plate Co.
549 West Fulton St.
Chicago, Ill. 60606

Uniform Plate Graining Co.
2120 West Lake St.
Chicago, Ill. 60612

METAL STRAIGHTEDGES — Local art or drafting supplies dealers

NGN NON–TOX SOLUTION — Lithoplate Co. (See Metal Plates, Aluminum)

PAPERS, TRANSFER
Côté Collé
stone-to-stone paper; transparent transfer paper; Everdamp transfer paper — F. Charbonnel
13, Quai de Montebello Ct.
Rue de l'Hôtel Colbert
Paris 5e, France

M. Flax (See Printing Papers, Handmade)

All varieties, including stone-to-stone, writing, grained, transparent, and Everdamp — L. Cornellisen & Son
22 Great Queen St.
London W.C. 2, England

PLATE CLEANER
Lithpaco Plate Cleaner — Lithoplate Co. (See Metal Plates, Aluminum)

PLATE CONDITIONER
F 602–71–502 — Lithoplate Co. (See Metal Plates, Aluminum)

PRINTING PAPERS, HANDMADE
Fine imported European and Japanese papers for printing; also tissues, glassine, and blotters

Andrews-Nelson-Whitehead, Inc.
Division of Boise Cascade Corp.
7 Laight St.
New York, N.Y. 10013

M. Flax
10852 Lindbrook Dr.
Los Angeles, Calif. 90024

PRINTING PAPERS, ORIENTAL

Yamada Shokai
5 Chome, Yaesu, Chuo-ku
Tokyo, Japan

Shimizu Seirindo
1–8 Honcho, Chuo-ku
Nihonbashi
Tokyo, Japan

PRINTING PAPERS, PROOFING
Radar Vellum Bristol

Moraine Paper Co.
Subsidiary of Kimberly-Clark Corp.
West Carrolton, Ohio 45449

Winsted Wedding Paper and Bristol

Rising Paper Co.
Housatonic, Mass. 01236

Large assortment of domestic bristols, vellums, and cover stocks

Zellerbach Paper Co.
4000 East Union Pacific Ave.
Los Angeles, Calif. 90054

PRINTING PAPERS, SPECIAL HANDMADE
Mill representative for Rives and Arches papers

Special Papers, Inc.
West Redding, Conn. 06896
Attn: Mr. Bernard Guerlain

PRO–SOL FOUNTAIN SOLUTION #54
Plate Etch for Aluminum

Polychrome Corp.
Yonkers, N.Y. 10702
Also: 3313 Sunset Blvd.
Los Angeles, Calif. 90026

SCRAPER BARS

Rembrandt Graphic Arts Co. (See Lithograph Stones, Used)

Graphic Chemical and Ink Co. (See Felts)

Also custom-made by local lumber and millwork sources

SCRAPER LEATHER

Local leather supplier or saddlery

SHOP RAGS
Mechanics' towels

Local mechanics' laundry

SNAKE SLIPS
Bender's Litholit-Korrekturstifte (Medium)
Also: Gamburger Korrektursteine

Rolcor Products
340–344 Hudson St.
New York, N.Y. 10013

Also: Frithjof Tutschke
300 Hannover-Kleefeld
Postfach 350, Germany

SPONGES
Dupont Cellulose Sponge, Coarse Pore 8A

Dupont Cellulose Sponge, Fine Pore 8AF

Handschy Chemical Co. (See Inks, Color)
Also local photographic suppliers and paint stores

TYMPANS, PLASTIC
Glass epoxy or Phenolic .031 gauge

Local plastics distributor

Bibliography

I. TECHNICAL WORKS

The first comprehensive account of the lithographic process was written by its inventor, Aloys Senefelder, and published in Munich under the title *Vollständiges Lehrbuch der Steindruckerey* (1818). French and English translations appeared in 1819. Other works soon followed, written principally by early master printers, among them Engelmann (1822, 1840) and Hullmandel (1824). As lithography gained in importance during the nineteenth century, a number of technical works were published, most of them designed primarily for use by the artisan-lithographer working in the trade. An excellent bibliography of nineteenth-century publications appears in Georg Fritz, *Handbuch der Lithographie und des Steindruckes* (1901).

Listed below are some of the key works published in the nineteenth century, together with selected technical manuals of more recent date:

1818 Senefelder, Aloys. *Vollständiges Lehrbuch der Steindruckerey*. Munich.

 ". . . containing clear and explicit instructions in all different branches and manners of that art: accompanied by illustrative specimens of drawings to which is prefaced a history of lithography, from its origin to the present time, by Aloys Senefelder, inventor of the art of lithography and chemical printing." The first English translation, published under the title *A Complete Course of Lithography* (London, 1819), has been reprinted (New York, Da Capo Press, 1968). A translation under the title *The Invention of Lithography* was published in 1911 (New York, Fuchs & Lang Manufacturing Co.).

1822 Engelmann, Godefroy. *Manuel du dessinateur lithographie*. Paris.

 A description of procedures for drawing on stone with special instructions for the then new technique of tusche washes.

1824 Hullmandel, Charles. *The Art of Drawing on Stone*. London, Hullmandel & Ackermann.

 Includes excellent descriptions and illustrations of drawing techniques; written by the foremost master printer in England. Second edition: Longman & Co., 1833.

1840 Engelmann, Godefroy. *Traité théorique et pratique de lithographie*. Mulhouse and Paris, Engelmann et Fils.

 An extended discussion of all aspects of lithography as practiced during its first golden age in France by a great master printer and innovator.

1878 Richmond, W.D. *The Grammar of Lithography*. London, Wyman & Sons.

 A standard work covering all aspects of lithography. Bibliography. Other editions were published by Wyman & Sons, 1880, and Myers & Co., 1912.

1883 Audsley, George A. *The Art of Chromolithography*. London, Sampson Low, Marston, Scarle & Rivington.

 "Popularly explained and illustrated by forty-four plates showing separate impressions of all the Stones employed: and all the progressive printings in combination, from the first colour to the finished picture."

1901 Fritz, Georg. *Handbuch der Lithographie und des Steindruckes*. Halle, Wilhelm Knapp.

 A thorough and well-illustrated text describing the machinery, materials, tools, and techniques used in creative and commercial lithography in Germany at the turn of the century. Extensive bibliography.

1904 Cumming, David. *Handbook of Lithography*. London, Adam & Charles Black.

 Practical descriptions of hand printing, offset printing, transfer techniques, and chromolithography. A third edition was printed in 1932; reprinted 1946, 1948.

1906 Henderson, George K. *American Textbook of Lithography*. Indianapolis, Levey Bros. & Co.

 A standard textbook for stone and metal-plate printing used in American trade schools of the period.

1907 Marou, Paul, and Broquelet, A. *Traité complet de*

l'art lithographique, au point de vue artistique et pratique. Paris, Garnier-Frères.

> A French technical manual, including a set of color separations and progressive proofs for a lithograph printed in eleven colors.

1912 Harrap, Charles. *Transferring*. Leicester, Raithby, Lawrence & Co.

> Covers all aspects of transferring materials, processes, and techniques employed in commercial lithography; equally relevant to creative lithography.

1914 Rhodes, Henry J. *The Art of Lithography*. London, Scott Greenwood & Son.

> A practical and specific textbook for the lithographic printer. Second edition, 1924.

1927 Harrap, Charles. *Offset Printing from Stone and Plates*. Leicester, Raithby, Lawrence & Co.

> Contains useful information on the chemistry and processing of stones and plates, applicable both to direct and offset printing. This is a revised edition of the author's earlier *Metallography*, first published in 1909 by Raithby, Lawrence & Co.

1930 Brown, Bolton. *Lithography for Artists*. Chicago, University of Chicago Press.

> A highly personal account of lithography compiled from the author's 1929 lectures at the Art Institute of Chicago. Although this book has been used for many years as a standard reference, the descriptions of techniques and procedures are often conflicting and obscure.

1931 Seward, C. A. *Metal Plate Lithography for Artists and Draftsmen*. New York, The Pencil Points Press.

> A clear, though elementary, account of metal-plate lithography for creative hand printing. This is the only early treatment of the subject published in the United States specifically directed to use by artists.

1932 Hartrick, A. S. *Lithography as a Fine Art*. London, Oxford University Press.

> A brief history of lithography and a description of the process by a founding member of the Senefelder Club in London.

1936 Wengenroth, Stow. *Making a Lithograph*. London, Studio Publications.

> A brief text describing the making of a lithograph by a leading American lithographer of the 1930s.

1937 Soderstrom, Walter. *The Lithographer's Manual*. New York, Waltwin Publishing Co.

> Published to commemorate the commercial lithographic industry; an illuminating account of its historic evolution.

1941 Arnold, Grant. *Creative Lithography and How to Do It*. New York, Harper & Bros.

> A well-written description of the drawing techniques and processes popular among American artist-lithographers in the 1930s and 40s. A paperback re-publication of the 1941 edition is available: New York, Dover Publications, 1964.

1950 Dehn, Adolph, and Barrett, Lawrence. *How to Draw and Print Lithographs*. New York, American Artists Group.

> A simplified description of the drawing and printing processes used by the authors, illustrated principally by examples of their work.

Kistler, Lynton R. *How to Make a Lithograph*. Los Angeles, Lynton R. Kistler.

> Twenty-four photographs with a brief related text.

1952 Hartsuch, Paul J. *Chemistry of Lithography*. New York, Lithographic Technical Foundation.

> A thorough and authoritative description of the chemistry of modern lithography. Although written for use in the commercial industry, the text is equally relevant to hand lithography. The 1952 edition has been superseded by an extensively revised second edition published in 1961.

1957 Reed, Robert F. *Offset Platemaking—Surface*. New York, Lithographic Technical Foundation.

> A comprehensive account of modern platemaking technology in offset printing; a useful reference for plate preparation in hand printing. This edition is a revision of the author's earlier *Offset Platemaking—Albumin Process*, 1945.

1958 Heller, Jules. *Printmaking Today*. New York, Holt, Rinehart, and Winston.

> A general textbook on printmaking for use in the high school or college classroom; includes a section on lithography.

1960 Trivick, Henry. *Autolithography*. London, Faber & Faber.

> A full account of the lithographic process, including printing from zinc and aluminum plates.

1962 Brunner, Felix. *A Handbook of Graphic Reproduction Processes*. New York, Visual Communication Books, Hastings House.

> Describes all printmaking processes, including lithography; many well-selected illustrations, very well reproduced, with a number of enlarged details. Parallel texts in English, French, and German. Second edition, 1964.

1965 Cliffe, Henry. *Lithography*. New York, Watson-Guptill Publications.

> A brief account of the process, with emphasis on metal-plate work as practiced in Great Britain.

Weaver, Peter. *The Technique of Lithography*. New York, Reinhold Publishing Corporation.

> A thorough and well-organized text describing modern techniques, processes, and approaches to the medium, as practiced and taught by the author in England.

1966 Weddige, Emil. *Lithography*. Scranton, International Textbook Co.

A recent treatment of the more popular techniques in current use, described by an American lithographer and teacher. Extensively illustrated with examples of color lithography by contemporary American and European artists.

1967 Jones, Stanley. *Lithography for Artists*. London, Oxford University Press.

> A general guide to basic processes, including an index to British supply sources. The author is director of Curwen Press Studio, a leading professional workshop in England.

1970 Knigin, Michael, and Zimiles, Murray. *The Technique of Fine Art Lithography*. New York, Van Nostrand Reinhold.

> A concise, illustrated text describing techniques applicable both to stone and metal plates. Includes chapters on color printing, photolithography, and other special processes.

II. HISTORY OF LITHOGRAPHY

Despite all that has been published, a truly comprehensive history of lithography has yet to be written. Michael Twyman's *Lithography 1800–1850* (1970) provides a thorough and scholarly account of the first half-century; Felix Man's *150 Years of Artists' Lithographs* (1953) and Wilhelm Weber's *A History of Lithography* (1966) also supply valuable insights into the medium's early years. Many later artists who made important contributions to lithography are mentioned by Weber only in passing. Joseph Pennell's *Lithography and Lithographers* (1898) remains useful as an account of the development of lithography in the nineteenth century. Twyman, Man, and Weber include bibliographies listing general works on lithography. Other useful bibliographies on the history of lithography are to be found in museum catalogues issued in conjunction with major exhibitions held in Boston (1937), Cleveland (1948), and Munich (1961).

The list below omits many of the specialized references to nineteenth-century lithography that appear in the bibliographies cited above. Also omitted are many of the earlier catalogues raisonnés and monographs on individual artists. Included are standard reference works, such as Béraldi (1885–92) and Delteil (1906–25), recent publications not listed elsewhere, and selected catalogues raisonnés of particular value to the contemporary artist-lithographer and artisan-printer.

1885 Béraldi, Henri. *Les Graveurs du XIXe Siécle*. Paris, Librarie L. Conquet, 1885–92. 12 volumes.

> An essential reference work, which lists and describes the oeuvre of the principal nineteenth-century printmakers, including lithographers.

1893 Hédiard, Germain. *Les Maîtres de la Lithographie*. Paris, Edmond Monnoyer, 1893–1901.

> A series of publications cataloguing the work of individual lithographers, among them Diaz, Fantin-Latour, Huet, Isabey, and others.

1898 Pennell, Joseph, and Robins, Elizabeth. *Lithography and Lithographers*. London, T. F. Unwin.

> An extended and thorough history of lithography in the nineteenth century, witty and

personal in style. A later edition: New York, Macmillan, 1915.

1906 Delteil, Loys. *Le Peintre-Graveur Illustré*. Paris, 1906–30. 31 volumes.

> An indispensable reference work, which catalogues and illustrates all the graphic work done by many of the principal artists of the nineteenth century.

1912 Weitenkampf, Frank. *American Graphic Art*. New York, Henry Holt.

> Chapter X discusses "Lithography: A Business, an Art." Revised edition: New York, Macmillan, 1924.

1913 Mellerio, André. *Odilon Redon*. Paris, Société pour l'Etude de la Gravure Française.

> A fully illustrated catalogue raisonné. Reprinted: New York, Da Capo Press, 1968.

1914 Wagner, Carl. *Alois Senefelder, sein Leben und Wirken: Ein Beitrag zur Geschichte der Lithographie*. Leipzig, Giesecke & Devrient.

> A biography of Senefelder, including a bibliography listing early works on lithography, chronologically arranged.

The Lithographs of Whistler, arranged according to the Catalogue by Thomas R. Way, with additional subjects not before illustrated. New York, Kennedy & Co.

> Fully illustrated. Way, Whistler's printer, published an earlier catalogue in London in 1905.

1923 Glaser, Curt. *Die Graphik der Neuzeit vom Anfang des XIX. Jahrhunderts bis zur Gegenwart*. Berlin, B. Cassirer.

> A general history of printmaking in Europe in the nineteenth and early twentieth centuries. Bibliography.

1925 Delteil, Loys. *Manuel de l'amateur d'estampes du XIXe et du XXe siècle*. Paris. Text, 2 volumes; plates, 2 volumes.

Dussler, Luitpold. *Die Incunabeln der deutschen Lithographie, 1796–1821*. Berlin.

> The standard catalogue of early German lithographs. Reprinted: Heidelberg, R. Weissbach, 1955.

1930 *Inventaire du fonds français après 1800*. Paris, Bibliothèque Nationale, 1930–. 14 volumes to date.

> A basic reference work, not yet complete. Volume 14 (through Lys) was published in 1967.

1937 Museum of Fine Arts. *Exhibition of Lithographs, 527 Examples by 312 Artists from 1799 to 1937*. Boston.

> Exhibition catalogue. Brief introduction, short bibliography.

Zigrosser, Carl. *Six Centuries of Fine Prints*. New York, Covici-Friede.

> Chapters VI and VII discuss lithography.

1939 Curtis, Atherton. *Catalogue de l'oeuvre lithographié et gravé de R. P. Bonington*. Paris, Paul Prouté.

> Illustrated catalogue raisonné.

Curtis, Atherton. *Catalogue de l'oeuvre lithographié de Eugène Isabey*. Paris, Paul Prouté.

> Illustrated catalogue raisonné.

Roger-Marx, Claude. *French Original Engravings from Manet to the Present Time.* Paris, Hyperion.
>Includes lithographs.

1942 Zigrosser, Carl. *The Artist in America: Twenty-four Close-ups of Contemporary Printmakers.* New York, A. A. Knopf.
>Includes chapters on Castellón, Kuniyoshi, Soyer, and others.

1944 Johnson, Una E. *Ambroise Vollard, Éditeur: an Appreciation and Catalogue.* New York, Wittenborn.
>Contains a biographical and critical essay, and a catalogue of prints, books, and sculptures published by Vollard.

1946 Lang, Léon, and Bersier, Jean E. *La Lithographie en France.* Mulhouse, Librarie F. Gangloff, 1946–52. 3 volumes.
>Volume I, *Des origines au début du romantisme* (1946); Volume II, *L'Epoque du romantisme* (1947); Volume III, *De la fin du romantisme à 1914* (1952).

1947 Leiris, M. *The Prints of Joan Miró.* New York, Curt Valentin.
>A brief introductory text and a portfolio of reproductions of forty lithographs.

1948 Cleveland Museum of Art. *Catalogue of an Exhibition of Lithography (1798–1948).* Cleveland.
>Lists 517 lithographs with biographical notes on the artists. Bibliography.

Roger-Marx, Claude. *L'Oeuvre gravé de Vuillard.* Monte Carlo, A. Sauret.
>One of a series of superbly illustrated catalogues raisonnés. Others in the series are devoted to Picasso (1949), Bonnard (1952), Chagall (1960), and Braque (1963), which see below.

1949 *Picasso Lithographe, Notices et catalogue établis par Fernand Mourlot.* Monte Carlo, A. Sauret, 1949–.
>Volume IV (1964) carries the catalogue of Picasso's lithographs to 1963.

1950 Cincinnati Art Museum. *International Biennial of Contemporary Color Lithography.* Cincinnati, 1950–58.
>Five biennial exhibitions were held under this title, the first in 1950, the last in 1958. Their catalogues, illustrated in color, have forewords by Gustave von Groschwitz.

1952 Roger-Marx, Claude. *Bonnard Lithographs.* Monte Carlo, A. Sauret.

1953 Man, Felix H. (pseud. for Bauman, Hans F. S.) *150 Years of Artists' Lithographs, 1803–1953.* London, William Heinemann.
>Contains a brief historical essay and notes on each lithograph illustrated. Bibliography.

1955 Klipstein, A. *Käthe Kollwitz: Verzeichnis des graphischen Werkes.* Bern, Klipstein.
>Illustrated catalogue.

1956 Johnson, Una E. *Ten Years of American Prints: 1947–1956.* New York, Brooklyn Museum.
>A revised and enlarged edition of *New Expression in Fine Printmaking,* first published in the Brooklyn Museum *Bulletin* (1952).

Lieberman, W. S. *Matisse: 50 Years of His Graphic Art.* New York, G. Braziller, and London, Thames and Hudson.
>Illustrated catalogue.

1958 *Joan Miró, His Graphic Work.* New York, Abrams.
>Extensively illustrated, some in color. Introduction by Sam Hunter.

1959 Laran, Jean. *L'Estampe.* Paris, Presses Universitaires de France. 2 volumes.
>Chapter X includes a brief history of lithography.

1960 *Chagall Lithographs, notes and catalogue by Fernand Mourlot.* Monte Carlo, A. Sauret, and New York, G. Braziller.
>Introduction by Julien Cain.

1961 *Bild von Stein: Die Entwicklung der Lithographie von Senefelder bis Heute.* Munich, Prestel-Verlag.
>Exhibition catalogue listing 423 lithographs with notes. Bibliography.

Arnaud, N. *Jean Dubuffet, gravures et lithographies.* Silkeborg, Musée de Silkeborg.
>The small black-and-white illustrations are of limited value.

1962 UCLA Art Galleries. *Lithographs from the Tamarind Workshop.* Los Angeles, University of California.
>Illustrated exhibition catalogue listing 138 lithographs produced at Tamarind during its first two years. Introduction by Frederick S. Wight.

Roger-Marx, Claude. *Graphic Art of the 19th Century.* New York, Toronto, and London, McGraw-Hill.
>A general history of printmaking in the nineteenth century, including lithography, with emphasis on developments in France. Extensively illustrated, some in color.

Zigrosser, Carl (Ed.). *Prints: Thirteen Illustrated Essays on the Art of the Print....* New York, Holt, Rinehart, and Winston.
>Includes several essays on aspects of the history of lithography.

1963 *Braque Lithographe, Notices et catalogue établis par Fernand Mourlot.* Monte Carlo, A. Sauret.
>Introduction by Francis Ponge.

Cleaver, James. *A History of Graphic Art.* New York, Philosophical Library.
>A brief general history of the graphic arts, including lithography. Technical glossary, bibliography.

Stubbe, Wolf. *Graphic Arts in the 20th Century.* New York, Praeger.
>A well-illustrated survey.

1965 Adhémar, Jean. *Toulouse-Lautrec, His Complete Lithographs and Drypoints.* New York, Abrams.
>An excellent study, very well illustrated, including many works in color.

1966 Weber, Wilhelm. *A History of Lithography.* New York, Toronto, and London, McGraw-Hill.
>A general history of lithography from its invention to the present day, with emphasis on the first half of the nineteenth century. Bibliog-

raphy. This is an English translation of the author's *Saxa Loquuntur: Steine reden, Geschichte der Lithographie*. Munich, H. Moos, 1964.

1967 Adhémar, Jean. *La gravure originale au XXᵉ siècle*. Paris, A. Somogy.

A companion work to Roger-Marx's *Graphic Art of the 19th Century*. Extensively illustrated, some in color. Bibliography.

Forgotten Printmakers of the 19th Century. Chicago, Kovler Gallery.

Excellently annotated catalogue of 843 prints, including lithographs by Calame, Charlet, Chéret, Deveria, Lunois, Raffet, Steinlen, and others.

1968 Brown University Department of Art. *Early Lithography: 1800–1840*. Providence.

Exhibition catalogue prepared by graduate students under the direction of Henri Zerner. Illustrated. Bibliography.

Cincinnati Art Museum. *American Graphic Workshops: 1968*.

Exhibition catalogue containing a brief account of the work of nine leading American workshops. Illustrated.

New Mexico, University of. *Bulletin* of the University Art Museum, Number 3, Fall 1968. Albuquerque.

Exhibition catalogue listing ninety-two nineteenth-century French lithographs in the University's collection. Introduction and notes by Louise M. Lewis. Illustrated.

1969 Museum of Modern Art. *Tamarind: Homage to Lithography*. New York.

Exhibition catalogue listing 169 lithographs produced at Tamarind between 1960 and 1969. Illustrated, some in color. Preface by William S. Lieberman. Introduction by Virginia Allen.

Baskett, Mary W. *The Art of June Wayne*. New York, Abrams.

A comprehensive account of the work of Tamarind's founder and director, including a complete list of her lithographs. Extensively illustrated, including many in color.

1970 Twyman, Michael. *Lithography 1800–1850*. London, Oxford University Press.

"The techniques of drawing on stone in England and France and their application in works of topography." An indispensable and highly

readable account of lithography's first fifty years. Excellent bibliography.

III. PUBLICATIONS OF THE TAMARIND LITHOGRAPHY WORKSHOP

As an important part of its program to stimulate and preserve the art of lithography, the Tamarind Lithography Workshop began soon after it was founded in 1960 to publish a series of books, pamphlets, and "fact sheets" dealing not only with specific technical problems but with every aspect of the operation of a lithography workshop and the marketing of the original print. Below is a selected list of Tamarind's principal publications:

1963 Goodman, Calvin J. *A Study of the Economic Aspects of a Lithography Workshop*. 132 pages.

1964 Goodman, Calvin J. *A Study of the Marketing of the Original Print*. 94 pages.

1966 *How a Lithograph Is Made and How Much It Costs*.

An illustrated record of the making of a commissioned print by José Luis Cuevas. Text by Bruce Henderson; Calvin J. Goodman, consultant. 20 pages.

A Management Study of an Art Gallery: Its Structure, Sales, and Personnel.

A study in depth of an existing New York gallery, the "Blue" Gallery, with attention centered on its print department. Edited by Ruth Weddle; John Goldsmith, chief investigator; Calvin J. Goodman, consultant. 110 pages.

1967 *Gallery Facility Planning for Marketing Original Prints*. Edited by Ruth Weddle; basic data by Ray Featherstone; Calvin J. Goodman, consultant. 36 pages.

1968 *Acquiring an Inventory of Original Prints*.

Edited by Ruth Weddle; written by Calvin J. Goodman incorporating data by Ray Featherstone. 53 pages.

Goodman, Calvin J. *Business Methods for a Lithography Workshop*.

An expanded, rewritten, "updated and reoriented" version of the author's earlier *Study of the Economic Aspects of a Lithography Workshop* (1963). Edited by Ellen Frank. 240 pages.

1969 *About Tamarind*.

An illustrated report on the Tamarind program and its accomplishments. Written by June Wayne and members of the Tamarind staff. 32 pages.

Index

NOTE: All references are to page numbers; those followed by an asterisk (21*) are to illustrations.

Guston, Philip: *Wash Shapes*, 135*
gypsum: in papermaking, 323
gypsum crystals (in stone), 264

Halleyville Hero (Nelson), 103–7*
halo effect, 111, 259, 305
hand rest, 26, 73, 99*
handwritten texts, *see* autographic writing
Hansen, Robert: from *Satan's Saint*, 380–81*
Hard-Edge art, 170, 186, 204
Heckel, Erich, 186
hemp: in paper, 323
hinges: in matting and framing, 120
Hommage to Carrière (Oliveira), 184*
hones: cleaning, polishing, and correcting, 49*, 65*, 67, 72–73, 87, 98*, 100, 101, 106*, 110, 155, 156, 204, 244*, 247, 249, 281, 292, 293, 375, 384*, 386, 392*, 395, 405, 406, 407, 411; Carborundum block, 292, 406; pumice, 281, 292, 375; rubber (Weldon and Roberts Retouch Transfer Sticks), 67, 155, 156, 249, 292; Scotch hones, 67, 72, 156; snake slips, 67, 292, 406, 407; Tam-O-Shanter sticks, 292
hors commerce, see artist's proofs
horsehair: as resist, 237
Huet, Paul, 76
Hullmandel, Charles, 76; tusche formula, 257
hydrochloric acid: in counteretch, 134, 136, 267, 268, 279–80
hydrogum (mesquite gum), 161, 281, 283; as mask, 145, 221, 283

impasto effects, 396
imposition process, 237–38
Impressionism: color theories, 166, 170
Imprimerie Lithographique (*Lithography Shop*; Charlet), 78*
India: paper, 322, 326–27, 340; *see also* Oriental paper
India paper (made in China), 327, 417, 421; matting and framing, 122
ink, 87, 88, 93, 103, 301–8, 310–19, 376, 377, 396; affected by atmospheric conditions, 302, 305; antiskinning agents, 310, 311; black ink, 88, 301, 308, 310, 312–13; bodying agents (stiffeners), 111, 286, 310, 311, 313, 318; and color of paper, 331; color permanency, 305–6; driers, 212, 286, 303, 310, 311–12; fats, waxes, and oils in, 257–58; length, 302; livering, 302; modifiers and reducers, 88, 212, 250, 278, 286, 302, 303, 304, 305, 310–12, 313, 411 (*see also* lithotine; magnesium carbonate; reducing oil; varnish; Vaseline); pigments, 302, 303, 305–8, 310; preparation for printing, 307*, 309*, 315–17; stocking of, 318–19; storage, 206, 213, 317, 319; tack, 302, 311; thixotropy, 302; tonal range, 88,187; viscosity, 301–2, 304, 305; waterlogged, 317–18
ink, color, *see* color ink
ink, developing, 410–11, 413, 414
ink, letterpress, 252
ink, metallic, 318
ink, roll-up, *see* roll-up ink
ink, rubbing-up, 394, 395
ink, serigraphic, 176
ink, transfer, *see* transfer ink
Ink, Triple, *see* Triple Ink
inking, 55, 58, 64*, 65*, 66–72 *passim*, 87, 88, 91*, 93, 94, 95, 101, 103, 108, 109, 110, 149, 157–60, 316; chalking, 318; filling in, 124, 158, 159, 160, 205, 206, 212, 218–19, 224, 278, 304; halo effect, 111, 259, 305; lakes, 308; lap marks, 71, 94, 219, 368, 369, 374, 396; overinking, 71–72, 108, 111, 112, 149, 187, 218–19, 302, 321, 356, 375; problems, 110–11, 317–18; roller, *see* roller, hand; rolling patterns and techniques, 71, 72, 91*, 93, 94, 103, 109, 110, 153*, 225, 365, 366–67*, 368, 369*, 372–73, 374, 375, 392*; scumming, 111, 112, 124, 144–45, 146, 147, 149, 150, 154, 156, 158, 159–60, 161, 213, 224, 249, 277, 278–79, 280, 284, 304, 306, 318, 330, 375, 398, 414; skinning, 319; tinting, 112, 160
inking equipment, 67, 87; ink knife, 67, 87, 89*, 206, 225, 293, 309*, 315, 316, 317; ink slab, 67, 87, 89*, 94, 95, 103, 108, 110, 151, 160, 206, 213, 219–20, 223*, 224, 225, 287, 302, 303*, 309*, 315, 316, 317, 368, 373, 374
Inomachi (Nacre) paper, 335–36
intaglio printing, 52, 55, 157, 159, 376, 405; comparison with color lithography, 176; photographic reproduction, 409; transfer proc-

ess, 227, 228, 231, 252
Interior with Pink Wall-paper I, II, III (from *Paysages et Intérieurs*; Vuillard), 174*
Irish seaweed: coating transfer paper, 232
iron (in stone), 264, 265, 266
iron marks (in stone), 20, 264
iron pyrites (in stone), 264*, 264–65
Isabey, Eugène, 76, 97
isopropyl alcohol, 282, 287
Italia paper, 218, 335
Italy: limestone, 263; lithography, 75; paper, 218, 331, 335, 421

Japan: paper, 113, 120, 322, 326–28, 330, 332, 335–36, 337, 340; gampi paper, 327; Gasen Shi Rampo paper, 421; kozo paper, 327; mitsumata (three forks) paper, 327; *Nagasi-Zuki* method, 328; *Tami-Zuki* method, 328; *see also* Oriental paper
Japanese baren, 252
Japanese brush, 291
Japanese prints, 170
jiffy cans, 287, 292
Jones, Allen, 170
Jones, John Paul: *Spanish Woman*, 42–43*
jute: in paper, 323

Kellheim stone, *see* Solnhofen stone
kerosene, 287, 288; clean ink-mixing equipment, 288, 315, 316, 317; clean rollers, 288, 315, 365, 370, 372, 374; clean stone, 67, 87, 89*; and crayon, 34; storage, 292; *see also* solvents
ketone, dimethyl, *see* acetone
ketone, methyl ethyl, 287
Kimwipes, 151
Kirchner, Ernst Ludwig, 186
Kistler, Lynton R., 59, 60, 76
Kistler etch table, 59, 60, 112, 377
knives, 292–93; *see also* inking equipment, ink knife
Kollwitz, Käthe: *Self-portrait*, 234*
Kleinman, Edouard, 166
Korea: paper, 322, 326–27, 340; *see also* Oriental paper
kozo paper. 327
Krushenick, Nicholas: *Untitled*, 179*

label printing, 227, 232, 376, 404–5; *see also* commercial printing
lacquer: in corrections, 396–97; as printing base, 398; in surface printing, 395, 396
lacquer thinner, 396, 398
lactol spirits, 155
Laga Velin Blanc Narcisse paper, 334
lakes (ink), 308
lamp, carbon arc: in photographic reproduction, 410, 411, 413
lamp, heat, 136, 240, 387
lampblack (carbon-black pigment), 257, 308, 310
lap marks (inking), 71, 94, 219, 368, 369, 374, 396
larch gum, 281
lard: in storage of roller, 365, 372
Lasteyrie, Charles de, 75, 76
latex: for cementing stone, 378
lay marks, *see* register marks and lay marks
leafing, metallic, 318
Léger, Fernand, 170; *Marie the Acrobat*, 171*
Lemercier: crayon formula and tusche formula, 257
Leslie, Alfred, 170
letterpress engraving, 409
letterpress ink, 252
letterpress paper, 328
levigator: in grinding (graining), 20, 24*, 26, 27*, 129, 240, 295–96, 296–99*; air-powered, 296, 297*; electric-powered, 296, 298*; Fox I Levigator, 296, 299*, 299
lifting and carting devices (for stone), 299*, 299–300, 300*
lift-off technique, 54, 387
light: injurious to prints, 117, 122; in workshop, 26, 431, 434
lime: in paper, 323, 327
lime, bisulphite of, 323
lime, chloride of, 323
limestone, *see* stone

printer: and artist, collaboration, 76, 79, 82, 84, 186, 207, 213, 217; and assistant, 84–85, 108; in proofing, 213, 217

printer's lead, 293; register marks, 96–97, 194

printer's mark: blindstamp, 114, 117; chop, 114, 117, 118*

printer's proof, see *bon à tirer* impression

printing: affected by atmosphere, 111, 256, 376, 431; color, *see* color printing; on damp paper, 228, 230, 231–32, 237, 238, 240, 241, 246, 249, 252, 286, 331, 339, 341*, 376, 414, 415, 417, 418*, 419*; double-printing, 219; on dry paper, 238, 252, 331, 414; edition printing, 103, 108–9, 114, 207, 218–21, 228, 332; ink, *see* ink; key impressions, 204, 252, 253; overprinting, 190, 191, 205, 206, 217, 218, 304, 318, 405; paper, *see* paper; press, *see* press; problems, 94–95, 110–12, 218–21; process, 90–93*, 103, 108–10; registration, *see* register marks and lay marks; size of edition, 108, 109–10; work station, 87, 89*, 435–36; *see also* individual processes; proofing

printing bases, 145, 147, 149, 151, 224; asphaltum, *see* asphaltum; benzine, 285, 387; Cornelin, 69–70, 71; ink, 149; lacquer, 398; lithotine, 149, 285; synthetic resin, 149; Triple Ink, 145, 149, 151, 152*, 162, 250, 398; vinyl acetate, 149

prints: affected by atmospheric conditions, 117, 118, 122; care of, 117, 118–19, 122; cleaning surface, 118–19; collecting, 113–14; documentation and records, 117, 120*, 426; faulty impressions destroyed, 113, 114; light as injurious to, 117, 122; margin, *see* margin; marked with blindstamp or chop, 114, 117, 118*; matting and framing, 119–20, 121*, 122; numbering, 113, 114, 115*, 117; restoration, 118; signing, 102–3, 109, 113, 114, 115*, 117; storage, 113, 117–19, 434–35

progressive proofs, 114

proofing, 58, 72, 87, 88, 89–93*, 93–95, 152–54*, 154, 155, 158, 160, 246*, 336, 405, 407, 408, 411, 421; *bon à tirer* impression, 76, 102–3, 109, 111, 113–14, 115*, 207, 212, 337, 357; cancellation proofs, 114, 116*; color, 163, 191, 192, 204, 206–7, 212–13, 214–17*, 217, 224; controls, 88; corrections, *see* corrections; after edition printing begins, 111, 112; materials and equipment, 87, 89*; presentation proofs, 114; press pressure, 356; problems, 94–95; progressive proofs, 114; before resuming printing, 109; state proofs, 114; trial proofs, 114, 213, 214–17*

proof paper, 87, 88, 93, 94, 110, 114, 207, 212–13, 218, 240, 337, 339, 407, 408; *see also* newsprint, as proof paper

pumice (block, powder): in beveling, 25*, 26; in grinding, 240, 290; in polishing, 281, 292, 375; in removing mask, 156, 398; *see also* snake slips

pyrites (in stone), 264*, 264–65

quartz crystals (in stone), 264*, 264, 266

quill: and tusche drawing, 41

rags, *see* cloth

rasps, 294–95; in beveling, 24*, 110, 294

Rauschenberg, Robert: *Booster* (*Booster and 7 Studies* series), 412*

razor blade: for corrections, 52, 54, 67, 274*, 293; to release paper, 409; *see also* blade

red (pigment), 306, 308; in bronzing and gold-leafing, 318; in color sequence, 190–91; ink, 313–14

red chalk, red oxide pigment, *see* chalk, red

red conté crayon, 28–29, 140, 232

red conté pencil, 28–29, 221

Redi-Coat wipes, 411, 413

Redon, Odilon, 97, 227, 378; *Druidesse*, 50–51*

reducing oil: as ink modifier, 206, 219, 250, 310, 311, 317

register marks and lay marks, 19, 140, 158–59; acetate sheets as overlays, 195, 220, 405; asphaltum, 198; blade, 96; in bleed printing, 409; boring tools, 198, 200*, 221, 224, 293; center-mark (T-bar) system, 194–95, 213, 214*, 220, 221, 405; chalk, 29, 54, 96, 140, 201; color printing, 163, 187, 191, 193–95, 195–97*, 198, 199–203*, 201–2, 204, 207, 212, 213, 221, 224, 252–53; crayon, 54, 140, 232; misregistration, 194, 195, 198, 220; Mylar sheets as overlays, 195, 196–97*, 213, 216*; needle, 198; for paper, 29, 54, 92*, 93–97, 95*, 96*; paper edge, 194, 214*, 215*; in papier collé printing, 421; pencil, lead, 140, 194, 195, 232; pinhole system, 198, 200–203*, 213, 216*, 217, 220, 221, 224, 405, 409; point, 96; printer's lead, 96–97, 194; problems, 220–21;

talc used to set, 195, 197*; in transfer process, 232; in transposition process, 405

Reichek, Jesse, 170; *Untitled*, 172*

relief printing, 376, 377, 406

Renoir, Pierre-Auguste, 170

resin, natural, *see* mastic; shellac

resin, synthetic, 396; as paper sizing, 232, 323, 324; as printing base, 149

resin-solvent varnishes, 304–5

resists and stop-outs: adhesives, 54; cloth, 237; gum arabic, 52, 53*, 54, 94, 100; horsehair, 237; rubber cement, 54; string, 237; tape, 54; in transfer process, 233, 237; white casein, gouache, and watercolor paint, 52, 233, 237; *see also* masking; rosin; talc

Reuter, Wilhelm: *Polyautographic Drawings by Outstanding Berlin Artists*, 75

rice paste: in paper sizing, 421

River Front (Bellows), 83*

Rives BFK paper, 218, 326, 332, 334, 335, 338; as backing sheet for papier collé, 421; as flanges in matting and framing, 122

Robert, Louis: papermaking machine, 324

rod (for registration), *see* register marks and lay marks, pinhole system

rod (for stirring), 60, 289–90

roller, hand, 70–71, 87, 94, 108, 110–11, 151, 159–60, 213, 219, 223*, 224–25, 361–63, 365, 368–70, 372–74, 376, 377, 396; affected by atmospheric conditions, 369, 370; chocks, 363, 365*, 365, 370, 373; for color printing, 260, 361, 368–70, 371*, 372–74, 377, 396; composition (glue-glycerine), 369, 370; gelatin, 369; glaze, 370, 372; grips, 110–11, 362; large-diameter, 372–74, 373*; leather, 26, 64*, 67, 69, 70–71, 72, 91*, 94, 95, 108, 109, 110, 293, 361–63, 363*, 364*, 365, 368, 369, 372, 384*, 386, 395; plastic, 370; rubber, 206, 361, 369–70, 371*; storage, 286, 287, 317, 362, 365, 370, 372, 374; stripping, 369, 370; synthetic, 206, 361, 369, 370, 371*, 372, 374; vulcanized-oil, 370, 371*, 372; *see also* inking; rolling patterns and techniques

roll-up ink, 67, 69, 70, 88, 93, 101, 108, 145, 149, 151, 154, 205, 213, 221, 301, 308, 310, 312, 313; in acid-tint technique, 386; conditioning leather roller, 362; as modifier and reducer, 250, 313, 411; modifiers and reducers in, 108, 247, 394, 407, 411; in photographic reproduction, 411, 414; in rubbing-up method, 394, 395; in transfer process, 247–48; in transposition process, 406, 407; viscosity, 302

roll-up process, 100, 101, 103, 111, 213, 219, 388, 392*, 395, 397; acid-tint technique, 382*, 384*; asphaltum drawing, 387; *manière noire* technique, 378; metal plates, 143*, 145, 149, 151, 153*, 154, 159, 160, 161, 162, 221, 249, 398; problems, 94; stone, 55, 57*, 60, 61, 65*, 67, 68, 70–72, 73, 106*, 250, 377, 406; surface printing, 396; transfer process, 238, 244*, 247; transposition process, 400*, 407, 408

rose (pigment): in color sequence, 190

rosin, powdered (rosin flour), 286; as etch resist, 62*, 63*, 65*, 66, 67, 72, 73, 87, 94, 98*, 100, 102, 104*, 111, 149, 221, 238, 245*, 248, 273, 276, 286, 377, 378, 386, 387, 392*, 395, 406, 407, 408, 411; as paper sizing, 323

rosin box, 67, 293

Rouault, Georges, 97, 378; *Burial of Hope* (*Petite Banlieue* series), 49*; *Portrait of André Suarès* (from *Souvenirs Intimes*), 33*

Royal Viking Dracula (Bengston), 185*

rubber blanket: as backing sheet, 237, 376

rubber brayer, 361, 371*, 372

rubber cement: as resist, 54

rubber hones, 67, 155, 156, 249, 292

rubber roller, 206, 361, 369–70, 371*

rubbing technique (frottage), 232–33; monotype transfers, 237

rubbing-up process, 249, 384*, 386, 389–92*, 394–95, 398, 404

Rue du Gros-Horloge (*Rouen*; Bonington), 80*

rulers, *see* straightedge; T-bar; T-square

Ruscha, Ed: *Annie*, 182*

Russia: lithography, 75

Rutherford press, 343

salt: as abrasive for leather roller, 365; as additive for tusche washes, 41, 47, 54

salt, inorganic: in etch solution, 146, 147, 268, 277, 282; in foun-

tain solution, 160, 279; *see also* bichromates; nitrates; phosphates

saltpeter: in crayon, 257

sand: as abrasive in graining, 290; as mask, 47; in *peau de crapaud* process, 144

S & H: hydraulic press, 344

sandpaper: for corrections, 52, 67, 73, 375, 376; mat edges smoothed by, 119

Satan's Saint (Hansen), 380–81*

scale, laboratory: for measuring dry chemicals, 290

scalpel: as scraping tool, 52; *see also* blade

School of Paris, 170

Schumacher brick, *see* pumice

scissors, 293

Scotch hones, 67, 72, 156

scraper bar, *see* press, hand, scraper bar

scraper box, *see* press, hand, scraper box

scraping: acid-tint technique, 387; leather roller, 362–63, 364*, 365, 368; *manière noire* technique, 378; metal plates, 154, 227, 281; stone, 49*, 52, 54, 61, 72, 100, 204, 221, 276, 375, 376, 378, 387, 388, 407; stone engraving, 376; transfer process, 233, 237; transposition process, 405; *see also* corrections

scratching: *manière noire* technique, 378; metal plates, 154, 157; stone, 49*, 52, 221, 378, 395; transfer process, 233; *see also* corrections; register marks and lay marks

scumble (dry-brush) technique, 40*, 41, 61, 66, 73, 140, 205, 233, 378, 387, 396

scumming, 111, 112, 124, 144–45, 146, 147, 149, 150, 154, 156, 158, 159–60, 161, 213, 224, 249, 277, 278–79, 280, 284, 304, 306, 318, 330, 375, 398, 414; *see also* antitint solution; tinting

seaweed: coating transfer paper, 232

Self-portrait (Kollwitz), 234*

Self-portrait with Arm Bone (Munch), 36*

Senefelder, Aloys, 75, 123, 163, 376; hand presses, 343; *Lion Killing a Deer*, 77*; tusche formulas, 257

sensitizing, *see* counteretch

serigraphy, 176; photographic reproduction, 409

set-off method, 29

set-off paper, 336, 337

Setswell compound, 219

shaving: in corrections, 157

shellac: for corrections, 396–97; in crayon, 257; in surface printing, 395, 396; in transposition process, 288, 399–403*, 406–7

shot glasses: for mixing and containing acid solutions, 101, 290

Siegal, Irene: making spot corrections, 98*; *Zippy Linnae, or The Collector*, 183*

Signac, Paul, 166

Signing and numbering prints, 102–3, 109, 113, 114, 115*, 117

silica (in stone), 265, 266

silk: and rubbing crayon, 34

silk-screen process, *see* serigraphy

silver-leafing, 318

Silver Series (Brach), 180*

Sisley, Alfred, 166

slate: in printing, 262; rubbings for monotype transfer, 237

slip sheet, *see* blotters, blotting paper; glassine; newsprint; tissue

snake slips, 67, 292, 406, 407

soap (in lithography), 256–57, 261–62, 271

soda (in stone), 266

soda, caustic, *see* caustic soda

sodium hydroxide, *see* caustic soda

sodium sulphate: in paper, 323

Solander boxes, 117–18

Solnhofen stone (Kellheim stone), 19, 20, 262–63, 266

solvents, 287–89; flash points, 287; storage, 287, 292, 436–37; *see also* acetone; alcohol; benzine; gasoline; kerosene; lithotine; mineral spirits; petroleum; turpentine

solvent tusche, *see* tusche, solvent; tusche, water; tusche washes

Spain: limestone, 263; lithography 75

Spanish Woman (Jones), 42–43*

spatter technique, 47, 140, 145, 233

spatula: mix color ink and scrape roller, 293

spermaceti: in crayon, 257

splashing technique, 233

sponge: acid-tint technique, 383*, 384*, 386; asphaltum drawing,

387; etching, 60, 67, 69, 70, 72, 73, 74, 87, 89*, 93, 98*, 100, 101, 102, 103*, 103, 106*, 110, 111, 112, 149, 150, 151, 155, 156, 159–62 *passim*, 212, 213, 294; rubbing-up process, 390*, 391*, 394, 395, 398; stipple technique, 233; stone engraving, 376; surface printing, 396

starch, 281; paper sizing, 231, 421–22

state proofs, 114

stearine: in crayon, 257

steel, stainless: in printing, 262

steel marbles: in metal-plate graining, 129, 131

stencils: in masking, 47

stick, pointed: for corrections, 156; in drawing, 41, 233

stipple technique, 140; for corrections, 73, 397; in surface printing, 396; in transfer process, 233, 247

stone (lithograph): beveling, 24*, 26, 27*, 110, 111, 294; blue, 263; breakage, 240, 263, 377, 387, 408; buff, 20, 433; canceling, 114, 116*; carbonates, 58, 67, 265, 266, 273, 274–75; cementing, 378; chalk marks, 20; chemical properties, 265–67; color, 20, 263–64, 395, 433; copper pyrites, 264–65; feldspar crystals, 20; fossils in, 262, 264, 265*, 265, 433; glaze, 284; grain structure, 265*, 274*, 275*, 404; gray, 20, 263–64, 380, 433; grinding, 20, 21–25*, 26, 27*, 114, 124, 129, 240, 255, 265, 290, 375, 378, 395, 433, 434*; gypsum crystals, 266; handling, 20, 26, 263, 377, 387, 408; heating, 240, 387; iron, 264, 265, 266; iron marks, 20, 264; iron pyrites, 264*, 264–65; level, testing for, 20, 25*, 94, 293; lifting and carting devices, 299*, 299–300, 300*; marks on, 26; and metal plates, comparison, 123–24, 129, 136, 140, 263; and paper, relationship in printing, 95–96; physical properties, 263–65; polishing, 72–73, 74, 240, 265, 281, 286, 292, 375–76, 406; protection of, 26; quartz crystals, 264*, 264, 266; selection, 19–20, 395; size, 20; Solnhofen (Kellheim), 19, 20, 262–63, 266; sources of supply, 19, 262–63, 267; storage, 26, 68, 74, 109, 114, 432*, 432–33, 433*; as support for metal plate, 136, 149, 158; veins, 20, 406, 433; as weight, 415, 422; white, 264, 266–67, 433; yellow, 20, 264, 266–67, 377, 433; *see also* individual processes and techniques

Stone with Tracks (from *L'Elémentaire;* Dubuffet), 235*

stop-outs, *see* resists and stop-outs

straightedge, 72–73, 295; for tearing paper, 293; for testing stone level, 20, 293

straw: in paper, 323

string: as resist, 237

subtractive techniques, *see* acid biting and acid-tint technique; scraping; scratching

sugar cane waste: in paper, 323

sulphuric acid, 267, 268, 285; bleaching in paper, 323; in corrections, 156

surface printing, 395–96

Surrealism, 166

Suzuki paper, 336

syrup: added to paste in transfer process, 237–38

talc, powdered (French chalk, talcum powder), 287; as cleaning agent to absorb solvent, 110–11, 220, 221, 287, 288, 317, 351, 360, 372, 374; as etch resist, 62*, 65, 66, 67, 70, 72, 73, 87, 89*, 93, 94, 99*, 100, 101, 102, 103, 104*, 109, 110, 111, 142*, 144*, 145, 149, 154*, 155, 156, 157, 159, 160, 161, 162, 221, 238, 243*, 247, 248, 250, 253, 256, 273, 276, 280, 287, 293, 377, 378, 386, 387, 389*, 391*, 392*, 394–98 *passim*, 399*, 406, 407, 408, 411, 414; to prolong life of gum arabic, 282

talc box, 293

tallow, mutton: for conditioning and storing leather roller, 286, 362, 365, 372; in crayon and tusche, 256, 257; in stone engraving, 376; as tympan lubricant, 286, 352

Tamarind Lithography Workshop, 170

Tam-O-Shanter sticks, 292

tannic acid, 285; in etch solution, 59, 60, 146, 147, 271, 273–75, 277, 285; in fountain solution, 279; in stone relief, 377

tape, 293, 295; marking stone position, 96; in matting and framing, 119, 120; as resist, 54

tap-out: in mixing and matching color ink, 315, 316, 317

tarlatan pad, 376

Taylor, Baron: *Les Voyages pittoresques et romantiques dans l'ancienne France*, 75–76